War, Occupation, and Creativity

War, Occupation,

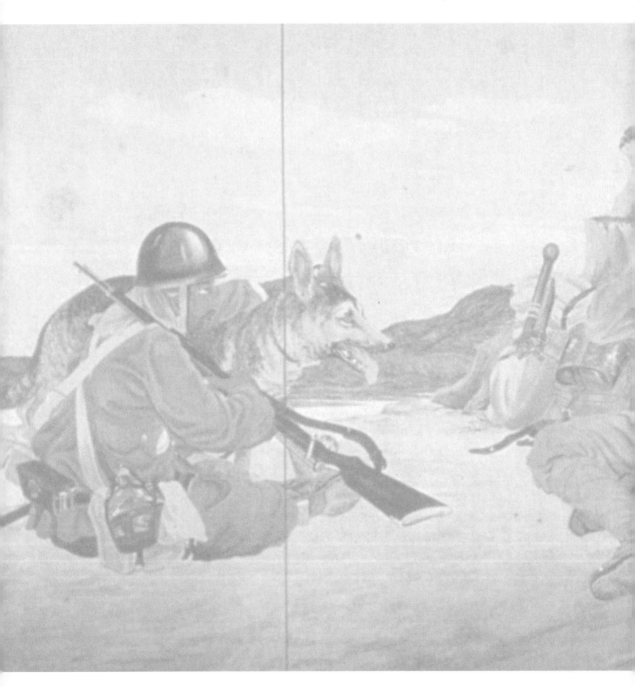

and Creativity

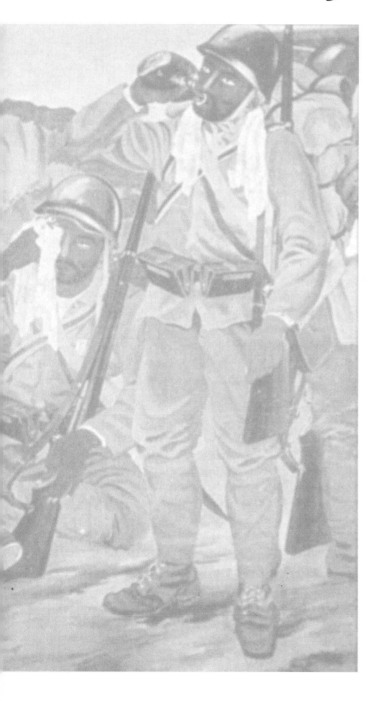

Japan and East Asia 1920–1960

Edited by

MARLENE J. MAYO

and

J. THOMAS RIMER

with

H. ELEANOR KERKHAM

University of Hawai'i Press

Honolulu

Library of Congress Cataloging-in-Publication Data
War, occupation, and creativity :
Japan and East Asia, 1920–1960 / edited by Marlene J. Mayo
and J. Thomas Rimer with H. Eleanor Kerkham.
p. cm.
Includes index.
ISBN 0–8248–3022–9 (cloth : alk. paper) —
ISBN 0–8248–2433–4 (pbk. : alk. paper)
1. Arts, East Asian. 2. Arts, Modern—20th century—East Asia.
3. East Asia—Intellectual life—20th century.
4. Korean War, 1950–1953—Art and the war.
5. Sino-Japanese Conflict, 1937–1945—Art and the war.
I. Mayo, Marlene J. II. Rimer, J. Thomas. III. Kerkham, H. Eleanor.
NX582.W37 2001
700'.95'0904—dc21 00–064894

Designed by Josie Herr

Printed by Thomson-Shore

To the memory of
our late colleagues, friends,
and dedicated scholar-teachers,
Dr. Mark Howard Sandler (1945–1997)
and
Dr. Alan Stephen Wolfe (1944–1998)

Contents

Contents

Black-and-white plates follow pages 114 and 146.

Acknowledgments

The genesis of this volume was a conference entitled "War, Reconstruction, and Creativity in East Asia, 1920–1960," which was held at the University of Maryland at College Park in 1992. This was followed by various presentations at the University Seminar on Modern Japan, Columbia University; the Mid-Atlantic Regional Association for Asian Studies; and the New York Conference, Association for Asian Studies, 1993–1997. The purpose of the original conference was to draw attention to the special problems and creative works of writers and artists in China and Japan and in Japanese-occupied Taiwan and Korea in the years before, during, and after World War II in the Pacific and East Asia. This was also a time that coincided with colonization and decolonization, both Japanese and Euro-American, as well as with the aftermath in East Asia of two global wars. Participants were scholars from Japan, South Korea, Taiwan, Britain, and the United States and represented the disciplines of history and the humanities and the behavioral and social sciences.

In planning the volume, we interpreted creativity broadly to include not only poets, playwrights, actors, and painters of East Asia but also filmmakers, actors, and cartoonists. Their inner drives and individual talents as creators were exhibited, 1920 to 1960, in the myriad guises of conquerors, colonized or decolonized. Some were courageous and defiant; others were assertively nationalistic or compliant and self-deceiving. Our common denominators were cultural imperialism and total war in East Asia, primarily as prosecuted by the Japanese state and people but fashioned in a world of Western European and American domination and ongoing revolution in China. We wished to explore the creative process in times of extraordinary disruption and of extensive imposition of artistic controls.

As principal organizers of the initial conference and as supporters of subsequent lectures and seminars, we are indebted to the deans, College of Arts and Humanities and College of Behavioral and Social Sciences, to the Inter-College Committee on East Asian Studies, and to the Office of International Affairs, University of Maryland at College Park, our primary sources of funding over the years. The Korea Foundation, Hōsei University in Tokyo, and the Cultural Cooperation Committee of Taiwan also helped our overseas participants with travel grants. We owe a special thank-you to an interdisciplinary campus subcommittee of scholars of East Asia, consisting of Professors Eleanor Kerkham, Jason Kuo, Mark Sandler, and Angelina Yee.

We are especially grateful to the Washington and Southeast Regional Seminar on Japan for providing large, expert, and perceptive audiences for our original

panels as well as additional financial assistance. Professor Richard Rice of the University of Tennessee, chair of the seminar, gave enthusiastic support and was a spirited and lively moderator, combining tact, humor, and discipline. We have been the beneficiaries of superb secretarial service and office support beyond the call of duty and wish to thank Darlene King of the History Department, Mary Mahoney of the Department of Asian and East European Languages and Literatures, University of Maryland, and Paula Locante, Department of East Asian Languages and Literatures, University of Pittsburgh. We owe a great debt to our friend Jun Aramaki for his expert help with difficult Japanese phrases and with translations and to Martha Ann Bari for her help in seeking out illustrations for Mark Sandler's essay. Christina Canova deserves a special thank you for her expertise in locating rare photographs.

In tribute to the good work of our original participants, much larger than represented in this volume, we look back upon our time with them as one of the highlights of our intellectual lives. We came together as scholars of wide-ranging interests and disparate views to address issues of common concern in the study of twentieth-century East Asia. We came away a little less parochial in our separate disciplines, geographic areas, and eras of concentration and far more aware of common themes and problems. We learned that on certain topics, there is still much reluctance to speak out, to publish, or to hold exhibitions; the politics of memory and identity, censorship and self-censorship, and nativist sentiment continues to distort or dampen discourse. We are pleased to see new work beginning to appear on Japanese, Korean, and Taiwanese creative life during the colonial and wartime periods—painting, popular songs, jazz, theater, dance, and radio broadcasting—as well as a continuing body of important scholarship on the art, literature, and cinema of the atomic bomb. China's war of resistance against Japan has been increasingly well represented in studies of popular culture, literature, and painting. Much still remains to be done on East Asian writers and artists and their perceptions of the Nanjing Massacre, Japanese prison life in the Soviet Gulag, the forced labor of Koreans and Taiwanese in wartime Japan, and postcolonial Korea during the American and Soviet occupations and the Korean War.

As scholars, we too have often confronted barriers in another form—arbitrary rules, closure of doors, limited access to books, records, or works of art in various libraries, archives, and museums. We render homage to those librarians and archivists here and abroad, often underfunded and overworked, who have not only organized and preserved but have also made readily accessible the sources we need to document the past and to pursue academic freedom. Among the many who have been indispensable in our labors are John Taylor and Will Mahoney, Modern Military Branch, National Archives (College Park, MD); Edward Boone and James Zobel, past and current curators, Douglas MacArthur Memorial and Archives (Norfolk, VA); Kuang-yao Fan and Kenneth Tanaka of the East Asian Collection and Amy Wasserstrom of the Prange Collection, McKeldin Library, University of Maryland; Yoko Akiba and Judy Liu, Asian Division, Library of Congress; Sachie

Noguchi, East Asian Library, University of Pittsburgh; Koide Izumi, Librarian, International House of Japan, Tokyo. We have profited immensely from the growing body of recent scholarship on the art and literature of twentieth-century global war, totalitarian regimes, foreign occupations, and nationalist resistance and hope that our volume in turn will inspire continuing and deepening exploration of creativity in twentieth-century East Asia, including issues of class, gender, and race. Our initial deliberations were much enlivened by the presence of Joseph R. Allen (Washington University, St. Louis), Poshek Fu (University of Illinois at Urbana-Champagne), Jeanne Paik Kaufman (independent scholar), Bonnie Oh (Georgetown University), the late Marshall Phil (University of Hawai'i at Mānoa), Miriam Silverberg (University of California at Los Angeles), John Solt (independent scholar), Michael Sullivan (Oxford University), and David Wang (Columbia University).

We have been deeply saddened by the untimely deaths in 1997 and 1998 of two of our original participants and close colleagues, Mark H. Sandler and Alan Wolfe. The Department of Art History and Archaeology, University of Maryland, has memorialized Mark with an excellence in teaching award, to be given annually to a graduate assistant for outstanding teaching performance. The University of Oregon has posthumously honored Alan with the Charles E. Johnson Memorial Award and established the Alan Wolfe Memorial Lecture. We too wish to honor these two scholars and friends and to dedicate this volume to their memories and to their splendid years of devoted teaching and scholarship.

The preparation of this manuscript, involving so many authors, languages, and subjects, has been a complicated process. We would like to thank especially our copy editor, Mr. Lee S. Motteler, who did a truly superior job with a difficult task, as well as Mary Mortensen for her timely and thoughtful help in preparing the index, and our managing editor, Cheri Dunn, who helped us move the manuscript through so many stages. In particular we would like to thank our editor, Patricia Crosby, of the University of Hawai'i Press, who has been a constant source of inspiration, guidance, friendship, and support through this long process.

Finally, we would like to thank the Japanese History and Humanities Workshop, University of Maryland, the Asian Studies Program and Japan Council of the University of Pittsburgh, and Mary Jane Edwards Endowed Publication Fund of the University of Pittsburgh for their generous help in supporting the publication of this volume.

MARLENE J. MAYO, *University of Maryland*
J. THOMAS RIMER, *University of Pittsburgh*

A Note on Transliteration

For transliteration of names, terms, and places into English, we have used systems in current standard use: pinyin for Chinese, Hepburn for Japanese, and modified McCune-Reischauer for Korean. We have also followed the accepted name order in East Asia—family names first and personal names second—except in those cases where authors have reversed this order for Western language publications. In deference to certain of our contributors, we have indicated preferred romanizations of their names. We have not added diacritical marks, such as macrons for well-known Japanese place names such as Tokyo, or in cases where they are not used in official U.S. documents or in English language titles.

Introduction

Marlene J. Mayo

IF RECENT DECADES HAVE TAUGHT US nothing else in the twentieth century, they have forced us to concede that no statement is a neutral statement; no art, however pure, can be created or understood apart from the politics of its time. Conversely, the real significance of those same politics, sometimes half-hidden, can often find distinctive and revealing reflections in the arts.

In the period of East Asian history chosen for this volume, the years from 1920 to 1960, the politics of imperial Japan and its complex and bewildering interrelationships with East Asia in the aftermath of World War I and with global America following World War II have been relatively well researched and studied.[1] Yet what might be called the aesthetic life of the period, as evidenced in such important areas of human creativity as literature and the visual and performing arts in Japan and in its colonies, has received relatively little scholarly attention in the West. Edward Said prompted and continues to inspire wide-ranging scholarly discourse with his books—*Orientalism* (1978) and *Culture and Imperialism* (1993)—and many articles, but his original focus was largely on European representations of cultural power and cultural penetrations in Africa and the Middle East.[2] For Japan, Stephan Tanaka has helped to initiate the task of exploring alterity, the problematics of East Asian adaptation to modern and Western civilization, and of the Japanese imperial project in *Japan's Orient: Rendering Pasts into History* (1993), a work concerned primarily with China as Japan's Other in the formulation of *Tōyōshi* (Eastern History) by Shiratori Kurakichi, professor of Oriental History at Tokyo Imperial University (1905–1924) and one of the founders of the Research Bureau of the South Manchuria Railway. The inaugural issue of the journal *Positions, East Asia Cultures Critique* (Spring 1993), which was devoted exclusively to colonial modernity, has moved scholarship forward in content and theoretical constructs.[3]

Otherwise, Japan's cultural imperialism in eastern Asia, particularly in its colonies, remains a relatively obscure and underexplored phenomenon in Western studies of imperial Japan, which still tend to emphasize strategic, economic, or political questions.

Though sporadically addressed by scholars in the West—most notably in essays on wartime literature written in the 1970s by Donald Keene and more recently in a book on changing views of war in modern Japanese poetry by Steve Rabson in the 1990s—the responses of Japan's creative artists to aggression and full-scale war against China and to the creation of Greater East Asia (1937–1945) have also not been pursued with the same rigorous intensity as the strategy, politics, and economics of Japan's modern warfare. The same is true for cultural politics and the fate of Japan's arts during the Allied Occupation (1945–1953), as the spread of the Cold War in Asia and the American dream replaced the militarist vision of a Greater East Asia under Japanese dominance and benevolence.

The present volume represents what we believe to be the first systematic, interdisciplinary attempt to address the social, political, and spiritual significance of the modern arts both in Japan and its empire—and former empire following defeat in World War II—during the period from 1920 to 1960. It looks at interconnections between the arts in the metropole *(naichi)* and in the peripheries *(gaichi),* in particular cultural modernity in the aesthetics of the homeland and its reproductions and assimilations in the colonial sphere. It takes a transwar (rather than an interwar) approach in an attempt to explore links between the post–World War I and World War II eras while at the same time examining the compliance of Japanese artists with colonialism, aggression, and war crimes.

Within the realm of empire, the emphasis of the volume is on Taiwan and Korea, the earliest full-fledged colonies of imperial Japan. The former, a prefecture of China when it was annexed in 1895, and the latter, an independent kingdom with a long history of political and linguistic unity when it was made into a protectorate in 1905, then appropriated in 1910, became regions of Japanese colonial administration and police control, economic development and exploitation, and cultural domination. In both cases, liberation at the end of World War II brought new forms of foreign domination, as did defeat to Japan. Most of the Japanese, Korean, and Taiwanese writers and artists treated here, despite their fame and significance in East Asian history and culture, are discussed in depth for the first time in English scholarship. All are presented within a dual framework of Japanese and European/American imperial power in East Asia and of Japanese-mediated cultural modernity.

The essays begin in the 1920s and the aftermath of World War I. This was a time of party governments, mass culture, and proletarian movements in Japan, but—as with the great Western powers—retention of empire in nearby East Asia, where new cultural policies were inaugurated in Korea in the wake of the March First Independence Movement of 1919 and in Taiwan to accommodate the home rule movement. They continue into the 1930s, with intensification of Japanese

aggression in China and total war in the Pacific and East Asia (1937–1945), accompanied by accelerated cultural absorption of the colonies, and next address Japan's defeat, Allied Occupation, and post-occupation dependency on the United States (1945–1960). Elsewhere, Japan's loss of empire initially meant liberation for former colonies and territories but swiftly turned into postcolonial strife in Nationalist Taiwan and a divided Korea soon to suffer the onset of the Korean War. By 1960, the terminating point of the narrative, massive riots in Japan had helped to topple a conservative party cabinet, which itself had strong connections to the 1930s; rebellion in South Korea had brought down the long postwar regime of Syngman Rhee; and Taiwan was enmeshed in bitter tensions between disillusioned islanders and dominant Nationalist newcomers from the Chinese mainland. These forty years, punctuated by war, occupation, and reconstruction, were turbulent, brutal, and harsh, but also important and even productive for the arts. During this time, Japan played multiple roles of occupier and occupied, colonizing and colonized, recreator of the modern and inventor of tradition, teacher and disciple, and victimizer and victim. The colonized were pupils, dissenters, rebels, collaborationists, and postcolonialists.

As we turn to the creative arts during this period, we see perhaps greater fluidity of interconnections than domination and discrimination would suggest. As does Sonia Ryang in her study of Japanese travelers to Korea, we leave "totalization aside and shift our attention to a field," in this case poetry, fiction, and painting, "where aspects of colonialism allow us to entertain a richer analysis," and perhaps widen "the range of discussion on the colonial past and its relation to the postcolonial present of both the colonizer and the colonized."[4] Japan, in state and nonofficial guises, both facilitated and frustrated literary and artistic expression, satisfied and controlled colonial artistic curiosity about the modern, and guided colonial judgments while molding artistic tastes. As a starting point, Japanese writers and artists themselves experienced in bewildering succession from 1920 to 1960 a liberal interlude of party democracy and pacifist internationalism, state expansion and aggression in China and East Asia, defeat in total war and loss of empire, followed by foreign occupation and domestic reconstruction. Throughout the entire period, various forms of official guidance and of state censorship and self-censorship were a constant factor in the lives of artists and writers in Japan and its conquests. The 1930s brought forced public recantations or *tenkō* of leftist or radical views, imprisonment for resisters, and recruitment of leading artists for war propaganda. Yet even as Japan's creative world celebrated the end of domestic media controls in 1945 and looked to the possibilities of an era of freer expression and reflective discourse, the nation was forced to deal with external forms of manipulation and reeducation imposed by an American-led Allied Occupation (1945–1952), one that became increasingly preoccupied with the emerging Cold War in Asia.

Long-held resentments of white imperialism in Asia, the shock of American firebombs and atomic bombs, and the physical and spiritual devastation that pre-

vailed in the years of occupied Japan helped to dim remembrance among many Japanese of their nation's own cultural imperialism and record of aggression and violence—its numbing destruction on the war fronts of China, Southeast Asia, and islands of the Pacific. Alive to their own pain and caught in the spread of the American dream in Asia, Japanese remained largely oblivious to their former colonial enterprise and its demeaning relations with Taiwanese and Koreans. Though the effects of total war in Asia were highly visible, artists of early postwar Japan were often indifferent to their moral responsibility or compliance with the prior colonial and wartime state or preferred to overlook expressions of aggressive nationalism in their wartime works (even omitting them from supposedly definitive collections). The complexities of historical forgetting and remembering in Japan's media and arts after the 1950s continued, with partial if not complete amnesia in the 1990s. As domestic and foreign critics of postwar Japan have long lamented, victim's justice began to supplant victor's justice in formal education, the mass media, and the arts, although greatly challenged in the 1990s by fifty-year public, private, academic, and mass media anniversaries relating to World War II in East Asia and the Pacific.

In this same period, former colonial peoples often preferred to forget what had been learned under Japanese control, while choosing to remember what had been suffered and endured. Before their takeover by Japan, Taiwan and especially Korea had prior though short histories of struggling with concepts of the new, the enlightened, or the modern in literature and art. In an erasure or negation of a valued past in the colonies, imperial Japan was self-consciously *naichi*—the inner land, the homeland, the metropole. Korea and Taiwan were marginalized as *gaichi*—the exterior or the outer lands. To these imagined backward lands, Japan brought elementary education, roads and railways, and harbor development. It implanted its language and forms of mass media and communications. It sent not only immigrants, tourists, and travelers but also administrators, soldiers, educators, engineers, and business managers. Among the educators and travelers were teachers and patrons of art, drama, and literature. Japan acted as the mediator of the modern in the popular culture and fine arts as well as in business, technology, and industry. Japanese played multiple roles as observers, adapters, and borrowers as well as teachers of modern Western literary and art idioms and strategies. In Korea, Japan also ironically presided over increased use of the han'gul vernacular script in Korean writing. In Taiwan, it could not insulate the population entirely from its earlier Chinese classical legacies or from the effects of the new literature and vernacular language of the May Fourth Movement and New Culture Movement on the mainland. Resident Japanese formed local poetry and art circles in the colonies; they participated together with colonial subjects in art exhibitions and published poems and stories in local outlets. In the heyday of enlightened Japanese cultural policy, the 1920s and early 1930s, Korean and Taiwanese students reversed the flow, flocking to Japan—especially to Tokyo and Kyoto—for a higher education not yet readily available to them in the colonies. A few among them, encour-

aged by resident Japanese teachers, went for advanced training in modern painting and literature or to mingle with Japanese artists. Once there, they gained technical skills, polished their Japanese, and joined student associations. And there, as in their colonized homelands, they often met with discrimination. As Miriam Silverberg points out, Korea (and the same could be said of Taiwan) was not defined as a "comparable cultural" land; cultural assimilation did not extend to cultural equality.⁵ Forced integration, or the making of imperial subjects, presented to local nativists the absurdity of becoming one in a hierarchy dominated by Japan. A Korea or a Taiwan united with Japan could only be a Korea or a Taiwan without national or ethnic identity. By 1940, it was a Korea of lost family names and of lost public language, as Japan required the taking of Japanese names for registration and made its language compulsory in the schools and media. In Taiwan, too, where measures were somewhat less severe and some elite Taiwanese families volunteered to take Japanese names, Japan was nevertheless intent on eradicating a prior identity and refashioning a *Tōyō*/Japan supraidentity.⁶

In the middle and late 1930s, as Japanese colonial administration turned harsh again in the wake of the Manchurian invasion and takeover (1931–1932) and the beginnings of full-scale war with China in the fall of 1937, Koreans and Taiwanese began arriving in Japan in much larger numbers as voluntary or forced labor, including men to work in mines and women solicited for the restaurant and bar trade. The Japanese colonial presence expanded as well. During the ensuing wars with China and the West, women of the Japanese Empire, especially young Korean women, were cajoled or forced into military sexual slavery for the Japanese armed forces. Although there was no land fighting in the Korean peninsula, men were conscripted for military service, laborers were engaged in vast internal migrations for war-related work, and, as in Japan, local artists and writers were mobilized for war propaganda. The same would be true for Taiwan, which acquired increasing strategic and logistical importance when the Sino-Japanese war moved southward. Taiwan became a training camp for warfare in Southeast Asia and home for the Tenth Army, as well as a complex of airfields and naval bases for strikes against Allied positions and shipping and a military supply depot. Although Allied troops did not invade Taiwan, islanders experienced a steady and destructive pounding from American bombing raids that accompanied General MacArthur's return to the Philippines in October 1944 and continued to war's end in August 1945.

In August and September 1945, Koreans and Taiwanese were released from long decades of increasingly repressive Japanese rule. The joys, however, of long-dreamed-for liberation were soon dampened as their homelands fell under new waves of external domination or civil strife, complicating the search for autonomy or full sovereignty. For Koreans, there was the blow of forced political division between north and south, the imposition of Soviet and American occupations until 1948, and the lacerations of the Korean War (1950–1953). Taiwan quickly became the destination of a Nationalist Chinese retreat from the mainland during a losing civil war with the Chinese Communists. In February 1947, Nationalist

troops brutally suppressed rebellious Taiwanese civilians, with great loss of life. By then, public use of the Japanese language was banned and large-scale resinicization was underway through compulsory introduction of Mandarin Chinese in administration and the schools. Well into the 1950s, artists and writers, many of them Japanized, were forced to conform to the rule of orthodox Chinese learning.

Japanese artists and writers, too, had to confront renewed issues of cultural identity and conformity with Western guidance. In 1945, Japan suffered the escalating agony of military losses and of firebombing and atomic bombing; Okinawa underwent the searing experience of Allied invasion. War and its effects were fully visible to the writers and artists of Japan. In Allied-occupied Japan, along with the miseries of defeat and hopes for physical recovery and reconstruction, there was also great fear of cultural wars with the victors—of erosion of national identity and of new forms of American-imposed modernity. Concomitant with the emerging Cold War in Asia, local women continued to be recruited to provide sexual services to soldiers, but this time to Americans in occupied Japan and in liberated South Korea and Nationalist Taiwan.

In this volume, we have therefore attempted to address not only memory losses but also a serious imbalance in Western studies of imperial and occupied Japan and of postcolonial East Asia, one that continues to distort representations of the modern and of creativity in East Asia. We have provided studies of the arts in Japanese-occupied Korea and Taiwan together with the responses of Japan's artists and writers to expansion and war in Greater East Asia and to ultimate defeat. This is, in part, also to complement a much larger body of ongoing research on the arts in twentieth-century China and on Sino-Japanese cultural relations and warfare. In mainland China, an arena of competitive Western and Japanese imperialisms and of civil war and fractured relations between Communists and Nationalists from the 1920s to 1949, Chinese writers and artists marched into exile in the middle and late 1930s to live and work with like-minded compatriots either in Communist Yenan or Nationalist Chungking. Many others remained in the cities and hinterlands of eastern China and Manchuria, where they recast their previous struggle to make creative statements against Western domination of the treaty ports into a new war of posters and paintings, songs, poems, and stories directed against Japanese aggression.[7] But for the mainland Chinese, too, there was a colonial gaze, one that was directed toward a lesser Orient of neighboring peoples— one that did not valorize the modern creative experiences of Taiwan and Korea. Added to this was a long history of oscillating, mostly dismissive Chinese views of Japan, one however much tempered by the Meiji Restoration and its aftermath.[8]

In addressing this period of forty years, individual contributors to our volume have ranged widely in their examination of art and creativity in the Japanese metropole and in Korea and Taiwan as areas of Japanese expansion and domination and of nativist reappropriation. They have followed Japanese writers and artists to wartime China as informal empire and border incursions were transformed in the 1930s into total war and a new thrust into Greater East Asia. And

they have examined the responses of Japan's cultural world to the great turnabout in 1945—defeat, foreign occupation, and reconstruction. Their scholarship and observations vary in approach from nonjudgmental or dispassionate to highly critical, and they distinguish between art that takes war, revolution, or occupation as its subject and art that is produced within a colonial, wartime, or postwar/postcolonial reconstructionist setting. For aggressors, collaborators, resisters, and victims, there was the production of art and literature in the service of the state or in the cause of national liberation. Contributors have looked at many different kinds and forms of creative activity in Japan and its empire for artistic content and aesthetic value but also for representations in art of the barbarism and savagery of total war, the quest for identity of subject peoples, and the exhilaration of national liberation or rebirth. In the Japanese colonies of Taiwan and Korea, where policies changed from moderately liberal in the 1920s to increasingly repressive in the 1930s, they have examined the double problem of the development of modern art and literature under Japanese colonial tutelage and constraints and of simultaneous resistance against Japanese colonial domination and cultural interference. As an added irony, suggest several contributors, the Japanese themselves were still in the process of assimilating Western artistic forms and techniques as they attempted to create their own modern styles and canons while self-consciously devising a means to deepen Asian and world understanding of the beauty of Japan's traditional culture. The wartime period would feature debates about "overcoming the modern" together with the rhetoric of Asia for the Asians. The victorious Allies who entered defeated Japan were much more in a mood to reform and punish their enemies (a resumption of the white man's/woman's burden?) than to admire Japanese culture, but they would also struggle with the imposition of an appropriate arts policy.

Part 1, Empire: Occupied Territories, provides evidence governing the creative lives of writers and painters who, working within the ever-increasing strictures of the Japanese colonial administrations in Korea and Taiwan, managed to find a means to develop and nurture their art. Japanese patronized artists as belonging to inferior cultures while simultaneously transmitting Japanese reconstructions of European artistic criteria of evaluation and putting into place a modern economic infrastructure to benefit the home country. In Korea and Taiwan, they increasingly confronted cultural policies of *kōminka*, forced transformation into loyal and obedient imperial subjects, and *dōka*, assimilation into Japanese culture with attendant loss of ethnic or national identity. Many of their artistic concerns are encapsulated in the first essay of this section, in which David McCann discusses the unspoken or perhaps ideologically imputed subjects of self, nation, and gender in the work of Sowŏl (Kim Chongsik), a popular Korean poet of the twentieth century who first achieved fame in colonial Korea in the 1920s. Writing in the Korean language, not Japanese, he composed his poems in the aftermath of the March First Independence Movement of 1919 during a time of liberalized cultural policy and heightened mastery of han'gul. In offering multiple readings or meanings of

one of Sowŏl's famous poems, McCann not only explores aesthetic issues but also questions the utilization of postcolonial nationalist mythologies in manufacturing definitions. True cultural heroes must be seen as addressing issues of Korean national identity in their art or as evading collaboration with Japanese oppression. A poet's melancholy must therefore be read as Korea's melancholy during Japan's occupation, not merely as a statement about the human condition or the individual poet's condition. Sowŏl died young and so escaped the subsequent dilemmas of intensified *kōminka* and wartime collaboration.[9]

In the next essay, Angelina Yee explores the problem of literary expression under the Japanese colonial regime in Taiwan. Writers, given the political realities in which they found themselves or in response to schooling in Japanese and their acquired skill and comfort in utilizing a foreign language, often chose to write in Japanese. This choice too was made in order to reach a cosmopolitan and potentially sympathetic public in Japan. In Taiwan's case, there were far fewer print outlets in Chinese than in Japanese, and full development of a vernacular native Taiwanese script and literature were in the future. Yee traces the complex case of a Taiwanese short story writer and novelist, Yang Kui, who lived most of his professional life in Taiwan and whose career spans the interwar and postwar periods.

As a colonial youth who managed to acquire higher education in Japan, Yang composed fiction in Japanese, first attracting attention in the metropole with a short story in 1934 but earning fame more broadly in East Asia through almost immediate translation (by others) of his work into Chinese. He became more rebellious after the mid-1930s, emerging as a proletariat author but having little option other than to continue to compose in Japanese as war came to Taiwan. Yee further pursues the postcolonial condition as reflected in Yang's career after 1945. With the liberation of Taiwan and the arrival of Chinese Nationalist mainlanders, he was a perfect target for the policy of resinicization of Japanized Taiwanese. Literature in Japanese was banned as was official use of the Japanese language. For his involvement in the February 1947 Incident and leftist sympathies, Wang was imprisoned for an extensive period, ending in 1960, the termination point of this volume. He was to spend the remaining years of his long literary career translating his older work, writing new stories in Mandarin Chinese, and establishing links to a younger and much differently educated postwar generation, including his grandchildren.[10]

Yang's fiction, in addition to its important niche in the literature of modern Taiwan, is also, from the perspective of Japan, part of a body of *gaichi* or colonial works that has only recently been elevated in Japan to serious, systematic study. For literature, the term denotes poetry and fiction written in Japanese not only by colonial authors but also by Japanese born in Korea, Taiwan, or Manchuria and Mongolia, or by longtime Japanese residents in these territories.[11] It is more difficult to find and study counterparts to Yang among Korean authors. Although extensive research continues on the origins and development of modern twenti-

eth-century literature in han'gul, including the literature of exile or diaspora, little scholarly work has been done on Korean fiction and poetry written originally in Japanese by Koreans, such as novelist and essayist Yi Kwangsu or poet Yi Sang— or by Japanese nationals either born in Korea or temporarily living there.[12] Another genre that deserves attention is Korean literature written in Japanese by Koreans resident in Japan—*zainichi bungaku*, or a form of "minority literature" as characterized by Beverly Nelson, who has introduced the work of Ri Kaisei (Yi Hoesǒng), a postwar Korean Japanese writer born in Sakhalin in 1935 and relocated with his family permanently to Japan in 1947.

An important but obscure link in this literature is the work of Korean-born writers who left Korea for education or careers in Japan in the 1930s and remained there. One such author is Chang Kyok-chu (1905–1996), who first earned critical favor with short stories in the proletariat vein published in Japan in Japanese (1932–1933), winning the *Kaizō* magazine prize in 1933. He also gained distinction as the sole colonial writer to be included in a 1939 compilation of synoposes, *Introduction to Modern Japanese Literature* (Tokyo), itself a work of cultural pride edited by the Kokusai Bunka Shinkōkai (International Cultural Society) and directed toward a Western audience. Contributing editor Yoshikazu Kataoka, in praising the young Korean author's prize-winning story of village life, "Kwon to iu Otoko" (A Man Called Kwon—in Japanese, Gon), called it a "special work," set in Korea, "a territory of a special significance to this country." He credited Chang (then known as Chō Kok Chū) with achieving "a certain degree of success" in depicting Korea's "local color, its peculiar customs and manners, the power of its landowner," and "the ugly sinuosities of elementary school teachers." Discredited by fellow Koreans for his zealous support of Japan's wartime goals, Chang elected to remain in postwar Japan with his Japanese wife and family, assuming the Japanese name Noguchi Kakuchū and continuing to publish—but as a marginal author. Norma Field has made an eloquent case for research on postwar resident Korean authors, including women.[13]

Next we enter the world of the visual arts and modernity in the colonies with essays by Youngna Kim (Kim Yongna) and Wang Hsiu-hsiung (Wang Xiuxiong), centering on the role of overseas training in Japan and on official exhibits in fostering taste and styles and providing public outlets and acclaim. In both Korea and in Taiwan, Japanese colonial authorities encouraged annual official art exhibitions modeled on those held in Tokyo. These were inaugurated in Korea in 1922 and in Taiwan in 1927 as part of Japan's new and enlightened cultural policy in the aftermath of World War I and colonial rebellion and protest.[14] The tendency was to recruit judges for screening committees and for prizes from the ranks of leading artists in Japan or from resident Japanese artists. Although colonial painters organized private forums as well, selection for official exhibition was by far the most important way for aspiring Taiwanese and Korean painters to gain fame and income. Exhibits became many things and served many purposes: important venues for public art, a training ground for participants, and a channel of cultural

imperialism in fostering approved themes and styles—both Western and Japanese. Japanese art teachers welcomed the expression of a Korean or Taiwan sensibility, whether arising from an exoticized or romanticized treatment of local scenery and daily scenes or as a way of respecting different customs and scenery or of patronizing local pride. As in Japan, young students received their initial training in Western-style drawing or watercolors at the elementary school level, usually from Japanese teachers. Discriminated against in admission to institutions of higher learning, which favored children of resident Japanese families, and lacking professional art academies at home, those with artistic talent matured either in normal colleges or in the studios of private instructors. The more gifted or driven Korean and Taiwanese painters went off to Japan for advanced training during the 1920s and 1930s. Very few managed to travel directly to the source in Europe or in the United States. Colonial art students also vied, often successfully, for selection and prizes in official exhibits in Tokyo, and the more venturous and experimental joined avant-garde groups. Japanese artists mediated both *seiyōga*, Western or oil painting or watercolors, and *tōyōga*, Eastern painting—in reality *nihonga*, or relabeled Japanese-style painting. In a double bind of cultural imperialism, *yōga* art reflected Japan's successful confrontation with the hegemonic West, whereas *nihonga* styles conveyed Japan's sense of cultural superiority and distinctiveness. By the end of the 1930s to 1945, colonial artists at home and the handful living in Japan, like their literary counterparts, had to make wrenching decisions involving protest, alternative employment, or wartime collaboration.[15]

Youngna Kim, in her essay on modern Korean painting in the 1930s—mainly works done in oil—raises additional questions of refracted tutelage. This was a process by which aspiring Korean artists learned to paint in Korea, often from Japanese mentors, followed by advanced training in professional schools in Japan with professors whose artistic goals were derived from modern European art or who were themselves trained in France or in Germany. Hers is one of the first extended essays on modern painting in Japanese-occupied Korea to appear in English, and she offers a wide range of illustrations, from landscapes and urban life to nudes and portraits. Until recently, this has not been an overly popular or well-researched topic. It has been hampered not only by the paucity, perhaps even suppression, of materials but even more so by bitter memories of the Japanese colonial presence. It has been more delicate or more difficult in Korea than in Taiwan to recognize the role of resident Japanese art teachers and the nature of personal relationships between Japanese and Koreans in the common pursuit of modern art. The official exhibitions featured works by resident Japanese, both amateur and professional, as well as by Korean competitors, but obscurity surrounds the number of prizes that went to Koreans and the range of subjects that were favored or discouraged. Although not central to Kim's study, the art scene in Korea was also very much affected by the continuing popularity of Chinese-derived Eastern-style painting and calligraphy, as well as by newer styles of Japanese *nihonga*. The conservative thrust in Western-style art resulting from official art exhibitions, in combination

with the intensified assimilation policies that accompanied Japan's escalating aggression in China, left little room for avant-garde experimentation at home or in Japan.

Although Kim confirms that Korean artists, for a variety of motives and pressures, participated in Japan's Greater East Asia propaganda war, a detailed study of collaboration remains difficult and controversial because of scarce materials and postwar identity politics. In the confusion of liberation, division, and war (1945–1953), North Koreans fled south, leftist sympathizers went north, and perceived cultural enemies were kidnapped or disappeared. Many paintings were lost, destroyed, or concealed. Nevertheless, there has been much renewed effort among a new generation of Korean art scholars in the 1990s, as cultural relations between Japan and South Korea somewhat improved and as historical distance expanded, not only to display pre-1945 paintings but also to reassess Japanese-Korean interaction in the realm of colonial modern art.[16]

In his reconstruction of colonial art and the authority of official exhibits in Taiwan, Wang Hsiu-hsiung traces many of the same issues in Taiwan during roughly the same colonial era. Much more so than in Korea, this has been a subject of considerable scholarly enterprise and popular nostalgia, some of which has been reported in Western publications.[17] Nativist pride in the first generation of Taiwan's modern painters is reflected in the twenty volumes so far published of the prestigious and well-illustrated Taiwan Fine Arts Series, which is devoted primarily to first-generation artists trained in the colonial period and is edited by leading art historians. Since the 1980s, there have been many public and private exhibits featuring works by the first generation of modern Taiwanese painters, some commanding huge prices on the art market. Lavishly illustrated popular art series do not hesitate to feature Japanese-trained artists of the colonial period—and their Japanese teachers as well. In addressing the role of the official exhibits, Wang shows the interplay between Taiwanese as art students and Japanese as teachers, judges, patrons, and resident artists. They are in the classroom together and in exhibits, often becoming friends. Though Wang does recognize the authority and power of official art exhibitions and notes the tastes and proclivities of the Japanese judges, he keeps an eye on the art itself and refuses to accept stereotypes or undocumented arguments. He is concerned basically with the technical and aesthetic advances made by Taiwanese painters in mastering new art forms and strategies. As he notes, artists of colonial Taiwan, both Taiwanese and resident or visiting Japanese, painted their share of local landscapes, urban scenes, and folk customs of the aborigines, by design or by choice. In art as in literature, there was a nativist movement in the 1930s. But in the case of Taiwanese painters, were they expressing valid local sensibilities? In the case of Japanese, on the other hand, were they necessarily purveyors of exoticism (or of Japan's Orientalism)? Unlike their more venturesome or dissident literary counterparts, Taiwanese painters either skirted or sublimated issues of Japanese colonial rule. Finally, as Kim and Wang both show, colonial artists were not on the whole greatly influenced by the lively world

of prewar Japanese avant-garde art but tended to stay safely within the more conservative mainstream.[18]

Since catalogues exist for wartime exhibits in Taiwan, in contrast to Korea, Wang is able to deal more extensively than Kim with colonial painters as artists of collaboration. As mentioned, Taiwan was the site of considerable military activity (1937–1945), from the training of Japanese troops for invasions of China and Southeast Asia in the early stages to U.S. bombing raids at the end. Korea, although not the contested battlefront it would become with the Korean War, nevertheless experienced extreme austerity during the Pacific War years and was subject to forced labor and military drafts, including mobilization of writers and artists for Greater East Asia propaganda.[19] Wang ends with a reminder of the spread of Chinese cultural imperialism, Nationalist style, in the initial postwar years (1945–1960), allowing us to see the fate or fortune of the first generation of largely conservative painters and to link their experiences with those of the first generation of modern Taiwanese writers featured in Yee's study. As resinification intensified, Taiwanese and mainlanders would fight culture wars over the orthodoxy of Chinese painting versus the validity of painting in the Japanese spirit. Ultimately, a Taiwanization movement would gain momentum in the arts as well as in politics and give rise to nativism and nostalgia in the 1970s and 1980s. The harshness of the postwar experience in Taiwan perhaps made it easier to look back and honor the prewar colonial painters—in particular to treasure their lovingly painted scenes of town and country life, an evolving art that postcolonial critics might otherwise tend to dismiss as products of Japan's Orient. For South Korea and North Korea, the politics of cultural identity have resulted in many more gaps to fill and explore than in Taiwan.[20]

Part 2, Conflagration: World War II in East Asia and the Pacific, illustrates the dilemmas, decisions, and self-deceptions of leading Japanese artists during the years of total war with China and the West (1937–1945). This section contains three essays devoted to representations of the Sino-Japanese War and Pacific War by leading cultural figures for the edification of the Japanese and overseas home fronts and gratification of Japan's leaders. A fourth essay illustrates doubts, integrity, and the limits of resistance. None of these figures has as yet been closely studied in Western scholarship on Japan for their strictly wartime production. Two of these men—a dramatist and an oil painter—were compliant, perhaps even enthusiastic, with the aggressive goals of the Japanese state from the beginning. A third, a novelist, when punished for telling what he saw and heard from soldiers on the war scene, soon learned how to please officials and continue to publish. The fourth artist was a filmmaker whose loyalty and patriotism did not embrace the making of war propaganda. Three of the four figures treated here actually traveled to the China front as war reporters or went also to Southeast Asia as the war expanded in late 1941. Until the past decade, Western scholars of modern Japanese literature, with few notable exceptions, have tended to neglect war works produced by leading literary figures and to gloss over wartime popular culture. This has not been

the case in Japan, even though Japanese have been much criticized for memory loss. It is tempting to say that broader reading in the Japanese language—primary sources and what Japanese say to each other about war guilt and war responsibility—might help restore a more balanced understanding.

Literary recriminations on ideological grounds began early in defeated Japan, in magazines and newspaper columns. Some writers apologized; others refused. In the aftermath of the Occupation and antiwar and antigovernment protests in the 1950s, wartime works began to attract serious and sustained attention from Japanese scholars and critics at least by the early 1960s, such as a special edition of *Bungaku* (Literature) in May 1961. Extensive collections of war literature were assembled in the 1970s and after, such as the sixteen-volume *Shōwa sensō no bungaku* (War Literature of the Shōwa Period, 1975), a genre that expanded to include retrospective war literature written after Japan's defeat—counterparts, for example, to Norman Mailer's sprawling 1948 Pacific War novel, *The Naked and the Dead*. Numerous individual writers authorized complete collections, although not all of these personal *zenshū* were in fact complete or contained wartime works in the original forms. In the 1990s, a new wave of Japanese studies began appearing on war and on the former colonies, generated in large part by the fifty-year commemorations of the attack on Pearl Harbor and Malaysia in 1941 and the ending—and the manner of the ending—of World War II in the Pacific in August 1945.[21] Issues of public, private, and historical reconstructions of memory (collective memory) in Japan, East Asia, and the West provided another stimulant to such studies, although the outcomes in formal education and in the mass media were not always monuments to truth and accuracy, as revealed in *sensō manga* (sensō comics) and textbook wars. Western scholarship, too, has been expanding on Japan's wartime poetry and prose. In contrast, studies of leading Japanese painters of the sacred or holy war are a belated addition to scholarly scrutiny in Japan and in the West, although once again, charges and countercharges within the art world date from the immediate postwar period. Illustrated volumes on war art and political cartoons first appeared decades ago. References to Japan's cinema at war are not novel, but full-length treatment and multivolume studies of wartime filmmaking (directors, actors, producers) are relatively recent. With these four essays, together with other recent research, we are joining the attempt to fill, in the words of J. Thomas Rimer, the many "blank spaces" in the Western scholarly record of Japan's wartime cultural production.

As indicated by the authors presented here, Japan's literature, art, and film of World War II were shaped and reshaped not only by vigilant censors and professional propagandists of Greater East Asia but also by prior conceptions of Self and Other derived from images of colonial peoples and the modern West, as well as by aesthetic values and literary and pictorial strategies. Well before the July 1937 Marco Polo Bridge Incident and the subsequent outbreak of total war with China, literary and artistic journeys to China and to Japan's colonies, as well as to Europe and America, were an established practice—to an extent a modern variation on a

much wider plane of Japan's classical and medieval traditions of literary travel. But this was wartime, total war to be exact, not a matter of tourism or travel for spiritual renewal. Though Japan's leaders and intellectuals spoke of Pan-Asian aims and the liberation of Asia from the West, they were engaged in widespread aggression against China and in intensified efforts to assimilate colonial and newly conquered peoples to a supra-Japanese identity. The intent was to blur if not eradicate ethic identities. Much earlier, Japanese artists, playwrights, poets, and novelists had attempted, with varying success in the late Meiji era, to respond to Japan's first modern wars with China (1894–1895) and Russia (1904–1905), but this was primarily to glorify exploits or empathize with the suffering of fellow Japanese rather than to question these particular wars or war itself.[22] If Japan's major writers—indeed the shapers of its modern literary canon—did subsequently reflect upon republican China in their travel accounts or upon Japan's newly colonized peoples and cultures, such impressions of neighboring Asians, as James Fujii argues, were long ignored as insignificant in critical evaluations of their overall literary production. His early-twentieth-century example is Natsume Sōseki, whose travel impressions of Korea and Manchuria in 1909 were dismissive and patronizing (as were those of American writer Jack London). Little has as yet been done to examine the travel writing or sketching trips to China and the colonies by major Japanese painters.[23]

Of considerable relevance to Japan's creation of visual and literary images of empire and total war was its intense emotional and psychological involvement in the Russo-Japanese War—until World War II, Japan's great war in modern memory. Admiral Tōgō's spectacular naval victory against the Russian Baltic Fleet in 1905 did not compensate for the huge land casualties in Manchuria or the economic drain on the Japanese countryside. Until the late 1930s, that war was lodged much deeper in the Japanese psyche than images of the European battlefields of World War I, a war in which Japan had limited direct experience apart from military observers and a small émigré community in Paris. For Japanese, the First World War was primarily one of economic gain and of diplomacy of empire, not one of fighting in the trenches or of the loss of a generation of young men. Japan did suffer limited casualties in the takeover of China's Shandong Peninsula (1915), and more so during the Siberian Intervention (1918–1922). But among the major concerns of the military during this unpopular expedition was the high incidence of venereal disease among the approximately seventy thousand Japanese soldiers.[24] Although some of the horrors of the First World War were perhaps transmitted during and after the war in battle photographs, silent screen newsreels or feature films, and translations of Western war literature, the Japanese public lacked firsthand representations of the war as a military and civilian experience. This was true even though Japanese artists and writers were in residence in Paris during the war years.[25]

In the meantime, Japanese literary and art journeys (if only to perform as judges in official exhibitions) continued in the 1920s and early 1930s to republican

China, Manchuria, and to Japan's colonies. However, as in the earlier case of Natsume Sōseki, the travel writing of such leading lights as Akutagawa Ryūnosuke, Tanizaki Jun'ichirō, or Yosano Akiko has yet to be fully incorporated into critical evaluations of their work and Japan's images of East Asia. The visits of newly famous Hayashi Fumiko to Taiwan in 1930 and her stopover in Harbin that year on her way to Paris via the Trans Siberian Railway call for full attention. When she returned home in 1933 by way of China, Manchuria had become part of the Japanese Empire and Japanese troops were engaging in border incursions into Chinese territory. Officials would soon encourage leading figures in all cultural fields—oil painters, famous novelists and poets, kabuki actors—to travel to the empire. After July 1937, the new destination in China for Hayashi and many others was the battlefront.[26] As before but on an extended scale, the mass media and propaganda officials commissioned journeys by prominent figures in the literary and art world. Daily newspapers and monthly magazines, on their own or in collaboration with the Cabinet Information Division (later Bureau of Information) or with the Home, War, and Navy Ministries, sponsored popular Japanese writers as war reporters in China. As explained by the *Japan Times and Mail* in early September 1938 to its readers at home and overseas, the real job of a newly appointed and distinguished party of twenty-two noted authors was to "give valuable information to the people and heighten their patriotism." The chosen were not "expected to write hasty reports on the battle but works of high literary value, though they may take years to complete."[27] As it turned out, they *did* write hasty reports. Representatives of all cultural fields, pure and popular, were enlisted in war propaganda. Actors, painters, filmmakers, comedians, dancers, and musicians went off to China and Manchukuo—and, after the expansion of the war in 1941, to Southeast Asia—both to entertain and to bring memories of home to the troops and also to bear witness to Japan's superior culture.[28] In producing war art and literature, creative artists had to deal with thought control and with censorship and guidance, a complicated process managed by special military officials, Home Ministry police, and directives from the Bureau of Information that included the possibility of interrogation, trials, and prison terms.[29]

In the opening essay in this section, Haruko Taya Cook examines the stringent conditions governing literary creativity in Japan and the inner limitations of the Japanese war novel, in this case *Ikiteiru heitai* (Living Soldiers), as produced by prize-winning author Ishikawa Tatsuzō in the early months of the Sino-Japanese War.[30] She also gives us the most detailed account yet written of the mechanics of wartime Japanese literary censorship and insights into self-censorship by the author and editor as well as formal censorship by officials of the Home Ministry. Squelched at the time, the novel would later take on special significance as a rare effort by a Japanese author to reconstruct the behavior of Japanese soldiers on the march toward Nanjing in December 1937.[31] Already established as a writer since the mid-1930s, Ishikawa was sent to report the war by a leading journal, *Chūō kōron* (The Central Review), arriving in Nanjing in early January 1938, three weeks

after the entry and wide-scale atrocities of the Japanese. His time in China was short, as was his write-up time back in Japan. When the Home Ministry caught up with the publication of his graphic but already severely self-censored account of the sometimes crude, even brutal behavior of individual soldiers, they quickly banned the March 1938 issue. Both to comply with the state and to ensure sales, *Chūō kōron* itself excised what was left of the text, already conveniently placed at the end of the issue. The novel was just as quickly published, this time unexpurgated, in late 1945, when it found favor with Japan's newly arrived American occupiers.[32] Reclaimed after the war, the novel remains as testimony if not to the full horror of the Nanjing massacre itself or the larger war taking place in China, as Ishikawa's critics have charged, then at least to the attitudes and behavior of ordinary Japanese soldiers. But this was not the end to Ishikawa's wartime production. Forced to stand trial in late 1938, he was given and accepted a second chance to produce more accommodating war works and managed to continue his career. The few writers who did actively resist were jailed, and others, less subservient or more cynical, found ways to write and survive or simply kept their silence.[33]

The second essay, by J. Thomas Rimer, examines the journey of one of Japan's leading modern playwrights, Kishida Kunio, as he too followed the Japanese troops to China (1937–1938), in more than just a continuation of a long tradition of literary travels. Kishida, then in his mid-fifties and renowned as one of the creators of modern Western-style drama in Japan, was more attuned to Paris and Europe, where he had spent three years after World War I, than to China or Beijing, though he had a passing acquaintance with classical Chinese literature from his student days. Nevertheless, Kishida accepted an assignment in the early stages of the Sino-Japanese war in October 1937 as a special correspondent to cover the war in northern China for the magazine *Bungei shunjū* (Literary Review).[34] Almost a year later, when the Japanese army had advanced farther southward toward the Wuhan cities, Kishida returned—this time to central China, in September and October 1938—with a commission from the *Asahi* newspaper. He was also one of the special twenty-two-member assembly of writers and critics brought together at that time by invitation of the Cabinet Information Division and dubbed the "Pen Brigade." Since the war seemed to be going well for Japan, the Brigade was expected to witness the quick fall of Hankou and the presumed glorious finale to the China war.[35] Kishida's reports from the two trips, published separately in the newspaper and combined into a book in late 1938, were discursive, overlapping, and apologetically journalistic—but sufficiently explicit as to the war front and supposedly expert as to China to satisfy Narasaki Tsutomu in a special article for foreign readers on "Epoch-making War Literature Now Being Produced by Japan."[36] Wartime praise aside, was he in fact—as postwar critics have charged—much too remote from the Chinese as a people and a culture or too blandly accepting of Japan's proclaimed war goals? Back in Japan, Kishida, along with other writers, engaged in an extensive propaganda lecture tour of the home front (mid-1940) to promote the China war, which by then had turned into a vast stalemate and

military nightmare. He also took a leading propaganda role as a prominent official (1940–1942) in the Imperial Rule Assistance Association and would produce patriotic works in 1943, though not necessarily to the military's liking.[37]

To more fully understand the structure and mechanics of literary collaboration in the China and Greater East Asia wars, considerably more needs to be known about the wartime activities of writers, their output, and their interactions with censors and propaganda officials. What details can be uncovered in the future, for example, about Kishida's and other writers' roles in the Japan Literature Patriotic Association (Nippon Bungaku Hōkokukai), formed in May 1942 to help create a new mental and world outlook—and to collect donations from the public for weapons? Much neglected are the Greater East Asia Literary Conferences (Daitōa Bungakusha Taikai) held in Tokyo in November 1942 and August 1943 and in Nanjing in late 1944. The first conference, which was convened when Japan was in military ascendancy, was a grandiose attempt to promote Pan-Asian solidarity— in reality a hierarchy led by Japan—among a large assembly of over sixty Japanese and Asian writers (mainly from Taiwan, Korea, China, Manchukuo, and Mongolia) and in the process to annihilate the culture of the West in East Asia. Presiding in the chair was Shimomura Kainan, journalist, poet, and head of NHK radio broadcasting. The agenda of the conference and the content of its plenary speeches, though less arcane than those of the historians, philosophers, and literary figures who had just taken part in a series of debates in Kyoto known as *kindai no chōkoku* (overcoming the modern), seem to share the same discourse and to echo the same concerns. The conference was called "to disseminate true Nippon spirit," declared headlines in the *Japan Times* (English, although in official disfavor, was nevertheless a prime means of communicating anti-Western diatribes in occupied territories), and to lay a foundation for the restoration of Asiatic culture. Said Shimomura in his opening address, the conference would impart "the augustness of Japan's fundamental characteristics and the true value of Japanese culture" while giving Pan-Asian delegates an opportunity to witness Japan's "unwavering determination" in the current war. Yoshikawa Eiji, best-selling author of tales of samurai heroes and soon to serialize "The Vendetta of Ako," a retelling of the story of the forty-seven loyal *rōnin* for international readers of the *Japan Times* (renamed *Nippon Times*, January 1, 1943), took a prominent role, as did Kikuchi Kan and Kume Masao. Shimazaki Tōson led the *banzais* at the end of the first session. The second conference, which included representatives from newly acquired territories in Southeast Asia, was, at least in rhetoric, more sensitive to the cultures of the various ethnic and national groups that make up Greater East Asia. It also established a literary prize in Tōson's honor, then recently deceased. In November 1944, despite Japan's military reverses in Saipan and the Battle of the Philippine Sea and the death of their Chinese collaborator, Wang Jingwei, a final literary conference was held in Nanjing. The *Nippon Times,* by then down to only four sheets of news, dutifully reported the presence of author Nagayo Yashirō in Nanjing but had little to say about Japan's invincible spirit.[38]

The third essay presented here, by the late Mark H. Sandler, is closely linked to Rimer's and resurrects the rarely displayed and, until recently, little discussed or exhibited war art of one of Japan's best-known modern oil painters, Fujita Tsuguji. Sustained scholarly work on war art in Japan began a little later than on war literature. Postwar artist and critic Tsukasa Osamu (born in 1935), for example, says that upon learning of such art in the 1980s he began to study it in an attempt to understand the distinctive characteristics of Japan's World War II art and the consciousness of its war artists, in particular Fujita. He wishes to "reveal the past debt and wounds to the public," and to be truthful in addressing Japan's war crimes. Does Fujita's art reveal agony? War art, Tsukasa observes, may be historical or documentary, patriotic for the nation, or propagandistic (even "devil-possessed" in praise of war) to mobilize the general public in support of war. It may praise war, or it may follow the paths of Goya, Delacroix, and others as a narrative of war. It may show a metamorphosis of the artist in response to changing circumstances, like that of Picasso during the Spanish Civil War and World War II.[39]

Fujita, whose initial fame was gained in Paris during and after World War I, resumed residence in Japan as a painter and teacher in the early 1930s for various personal and financial reasons. Like Kishida, he was quick to become a willing propagandist of the "holy war" in China after July 1937 and of Greater East Asia and the Pacific after December 1941.[40] Fujita also had a brief taste of World War II in Europe when he returned to Paris in 1939 only to be forced to leave in the spring of 1940 when Hitler transformed the phony war in northeast Europe into the Nazi Blitzkrieg. Although Fujita, by then approaching his mid-fifties, painted most of his many combat pictures—among them the bombing of Pearl Harbor— in a studio using photographs or models of war material supplied by the military, he also made trips to the scenes of recent battles in Manchuria, China, and Southeast Asia and interviewed participants. As Sandler notes, he happened to meet Kishida in Jiujiang in late 1938 after a sketching trip to the Wuhan area in preparation for his first war works. By 1943, Fujita was the predominant Japanese war painter and was in charge of special military exhibitions. As the war drew closer to Japan in 1944, the grand public shows would come to an end; canvases were rolled up and put into safekeeping, but Fujita would be commissioned once again in 1944 to paint the Battle of Saipan and also fighting at Leyte.[41] How, ask critics decades later, is this art to be understood or evaluated? What was Fujita's real interest in the wartime projects as expressed in his own words of the time, not later?[42] Apart from ideology, even his most extreme Japanese critics, Iri and Toshi Maruki, artists of the atomic bomb, saw power, possibly greatness, in such paintings they refer to as "The Battle of Attu" (1943) and the "Last Day at Saipan" (1944). In the end, how much room was there in Japan, they ask, for any other art—or, by extension, literature? Even for the doubters?[43]

In the last essay of this section, Kyoko Hirano takes up precisely that point— the room for wartime dissent, in this case as seen in the career of a popular and highly regarded film director, Itami Mansaku. In this first close-up study of Itami in Western scholarship, she gives us an example of a less compliant, more skepti-

cal artist. Although a loyal and patriotic Japanese, Itami was nevertheless unusual among his colleagues for consistently skeptical views from an important position within the wartime film industry (1937–1945) and for his witty, irreverent approach to the past in dramatizing samurai escapades in his popular films. Inactive as a director on the home front during most of the Pacific War period and increasingly in ill health, he felt driven soon after Japan's defeat to speak out on issues of war art and war guilt. Japanese films, as he knew, had been an immense and popular force all over East Asia and had been an effective vehicle of propaganda for Japanese imperial goals as well as anti-Western imperialism.[44] The implication is that it would be important to look again, much more minutely, at the wartime and early postwar films and activities of such famed directors as Ozu, Mizoguchi, and Kurosawa, as well as film production in Manchukuo and other parts of Japan's empire.

Hirano's use of Itami's wartime diary as evidence of his inner views also reinforces the value of examining literary diaries kept by prominent writers—for example, Nagai Kafū, Tanizaki Jun'ichirō, Takami Jun, and Itō Sei—but in the process taking care to note whether or not they have been doctored or censored for postwar publication. In the less well known realm of Japanese avant-garde poetry, the diary of Kitasono Katsue, as examined in a new monograph by John Solt, reveals the humdrum wartime existence of an iconclastic, experimental poet turned patriot—concerns for underpants, tropical fish, or daily finances that undermined creative energies even before American B-29s began to drop bombs on Tokyo—as well as the activities of the Japan Literature Patriotic Association. Kitasono never apologized later for his war poetry, though he removed it from compilations of his complete works. Among many forgettable lines of propaganda, he managed to produce, as Solt discovered in the margins of Kitasono's diary, a haiku from December 1944 of some skill, even employing a seasonal word: "enemy planes / the sky's blueness / ginko leaves scatter."[45] Would such sources and new questions help in reassessing icons like Kawabata Yasunari? Although he was not a member of a pen brigade to the war front, he did, as Keene has noted, participate in wartime literary debates, write essays and popular stories, and join home front propaganda missions.[46]

These wartime stories all have their postwar codas, another reminder that the time lines in twentieth-century Japan's cultural history should not be kept rigid. Itami's early death in 1946, after a round of stinging essays, silenced a voice of considerable integrity in postwar cinema discourse and film direction. Ishikawa would manage to find modest favor as a writer. However, both Kishida and Fujita, though by no means alone in their compliance as artists with the militarists of the wartime state, were quickly singled out as official war artists and denounced by fellow Japanese as war criminals of theater and art. Kishida remained in postwar Japan, taking a low profile during the Occupation years and suffering the indignity of being named in the official media purge in 1948. He ultimately regained his place as a pioneer in Japan's modern theater movement and was selected by his peers in the Japan PEN Club as a delegate to the World Pen Conference in Nice (1952). This did not, however, stifle controversy about his wartime role. Although Fujita, under

orders to help the occupiers in locating—and confiscating—Japanese war art, played down the importance and artistic value of his own work and wanted it to be forgotten, this was apparently not his view when creating the paintings. With the sponsorship of sympathetic Americans, he left Japan for good in March 1949, arriving in New York to resume his career under Immigrant Professor Status and with the offer of a teaching position at the Brooklyn Academy of Fine Arts.[47] However, Fujita made a hasty exit for Europe, where he ultimately became a French citizen, after he was denounced in November 1949 by an important group of American painters led by Ben Shahn. In a letter to the owner of the gallery where Fujita's latest work was on exhibit, they called him a fascist artist "who lent himself to lying and distortion in his painting to further the ends of the Japanese militarists." The attack is particularly interesting since Shahn, a passionate and consistent critic of social injustice, had himself been a contributor to official war art but on the winning side and would come under scrutiny as a critic of the Cold War.[48] Official appropriations of artists and writers during wartime, whether in Japan, Germany, or among the Allies, serve as a reminder that politics, censorship, and media guidance were an ever-present challenge and barrier to creativity and artistic expression in democracies, where presumably there was choice, as well as in authoritarian regimes.[49]

Part 3, Aftermath of Total War: Allied Occupied Japan and Postcolonial Asia, shifts the focus more completely to Japan's defeat and lengthy foreign occupation while respecting the connective links with the interwar years. In a reversal of fortune, Japan's experience with empire abruptly ended, as it was shorn of modern colonies and overseas territories—and as Okinawa, scene of the savage last campaign of the Pacific War, was detached by the winners for Cold War military and strategic goals. In addition to restoring Sakhalin, the Soviet Union descended upon the Kuriles as a prize of war for its belated entry, and its armies took Japanese military and civilian captives from Manchuria and North Korea off to a long exile or death in the labor camps of Siberia. The central Pacific mandates quickly became a part of the postwar American Trust Territory of the Pacific Islands under the United Nations. As much noted, the ferocious American air assault of firebombs and atomic bombs on Japan's home front in 1945 had the effect of helping the Japanese to displace the war crimes trials and recreate themselves as supervictims, with diminishing memories of their own aggression or complicity in total war.[50] Even as the Japanese people engaged in a struggle for physical survival among vast urban ruins and for some kind of spiritual reconstruction, the Koreans living in Japan were made to endure continued and harsh discrimination. Elsewhere, neighboring peoples set about creating postcolonial East and South Asia as they engaged in struggles to deter a return of Western colonial rulers and eliminate unwelcome Japanese legacies. As the Occupation continued, Japanese critics, increasingly incensed by a presumed foreign invasion of traditional Japanese culture and threat to Japan's cultural identity, conveniently forgot the racism, nativism, and cultural blindness of its policies during the years of Greater East Asia.

Although the political, military, and economic history of the Occupation years and immediate aftermath have been well examined, and John Dower has given us a monumental, prize-winning study of Japan's inner travail in *Embracing Defeat: Japan in the Wake of World War II* (W. W. Norton/New Press, 1999), relatively little attention has been given to creative artists and cultural politics apart from cinema and radio broadcasting.[51] From the start, the occupation authorities had a policy for the arts, but one that privileged the obvious—traditional fine arts or objects and structures that might be labeled canonical or art treasures. Although the occupiers went to elaborate lengths to help Japanese preserve and protect such treasures, they nevertheless assumed that they had a right to confiscate ultranationalist books, films, and paintings produced during the war years (1931–1945), using the rationale that such works were propaganda and without real artistic merit. The assumption that Japanese creative artists in all fields became freer after 1945 with the lifting of wartime controls and pressures could benefit from closer examination and further documentation. Media controls would continue to hamper as well as to liberate creative activity and skew intellectual discourse in postwar Japan, but this time the propaganda makers and the censors were the victorious Americans and their Allies—and in the interests of demilitarization and democratization, the list of approved and disapproved topics was far different from that imposed by the Shōwa state. Even with the gradual lifting of foreign controls in 1949 and after, how much more free would Japan's creative world be in the context of an escalating Cold War in Asia? The delay caused by American censorship in the appearance of uncut literary and visual representations of the atomic bomb (1951–1953) intensified feelings of victimhood and undercut Occupation programs to instill war guilt and responsibility.

All four of the essays here reflect problems of foreign and self-imposed censorship and involve the politics of remembering and forgetting. In the first essay, Sodei Rinjirō takes up another aspect of the visual arts—political cartoons and their large popular audience. He begins with the late 1920s, but his primary concern is with the Occupation and the examination of a double conversion. Sodei, who prizes satire above all in the work of truly great cartoonists, peers over the shoulder of Katō Etsurō, a clever and successful cartoonist identified in his younger life with the leftist movement but an easy convert to militant patriotism in the late 1930s. Katō, as one of Japan's court jesters, poked fun and shot barbs throughout the war years at an aggrandizing and pompous West but refrained from spoofing Japan's behavior.[52] Through the medium of the *Japan Times/Nippon Times* and its weekly edition, over one hundred seventy of Katō's cartoons also reached into many corners of the Co-Prosperity Sphere from 1939 to 1945. He mercilessly satirized Roosevelt, Churchill, and Chiang Kai-shek at will—but never made light of Japanese leaders or questioned Japan's war goals in Greater East Asia. Nor did he use his pen to draw the lives of ordinary Japanese soldiers, as did Bill Mauldin for American GIs in Europe.[53]

How would Katō perform during the Allied Occupation, asks Sodei, when the

21

tables turned and Japan became an occupied country—America's Orient? He would soon learn that the foreign authority in charge, General Douglas Mac-Arthur, welcomed attacks on Katō's former bosses, the militarists, including lampoons directed against postwar Japanese politicians and, up to a point, even the emperor—but not, of course, against himself, the United States, or its Allies. Posters and illustrations for contemporary books, magazines, and newspapers were closely monitored, together with political cartoons and cartoon strips. The bans included depictions of GIs with Japanese women. Instead of embracing the official Occupation line of democratization, Katō, in a "double turnabout," would revert to his original stance—socialist-inspired criticism of the political scene.[54] Like many other artists, he nevertheless had to live with and reflect upon his record as an active collaborator in wartime propaganda, a stigma that perhaps diminished over time as he pushed the edges of Allied censorship rules, joined the Japan Communist Party, and became resident cartoonist for its newspaper, *Akahata* (Red Flag), until the end of his career. At least, in satirizing Americans once again—and capitalism—he would remain consistent during and after the war years.[55]

In the second essay in this section, Marlene Mayo takes up the subject of kabuki in order to illustrate cultural politics, individual myopia, and historical amnesia at the highest levels on both sides, victors and defeated, in occupied Japan. She also points to a form of reverse learning among Americans that dimmed wartime memories and perhaps transcended Orientalism or an exoticized Japan. Americans arrived fully prepared to protect the fine arts as a mark of Eastern civilization and to liberalize Japan's art world, but they were uncertain about the legitimacy of older forms of Japanese theater in a democratic Japan. Then they hit upon the Shakespeare analogy. In this they were encouraged—indeed prompted—by Japanese protectors, who succeeded in transforming the American wartime image of kabuki as vicious feudal drama into a new one of an intangible cultural treasure, equally worthy of devotion and preservation as the tangible traditional arts (a term that vaguely encompassed classical and medieval fine arts and architecture and popular urban culture of the Tokugawa period). In the process, Americans became participants in the re-creation and legitimization of the kabuki canon, perhaps without fully understanding all of the underlying assumptions. In that sense, changing attitudes toward kabuki were part of a larger shift from patronizing Western views of Japanese theater to increasingly positive admiration and interest in cultural borrowing.[56] Similarly, as the occupiers became better acquainted with Japanese culture, they also took up an interest, often knowledgeable, in Japan's modern literature, poetry, film, and drama as well as in classical forms. In another of many ironies, it was Kishida Kunio himself who had dismissed kabuki and its frozen aesthetic when addressing Western readers in 1935 through the forum of *Contemporary Japan*. In 1940, Murayama Tomoyoshi, who would be commissioned in 1943 to write a propaganda play, followed suit—kabuki was not relevant to representations of modern life.[57]

In the process of restoring or "saving" kabuki, myths were created, as in the

case of the exaggerated credit given to art curator Langdon Warner for sparing Kyoto from fire and atomic bombing. In the kabuki story, the complex role of theater scholar Earle Ernst, who struggled with the occupier's mandate to demilitarize and democratize Japan while coming to admire Japanese creativity, has been obscured in a wave of adulation for another American, Faubion Bowers, who loved without question the artistry and aesthetics of kabuki and found the initial proscriptions to be absurd. The exact wartime role of kabuki and the nature and degree of the compliance of its producers, actors, and playwrights with the goals of Greater East Asia remains an open field for research, a task made more difficult by its current status as a cultural icon and its tendency to present itself as just another victim of the militarists.[58]

Eleanor Kerkham's essay on Tamura Taijirō is an exposé of wartime atrocities on two levels of denial, Americans and Japanese, as well as an exploration of constraints upon postwar Japanese literary creativity. Within the context of a rapidly escalating human rights issue long delayed in global consciousness until the early 1990s, she shows how a romanticized and yet, for its time, shocking literary indictment in 1947 of Japan's wartime exploitation of a Korean military comfort woman fell victim to American censors and to the author's own theories on sexuality in the new "literature of the body."[59] The work, a novella entitled *Shunpuden* (Biography of a Prostitute), centering on a character who was clearly identified as a young Korean woman, was totally suppressed when submitted for magazine publication in 1947 by Tamura Taijirō, a professional writer with long military service on the China front as an ordinary soldier and noncommissioned officer. Another self-censored version was published in book format in May 1947, with all mention of Korean women excised. The story line was further mangled in 1950 when produced as a film that reinvented the Korean victim as a Japanese entertainer, an expedient that continued in a later film version. Truth in confronting and documenting the war in all of its horrors remained a lingering victim in Japan long after the Occupation. The Japanese government continued its denials of military sexual slavery until 1992, when written documentation, though at first sparse, became impossible to deny. It continues to resist official restitution or reparations. Leading Japanese historians have bolstered this resistance with refusals to entertain oral testimonies or oral history as an important form of historical reconstruction or to examine underlying assumptions about gender and sexuality. In the meantime, another form of military prostitution, this time American, would entrench itself in occupied Japan in the growth of red-light districts near American bases and of street solicitation outside the bounds of licensed prostitution. After the peace and security treaties of 1952, it would continue in Japan and in Okinawa, the Philippines, South Korea, and Vietnam.[60]

A final essay by the late Alan Wolfe on themes of decadence and democracy in the immediate postwar essays and fiction of a leading writer, Sakaguchi Ango, is also a summation of conflicts and confusion within the ostensibly liberated Japanese literary world. Again, what did writers do, what *could* they do, with their new

freedoms and also new constraints?[61] Wolfe provides an overview of early post-war intellectual movements and poses the central issue of how human values were to be reconstructed in the aftermath of empire, total war, and a revolution guided or imposed by victors over losers. After his death in 1955, Sakaguchi's legacy of stories, novels, and criticism continued as an arresting but, until recently, fading voice in the literary landscape of a tumultuous postoccupation Japan, too often displaced by interest in Dazai Osamu. Wolfe was early to recognize the significance of Sakaguchi and, at the time of his own death, was thinking about intertextuality—in particular linkages between Sakaguchi's writing and Kurosawa's films.[62] However much we may wish to view postwar Japan in a continuum that begins in the late 1930s or question the time line of 1945 as a strict dividing point in twentieth-century Japanese history, Sakaguchi's work, as well as that of Itami Mansaku and Tamura Taijirō, reminds us that for Japanese, especially in the years 1945–1946, a sense of rebirth or creation of a new person was deemed essential to spiritual recovery.[63]

Throughout all of these essays run common themes of artistic creativity, either in confrontation or in collaboration with cultural imperialism—or in indifference, resignation, and retreat. Concerned artists took positions of defiance or silence or struggled with national governments and occupation bureaucracies that imposed carefully contrived policies of civil censorship and media propaganda upon home populations and on defeated or occupied peoples. Overt critics risked losing the means even to write, to paint, to speak, and to produce. Collaborators received favors, a livelihood, and praise. The essays further illustrate a consistent exercise of self-restraint and self-censorship by writers and artists, revealing an ability to see or not to see in times of empire and war.

These twelve contributors in addition provide much evidence of racial, ethnic, and gender insensitivity—among Japanese, Taiwanese, and Korean creators of art as well as among Europeans and Americans—as enemies became liberators, friends, or occupiers. In the aggregate, the research prepared especially for this volume demonstrates once again the existence of strong historical linkages between interwar, wartime, and early postwar Japan and between Japan and its East Asian neighbors in art and culture, not only in political and economic life. Together, the essays recall, by evoking the special vision of performing, visual, and literary artists, the disruption and cataclysm of imperialism, war, and occupation along with the mixed and complex experiences of decolonization of both European and Japanese empires in Asia amidst the global contest of Soviet Russia and the United States.

In the end, however, we as readers of this volume are left to muse once again upon the works these artists created, the mixed legacies of all these creative personalities of East Asia and imperial Japan who somehow found the energy, the materials, and the appropriate forms that might allow them to represent, as they saw it, the horrors or heroics of modern war in Asia, the miseries of colonial exploitation, and, finally, the joys as well as the hardships and disillusionments of national liberation and reconstruction.

Notes

1. The necessary background to this interwar and transwar period, the emergence of Meiji Japan as an imperial power, particularly in its political, economic and security dimensions, was first extensively explored in Western scholarship by Hilary Conroy in *Japan's Seizure of Korea, 1868–1910: Idealism and Realism in International Relations* (Philadelphia: University of Pennsylvania Press, 1960), followed by Marlene J. Mayo in such essays as "Attitudes toward Asia and the Beginnings of Japanese Empire," *Occasional Papers of the East Asian Institute* (New York: Columbia University, 1967), 16–31; and "The Korean Crisis of 1873 and Early Meiji Foreign Policy," *Journal of Asian Studies* 31:4 (August 1972), 793–819; and as editor of one of the old Heath series (famous for reducing complex historical questions into either/or binaries), *The Emergence of Imperial Japan: Self-Defense or Aggression?* (Lexington, MA: Heath, 1970). Andrew Choogwoo Nahm incorporated Korean views and scholarship in editing a 1973 conference volume, *Korea under Japanese Colonial Rule: Studies of the Policy and Techniques of Japanese Colonialism* (Kalamazoo, MI: Center for Korean Studies, Institute of International and Area Studies, Western Michigan University). More recent overviews include William G. Beasely's *Japanese Imperialism, 1894–1945* (Oxford: Clarendon Press, 1987), and the first of a trilogy of conference volumes on Japan's modern colonial enterprise, *The Japanese Colonial Empire, 1895–1945* (Princeton, NJ: Princeton University Press, 1984), ed. by Ramon H. Myers and Mark R. Peattie; the second volume deals with Japan's informal empire in China and the third covers Japan's wartime empire, 1937–1945. Peter Duus reassesses late-Meiji Japan's deliberate acquisition of overseas territory in *The Abacus and the Sword: The Japanese Penetration of Korea, 1895–1910* (Berkeley: University of California Press, 1995). A companion work, categorizing Japan as a "novice imperialist" in Korea and Manchuria (and presumably Taiwan), is Stewart Lone's *Japan's First Modern War: Army and Society in the Conflict with China, 1894–95* (New York: St. Martin's Press, 1994), the first full-length treatment of the war in English scholarship. Louise Young's recently published work, *Japan's Total Empire: Manchuria and the Culture of Wartime Imperialism* (Berkeley: University of California Press, 1998), extends existing scholarship to encompass colonial Manchuria and Japanese immigration. Barbara J. Brooks adds another dimension—the migration of Japanese colonials to other parts of the empire—in her chapter entitled "Peopling the Japanese Empire: The Koreans in Manchuria and the Rhetoric of Inclusion," in *Japan's Competing Modernities: Issues in Culture and Democracy, 1900–1930*, ed. by Sharon A. Minichiello (Honolulu: University of Hawai'i Press, 1999), 25–44. In the much more extensive and specialized Japanese discourse on empire, a useful beginning is the eight-volume Iwanami Kōza series, *Kindai Nihon to shokuminchi* (Modern Japan and Its Colonies) (Tokyo: Iwanami Shoten, 1992–1993), especially vol. 7, *Bunka no naka no shokuminchi* (The Colonies as Seen in Culture).

2. The relevance of Said to Japan's Orient or to East Asia remains problematical; for an early critical reaction, see "Review Symposium: Edward Said's *Orientalism*," especially Richard H. Minear, "Orientalism and the Study of Japan," in the *Journal of Asian Studies* 39:3 (May 1980), 507–517. More recently, Kono Ayako has again raised the issue of application of the term at the turn of the century and incorporated elements from an ongoing dialogue between Karatani Kōjin and Ueno Chizuko; see "Japanese Theater and Imperialism: Romance and Resistance," *U.S.–Japan Women's Journal* 12 (1997), 17–47. See also Jennifer Robertson's observations on Japanese Orientalism in *Takarazuka: Sexual Politics and Popular Culture in Modern Japan* (Berkeley: University of California Press, 1998), 97–99.

3. In this inaugural issue, Miriam Silverberg plays with the theme of the colonial within the modern, a distinctive 1920s and 1930s *modan;* see "Remembering Pearl Harbor; Forgetting Charlie Chaplin, and the Case of the Disappearing Western Woman: A Picture Story," 24–76. She points to the culpability of Japanese modern culture as part of the history of the Japanese colonial enterprise and encompasses café culture infrastructure in the homeland and in Japanese colonizer communities, but she limits her investigation of the *modan* to leisure and material culture (one might note that the American/Western woman may have disappeared along with ads for Hollywood movies—but not necessarily the German or Vichy French/Western woman). Also highly relevant is James A. Fujii's essay, "Writing Out Asia: Modernity, Canon and Natsume Sōseki's *Kokoro*" (194–223), in which, borrowing from Said, he chastises scholars of modern Japanese literature (in Japan and in the West) for ignoring relationships and absences between Japanese literary production, in particular canonical texts, and Japan's colonial presence in Asia. In a more extended discussion, Fujii also taps into the travel literature of major writers who visited Korea and Manchuria (especially Manchuria): *Complicit Fictions: The Subject in the Modern Japanese Prose Narrative* (Berkeley: University of California Press, 1993), a useful complement to Joshua A. Fogel, *The Literature of Travel in the Japanese Rediscovery of China, 1862–1945* (Stanford: Stanford University Press, 1996), and to Sonia Ryang, "Japanese Travelers' Accounts of Korea," in *East Asian History* 13:14 (1997), 133–152.

4. "Japanese Travelers' Accounts," 133. Here the focus is mainly on the 1920s and 1930s, and the accounts range from those of professional writers to administrators, teachers, and tourists.

5. "Remembering Pearl Harbor," 34. To this we might add that neither did China regard Korea and Taiwan as comparable cultures. Both were expendable exteriors and marginal areas of lesser cultural accomplishments. A rethinking or recasting of China's tribute system in terms of imperialism and insignificant others would be beneficial.

6. Wonmo Dong, "Assimilation and Social Mobilization in Korea," in Nahm, ed., *Korea under Japanese Colonial Rule,* 146–182. For Taiwan, a classic study is E. Patricia Tsurumi, *Japanese Colonial Education in Taiwan* (Cambridge: Harvard University Press, 1977); also see her article, "Colonial Education in Korea and Taiwan," and Edward I'te Chen's, "The Attempt to Integrate the Empire: Legal Perspectives," both in Myers and Peattie, eds., *The Japanese Colonial Empire,* 240–274 and 275–311. Though often lumped together as colonies of imperial Japan, it is vital to remember the separate cultural and historical identities of Taiwan and Korea, as well as their common colonial plight.

7. An impressive body of research and scholarship is underway on art and literature during China's civil warfare and war of resistance against Japan. In *Unwelcome Muse: Chinese Literature in Shanghai and Peking, 1932–1945* (New York: Columbia University Press, 1980), Edward Gunn broke new ground in examining the process and effects of Japanese prescription and proscription of Chinese writers in two key cities of occupied China. Gunn has also provided an illustrated survey, "Literature and Art of the War Period," in James Hsiung, ed., *China's Bitter Victory: The War with Japan, 1937–1945* (Armonk, NY: M. E. Sharpe, 1992), 235–273. Poshek Fu has recast the oppressive and spiritually conflicted literary world of Japanese-occupied Shanghai into a "gray zone" in *Passivity, Resistance, and Collaboration: Intellectual Choice in Occupied Shanghai, 1932–1945* (Stanford: Stanford University Press, 1993); he sees the eight years not simply as a problem of literary merit or styles but as "a drama of fear, suffering, survival, and moral ambiguity" (20). Fu's grand theme is the moral situation of writers—the historical context for their texts. See also contribu-

tions on war literature by Poshek Fu, David Wang, Catherine Pease Campbell, and others, in addition to a bibliography of literature on the Sino-Japanese War, in *Modern Chinese Literature,* 5:3 (Fall 1989). Hung Chang-tai adds *War and Popular Culture: Resistance in Modern China, 1937–1945* (Berkeley: University of California Press, 1994). Less studied are Chinese writers and artists who identified with the regime of Wang Jingwei or participated in Tokyo's Greater East Asia literary conferences and art exhibits in 1943 and 1944 (see below). Artistic interactions between China and Japan both before and during the war are dealt with by Michael Sullivan, *Art and Artists of Twentieth Century China* (Berkeley: University of California Press, 1996); and by Ralph C. Croizier, *Art and Revolution in Modern China: The Lingnan (Cantonese) School of Painting, 1905–1951.* For painting and the cultural politics of the immediate postwar era in China (parallel to occupied Japan and liberated/reoccupied Taiwan), see Julia F. Andrews, "Traditional Painting in New China: *Guohua* and the Anti-Rightist Campaign," *Journal of Asian Studies* 49:3 (August 1990), 555–586; and in the same issue, Ralph Croizier, "Art and Society in Modern China—A Review Article," 587–602. Andrews expands her study with *Painters and Politics in the People's Republic of China, 1945–1979* (Berkeley: University of California Press, 1994) and as coeditor with Kuiyi Shen of *A Century in Crisis: Modernity and Tradition in the Art of Twentieth Century China* (New York: Guggenheim Museum, 1998).

8. See Douglas Howland, *Borders of Chinese Civilization: Geography and History at Empire's End* (Durham: Duke University Press, 1996), a work that deals primarily with China's Japan gaze.

9. *Dōka,* argues Andrew Nahm, "essentially meant the obliteration of the racial and cultural heritage of the Koreans, not convergent assimilation between the Korean and Japanese cultures and peoples"; *Korea, Tradition and Transformation: A History of the Korean People* (Seoul: Hollym, 1988), 254. For the creative climate in colonial Korea prior to the late 1930s, Michael Robinson assesses the impact of the highly developed but not foolproof Japanese censorship controls and notes the rise of a successful commercial press using the Korean language; see his "Colonial Publication Policy and the Korean Nationalist Movement," in Myers and Peattie, eds., *The Japanese Colonial Empire,* 312–343. Young Hee Lee gives voice to the few Korean women writers of the colonial era in "Women's Literature in the Traditional and Early Modern Periods," as does Carolyn P. So, "Seeing the Silent Pen: Kim Myongsun (1896–1951), a Pioneering Woman Writer," in a special issue of *Korean Culture* (15:2, Summer 1994) devoted to women's literature. M. J. Rhee discusses "Modernity as a Problematic Notion: Korean Modern Architecture during Japanese Colonial Administration, 1910–1940," in *Asian Pacific Quarterly* 26:4 (Winter 1994), 1–9.

10. For a Japanese source on the literature of colonial Taiwan, including a reference to Yang's fiction, see chapters 3–4, Ozaki Hotsuki, *Kindai bungaku no shōkon: kyū shokuminchi bungakuron* (Scars of Modern Japanese Literature: On Literature in the Former Colonies) (Tokyo: Iwanami Shoten, 1991), a reprint adding Manchuria. Postcolonialists in Taiwan, as in Korea, viewed literature written in Japanese as a contaminated departure from modern literature, neither integral to its development nor a worthy body of national sentiment and creativity. In a series of articles in *Free China,* John Balcom provides an excellent counterpart to Yang's fiction in his review of Taiwanese colonial poetry and post-liberation fiction written in the Japanese language (based in part on chapter 2 of his doctoral dissertation in comparative literature at Washington University, St. Louis, "Lo Fu and Contemporary Poetry from Taiwan"). During World War II in Asia, local poets "had to express themselves in Japanese—or not at all." Overall, Balcom finds "a mixture

of adaptation and resistance" in colonial-era Taiwanese poetry "that produced a literature with a strong regional identity." See "A Literary Revolution" (May 1999); "Preserving Identity through Poetry" (June 1993); "Overcoming the Language Barrier" (July 1993); and a moving piece about a somewhat younger and long-lived Japanese-trained counterpart to Yang Kui, the poet Lin Hengtai (Lin Heng-tai), "Modern Master, Native Son" (December 1995).

11. An example of this growing scholarship is Kurokawa Sō, ed., *Gaichi no Nihongo bungakusen* (Selected Works of Overseas Japanese Language Literature), 3 vols. (Tokyo: Shinjuku Shobō, 1996). Both local writers and resident Japanese are included (vol. 1, Taiwan; 2, Manchuria; 3, Korea). Kawamura Minato has contributed many books and articles on this subject in the past decade, among them *Manshū hōkai: "Tōa bungaku" to sakkatachi* (Collapse of Manchukuo: "Greater East Asian Literature" and Its Writers) (Tokyo: Bungei Shunjū, 1997). See also Ozaki, *Kindai bungaku no shōkon*. Modern drama, music, dance, cinema, and radio broadcasting were also introduced to the *gaichi* or developed there under Japanese rule. In Korea's case, there are brief allusions to developments in the colonial period in Yi Tu-hyon et al., *Korean Performing Arts—Drama, Dance and Music Theater* (Seoul: Jipmoondang, 1992), Korean Studies Series no. 6. For radio, see Michael E. Robinson, "Broadcasting in Korea, 1924–1937: Colonial Modernity and Cultural Hegemony," in *Japan's Competing Modernities*, 358–378; for dance, Sang-cheul Choe's Ph.D. dissertation, "Seung-Hee Choi, Pioneer of Modern Korean Dance: Her Life and Art under Japanese Occupation, 1910–1945," New York University, 1996 (Choi was known in Japan and abroad as Sai Shoki).

12. Critical examination of Korean literature written originally in Japanese—even the existence of such literature—has been glossed over or ignored in specialized and popular journals accessible to foreign readers, such as *Korea Journal, Korean Culture,* and *Koreana*. For valorization, the politics of national identity demands that colonial/occupied literature be written in Korean and that it express resistance. The controversial case of Yi Kwangsu—a key early modern Korean writer who became a wartime collaborationist— is openly addressed by Beongcheon Yu in *Han Yong-un and Yi Kwang-su: Two Pioneers of Modern Korean Literature* (Detroit: Wayne State University Press, 1992). Ann Lee (his granddaughter), however, gives no hint of any early writing in Japanese in "Yi Kwangsu and Korean Literature: The Novel *Mujong* (1917)," *Journal of Korean Studies* 8 (1992). For a rare study of Korean poetry written in Japanese, see M. J. Rhee, "Border Writing: Yi Sang and Colonial Korea," in *The Doomed Empire: Japan in Colonial Korea* (Aldershot, England: Ashgate, 1997). Of related interest, Oh Yang Ho discusses Korean diaspora fiction in "Korean Literature in Manchuria: Exile and Immigrant Literature during the Japanese Colonial Period," *Korea Journal* (Winter 1996), 100–119; see also Ross King, "'Glasnost' and Soviet Korean Literature," *Korean Culture* (Winter 1996), including the translation of a short story written in Russian (34–45). In Japan, research is advancing on resident Korean *(zainichi)* literature written in Japanese, together with Korean colonial or *gaichi* literature. An example of a Korean-born Japanese author who incorporated memories of prewar and wartime colonial Korea into his postwar fiction is Kajiyama Toshiyuki; see *The Clan Records: Five Stories of Korea* (Honolulu: University of Hawai'i Press, 1995). Still different is Tachihara Masaaki, born in Korea in 1925 of mixed Korean-Japanese parentage and educated in Japanese; see Steven Kohl, *Cliff's Edge, and Other Stories* (Ann Arbor, MI: Midwest, 1980); and *Wind and Stone: A Novel* (Berkeley: Stone Bridge Press, 1992). More problematical is the case of Abe Kōbō. Although Nancy Shields concedes that Abe's works are not autobiographical, she believes that his youthful residence in Mukden and images of

Manchuria—its "barren spaces, city mazes and solitary human figures inexplicably thrown together" are incorporated in his creative work. "Manchuria is his homeland and he was profoundly affected by it to the point of self-denial"; *Fake Fish: The Theater of Kōbō Abe* (New York; Weatherhill, 1996), 28, 38.

13. Nelson, "Korean Literature in Japan, a Case Study: Ri Kai Sei," in *Studies on Korea in Transition,* ed. by David R. McCann et al. (Center for Korean Studies, University of Hawai'i, 1979), 126–159, 234–236; also Nelson's translation of Ri's 1972 prize-winning short story, "The Woman Who Ironed Clothes," in *Black Crane: An Anthology of Korean Literature* (Ithaca, NY: China-Japan Program, Cornell University, 1977), East Asia Papers 14, ed. by David McCann, 92–136. Takeda Seiji's *"Zainichi" to iu konkyo* (The Foundation of "Zainichi") (Tokyo: Chikuma Shobō, 1995; reissue of 1983 book), is a study of Ri Kaisei and other Korean-born authors. For Noguchi Kakuchū and his peers, see Im Jon Hye, *Nihon ni okeru Chōsenbungaku no rekishi: 1945 made* (History of Korean Literature in Japan before 1945) (Tokyo: Hōsei Daigaku, 1994), which includes poetry, prose genres, and propaganda; Hayashi Kōji's essay, "Chō Kakuchū ron" (On Chō Kakuchū/Chang Hyok-chu), *Kikan sanzenri* (3000 Miles Quarterly), 36:4 (Winter 1983), a resident Korean journal published in Tokyo; and Jeanne Paik Kaufman, "A Korean Literary Voice in Japan: The Fiction of Chang Hyok-chu," presented at the University of Maryland, April 1992; and George Hicks, "Korean Writers in Japanese," in his *Japan's Hidden Apartheid: The Korean Minority and the Japanese* (Aldershot, UK: Ashgate, 1997), 157–158. As Chō Kakuchū, he contributed a collaborationist essay on the wartime loyalty of Korean soldiers to the *Nippon Times* in 1944. Norma Field discusses two postwar resident Korean writers in "Beyond Envy, Boredom, and Suffering: Toward an Emancipatory Politics for Resident Korean and Other Japanese," *Positions* 1:3 (Winter 1993), 640–670. Sonia Ryang briefly refers to literature by postwar resident Korean writers of North Korean descent in *North Koreans in Japan: Language, Ideology, and Identity* (Boulder, CO: Westview Press, 1997). See also Melissa L. Wenders, "Lamentation as History: Literature of Koreans in Japan, 1965–1999," Ph.D. dissertation, University of Chicago, 1999.

14. Such exhibits were for a brief time also held in Manchukuo in the late 1930s and, like *gaichi* literature, are a good subject for future research. The necessary historical background is Young, *Japan's Total Empire,* where some attention is given to Japanese travel writers and tourism, including a few literary figures (259–268). Also, Sandra Wilson, "The 'New Paradise': Japanese Emigration to Manchuria in the 1930s and 1940s," *International History Review* 17:2 (May 1995), 249–286. Until 1944, wartime exhibits of military art in Japan were sent to colonies and newly occupied regions, and cultural exchanges involving art were made with Italy and Germany.

15. For some of the theoretical issues involving shows or displays of imperial power in colonies, see Ivan Karp and Steven D. Lavine, eds., *Exhibiting Cultures: The Poetics and Politics of Museum Display* (Washington, D.C.: Smithsonian Institution Press); also Timothy W. Luke, *Shows of Force: Power, Politics, and Ideology in Art Exhibitions* (Durham: Duke University Press, 1992). Similar questions might be asked of literary prizes. Many Japanese artists at home also protested the narrowness of selections for official exhibits and organized their own antimainstream groups for public displays, often extending hospitality to colonial painters and to Chinese artists. Tsuruta Takeyoshi includes Chinese art students in Japan in parts 5 and 6 of his study of Chinese painting in the twentieth century; see *Bijutsu kenkyū* (Journal of Art Studies), Nos. 367 and 368 (March 1997 and March 1998).

16. In the small but growing body of Korean language scholarship on twentieth-century Korean art, there is more focus on the post-1945 years than on the era of Japanese

occupation. Kim has herself briefly surveyed the larger period, from 1910 to the 1980s, in her chapter "Modern Korean Painting and Sculpture," in John Clark, ed., *Modernity in Asian Art* (Broadway, NSW, Australia: Peony Press, 1993), 155–168; and has recently published a book of overview essays, *Issip segi ui Han'guk misul* (Art of Twentieth Century Korea) (Seoul: Yekyong, 1998). For a glimpse of discourse in Korea on naming names in war art, see "Pro-Japanese Collaborator or Not?" *Newsreview* (Seoul), August 18, 1993. With the exception of occasional articles in the *Korea Journal,* little has appeared in English on the cultural politics of postliberation art in South and North Korea, including the period of the Korean War, although translations of Korean War fiction have begun to appear. The late Marshall R. Phil touched on the colonial past and post-1945 era in taking a rare look at North Korean literary activity; see "Engineers of the Human Soul: North Korean Literature Today," *Korean Studies* I (1977). 63–92. For a rigorous theoretical framework that explores some of these problems and emotions, see Chungmoo Choi, "The Discourse of Decolonization and Popular Memory: South Korea," *Positions* 1:1 (Spring 1993), 77–102.

17. Among Western scholars, John Clark, though limited in his initial research to catalogues and secondary materials, is the pioneer; see "Taiwanese Painting and Europe: The Direct and Indirect Relations," in *China and Europe in the Twentieth Century,* ed. by Yu-ming Shaw (Taipei: National Chengchi University, 1985), 43–60; also "Taiwanese Painting under the Japanese Occupation," *Journal of Oriental Studies* (Hong Kong), 25:1 (1987), 63–105. Taiwanese art historians, as indicated, have also been prominent in introducing such art to a Western audience.

18. Noted by Yan Juanying (Yen Chuan-ying) in comparing artists and writers, "The Art Movement of the 1930s in Taiwan," in Clark, ed., *Modernity in Asian Art,* 45–59. For interwar Japanese avant-garde art, see John Clark, "Artistic Subjectivity in the Taishō and Early Shōwa Avant-Garde," in Alexandra Munroe, ed., *Japanese Art after 1945: Scream against the Sky* (New York: Henry N. Abrams, with Yokohama Museum of Art and *Yomiuri Shimbun,* 1994), 41–54. It was a resident Japanese painter and art teacher, Shiozuki Tōho, who best expressed social criticism in the official exhibit of 1932; his large oil painting in shades of red, entitled "Mother," a depiction of a woman and three children—dazed survivors of a Japanese army massacre—is a painful evocation of colonial brutality and memorializes the deaths of hundreds of aborigines in the Musha (Wu-She) Incident of 1930. See Yu-lan Chang, "Japanese Policies toward the Formosan Aborigines: The Wu-She Incident of 1930," MA thesis, University of Oklahoma, 1974, which deals with charges that Japan may have used poison gas.

19. See Kawamura Minami and others on collaborative literature in Korea and Taiwan and in Beijing and Shanghai during the Greater East Asian War; special section of *Bungakkai* (Literary World) 49:3 (March 1995). Yu cites Yi Kwang-su as a collaborator in *Han Yong-un and Yi Kwang-su,* 97–103. Also see Ozaki, *Kindai bungaku no shōkon.*

20. Lai Tse-han et al, *A Tragic Beginning: The Taiwan Uprising of February 28, 1947* (Stanford: Stanford University Press, 1991). For an overview of the post-1945 cultural scene, see Edwin A. Winckler, "Cultural Policy on Postwar Taiwan," in Stevan Harrel and Chun-chieh Huang, eds., *Cultural Changes in Postwar Taiwan* (Boulder, CO: Westview Press, 1944), 22–46. Jason Guo surveys cultural politics in postcolonial painting in "After the Empire: Chinese Painters of the Post-War Generation in Taiwan," Clark, ed., 105–115; and similarly in "Painters of the Postwar Generation in Taiwan," Harrel and Huang, *Cultural Changes,* 246–274.

21. In English-language scholarship, Donald Keene, as indicated, was an exception for many years in writing about war literature; see "The Sino-Japanese War of 1894–95 and Japanese Culture" and "Japanese Writers and the Greater East Asia War," both of which appeared in *Landscapes and Portraits: Appreciations of Japanese Culture* (Tokyo: Kodansha, 1971) 252–321. However, much of the data in the latter piece was based on revelations made by the Japanese themselves a decade earlier in issues of *Bungaku* (1961–1962). Other major contributions by Keene are "Japanese Literature and Politics in the 1930s," *Journal of Japanese Studies* 2:2 (Summer 1976), and "The Barren Years: Japanese War Literature," in *Monumenta Nipponica* 33 (1978)—recast as chapter 32, "War Literature," in *Dawn to the West: Japanese Literature of the Modern Era, Fiction* (New York: Holt, Rinehart, Winston, 1984), 906–961. Yoshio Yamamoto, in producing the first doctoral dissertation on the topic, "The Relationship between Literature and Politics in Japan, 1931–1945," University of Michigan, 1964, drew heavily from Japanese materials. In 1983, Noriko M. Lippett reviewed Japan's "War Literature" in an extensive entry for the *Kodansha Encyclopedia of Japan*. As an example of renewed studies in the 1990s, we have Steve Rabson's overview on Japanese poetry and modern war, *Righteous Cause or Tragic Folly*, and J. Victor Koschmann's critique, "Victimization and the Writerly Subject: Writers' War Responsibility in Early Postwar Japan," *Tamkang Review* 20:1–2 (1995), 61–75. Several recent Ph.D. dissertations are devoted exclusively to the literature of total war: Zeljko Cypris, "Radiant Carnage: Japanese Writers on the War against China," Columbia University, 1994; David Rosenfeld, "'Unhappy Soldier': Hino Ashihei and Japanese World War Two Literature," University of Michigan, 1999; and Charles R. Cabell, "Maiden Dreams: Kawabata Yasunari's Beautiful Japanese Empire, 1930–1945," Harvard University, 1999. As noted below, recent studies of Hayashi Fumiko include significant references to her wartime works if not to her colonial travel. John W. Treat assesses Ibuse Masuji's wartime writing when serving as a soldier in Singapore in *Pools of Water, Pillars of Fire: The Literature of Ibuse Masuji* (Seattle: University of Washington Press, 1988), 102–131. For the few dissenting Japanese literati, see Miriam Silverberg's *Changing Song: The Marxist Manifestos of Nakano Shigeharu* (Princeton, NJ: Princeton University Press, 1990); and Ishikawa Jun, *The Legend of Gold and Other Stories*, trans. William J. Tyler (Honolulu: University of Hawai'i Press, 1998).

22. For art illustrating Japan's first modern wars, see Shumpei Okamoto, *Impressions of the Front: Woodcuts of the Sino-Japanese War, 1894–1895* (Philadelphia Museum of Art, 1983); Henry DeWitt Smith, *Kiyochika: Artist of Meiji Japan* (Santa Barbara Museum of Art, 1988), 82–97, 110–113; Elizabeth de Sabato Swinton, *In Battle's Light: Woodblock Prints of Japan's Early Modern Wars* (Worcester, MA: Worcester Art Museum, 1991); and Frederic A. Sharf and James T. Ulak, *A Well-Watched War: Images from the Russo-Japanese Front, 1904–1905* (Washington, D.C.: Arthur M. Sackler Gallery, 2000). For its December 6, 1937 issue, *Life* magazine, having been denied firsthand coverage for its reporters of the second Sino-Japanese War and the entry of the Japanese army into Nanjing, decided to run several pages of color woodcuts dating from 1894–1895 (without clear attribution of their source). For attempts to dramatize the wars on the modern Japanese and kabuki stages, see Kano Ayako, "Japanese Theater and Imperialism," 27–32. Rabson provides an extensive discussion of poetry and these wars in the opening half of his book, *Righteous Cause or Tragic Folly*. David Wells and Sandra Wilson, eds., *The Russo-Japanese War in Cultural Perspective, 1904–05* (New York: St. Martin's Press, 1999), especially Sandra Wilson, "The Russo-Japanese War and Japan: Politics, Nationalism, and Historical Memory," 160–193.

23. Both the South Manchuria Railway and the *Asahi shimbun* had commissioned

Natsume Sōseki in 1909 to write travel impressions of Manchuria and Korea (a modified form of the tradition of *kikōbun*). In his article, "Writing Out Asia," and his book, *Complicit Fictions,* Fujii is especially interested in linkages between Sōseki's 1909 travel account, *Mankan tokoro dokoro* (Manchuria and Korea, Here and There), and his 1914 novel, *Kokoro*. Fujii has less to say about images of colonial Korea, a subject taken up in Sophia Ryang's "Japanese Travelers' Accounts," including lesser literary figures. Joshua A. Fogel is the prime source for modern Japanese literary travelers to China, noting, as does Fujii, that travel accounts by canonical and lesser figures are sometimes even left out of their collected works. He follows the trail to China (but not to Taiwan) from the Meiji era to the early 1930s in "Japanese Literary Travelers in Prewar China," *Harvard Journal of Asian Studies* 49:2 (1989), 575–602, and more extensively, adding the second Sino-Japanese war, in the already cited *Literature of Travel* (see note 3). The larger question addressed by all three scholars is the extent to which such accounts (one might also include Kume Kunitake's diary of the return trip through Southeast Asia and China of the Iwakura Embassy in 1873), along with guidebooks, tourist literature, and historical and archeological scholarship, shape "Japan's Orient." Of related interest is "British Literary Travellers in Southeast Asia in an Era of Colonial Retreat," by Clive J. Christie, *Modern Asian Studies,* 28:4 (1994), 673–737; and, for theory and insights, Mary Louise Pratt, *Imperial Eyes: Travel Writing and Transculturation* (London: Routledge, 1992). Paul Fussell's *Abroad: British Literary Traveling between the Wars* (Oxford: Oxford University Press, 1980) covers China but not Japan or its empire. For an exception to the paucity of work on Japanese painters and travel to republican China, see John Clark, "Artists and the State: The Image of China," in Elise K. Tipton, ed., *Society and the State in Interwar Japan* (London: Routledge, 1997), 63–89; much as does Fogel in his work on literary travel, Clark shows how prior images from the period of Japan's informal empire in China helped condition those of total war.

24. Rabson, *Righteous Cause,* 124, 182–184. Almost a decade after the fact, the expedition inspired antiwar short stories in 1927–1928 by proletarian writer Kuroshima Denji, who had been a soldier in the expedition army; in 1930 he also produced an antiwar novel set in China; Keene, *Dawn to the West: Fiction,* 603–610. For concerns about VD, see Suzuki Yūko, "Karayukisan, 'jugun ianfu,' senryōgun 'ianfu' (Japanese Overseas Prostitutes, 'Military Comfort Women'; Occupation Forces 'Comfort Women')," vol. 5, *Kindai Nihon to shokuminchi* (Modern Japan and Its Colonies) (Tokyo: Iwanami Kōza, 1992), 234–326.

25. Reflections on the battlefield and death are apparently absent in Shimazaki Tōson's account of his sojourn in Paris (1914–1915); *Righteous Cause,* 168–171. Lee Ann Younger indicates a similar psychological distance from war itself in her reconstruction of painter Fujita Tsuguji's life in wartime Paris, "The Making of a 'Japanese-Parisian' Vanguard Artist: The Life and Work of Foujita, 1913–1929," unpublished master's thesis, University of Maryland, 1994. For background, see Marc Feero, "Cultural Life in France, 1914–1918," in Aviel Roshwald and Richard Stites, eds., *European Culture in the Great War: The Arts, Entertainment, and Propaganda, 1914–1918* (Cambridge University Press, 1999); Kenneth E. Silver, *Esprit de Corps: The Art of the Parisian Avant-garde and the First World War, 1914–1925* (Princeton University Press, 1989); and, for comparison, Samuel Hyns, *A War Imagined: The First World War and English Culture* (New York: Atheneum, 1991).

26. Compare evaluations of poet Yosano Akiko's visit to Manchuria and Mongolia in 1928 at the invitation of the South Manchuria Railway in Fogel, *The Literature of Travel,* 266–269, and Rabson, *Righteous Cause,* 127–136 (which includes her turnabout after the Manchurian Incident, 1931). For Hayashi Fumiko's colonial travels and later war works, see

Joan Ericson, *Be a Woman: Hayashi Fumiko and Modern Japanese Women's Literature* (Honolulu: University of Hawai'i Press, 1997), 49, 79–82; and Susanna Fessler, *Wandering Heart: The Work and Method of Hayashi Fumiko* (Albany: State University of New York, 1998), 17, 37–41, 132–135, who notes that Hayashi omitted her 1938 war reports from her collected works. Other important avenues of research are Japanese fiction of the 1920s and 1930s set in the colonies, such as a 1924 Satō Haruo short story about Taiwan or Kawabata Yasunari's incorporation of resident Koreans in one of his stories of the late 1920s.

27. September 11, 1938. In follow-up, the newspaper ran a photo captioned, "Pen-Men Pay Their Respect," showing the writers in khaki uniforms at the Meiji Shrine prior to their departure that afternoon from the Tokyo Train Station (September 14, 1938). Fogel's chapter on Japanese wartime travel to China (1937–1945), "Literature of Travel," includes journalists and businessmen as well as literary figures, film critics, and artists. Another official agenda at this time was apparently to restore the reputation of the Japanese army, much criticized in the West for its brutal occupation of Nanjing in December 1937. *Life* magazine photographer Paul Dorsey was permitted to cover Japan's "model occupation" of Hankou, the "Chicago of China" (December 12, 1938 issue).

28. Jennifer Robertson, chapter on "Performing Empire," in *Takarazuka: Sexual Politics and Popular Culture in Modern Japan* (Berkeley: University of California Press, 1998) is welcome in-depth scholarship for the wartime period. However, it deals primarily with images presented to audiences at home and the troupe's contribution to the vision of Japan's "global hierarchy" rather than its overseas journeys. *Grand Kabuki: Overseas Tours, 1928–1993* (Tokyo: Shōchiku, 1994) ignores wartime travel to the empire, skipping from the Soviet Union tour of 1928 to the China tour of 1955. At that time, most of the major kabuki actors were under Shōchiku management.

29. Richard Mitchell, *Thought Control in Prewar Japan* (Ithaca, NY: Cornell University Press, 1976); and Patricia Steinhoff, *Tenkō: Ideology and Societal Integration in Prewar Japan* (New York: Garland, 1991). For comparison, see "Literary Policy in the Third Reich," by Jan-Pieter Barbian, in Glenn R. Cuomo, ed., *National Socialist Cultural Policy* (New York; St. Martin's Press, 1995), a work that includes essays on theater policy, the visual arts, and symphonic music, all with more emphasis on the Nazi "racial state" than on aesthetics.

30. Cook has previously examined a wide range of officially delegated Japanese literary figures in wartime China, including some with combat experience; see "Voices from the Front: Japanese War Literature, 1937–1945" (master's thesis, University of California, 1984). Besides Ishikawa, her writers include Hino Ashihei, Hibino Shirō, Ueda Hiroshi, Shibata Kenjirō, Hayashi Fumiko, and Ozaki Shirō. For the testimony of a haiku poet, Suzuki Murio—a soldier in China and a war prisoner in Siberia—see "As Long as I Don't Fight, I'll Make It Home," in Haruko Taya and Theodore Cook, *Japan at War: An Oral History* (New York: New Press, 1992), 127–134.

31. Novelist Hayashi Fumiko, touted in early January 1938 as the first Japanese woman to arrive in Nanjing, did not allude to atrocities in the columns she wrote for her *Asahi* newspaper sponsors (Ericson, *Be A Woman*, 80, 90, and n. 33). For a rigorous examination of historical literature on the Nanjing incident, see Daqing Yang, "Convergence or Divergence: Recent Historical Writings on the Rape of Nanjing," *American Historical Review* 104:3 (June 1999), 842–865, updated in Joshua A. Fogel, ed., *The Nanjing Massacre in History and Historiography* (Berkeley: University of California Press, 2000). One of the most cooperative and popular writers for the Great East Asian War but much ignored in scholarship was Yoshiya Nobuko, who, with Hayashi Fumiko, was the only other woman author to

travel with the "Pen-Men" to witness the fall of Hankou; she had produced an earlier war report based on a trip in late 1937 (Keene, *Dawn to the West: Fiction,* 910).

32. For an equally quick press notice of publication of the novel, see *Nippon Times,* October 17, 1945 (the article claimed that several thousands of books were banned under prior Japanese press laws and the General Mobilization Law of 1938).

33. For the more compliant soldier-author, Sgt. Hino Ashihei, see Donald Keene, *Dawn to the West: Fiction,* 916–926, and Rosenfeld, "Unhappy Soldier." In the United States, a selective English translation published in 1939 by Ishimoto Shidzue (later Katō Shidzue) of Hino's novels was denounced as militaristic; Helen M. Hopper, *A New Woman of Japan: A Political Biography of Kato Shidzue* (Boulder, CO: Westview Press, 1996), 125–130. A less felicitous but more faithful translation of Hino's war novels by Noel Bush and his wife, Kaneko Tsujimura, was published with little fanfare in Tokyo in 1939–1940 (by Kenkyū-sha) and in London in 1940 (by Putnam).

34. At about the same time, this same journal commissioned Kuki Shūzō, a philosopher well known for his essays on the "Edo aesthetic," to comment on the outbreak of war. The result, "Jikyoku no kansō" (Thoughts on the Current State of Affairs), asserted: "By vanquishing China, we Japanese must teach them in a decisive manner the spirit of Japanese philosophy. It is our cultural-historical duty to lend spiritual succor to the renewal of their motherland by imprinting *bushidō,* our idealistic philosophy in the innermost recesses of their bodies." This is quoted and discussed by Leslie Pincus in *Authenticating Culture in Imperial Japan: Kuki Shūzō and the Rise of National Aesthetics* (Berkeley: University of California Press, 1996), 231.

35. The members, who had to wait longer for Hankou to fall than anticipated (October 27–28), read like an all-star cast: Kikuchi Kan, Satō Haruo, Kume Masao, Kataoka Teppei, Hasegawa Shin, Niwa Fumio, Ozaki Shirō, Yoshikawa Eiji, and, as previously noted, two women—Hayashi Fumiko and Yoshiya Nobuko. Composer and symphonic conductor Yamada Kōsaka and oil painter Fujita Tsuguji were also sent to observe the advance.

36. *Japan Times and Advertiser,* May 4, 1942; subtitled, "Many novels depicting sounds, scenes from fighting front received enthusiastically." The author praises Kishida's "Fifty Days at the Front" not only for "his impressions of the frightful appearance of a devastated battlefield and of shells exploding nearby" but also for regarding "the Chinese cities and villages with the eyes of a man of culture" and forming "an accurate opinion on Chinese customs and habits and cultural establishments." Japanese readers, he asserted, liked "to check on the author's knowledge of China."

37. Kishida's 1943 works were the text of a play (not performed), *Kaeraji-to* (I Shall Not Return), published in *Chūō kōron,* June 1943; and a book addressed to other writers, *Chikara toshite no bunka* (Culture as Strength). See David Goodman, ed., *Five Plays by Kishida Kunio* (expanded edition, Ithaca, NY: East Asia Program, Cornell University, 1995), 6–8; also, Ben-Ami Shillony, *Politics and Culture in Wartime Japan* (Oxford: Oxford University Press, 1983), 124–125. As summarized by Keene, Kishida declared in his 1943 book that the objective of the war was to sweep away "Anglo-American" culture from Japan and East Asia; all cultural and entertainment figures should cooperate with government agencies (*Dawn to the West: Fiction,* 936). Other than these references, Kishida's wartime activities, which brought him severe criticism after the war, have not been closely examined by Western scholars. Goodman notes (as no doubt did Kishida himself) that over one hundred leftist leaders of the *Shingeki* or New Drama movement were arrested and many jailed in August 1940.

38. For a discussion of the three Greater East Asia Writers' Conferences and of the two Japanese literary works commissioned by the Greater East Asia Conference of December 1943 (playwright Morimoto Kaoru and novelist Dazai Osamu), see Ozaki, *Kindai bungaku no shōkon,* part 1; also Keene, "Japanese Writers and the Greater East Asia War," 309–310. The *Japan/Nippon Times,* which gave extensive coverage in November 1942, was less elaborate in August 1943 and barely there in November 1944 (On September 20, 1944, it cited novelist Yokomitsu Riichi for the prediction that the forthcoming conference in Nanjing would "clearly reveal how British and American activities in the past made them our common enemies"). The diary of dissident journalist Kiyosawa Kiyoshi confirms that the second conference (he was not invited) received "much fanfare" in the newspapers and included "sympathetic writers from Manchuria and Taiwan"; entry for August 28, 1943, in Eugene Soviak, ed., *The Wartime Diary of Kiyosawa Kiyoshi,* (Princeton, NJ: Princeton University Press, 1999), 70. In an earlier reference, February 10, 1943, Kiyosawa has Masamune Hakuchō (after an automobile ride with leading literary collaborator Kikuchi Kan) demeaning writers "as a bad lot. I hate to attend their gatherings" (16). For efforts to promote Japanese language and culture in newly acquired territories after 1941, see Grant K. Goodman, ed., *Japanese Cultural Policies in Southeast Asia during World War II* (New York: St. Martin's Press, 1991).

39. Tsukasa Osamu, *Sensō to bijutsu* (War and Art) (Tokyo: Iwanami Shoten, 1992). Kazu Kaido observed (in 1985) that after 1937 Japanese avant-garde artists, too, painted "both willingly and unwillingly, and these remain testimony to a period of bitter and desperate artistic compromise; even now, most of the artists involved do not wish to talk about these works"; see *Reconstructions: Avant-Garde Art in Japan, 1945–1965* (Oxford University: Museum of Modern Art, 1985), 11. Serious study of Fujita's war works dates from the late 1970s with such publications as Tanaka Hisao's book, *Nihon no sensōga: sono keifu to tokushitsu* (Japanese War Art: Its Lineage and Special Characteristics) (Perikansha, 1985); followed by Tanaka Jō, *Hyōden Fujita Tsuguji* (A Critical Biography of Fujita Tsuguji) (Tokyo: Geijutsu Shinbunsha, 1988). In 1992, a symposium was held on war and art, including the Fifteen Years War, at Ibaragi University; see brief report and two related articles in *Bijutsushi* (Art History) 44:2 (March 1995), which indicate that questions of aesthetics and distinctions between high and low art, in addition to embarrassed reticence, had held up research. As in the case of drama and literature, details are missing in studies of the organization, functioning, and internal discourse of wartime art associations and exhibits; also of the harassment of avant-garde and noncompliant painters. For a brief overview of twentieth-century Japanese war art, one that omits World War I and the Siberian Exhibition, see *Imeeji no naka no sensō: Nisshin/Nichiro kara reisen made* (War Illustrated in Images: From the Sino-Japanese and Russo-Japanese Wars to the Cold War), by Tan'o Yasunori and Kawata Akihisa (Tokyo: Iwanami Shoten, 1996); both authors participated in the Ibaragi University Symposium in 1992. Of special interest on the concept of war art as understood and produced in Britain at the beginning of World War II is Sir Kenneth Clark, "The Artist in Wartime," *The Listener* (October 26, 1939), 810; and Sarah Griffiths, "War Painting: A No-Man's-Land between History and Reportage," *Leeds Art Calendar* 78 (1976), 24–32. For Picasso, see catalogue, *Picasso and the War Years, 1937–1945,* ed. by Steven A. Nash (Fine Arts Museum of San Francisco, 1999).

40. An early wartime painting of Fujita's, one not reproduced elsewhere, is the "Thousand Stitch Belt," painted for the privately sponsored Nikakai Exhibition in the fall of 1937; it depicts a street scene in Tokyo of three women and a girl, each adding a stitch "as a charm against bullets" to belts to be worn by soldiers (illustration, *Japan Times and Mail,*

September 6, 1937). Fujita's first officially commissioned battle scenes followed in 1938, memorializing actions leading to the fall of Wuhan in October. Although the military favored oils for realism in art, many effective works were produced in *nihonga* styles. See the Pacific War anniversary issue of *Bijutsu shinchō* (Art Currents) 46:8 (August 1995); also J. Thomas Rimer, "Encountering Blank Spaces: A Decade of War, 1935–1945," in Ellen Conant, ed., *Nihonga,* 57. Bert Winther-Tamaki provides an analytical and theoretical overview, but with examples drawn primarily from the Pacific War period, in "Embodiment/Disembodiment: Japanese Painting during the Fifteen Year War," *Monumenta Nipponica* 52:2 (Summer 1997), 145–180.

41. As Sandler once observed, to appreciate fully the monumental scale of Fujita's war work, it is necessary to see it on exhibit. Otherwise, for impressive color reproductions, there is an early postoccupation collection, *Taiheiyō sensō meigashū* (The Pacific War Art Collection) in two volumes (Tokyo: Nōberu Shobō, 1967/1968); as well as the previously cited special war art issue of *Bijutsu shinchō* (August 1995), 30–35. Although difficulties have surrounded the display, illustration, and reproduction of war art by Fujita and other Japanese painters, there are easily available black-and-white U.S. Army Signal Corps photographs of 153 confiscated Sino-Japanese and Pacific War paintings at both the National Archives, Still Pictures (Archives II, College Park, MD) and at the MacArthur Memorial Archives (Norfolk, VA). In addition to a beautifully bound folio album prepared especially for General MacArthur, the MacArthur Archives has many color transparencies but not a full set. The collection at Archives II is contained in two smaller albums (3172 and 3173) and identified as "Japanese War Art Painting in Custody of U.S. Army of Occupation in Japan;" prints are in SC 111, Box 146. The original photos were made by G. Demetrius Boria in November 1947 at the Tokyo Prefectural Art Museum, Ueno, where the canvases were housed in five rooms from 1945 to 1951. The confiscation points included, with Fujita's expert help, the Yasukuni Shrine, the Navy Museum, the Ministry of War, the army warehouse at Kanda in Tokyo, the Japanese Red Cross Headquarters at Takayama City, and as many as twenty-eight in Seoul, U.S.–occupied Korea (including one by Fujita, *The Fighting of Five Scouts at Guadalcanal*). Selected paintings were put on display for one month—August 1946—but only for the eyes of GIs and civilian occupiers; MPs guarded the doors to intercept Japanese gate-crashers. See *Time,* September 1946 for an illustrated article; also the *Nippon Times* (August 22 and 25) and *Stars and Stripes* (September 1). Since Fujita's Saipan painting was commissioned late in the war and completed in 1945, together with his final painting of action at Leyte Island, there is some question as to who actually saw it (this painting, collected at the War Ministry, is ironically mislabeled in English in the 1967 publication cited above, Plate 79, as *Japanese Prefer Dishonor on Saipan,* instead of *Japanese Prefer Death to Dishonor on Saipan Island,* apparently the title given at the time of confiscation; the catalogue title in Japanese is *Saipan no gyokusai* ["*gyokusai*" signifying smashed jewels or smashed bodies, including both military and civilians, all supposedly willing to die loyally by mass suicide]; the painting has been variously labeled in essays and catalogues [Fujita's original choice is unclear]: *The Culmination of the Loyalty of Our Compatriots at Saipan, Last Days at Saipan, and Sacrificial Days at Saipan*). In a radical reinterpretation of the last days on Saipan, Haruko Taya Cook has pointed out that many more Japanese civilians (mostly Okinawans) surrendered to the Americans than committed suicide; see "Turning Women into Weapons: Japan's Women, the Battle of Saipan, and the Nature of the Pacific War," in Nicole Ann Dombrowski ed., *Women and War in the Twentieth Century: Enlisted with or without Consent* (New York: Garland, 1999), 240–261.

42. Winther-Tamaki's references to Fujita's comments in various wartime publications indicate pride and enthusiasm ("Embodiment/Disembodiment"). However, to a reporter for the *BCON* (British Commonwealth Occupation News) issue of November 17, 1947, Fujita brushed the paintings aside as "trash." Much later, in 1966, *Time* magazine (which over the years featured Fujita at least four times), would photograph him in France praying in his private chapel near Reims under his baptismal name, Léonard, "to atone for his sins" (October 28), 76. Ishiguro Kazuo's novel, *An Artist of the Floating World* (London: Faber, 1986), is a haunting story of the self-deception of a Japanese artist who served the Japanese Empire with propaganda works in World War II.

43. Interview with the Marukis, "We Wouldn't Paint War Art," in Haruko Taya Cook and Theodore Cook, *Japan at War: An Oral History*, 253–257. Though the Marukis could have actually viewed the Attu painting at a wartime exhibit, they probably could not have seen the Saipan work on public display until after its restoration to Japan by the United States, together with other confiscated war art in the 1970s. For those who would prefer to forget the existence of such war art or refuse to show it to the public, see "Painting over the Pain: 'Death Railway' Art Hopes to Heal Old Wounds," *Japan Times Weekly International Edition*, August 10–16, 1999.

44. For the larger cinema scene, see Abe Mark Nornes and Fukushima Yukio, *The Japan/America Film Wars: World War II Propaganda and Its Cultural Context* (Chur, Switzerland: Harwood Academic, 1994). The personal views of film and stage actors too deserve more attention; see Frida Freiberg, "*China Nights* (Japan, 1940): The Sustaining Romance of Japan at War," in John Whiteclay Chambers and David Culbert, eds., *World War II: Film and History* (New York: Oxford University Press, 1996), 31–46. The use and abuse of atomic bomb imagery is well handled in Mick Broderick, ed., *Hibakusha Cinema: Hiroshima, Nagasaki, and the Nuclear Image in Japanese Film* (London: Kegan Paul, 1996). An important addition to film discourse is Joanne Izbicki, "Scorched Cityscapes and Silver Screens: Negotiating Defeat and Democracy through Cinema in Occupied Japan," Ph.D. dissertation, Cornell University, 1995. In a new book, Mitsuhiro Yoshimoto discusses war guilt and victim consciousness within the larger framework of early postwar concerns about *shutaisei*, or subjectivity; *Kurosawa: Film Studies and Japanese Cinema* (Durham, NC: Duke University Press, 2000), 122–134.

45. See John Solt, *Shredding the Tapestry of Meaning: The Poetry and Poetics of Kitasono Katue (1902–1978)* (Cambridge, MA: Harvard University Asia Center, 1999), 191 (Katsue's preferred romanization). This is a necessary companion work to Rabson's *Righteous Cause*, which discusses Takamura Kōtarō, Saitō Makoto, and other mainstream poets during the war years and after (191–206). Also see David C. Earhart, "Nagai Kafū's Wartime Diary: The Enormity of Nothing," *Japan Quarterly* (October–December 1994), 488–503. Fragments from the diaries of Itō Sei are cited in Nakamura Takafusa, *A History of Showa Japan. 1926–1989* (Tokyo: University of Tokyo Press, 1998), 241–243, 247.

46. Keene, *Dawn to the West: Fiction*, 820–825. For Kawabata's wartime writing and travel to Manchuria, see Cabell, "Maiden Dreams," Part 3.

47. Occupation records reveal that Fujita was approached as early as October 1945 to aid Americans in recovering Japanese war art (prompted by American combat artists and the Historical Properties Division of the War Department). General Douglas MacArthur, mindful of Nazi looting in Europe, had some difficulty in finding an acceptable rationale: Were these war paintings art, booty, or propaganda? It was subsequently decided that the art was in fact "vicious propaganda" without artistic merit; therefore, it was not inappro-

priate to prevent Japanese from viewing the paintings. The confiscated works comprised 153 paintings (mostly oils, but some *nihonga*) that were retained, as noted, under U.S. Army custody in Japan from 1945 to 1951, when they were shipped for a long stay in the United States (subsequently returned after 1971 on permanent loan to the National Museum of Modern Art, Tokyo); see Record Group 331 (Supreme Commander for the Allied Powers, Japan), Archives II, and U.S. Army Art Collection, U.S. Army Center of Military History, Washington, D.C. Meantime, Fujita, though unhappy in Japan, resumed painting while lecturing at his alma mater, the Tokyo School of Fine Arts, and at the Tokyo Army Education Center. For his initial postwar art and the grant of several requests to enter the United States, see exchange of radiograms, SCAP and Department of Army, 1 December 1948, 16 February 1949, 25 February 1949, RG 9, MacArthur Memorial Archives; also Sylvie Buisson and Dominique Buisson, *La Vie et L'oeuvre de Léonard Foujita* (Paris: ACR Éditions Internationale, 1987), 200–204.

48. *Nippon Times,* December 3, 1949. Shahn was also friendly with Japanese artist Kuniyoshi Yasuo, a longtime resident of the United States and prewar acquaintance of Fujita. For evaluations of Shahn's wartime and postwar art (which included a protest against atomic bomb testing after fallout killed a Japanese fisherman and injured several others in the *Lucky Dragon* Incident, 1954), see Howard Greenfeld, *Ben Shahn: An Artist's Life* (New York: Random Harvest, 1998); and Frances K. Pohl, *Ben Shahn: New Deal Artist in A Cold War Climate, 1947–1954* (Austin: University of Texas Press, 1989). For two revisionist reviews of a retrospective exhibit that raise questions about the interrelationship of art and politics, this time in a democracy, see Paul Richard, "Ben Shahn, Anchored to His Times—the victims in his painting bore up, but the work doesn't," *Washington Post,* November 19, 1998; and Michael Kimmerlman, "Trying to Separate Ben Shahn's Art from His Politics," *New York Times,* November 13, 1998.

49. Japanese studies of China and Pacific War art still lag in comparison to such works as Merion and Susie Harries, *The War Artists: British Official War Art of the Twentieth Century* (London: Imperial War Museum and Tate Gallery, 1983); and Cecile Whiting, *Antifascism in American Art* (New Haven: Yale University Press, 1989), which does not, however, include American combat art, another neglected topic, perhaps because of postwar scorn for figurative art. For a collection of World War II combat art by all of the participants, including the United States and Japan, see Ken McCormick and Hamilton Darby Perry, eds., *Images of War: The Artist's Vision of World War II* (New York: Orion Books, 1990). Indicative of what might be done in more detailed examinations of Japanese war art are the following: Brandon Taylor and Wilfried von der Will, eds., *The Nazification of Art: Art, Design, Music, Architecture and Film in the Third Reich* (Winchester, England: Winchester Press, 1990); Jonathan Petropoulos, "A Guide through the Visual Arts Administration of the Third Reich," in *Nationalist Socialist Cultural Policy* (1995); and especially Peter Adam in *Art of the Third Reich* (New York: Harry N. Abrams, 1992), which covers exhibitions, Hitler and the artists, and the ideology to be embedded in the arts—painting, sculpture, interior design, sites, and architecture. Also, broadly comparative but without Japan is Igor Golomstock, *Totalitarian Art in the Soviet Union, the Third Reich, Fascist Italy and the People's Republic of China* (New York: Harper-Collins, 1990); Communist China is added here only as an appendix. "Totalitarian art," reminds Golomstock, "did not appear out of a vacuum" (xiv). Care must be taken in applying the label and criteria to Japan, as in the case of fascism. But did the military manipulation of Tennoism in Japan play an analogous role in Japan to "Big Brother" in other totalitarian societies?

50. Although atomic bomb art and literature are not included in this volume, there is considerable Japanese- and Western-language scholarship—covering painting, poetry, fiction, film, and *manga* or cartoons. For example, John Dower and John Junkerman have introduced painters Iri and Toshi Maruki (protesters in wartime, well before their postwar collaborative work on atomic bomb, Nanjing Massacre, and Holocaust murals) in the documentary film, *Hellfire, A Journey from Hiroshima* (1985). For literature, John Whittier Treat has published a monograph, *Writing Ground Zero: Japanese Literature and the Atomic Bomb* (Chicago: University of Chicago Press, 1995); and Richard Minear has reconstructed mangled texts of censored atomic bomb poetry and fiction from the Allied Occupation period in *Hiroshima, Three Witnesses* (Princeton, NJ: Princeton University Press, 1990). Another work with literary samplings is Kyoko and Mark Selden, eds., *The Atomic Bomb, Voices from Hiroshima and Nagasaki* (Armonk, NY: M. E. Sharpe, 1989). Two massive collections in Japanese are: *Nihon no genbaku bungaku* (Japanese Atomic Bomb Literature) (Tokyo: Horuka Shuppan, 1983), 15 vols.; and *Nihon no genbaku kiroku* (Japanese Atomic Bomb Records) (Tokyo: Nihon Tosho Senta, 1991), 20 vols. (originally published over the years 1949–1988).

51. There has been slow follow-up, for example, to essays on art, literature, and drama appearing in Thomas Burkman, ed., *Occupation of Japan: Arts and Culture* (Norfolk, VA: MacArthur Memorial, 1988). Thomas Havens picks up after the Occupation in *Artist and Patron in Postwar Japan: Dance, Music, Theater, and the Visual Arts, 1955–1980* (Princeton, NJ: Princeton University Press, 1982). In her introductory essay, Alexandra Munroe joins the postwar art scene to the 1942 debates in Kyoto, "overcoming the modern," suggesting that leftists had to rethink Japanese modernization as refuting Western imperialism while at the same time taking on Japanese Pan-Asianism and "authoritarian orthodoxy" or conformism; *Japanese Art since 1945*, 23–24. However, scant attention is given to the Occupation period per se; the same is true in Emiko Yamanashi, "Painting in the Time of 'Heavy Hands'" (see, however, her reference to *Psychic Landscape,* painted in 1949 by Tsuruoka Muso after ten years of silence), in Mark H. Sandler, ed., *Age of Confusion: Art and Culture of Japan during the Allied Occupation, 1945–1952* (Washington, D.C.: Arthur H. Sackler Gallery, 1997), 232; and Rimer, "Postwar Development: Absorption and Amalgamation, 1945–1968," in Conant, ed., *Nihonga.* A good source for illustrations from the wartime and immediate postwar period is *Shōwa no kaiga* (Paintings from the Shōwa Era), 2 vols. (Sendai: Miyagi Prefectural Art Museum, 1991).

52. This essay is a companion piece to an earlier one by Sodei, "Satire under the Occupation: The Case of Political Cartoons," including twenty-two illustrations by Kondo Hidezō, a rival to Katō; John Dower follows with commentary and a second set of illustrations, 107–123; Burkman, *The Occupation of Japan*, 93–123. See also interviews with Yokoyama Ryūichi, cartoonist of the highly popular series *Fuku-chan*, "Cartoons for the War," in Haruko and Theodore Cook, *Japan at War*, 95–99 and 471–472. Frederik L. Schodt provides a historical introduction to modern cartooning in "A Thousand Years of Manga," in *Manga! Manga! The World of Japanese Comics* (New York: Kodansha, 1983), 23–67. As of March 1941, cartoonists had a new wartime association and were planning a show, the Shōwa Manga Exhibition; *Japan Times and Advertiser,* March 4. For Western-style satire, see Charles Press, *Political Cartoons*, chapter 6, "Wartime Cartoons: Democracy's Dark Side" (Rutherford, NJ: Fairleigh Dickinson University Press, 1981).

53. Katō's cartoons began to appear in late July 1939 as a regular feature of the *Japan Times and Advertiser* and continued to early 1945, when newspaper stock became scarce;

see the Yōshodō microfilm edition of the newspaper. One of his best, December 20, 1941, depicts a battered Churchill and Roosevelt in sailor suits, each with a bandaged leg and propping up the other, asking in the aftermath of Pearl Harbor and Malaya, "Can we get home?" Katō frequently drew cartoons showing Japan's forceful ejection (kicks, punches, battering rams) of the West from East Asia. For the Chinese version, however, see Chang Tai-hung's extensive selection of anti-Japanese war cartoons in *War and Popular Culture,* chapter 3. Mauldin drew GIs, but only in the European War; see *Up Front* (originally 1945; reprint by W. Norton, 1968). John Dower has a set of Japanese and American war cartoons in *War without Mercy: Race and Power in the Pacific War* (New York: Pantheon Books, 1986). Otherwise, the following collections are strictly Western in coverage (including both the Allies and Nazis): Roy Douglas, *The World War, 1939–1945: The Cartoonists' Vision* (London: Routledge, 1990); and Mark Bryant, *World War II in Cartoons* (New York: Gallery Books, 1989).

54. Dower prefers to say "multiple conversions" rather than "ideological somersaults" in referring to this and other cases and to remind readers that conversions occurred frequently (Burkman, *Occupation of Japan: Arts and Culture,* 108).

55. For American cartoons during the Occupation years, see the newspaper *Stars and Stripes.* In addition to reprints of popular comic strips from home, it carried original cartoons of the Japan scene—often embarrassing in their racist or sexist humor.

56. Witness a growing body of Western literature since the 1950s on the aesthetics, staging, and acting of kabuki and also on the themes and techniques of modern Japanese theater; see Benito Ortolani, "History of Western Research on the Japanese Theatre," chapter 12 in *The Japanese Theatre: From Shamanistic Ritual to Contemporary Pluralism,* rev. ed. (Princeton, NJ: Princeton University Press, 1995).

57. Kishida, perhaps overly intent on gaining support for modern Japanese drama, concludes: "No matter how the *No* and *Kabuki* may be esteemed by Westerners from the aesthetic viewpoint, we must point out the cultural reactions that these dramas create and emphasize that they give neither encouragement nor comfort to modern life" ("New Movements on the Stage," December 1935, 356). Maruyama, writing five years later during wartime, called kabuki the "national drama of Japan" and "artistically valuable," but he alludes to its inability to "dramatize the new era," as had already become evident during the first Sino-Japanese War ("Development of the New Drama in Japan," May 1940, 186). The Cabinet Information Bureau was to decide otherwise.

58. Although symposia on wartime and occupied theater have been held in Japan, there is apparently less revisionist scholarship than on literature and art. A new book by journalist Okamoto Shirō tends to repeat many of the conventional, adulatory views of mainstream scholars and prominent kabuki actors: *Kabuki o sukutta otoko: Makkasa no fuku-kan Fobian Bawazu* (The Man Who Saved Kabuki: Faubion Bowers, Aide to MacArthur) (Tokyo: Shueisha, 1998); for an excerpt in English, see "Kabuki's American Patron Saint," *Japan Echo,* June 1999. Here, Jennifer Robertson's recent work on *Takarazuka* comes to mind—"performing empire" is also an apt term for kabuki. A good place to focus research would be on the internal discourse of theatrical journals during the war years (1937–1945), keeping in mind censorship and forced reductions and mergers. Whether or not one accepts the applicability of fascism to the Japanese scene or comparisons with Nazi Germany, there is much to learn from studies of fascist theater (and the theatre of fascism) or in attempting to apply some of the ideas of Walter Benjamin to kabuki and *shingeki.* Leslie Pincus, *Authenticating Culture in Imperial Japan* (Berkeley, 1996), offers stimulating reflec-

40

tions along these lines (214–218). Suggestive as to topics and approaches are Bogushaw Drewniak, "The Foundations of Theater Policy in Nazi Germany," in Glenn R. Cuomo, ed., *Nationalist Socialist Cultural Policy* (New York: St. Martin's Press, 1995); and Gunter Berghaus, ed., *Facism and Theatre: Comparative Studies on the Aesthetics and Politics of Performance in Europe, 1925–1945* (Providence: Berghahn Books, 1996).

59. Kerkham fully cites the large and growing historical and journalistic work by Japanese, Koreans, Americans, and Australians on comfort women, with a special tribute to the research talents of Japanese historian Yoshimi Yoshiaki, one of the first (1992) to discover official documentation of military sexual slavery. Thus far, little has been available on Nationalist Chinese military prostitution or complicity with Japanese commanders in occupied China; however, recent discoveries in Taiwan, as she indicates, help to document the hierarchy of arrangements between the Japanese military and local commercial enterprise in procuring young women for sexual service. A useful recent survey on comfort women is marred by undocumented statements about Tokugawa samurai and changing gender roles: Chung Chin-shun, "An Overview of the Colonial and Socio-economic Background of Japanese Military Sex Slavery in Korea," *Muae: A Journal of Transcultural Production* 1 (1995), 204–215. As noted by Kerkham, Japanese feature filmmakers—in two attempts, 1950s and 1970s—have failed to portray the reality of the comfort women; documentary filmmakers have done better, as in the case of *Sensō Daughters,* produced in Australia by Sekiguchi Noriko (video version, 1990). After Tamura, Japanese writers have been evasive; in the West, "literature of the body" has not yet been fully addressed. For a sampling, see J. Victor Koschmann, *Revolution and Subjectivity in Postwar Japan* (Chicago: University of Chicago Press, 1996), 57–60. However, the early 1990s protest art of Tomiyama Taeko and Shimada Yoshiko illustrates both the expanded postwar presence of women artists in a male-dominated Japanese art world and the further development of a Japanese feminist social consciousness; see "'Post-Colonial' Feminist Locations: The Art of Tomiyama Taeko and Shimada Yoshiko," *U.S.–Japan Women's Journal* 12 (December 1996).

60. See Hiroko Tomida and K. D. M. Snell, "Japanese Oral History and Women's Historiography," *Oral History* 24:1 (Spring 1996) (Published at Essex University, Great Britain), 88–95. Military historian Hata Ikuhiko has been particularly resistant to oral testimony by the comfort women and by returned Japanese military and civilian personnel (male and female)—also oblivious to androcentric sexual attitudes. Japan's semiofficial outlets tend to give mainstream or conservative critiques more publicity than the findings of revisionist scholars; see Hata, "The Flawed U.N. Report on Comfort Women," *Japan Echo* (Autumn 1996). Especially adept at addressing cultural blinders is Yamashita Young-ae, "Nationalism in Women's Studies: Addressing the Nationalist Discourses Surrounding the 'Comfort Women' Issue," *U.S.–Japan Women's Journal* 15 (1998), 52–77. Sheldon Garon, *Molding Japanese Minds: The State in Everyday Life* (Princeton, NJ: Princeton University Press, 1997), in his overview of licensed prostitution in modern Japan from the Meiji period to 1956 (when the antiprostitution law was passed), sees the recruitment of comfort women primarily as an extension of state controls overseas—a reflection too of one of the oldest answers to the oldest profession. But is it? Garon mentions but does not deal with the complexities of the world of unlicensed prostitution, nor does he integrate his findings with the story of overseas prostitution featuring the *karayukisan* or the history of sexuality in Japan. His brief passages on comfort women (110–111), which were not part of his article for the *American Historical Review* in 1993, seem to indicate marginalization of the issue. Kiyosawa Kiyoshi's war diary offers pithy observations on gender issues: "Love

suicide has disappeared in society. The views of male-female morality have changed. That is to say, there is no social necessity for it anymore. Of late, I hear that the crime that has increased the most is rape"; *Diary of Darkness* (entry for June 18, 1943), 39. Another avenue for additional research and a link to occupied Japan is GI sexual behavior behind Nationalist Chinese lines and elsewhere in the Pacific War theaters.

61. Apart from the work of historian Richard Minear and a handful of Western scholars, materials in the Gordon W. Prange Collection, University of Maryland, have been underutilized in Western studies of the fiction, poetry, and drama of occupied Japan. This large repository of books, magazines, and newspapers, now fully accessible, is invaluable in showing what was published, what was censored and why, and what was banned or confiscated. It includes, for example, the first postwar reprint of Hayashi Fumiko's *Hōrōki* (Record of a Vagabond), 1946, with an afterword, as well as the unexpurgated 1945 version of Ishikawa Tatsuzō's *Ikiteiru heitai*. It demonstrates that Kawabata ran into some minor trouble with one of his first postwar short stories and that an entire story by Tanizaki was suppressed, both in 1946. On the other hand, short stories by Ishikawa Jun and Sakaguchi Ango containing taboo references to occupying GIs somehow cleared censorship (rare instances, however), while other work by them was caught and stopped. The collection reveals the permissible limits of literary (indeed all) public discourse at this time and is invaluable in checking omissions and revisions by authors in preparing ostensibly full collections, or *zenshū,* after 1950. As in the case of cartoons or other visuals from 1945 to 1950, Japanese readers were for the most part denied fiction and poetry with references to sexual fraternization, the atomic bomb, or American products bought on the black market (readers of translations should be alerted to this). Equally revealing as to gender, racism, and ethnicism are remarks that famous and ordinary Japanese wished to publish but could not. By contrast, Japanese scholars have made good use of the materials since the late 1970s; a recent publication on literary censorship based entirely on the Prange Collection is Yokote Kazuhiko, *Hi senryōka no bungaku ni kansuru kisoteki kenkyū* (Basic Research on Japanese Literature under Occupation), vol. 1 (Sources), vol. 2 (Studies) (Tokyo: Musashino Shobō, 1996). This work exists, however, in a scholarly vacuum, lacking a full Japanese and Western bibliography.

62. Although Wolfe did not live long enough to put the final stamp of his intricate mind and multiple theoretical, political, and aesthetic concerns on Sakaguchi's postwar work, he will continue to inspire future studies. For his contributions to the field of Japanese literature and to literary criticism and for his achievements as scholar, teacher, and critic, see the tribute by Brett de Bary, Carol Gluck, and Bruce Cumings, *The Bulletin of Concerned Asian Scholars* 31 (January–March 1999), 79–81. For a reassessment of Sakaguchi's works and reputation, see Robert A. Steen, "To Live and Fall: Sakaguchi Ango and the Question of Literature," Ph.D. dissertation, Cornell University, 1995.

63. On issues of artificial periodization and the deep structures of history, see Carol Gluck, "The Past in the Present," *Postwar Japan as History* (Berkeley: University of California Press, 1993), 64–98; and Dower, *Embracing Defeat* (1999).

PART

I

EMPIRE:
Occupied Territories

Korea the Colony and the Poet Sowŏl

David R. McCann

THE PERIOD OF THE JAPANESE occupation in Korea has until relatively recently been treated as an interval divided between people who were active Korean nationalists and those who were collaborators. It is not surprising, given the length of the occupation—thirty-five years from 1910 until the Japanese surrender in 1945 —that historical hindsight has found many Koreans to condemn whose nationalist resolve wavered during the last several years of the occupation, when military mobilization and a thoroughgoing program of cultural repression—euphemistically called *cultural assimilation*—combined to make anything other than self-imposed exile a form of collaboration. Equally severe, in contrast, has been the demand for exemplary nationalists that was created by the political ideology constructed in the South following the Korean War, most notably during the eighteen-year regime of Park Chung Hee, from the military coup d'état in 1961 until his assassination in 1979. The intellectual, political, and artistic leadership of the 1920s and 30s was culled for suitable selections to the national canon, so that their works, deeds, and words could be taught to successive generations of students as expressions of Korean national will in confronting the Japanese occupation.

The secondary school curriculum tended to moot the important point of the identity of the Korean nation that the canonical figures are said to have exemplified. While Koreans long have shared a strong sense of national cultural identity, the Japanese occupation followed by the 1945 division has made the nature of the Korean nation far more problematic. The so-called *minjung* (people, or the masses) movement of the 1980s,[1] for example, seemed to pit the establishment against what might be called a radical populist movement in politics and culture, a movement that, among other things, argued that cultural and political legitimacy was to be appropriated only from the people—and specifically the common peo-

ple. The apparent radicalism of this movement lay in its contrast with the political establishment more than any revolutionary program; that and the establishment's propensity to base claims for its legitimacy on the power to wield political authority through control of the military rather than by any clear mandate to govern. It is arguable that national political identity in South Korea was extremely tenuous even as late as the presidential election of 1987, when the opposition political parties could not set aside parochial ambitions in favor of unified political purpose. Roh Tae Woo "won" the election with only about one-third of the popular vote, while Kim Young Sam and Kim Dae Jung split the majority and yet oddly termed *opposition* vote between them.

In *Sumatran Politics and Poetics,*[2] John Bowen explores the mediational functions that literature performed in twentieth-century Sumatran political history. Among other things, his work is a study of the ways in which political issues were engaged and mediated in poetry, a reading of poetry as a renegotiation of unresolved political issues. If questions of Korean nationalism, national identity, patriotism, and collaboration currently remain problematic, whether in terms of the conditions in Korea during the Japanese occupation or in more recent situations such as the 1987 presidential election campaign, then regarding Korean literature it is sensible to raise the question not of what is neatly "expressed in it," but rather what remains problematic.

This essay will examine a few representative works by one of the most highly regarded of Korea's poets from the 1920s, Sowŏl, Kim Chŏngsik (1902–1934). I shall examine the poems first as expressions of Korean national sentiment over the Japanese occupation—the reading or meaning assigned to the works within the established construct of the Korean literary canon. The major portion of this study will pursue the notion of the unspoken, unvoiced subjects in Sowŏl's poems rather than their evocations of the Korean nation or their direct engagement with popular struggle. I shall suggest that the questions of self, voice, and gender in the poems comprise a nexus that replicates or rescripts the "situation" of "Korea" during the Japanese colonial period. The problematic elements that seem characteristic of Sowŏl's poetry include the poetic self defined by isolation and absence; the poetic voice captured in the moment of crossover from silence into speech; and the gender of the generally recognized and yet largely unexamined female *persona* appearing—or perhaps, even more characteristically, *not* appearing—in the poems.

A Writer's Life

For anyone having an interest in learning about modern Korean poetry—and by extension, Korean history—Sowŏl (his pen name) Kim Chŏngsik is a favorite subject. Sowŏl was a cosmopolitan citizen of the new Korea, and yet he died in rural poverty and obscurity. He lived through the middle of the Japanese colonial occupation of Korea, through a time of great ferment and experimentation with new, foreign styles and schools of literature, and yet he is now known as a traditional, melancholy, "folk-song poet." In the years after his death in 1934, Sowŏl became

Korea's most popular twentieth-century poet. Many editions of his one book of poems, *Azaleas (Chindallaeggot),* have been published, while new discoveries of fugitive or manuscript poems have continued to add to his oeuvre. Sowŏl seems easy to know, furthermore; his five or six best-known poems, published in all the Korean national language and literature textbooks, are melancholy laments, beautifully constructed lyrics that seem to have an especially strong appeal to younger Korean readers and, in translation, to foreign readers as well.

Born in 1902 in the town of Chŏngju in North P'yŏngan Province, near the city of P'yŏngyang, Sowŏl attended the Osan Elementary School, where several leading writers taught—writers such as Kim Ŏk, who became Sowŏl's teacher and literary mentor, and Yi Kwangsu, the first modern novelist of Korea; and where Ch'ae Mansik, who eventually became one of Korea's leading political figures, served as school principal.[3]

The Osan School was closed in 1919 following the nationwide demonstrations for Korean independence that had begun in Seoul with the reading of the Korean Declaration of Independence on March first. Ch'ae Mansik was the evident cause for the forced closing, since he had taken an active part in the planning of the demonstrations. Sowŏl, who was to have graduated in 1920, received his certificate of graduation early, then went down to Seoul and continued his studies at Paejae Academy, a school that had been founded by Protestant missionaries in 1886. Kim Ŏk also went to Paejae to teach at that time.

Sowŏl graduated from Paejae and went to Tokyo in 1923, where he intended to enter Tokyo Commercial College. The records of the college are lost, however, so it remains unknown whether he ever matriculated. Financial problems in the family business—his grandfather owned a mine—may have been the cause of his return soon after; Japanese colonial regulations made the mining business uncertain for non-Japanese mine owners. He was back in Seoul by October of 1923, evidently trying to become established in the literary world. At this time he became close friends with another Paejae graduate, the writer Na Tohyang, and the two young friends took up the writer's role with enthusiasm, becoming known for their drunken carousing. Na Tohyang, later remembered as Sowŏl's only close friend in the literary world, died in 1927.

Sowŏl's poems soon began to appear in substantial numbers in the leading literary and intellectual journal of the day, *Kaebyŏk* (Creation) magazine; and his book *Azaleas* was published in 1925. Kim Ŏk, an editor of the magazine, no doubt provided the requisite introduction, the key that all new writers needed then as they do today in Korea to unlock the door to a literary debut.

Initial success in the modern world of letters was followed by disappointment. In his "Recollection of Sowŏl" published shortly after Sowŏl committed suicide in 1934, Kim Ŏk recalled that Sowŏl "hated to be called a folk-song poet, for whatever reason, and demanded that as a poet he be called a poet."[4] One possible reason for Sowŏl's dislike of the term, by which he is known even today, is suggested by the egregiously mean-spirited reference to his poems in *Kaebyŏk* magazine's 1925 "Poets in the Contemporary World of Poetry." The author of the review,

Kim Kijin—another Paejae graduate and a leader in proletarian literature who went to North Korea after liberation in 1945—observed that, "outside of a certain prettiness of expression in the folk-song style, there is nothing much worth considering in Sowŏl's poems." He recommended that Sowŏl confine his literary efforts to his "original territory," the realm of the folk-song-style lyric."[5] Sowŏl left Seoul, first to try to make a living as the agent for the Kusŏng branch office of the newspaper *Tonga ilbo* (East Asia Daily News), then later as a moneylender. His last years were spent in drunkenness, and he died of an opium overdose—probably intentional.

Several themes emerge from this brief sketch of Sowŏl's life. His life was split between the countryside and the city. He was isolated from the Korean literary world. He experienced repeated financial difficulties. He drank. He was connected through his educational history with leading writers and politicians and with cultural national leaders of various persuasion; and he was directly aware—through the closing of Osan School, the financial troubles of the family business, and his presence in Korea at the time of the 1919 independence demonstrations—of the Japanese occupation of Korea and the Korean national resistance to it. Yet in his poetry there is hardly a hint of the colonial, urban, metropolitan, financial, nationalist elements of his times. This almost studied absence in his poetry of any direct reference to Korea's national plight may well explain the exasperation with Sowŏl that an activist such as Kim Kijin expressed in his 1925 review.

The mid-twenties in Korea saw the development of the nationalist movement and, ultimately, the split between the leftists and the centrist cultural nationalist movement. Political and intellectual life in Korea in the 1920s became increasingly heated and volatile. Magazines such as *Kaebyŏk* that had flourished in the early twenties were shut down by the Japanese toward the end of the decade as the colonial government imposed increasingly severe censorship in its effort to beat down the Korean nationalists.[6] Sowŏl seems to have engaged with none of this; instead he wrote beautiful, traditional folk-song-style lyrics.

If one organizes his biography according to the time of greatest literary output, Sowŏl was an urban poet, a writer of the capital district. If one situates the poet by his origins and eventual destination—and more importantly, by what he actually wrote—Sowŏl was a rural poet, one who came from the countryside and returned to it constantly in his life and works. But in combining the rural and urban, in moving from countryside to city and then back again, Sowŏl was actually following a pattern that many other Koreans pursued during the colonial occupation period. The bifurcated life, as much as the rural or urban designation of one's residence, was a salient characteristic of life during the occupation. In having a similarly restless life, at least in its broad outline, Sowŏl was a true denizen of 1920s Korea; and as a bridge between the two, even though the urban pole remains largely hidden, Sowŏl's poems articulate or negotiate the unresolved political ideological dilemma of their day: how to be both modern and Korean as a writer.

We note the absence of references to Korea in the poetry of one of Korea's colonial-era poets. Let us further prepare to note the absence in the poems of any

direct reference to the colonial situation—any reference to employment, to the ladder of success, to the colonial administration, to banking and commerce, to streets and traffic noise, to markets. The city, the colony, "Japan," and "Korea" are *absent* from Sowŏl's poems. How has Sowŏl managed to find lodging in the Korean national literature textbooks? Kim Kijin's words of dismissal—"prettiness of expression in the folk-song style"—have been turned inside out, as Sowŏl is particularly admired today for the beauty of his expressive use of the Korean language. To the social activist, such aesthetic qualities evidently seemed of secondary importance. In his 1934 "Remembrance of Sowŏl," Kim Ŏk divided the oeuvre into works in the folk-song style, *minyosi,* which he thought were the more successful, and those defined almost by default as poems—*si.* Kim Ŏk praised the beauty of expression, the skillful use of language, and the rhythmic qualities of the former, while finding Sowŏl's "poems" to be "rather formal products of the intellect."[7] Just how beautiful or how skilled in language and rhythm the poems were, Kim Kijin cannot have known, or cared, at least in part because such a judgment must represent an accretion of readings, the result of years passing, successive editions being published, and finding new readers.

It also helps to have become part of the national education curriculum. In the decades since the freeing of Korea from Japanese occupation in 1945—and especially in the period since the end of the Korean War—the governments in the South (and presumably in the North as well) have devised education programs and textbooks that fostered nationalist histories.[8] The national history of the South has come to mean the struggle during the Japanese occupation period to resist the Japanese while preserving and articulating the Korean nationalist ideology, or to have been a collaborator; and during the Korean War, either to have fought for the rightist democracy of the South, for the Communist people's dictatorship of the North, or to have died. In a view of history that is defined by such binary oppositions, it becomes essential in narrating the history to be able to assign every significant figure to one side of the equation or the other. What are we to do then with a writer like Sowŏl, who did not address in his works—anywhere—the issue of Korean national identity, who instead wrote melancholy lyrics in the folk-song style? What are we to do, in other words, with questions of ambiguity, with literary works that remain ideologically problematic even though the framework of their reading is one that requires certainty and binary resolutions?

The solution to the ideological problem of a writer like Sowŏl has been to shift attention away from the texts of the poems and address instead the attributed affective response to them. That is, instead of attending to the problematic subject matter of the poems, the textbooks look at their melancholic tone—which is itself a construct of the reader's response, not an intrinsic quality of the poetry—and then assert that since there is melancholy in the poems, or expression of the traditional Korean sense of *han,* an accumulated resentment of oppression, the poems must have been expressing the melancholy that the Korean people are reported in the national history textbooks to have felt during the period of the Japanese occupation. By this circular path of ideological reasoning, through a curric-

ulum designed by government committee, Sowŏl is redeemed in the (South Korean) national histories. Sowŏl's story becomes acceptable, thereby, as a part in the national political narrative—as one of the parts in the dramatic script of the nation's history.

Because national history seems in many respects to resemble individual history—that is, autobiography—there seems to be an easy route from the text to an inverted, sociologized form of the pathetic fallacy, a reading of the poem for historical as well as autobiographical meanings. There is an equally beguiling and solipsistic snare waiting for those who try to piece out the "subject" of a poet's oeuvre, since that subject is repeatedly recreated through the reading of the works. Rather than seeking a subject, therefore, in the next section I shall begin with the assumption that a poem is a momentary contract—a negotiation. I shall then observe not what the "subject" of the negotiation is, but what the entities are between which the poem stands as a temporary contract. This procedure will shift the idea of the lyric from a poem expressing the feelings of one person separated from another, for instance, or from another place or time, to the lyric as the negotiation of a relationship defined by complementary distribution between the reader, who is not present as the poem is written, and the writer, who is not present as the poem is read.

The World of Sowŏl's Poems

Many of Sowŏl's poems situate themselves between the human world and the natural world or between the individual and the larger world. The individual world of the self is limited and yet paradoxically also defined by its separation from another. Many of his poems seem to be love lyrics—in other words, laments for the departed or soon-to-be-parted-from lover. A characteristic gesture in the poems is to employ elements of the natural world to reconstruct the connection between the speaker and the absent one addressed, or about whom the poem is constructed. The poem negotiates the renewed connection and then leaves itself behind as the contract. Thus in his well-known poem "Azaleas," the flowers gathered up in the second stanza are placed on the lover's path and then stepped upon, trod upon, in the third. Paradoxically, the flowers become the bridge between the speaker and the loved one, as between the present moment of the poem and the future moment of separation.

Azaleas

Sick of seeing me,
if you go away
I shall let you go without a word.

From Mount Yak in Yongbyŏn,
azaleas
I shall pluck an armful to scatter on your path.

Step by step away,
on the flowers placed before you,
step first, lightly, and go.

Sick of seeing me,
if you go away,
though I die; No, I shall not shed a tear.[9]

Or to take another representative example, in the poem sequence "In Chemul-p'o," the moon "Fixed at the mid-point of the sky" in the final stanza faces the cloud that has "climbed / the east, glowing red, faintly red," and the two separate selves of the poem—the lonely person speaking and the lover or other that the speaker seems trying to forget—are raised into airy contemplation of one another, the one glowing, the other fading.

In Chemulp'o

Night

Truly desolate, falling asleep alone.
Deep in my heart I long for you,
even as it seemed I might at last forget.

Here in Inch'ŏn, once called Chemulp'o,
the sun has faded into darkness.
The night slows in a drizzle.
Chill winds blow in from the sea.

Yet I lie down;
in silence, I lie down.
Pressing the shore, the high spring tide
runs pale against a blur of tears.

Dawn

With fallen leaves hiding my feet
I stood by the pool's edge
before a tree's dim reflection,
the eastern sky still dark, still dark.
Like tears of love, clouds flowed down
over my lonely dreams. And yet—

And yet, my love, a cloud has climbed
the east, glowing red, faintly red.
Fixed at the mid-point of the sky,
the old half moon fades into gray.[10]

A number of Sowŏl's poems present the situation of a person abandoned or parted from another. Even when the poem is not a love lyric, the speaker is alone

and isolated from himself and the landscape. The poem called "The Road," for example, begins literally *on the road,* as Kerouac wrote of it. Traveling somewhere, though no place calls him, with no thought of returning home and, at the end, apostrophizing the wild geese that seem to travel a road in the air, the poet stands on a featureless landscape between the time past of the previous night and the future of yet another day that leads nowhere. The title of the poem is made ironic by the conclusion, for while he stands at the center of the crossroads, nothing that leads away from the point where he stands is a road *for him.* So the crossroad is not a road but a spot, a location, the x on a map that fixes the speaker's location between other places and times. And the trains and boats that do travel to Chŏngju, his actual home, seem to separate him from the place, almost as if the fact of the train's and the boat's going there is what prevents him from doing so:

The Road

Again last night
at a country inn
crows cried before dawn.

Today
how many miles
again lead where?

Away to the mountains,
to the plains?
With no place that says *come*
I cannot go.

Don't talk of my home,
Chŏngju, Kwaksan,
while the train and the boat go there.

Hear me, wild geese in the sky:
Is there a road of the air
that you travel so sure?

Hear me, wild geese in the sky:
I stand at the center of the crossing.
Again and again the paths branch away,
but none of them is mine.[11]

Somehow it appears as if the speaker's natural connection to his home has been broken by the fact that other things, the trains and boats (the modern world of commerce?) now ply their way there. The next stanza immediately shifts to the geese passing by overhead; and the sureness of their travel—the road that they seem to occupy up there in the sky—establishes a direct contrast between the

natural sense of place and destination that leads the geese from place to place and the absence of such a sense in the speaker's view of his world. This split between the human and natural worlds resembles the lyric situation of "Azaleas," in which the flowers and the poem both connect and separate speaker and lover, past and present.

Other poems describe places of exile or human connections blocked by natural obstructions or by distance, height, or rain. In "The Cricket," the speaker is stopping at some remote country inn.

The Cricket

The voice of mountain winds,
of cold rains falling.
On a night when you talk of life's changes
and the fire at a country inn fades,
a cricket cries.[12]

"Samsu Kapsan" is a poem of exile, literal and literary, as the remote place named in the title is also a place to which government officials were banished during the Chosŏn period.

Samsu Kapsan

For Kim Ansŏ

What brought me to Samsu Kapsan?
Here, the wild peaks,
waters tumbling down, the steeps
piled up! Alas,
what place is this
Samsu Kapsan?

Longing for my home
I cannot return.
Samsu Kapsan is so far, so far!
That ancient road to exile
leads here!

What place is Samsu Kapsan?
I have come here, but cannot return.
No way back! If only
I were a bird I could go free.

I cannot go, cannot go
back to the home where my love stays.
To come, or to go: the thought mocks me!
Alas, Samsu Kapsan imprisons me.

I long for home, but Samsu Kapsan
is my prison.
No way back. For this body
there is no escape
from Samsu Kapsan.[13]

Even the cheery "Bicycle" finds the speaker thinking of going "riding, rolling all around":

Bicycle
Night after night after night
I spread out my bed and lie down
filled with longing for you.

The quilt's stiff edge
gnaws at my neck as I lie
filled with longing for you.

I roll myself up, but then
throw the quilt off and stand,
transfixed by the thought of seeing you.

How I wish I could see you!
But see, you
think of me too, longing and longing
and unable to go.

Day after tomorrow
Is Sunday;
Sunday, a holiday.

When the holiday is here
I'll hop on my bicycle
and go riding, rolling all around.

The bird that cries
in the pines by my house
is the bird by your back door too.

The bird cries *cuckoo*
cuckoo, cuckoo.
Here *cuckoo*, there *cuckoo*.

Away in daylight
and returning at night, that call
is your voice longing for me.

Day after tomorrow, Sunday
I'll hop on my bicycle
and go riding, rolling all around.[14]

Even those poems that seem to be firmly situated in the name of a particular place will turn out to be apart and separate. "In Chemulp'o" finds the speaker alone and desolate, at night in the port city; Wangsimni, a part of Seoul, recaptures its literal meaning, "the next ten miles," in the poem of that title, in which the speaker finds himself caught always in the next ten miles, a place that is between other places, filled with rain and longing:

The Next Ten Miles
Rain is falling,
falling still.
Though it rains five days,
let it fall.

She promised to come on the twentieth,
and on the first, to go.
Rain falls for the next ten miles
as I walk and walk.

Over there a bird cries,
passing the next ten miles.
Wet with rain and weary,
the bird cries.

Willows too, by Ch'ŏnan Crossing,
are weighed down by the damp.
Let it rain five days.
Crossing the mountain top, the clouds too
are weeping.[15]

"My House" turns out to be located "by the base of a hill away at the edge of the field, / behind the verge of the wide sea's waters," which seems as removed as it is possible to be while still being somehow located.

My House
By the base of the hill away at the edge of the field,
behind the verge of the wide sea's waters
I shall build it, my house,
and put before it a wide road.
People going by on that road,
lonely road going sometimes away from itself.
The day darkens over the pale white head of the stream.
I stand waiting by the gate
as the daybreak bird cries, and through morning shadows
the world glistens pale, and still,
and I watch, sharp-eyed, the ones who pass by on the road,
wondering Is it you? Is this one you?[16]

A number of the poems describe situations where a promise to meet is not kept ("This Thought of Meeting," "Wedding Pillow," "Facing the Lamp") or is broken:

This Thought of Meeting

Evening sun has faded down a dim road.
Distant mountains draw clouds down into darkness.
What brings even now this thought of meeting
when my love has no way to find me?
For whom are my aimless steps hurrying?
The moon rises. Wild geese call in the sky.[17]

Wedding Pillow

Clenched teeth grind
at thoughts of death.
Moonlight dapples
the window edge.

In restless sleep
tears drench the pillowing arm.
Spring pheasant, sleepless
comes crying in the night.

The floating moon pillow—
Where is it kept?
On the pillow where two once slept,
wasn't a vow made for life and death?

In spring the cuckoo
by the foot of the hill
will cry well enough,
my love, my love.

The floating moon pillow
Where is it kept?
Moonlight dapples
the window edge.[18]

Facing the Lamp

Alone,
as I sit facing the reddish flame of the lamp,
all thoughts gone, I want only to weep,
though there is no one now who knows why.

Lying down alone in the night's darkness,
all thoughts gone, I want only to weep.
There is none who knows why
though I could tell, I could tell the reason.[19]

The disconnectedness of the poems is not simply the originator of the lyric moment, the premise for the poem. In "Azaleas," for example, the separation has not occurred; in "A Day Long After," though separated now, there may come a time of reuniting, at which time the speaker will have forgotten; or the loved one is somehow near, just beyond ear's reach in the poem "Dream Visit."

A Day Long After
If you should seek me, some day long after,
then I would say "I have forgotten."

And if you should blame me in your heart,
"Missing you so, I have forgotten."

And if in your heart you blame me still,
"I couldn't believe. I have forgotten."

Not forgetting today nor even yesterday,
but some day long after, "I have forgotten." [20]

Dream Visit
Deep in the night
the lamp glows dim red.

A footstep
just beyond ear's reach—
the sound of a step dies away.

Though I turn and turn,
lost sleep won't return.

Deep in the night
the lamp glows dim red. [21]

One of Sowŏl's briefest, simplest (and most popular, in a way, having been made into a lyric song) lyrics is also most compactly about the separation not of the speaker from others, but of the speaker from the present moment:

O Mother, O Sister
O mother, O sister, let us live by the river!
In the garden, the golden sands glitter;
beyond the back gate, the reeds sing.
O mother, O sister, let us live by the river. [22]

In its four lines, the poem captures the pure longing for the past to become the future. Presumably the speaker once lived with mother and sister—and presumably does not at the time of the poem, which is the present. The poem leaps across the present; it is the present joining the past, the time when the speaker and his mother and sister lived together, to the future, when they will do so again, in the idealized space by the river, by the water, which the poem creates by naming

them. Reeds sing and golden sands glitter *in the poem,* in the present, which connects past and future with its wish. The landscape of the poem, brief and abstract as it finally is, connects or reintegrates.

The longing that seems to suffuse this poem is not simply nostalgia for the past. The secondary literature on Sowŏl, including the secondary school textbooks, takes note of the melancholy of his poems, the fact that so many of them are about separation, and then draws the connection between the idea of absence and Korea's situation as a country occupied by Japan. While such readings are supportable, they cannot really be argued or disputed, especially by the non-Korean reader who occupies an "unprivileged" position with respect to the Korean national experience—problematic as the definition of that experience continues to be—during the Japanese colonial occupation. Such readings seem, in fact, more a matter of taste than of critical reading. Without trying to dispute the point, or the taste, one can nevertheless find other flavors in Sowŏl's poems—the sense of disconnectedness, of geographical uncertainty, the absence of location, the puzzlement of time, the immanence of parting, to name a few. Further, weaving through such themes there also seems to be a strong awareness of the inadequacy of language, of language's failures to name, to locate, to identify, to connect; or rather, the speaker seems aware that language does the opposite: It *un*names, *dis*locates, *dis*connects. The poems work through this contradiction. The symbols or emblems of nature are brought into the poems to connect, but then they also invariably disconnect. Even the words uttered in the poems disconnect. Allied with this sense of language's uncertainty is an accompanying awareness of the border between speech and silence and a perfectly sensible reluctance or hesitation to speak, since it is precisely the act of speech in the poems that creates distance, confusion, and separation—that dislocates.

One of the more explicit instances of such dislocation is the poem "The Road Away," in which the speaker observes that just to state "(I) Miss you" is to make the longing more intensely felt. Since speaking intensifies the discomfort of parting, this in turn raises the question of simply leaving, again, "without a word." Even in the fictional world of the poem this is not possible, however, because the speaker has already uttered several words. The second stanza of the poem establishes the equivalence of speaking and leaving: The lines *kŭripta / marŭl halkka,* "I miss you. / Should I say it?" in the first stanza are answered by the grammatically equivalent phrase *Kŭnyang kalkka,* "Just go?" To speak is thus to imply separation. There is no way out of the dilemma, and so the poet turns to the natural world, to the image of the waters that flow on without parting, without becoming disconnected, saying "Come on, let's / go quickly, quickly," an improvement, evidently, over the literal parting that is at least implied by the articulation of longing. (If there had been no parting to begin with, there would be no yearning, just as the lyric as a form requires the rhetorical absence of the other.) The poem is, among other things, "about" speaking; that is to say, it raises the question of whether or not to speak, and in so doing, speaks, and thereby takes its shape as a poem

around or about the subject of whether or not to speak. The multidimensional image of the river—it has length, volume, moves through time and past a point, and also has the power of speech—and with it, the poem it carries off, brings at least a momentary integration of past, present, and future in the final lines of the poem.

The Road Away

Miss you.
Should I say it,
would only miss you more.

Should I
leave without a word,
yet again?

Ravens on the mountains, in the fields;
as the sun sinks lower on the Western hills,
they cry.

River waters flowing, tumbling
down say *Come on, let's
go quickly, quickly,* and still
they do flow away.[23]

The poem "Forsaken" works in the opposite direction, bringing an ironic uncoupling of the dramatic sense of the final lines of the poem from their meaning out of that context. The speaker cries out in a dream, awakens, and goes outside, where

I hesitate, hands clasped behind me,
nervously scanning the ground.

From within the firefly-swarming forest
someone calls out "I'm going, stay well!"
and sings.[24]

The situation of the poem, which to be understood requires the meaning of the title, reverses the prose meaning of the salutation in the final stanza. The greeting, that is to say, is for another, as is the song that follows in the final line, so its benediction for the hidden lover becomes an ironic malediction for the speaker who, in the poem, overhears.

The poet treats such reversals of meaning explicitly in the poem "Lonely Day."

Lonely Day

That day I received
your letter,
a sad rumor started around.

Your *Toss it in the water*
I understand to mean
Think of this each time you dream.

Though you wrote in haste,
each syllable in your flowing hand
is a record of your tears.

Your *Toss it in the water*
was to say *With a clear heart,*
read this with hot tears falling.[25]

The one who wrote the letter tells the receiver, the speaker in the poem, to throw it away, to "toss it in the water." The speaker, though, takes that to mean *remember*—especially, *remember each time you dream.* And the final stanza amplifies the instruction to mean that the phrase in the letter actually means *remember, and let your tears fall,* just as the writer of the letter wept as she wrote.

The foregoing sketch of Sowŏl's poems, especially their concern with language and its uncertainties, is meant to suggest how Sowŏl's works seem to negotiate the relationship of reader and text, past and present, here and elsewhere. The rhetorical situation of Sowŏl's poems is one of isolation and alienation; and the words that he wrote or spoke within the dramatic context of the poems only intensified the separation, the sense of otherness. In images of the natural world, Sowŏl found the terms by which to reassert the connections, at least within the poem's moment. Sowŏl discovered such symbols in the natural world of language as well as the landscape "outside," as phrases and words in the poems act as unifiers just as the river does in "The Road Away." Yet it must be added that, even as they unify, the words simultaneously underline the ultimate precariousness of the union. The river works in the poem to resolve the dilemma of language in "The Road Away," but it works only within that poem's negotiated space; and in the several poems that repeat a phrase or line, in their reiterations the words hold the disparate elements of the poem together—but only for as long as the poem lasts. In one of the more remarkable instances, Sowŏl repeats the phrase "I have forgotten" through the poem "A Day Long After" (see above) paradoxically to affirm and to deny language's ability to make connections between the present and the future, between one person and another, between one stanza and the next, between the reader of the poem and the poem itself.

Korea's so-called first modern poem, "From the Sea to Children" *(Hae egesŏ sonyŏn ege)*, written by Ch'oe Namsŏn and published in his magazine *Youth (Sonyŏn)* in 1908, only fifteen years or so before Sowŏl, was a self-assured, bombastic piece of didacticism. Speaking with another voice, the sea's, Ch'oe roared out his summons to the modern age in a poem that is now remembered more as a historically significant document than as a literary work. The second stanza goes as follows:

Ch'ŏlsŏk, ch'ŏlsŏk, ch'ŏk, sswa-a.
Nothing can cause me fear.
Whoever might have claimed strength and power on earth,
let him come before me; it cannot move me.
However huge a thing, it cannot match my power.
To me, to me, before me.
Ch'ŏlsŏk, ch'ŏlsŏk, ch'ŏk, t'yururung, kwak.[26]

The Japanese takeover of Korea in 1910 thwarted Ch'oe's generation of intellectual, literary, cultural pioneers and their call to future generations to engage in the modern discourse and to listen to the new voice of power and authority. Press censorship was imposed, the journals and newspapers of the day were sharply restricted, and publications that even faintly hinted of Korean nationalist thought were prohibited. The period of the teens in Korean literature has therefore come to be known as the Decade of Darkness.

In 1919, following the death of King Kojong of Korea, the Japanese authorities permitted Korea's citizens to travel to Seoul to observe the king's funeral. Using religious organizations—which alone of Korean institutions had remained relatively free of Japanese control—for communications and meetings, a group of nationalist leaders prepared a Declaration of Korean Independence, organized a series of demonstrations, and started, with the reading of the declaration on March 1, what became known as the March First Independence Movement. The movement was directed to the attention of the world community then gathered—so it seemed—in consideration of Woodrow Wilson's Fourteen Points at the Peace Conference at Versailles. But the Western community was too busy with the details of the treaty and with the devastation that the First World War had caused in Europe to pay attention to Korea's plea for consideration. Japan crushed the demonstrations, so once again the national voice was stifled.

The early twenties brought considerable easing of the restrictions on publications in Korea, at least in part because of the Japanese embarrassment before the world community that the March First Movement—and the generally critical press coverage of the Japanese suppression of it—had brought. *Kaebyŏk* magazine, in which many of Sowŏl's poems were first published through the sponsorship of his former teacher, Kim Ŏk, carried not only the poems and short stories of the day, but also a significant part of the discussion and debate concerning Korea's situation. The early twenties became a time of considerable ferment, of intellectual exchange, of reassessment of the previous years' accomplishments in literature. (For example, an entire issue of *Kaebyŏk* was devoted to the works of the contemporary Korean novelist and poet Yi Kwangsu.) It was a time when many new writers, in many new configurations of literary groups, began to be published. And yet, through all the excitement and challenge of expression, it continued to be a time when the Japanese censors kept watch over the poetry, short stories, and essays, as well as the journals that published them.[27]

The early twenties were a period of great change in Korea, a brief but powerful Renaissance of Korean intellectual and artistic activity. At the same time, it was a period of pessimism, uncertainty, and doubt; of national debate paradoxically colored by Western literary and intellectual fashions. Sowŏl's poems seem to capture that moment, hovering between silence and speech, between locations, between some form of identification with another person and separation. In his long remembrance of his former student, Kim Ŏk cited "The Road Away" as having marked a daring breakthrough in modern Korean poetry.[28] Although Kim Ŏk noted specifically the breaks in the lines as they followed the natural patterns of speech rather than a set metrical form, in retrospect we may also take note of the break with other traditions that is implied by the question posed in the first stanza. Shall *I* speak, rather than *you*, the older generation? Shall I *speak*, rather than keep silence? Shall I speak, rather than deliver a lecture or sermon? All of these renegotiations of difference are implied by Sowŏl's initial question.

Conclusion

With an uneasy sense that all writing is solipsism, the concluding section of this essay begins with the acknowledgment that what I say about Sowŏl's poems, about others' readings of them, or even about the Japanese "reading" of Korea as a colony, is in effect no more than an extended metaphor for my own engagement with the poems, a move to displace the merely solipsistic reading with what seems to be grounded in other matters, less personal and more cultural or historical. For the outsider, for the reader, for *this* reader, Sowŏl's poems create spaces that the mind is eager to fill with its own instances or presences. The reader—*this* reader—will find the poems inviting and move to occupy the poems in reading, analyzing, interpreting. The process of appropriation that I acknowledge here should also raise parallel questions about culture and the spaces that are created by historical and cultural narratives that the foreign "reader," whether state or individual, may likewise be tempted to occupy, to possess, so as to wrest control of the narrative from those who had held it.

In turning toward its conclusion, this essay will pivot on a single poem, "Azaleas," Sowŏl's best known, and without question one of the most widely known of all modern Korean poems. By means of a series of readings of this one poem, I hope to recapitulate the major points of this essay. I will conclude that one of the key features of the poem and of this project in reading it in the context of the Confucianized, hierarchical, binary, moralizing version of history that Korea has written about itself is its invisible, ambiguous, and most significantly female voice.

Five readings—meanings—can be found in or balanced upon Sowŏl's "Azaleas." The poem can be read as a love poem, a sad lyric of parting. The fictionalized biographies of Sowŏl say he had separated from a lover and so wrote the poem. Or one can say that a love lyric simply requires separation as its initial premise. In any event, it is a slightly odd lyric in the sense that the separation has

not occurred but is anticipated; and anticipated not entirely with sadness, since there will be no tears shed at the time of parting, and the speaker, in fact, will decorate the path upon which the lover will walk.

The sadness and melancholy of the poem can also be equated with Korea's situation during the Japanese occupation. One critic observes that Sowŏl seems aware of the "barred possibilities" of the period, but that his poetry "seems to be merely a gesture of desperation; it never becomes an energetic pursuit of an answer."[29] The second meaning of "Azaleas," therefore, is that it expressed the plight of the Korean nation during the period of the Japanese occupation.[30]

The poem can also be read as a spell, an incantation, to drive off the Japanese invaders. The time of separation in this reading is certainly not to be dreaded, but hoped for, and in the joyful anticipation of it, the speaker goes all the way to Mount Yak to gather flowers to decorate, to make bountifully clear, the path away. The path in this reading leads not to some place, but into another time, the time when Japan finally tires of its forced occupation of Korea and goes away. The flowers, that is to say, mark a path into the future. In this somewhat idiosyncratic reading, the final line of the poem speaks of a determination, an ironic strength, rather than sentimental resignation.[31]

All of the preceding readings of the poem assume that it somehow represents directly or indirectly a reality existing outside of the poem—that is, the author of the poem was feeling sad and melancholy because he had become separated from his lover; or he was sad and melancholy because all Koreans were sad and melancholy at the time; or he was clever and ironic, coding his true intentions, because that was a good and useful strategy for Korean writers to use in order to negotiate the reality of the Japanese occupation. There is another meaning to "Azaleas" that follows a slightly different mimetic conception of poetry. In 1921 Kim Ŏk published a collection of translations of Western poetry entitled *The Dance of Anguish (Onoeŭi mudo)*. Among the translations was a version of Yeats' "He Wishes for the Cloths of Heaven." Yeats' poem, it will be recalled, speaks of spreading dreams under the feet of his beloved and closes with "Tread softly, because you tread on my dreams." Kim Ŏk's rendering of the last lines of the poem was as follows:

> *A-a kanan hayŏra, nae soyuran kkum pakke ŏpkŏra*
> *kŭdaeŭi palarae nae kkumŭl p'u noni,*
> *naŭi saeng-gak kadŭlhan kkum urŭl*
> *kŭdaeyo, kamanhi palpgo chinaera.*[32]

(Ah, I am poor; for my possessions, nothing more than dreams.
I have spread my dreams beneath your feet.
Over these dreams, full as they are of my thoughts,
step softly, would you, and go.)

Kim Ŏk was Sowŏl's teacher and literary mentor, so it is reasonable to assume that Sowŏl read the translation and may well have discussed it with his teacher.

In his "Remembrance," Kim Ŏk wrote: "I think back on . . . the time when Sowŏl was just eighteen or nineteen . . . when he and I would meet almost every day to talk about the poets of East and West and their works."[33] Thus to focus upon the Korean poet's works ultimately is to enter Yeats' world and to be dispossessed of the melancholy lyric by Irish and Korean nationalist histories and readings that have been imposed on the poems in the time since they were published.

A fifth reading of the poem will show that its subject is itself; or rather, that the poem comes remarkably close to performing an exact imitation of the relationship between the words and the reader's creation of meaning from them, by which the putative "I" of the poem is the poem itself, and the "you" who may eventually grow sick of seeing it is the reader. The poem is then seen to be full of tricks and paradoxes: It is made of words and yet states that it is wordless; it is fixed and yet fluid; it throws flowers on top of itself to force the reading eye to slow down; it repeats itself and yet at the end does not; and its beginning is its ending. Further, in the complex structure of sounds echoing one another throughout the lines of the poem, two phrases stand in absolute phonological isolation from all the others— *kasilttae enŭn* ("When you go away") and *chindallaeggot* ("Azaleas")—and yet strongly mimic each other, by which I mean to suggest that either phrase or word could be phonologically unpacked, disassembled, and then built up in a different order with the other complementary phrase the result.[34] The poem is a remarkable tour de force, an exemplum of the contractual negotiation discussed above.

Finally, I would foreground an observation about the poem that lingers in the background of other commentaries: The voice of the poem is a woman's, not a man's.[35] This accommodates Kim Ŏk's initial designation of Sowŏl as a folk-song-style poet, since Korean folk songs such as "Arirang" and "Kasiri," generally seen as models for his poems, are in turn read as women's songs.[36] Carrying the logic of this observation past folkloric labeling, this must mean that if "Azaleas" is read as an expression of sadness at the Japanese occupation, its feminine voice implies a sexual connotation to the occupation that conjures up an array of extremely difficult issues, not least of which is the evident self-loathing that the history of Japan's extended occupation of Korea has occasioned. One of the most evocative poetic negotiations of the occupation, therefore, is also a powerfully conflicted one, at least implicitly.

More directly confrontational statements, such as the loudly masculine yawp of Ch'oe Namsŏn's "From the Sea," or even such indirect negotiations of Korea's colonized status as Yi Sanghwa's 1926 poem "Does Spring Return to Stolen Fields" —which to the Japanese censors implied Korea's general situation, not merely the cadastral survey that made large-scale Japanese expropriation of Korean land possible—elicited more direct responses from the Japanese who annexed the country or banned the publications. After years of working to promote the study and appreciation of Korean history and culture as a way to strengthen Korean nationalism, Ch'oe Namsŏn's determination eventually faltered, and he is consequently remembered now for his later collaborationist views as much as for his earlier pio-

neering cultural nationalism. To explore the more ambiguous alternative—the thirty-five years of Japanese oppression and of Korean resistance *and* accommodation to it—will require that we consider the role of the feminine in literature, religion, culture, and other areas of Korean life that the Chosŏn Confucianist cloud or the angry male voice and other gestures of the twentieth century have obscured.[37] This is the disintegration to which the rigid ideological constructs of Korea's last fifty years can now be subjected.

Notes

1. Hagen Koo, ed., *State and Society in Contemporary Korea* (Ithaca: Cornell University Press, 1993), 131.

2. John R. Bowen, *Sumatran Politics and Poetics* (New Haven: Yale University Press, 1991).

3. See Kim Yŏngsam, ed., *Han'guksi taesajŏn* (Encyclopedia of Korean Poetry) (Seoul: Ŭlyu ch'ulp'an'gongsa, 1988).

4. For Kim Ŏk's "Recollection of Sowŏl," *(Sowŏl ŭi ch'uŏk),* see Yi Yongch'ŏl, ed., *Sansaega unda* (A Mountain Bird Cries) (Seoul: Kŭpŏtchip, 1968), 213.

5. Kim Kijin, *Hyŏndaesidan siin* (Poets in the Contemporary World of Poetry), *Kaebyŏk* (Creation), (Seoul: Kaebyŏksa, 1969–1970), April 1925, 30–31.

6. See Michael Robinson, *Cultural Nationalism in Colonial Korea, 1920–25* (Seattle: University of Washington Press, 1988).

7. Kim Ŏk's "Recollection of Sowŏl," 213.

8. See Bruce Cumings, *Korea's Place in the Sun: A Modern History* (New York: W. W. Norton, 1997), 139–140.

9. Yun Chuŭn, ed., *Kim Sowŏl si chŏnjip* (Complete Poems of Kim Sowŏl) (Seoul: Hangmunsa, 1994), 123. This edition is outstanding, a complete variorum collection with full listings of relevant articles, other editions, theses, and dates. For this poem, I follow here an experimental reading of stanza three derived from Professor Kwŏn Yŏngmin's suggestion that the phrase *chŭryŏ palpko,* "step treading" in the reading of all other commentaries, is P'yŏngan Province dialect (Sowŏl's native region) for *chirae palpko,* "step first." Professor Kwŏn offered this reading of the phrase during his visit to my Modern Korean Literature class at Harvard University on February 11, 1998.

10. Ibid., 35–36 ("Night") and 85–86 ("Dawn"). "Night" and "Dawn" were originally published together in *Kaebyŏk* magazine (February 1922) under the title "In Chemulp'o," *Chemulp' esŏ.* All published versions of Sowŏl's poems since then have separated the two parts of the one poem, perhaps misled by the two subtitles.

11. Yun Chuŭn, ed., *Kim Sowŏl si chŏnjip,* 110–112.

12. Ibid., 77.

13. Ibid., 224.

14. Ibid., 184–185.

15. Ibid., 117–118.

16. Ibid., 83–84.

17. Ibid., 65.

18. Ibid., 160.

19. Ibid.

20. Ibid., 17–18.

21. Ibid., 59.

22. Ibid., 144–145.

23. Ibid.

24. Ibid., 114–115.

25. Ibid., 162.

26. *Sonyŏn* (Youth) 1:1 (Seoul: Munjangsa, 1971), 1–4. Ch'oe Namsŏn (1890–1957), a pioneer in Korean modern literature and thought, author of the March 1, 1919 Declaration of Korean Independence and a major cultural/political historian, was also an archetypal collaborator. In the 1930s and 40s he published and in other ways supported Japanese actions in Korea, persuaded that Korea's survival was linked with Japan's. The Liberation in 1945 caught him on the wrong side of all the issues, and he lived out his life in obscurity. For an illuminating study of Ch'oe's historical projects, see Chizuko T. Allen, "Northeast Asia Centered Around Korea: Ch'oe Namsŏn's View of History," *Journal of Asian Studies* 49 (1990), 787–806.

27. On Japanese censorship see Robinson, *Cultural Nationalism.* Also see Ki-baik Lee, *A New History of Korea,* translated by Edward W. Wagner and Edward J. Shultz (Cambridge: Harvard University Press, 1984), 347.

29. Kim Ŏk's "Remembrance," 211–212.

29. Kim Uch'ang, "Sorrow and Stillness: A View of Modern Korean Poetry," *Literature East and West* 13:1–2, 147.

30. Myong-Ho Sym, *The Making of Modern Korean Poetry: Foreign Influences and Native Creativity* (Seoul: Seoul National University Press, 1982), 240–244.

31. Compare with Yi Sanghwa's 1926 poem "Does Spring Return to Stolen Fields," *(Ppaeatkin tŭledo pomŭn onŭn'ga),* which inscribes the rite of *Ttang ttagi*—stamping on the earth—to awaken the Korean spirits and drive out the Japanese. Yi's poem was censored in the June 1926 issue of *Kaebyŏk.*

32. Kim Ŏk, *Onoe ŭi mudo* (Dance of Anguish), *Han'guk hyŏndaesisa chaeryo chipsŏng* 1, *Materials in the History of Modern Korean Poetry* (Seoul:Taehaksa, 1982), 121.

33. Kim Ŏk's "Recollection of Sowŏl," 205.

34. David R. McCann, "The Meaning and Significance of So Wŏl's 'Azaleas,'" *Journal of Korean Studies* 6 (1988–1989).

35. Myong-Ho Sym, *Making of Modern Korean Poetry,* 235.

36. David R. McCann, "Arirang: The National Folksong of Korea," in David R. McCann, John Middleton, Edward Shultz, eds., *Studies on Korea in Transition* (Honolulu: Center for Korean Studies, University of Hawai'i, 1979).

37. See David R. McCann, review of Marshall R. Pihl and Bruce and Ju-Chan Fulton, eds., *Land of Exile: Contemporary Korean Fiction* (Armonk, NY: M. E. Sharpe, 1993) in *Korean Studies* 19 (1995). Also see Sheila Miyoshi Jaeger, "Women, Resistance and the Divided Nation: The Romantic Rhetoric of Korean Reunification," *Journal of Asian Studies* 55:1 (1996).

Writing the Colonial Self: Yang Kui's Texts of Resistance and National Identity

Angelina C. Yee

Tʜᴀᴛ ᴛʜᴇ ʟɪᴛᴇʀᴀᴛᴜʀᴇ of Taiwan under Japanese occupation has been shunned by the canons of literary history should surprise no one. It is a shameful page in Chinese history, one that few can look upon with equanimity. Much of the literature of that period was written in Japanese by a people whose nationhood was held hostage, and, from a chauvinist standpoint, ill fits the traditional categories of national literatures. In an age when art and politics are seen as antinomies, writing on irrepressibly political subjects in borrowed tongues, whether Japanese or the Mandarin vernacular, is found wanting in aesthetic satisfaction. And from the point of view of political requirements, few of the works laboring under colonial censorship answer the need for a rousing clarion call. Indeed, Joseph Lau, anthologist and translator of Taiwanese fiction, while resurrecting a few works of the colonial period to Western attention, warns that they make "rewarding reading only from a historical perspective: as records of a people under foreign domination."[1] The caveat addresses a reading habit that decontextualizes writing and valorizes a disembodied art above history. A careful reading of the writings during that period reveals much that deserves attention, not only as documents of political history but as hybrid products in a particularly turbulent phase of cultural history.

In a laudable effort at recovering a submerged literature that has long suffered both censorship and neglect, publishers in Taiwan have recently reissued an impressive array of writings from the colonial period.[2] Their publication coincides with a resurgence of interest in establishing a local Taiwan identity within and against the dominant narrative of a unified China. At a time when demands for localization of the government on the island and for dual representation in the United Nations are arousing intense controversy, when ethnic conflagrations

around the globe remind us anew of the immense power of nationalism, and when, within academia, the notion of nationalism has come under increasing scrutiny, it is worthwhile to review how Taiwan writers, rooted in an age-old Chinese consciousness, perceived themselves and their national and cultural identity during the Japanese colonization. If nations are merely "imagined communities," as Anderson has suggested,[3] made of cultural "shreds and patches" as Gellner has argued,[4] and if nation building is a process of narration as Homi Bhabha has shown,[5] what was it like to be objects of such narrative strategies of conquest and assimilation? What psychological fragmentation, accommodation, and resistance did colonial subjects endure when new master narratives were superimposed on the primordial national narrative? What happened to the "will to nationhood" as described by Renan,[6] and what sorts of historical remembrance and forgetting must have taken place within colonial subjects? Specifically in the case of Taiwan, what does the fifty-year colonial period tell us about the colonization of consciousness and the interrelationship between cultural, national, and self identities?

Among the Taiwanese writers recently anthologized, I choose to focus my study on Yang Kui (1905–1985), the first Japanese-language writer from Taiwan to gain literary recognition in Japan, who has especially drawn praise from mainlanders and Taiwanese alike for his indefatigable resistance to colonial rule. His distinction lies not only in his literary achievement, nor even in his assiduous efforts at waging political struggle through literature, but in a remarkable life of putting into practice his beliefs. A study of Yang Kui would be woefully inadequate if confined to what have been traditionally classified as works of literature: In all his writings, generic distinctions between fiction, autobiography, and history are blurred. And it would be giving him short shrift to describe Yang Kui merely as a practitioner of an engaged literature, for he himself made only a passing differentiation between literature and politics, and his life itself is a text of resistance against tyranny writ large.[7] My choice of Yang Kui as a subject of inquiry does not hinge on his cultural or political representation; rather it is predicated on his exemplification of the ambiguities surrounding the notions of culture, nationhood, and selfhood. I examine the ways in which Yang Kui's writing negotiates the politics of colonization and the construction of selfhood at a moment in Taiwanese history when identity was a burning issue. In so doing, a rather more complex picture of Yang Kui emerges, one that defies the political categories conveniently attached to him. Precisely because of the near unanimity on his anticolonial stand, I hope to show the complicated effects of the colonization of consciousness even in the case of the staunchest resistance fighters. In order to assess the psychological turbulence in which writers of his generation must have been embroiled, this essay will not only focus on his writings before the retrocession—all of which were originally published in Japanese and later translated into Chinese with or without Yang's participation—it will also take into account his later writings and speeches in Chinese.

The Japanese: Where's the Enemy?

Born to a small tin shop owner in Tainan ten years after Taiwan's occupation by
Japan and educated in the colonial public schools, where only Japanese was taught,
Yang went on to study in Japan in 1924—a time when the proletarian literary
movement was raging and Marxism was in vogue. There, as a poor self-support-
ing student, he fraternized with Japanese workers, joined student demonstrations,
and took part in worker study groups.[8] His formal studies terminated three years
later, when he returned to Taiwan in response to calls for the formation of peas-
ant cooperatives. He soon rose to prominence as a political activist and cultural
leader. He was imprisoned over a dozen times by the colonial authorities for his
manifold roles in the labor movement, peasant movement, and cultural associa-
tions. Ironically, though he had fought Japanese colonial practices and worked to
improve relations between the Taiwanese and the mainlanders after the island's
return to China, he was incarcerated by the Nationalist government under suspi-
cion of Communist leanings, the last time for twelve years.

He remained undaunted in the face of adversity and found solace in humor in
the worst of times. When at the age of twenty-four he and his fiancée Ye Tao—a
revolutionary in her own right[9]—took leading roles in the first Tainan labor
unions, they were both arrested, together with four hundred others, the very
night before their planned wedding in his native Xinhua. Chained and handcuffed
with Ye and paraded in the streets, he ruminated that people must have thought
they had been caught trying to elope; as they were being transferred from the
Tainan prison to the one in Taizhong, he joked that he enjoyed an officially paid
seventeen-day honeymoon trip.[10] Of his comings and goings in and out of prison,
he philosophized that it had become a way of life; and of the Japanese police who
trailed him after his release from prison, he quipped that they gave him free pro-
tection for his reclusive life as a woodcutter.[11] He reserved his most trenchant
humor for his lengthy prison term under the Kuomintang (KMT), noting that, for
the drafting of the brief Declaration of Peace for which he was sentenced, he
received the highest pay ever: a twelve-year free meal ticket.[12]

But beneath his levity lies a somber realization that humor is the only recourse
available to peoples silenced by terror. As he retold his elders' story of how the vil-
lagers would, out of habit, clean up their houses before fleeing to the mountains
when the Japanese invaders came, even scrubbing their night-soil barrels—and
how the Japanese mistook these human fertilizer containers for rice barrels—he
wryly observed that it was from such stories that the people derived some Ah-Q-
style consolation in their "bruised souls."[13]

It was after a severe crackdown by the colonial authorities on peasant organi-
zations, cultural associations, and labor unions that Yang retired from activism and
sought refuge in the mountains of Shoushan near Gaoxiong, where he chopped
wood for a living. Encouraged to write by Lai He (1894–1943), who, like Lu Xun
on the mainland, established literary writing in the vernacular and was generally

regarded as the "father" of modern Taiwanese literature, Yang significantly changed his given name Gui, which means "high office," to Kui, "reaching all paths," a name that recalls an enduring symbol of resistance against injustice: the beloved Li Kui in the popular novel *Shuihu zhuan* (Outlaws of the Marsh), distinguished for his fierce loyalty and impetuous daring.[14]

Yang's celebrated story, "Shimbun haitatsufu," or "Songbaofu" (The Newspaper Boy), first published in the *Taiwan xinmin bao* (Taiwan New People's News) in 1932, won top prize in a writing competition sponsored by the Japanese leftist journal *Bungaku hyōron* (Literary Review) in 1934. Two years after its publication in Japanese, "Songbaofu" was translated into Chinese by Hu Feng, and included, along with Lü Heruo's "Niu che" (Oxcart) and Yang Hua's "Boming" (Star-Crossed), in the anthologies he edited and published in Shanghai, presumably widely read in China and Southeast Asia: Yang Kui spoke years later with surprise at the number of mainland writers familiar with his work who sought him out after Taiwan's return to China.[15] In this connection, it should be noted that by naming the anthologies *Shanling: Chaoxian Taiwan xiaoshuo xuan* (Mountain Spirits: Selected Stories from Korea and Taiwan) and *Ruoxiao minzu xiaoshoo xuan* (Stories of Small, Weak Nations), thereby categorizing Taiwan with Korea and "other" small nations, Hu Feng exemplified the attitude of mainlanders—even the most progressive ones at the time—toward what the government was to claim had always been an inalienable part of China.

"Songbaofu" represented the first attempt by a Taiwanese writer to enter the Japanese literary arena. Told in the first person, the story is a disarmingly unadorned account of a foreign student's disillusioning experience in Japan, yet the self/other opposition is not primarily drawn along national lines. The narrative is remarkable in its skillful structuring of events building up to a climax—of how the student was duped by a newspaper distributor into weeks of arduous labor performed all in vain in the end—and for its wealth of realistic detail. The I-narrator takes pains to depict the mats laid out on the floor of the newspaper boys' dormitory, the number of bodies laid side-by-side, crisscross, filling every space on the floor. He injects comedy into a scene of pathos as he describes how he was afraid to get up to go to the bathroom at night for fear of waking the bodies pressed against him on all sides—and because, once up, there was no ground on which to get a footing.[16] The generous use of interior monologue and flashback marks its stylistic modernism, and the reminiscences of his father's death from imprisonment, a result of refusing to yield his land to Japanese sugar companies, are moving chronicles of a colonial people's suffering. All these are no small achievements in themselves in the context of the 1930s, when Taiwanese intellectuals schooled in classical Chinese and confronted with the exigencies of Japanese were caught in a linguistic quandary and a vernacular literature had yet to be forged.[17] Yang Kui represented the first crop of Taiwanese writers adept at the use of Japanese. Beyond the pathos successfully conveyed by narrative technique, however, what is striking about the story and undoubtedly welcome to the Japa-

nese reader is not merely the absence of jingoistic rhetoric, but the foregrounding of the generosity of a fellow Japanese worker who lends a helping hand to the I-narrator during a time of financial duress. Their deepening fraternity is extolled in the same breath that the newspaper boss' exploitation is condemned. The story ends with his introduction to a Japanese labor unionist who helps the newspaper boys expose the boss' chicanery collectively, and the narrator comes to the understanding that exploitation is common to Japanese and foreign workers alike. The conclusion analeptically invests the dormitory scene with a symbolic significance of the brotherhood among the suffering underclass, Chinese and Japanese. The result is a story refreshingly free of sloganeering, and the measured, subdued tone in which it is told rings with an authenticity that only the best of May Fourth writers can rival.[18] In fact, as Yan Yuanshu has observed, the deeply personal beginning of the story gives no hint that the I-narrator is non-Japanese;[19] neither is there any suggestion that he is subjected to political persecution or national hostility. It is not until the second half of the story, when a family crisis forces him to make a choice between leaving and staying in a land at once hospitable and harsh, and when epistles from home bring back memories of the misfortunes befalling his native villagers ever since the Japanese occupation, that a self-consciousness of marginality emerges. His remembered home therefore casts an ironic light on his initial identification with Japan. Yang's refusal to essentialize the enemy as a dehumanized Japan and his avoidance of abstract glorification of war against the colonizer may easily be attributed to due regard for colonial censorship—and the second half of his story was indeed suppressed when it was first published in Taiwan. Nonetheless, the balance between good and evil and the emotional dilemma of leaving Japan or staying portrayed in the story—the fact that he chose to publish in Japan at all—betrays an intense admiration for the metropolitan country memorably described by Albert Memmi as typifying the relationship between colonized and colonizer:[20]

> "This may be my last glimpse of Tokyo." The thought wiped out even memories of the _____ Newspaper Distributor boss. All I felt was a reluctance to leave. Last night, thinking of my hometown, I could not rest, yet now the images of my mother and my brothers, whom I longed to see again, became blurred by the desolate picture of our poverty-stricken, deserted village. I was suddenly overcome by fear of returning home. (*Yang Kui ji* 45–46)

The reader's receptivity of such ambivalence toward one's native home relies to a certain extent on a historical appreciation of the economic disparity between Japan and Taiwan—and to a large extent on the skill with which the narrator negotiates between multiple imperatives: the ideological conviction of supranational socialism; political accommodation and avoidance of direct confrontation with Japanese colonialism; and the self-identity of a Taiwanese colonial subject. What remains unarticulated in the space between is admiration for the metropolitan

culture. In his reconstructions of the forces that most influenced him, recorded in his memoirs and interviews toward the end of his life, Yang, while decrying the discriminatory practice of a segregated school system between Japanese and Taiwanese, freely acknowledged the superiority of the Japanese-style education he had gone through to the Chinese education that prevailed later. He spoke gratefully of his intellectual debt to an enlightened Japanese elementary schoolteacher who "made no distinction between Japanese and Taiwanese," took the talented boy under his wing, and introduced him to the world of Western and Japanese literature.[21] He singled out the flamboyant, eccentric, and highly influential anarchist Ōsugi Sakae as having left the deepest imprint on his youth consciousness and professed that Ōsugi's murder disturbed him profoundly.[22] Like other intellectuals from the mainland who studied abroad in the twenties, it was ironically in Japan, where a great many Western texts were translated into Japanese, that he experienced relative intellectual freedom, and where, like his mainland counterparts, he found in Marxism an ideology he perceived as congenial to the mission of bettering his compatriots' lot. In fact, it was in Japan that he had his first brush with the law when he participated in a Korean students' demonstration.[23]

It is difficult to assess intellectual debts, by the writer himself or others. Although Yang expressed a preference for nineteenth-century Russian and French novelists and acknowledged no specific Japanese models in his conversations with literary figures after the retrocession, one would surmise that he must have been influenced by Japanese writers. Writing as he did in Japanese, he had read Natsume Sōseki and Akutagawa Ryūnosuke, was a frequent guest at the playwright Sasaki Takamaru's avant-garde theater group, and mingled with Japanese leftist writers.[24] Something of how he felt toward the Japanese in his youth that remained unaltered in the 1974 version of the story, which differed elsewhere from the original,[25] can be gleaned from the fictional representation of his encounter with a Mr. Tanaka in "Songbaofu." Rendered penniless by the unscrupulous newspaper boss, he accepts with shame and gratitude Tanaka's largesse even as the latter deflects his effusions of thanks with embarrassment; though the question of nationhood never comes up explicitly in their relationship, it is constantly lurking beneath the surface. The I-narrator, concluding that Japan as a nation is not an enemy and that the land abounds with decent people, draws a deliberate contrast between his Japanese friend's loyalty and his own brother's treachery:

> At home, I had thought that all Japanese were evil, and hated them one and all. But since I arrived here [in Japan], I have found that not all Japanese are bad. I have warm feelings for the innkeeper; as for Tanaka, there is more affection between us than between brothers. . . . No, when I think of my brother, who is now a policeman [in Taiwan], what a brother! Even to compare the two would be an insult to Tanaka. (*Yang Kui ji* 55)

Rather than his parents, whose passive resistance to colonialist encroachment and economic deprivation is depicted with deep pathos, the true heroes of the story

are Japanese: the trade unionist, the newspaper boys who unite against capitalist exploitation, and Tanaka. In fact, Tanaka is the ideal man, the reason for the narrator's lingering affection for Japan:

> It would be fair to say that such emotional fluctuations [about leaving Japan] were affected to a certain extent by the attraction of Mr. Tanaka, whom I was about to see and with whom I was loathe to part.
>
> Such an endearing, rational, down-to-earth, forthright person was he, one who never stood on ceremony . . . the very model of my ideal man.
> (*Yang Kui ji* 46)

It is interesting to note that the last paragraph, with its explicit assertion of Tanaka's paradigmatic role, was deleted from the 1974 version. Still, the later version expressly identifies Tanaka as the motivating force behind the I-narrator: "I must work hard, I must give it all I have—Tanaka said so"; and the thoughts with which he consoles himself in his darkest hour are Japanese: "The Japanese have always said: 'Though there are ghosts in the world, there are Buddhas too.'"[26] Such pointed deference to Japanese wisdom in the emotional detachment of hindsight years after the departure of the colonial authorities is unusual, even among his Japanese-educated peers. It not only flaunts the writer's inheritance of the colonizer's architecture of knowledge but shows his disinclination for a simplistic nationalism.

Yang's unabashed admiration of the Japanese had a real-life correspondence subsequently in his remarkable friendship with a Japanese colonial policeman, Irita Haruhiko, who was moved to request a meeting with Yang after reading "Songbaofu" and to offer him money. The gift enabled Yang to pay off his debts and establish a farm in 1937 after the banning of the special Chinese-language section of the *Taiwan xin wenyi* (New Taiwan Literature and Arts), which had been tolerated in the relatively enlightened administration of the Taishō era. The sympathetic policeman, who subscribed to the American *New Masses* and the English edition of the *Moscow News,* quit his job soon afterward—even though an overseas colonial assignment was considered a lucrative position for college graduates in those depressive days when jobs were scarce—and started writing articles exposing Japanese police corruption, becoming fast friends with Yang. When his leftist leanings became apparent, however, he was ordered expelled from Taiwan and recalled to Japan. He committed suicide days before his scheduled departure. As he was breathing his last, he enigmatically called out Yang's oldest son's name, "Zibeng" (Collapse of Capitalism); he willed that his ashes be used for fertilizing Yang Kui's flower beds and authorized Yang to take care of his books, among which were Lu Xun's collected works. This was how Yang started reading Lu Xun, whose works were banned both in Japan and Taiwan.[27]

His Japanese experience, what the Chinese are wont to call "a story of blood and tears," devolves into another blood- and tear-stained story in another locale in the second half of "Songbaofu": the suffering of his native villagers. A careful

symmetry is set up between the Japanese story and the story at home, unified by a gradually disclosed thematic continuity: "Those who suck our blood, cut our flesh and squeeze our marrow are no different [in Japan and at home]" (*Yang Kui ji* 35). What is used figuratively—the blood that boils over the oppressor's treachery and the tears of gratitude over Tanaka's fellowship—is reconfigured literally in the second story. Spatially embedded in the first story, the second, "real" story exists only in memory; therefore its very pastness in turn temporally frames the first story's Japanese present. Brought back by his mother's letters, past reality accosts him with the intensity of suffering, and the humiliation of the epithet "Chinese pig!" inflicts fresh wounds. Hence the narrator is confronted with the choice between staying and leaving Japan, a choice that entails distinguishing and choosing between remembrance and actuality. As he boards the ship to return to Taiwan, armed with new ideas to effect reform in his native land—in the 1974 version, amidst the cheers of his Japanese friends—the symmetry he has carefully set up reverses positions: With his homeland nearing on the physical horizon, his Japanese experience becomes a memory, his remembered home a reality.

But his homebound journey perturbs the formal symmetry of the story as the blood and tears of his birthplace loom large, for his father's heroic death in resisting Japanese encroachment and his mother's ultimate self-sacrifice can scarcely be seen, in the East Asian cultural context, on equal terms with intellectual nurturing and brotherly love. Feelings of nationalism, heretofore silenced, become transposed from his parents after their death on to the narrator. Hence the balance between the narrator's Japanese identity and his Chinese identity proves to be a fictional, fictive construct that parallels the young Taiwanese intellectual's precarious mental construct, and a little story of capitalist exploitation that mirrors imperialist exploitation becomes a story of self-identity. The hero who returns to his homeland is not the same colonial victim that landed in Tokyo months before; he has gained a measure of self-knowledge and an added identity: the identification with oppressed people amidst whose applause he returns to his motherland—motherless, but no longer orphaned.[28] To the reader conscious of history, however, what is passed by in silence in the story and yet emerges in the metafictive context of national conflicts is the loss of clarity of the narrator's national identity.

If there is any trace of discomfort with the narrator's transnational, bicultural identity or with the Japanese better self playing the role of the superego, it is to be found in the extraordinary lengths to which the writer goes to depict Japanese virtue. Two of his lesser-known works, "Ori seibatsu," or "Wantong fagui ji" (How the Naughty Boys Vanquished the Demon) (1936) and "Zosan no kage ni— nonki na jisan no hanashi," or "Zeng chan zhi beihou—lao choujiao de gushi" (The Old Buffoon—The Story behind Increasing Production) (1944), continue his intriguing and, in the light of his hallowed role as nationalist fighter, disturbing portrayal of the Japanese.[29]

"Wantong fagui ji," published in the bilingual *Taiwan xin wenxue* (New Taiwan Literature), founded by Yang Kui and written at the peak of his creativity, is

his most modernist text and certainly some of the most experimental writing by a Chinese writer during this period. It narrates from the subject position of a Japanese artist who visits Taiwan. Armed with inflated visions of beauty and plenty, he is met by a scene of squalor and destitution. Set eerily in the midst of rubble surrounding decrepit dwellings—which recalls the ruination of war—is an almost idyllic picture of the harmony of children of all nationalities playing together. Their happiness is shattered by a capitalist of unidentified nationality who has appropriated the children's playground to build a mansion guarded heavily by ferocious dogs. Distressed by the children's deprivation, the artist comes to the realization that art's meaning lies in its power to change people's lives. He presents the children with a gift: a painting of children standing on each other's shoulders, clutching primitive weapons aimed at a cowering capitalist and his hostile, ferocious dogs. Bathing the column of children in a stream of sunlight emerging from the dark, dank ground, the picture endows the obvious collective moral with a religious aura. Inspired by the gift, the children succeed in the fight to reclaim their playground (*Yang Kui ji* 67–83).

If the message of this story is a call for subjugated peoples to take up arms against the larger evil—capitalist imperialism—the reader cannot but marvel at the risk Yang is willing to take: the appearance of pandering to the Japanese by casting a Japanese hero in a godlike, life-giving role, a risk delicately balanced by naming the painting and the story "Vanquishing Demons" and ending with repeated triumphal cries of "Fagui wansui!" (Long live demon-bashing!), with their unmistakable reference to the "foreign devil." Read in conjunction with the next story, however, it is harder to dismiss Yang's belief in the salutary effects of Japanese culture.

"Zeng chan zhi beihou," published during the height of the Sino-Japanese war, was written on commission by the colonial administration's Information Office—with which Yang apparently maintained cordial relations—in response to the call for increasing production in support of the war effort.[30] This was a time when the colonial authorities stepped up pressure for the production of a "masculine, elegant, optimistic, scientific new Japanese culture founded on Japan's national spirit, with the purpose of reinvigorating the national spirit at home and promoting a Greater East Asian culture abroad."[31] An investigative report on miners' lives, "Zeng chan zhi beihou" is narrated from the point of view of a colonial government reporter whose nationality remains ambiguous throughout. As he follows the Taiwanese miners down the shaft, he is impressed by their courage, which he likens to that of the Japanese soldiers. He discovers the motivating spirit behind it all: an old Japanese man who brightens up the life of the entire community by his cheerful optimism and dauntless altruism. A self-styled buffoon, the old man has adopted a native Taiwanese girl, Jinlan, a willing disciple to whom he unselfishly passes on the Japanese language and traditional Japanese manners. The narrator concludes his investigation humbled by the intrepidity of the miners and, inspired especially by the old man, resolves to improve their life. The story

ends with an unequivocal endorsement of Japanese culture as Lao Zhang, his former Taiwanese hired hand, informs him that he has decided to stick to a miner's life in spite of hardship:

> I smiled when I read [Lao Zhang's] letter.... Needless to say, it is extremely important to take to heart the understanding that ... increasing coal production serves our country's needs. Although [the miners] might be found wanting in this regard, that they should have the progressive idea of following the Japanese was enough to move me and fill me with respect.
>
> I felt that since he had decided to stay, regardless of whether the decision was made because of the Division Head, the old man or Miss Jinlan, such an ingenuous attitude of pursuing beauty, of not hesitating to leap into danger signaled the sprouting of a beautiful Japanese spirit. (*Yang Kui ji* 205)

Read in the historical context of an increasingly militarist Japan that pushed the cultivation of a "national spirit," the story's metaphorical significance is inescapable. The nurturing old man epitomizes a truly "beautiful Japanese culture," one that is benign, selfless, and transcends national boundaries, of which the product is the lovely adopted Taiwanese girl; Lao Zhang's marriage with Jinlan is the felicitous merging of Taiwan with Japanese culture. On a more personal level, the old buffoon, the embodiment of the best in Japanese culture, is Yang's ideal self—and reminiscences of family members attest to a similar role he played in real life[32]—while Lao Zhang, the disciple of [Japanese] beauty, represents the deserving Taiwanese people.

Is Yang's unreserved praise for the Japanese people intended to reflect ironically on the government's militaristic and exploitative policies? Could one explain these stories as self-conscious exercises in people's diplomacy, calculated risks to woo the Japanese public while mouthing support for the colonialist assimilation policy? However one may answer these questions, to the nationalist and even to the internationalist, the nagging question remains: Why portray Japanese culture as superior and the Taiwanese people as worthy followers? The moral of pursuing a "beautiful Japanese spirit" that these stories convey thus poses a serious challenge to the canonization of Yang Kui as a nationalist fighter. By responding to and abetting the call for "harmony between the Chinese and the Japanese," a notorious cover for imperialist aggression, is he not finally guilty of capitulating to Japanese cultural imperialism? It would be naive to answer these questions either in the affirmative or negative without suspecting that beneath the discursive endorsement of Japanese culture and people must lie a subtext of Yang's uneasy accommodation with his cultural heritage and his national identity.

As *nation* is a mental construct built on cultural "fragments," the questions of national identity and culture are ineluctably interfused: Nations are formed, consolidated, or destroyed on the basis of fabricated myths of commonalities or differences in culture. It was in the name of a common culture, with Japan poised as

the torchbearer, that Japanese militarism justified its bid for hegemony in East Asia, and though Yang Kui sought to separate the two, it was cultural politics following military conquest that consolidated Japan's hold on the colonies. Would it not be fair to assume that the converse must also be true—that cultural assimilation leads inevitably to national identification or some measure of national affinity?

To this question there can be no single answer. Apart from questions of definitions, there are varying levels and degrees of identification, and my purpose is precisely to show the ambiguities and fragmentation to which colonial psyches are subjected. One could cite, as evidence of Yang's unflinching national fidelity, his various pronouncements after the war. In all his interviews after his release from prison, he repeatedly recalled the same abhorrent images of alien domination: Japanese tanks rumbling by on their way to crush a peasant uprising; his visit to villages where the Jiaobanien Incident took place, in which scores were systematically beheaded and pushed into previously dug holes; his own brother being conscripted; a family friend bludgeoned to death by the colonial police. From an early age he grew indignant at the Japanese version of history, which branded Taiwan resistance fighters as "bandits," and he vowed to rewrite Taiwanese history.[33] The bulk of his stories and plays, however muffled or conciliatory, contain veiled attacks on imperialism. And he steadfastly maintained that the day when news of the Japanese surrender reached him was the happiest day of his life, when for the first time he felt "the dignity and happiness of being Chinese."[34]

A comparison between the original translation of "Songbaofu" and its 1974 edition reveals some telling discrepancies. Whereas the 1936 version is relatively free of anticolonialist rancor, its later version, emended by Yang himself, contains additions of strongly worded passages affirming an anti-imperialist stand and the international unity of workers against capitalism.[35] When questioned about the discrepancies in his later years, he conceded that, besides concern for censorship, an author had the right to make changes as his thinking evolved and to enable contemporary readers to better grasp the "spirit of the work."[36] If this means that in the author's own mind the original version represented his thinking at a particular historical moment, it also means that he subsequently became alert to his concessions to the colonizer and tried, by escalating his political rhetoric, to reinforce a stance.

Revisiting Japan in 1982, some forty-five years after his last visit and fifty-five years after his student days there, he reminisced that his decision to study abroad in Japan was a "crucial move" that "impacted his entire life."[37] He recaptured nostalgically the poignant experience he had there: his near fatal stint as a construction worker; haphazard employment; plotting with Japanese friends in support of Korean students' demonstrations; and declared that there were far more "good people than evil" in Japan. His sense of identity with the Japanese masses went beyond cultural admiration. He had lived in Japan during the depression years, when unemployment figures reached over 3 million. If he felt instant national rejection, he never articulated it. Instead, he disputed suggestions that national

discrimination existed even among Japanese progressive organizations and asserted his feeling of "connectedness" with fellow workers in the Labor Peasant Party.[38] As a student, Yang embraced the poor Japanese workers' cause and joined student-organized worker study groups to investigate the slum areas near Asakusa, where workers were concentrated and where he witnessed numerous people die of cold, wrapped only in straw mats. He worked with the Japanese students in speechifying and pamphleteering, alerting workers to the evils of capitalism. He actively participated in Korean students' demonstrations in solidarity with their countrymen in colonial Korea and in Japanese students' demonstrations against the Tanaka government's proposal to invade Manchuria. And he pointedly reminded us that even among Japanese authorities, benign souls existed: The police chief who questioned him after his arrest for taking part in a Korean students' demonstration treated him to a decent meal and promised to find him a job when Yang claimed he had participated only because he was unemployed.[39]

Even before the war, one could point to writings more clearly and skillfully demonstrative of his anticolonial stand than any other writer's. One such example is his ironically titled "Den'en shōkei," or "Tianyuan xiaojing" (Pastoral Scenes) (1936), later renamed "Mohan mura," or "Mofan cun" (Model Village), in which he demythologizes the achievements of Japanese colonial rule by satirizing, in the style of Gogol's "Inspector General,"[40] the local colonial government's flurry of activities on the occasion of a prefect's visit to showcase the village as a model community. Castigating the Chinese collaborator in the same breath as he caricatures the Japanese overlord, he parodies the administration's efforts at whitewashing a generally bleak economic picture and its preoccupation with appearance and decorum in total disregard of the local people's comfort or welfare. As farm implements, even haystacks, are stashed away inside the house for appearance's sake, one is confronted with the concrete reality of foreign subjugation when ancestors' and Buddha's pictures are ordered replaced by those of Japanese gods. The village is populated by dislocated and dispossessed people, represented by two main characters: Chen Wenzhi, a traditional Chinese scholar now out of commission as a result of the colonial government's suppression of the Chinese language, and Ruan Xinmin, a landlord-collaborator's Japanese-educated son appalled by the misery of his native villagers. Both undergo a crisis of consciousness and find a solution in the united strength of peasants. While the source of inspiration for them lies in their firsthand experience with the peasants' mutual support in distress, the call to arms comes from Japanese peasants' struggle to reclaim land appropriated by the government (*Yang Kui ji* 235–297).

His works of satire, resistance, and positive action may be read with profit against another work by a contemporary of Yang Kui's, Wu Zhuoliu, whose famed novel *Yaxiya de gu'er* (Asia's Orphan) was written in secret some ten years after "Songbaofu" and published only after the war. The plight of colonial Taiwan's traumatized identity is by now a familiar if no less affecting one. Discarded by mainland China and brutalized by colonialist Japan, the Taiwanese intellectual raised

under colonial education is lulled by a false sense of identification with the metropole until a rejection by a Japanese girl hammers home the vulnerability of romance between ruler and subject. As he turns belatedly toward a motherland at war with Japan, he finds himself eyed with suspicion; even the people on Taiwan are unaccepting of a native son turned "fake foreign devil."[41] Wu's depiction of the wavering intellectual alienated from self and others in his search for identity through nationhood offers a poignant picture of the crushing logic of imperialism and its psychological effects. Whereas Wu's protagonist moves from a position of imaginary union between Self and Other to one of self-alienation and self-fragmentation, Yang Kui consciously refuses to be marginalized or pulverized and works positively toward a construction of identity with oppressed peoples and progressive artists transcending national boundaries. One could argue, however, that the difference is more apparent than real. Yang's texts glorifying Japanese people and culture as well as those told from a Japanese subjectivity testify to the writer's struggle to build an identity that would reconcile his nationalism with his cultural and spiritual affinity with Japan. When discussions of nationhood are suppressed—and this was the case in Taiwan both before and after the retrocession—many writers resort to silence or turn inward in self-searching, as evidenced in the introspective writings of Weng Nao, Zhang Wenhuan, Long Yingzong, and Wu Yongfu. Yang Kui persisted in writing and publishing whenever he could, even in jail, and surprisingly, it is in explorations of selfhood that his best writings emerge.

Re-Creation of the Self

As censorship tightened its grip on the cultural scene, Yang turned increasingly to construction of a positive selfhood, a project that did not stop at exploring the problematics of colonized identity through writing. Neither did he stop at passive resistance, for he had already shown his disdain for the colonial regime by refusing to seek office—something he could easily have done as a Japanese-educated intellectual. Retiring from political activism after a series of arrests and the crackdown on literary journals, he found new creative energy in a conjunction of gardening, writing, and cultivating a harmonious family life. This he did without reclusiveness or transcendentalism in the traditional eremitic sense; rather, action on the home front was imbued with a moral urgency. In a gesture of defiance against the colonial authorities, he named his garden Shouyang, an allusion to the legendary brothers Po Yi and Shu Qi, who remained loyal to the Shang dynasty and refused to submit to the Zhou reign, choosing instead to flee to the mountains and finally dying of starvation at Mount Shouyang.[42] In the lyrical essay "Doro ningyō," or "Ni wawa" (Clay Dolls) (1942), the I-narrator delights in reciting, as he goes about his gardening chores, a poem by Dongfang Shuo (ca. 161 B.C.) commemorating the brothers:

I have exhausted all hiding places—
Let me hide in holes and caves.
Let me not flourish with the lawless,
Better follow the lonely bamboo to Shouyang. (*Yang Kui ji* 106)

Indeed, he saw in his garden a metaphor both for self-cultivation and for combat against external forces of oppression. In "Shuyoen-zakki," or "Shouyang yuan zaji" (Miscellaneous Notes of Shouyang Garden) (1937), he confesses that he is "not reconciled to following Bo Yi and Shu Qi all the way." Instead, he finds existential meaning in his daily chores: "When the vegetables and flowers are invaded by bugs, we kill the bugs one by one; when weeds overgrow we pull them out one by one: this is our call of duty." Of the nomenclature of his garden he muses, alluding to its namesake, that "even though we both call Shouyang our home, those who are aware, willing to fight, and determined to live are not necessarily doomed to starve" (*Wenxue shengya* 115–121).

Yang Kui's subsequent works, written during the period of the Sino-Japanese War when a strict censorship was enforced and the *kōminka* campaign rigorously waged, turned increasingly to a lyrical and allegorical style. Collected in the post-war anthologies *E mama chujia* (Mama Goose Gets Married) and *Mengya* (Sprouts), these include lyrical essays reminiscent of Lu Xun's *Yecao* (Wild Grass) and writings that cross the boundaries between fiction and autobiographical essay.

In "Udori no yome iri" (1942), in *E mama chujia*, the first-person narrator draws a moral parallel between (a) his gift of a goose—thereby separating her from her flock and gander—to clinch a deal with the (Japanese) hospital administrator and (b) a friend's father's betrayal of his daughter to appease his (Japanese) creditor (*Yang Kui ji* 115–147). The analogy brings about a shock of recognition on several scores: the corruption of the hegemonic Other; the hypocrisy of the notion of co-prosperity among unequals; and, more importantly, the corruptibility of the sub-jugated Self.

As the war raged and repression intensified, death and regeneration became recurrent themes in his works. "Muison," or "Wuyi cun" (The Doctorless Village) (1942), is narrated in the voice of a young country doctor who for lack of business whiles away his time writing poetry. A rare call summons him to a patient's death-bed, and he is suddenly awakened to the futility of medical knowledge when the villagers can ill afford it. The story ends with him once again escaping into poetry writing, this time with a redoubled sense of remorse and guilt as his identity as medical doctor is shaken by his helpless confrontation with death (*Yang Kui ji* 85–95). In "Ni wawa," the narrator ruefully reflects on the malleability of humans as his own son, finally recuperated from a prolonged illness, clamors to join the Japanese army, as all good Taiwanese sons were taught to do. The narrator's lament, that "there is nothing crueler than to have children of a fallen nation befall other nations" (*Yang Kui ji* 112), reflects Yang's deep and persistent anxiety on the issue of identity, not only for himself or his generation but for succeeding generations.

The remedy, as Yang Kui would have it, is self-transformation and self-cre-

ation through physical labor and struggle with nature. In Yang's letters, essays, and stories he repeatedly celebrates the joy of productive labor and particularly the aesthetic pleasure of gardening, which in turn parallels the pleasure of the pen. In "Me moyuru," or "Mengya" (1942), he depicts an ideal world of ravishing flowers and passionate plays and a growing child raised in love of labor (*Yang Kui ji* 149–159); in "Wo you yikuai zhuan" (I Have a Brick) (n.d.), he dreams of a "peach blossom spring," a utopia where the pleasures of gardening and writing are one and the same, both metaphors of and concrete means to self-cultivation, self-expression, and self-regeneration (*Xuanji* 24–27).

Thus to Yang, identity is not an external given, but a mental state one ceaselessly cultivates and strives for; hence his participation in marathon races until a ripe old age, his choice to live by his own hands—"writing poetry with the hoe on mother earth," as he put it[43]—and his self-characterization as the "turtle," the "foolish old man who tries to move the mountain" (*Xuanji* 29).

The Enemy from Within

Yang's project of self-re-creation turned increasingly inward in the postwar years, based on the recognition that the propensity for aggression exists not just in others, but in ourselves, and his writings reflect an increasing alertness to its dangers. His deep worry proved prophetic. It is one of the supreme ironies of modern Chinese history that many who vowed allegiance to a national cause and agitated on its behalf were met with suspicion. Yang and his wife, who buoyantly started learning Mandarin Chinese from their daughter and led volunteer groups to clean up the streets after Taiwan's repatriation, rousing the masses to the strains of national pride, were twice jailed by the KMT in the wake of the February 28 Incident. The incriminating Peace Declaration Yang drafted and for which he was handed a twelve-year sentence called for reconciliation between mainlanders and Taiwanese, granting of freedom of expression, and returning government to the people; the declaration was banned from publication until recently (*Wenxue shengya* 321–322). Even while serving sentence in the penal colony of Lüdao (Green Island), Yang continued to solicit contributions to the journals he edited, the *Xin shenghuo bibao* (New Life Bulletin) and the *Xinsheng yuebao* (New Life Monthly), and to write works that affirmed his spirit of resistance. Some of the most moving testimonies to Yang Kui's enduring optimism come from his writing during his lengthy prison term. "Chunguang guanbuzhu" (Spring Light Cannot Be Shut Out) (1962), which he later renamed "Yabubian de meigui" (Uncrushable Rose), is set in the war period of 1941–1945, when students were conscripted into Japanese construction units. As the conscripts toil away, the sight of a small fishing boat—the first sign of life outside of the labor camp—causes a commotion, and the discovery of an uncrushed rose from under a rock symbolizes the people's undiminished yearning for freedom and struggle for life (*Yang Kui ji* 299–305). Though the story is carefully situated in the colonial era, the parallel between the prisoners' intradiegetic predicament and the writer's invites a telescoping of his dual struggle against Japanese

and KMT tyranny. It is noteworthy that in this as well as in Yang's other literary writings in the postwar period, anti-Japanese rhetoric is conspicuously absent, even though it was then safe to unleash it. Whether this reflects the national shift from preoccupation with external hostility to obsession with internal strife—that between the KMT and the Chinese Communist Party on the one hand and between the KMT and the islanders on the other—or whether Yang had no taste for belaboring a self-evident subject, it is a measure of his commitment to a deeper cause that he continued to identify and uproot the enemy from within. Hence his "Yuanding riji" (A Gardener's Diary) (1956) echoes the prewar story "E mama" in its self-reflexiveness, but with more relentless self-irony: His battle with ants infesting his garden assumes a moral and political significance as he satirizes himself as an imperialist from the ants' position (*Xuanji* 12–23). His "Jiashu" (Letter Home) (1954), one of his most personal published texts, thanks his oldest child for sacrificing his education to take care of the family during his father's imprisonment and encourages him to carry on despite setbacks.[44] "Wo de xiao xiansheng" (My Little Teacher) (1956) vividly portrays his Mandarin sessions with his seven-year-old daughter, a joyful exercise signifying his enthusiastic embrace of Taiwan's return to the motherland that casts his incarceration in an ironic light (*Meigui* 119–124). And "Taitai dailaile hao xiaoxi" (My Wife Brings Good News) (1956) is an intimate celebration of his family, the surest basis, he believes, for a common-wealth of nations: "their ox-like health, ox-like persistence and endurance, their genuine human love and mutual understanding" (*Xuanji* 51–56). "Cai bashiwu sui de nüren" (The Woman Who Is Only Eighty-Five) (1957) is an uplifting story of children relying on their own hands and resources for their livelihood and an old lady of eighty-five youthfully hiking up a mountain, thumbing her nose at bystanders who thought she needed help—a story that affirms Yang's belief in the undaunted spirit, in the stubborn will to cling to life (*Yang Kui ji* 307–319).

China and Roots

Thus far I have discussed the problematics of Yang Kui's self-identity in terms of his relationship with Japan. What about mainland China? His discussions of his own intellectual lineage leave mainland writers unmentioned, although he acknowledges an ideological affinity with them.[45] Of his admiration for Lu Xun we can be more certain. A eulogy of Lu Xun appeared in the November 1936 issue of *Taiwan xin wenxue,* of which Yang was editor.[46] Zhang Yu, a mainland acquaintance of his who moved to Taiwan, testifies to Yang Kui's ardent study of Lu Xun's works after the war (Zhang 86). Yang also translated into Japanese and published bilingual versions of selected works of Lu Xun, Yu Dafu, Lao She, and Shen Congwen in the early postwar years; however, whether in deference to the political climate or otherwise, he refrained from mentioning any mainland writers in interviews until long after his release from Ludao.[47]

Recalling his student days in Japan, he mentioned elliptically that cordial relations existed between mainland and Taiwanese students in Japan, but volunteered

no information on the nature of his relationship with others. There could well have been none, for though he joined Taiwanese organizations such as the Taiwanese Youth Association in Japan, he took no part in Chinese organizations. He professed ignorance of the political situation on the mainland, since he read no Chinese, and, because of dialectal differences, would presumably have had difficulty in oral communication with mainlanders; nowhere has he articulated any desire for integration with them. It was in Japan that he learned of mainland China's revolution and read in translation Sun Yat-sen's Three People's Principles,[48] which he sought to disseminate by publishing articles on Sun's thoughts in his *Yiyang zhoubao* after the war. When news of the 1927 KMT liquidation of the CCP reached him in Japan, he witnessed Chinese students of opposing camps come to blows and expressed dismay at the internal feuding.[49] He did speak admiringly, however, of two Taiwanese brothers he knew who decided to join the revolution in China, and he dismissed praise for his decision to endure persecution in Taiwan rather than go to the mainland, attributing it in part to the constraint of objective circumstances, since he was constantly tailed by the police.[50]

It is in "Mofan cun," the most ostensibly fictive of his stories, where the clearest indication of his prewar position with regard to mainland China occurs. Ruan Xinmin, the landlord's son, having confronted his father with his exploitation of the peasants, has run away from home. His whereabouts becomes the subject of intense curiosity among the villagers, especially after a carton of socialist literature arrives at scholar Chen's house:

"Where did Master Ruan go?" asks a young man.

"I don't know. He only said he would not be able to see us for a while, that these books were his only present. He told me to pass them on to you after I'd finished. . . ." Flipping through the pages of the book in his hands, Chen Wenzhi continues: "He said he had wanted to be a lawyer in the city to fight for rights and privileges for the poor. But then gunfire started at Lugouqiao [Marco Polo Bridge], and he said it was no use to be a lawyer any more. . . ."

"Lugouqiao? Where is that?"

"Near Beiping. The Japanese have occupied the entire northeast. Looks like they are determined to devour all of China. . . ."

As Chen Wenzhi speaks he puts down the book and starts flipping through another one. These young men have never read a book or newspaper; small wonder they understand so little. Nevertheless, the Taiwanese people are Chinese. The Japanese have occupied all of Taiwan, subjecting the Taiwanese to a life unworthy of beasts. . . . Everybody knows this from daily experience. Although Taiwan is ruled by the Japanese, we still have our motherland on the other side of the sea. . . . Again this is something everybody is vaguely conscious of. Reports that the Japanese want to devour all of China have stirred everyone's deepest emotions. (*Yang Kui ji* 293–294)

Ruan's abandonment of his plan to be a lawyer in response to the gunfire at Lugouqiao hints at his escape to the mainland to fight in the front lines. Although the effect of his disappearance to China on the course of events may be negligible, he becomes the source of inspiration for continued struggle in Taiwan. Through the different paths taken by the two protagonists, the narrator is surely intimating that whether one seeks one's roots on the mainland or stays in Taiwan, the struggle remains one and the same; a common destiny binds the people on both sides of the Taiwan Strait.

In this connection, it should be noted that in 1944 Yang formed, together with a circle of friends, the Taizhong Yineng Fenggonghui (Taizhong Arts Society), which they secretly named the Scorched Earth Society—an allusion to the mainland slogan of "scorching the earth to resist the Japanese invaders"—and adapted the Russian play *Roar! China* by Sergei Mikhailovich Tret'iakov (1892–1939).[51] Ostensibly a play denouncing British imperialism in China, it was staged in Taizhong, Zhanghua, and Taibei (Taipei), presumably in Japanese (Lin 134). With Japan's surrender in 1945, plans for performances in the Minnan language were abandoned (*Yang Kui ji* 370). His use of Japanese in writing must be understood in the context of Taiwan's colonization, which predated China's vernacular movement by some twenty years. Although news of exciting new developments in Chinese language and literature on the mainland was brought to Taiwan—primarily through the writings of Zhang Wojun (1902–1955), a Taiwanese who studied in Beijing—a corresponding movement on Taiwan did not catch fire easily. This is partly because the Mandarin vernacular was, for the Taiwanese, also an acquired language that was increasingly suppressed by the colonial government and partly because a written language of the Taiwanese vernacular had yet to be fashioned.[52] Yang Kui learned to read and write Chinese as a grown man, first from his daughter, then, ironically, in the penal colony on Lüdao. He must have felt self-conscious about his use of Japanese, for he published nothing in Japanese after the return of Taiwan to China, even though most journals and newspapers retained their Japanese pages in the initial postwar period, and he was at one point invited to be editor of a Japanese page—a position he soon relinquished. He painstakingly translated his Japanese stories into none-too-polished Chinese.[53] According to Zhang Yu, Yang ceremoniously published the Chinese version of his "Songbaofu" in a crudely printed monograph after the war, its first full edition in Taiwan, as if to endorse Hu Feng's translation, and, in Zhang's estimation, to "renounce the original Japanese" (Zhang 86–87). This assessment is probably overstated, however, for, whether with Yang's approval or not, a bilingual version of "Songbaofu" appeared in Taiwan in 1946 and again in 1947.[54]

In the postwar period, while still a political prisoner in 1959, Yang daringly recapitulated his discontent with the split between the Communists and Nationalists in *Niu li fenjia* (The Cow and the Plough Split Up), a thinly veiled political satire written and performed in Lüdao, in which both sides of a feuding family are denounced (*Xuanji* 191–214).

It therefore stands to reason that critics have hailed Yang Kui as a Chinese nationalist, a worthy heir to Lai He, who persisted in writing in vernacular Chinese.[55] However, whereas Lai may be more easily described as a nationalist, one who devoted his writings to berating the colonial government for its corruption and brutality while deploring the local people's ignorance and backwardness, Yang's ideological position is far more complex. Shying away from a simplistic nationalism, he was an internationalist who chose to apply class analysis in his prognostication of social ills; he maintained an ambivalence toward Japan and Japanese culture, which Lai rejected decisively; and, particularly in the wake of the February 28 Incident and his own prolonged incarceration, he kept a cautious distance from the mainland and mainlanders. Neither could Yang comfortably fit into the shoes of a Taiwanese nationalist: Never considering Taiwan divorced from the mainland, he refuted in no uncertain terms suggestions that the Taiwanese people were a distinct people from mainlanders, and, while expressing understanding of the Independence Movement, called for a gradual process of unification between Taiwan and the mainland, one truly based on the genuine wishes of the people.[56]

Beyond ideological allegiance, Yang maintained an enduring optimism that distinguished him even in the worst of times. He decried the "lachrymosity" of Wu Zhuoliu, who in the title of his novel characterized colonial Taiwan as "Asia's Orphan"—a metaphor that has since caught the imagination of sympathizers of an independent Taiwan—and, declaring that Taiwanese tradition "by and large constituted a minor tradition of mainland tradition, with, however, a new content," he called for a "grassroots culture," a "realist, radical, and exalted literature of social change."[57]

It would be equally imprecise to describe Yang Kui as a socialist. While subscribing to an anticapitalist and anti-imperialist stand, he was not an institutional socialist. He refrained from joining political parties, renounced the use of violence to effect social change, and never held out visions of an ideal system of government. In the years immediately preceding the war and after it ended—perhaps to some extent as a result of political repression—he relied increasingly on the strength of the individual. The utopian world of which he dreams, of flowers and poetry, is the result of individual will and collective labor. Hence, in the two phases of his life he appears to be recapturing in writing and in action the thinking of the idol of his youth, Ōsugi Sakae, whose "individualist anarchism" places a dual emphasis on the individual's self-creation on the one hand and organized action on the other.[58]

The Lone, Raised Head

I began by claiming that Yang Kui's life is a text of resistance to tyranny. Yet his struggle was never merely national or external, but one enormously complicated by questions of class, culture and self-identity. I would like to end by considering, in this light, the title of his last volume of essays, which is illustrative of the dia-

logic interplay between Yang Kui's art, his political stance, and his selfhood. *Yang-tou ji* (Sheep's Head Essays) is, on the first level, a reference to his childhood nickname, which is a pun on his last name.[59] But retaining a childhood name is in itself a gesture of defiance, an affirmation of his unchanging stance in contradistinction from those whose names / positions change, he notes sarcastically, in accordance with political winds. On a second level, the name is an allusion to the Chinese adage, "hanging out a sheep's head while selling dog meat"; hence the sheep's head is a figure for deceit, which used reflexively is Yang Kui's modest self-satire of his own writing. But since he also mentions the fact that the once devalued dog meat is rapidly gaining stature, the dog meat behind his sheep head represents his faith that his writings, embodying his beliefs, will prove more valuable in the course of time. Thirdly, a prefatory anecdote of a young sheep breaking through the ring of protection offered by older sheep the moment a fierce dog is sighted illustrates Yang's desire to "hang out" his innermost self through his writing, to let it stand the test of time.[60] The hanging out of a stubborn head, which echoes the name of his garden, Shouyang—also a pun on the words meaning "raised head"—is Yang Kui's self-portrait, a picture of resistance against the devastating effects of war and of adverse nature. It is his emblematic statement of resistance against the self-pitying victim psychology, of avoidance of empty rhetoric and concretization of combat against oppression, and of his incessant struggle for self-definition and self-affirmation.

If, however, by the mediation of such a literary image Yang Kui seeks to define himself, he is all too aware of the pitfalls of labels. For the disjunction between sheep's head and dog meat, between what is vaunted and what is delivered, between rhetoric and reality, is an unbridgeable gap. And behind what Yang Kui professes is a storehouse of contradictions he has not cared to resolve. In the end, Yang Kui's hybrid identity as it is constantly reconstructed in the practice of his life and writing must complicate the conventional, monolithic image of the anticolonialist fighter. His chosen image of a lone raised sheep's head is a split image that accords with the discrepancies within and between his other self-portrayals: the Shouyang recluse who refuses to die of starvation; the uncrushable rose; the family man who has survived "seventy years under an iceberg";[61] the "foolish old man who tries to move the mountain"; the seventy-year-old who challenges young people to a race (Lin 195–197); the proudly Japanese-educated Chinese Taiwanese who favors unification; the "humane socialist" who rebuffs institutions; the follower of the individualist anarchist; the grassroots activist who insists on "standing and walking alone."[62] This is an image of individual defiance, one that battles against both the perception and the psychology of orphanage on the one hand, and against all ideological pretenses on the other. It is only through a recognition of the process of constitution in the multifaceted, fragmented selves of a resistance fighter such as Yang Kui that we can begin to appreciate the psychological impact of colonialism on colonial subjects.

A symptomatic reading of the literary texts produced in Taiwan during her

fifty-year Japanese occupation offers a case study of the abrupt, violent, at times numbing, and often searingly painful process of colonization of the consciousness in a matter of two or three generations. Caught between competing cultural authorities, the writers of colonial Taiwan, through their lives and work, painted a multifaceted landscape of national longing and individual yearning. The two are mutually qualifying and subversive. An ancestral China that represented an elusive source of succor for the memory and the imagination was also a constant symbol of lack and desire. The struggle to reappropriate a local cultural space and reinvent a national myth is now only just beginning.

Notes

Editor's Note: A preliminary version of this essay was presented at the conference "War, Reconstruction, and Creativity: East Asia 1920–1960," held at the University of Maryland, College Park, on April 25–26, 1992. A later version was published in volume 17 of *Chinese Literature: Essays, Articles, and Reviews* (December 1995). The editors of the present volume thank the editors of the journal for permission to reprint this essay in its original context.

1. Joseph S. M. Lau, ed., *The Unbroken Chain: An Anthology of Taiwan Fiction since 1926* (Bloomington: Indiana University Press, 1985), x.

2. Of these, the most ambitious have been the anthologies *Riju xia Taiwan xin wenxue* (New Taiwan Literature under Japanese Occupation), Li Nanheng, ed. (Taipei: Mingtan, 1979), and *Taiwan zuojia quanji* (Complete Works of Taiwan Writers) (Taipei: Qianwei). The latter, first published in 1991, is an ongoing project that includes contemporary writers.

3. Benedict Anderson, *Imagined Commmunities: Reflections on the Origin and Spread of Nationalism* (London: Verso, 1983).

4. Ernest Gellner, *Nations and Nationalism* (Ithaca: Cornell University Press, 1983).

5. Homi Bhabha, "Introduction: Narrating the Nation," in Bhabha, ed., *Nations and Narration* (London: Routledge, 1990), 3–7; and "Dissemination: Time, Narrative, and the Margins of the Modern Nation," in ibid., 291–322.

6. Ernest Renan, "Qu'est-ce qu'une nation?" in *Oeuvres Completes* (Paris: 1947–1961), vol. 1, 887–907. Trans. and annotated by Martin Thom in Bhabha (1990), 8–22.

7. For a detailed biography of Yang Kui, see Lin Fan, *Yang Kui huaxiang* (A Portrait of Yang Kui) (Taipei: Bijiashan, 1978), hereafter Lin. See also Kawahara Isamu, "Yang Kui de wenxue huodong" (Yang Kui's Literary Activities), trans. and supp. by Yang Jinding, *Taiwan wenyi* (Taiwan Art and Literature) 94 (1985.5), 183–199.

8. "Yang Kui huiyi lu" (Yang Kui's Memoirs), narr. Yang Kui, rec. Wang Shixun, *Yang Kui de wenxue shengya: xianqu xianjue de Taiwan liangxin* (Yang Kui's Literary Life: Taiwan's Conscience, a Present Precursor), ed. Chen Fangming (Taipei: Quanwei, 1988), 156–161 (hereafter *Wenxue shengya*).

9. For Ye Tao's life and contribution to the peasant and women's movement on Taiwan, see Yang Kui, *Riju shiqi Taiwan funu jiefang yundong: yi Taiwan minbao wei fenxi changyu* (1920–1932) (Taiwanese Women's Liberation Movement under Japanese Rule: With *Taiwan minbao* as Field of Analysis [1920–1932]), (Taipei: Shibao, 1993), 339–362, 617–620. See also Yang Kui, "Wo de taitai Ye Tao," in *Wenxue shengya*, 133–141, and Itaguchi Reiko, "Yang Kui he Ye Tao" (Yang Kui and Ye Tao), in *Wenxue shengya*, 219–232.

10. Yang Kui, interview, "Yige Taiwan zuojia de qishiqi nian" (A Taiwanese Writer's Seventy-Seven Years), by Dai Guohui and Uchimura Gosuke, trans. Ye Shitao in *Wenxue shengya*, 189.

11. Yang Kui, "Buxiu de laobing" (The Immortal Veteran), interview by Song Zelai, *Wenxue shengya*, 206.

12. Chen Fangming, "Fangdan wenzhang pingming jiu—lun Yang Kui zuopin de fan zhimin jingshen" (Bold in Writing, Unrestrained in Drinking—A Discussion of the Anti-Colonialist Spirit in Yang Kui's Works), *Yang Kui ji* (Collected Works of Yang Kui), vol. 7 of *Taiwan zuojia quanji: Duanpian xiaoshuo juan* (Taipei: Qianwei, 1991), 341.

13. "Yang Kui huiyi lu," 145–146.

14. Yang had originally submitted his first writings to Lai He, an editor of *Taiwan xinmin bao* (Taiwan New People's News), under the pseudonym Yang Da. It was Lai He who changed the second character to Kui. Whether Lai had mistaken it for a graphic error or whether he had thought this would make a better name, Yang happily accepted the change. See Yang Kui "Yi Lai He xiansheng" (Remembering Mr. Lai He) in *Taiwan wenxue* (Taiwan Literature) 3.2 (1943). Rpt. in *Lai He xiansheng quanji* (Complete Works of Mr. Lai He), Ming vol. 1 of *Riju xia Taiwan xin wenxue* (Taipei: Mingtan, 1979), 416–417.

15. "Yige Taiwan zuojia," 190; Zhang Yu, "Yang Kui, 'Songbaofu,' Hu Feng—yi xie ziliao he shuoming" (Yang Kui, 'Newspaper Boy,' Hu Feng—Some Materials and Notes) *Xin wenxue shiliao* (Historical Materials on New Literature) 37 (Beijing: November 22, 1987), 84 (hereafter Zhang). I am grateful to Hung Chang-tai for drawing my attention to this article.

16. The edition I am using is Hu Feng's translation in *Shanling: Chaoxian Taiwan xiaoshuo xuan* (Shanghai: Wenhua Shenghuo, 1936), 175–226. Rpt. in *Yang Kui ji*, 15–58.

17. For a concise introduction to the literary scene in colonial Taiwan, see Zhong Zhaozheng, "Xuelei de wenxue, zhengzha de wenxue—qishi nian Taiwan wenxue fazhan zongheng tan (zong xu) (A Literature of Blood and Tears, a Literature of Struggle—A General Survey of the Development of Seventy Years of Taiwan Literature [General Introduction]), in *Lai He ji*, 1–38. For debates on linguistic choices, styles, and themes during the literary movement, see Li Nanheng, ed., *Wenxian ziliao xuanji* (Selected Literature and Materials), Ming vol. 5 of *Riju xia Taiwan xin wenxue*. See also Ye Shitao, *Taiwan wenxue shigang* (An Outline of Taiwan's Literary History) (Gaoxiong: Wenxuejie zazhi she, 1987), 1–68.

18. Hu Qiuyuan, as a matter of fact, takes it further in his preface to Yang Kui's *Yangtou ji* (Sheep's Head Essays), praising Yang's writing as superior to the mainland leftist writers of the thirties. See *Yangtou ji* (Taipei: Huihuang, 1976), 3–12.

19. Yan Yuanshu, "The Japanese Experience in Taiwanese Fiction," *Tamkang Review* 2 (1973), 167–188.

20. *The Colonizer and the Colonized* (New York: Orion Press, 1965). See also Frantz Fanon, *The Wretched of the Earth* (New York: Grove Weidenfeld, 1963) and Homi K. Bhabha, "Remembering Fanon: Self, Psyche and the Colonial Condition," in Barbra Kruger and Phil Mariani, eds. *Remaking History* (Seattle: Dia Art Foundation, Bay Press, 1989), 131–148.

21. "Huiyi lu," 148–150, 153; "Yige Taiwan zuojia," 180; "Buxiu de laobing," 203–204. For an in-depth discussion of colonial education in Taiwan, see E. Patricia Tsurumi, *Japanese Colonial Education in Taiwan, 1895–1945* (Cambridge: Harvard University Press, 1977).

22. "Huiyi lu," 152; "Yige Taiwan zuojia," 182.

23. "Huiyi lu," 161–162; "Yige Taiwan zuojia," 187–188.

24. "Yige Taiwan zuojia," 185.

25. For a comparison of the more important textual differences between the various Japanese and Chinese editions of "Songbaofu," see Tsukamoto Terukazu, "Yang Kui zuopin 'Shinbun Haitatsufu' (Songbaofu) de banben zhi mi," trans. by Xiang Yang, *Taiwan wenyi* 94 (May 1985), 165–180.

26. "Songbaofu," *Yang Kui xuanji,* ed. Cong Su (Hong Kong: Literary Trend Press, 1986) (hereafter *Xuanji*), 166. The Chinese translation gives the logic of the original a contrapuntal nudge: "Wataru seken ni oni wa nashi" (There are not only ghosts in the world). I am indebted to Eiko Miura and Kazuo Yaginuma for their insights on this point.

27. "Yige Taiwan zuojia," 194–197; Yang Kui, "Baodao ji: guangfu qianhou" (Precious Sword: Before and after Retrocession), *Yabubian de meigui* (The Uncrushable Rose), vol. 2 of *Yang Kui quanji* (Complete Works of Yang Kui) (Taipei: Qianwei, 1985), 190–191 (hereafter *Meigui*). Note that Yang, in an unconventionally forthright manner, volunteered information on his first stirrings of love for a Japanese girl while in high school (Lin 62–64).

28. A mere suggestion in the original, this point is accentuated in the 1974 version with the addition of a workers' victory celebration in which the I-narrator speaks to the audience about conditions at home and his determination to return home to wage struggles against injustice:

> As I spoke I grew increasingly agitated, and the audience responded emotionally, as if on fire. When I had spoken my last words and was about to leave the podium, an applause broke out along with a chorus of shouts: "Go! Struggle to the end!"
> The meeting turned into a send-off party for me, as if sending a warrior on to the battlefield. (*Xuanji* 187)

29. In "Yang Kui you meiyou jieshou tewu gongzuo?" (Did Yang Kui Accept Intelligence Work?), *Nanfang yuekan* (Southern Monthly) 2 (November 1986), 122–125, Zhang Henghao mentions another work in the same vein: "Shouyang jiechu ji" (The Dissolution of Shouyang) in *Taiwan wenyi* (June 14, 1944). I have not seen this work.

30. Lin Fan's portrayal of Yang Kui suggests that his personality impressed the colonial authorities, even the chief of the Intelligence Office. See Lin, 133.

31. Luo Chengchun, "Long Yingzong yanjiu," *Wenxue jie* 12–13 (November 1984–February 1985). Reprint *Long Yingzong ji* (Taipei: Qianwei, 1991), 233–326.

32. See, for instance, the essays by his daughter Yang Sujuan and granddaughter Yang Cui in *Yangtou ji*, 201–232. See also Yang Sujuan, "Xinjin shang be baihua: fuqing yu wo, jian jimuqing Ye Tao nushi" (The White Flowers on the Lapel: My Father and I, and Recalling My Mother Madam Ye Tao), *Lianhe wenxue* 8 (June 1985), 22–25; Yang Jian, "Nitu de huigui: huanian xianfu Yang Kui xiansheng" (Returning to the Soil: Remembering My Father Mr. Yang Kui), *Lianhe wenxue* 8 (June 1985); Yang Cui, "Xiangnian he qiyuan" (Nostalgia and Prayer), *Zhonghua zazhi* 262 (1985.5), 44.

33. "Yige Taiwan zuojia," 176. "Taiwan lao shehui yundong jia de huiyi yu zhanwang—Yang Kui guanyu Riben, Taiwan, Zhongguo dalu de tanhua jilu" (Veteran Taiwanese Social Activist Looks Back and Forward—Yang Kui's Conversation on Japan, Taiwan, and Mainland China), interview by Dai Guohui and Wakabayashi Masao (hereafter

"Huiyi yu zhanwang"), *Taiwan yu shijie* (Taiwan and the World) 21 (May 1985), 37; "Taiwan wenxue dui kang Ri yundong de yingxiang" (The Influence of Taiwanese Literature on the Movement of Resistance against Japan) (hereafter "Yingxiang"), *Wen ji* (Literary Quarterly) 2.5 (June 1985), 20. On his appeal to rewrite a history of Taiwan, particularly that of oppressed peoples' struggles against Japanese imperialism, see his "Ke bu rong huan de Taiwan kang Ri shi" (The Pressing Need for a History of Taiwanese Resistance against Japan), *Meigui*, 185–187.

34. See Yang Kui, "Yige Riju shiqi wenxue gongzuozhe de ganxiang" (Thoughts of a Literary Worker during the Japanese Occupation), *Meigui*, 177–178.

35. For a more detailed comparison of the various editions, see note 18.

36. Wang Lihua, "Guanyu Yang Kui huiyi lu biji" (Notes on Yang Kui's Memoirs), *Wenxue shengya*, 281.

37. "Huiyi lu," 154.

38. "Huiyi yu zhanwang," 38–39.

39. "Huiyi lu," 161–162.

40. Yang has expressed admiration for Gogol, among other Russian writers such as Dostoevsky, Tolstoy, and Gorky. See "Buxiu de laobing," 206.

41. *Yaxiya de gu'er* (Taipei: Nanhua, 1962). For a contemporary critic's views on the novel, see Chen Yingzhen, "Shiping 'Yaxiya de gu'er'" (Some Preliminary Comments on *Asia's Orphan*) in the Beijing: Renmin (1986) edition, 237–251.

42. "Yige Taiwan zuojia," 195; in "Buxiu de laobing" he vows: "I will never bow to Japanese arrogance, not even at my last breath" (211).

43. "Kenyuan ji" (Gardening Notes) (1963) in *Meigui*, 21.

44. *Meigui*, 51–54. For letters to his family during his prison term in Lüdao—letters that did not reach them until after his death and published posthumously—see *Lüdao jiashu* (Letters Home from Green Island) (Taizhong: Chenxing, 1987).

45. *Youshi wenyi* (Young Lion Art and Literature) 250 (October, 1974), 110.

46. Though Yang seemed to acquiesce in the suggestion that he wrote the eulogy, Ye Shitao disputes this claim, attributing it instead to Wang Shilang. See Ye's "Riju shiqi de Yang Kui: ta de Riben jinyan yu yingxiang" (Yang Kui during the Japanese Occupation: His Japanese Experience and Its Influence) *Lianhe wenxue* 8 (June 1985), 21.

47. "Huiyi yu zhanwang," 37–44. In a written message to an art and literature forum in 1974, Yang Kui mentions that people were imprisoned in Lüdao for having read, in their eagerness to learn Chinese, Lu Xun, Mao Dun, Ba Jin, and other mainland leftist writers; although this is not cited as a reason for his own incarceration, Yang is obviously familiar with their works. See "Yingxiang," 19–24. The *Yiyang zhoubao* (One Sun Weekly), which Yang Kui founded in 1945 after Taiwan's return to China, contains reprints of the above writers' texts.

48. "Buxiu de laobing," 205.

49. "Huiyi lu," 158–159; "Huiyi yu zhanwang," 39.

50. "Yige Taiwan zuojia," 194.

51. English trans. by F. Polianovska and Barbara Nixon (London: International Publishers, ca. 1932).

52. See note 17, especially Ye Shitao, *Taiwan wenxue shigang*, 19–28 and Liao Yuwen, "Taiwan wenzi gaige yundong shilüe," in *Taibei wenwu* 3:3–4:1 (December 19, 1954–May 5, 1955). Reprint *Wenxian ziliao xuanji*, 458–496.

53. Zhang, 86. For a concise discussion of the literary scene after Taiwan's return to China and language problems, see Wang Shilang, "Rijuxia Taiwan xinwenxue de sheng-cheng ji fazhan—dai xu" (Preface: The Birth and Development of a New Taiwan Litera-ture during the Japanese Occupation), *Rijuxia Taiwan xinwenxue,* Ming vol. 5, 1–12. See also Ye Yunyun, "Shilun Zhanhou chuqi de Taiwan zhishi fenzi ji qi wenxue huodong (1945–1949)" (A Tentative Discussion of Postwar Taiwan Intellectuals and Their Literary Activities), *Wen ji* 2.5 (June 1, 1985), 1–18.

54. See "Yang Kui de wenxue huodong," 183–199. While I have not seen the Chinese edition to which Zhang refers, Ye Yunyun, an acquaintance of Yang's, has shown me a photocopy of a crudely printed bilingual version—of the kind Zhang describes—that Yang gave her and that she believes was published privately by Yang Kui himself in the postwar period. If this is the case, it would be further proof that Yang did not "renounce" the original Japanese.

55. Zhang Yu claims that Lai He drafted in Japanese before writing in Chinese (Zhang 87); I have found no corroboration for this practice, especially since Lai was well schooled in classical Chinese. See Zhang Henghao, "Juewu xia de xisheng—Lai He ji xu" (Con-scious Sacrifice—Preface to the Selected Works of Lai He) in *Taiwan zuojia quanji: Lai He ji,* 43.

56. "Huiyi yu zhanwang," 43.

57. "Buxiu de laobing," 214, "Caogen wenhua' de zai chufa," (The Relaunching of a "Grassroots Culture"), *Meigui,* 199–206.

58. For Ōsugi Sakae's life and thoughts, see Ōsugi Sakae, *The Autobiography of Ōsugi Sakae,* trans. and annotated by Byron K. Marshall (Berkeley: University of California Press, 1992); and Thomas A Stanley, *Ōsugi Sakae, Anarchist in Taishō Japan: The Creativity of the Ego* (Cambridge: Council on East Asian Studies, Harvard University, 1982).

59. Yang Kui, *Yangtou ji* (Taipei: Huihuang, 1976).

60. "Yangtou ji," *Xuanji,* 30–34, 61, 62.

61. "Bingshan dixia guohuo qishi nian" (Living Seventy Years beneath an Iceberg), in *Meigui,* 37–40. For an appreciation of Yang Kui's staunch political stand, see Wang Xiaobo, "Yang Kui shi 'shenme dou bushide hun hun ma?-jian lun ta wannian de sixiang licheng" (Was Yang Kui a Nobody and Doing Nothing? Reflections on Yang's Spiritual Experience in His Later Years), *Xinhuo zhoukan* 45 (1985), 37–43; and "Bingshan xia de Taiwan liangzhi: wo suo zhidao de Yang Kui xiansheng" (A Decent Scholar in Taiwan Beneath an Iceberg: Mr. Yang Kyu as I Know Him), *Xinhuo* 55 (1985).

62. Although Yang published the *Yiyang zhoukan*—which focused on discussions of Sun Yat-sen's Three Principles—after Taiwan's return to China, he had no desire to join the Sanmin Zhuyi organizations but sought to set up his own organization following his own guidelines. See "Huiyi yu zhanwang," 41, 42.

A Final Editor's Note: Two of Yang Kui's stories have been translated into English. See "Paperboy," translated by Rosemary Haddon, *Renditions* 43 (Spring 1995), 25–27; also "Mother Goose Gets Married," trans. by Jane Parrish Yang, in *Unbroken Chain: An Anthol-ogy of Taiwan Fiction since 1926,* ed. by Joseph S. M. Lau (Bloomington: Indiana University Press, 1983), 33–53.

The Development of Official Art Exhibitions in Taiwan during the Japanese Occupation

Wang Hsiu-hsiung

THE OFFICIAL ART EXHIBITIONS held in Taiwan during the latter half of the Japanese occupation (1927–1944) represent an important milestone in the development of the island's fine arts. These exhibitions introduced to Taiwan styles of painting first developed in Meiji Japan in both the Western *(yōga)* and modern Japanese *(nihonga)* manner, which in turn redirected the Chinese pictorial styles originally familiar in Taiwan.

In this general presentation, four major points at the outset will help to define the significance of these official exhibitions in Taiwan's modern art history. First, since both categories of painting were represented, *nihonga* and *yōga*, the progress in artistic development that these exhibitions made possible can be understood only when the two categories are examined side by side. Painters in the Western style not only made use of oil paint on canvas as their major medium, but also used Western pictorial styles as a basis for their personal artistic idioms. Artists in the more traditional or *nihonga* style continued to use such traditional media as ink on silk or paper, yet sometimes introduced certain Western concepts, such as the use of light and shadow.[1]

Second, these official exhibitions were open both to native Taiwanese and resident Japanese painters. The continuing success of these exhibitions permitted the development, in turn, of reciprocal influences between Japanese and Taiwanese artists. The various artistic attainments of these painters, then, can be judged without ideological bias.

Third, the development of these exhibitions mirrored, sometimes closely, certain contemporary political measures. They were also subject to views held by distinguished jurors and the published art criticism of the time. Fourth, these official exhibitions were well covered by the largest newspaper in Taiwan during the

Japanese occupation, the *Taiwan nichinichi shinpō* (Taiwan Daily Newspaper), which in carrying special reports in both Japanese and Chinese, comments by jurors, and serious art criticism, and also in sponsoring the Taiwan-Japan Award, greatly stimulated public interest in modern art and guided public appreciation of the works on display. What follows here includes, therefore, a few observations on each of these topics. A comprehensive view of these issues calls for continued study and research.[2]

Development of the Taiwan Exhibition and Its Educational Significance

When the government of Qing China was defeated by Japan in the first Sino-Japanese War, it was forced to cede the province of Taiwan in the Treaty of Shimonoseki (1895). The subsequent Japanese occupation lasted until the end of World War II in late 1945. Thus, Taiwanese culture sustained a strong Japanese influence for some fifty years. When the area first fell under Japanese domination, the government in Tokyo followed a long-term policy of integration—turning Taiwan into a permanent part of Japanese territory—in time coming to regard the island strategically as a base for future advance to the south. Within three years of the initial military occupation, Taiwan was set up as a colony *(shokuminchi)* administered under the control of a military governor-general, not as a prefecture as in the cases of the borderlands of Okinawa and Hokkaido in the 1880s. During the first twenty-odd years of the Japanese occupation, the colonial government-general (Sōtokufu) gave most of its attention to putting down insurrections and engaging in large-scale construction projects pertinent to economic development. During the second half of the period, however, following World War I, cultural initiatives such as official art exhibitions were begun. The year 1927, when the exhibitions commenced, is also associated with a shift in Taiwan from military to civilian governors-general and with a series of initiatives in colonial policy to create friendlier and less discriminatory ties between Japanese occupiers and Taiwanese nationals. In other words, after thirty years the office of the Japanese governor-general began to pay serious attention to cultural affairs in Taiwan. The population of the island at this time was over 3.5 million, including Taiwanese and aborigines, with an additional 190,000 Japanese in residence as administrators, police officials, educators, and businessmen.[3]

The art exhibitions in Taiwan were modeled on the system of official exhibitions held in Japan, initially called the Bunten in 1907 and sponsored by the Ministry of Education (with subsequent name changes to Taiten or Imperial Exhibition in 1919 and Shin Bunten in 1935 and after), which originally was adapted from the system of Salon exhibitions developed in nineteenth-century France.[4] The exhibitions in Taiwan went through two stages. The first of these, entitled the Taiwan Fine Arts Exhibition or Taiwan Bijutsu Tenrankai (which I will refer to as the Taiwan Exhibition or Taiten), was held annually in Taipei, from 1927 to 1936, under

the supervision of the Taiwan Association of Education, a semiofficial organization; there were ten exhibitions in all. After a year of interruption in 1937, when the second Sino-Japanese War began and rule by military governors was restored to Taiwan, the exhibition was revived and renamed the Fine Arts Exhibition of the Taiwan Government-General or Taiwan Sōtokufu Bijutsu Tenrankai (referred to as Futen), so-called because it was now put under the direct supervision of the office of the colonial government; it was held six times, from 1938 to 1943.

It has often been suggested that the idea for the Taiwan Exhibition originated with the resident Japanese watercolor painter and art teacher, Ishikawa Kin'ichirō (1871–1945), and three Japanese colleagues in Taiwan, painters Shiozuki Tōho (1885–1954), Gōhara Kotō (1892–1962), and Kinoshita Seigai (1889–1988). They are said to have advised Governor-General Kamiyama Mitsunoshin (1869–1938), the fourth civilian official to hold the post, to set up such an exhibition.[5] As a matter of fact, the Japanese government in Taiwan took the initiative on its own in opening such an official exhibition. Even without the advice of these Japanese artists, the institution of such an exhibition was doubtless inevitable both as sound cultural policy and as a useful means by which to assimilate the Taiwanese into a Japanese view of a modern society. The public addresses given by various high Japanese colonial officials at the opening of the first exhibition in 1927 indicate that the primary purpose was educational. The goal, their rhetoric proclaimed, was to promote culture in order to enrich the spiritual life of the people of Taiwan and promote lofty ideals, as well as to reflect the prosperity of Japan through the fine arts. Their statements further emphasized the fact that "there is no difference between the Japanese and the Taiwanese with regard to the appreciation of beauty."[6] According to E. Patricia Tsurumi, Kamiyama's underlying policy during his two years there (1926–1928) was expressed as *"minzoku yōwa,* a fusion of supposedly equal elements," and required an end to discriminatory treatment of Taiwanese. However, his immediate successor as governor-general, Kawamura Takeji (1871–1955), spoke in harsher tones (1928–1929) of making Taiwanese into imperial subjects who "dress, eat, and live as Japanese do, speak the Japanese tongue as their own and guard our national spirit in the same ways as do Japanese born in Japan."[7] The inner conflict in official Japanese approaches to assimilation is well expressed by these two officials.

It is also true that the official exhibitions were preceded by several private shows in Taiwan organized by Ishikawa and his Taiwanese students and the creation of at least two private art associations in the 1920s. Moreover, Ishikawa, a watercolor painter of modest reputation trained in the late Meiji period, had previously participated in several official and private exhibitions in Japan and was a member of the Meiji Fine Arts Society. For many years (1910–1916, 1923–1931), he was an art teacher at the Taipei Normal School for Taiwanese youth and, together with Shiozuki, has been credited with redirecting modern art education in the colony and encouraging talented young Taiwanese artists to study at professional art schools in Japan. Ishikawa's many contributions to art education included tak-

ing his students to actual sites for sketching from real life rather than relying on copybooks. Shiozuki, a virtuoso oil painter in the Fauvist style, taught at schools attended mainly by children of resident Japanese families from 1921 to 1945, but he gave private lessons and exercised considerable influence on Taiwanese artists through exhibitions and the wide appeal of his works.

The other two well-known Japanese artists in residence, Gōhara and Kinoshita, both of whom were *nihonga* painters, also promoted training and professional development in Japan. Gōhara, a graduate of the Normal Section of the Tokyo School of Fine Arts (Tokyo Bijutsu Gakkō), arrived in Taiwan in 1917 to begin a teaching career at middle schools in Taichung and Taipei that lasted until 1936. He was much admired for his paintings of landscapes and of flowers and birds. Kinoshita, the only one of the four who did not teach art in Taiwan's schools, made a meager living as a professional painter, also of landscapes and birds and flowers, and remained in Taiwan from 1918 until the end of the Japanese occupation. He had studied in Japan with one of the most famous and prolific artists in Kyoto painting circles, Takeuchi Seihō (1864–1942), who promoted sketching from life. Ishikawa and Shiozuki were thus greatly responsible for bringing Western-style painting or *yōga* (also called *seiyōga*) to Taiwan, and Gōhara and Kinoshita for introducing *nihonga,* which was soon renamed *tōyōga,* or Eastern-style painting, so as not to overly offend the nativist sensibilities of the Taiwanese. In addition, all four Japanese played significant roles as resident jurors for the official exhibitions and sometimes exhibited works themselves.[8]

Encouraged by their Japanese mentors and anxious to improve their skills as painters and to pursue art careers, a small stream of Taiwanese students—perhaps no more than twenty-five and for the most part from well-off gentry families— continued their art training in Japan. Beginning in the mid-1920s, most of them attended the Tokyo School of Fine Arts, but some went to other schools in Tokyo or Kyoto or enrolled in private ateliers. Four of these artists got to Paris for further education in modern art in the early 1930s. In Tokyo, Kyoto, and Paris, they were also introduced to the art world of private shows and official exhibits and were occasionally even selected to show their work.[9] Moreover, official art exhibitions had already been inaugurated in Korea in 1922.[10] Clearly, on both official and private levels and for political and cultural reasons, the Taiwan Exhibition was an idea whose time had arrived.

The exhibitions received intensive publicity in Japanese and Chinese columns from the *Taiwan nichinichi shinpō,* which helps to explain their success in an era before the appearance of private galleries, public art museums, or art schools in Taiwan.[11] One month prior to each opening, it was the practice of this newspaper, the largest in Taiwan, to carry a series of intensive special reports, sometimes as many as twenty-five, on participants and their studios. On the day of the opening (late October), it printed a special issue on the exhibition, covering in full detail all of the activities, comments by the jury, and reviews, all of which were aimed at arousing public interest in the fine arts. After the opening, the newspaper featured

a separate painting every day, accompanied by a poem selected to capture the essence of the work. Moreover, special articles were written to expand public appreciation of the paintings. The exhibitions were analyzed as a whole, as were the strengths and weaknesses of individual paintings.

Public response was gratifying. Ten thousand attended the opening of the first exhibition, held in the auditorium of an elementary school on October 22, 1927. There were more than three thousand visitors at the opening of the fifth Taiten in 1931, a drop in numbers but still an impressive number if the relatively high admission fee for Taiwanese at that time—twenty Japanese sen—is taken into account.[12] Such great effort to teach the public was not equaled by the Taiwanese mass media in the early aftermath of liberation from Japanese rule.

With such coverage, the *Taiwan nichinichi shinpō* assisted in transplanting to Taiwan a Japanese tradition of paying high respect to successful competitors and according high social status to notable artists. Once painters were represented in the Taiwan Exhibition, reporters would swarm around them and write special articles in their honor. Their photographs and paintings would appear in the newspaper, together with critical assessments, thus affecting the public's knowledge and evaluation of painters. In this way, artists represented in the official exhibition would become local celebrities, receiving admiration and high social status—no doubt feeding into their sense of superiority—or even gaining wealth and fame. The possibility of attaining such status and economic rewards motivated a large number of the elite in Taiwan to engage in artistic creation. In fact, the official exhibition was the only channel, prior to the institution of private galleries in postwar Taiwan, for a painter to become well known. Thus, the newspaper contributed much to establishing and promoting the image and authority of the official exhibitions.

Criticism and exhibitions are complementary to each other. Another contribution of the *Taiwan nichinichi shinpō* to the official exhibitions was in publishing art criticism. From the onset, the critiques were competent and over time improved in quantity and quality. At first, only reporters provided commentary, but soon art critics took over the task. Criticism served the functions of interpreting the composition, form, content, and even the symbolic significance of various paintings to the public and helped to elevate the aesthetic appreciation of the viewers as they formed personal judgments. It also provided a forum of discourse among artists, jurors, and critics on such issues as the nature of creativity, artistic thought, and the fundamental meaning of art.

There were two major types of criticism—judgments, sometimes harsh, of individual works, and comments on individual artists. Jurors and art critics alike, and this included Japanese, were in general agreement that painters in Taiwan should not blindly follow the direction of the Imperial Exhibitions in Japan but rather develop their own local themes and subjects and so reflect the cultural context of contemporary life in Taiwan. Only in this way could the spirit of the subject be fully and vividly grasped, explored, and expressed. Critics further believed

that in pursuing local color, painters should focus on natural scenes and daily customs particular to Taiwan, which the painter would then develop through individual interpretation and style. Subject matter would then be imbued with the feelings and sensibilities of the Taiwanese people, or, in the case of a resident or visiting Japanese painters, to the special features of life in Taiwan.

Jurors and Awards at the Taiwan Exhibition, 1927–1936

Seventy years ago, the only channel through which an artist's accomplishments could be recognized in Taiwan was through the official art exhibitions. Winning an award in any of these official art shows was not unlike receiving a certificate for outstanding artistic attainment and was thus of critical importance in the successful development of an artist's career. Their works, once accepted in such exhibitions, might be purchased by governmental institutions or wealthy patrons. The major significance of acceptance lay, however, in official recognition of artistic merit. Like all such competitive exhibitions, the taste of the jurors exerted, in turn, a certain influence on the pictorial styles (and themes) used by those entering the competitions. The role of these jurors therefore deserves close consideration.

Among the jurors for Taiten and Futen, the most prominent were the four resident Japanese artists mentioned above—Ishikawa and Shiozuki in the Western art category and Gōhara and Kinoshita in Eastern art. Shiozuki indeed served in all of the sixteen official exhibitions, and Kinoshita missed only one. Ishikawa was a judge in the first five exhibitions, 1927–1931, then returned to Japan in the spring of 1932. Gōhara was on the scene until 1935. From the second exhibition onward, however, the director of the Tokyo School of Fine Arts was asked to recommend one or two of its professors to serve on the annual juries of the Taiten for both types of painting.[13] Among those who journeyed to Taiwan in this period, the best known *nihonga* painter was Matsubayashi Keigetsu (1876–1973), who first came in 1928–1929 and returned again in 1934 and 1939. Also influential in the early 1930s was Yūki Somei (1875–1957), who was well known for his skill in adapting features from Western art into *nihonga*. In Western oil painting, the first juror to come from Japan in 1928–1929 was Kobayashi Mango (1870–1947), who had studied in Germany, France, and Italy before World War I. Even better known in the 1930s were the painters Umehara Ryūzaburō (1888–1986) and Fujishima Takeji (1867–1943), who served in 1934–1935 and were among the leading Western-style painters of modern Japan.[14]

Of particular interest is the fact that in the sixth, seventh, and eighth exhibitions (1932–1934), three Taiwanese artists were appointed to serve as jurors. At the time of their appointment, they were still quite young—Chen Jin (1907–1997), a *tōyōga* painter conversant with *nihonga* styles, was only twenty-six; as for her two colleagues in the *yōga* category, Liao Jichun (1902–1976) was thirty and Yan Shui-long (1903–1997) was thirty-one. All three had studied in art schools in Japan, and Yan in addition had spent two years in Paris. Beginning with the ninth exhibition,

1935, however, they were excluded from the jury. The reasons for this, contrary to explanations given by some scholars,[15] did not necessarily involve racial or ethnic discrimination by the Japanese. Rather, it is more likely that these three Taiwanese painters were seen by other Taiwanese as too inexperienced to give authoritative judgments. When they were originally selected, they were among the first generation of modern Taiwanese painters, which accounts for their youth. In a culture that honors age, however, youth does not present an aura of authority. Moreover, the artistic attainments of these young Taiwanese painters, though commendable, may not yet have achieved universal recognition. Indeed, the jurors who replaced them in the *yōga* category were the mature and renowned Japanese artists Fujishima and Umehara, whose great fame in Japan certainly brought an indisputable authority of judgment to the Taiwan Exhibition and was helpful in promoting high standards. In the *tōyōga* category, 1935, Araki Jippo (1872–1944) and Kawasaki Shōko (1886–1887), influential *nihonga* artists in official exhibitions in Tokyo, joined resident Japanese artist Gōhara in judging *tōyōga* works (this was the only time Kinoshita did not serve as juror). Recent research also suggests that, behind the scenes, other young Taiwanese artists may have been jealous of the appointment of Yan.[16] Perhaps, too, there was uneasiness among conservative Taiwanese with the public role of Chen Jin, who was the only woman in this early group to attain fame and was still evolving as a *tōyōga*-style painter. Discrimination by Japanese authorities, therefore, may have played only a secondary role in the replacement of the young Taiwanese jurors in the early 1930s. Whatever the final explanation, in November 1934 several Taiwanese artists, mostly *yōga* painters, banded together to form the Taiyang Fine Arts Association (in Japanese, Taiyō Bijitsu Kyōkai), a private venue for the display of modern works. It too held annual exhibits until World War II, utilizing only Taiwanese judges; it helped to raise standards but remained primarily a staging ground for admission to Taiten.[17]

An examination of the number of works selected for the ten Taiwan Exhibitions, 1928 to 1936, is revealing. In the section on *tōyōga*, for example, although roughly the same number of paintings by Japanese and Taiwanese were accepted for exhibition, the Taiwanese painters had a higher ratio of works receiving "Outstanding Awards"—such as the *Taiten* prize, the Taiwan-Japan Award, or the *Asahi* Newspaper award. This suggests that, in fact, the quality of paintings submitted by Taiwanese artists was higher in the view of the judges than those by resident Japanese painters. Both the Taiwanese and Japanese participants ranged from amateur to professional status and included student artists.

In the section devoted to Western-style art, or *yōga*, the number of paintings successfully submitted by Japanese painters was nearly double that of Taiwanese competitors. Again, the Taiwanese, based on the statistics available, consistently received more awards than the Japanese contestants.[18] Nevertheless, the quality of the Taiwanese paintings gradually began to decline after the seventh exhibition in 1933, probably because fewer Taiwanese art students managed to study Western-style painting in Japan or in Paris and tended to be graduates of normal schools in

Taiwan. In part this was a result of a decision by the Tokyo School of Fine Arts, beginning in 1930, to require overseas students to meet the same standards in entry examinations and to test on the same subjects as Japanese aspirants. Previously, as a means to encourage Taiwanese and other Asian students, the school had granted special admission without direct competition with Japanese candidates. This was obviously an advantage, since the Taiwanese hopefuls had less substantial art training available to them at the secondary school level back home. Since this liberal policy evidently lowered academic standards at the Tokyo School, it was canceled. In Taiwan, too, Japanese contestants enjoyed better educational opportunities in the middle and higher schools and at the new University in Taipei, in addition to benefiting from higher economic levels. Along with professional Japanese painters living in Taiwan, there were quite a few gifted Japanese amateurs—students, administrators, businessmen, and physicians—who liked to test their talents in these exhibitions.[19]

Substantially fewer paintings were submitted to the *tōyōga* section, especially after the first three exhibitions of 1927–1929. There are two reasons for this decline. In the first place, paintings in the traditional Chinese manner of ink on paper, depicting such favorite literati subjects as the Four Gentlemen—plum blossom, orchid, chrysanthemum, and bamboo, symbolizing the loftiness of a scholar's integrity—were not eligible. This was a reflection of conscious Japanese cultural policy to discourage the use of traditional Chinese pictorial themes and subjects (the colonial administration in Korea, however, chose not to eliminate traditional art in the official exhibitions held in Seoul). Such painters had to change their style in order even to think of competing. Second, successful painting in the *tōyōga* manner required mastery of techniques that could not be learned easily in a short span of time. An excellent example is the early career of Chen Jin (1907–1997), who came from a prosperous gentry family. Encouraged by Gōhara, her Japanese art teacher in middle school, she went to Tokyo at age nineteen and studied under Yūki Somei and others at the Tokyo Women's Art School from 1925 to 1929. She earned a reputation as one of the "Three Talented Youths" when three of her works were selected for the first official exhibition in 1927. Other paintings by her were accepted in 1928 and 1929. However, her training in *tōyōga* painting (in reality *nihonga*) continued in Japan with Kaburagi Kiyokata (1878–1973), a specialist in painting *bijinga* or beautiful women, in part because one of the visiting jurors from Japan in 1928, Matsubayashi Keigetsu, praised her work but recommended further development. Chen was to gain such proficiency that her works would be accepted in nine official exhibitions in Tokyo, beginning in 1934 with the Imperial Art Exhibition or Teiten.[20] Latecomers of the 1930s did not have the same range of opportunities or come from such wealthy backgrounds. Thus the number of paintings submitted in this category, as well as those selected, gradually decreased. Another factor was the modest exhibition space available in Taipei. In the end, the number of *tōyōga* works selected for exhibition at Taiten was limited to no more than eighty.

By contrast, the Taiwan exhibition maintained a high standard of excellence in the Western or *yōga* category. In the sixth exhibition in 1932, for example, only 68 paintings were selected from a large total of 619 works submitted, while in the eighth exhibition in 1934, 67 were selected from roughly the same number of submissions. Given the fact that in Japan, at the fifteenth Imperial Art Academy exhibition held that same year, where 480 works were chosen for hanging from 2,837 works submitted, it would appear that the Taiten was even more competitive than its model.[21] A comment by painter Wada Sanzō (1883–1967), one of the Japanese members of the 1932 jury in Taipei, confirms this belief: "Compared to the Imperial Art Academy Exhibition in Tokyo, the Taiwan Exhibition is by no means inferior. However, there are fewer outstanding works in the Taiwan Exhibition."[22] It is also important to note that, from the time of the tenth exhibition in 1936 to the successor wartime shows in 1938–1943, individual painters were permitted to enter only one work each, in part to make room for younger or less experienced painters. Such a limitation helps to explain the decrease in the total number of submitted works in both the *yōga* and *tōyōga* categories.

Based on these facts, it appears once again that scholars who claim that the Japanese discriminated in those days against the Taiwanese in the official art exhibitions are wrong. Their statements, perhaps derived from a narrow-minded sense of nationalism, are not supported by the historical data, which indicates, as I mentioned above, that although more Japanese paintings may have been selected for entry into the exhibitions, there were consistently more award-winning artists—in both sections—from Taiwan. It cannot be denied that there were various discriminatory measures taken in the arena of politics, economics, and education, but those problems were reduced to a minimum in cultural matters such as these art exhibitions. Indeed, the promotion of high artistic standards in Taiwan was of benefit both to Taiwanese and Japanese painters. There was no reason to suppress Taiwanese painters with respect to these official exhibitions.

Government Exhibitions, 1938–1943

Because of the escalation of Japan's war with China, following the Marco Polo Bridge Incident in July 1937 the official art exhibitions were temporarily discontinued for one year. In 1938, they were resumed by the government-general of Taiwan and renamed the Fine Arts Exhibition of the Taiwan Government-General, or Futen, as noted earlier. Once again, the post of governor-general was assigned to a high-ranking military official. Although control of the exhibit was more direct and the name elevated to a higher status, the activities carried out were little different from those of the previous system. Six exhibitions were held in this second stage, from 1938 to 1943, and the jurors for all six consisted entirely of Japanese. Eminent painters from Japan took the places of Ishikawa, who had departed permanently for Japan in 1931, and of Gōhara, who left in 1935, but Shiozuki and Kinoshita remained on the scene as jurors in the Western and Japanese styles, respec-

tively, until the last exhibition in 1943. In fact, Shiozuki was the only juror in the Western category in 1943. As before, an examination of the statistics of these six events yields some significant findings.

In the section devoted to *yōga*, Japanese artists began winning more awards than the Taiwanese exhibitors. Two factors account for this phenomenon. In the first place, a new regulation was adopted to encourage new or young artists. Painters who had won frequent awards in previous exhibitions were raised to the "recommended level" and allowed to show their work without the need to compete. Second, there were fewer qualified Taiwanese oil painters available to enter the competitions. As noted, the chief reason for this shift was a change in the admission policy in 1930 at the Tokyo School of Fine Arts, which remained by far the most advanced training center for painters in the Japanese Empire and had also attracted aspiring modern art students from China. Accordingly, there were only three Taiwanese art students enrolled in the school by the end of the 1930s.[23] By then, of course, the Sino-Japanese War had greatly altered student life in Taiwan and in Japan. More and more attention was given to the mobilization of resources in Japan and the colonies for total war.

In the *tōyōga* category, however, Taiwanese artists now outnumbered resident Japanese, both in terms of works submitted for exhibition and awards won. Although the senior Taiwanese painters were allowed to display their works freely —subject to one painting each—they had many younger colleagues who were successful in winning major awards at the wartime Futen. A few of these artists had acquired higher training in Japan, but others reached artistic maturity as students in Taiwan of the senior generation. The ratio of awards certainly encouraged younger Taiwanese artists to work in the *tōyōga* styles in this second period of exhibitions.

In the Futen years as in the previous Taiten period, many more works were submitted in the category of *yōga* than of *tōyōga*, a trend discernible as well in the official exhibitions held in Japan.[24] Since the urge to westernize and modernize had dominated Japanese thinking during much of the Meiji period, beginning in 1868, modern Western culture was regarded as superior in many aspects to Asian culture. During this early stage of Japanese assimilation of modern art, it was no wonder, therefore, that more Japanese painters chose to work in the Western or modern manner. This was also true in Taiwan. In addition, financial and educational status may have played a role in the creation of this phenomenon. Those who worked in *yōga* styles tended to come from wealthier backgrounds than *tōyōga* artists. On the whole, aspiring Taiwanese painters who chose to work in *tōyōga* styles had received only an elementary education; indeed, many of them had originally been what we might term "craft painters" and therefore should be judged as craftsmen or artisans. There were only a few exceptions, such as the previously mentioned Chen Jin.[25] By the 1930s, the early years of Shōwa Japan, a much different atmosphere had come to prevail, one highly conducive to Japanese cultural imperialism and a drive to assimilate so-called lesser colonial peoples into the

higher Japanese culture. At this point, the choice in Taiwan to paint in the style of *tōyōga* might in some cases have been motivated, ironically, by anti-Japanese sentiment, since *tōyōga* contained vestiges of older East Asian motifs and sensibilities.

102

Style and Subject Matter of the Works Shown in Official Exhibitions

Although these official exhibitions lasted only for sixteen years, their influence on the development of the fine arts in Taiwan—in this case painting—was substantial. Not only did the competitions at Taiten and Futen help shape a style of *tōyōga* that possessed important stylistic differences from *nihonga* works created in Japan, they also initiated and encouraged the development of Western-style watercolor and oil painting in Taiwan. On the whole, it can be said that the official exhibitions redirected the fine arts movements in Taiwan away from the Chinese literati tradition into new directions that were Japanese and European oriented.

Nihonga *Section*

Here, at least six major characteristics of note can be discerned in the work of official exhibitors (as illustrated in the accompanying plates).

1. *Shaping* tōyōga *into a Taiwanese Style.* At the time of the first Taiten in 1927, virtually all ink paintings in the traditional Chinese literati style were turned down by the jurors, with the exception of works by the "Three Talented Youths," young Taiwanese artists who were still undergoing initiation into Japanese style painting—Chen Jin and Lin Yushan, then in Japan, and Guo Xuehu in Taiwan.[26] Soon, paintings in the older literati styles were excluded from the official exhibitions altogether. On the other hand, *nihonga*—Japanese painting in the modern style—began to take root in Taiwan and develop both in scope and variety as *tōyōga*. New standards were set at the 1927 Taiten, with landscape works exhibited by Gōhara and Kinoshita. Taiwanese painters subsequently created a style based on careful observation, detailed representation, and a brilliant use of color.[27] An excellent example of theme and color is Lin Yushan's *Lotus Pond* (fourth Taiten, 1930, Plate 1), which represented greater mastery of *tōyōga* painting than his first entry as one of the "Three Youths" in 1927. Lin (1907–), born in the town of Jiayi to a family that owned a traditional picture shop, had begun when very young as a painter in the Chinese literati style and continued art lessons when clerking as a teenager for a Japanese judge who as a part-time monochrome ink painter. After becoming interested in sketching from life, Lin briefly shifted to watercolors and entered the Western Department of the Kawabata School of Painting (Kawabata Gagakkō) in Tokyo (1926–1929); he soon switched back to *nihonga* styles under Yūki Somei and others. In the mid-1930s, he would return to Japan for additional training in Kyoto at the private school of famed *nihonga* painter Dōmoto Inshō (1891–1975). Lin exhib-

ited in all of the Taiten exhibitions and in most of the Futen, winning several prizes.[28]

2. *Developing Local Color.* A closely related characteristic of the new art was the preferred subject matter. Since the beginning of these exhibitions in the late 1920s, both resident Japanese jurors and visiting painters from Japan had encouraged local painters to cultivate themes particular to the Taiwanese environment.[29] Choosing local subject matter derived from daily life in Taiwan was a straightforward way to accomplish this goal. Resident Japanese artists took the lead in producing works permeated with local color, as, for example, Murakami Hideo's *Water Lamps in Jilong* (first Taiten, 1927, Plate 2), a depiction of a popular annual festival. Following these general guidelines, a number of young Taiwanese painters cultivated and explored indigenous subject matter, turning out such striking works as *Sugar Cane,* submitted by Lin Yushan in 1932 (sixth Taiten, Plate 3). In addition, a number of paintings were created that depicted the aboriginal population of the island and were based on expeditions to their mountain villages. On the whole, these pictures were produced by resident Japanese painters who were perhaps sufficiently removed from the subject matter to see its visual potential. A typical picture dealing with aborigines is Akiyama Shunsui's *Hunting for Human Sacrifice* (ninth Taiten, 1935, Plate 4). A work by Miyata Yatarō entitled *Waiting for Customers* (eighth Taiten, 1934, Plate 5) is especially noteworthy, portraying as it does Taiwanese prostitutes sitting in front of a brothel. The painter has succeeded in expressing the women's gloom and desperation, thus capturing the dark side of Taiwanese society under the Japanese Occupation.

It would be too hasty, however, to conclude that paintings of this sort, reflecting either romantic visions or sharp social commentary, merely displayed the oppressive force of colonialism. The use of such subjects was also sanctioned in the official Japanese exhibitions of the time held in Tokyo. In Taiwan, they may of course represent an expression of exoticism felt by these Japanese artists, but on the other hand they may also display a desire to make some kind of factual record or to explore the many facets of this recently acquired "southern territory." For Taiwanese artists, however, they were a form of nativism.

3. *Westernizing* tōyōga. Because of the popularity of painting in the Western fashion, certain devices common to this painting, such as the use of light and shadow, began to find their way into the styles employed by *tōyōga* painters in Taiwan. Miyata Yatarō's *Striking Force of a Mountain Stream* (sixth Taiten, 1932, Plate 6) shows strong Western influences in its arrangement of four female nude figures. The same tendency, of course, could be observed earlier in the evolution of *nihonga* in late Meiji Japan.

4. *Encouraging Works Showing a New Creativity.* Whatever the official preferences, when the jurors came across paintings that were innovative and

somehow different from the conventional submissions, they often rewarded them with a special "Taiwan Exhibition Award." A good example is *Sisters Catching Butterflies,* submitted by Cai Mada (fourth Taiten, 1930, Plate 7). Scholars have remarked that Cai's unusual style was the result of his studies in Beijing rather than in Japan and that he thereby brought a fresh stimulus into the virtually homogeneous range of styles normally seen at the Taiten.[30] Unfortunately, little else is known about this artist, who ceased painting after World War II, perhaps because of the sharp attack on *tōyōga* by newly arriving Nationalist Chinese in retreat from the mainland civil war.

5. *Abandoning "Mere Verisimilitude" in a Search for "Vital Force."* Despite the attention to local color in paintings done in the *tōyōga* style during the early years of modern art activities in Taiwan, many of the works tended to be overcrowded in composition and too brilliant in hue. With the exception of paintings awarded the top prizes, most of the submissions in this category tended to give an impression of vulgarity and, as a result, were highly criticized. Matsubayashi Keigetsu made the following comment when he served as juror for the third Taiten in 1929: "It is quite pleasant to see that most of the works exhibited have taken their subject matter from the Taiwanese environment. However, it is a mistake to pursue verisimilitude alone, which can merely produce something of low artistic value. Rather, one must first digest the form in one's mind. The depiction of nature is a process that moves from the inside to the outside, not from the outside to the inside."[31]

A few years later, in 1932, another eminent *nihonga* painter, Yūki Somei, who served as a juror for the sixth Taiten, commented that "although it is good for paintings in the *nihonga* style to base artistic depiction upon nature itself, the real spirit of *nihonga* can only be fully explored through the study of the works of the masters in this style."[32]

An unsigned critique from the ninth Taiten, October 1935, is particularly noteworthy in stressing masterpieces:

> It is very pleasant indeed to see that the section of paintings in the *nihonga* style shows progress every year. Painters, however, should pay equal attention to technique and knowledge alike. Technique can be improved by painting after nature; here, however, one must move from merely catching the surface realism to grasping the vital force of the object, from a prettiness that is easily understandable to the public to a higher beauty that is lofty and elegant. Knowledge can be accumulated not only by reading books but by looking closely at masterpieces. There are six faults to note in the new Taiwan Exhibition, namely: (1) talking about the importance of changes without making any real changes; (2) creating compositions that are overly complex because the painter puts too much

effort into making his work a tour de force; (3) following the mistaken conception that a work larger in size is higher in quality; there are too few paintings that are small and yet original and pleasant; (4) providing too much decoration; (5) using brushwork that is not learned from a close examination of past masterpieces and the *way* of calligraphy; and (6) following too closely the techniques of paintings in the Western style, despite the fact that artists are working in the style of *nihonga*.[33]

As a result of such comments from jurors and critics, more and more attention came to be paid in the later period of the Taiten and throughout the Futen years to what came to be called the concept of "divine verisimilitude"—that is, to painting that possessed a "vital spirit."

Again, the work of some of the visiting Japanese jurors served as examples of this desirable spirit, and, of course, the increased emphasis on this trait may have reflected wartime propaganda about the Japanese spirit. Interestingly, Taiwanese painters who paid attention to the "vital spirit" argument tended to have studied in Japan. Their technical discipline certainly helped create an art that placed this "vital spirit" into a position of priority. Examples of this movement can be found in Lin Yushan's *Two Water Buffalo* (fourth Futen, 1941, Plate 8) and Chen Jin's *Singing while Pounding the Pestle* (first Futen, 1937, Plate 9), in both cases exhibiting advances beyond their original entries in 1927. These works in the modern *nihonga* style show a simplification in composition, brushwork, and coloration that reveal something of the spirit of *nanga* (Southern School painting) or *bunjinga* (literati painting)—that is, a form of Japanese art in the Tokugawa period that in turn derived inspiration from orthodox literati painters in China.

6. *Moving from Minute Depiction to Exploring the Innovative.* There were some painters entering these exhibitions who sought changes in form, color, and line, and who thus produced works that show great innovations, such as *Winter Sun* by Lin Zhizhu, presented at the fourth Futen, 1941 (Plate 10). The emphasis that Lin placed on the patterns of the tiles in this painting reveals an interest in geometric formation and structure. In addition, the simplified conception of perspective and composition is quite striking. Lin (1917–), who was from a large landowning family near Taizhong, went to primary and middle school in Japan, then followed his older brother in the mid-1930s to the Eastern Department of the Imperial School of Fine Arts (Teikoku Bijutsu Gakkō), predecessor of today's Musashino Art College. He then entered the private painting studio of Kodama Kibō (1898–1971) in 1940 to perfect his skills.[34] His ability to compete and win prizes at Taiten was of great encouragement to younger Taiwanese artists of the second generation.

Yōga *Section*

When the Japanese began to study Western painting in the late nineteenth century, they were able to digest the Western styles, by and large, through two major approaches. The first involved the nationalization of subject matter—that is, the employment of the Western visual manner and style to depict the folklore, customs, social and environmental features, and landscapes that were indigenous to Japan. Representative modern Japanese painters who followed this approach included Asai Chū (1856–1907), Ishii Hakutei (1882–1958), Yorozu Tetsugorō (1885–1992), and Kishida Ryūsei (1891–1929). Other artists, however, proposed that Japanese painters should digest the various styles of the Western schools as a prelude to developing individual styles congenial both to their personal tastes and to the national prestige. This second approach can be seen in the work of such fine painters as Umehara Ryūzaburō, Yasui Sōtarō (1888–1955), and Hayashi Takeshi (1896–1975). In the aftermath of World War I, when Taiwanese painters were first learning modern art through Japanese filters, the styles developed by Umehara and Yasui would come to dominate the creation of *yōga* painting in Japan.[35] Given this general trend, it is easy to comprehend why the visiting Japanese jurors advised Taiwanese painters entering the local official exhibitions to devote themselves to creating local color and individual style as embodiments of their own personal tastes.

Five observations can be made about Western-style painting or *yōga* in Taiwan during this period of Japanese occupation.

1. *Relations between Art Styles in Taiwan and in Japan.* Since most of the Taiwanese painters who won awards at Taiten and Futen had studied at art schools and academies in Tokyo or Kyoto, their works echoed what they had absorbed there. Those who studied at the Tokyo School of Fine Arts in the late twenties and early thirties painted for the most part in a style that fell somewhere between Impressionism and Postimpressionsim. This is a trend that can be seen in the work of such famous first-generation oil painters as Yan Shuilong (*Miss K,* seventh Taiten, 1933, Plate 11); and Li Meishu (*Girl at Rest,* first-place prize, ninth Taiten, 1935, Plate 12). Yan (1903–1997), who came from a poor family in southwestern Taiwan, began earning a living as an elementary schoolteacher after graduation from normal school. A Japanese colleague noted his talent and encouraged him to study in Japan. Yan spent most of the 1920s in Tokyo, where he worked at various odd jobs and trained at the Tokyo School of Fine Arts from 1924 to 1929 under Fujishima Takeji. He then made his way to Paris, where he stayed from 1929 to 1932, one of four Taiwanese artists known to have studied or exhibited there. Though displaced as one of the young Taiwanese jurors in 1935, Yan continued to exhibit but also took up a strong interest in local handicrafts.[36] Li Meishu (1902–1983), born to a well-off farming family in Sanzia Village near Taipei, began learning Western-style drawing in fifth grade classes taught by

a Japanese art instructor. Years later, after taking a summer art course in watercolors with Ishikawa and contrary to the wishes of his parents, he entered the Tokyo School of Fine Arts in 1928, having already exhibited at the first Taiten. He worked with Okada Saburōsuke, did well, and graduated eighth in his class in 1934. The government-general bought his 1934 and 1935 entries and helped make him famous.[37] A third artist who painted in a similar style was Li Shiqiao. His *Pearl Necklace* (ninth Taiten, 1935, Plate 13) was purchased by the Taiwan government-general, as was another entry in 1936. Li (1908–1995), whose family of rice farmers was wealthy but not overly supportive of his art interests, had worked with Ishikawa at the Taipei Normal School. In Japan he took drawing lessons and finally gained entry to the Tokyo School of Fine Arts (1932–1936)—after twice failing the entrance examination—and became adept at figure painting. Following graduation, Li alternated between Tokyo and Taipei, exhibiting in official and private shows and earning a good income by making portraits of rich landlords in Taiwan. He apparently did not return permanently to Taiwan until 1943.[38]

Other painters who had graduated from the Tokyo School of Fine Arts in the late 1920s or early 1930s made use of academic styles that ventured into Postimpressionism, Fauvism, and even Expressionism. An early painting by Chen Zhiqi (1906–1931), *Seashore* (which won a special prize at the first Taiten, 1927, Plate 14), reveals a strong Expressionist flavor, especially in the bold deformation of the rocks. Chen was especially beloved by his peers in this pioneer period, and he enjoyed moral support from both Ishikawa and Shiozuki for study in Japan when he was expelled from the Taipei Normal School for student activism in the mid-1920s. He entered the Tokyo School of Fine Arts in 1925 after a short period in the private studio of Okada Saburōsuke, as well as the studio of Yoshimura Yoshimatsu (1886–1965), who befriended and taught several Taiwanese students.[39]

Works by prolific oil painter Chen Chengbo, such as *Longshan Temple* (second Taiten, 1928, Plate 15), and by Liao Jichun, *Girl Holding a Bamboo Basket* (fourth Taiten, 1930, Plate 16), also fall into this category. Chen (1895–1947) was another first-generation artist from the town of Jiayi. He too had learned watercolors from Ishikawa at the Taipei Normal School and for several years worked as a schoolteacher. His subsequent training at the Tokyo School of Fine Arts from 1924 to 1929 was followed by residence in Shanghai (1929–1933), where he taught calligraphy to make a living. His many successful entries to Taiten lovingly celebrated the surrounding scenery and town life of his place of birth. Long after his death in 1947, his paintings of local scenes would come to command huge figures during a back-to-the-roots nostalgia movement in Taiwanese culture in the 1970s and 1980s.[40]

Liao (1902–1976), who was to gain a reputation as one of the finest of

the first generation of oil painters, came from a poor background in central Taiwan and had to take an elementary schoolteaching job after graduation from Taipei Normal School. Part-time jobs were necessary to finance his years at the Tokyo School of Fine Arts (1924–1927). He exhibited successfully at the first Taiten, winning prizes in 1930 and 1931, and continued throughout the 1930s to show works both in Japan and in Taiwan.[41]

In contrast to Taiwanese who studied academic styles at the Tokyo School of Fine Arts, others who entered private schools or worked in ateliers in Japan produced works that often showed more originality. From the outset, the paintings of these artists moved into the realm of Postimpressionism or Fauvism. Such modern painters as Yang Sanlang (1906–1995), Hong Ruilin (1911–1996), and Liu Qixiang (1908–1995) belong in this category. This approach is well represented by Yang's *Early Spring in Paris* (seventh Taiten, 1933, Plate 17), Hong's *Motherhood* (tenth Taiten, 1936, Plate 18), and Liu Qixiang's *Young Man with Violin* (fifth Taiten, 1931, special selection, Plate 19). The brushwork and coloration of these three works tend to suggest tense emotion. Yang had spent seven years in Kyoto during the 1920s, training at the Kansai Art Academy (Kansai Bijutsuin) and the Kyoto Municipal Special School of Painting (Kyoto Shiritsu Kaiga Senmon Gakkō). He then decided in 1932 to make the journey to Paris, where he copied paintings in the Louvre and participated in the Autumn Salon. Upon returning to Taiwan in 1934, he was a cofounder of the Taiyang Fine Arts Association in 1934 and gained a reputation as Taiwan's leading oil painter.[42]

Hong, a native of Taipei, had first learned ink painting and calligraphy from his father but later fell under the influence of Ishikawa at a private painting academy in Taipei in 1927. This led him to Tokyo in the late 1920s to study briefly at the Kawabata Painting School, followed by the Imperial School of Fine Arts from 1931 to 1936. He was influenced by the proletarian movement in Japan, and his paintings from student days include one of a Tokyo slum. After returning home, he took a permanent job in a coal mine and would later gain considerable fame for his many paintings of coal miners.[43]

Liu, a precocious child whose rich family sent him to a private Japanese higher school (Aoyama Gakuin) in the early 1920s, entered the Western Department of the newly established Culture Academy (Bunka Gakuin) in Tokyo in 1927. There he studied with such famous artists as Arishima Ikuma and Yamashita Shintarō and displayed with the Second Division Society (Nikakai), a nonofficial showcase for talent favored by Arishima, as well as earning special mention in Taiten in both 1930 and 1931. After graduation in 1931, he too went off to Paris, remaining three years and exhibiting at the Autumn Salon. In 1935, Liu settled in Tokyo, married a Japanese woman, and exhibited mainly in Japan. He returned to Taiwan after World War II, making his postwar career in his birth city of Tainan and founding the Southern Taiwan Art Exhibition.[44]

Compared with the more or less homogeneous style presented in the works created by Taiwanese painters, resident Japanese artists who entered these basically conservative official exhibitions showed more diversity and provide us with a rich example of Japanese colonial or *gaichi* art. In addition to representing such styles as Impressionism, Fauvism, and Expressionism, they also created works that might be considered as semiabstract, or as belonging in the category of Surrealism. Moreover, many of these works maintained a rather high quality. For example, Shiozuki Tōho, as teacher, juror, and exhibitor, chose styles that varied in accordance with his subject matter. In *Composition III* (fifth Taiten, 1931, Plate 20), the black tonalities he created were much imbued with the kind of semiabstract idiom found in Kandinsky's early "color symphony" paintings, whereas his painting of *Woman* (seventh Taiten, 1933, Plate 21), expressed profound insight into the thought and emotion of the subject and suggested Rouault. The creation of work of this type may well have been influenced by the strong colors used by Umehara Ryūzaburō, some of whose major works were displayed in Taiwan. In terms of experimentation, Natsuaki Kokuji's *Transitory Feeling* (Plate 22), displayed in the same 1931 show as Shiozuki's *Composition III,* shows a combination of lyricism and cubist rigor rarely seen in these basically conservative official shows.[45]

2. *Local Color and Individuality.* As seen in the previous examples of *tōyōga* art, Japanese painters living in Taiwan initiated the depiction of scenes and customs indigenous to Taiwan. This trend can be seen as well in painters of *yōga,* and many good works were produced. Ishikawa, for example, contributed a watercolor, *Suburbs of Xinzhu,* to the third Taiten, 1929 (Plate 23). An outstanding example at the same exhibition is Shiozuki's *Fire Sacrifice* (Plate 24), another of his oil paintings depicting the life of aborigines. This picture was revered as a masterpiece among all the works shown in the various Taiwan exhibitions. In such paintings, the artists attempted to represent Taiwanese subject matter in compositional modes that were individually conceived. Resident Japanese competitors painted a wide variety of scenes, ranging from houses by the sea and workers engaged in tea processing to rural chicken huts and renderings of fish from the surrounding seas.

There were also a number of successful works in oil by Taiwanese artists that embraced local color. Two of best were Chen Zhiqi's *Banana Planation* (third Taiten, 1929, Plate 25) and Chen Qingfen's *Garden Manor of Lin Ben-yuan* (ninth Taiten, 1935, Plate 26), which won a special award. Chen Zhiqi's early death in 1931, following an illness contracted on a journey to an exhibition in Japan, was widely mourned; Ishikawa was chief among his eulogists. Chen Qingfen (1911–), born in Taipei, had gone to Japan for schooling when very young and, immediately following his graduation from the Tokyo School of Fine Arts in 1928, spent five years in France, where he entered a studio and took a strong interest in Parisian settings.[46]

As seen in all of these works, the one characteristic that best describes

the official exhibitions in Taiwan for both categories, *nihonga* and *yōga*, is local color.

3. *A Merging of East and West.* Some of the *yōga* painters assimilated the brush-work techniques and compositional concepts of the *tōyōga* painters, adroitly merging the two. The works of Chen Chengbo, already noted as a versatile painter of the first generation, were the most successful in taking this approach. The results can be seen in his *Tiger Hill in Suchou* (fourth Taiten, 1930, Plate 27). Critics have noted that Chen's Western-style works embodied ideas from traditional Chinese landscape painting, a unique approach that caused much attention and praise in his day.[47]

4. *Receptiveness to Extraordinary Works.* In any art exhibition sponsored by official agents, the submitted and selected works tend to fit into stereotypical patterns. Such was the case in Taiwan, but an occasional work of individuality appeared, and, more often than not, the artist was rewarded. In the third Taiten in 1929, for example, a work was displayed that was extraordinary both in terms of subject matter and style: Ren Ruiyao's *Balcony* (Plate 28). The vitality of the work is well expressed both through the postures of the two figures and the tonal changes in the composition, which possess an unusual sense of rhythm. The appreciative jurors gave Ren a "special selection" award. Ren (dates unknown) is another painter who has not been heard from since World War II.

5. *Differences between Japanese and Taiwanese Painters.* As we look back over these sixteen exhibitions, certain differences between the Japanese and the Taiwanese painters become apparent. The Taiwanese placed greater emphasis on the perfection of technique and the aesthetic charm of forms and shapes. In contrast, although amateur Japanese painters were often inferior to the Taiwanese in mastery of technique, they were more devoted—professionals and amateurs alike—to exploring problems of humanity and to making social statements with their works. As colonial masters, of course, they were perhaps somewhat freer to do so. Their paintings of prostitution, gambling, or other similar local scenes not only depicted the problems of society but expressed inward exploration and reflections on issues of human dignity.

The prime example is Shiozuki's *The Mother* (sixth Taiten, 1932, Plate 29). On the surface, it was simply a portrayal of an aboriginal woman and her two children. Viewers in fact knew that it was depicting them as survivors of the Musha Rebellion, a brutal five-month annihilation campaign in retaliation for a massacre by aborigines of over one hundred Japanese. The Japanese victims had been attending dedication ceremonies for a government building in a mountain village, Musha (Wushe in Chinese), in October 1929, when set upon by aborigines. Units of the Japanese army and air force, which were rushed to the scene when island police were unable to contain the uprising, are said to have used machine guns, artillery, planes, and allegedly even poison gas to rout the aborigines, killing almost five hundred in the process. Subsequent investigation turned up information of

Japanese police abuse and discrimination, though the full story was not made public at the time. Shiozuki's painting, done in Fauvist tones of red, not only alludes to the brutal side of Japan's occupation but also shows a desire in the consciousness of the artist to protest such miseries.[48] The first generation of Taiwanese painters, on the other hand, seemed to pursue an "aestheticism" within their ivory towers. Seldom did they venture forth, at least in the official exhibitions, to seek to create serious and passionate explorations on the moral issues of life.[49]

War-Related Subject Matter in the Government Exhibitions

The six Futen (1938–1943) were held under the shadow of total war with China and the outbreak of World War II in the Pacific and East Asia. The Taiwanese population grew close to 5,700,000 in 1940, with over 346,000 Japanese in residence. During this critical period, Japan reverted to military governors in Taiwan and accelerated the Kōminka movement—the forced transformation of Taiwanese into loyal subjects of the emperor. All Chinese-language publications were banned in 1937 as efforts were made to spread the use of Japanese.[50] Some Taiwanese painters chose Japanese names or volunteered for war-related labor service.[51] The art exhibitions were continued by the government-general as a forum for patriotism as well as artistic attainment, although painting supplies had to be rationed. Accordingly, a large number of works containing war themes and painted by both Japanese and Taiwanese artists began to appear in the exhibitions. Basically, these wartime works can be divided into four types.

1. *Depictions of Life in the War Zone.* At first, only a few paintings depicted actual battles or life on the front lines in China or in Southeast Asia. This was primarily because most of the painters in Taiwan had no firsthand experience of battle. War came directly to the Taiwan home front late in the hostilities in the form of American bombings in 1944. Prior to that time, Taiwan's participation in the Sino-Japanese War and World War II took the form of either economic contributions or voluntary and forced labor. Military participation was instituted in 1943—but through volunteer units, not conscription. Then too, some artists in Taiwan were not skilled in figure painting, an essential ingredient in representing battle themes.

 Examples of early war painting include Akiyama Shunsui's *Soldiers in Mainland China* (exhibited at the first Futen, 1938, Plate 30), a work in the *tōyōga* style. A later example is Chen Jinghui's *Inspecting the Knapsack* (fifth Futen, 1942, Plate 31). Curiously, Chen (1901–1968), a Taiwanese painter also in the *tōyōga* manner, produced more paintings of this type than any of the other artists active at the time, including resident Japanese. He had been adopted in the 1920s by a Japanese family and had studied at the Kyoto Municipal School of Arts and Crafts and the Kyoto Municipal Special School of Painting before returning in 1932 to teach in Danshui. Later, he took the

Japanese name of Nakamura Yoshiteru.[52] Apart from war themes, an earlier painting of his, *On the Way* (seventh Taiten, 1933, Plate 32), which received the Taiwan-Japan Award, reveals a delicate arrangement of design through the postures and expressions of the five young girls.

2. *Depictions of Increased Productivity.* The most numerous type of paintings depicted increased productivity for use on the fighting front or embodied propaganda suitable for intensifying the fighting spirit of soldiers. Chen Jing-hui produced many *tōyōga* works of this kind as well, including *Water* (sixth Futen, 1943, Plate 33). A work by Weng Kunde, *Platform of a Railway Station* (first Futen, 1938, Plate 34), shows a scene typical of its time, with numerous bystanders waving rising sun flags. Weng, by the way, went to China after the war and was never heard of again. Some artists even chose animals to reflect an awareness of war, as can be seen in a *tōyōga* work by Lin Yushan that utilized dogs: *Waiting for a Command* (second Futen, 1939, Plate 35).

3. *Depictions of Local Scenes in Newly Occupied Japanese Territories.* With Japanese expansion into much of eastern China during the Sino-Japanese War, followed by Southeast Asia and Indonesia early in the Pacific War, paintings began to appear that focused on the scenery and daily life of these areas. Tokuhisa Tokuharu's *Impressions of Central China* (third Futen, 1940, Plate 36) and Mizuya Munemitsu's painting of *Houses in Malaysia* (fifth Futen, 1942, Plate 37) illustrate the variety of styles and subject matter chosen by resident Japanese participants.

4. *Depictions of Ostensibly War-Related Themes.* Some works were given war-related titles even though unrelated to war. In view of the wartime atmosphere, paintings related to the war were strongly promoted by the colonial government. Many artists, if they were to paint at all or to acquire scarce painting materials, found it necessary to accommodate to this pressure even when they harbored personal reservations. Among numerous examples of works that, despite their titles, showed little relation to war or war themes, Iida Takao's *Envisioning the Southern Mutual Co-Prosperity Sphere* (fourth Futen, 1941, Plate 38) serves as a telling example. It simply represents people in a novel setting and has no specifically indigenous southern motif. Another painting, this one by a Taiwanese, is Guo Xuehu's *Guarding the Rear of the Frontline* (first Futen, 1938, Plate 39). Guo, initially an artist in the traditional Chinese manner, was one of the first to seriously pursue painting in the *tōyōga* style in Taiwan. In the beginning, self-taught and a successful exhibitor in the first Taiten, he began consulting Gōhara in 1929 and became a frequent visitor to Japan in the 1930s for further study of *nihonga*. A prizewinner at all of the official shows in Taiwan, he painted and exhibited in mainland China and Hong Kong in 1941–1942 and was among those who took a Japanese name. After 1945, perhaps as a result of negative reaction to his brand of art by the new Nationalist rulers of Taiwan, he moved to Japan and eventually to the United States.[53]

Conclusion

These sixteen official exhibitions, Taiten and Futen, held during the second half of the almost fifty years of Japanese occupation—from 1927 to 1943, with a one-year break in 1937—not only brought about the creation of a group of artists proficient in *tōyōga* styles but established the Western styles of *yōga* painting in Taiwan as well. These exhibitions undeniably mark an important milestone in the history of the visual arts in Taiwan. It is my sincere hope that further and more detailed studies of this period can be made, both by myself and by other scholars.

I should like to point out briefly as a final observation that these official exhibitions also fostered the work of the first generation of Taiwanese *yōga* painters, bestowing upon them a real authority that carried over to the early postwar years. After World War II, when Taiwan was liberated from Japanese control and Chinese Nationalists first came from the mainland to Taiwan, it was this first generation that assumed the task of educating a new generation of modern artists in Taiwan. They did this by resuming the practice of official exhibitions in 1946 (this time called Shengzhan, or Provincial Exhibitions, and sponsored by the Nationalist government), and also by serving as exhibitors and judges at these shows and monopolizing teaching posts in academic art departments.[54]

Tōyōga artists like Chen Jin exhibited, too, in this early phase of liberation from 1947 to 1950, but the category was renamed *guohua,* or national painting. With the arrival of the Nationalists (1945–1949) as the new rulers of Taiwan, painters in the *tōyōga* manner were treated differently from those who worked in oil. Their output was looked upon both by the new Chinese officials and by refugee or exiled painters from China as emblems of national shame. Denounced as "Japanese paintings" and misunderstood or unappreciated as art, *tōyōga* was cast outside the parameters, as Chinese-style art came to be favored in exhibitions after the early 1950s. As Sinification replaced Japanization in the lives of postcolonial Taiwanese (Mandarin Chinese quickly became the official language), *tōyōga* painters lost the artistic and social status they had once possessed during the years of Japanese occupation. Lin Yushan, one of the best known of the pre-1945 *tōyōga* artists, changed to Chinese styles and managed to survive as a prominent painter. Only in the 1970s and 1980s, when assumptions were questioned, taboos lifted, and modern Taiwanese history and culture reexamined, would former *tōyōga* artists like Chen Jin be acceptable again, but under the new label of *jiao caihua,* or acrylic paintings. In a few university art departments, *tōyōga* styles would be taught once again.[55]

In *yōga,* there were proportionately few artists active in the 1950s and after who had thoroughly mastered Western-style oil painting or who had been trained in Japanese art academies. One of the best of the senior group, Chen Chengbo, who became a local official in newly liberated Taiwan, was executed during the February 1947 Uprising when Nationalist troops may have killed as many as twenty thousand Taiwanese during their violent takeover of the island.[56] In protest, another prominent senior *yōga* artist, Li Shiqiao, withdrew his newly com-

pleted painting, *Construction* (Plate 40), a work indicating a release of energy and hope, from the second Provincial Exhibition, substituting a lesser one and displaying only irregularly in the 1950s.[57] Accordingly, the remaining *yōga* painters of the first generation retained their authority long into the postwar period, and as a result, Western-style painting in Taiwan became extremely conservative. In fact, these artists merely continued after the war to practice the same kind of "aestheticism" they maintained during the Japanese occupation of the island. Even to the 1990s, their attitudes still exerted an impact on many painters in contemporary Taiwan, although seriously challenged by younger artists born in Taiwan or in mainland China. In addition, without the presence of the kind of Japanese painters who visited, worked, or taught in Taiwan during the Occupation era, the first generation of Western-style painters for many years faced no serious outside artistic competition or stimulus. Most of these painters made no progress. Their artistic apogee, ironically, can best be seen in the works they created for the official art exhibitions sponsored and promoted by the Japanese colonial government.

Notes

Editors' Note: The editors are extremely grateful to Dr. David Teh-yu Wang, independent art historian (Silver Spring, Maryland), for his translation of Professor Wang's essay and for providing additional information based on his own research and publication. Only information that is known about the paintings illustrated here has been provided. The present whereabouts of the majority of these paintings remains unknown. Most of the illustrations have been reproduced from photographs in the original exhibition catalogues, where no dimensions or information on provenance were given.

1. For traditional-style painting in Taiwan before the Japanese occupation, see *Taiwan meishu sanbainian zhan* (Three Hundred Years of Fine Arts in Taiwan) (Taipei: Fine Arts Museum, 1990); also Wang Yaoting (Wang Yao-t'ing), "From Fukien Style to Life-Drawing: An Aesthetic View on a Stage in the Development of Taiwanese Ink Painting," in *Eastern Aesthetics and Modern Arts Conference Treatise* (Taipei: Fine Arts Museum, 1992), 123–153 (in Chinese, with English synopses).

2. Introductory work on early modern painting in Taiwan (covering both *yōga* and *nihonga* styles) was undertaken in the 1970s by painter and social critic, Xie Lifa (Hsieh Li-fa), in a series of essays for the art magazine *Yishujia* (Artist). These were subsequently published in book format as *Riju shidai Taiwan meishu yundongshi* (History of Fine Arts Movements in Taiwan during the Japanese Occupation) (Taipei: Yishujia Chubanshe, 1979 (3rd ed., 1992). For a synopsis in English, see introduction to Xie (as Hsieh Li-fa), *The Taiwanese Painting in the Twentieth Century* (Long Beach, CA.: Oriental Healing Institute, 1983). In June 1985, *Yishujia* published a convenient set of one hundred illustrations of twentieth-century Taiwanese paintings and sculpture, much of it pre-1945; this signified the intensification of scholarly efforts to study Taiwan's art and culture and reflected the growth of Taiwanese consciousness, culminating in the end of martial law in 1987 and the founding of political parties. In 1989, art historian Yan Juanying (Yen Chuan-ying) published a three-part series, "Taiwan zaoqi xiyang meishu de fazhan" (Development of Western-Style Art in Taiwan), in *Yishujia* 168–170 (May–July 1989). See also her essay, "The Art Move-

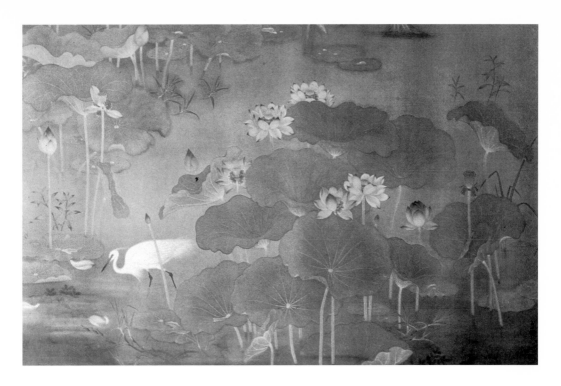

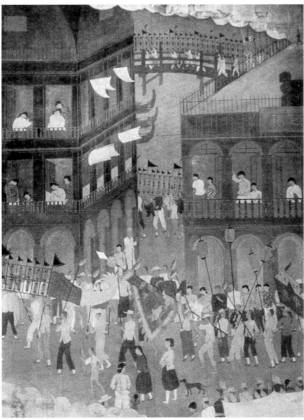

Plate 1. *(Top)* Lin Yushan, *Lotus Pond,* 1930. Glue, pigments on silk. 147.5 cm x 215 cm. National Taiwan Museum of Fine Arts.

Plate 2. *(Left)* Murakami Hideo, *Water Lamps in Jilong,* 1927. Glue, pigments on silk.

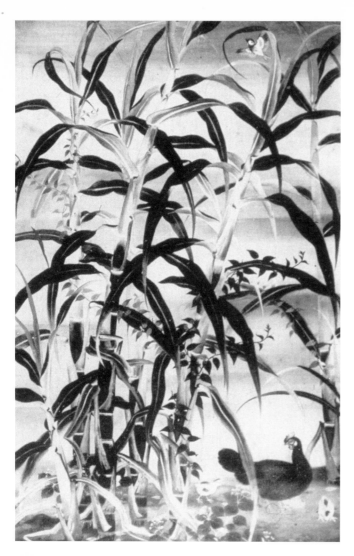

Plate 3. *(Left)* Lin Yushan, *Sugar Cane,* 1932. Glue, pigments on silk.

Plate 4. *(Below)* Akiyama Shunsui, *Hunting for Human Sacrifice,* 1935. Glue, pigments on silk.

(Opposite page)

Plate 5. *(Top)* Miyata Yatarō, *Waiting for Customers,* 1934. Glue, pigments on silk.

Plate 6. *(Bottom)* Miyata Yatarō, *Striking Force of a Mountain Stream,* 1932. Glue, pigments on silk.

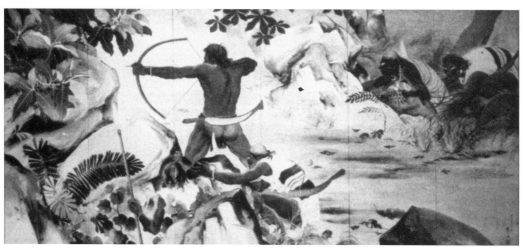

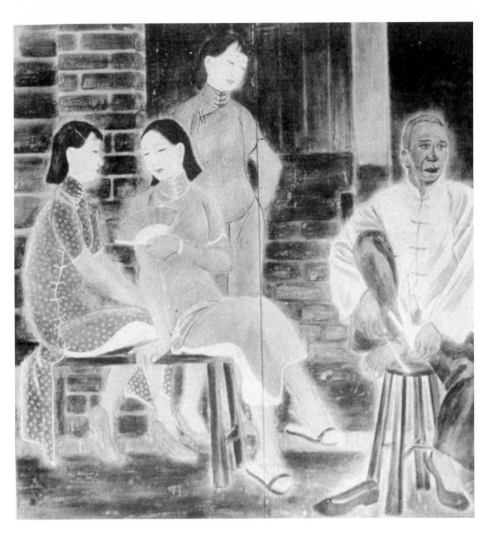

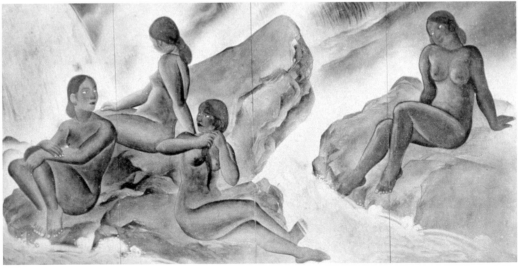

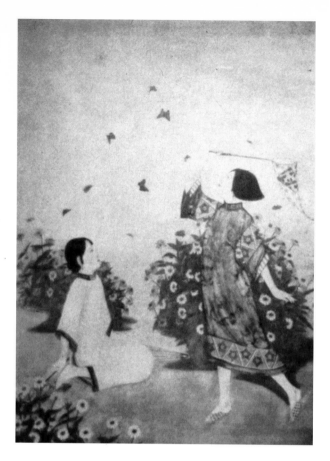

Plate 7. *(Left)* Cai Mada, *Sisters Catching Butterflies,* 1930. Glue, pigments on silk.

Plate 8. *(Below)* Lin Yushan, *Two Water Buffalo,* 1941. Glue, pigments on silk. 134.5 cm x 174 cm. Collection of the artist's family.

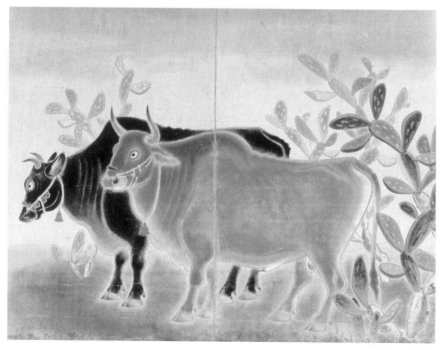

Plate 9. *(Top)* Chen Jin, *Singing while Pounding the Pestle,* 1937. Glue, pigments on silk. Collection of the artist.

Plate 10. *(Left)* Lin Zhizhu, *Winter Sun,* 1941. Glue, pigments on silk. 147 cm x 141 cm. Private collection.

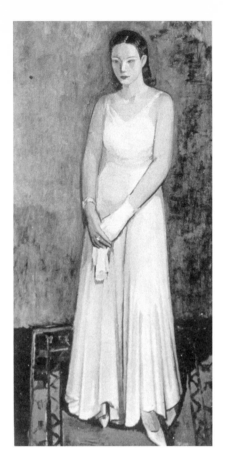

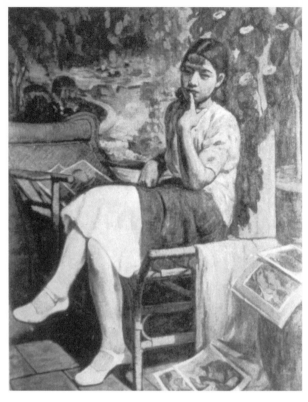

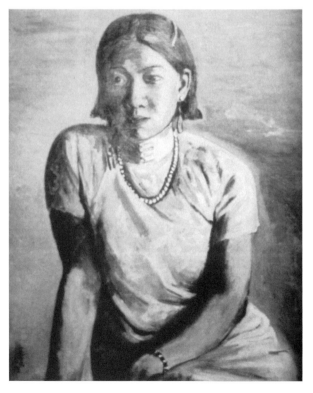

Plate 11. *(Top left)* Yan Shuilong, *Miss K.,* 1933. Oil on canvas.

Plate 12. *(Top right)* Li Meishu, *Girl at Rest,* 1935. 162 x 130 cm. Collection of the artist's family.

Plate 13. *(Right)* Li Shiqiao, *Pearl Necklace,* 1935. Oil on canvas.

(Opposite page)

Plate 14. *(Top)* Chen Zhiqi, *Seashore,* 1927. Oil on canvas.

Plate 15. *(Bottom)* Chen Chenbo, *Longshan Temple,* 1928.

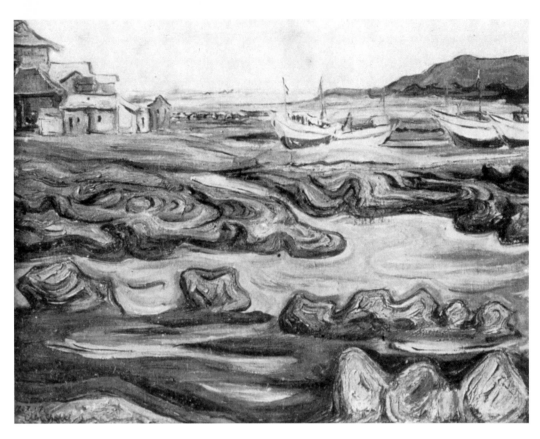

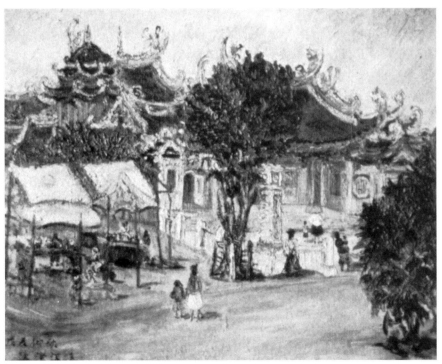

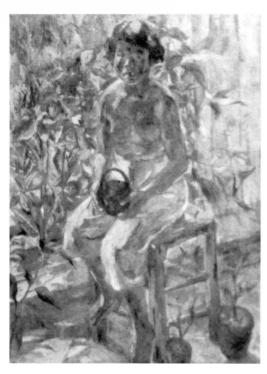

Plate 16. *(Left)* Liao Jichun, *Girl Holding a Bamboo Basket,* 1930. Oil on canvas.

Plate 17. *(Below)* Yang Sanlang, *Early Spring in Paris,* 1933. Oil on canvas.

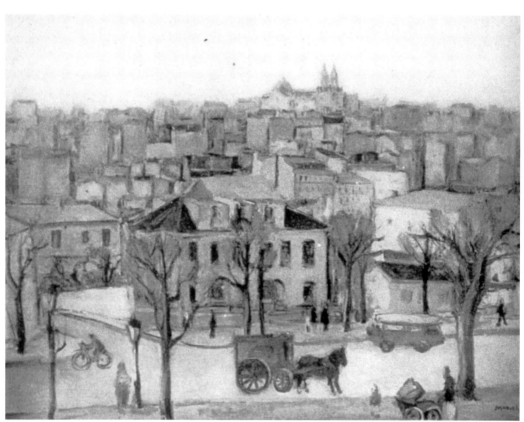

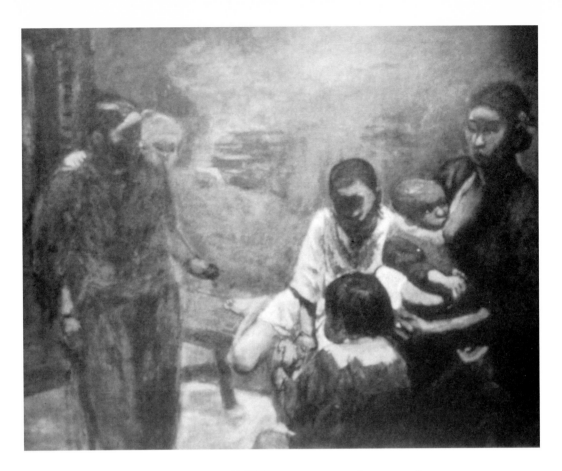

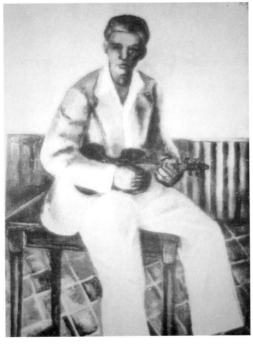

Plate 18. *(Top)* Hong Ruilin,
Motherhood, 1936. Oil on canvas.

Plate 19. *(Left)* Liu Qixiang,
Young Man with Violin, 1931.
Oil on canvas.

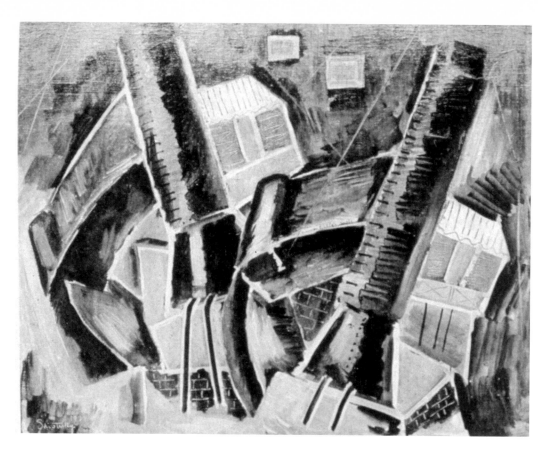

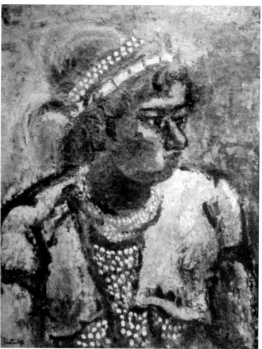

Plate 20. *(Top)* Shiozuki Tōho,
Composition III, 1931. Oil on canvas.

Plate 21. *(Left)* Shiozuki Tōho,
Woman, 1933. Oil on canvas.

(Opposite page)

Plate 22. *(Top)* Natsuaki Kokuji,
Transitory Feeling, 1931. Oil on canvas.

Plate 23. *(Bottom)* Ishikawa Kin'ichirō,
Suburbs of Xinzhu, 1929. Watercolor
on paper.

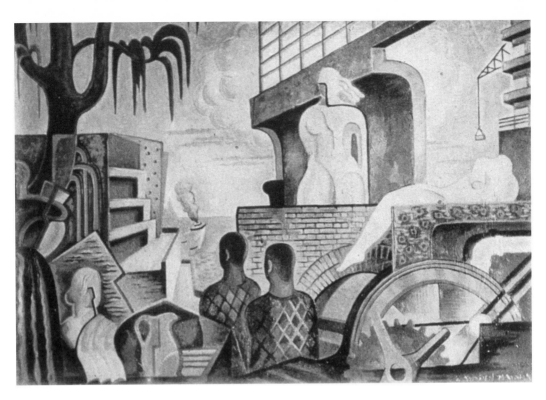

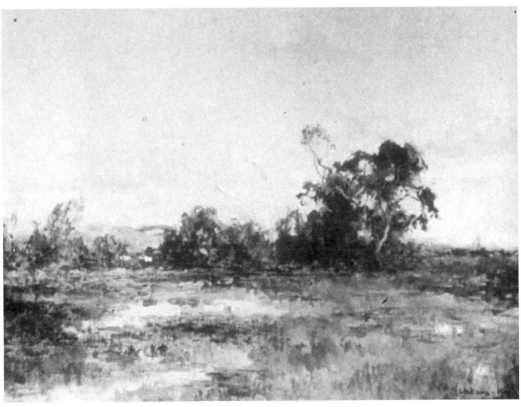

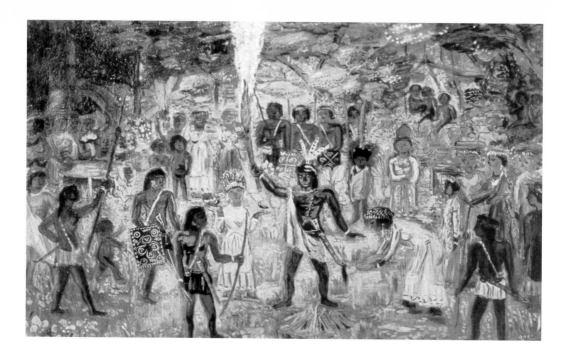

Plate 24. *(Top)*
Shiozuki Tōho,
Fire Sacrifice, 1929.
Oil on canvas.

Plate 25. *(Right)*
Chen Zhiqi, *Banana
Plantation*, 1929.
Oil on canvas.

(Opposite page)

Plate 26. *(Top)* Chen Qingfen, *Garden
Manor of Lin Benyuan*, 1935. Oil on canvas.

Plate 27. *(Bottom)* Chen Chengbo,
Tiger Hill at Suchou, 1930. Oil on canvas.

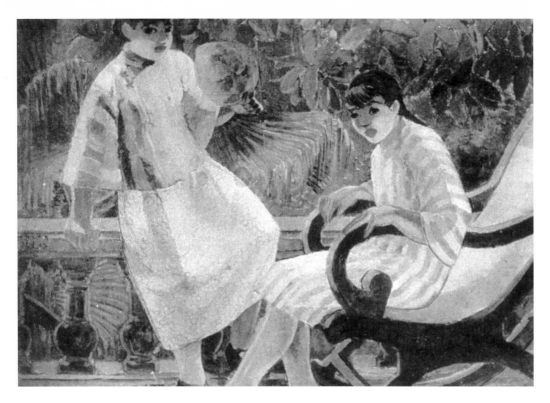

Plate 28. *(Top)* Ren Ruiyao, *Balcony*, 1929. Glue, pigments on silk.

Plate 29. *(Right)* Shiozuki Tōho, *The Mother*, 1932. Oil on canvas.

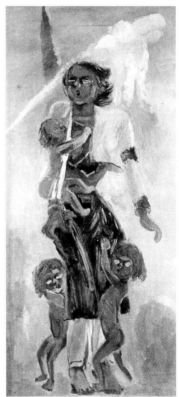

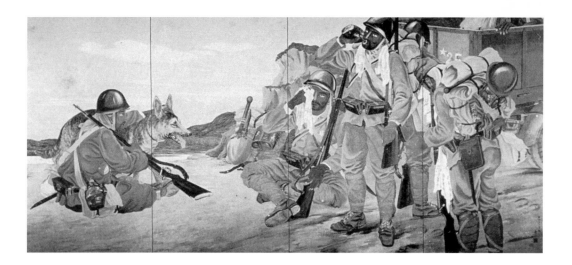

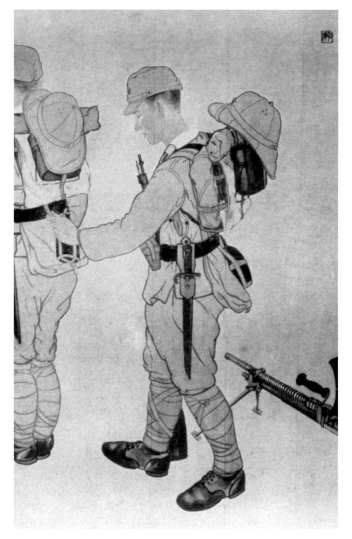

Plate 30. *(Top)* Akiyama Shunsui,
Soldiers in Mainland China, 1938.
Glue, pigments on silk.

Plate 31. *(Left)* Chen Jinghui,
Inspecting the Knapsack, 1942.
Glue, pigments on silk.

Plate 32. *(Top)* Chen Jinghui, *On the Way*, 1933. Glue, pigments on silk.

Plate 33. *(Right)* Chen Jinghui, *Water*, 1943. Glue, pigments on silk.

(Opposite page)

Plate 34. *(Top)* Weng Kunde, *Platform of a Railway Station*, 1938. Glue, pigments on silk.

Plate 35. *(Bottom)* Lin Yushan, *Waiting for a Command*, 1939. Glue, pigments on silk.

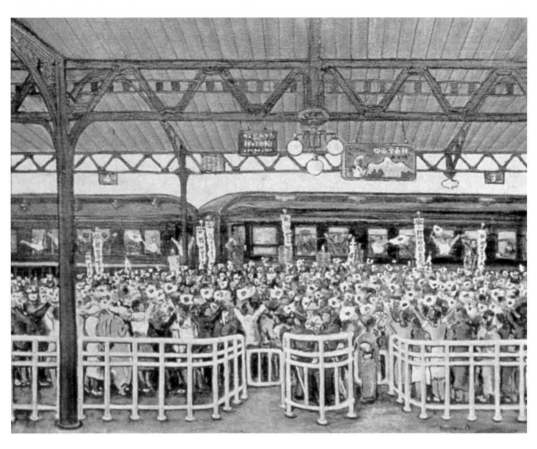

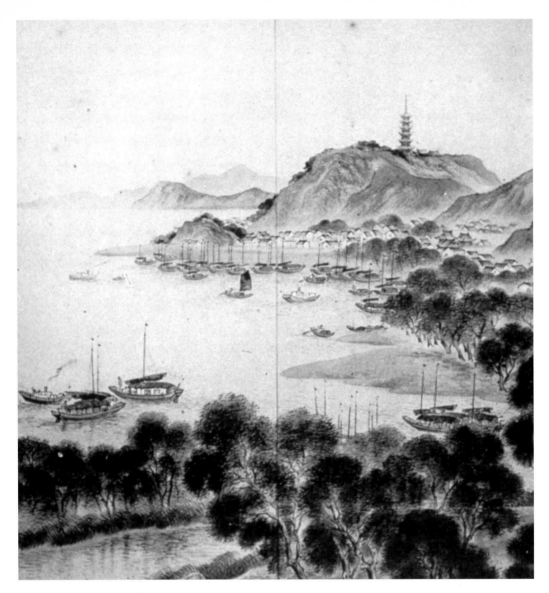

Plate 36. Tokuhisa Tokuharu,
Impressions of Central China, 1940.
Glue, pigments on silk.

(Opposite page)

Plate 37. *(Top)* Mizuya Munemitsu,
Houses in Malaysia, 1942. Glue,
pigments on silk.

Plate 38. *(Bottom)* Iida Takao, *Envision-ing the Southern Mutual Co-Prosperity
Sphere,* 1941. Oil on canvas.

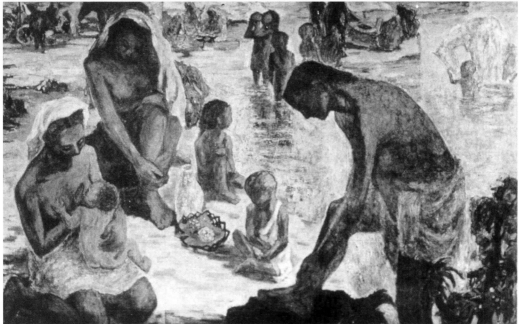

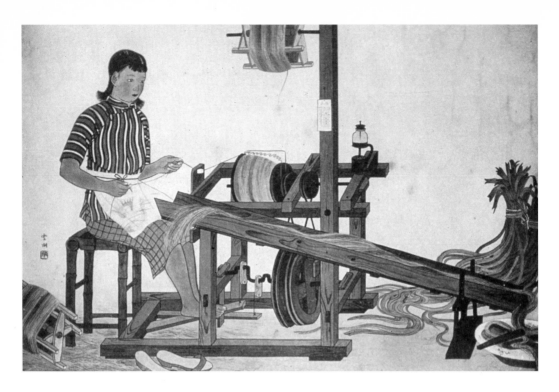

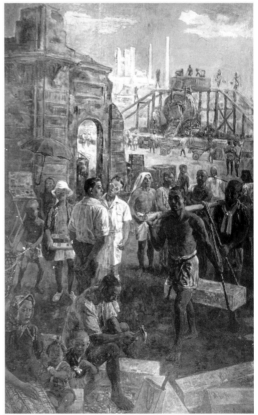

Plate 39. *(Top)* Guo Xuehu, *Guarding the Rear of the Frontline,* 1938. Glue, pigments on silk.

Plate 40. *(Right)* Li Shiqiao, *Construction,* 1947. Oil on canvas. 216 cm x 162 cm. Collection of the artist's family.

ment in the 1930s in Taiwan," in *Modernity in Modern Asian Art,* ed. by John Clark (Broadway, Australia: Wild Peony Press, 1993), 45–59. For the first studies of this subject by a Western scholar (based primarily on secondary sources—especially Xie—and catalogue illustrations), see John Clark, "Taiwanese Painting under the Japanese Occupation," *Journal of Oriental Studies* 25:1 (1987), 63–105; and "Taiwanese Painting and Europe: The Direct and Indirect Relations," in Yu-ming Shaw (ed.), *China and Europe in the Twentieth Century* (Taipei: Institute of International Relations, 1988), 43–60. Michael Sullivan provides brief comments on Taiwan's pre–World War II period in his "Art in Taiwan," in *Art and Artists of Twentieth Century China* (Berkeley: University of California Press, 1996), 178–181.

3. Edward I-te Chen surveys Japan's administrative and legal control of Taiwan in "Japanese Colonialism in Korea and Formosa: A Comparison of the Systems of Political Control," *Harvard Journal of Asiatic Studies* 30 (1970), 126–158; and more recently in "The Attempt to Integrate the Empire: Legal Perspectives," in Ramon Myers and Mark Peattie (eds.), *The Japanese Colonial Empire, 1895–1945* (Princeton, NJ: Princeton University Press, 1984), 240–274. Mid-1920s population estimates are based on E. Patricia Tsurumi, *Japanese Colonial Education in Taiwan, 1895–1945* (Cambridge: Harvard University Press, 1977), 127, 280 (n. 43).

4. See essays by Ellen P. Conant, "'Bunten,' A National Forum, 1907–1918," and J. Thomas Rimer, "'Taiten' and After, 1919–1935," in Ellen P. Conant (ed.), *Nihonga, Transcending the Past: Japanese-Style Painting, 1868–1968* (Tokyo: Japan Foundation; St. Louis: Washington University Art Museum, 1995); also Tanaka Atsushi, "'Bunten' and the Government-Sponsored Exhibitions (Kanten)," ibid., 96–97. In Japanese, see Nippon Bunka Cho, *Waga kuni no bunka to bunka gyōsei* (Our Country and the Administration of Its Culture) (Tokyo: 1988), 131–132.

5. Wang Baiyuan (Wang Pai-yuan), *Taiwan sheng tongzhi kao* (History of Taiwan Province) (Taipei: Taiwan sheng wenxian weiyuan hui, 1958), 26. Also Xie, *Riju shidai Taiwan meishu yundongshi,* 86; and Yen Juanying, "Taiwan zaoqi xiyang meishu de fazhan," *Yishujia* 168 (May 1989), 160.

6. See "Taiwan zhanglan huihao" (Special Issue on the Taiwan Art Exhibition), *Taiwan nichinichi shinpō,* October 28 1927, sec. 4. Also "Kyōikukai shusai daiichikai Taiwan bitenkai no shiki" (Opening of the First Taiwan Art Exhibition Held by the Board of Education), ibid, sec. 6.

7. Tsurumi, *Colonial Education in Taiwan,* 108, 109, 278 (n. 3), 279 (n. 8).

8. Among specialized articles, see: Xu Wuyong, "Shiozuki Tōho yu ziyoushuyi sixiang" (Shiozuki Tōho and Liberal Thought), *Yishujia* (January 1976); also Nakamura Giichi, "Shiozuki Tōho ron: aru chihōgaku no unmei" (Discussion of Shiozuki Tōho: Certain Local Movements), *Miyazaki-ken chihōshi kenkyū kiyo* (Bulletin of Local History Research in Miyazaki Prefecture) 10 (1983); also Nakamura Giichi, "Ishikawa Kin'ichirō to Shiozuki Tōho: Nihon kindai ni okeru shokuminchi bijutsu no mondai" (Ishikawa Kin'ichirō and Shiozuki Tōho: The Problem of Colonial Art in Modern Japan), *Kyoto Kyōiku Daigaku Kiyō* (Bulletin of Kyoto Education University) A/76 (March 1990), 177–193. Japanese art teachers and artists have attracted considerable attention from art historians. Comments on Ishikawa and Shiozuki appear with illustrations in *Taiwan zaoqi xiyang meishu huiguzhan* (Retrospective Exhibition of Early Western Art in Taiwan) (Taipei: Fine Arts Museum 1990), 126–135.

For resident Japanese *nihonga* artists, see Liao Jinyuan (Liao Chin Yuan), "Kindai *Nihonga* no Taiwan: Kinoshita Seigai (1887–1988) o tzushite" (The Transplantation of

Nihonga into Taiwan: Through the Japanese Painter Kinoshita Seigai), *Bigaku* (Aesthetics) 40:4 (Spring 1996), 37–48; and Li Jinfa (Li Chin-fa), *Riju shiqi Taiwan dongyanghua fazhan zhi yanjiu* (*Tōyōga* Painting in Taiwan during the Japanese Occupation) (Taipei: Fine Arts Museum, 1993), 139–148. Xue deals briefly with Kinoshita and Gōhara in *Riju shidai Taiwan meishu yundongshi,* 87–91.

9. For a list of Taiwanese art students in the Western Art Department at the Tokyo School of Fine Arts (1910s to 1930s), see catalogue, *Taiwan zaoqi xiyang meishu huiguzhan* (The Retrospective Exhibition of Early Western Art in Taiwan) (Taipei: Taipei Fine Arts Museum), 173; their major professors are listed on p. 178. Yoshida Chizuko outlines the organization and training at the school in "The Tokyo School of Fine Arts," in Conant (ed.), *Nihonga* (St. Louis), 86–87. E. Patricia Tsurumi provides a comparative overview of higher education at home and in Japan (which, however, omits the fine arts) in "Colonial Education in Korea and Taiwan," in Myers and Peattie (eds.), 275–311. A very small number, twenty to thirty—or less than 1 percent among approximately twenty-four hundred Taiwanese students in Japan in the mid-1920s—were at art schools; most were in medical, engineering, and business curricula (Clark, "Taiwanese Painting under the Japanese Occupation," 63). Clark briefly deals with three of the four Taiwanese art students who went to Paris in "Taiwanese Painting and Europe," 44–48.

10. Kim Youngna, "Modern Korean Painting and Sculpture," in John Clark, *Modernity in Asia Art,* 155–168. It should also be mentioned that traditional and modern Chinese artists staged a joint national exhibition in Shanghai in 1919; after the Guomintang (Nationalist Party) reunited China, the first official National Art Exhibition was held in Shanghai in 1929 under the Ministry of Education but was repeated only at four-year intervals (Sullivan, *Art and Artists of Twentieth Century China,* 58–59). For the beginnings of modern Taiwanese sculpture, see Wang Hsiu-hsiung, *Taiwan diyiwei jindai diaosujia: Huang Tushui de shengya yu yishu* (The First Modern Sculptor of Taiwan: The Life and Art of Huang Tushui/Huang Tu-shui), Taiwan Fine Arts Series 19 (Taipei: Yishujia Chubanshe, 1996). Each of the volumes in this series contains a Chinese-language introduction, with summaries in English and Japanese.

11. However, Chinese-language publications were banned in Taiwan after the outbreak of total war between China and Japan following the Marco Polo Bridge Incident in July 1937; George H. Kerr, *Formosa: Licensed Revolution and the Home Rule Movement, 1895–1945* (University of Hawai'i Press, 1974), 182.

12. Attendance figures for the opening days, 1927 and 1932, are based on accounts in *Taiwan nichinichi shinpō.* Each of the sixteen exhibitions was accompanied by a catalogue. Although these have not yet been reprinted, partial sets are available at the National Library in Taiwan (Taipei) and in the possession of first-generation painter Lin Yushan; when put together, the two sources make a complete set.

13. See *Taiwan nichinichi shinpō,* September 3, 1928.

14. For lists of resident and visiting Japanese judges in both categories, 1927–1943, see Wang Xiuxiong, "Riju shidai Taiwan guanzhan de fazhan yu fangke taishu: jianlun qi beihou de dazhong chanbo yu yishu piping" (The Development of the Official Art Exhibition in Taiwan During the Japanese Occupation: A Study also on Style, Mass Media, and Art Criticism; reprinted), one of a collection of five essays by Wang in *Taiwan meishu fazhan shilun* (A Discussion of the Historical Development of Taiwan's Art) (Taipei: National Museum of History, 1995), 64–65. Also reproduced in Kuo Jisheng (Jason Kuo), ed., *Taiwan shijue wenhua* (Visual Culture in Taiwan) (Taipei: Yishujia Chubanshe, 1995).

15. For example, Xie Lifa, *Riju shidai Taiwan meishu yundongshi* (1979 edition), 122; Yan Juanying, "Taiwan zaoqi xiyang meishu de fazhan," *Yishujia* (July 1989), 178.

16. Art historian Yan Juanying further suggests, based on an interview decades later with oil painter Yang Sanlang, that the proposed ban by other Taiwanese painters against the young jurors was in part a protest against Yan Shuilong, who had spent nine years in Japan and four in Paris but was an infrequent exhibitor at Taiten. Despite his youth, Yan had nevertheless been recommended as a juror by Shiozuki; "The Art Movement in Taiwan in the 1930s," 52, 54. On the other hand, Yan Shuilong was proficient in *yōga,* and jealousy did not prevent his appointment in late 1934 to the jury board of the newly created private art association, Taiyang. Its exhibits, exclusively of Western-style paintings, were held in May, starting in 1935. Under the rules of the official exhibitions, Taiten and Futen (held in October), only works not previously exhibited could be submitted.

17. Ibid., 55–57.

18. For tables comparing the number of entries and prizes won by Taiwanese and by resident Japanese in both categories, see Wang Xiuxiong, "Development of the Official Art Exhibition in Taiwan," 73, 78.

19. In addition to professional Japanese *nihonga* painters who entered the first exhibition, there were several gifted amateurs, such as the son of the director of the Imperial Hospital in Taipei. For the most part, however, little is known about the resident Japanese participants, professional or otherwise, in either category of the subsequent official exhibitions.

20. A recent study illustrating the process by which Chen Jin mastered *nihonga* techniques and styles is Shi Shouqian (Shih Shou-Chien), *Chen Jin* (Ch'en Chin), Taiwan Fine Arts Series 2 (Taipei: Yishujia Chubanshe, 1992). More popular as a text but nicely illustrated is Dian Lijing (Tien Li-ching), *Guihxiu, shidai: Chen Jin* (Gentlewoman, Period: Chen Jin) (Taipei: Xiangshi Tushe, 1993). The other two "young artists" in 1927 were Lin Yushan and Guo Xueshu (see below). All three would enjoy highly successful careers at the official exhibitions.

21. Table, Wang Xiuxiong, "Development of the Official Art Exhibition in Taiwan," 75.

22. *Taiwan nichinichi shinpō,* October 14, 1928.

23. Also in the 1930s, another promising first-generation oil painter who trained at the Tokyo School of Fine Arts, Guo Bochuan (1890–1974), became an art teacher in Beijing and did not return until after the war; Clark, "Taiwanese Painting under the Japanese Occupation," 92. Still another early graduate, Liu Jintang (1894–1937), took various teaching positions in China, including at the National Beijing School of Fine Arts and never returned to Taiwan; *Liu Jintang bainian jinianzhu* (Liu Jintang Centennial Memorial Exhibition) (Taipei: Taipei Fine Arts Museum, 1994).

24. Table, Wang Xiuxiong, "Development of the Official Art Exhibition in Taiwan," p. 78.

25. Yan Juanying, "The Art Movement in the 1930s in Taiwan," also points out that few Taiwanese painters competing in the *tōyōga* division had formal art education abroad (53). Another exception was Chen Jinghui (see below).

26. Guo, a self-taught ink painter, submitted, for example, a work in 1928 known as *Mt. Yuan* (site of the Sōtokufu headquarters) and purchased at a high price by the colonial government, even before he began consulting Gōhara in Taiwan (1929) and before the first of his many visits to Japan (1931). See Lin Boting (Lin Po-t'ing), Chinese introduction, *Guo Xhuhe* (Kuo Hsueh-hu), Taiwan Fine Arts Series 9 (Taipei: Yishujia Chubanshe, 1993).

As indicated, Chinese professional painters or craftsmen who wished to compete in Taiwan's official exhibitions, such as Guo's teacher, Cai Xuexi (1884–?), had to change their styles and did so. In Korea's official exhibits, however, Chinese ink styles persisted, together with more heavily influenced *nihonga* painting in the *tōyōga* category; for several years, calligraphy was exhibited in a third category. See Kim, "Modern Korean Painting and Sculpture," 157–158; also Nakamura Giichi, "Teiten, Senten, and Taiten," in *Retrospective Exhibition of Early Western Art in Taiwan*, 20–21.

27. For the emergence of *nihonga* styles in Japan, see Conant (ed.), *Nihonga;* and Lawrence Smith, *Nihonga: Japanese Painting, 1900–1940* (London: British Museum Press, 1991). For recent scholarship on the evolution of *tōyōga* styles in colonial Taiwan, see Lin Boting (Lin Po-t'ing), "Taiwan Dongyanghua de fazhan yu Tai-Fuzhan" (The Development of Tōyōga-Style Painting as seen in the Taiten and Futen Exhibitions), in Guo Jizheng (Jason C. Kuo), ed., *Dangdai Taiwan huihua wenxuan, 1945–1990* (Selected Essays on Contemporary Painting in Taiwan, 1945–1990) (Taipei: Xiongshi Tushe, 1991), 56–94; and Lin Jinfa, *Rizhu shiqi Taiwan Dongyanghua*. Also, Jason Kuo, "Art and Cultural Politics: *Nihonga / Tōyōga / Chiao-tsai-hua* in Taiwan, 1895–1983," in *Postwar Taiwan in Historical Perspective*, ed. by Chun Chieh-Huang (University of Maryland Press, 1997), 220–234.

28. Lin Yushan's development is illustrated in Wang Yaoding (Wang Yao-t'ing), *Lin Yushan* (Lin Yü-shan), Taiwan Fine Arts Series 3 (Taipei: Yishujia Chubanshe, 1992). For illustrations of Gōhara's triptych, *Southern Fragrance* (first Taiten, 1927) and Kinoshita's *Panorama of New Lofty Mountain* (first Futen, 1938), see Wang, "The Development of the Official Art Exhibition," 109 (Fig. 8) and 115 (Fig. 20).

29. By way of contrast, traditional painters who came from mainland China to Taiwan after World War II, even after living in Taiwan for more than four decades, mostly still depict subject matter that can only be seen in mainland China.

30. *Taiwan nichinichi shinpō*, October 28, 1930.

31. Ibid., November 13, 1929.

32. Ibid., October 21, 1932.

33. Ibid., October 26, 1935.

34. Clark on Lin Zhizhu, "Taiwanese Painting under the Japanese Occupation," 99; Ni Zhaolong (Li Chao-lung), "Introduction," *Lin Zhizhu* (Lin Chih-chu), Taiwan Fine Arts Series 20 (Taipei: Yishujia Chubanshe, 1998).

35. For trends in late Meiji art, see Frederick Baekeland, *Imperial Japan: The Art of the Meiji Era (1868–1912)* (Ithaca, NY: Herbert F. Johnson Museum of Art, Cornell University, 1980), and Harada Minoru, *Meiji Western Painting* (New York: Weatherhill, 1974). For illustrated biographies of Umehara and Yasui, with special emphasis on their training in Europe, see Takashina Shūji et al. (eds.), exhibition catalogue, *Paris in Japan: The Japanese Encounter with European Painting* (Tokyo: Japan Foundation; St. Louis: Washington University Gallery of Art, 1987).

36. Biographical data in Zhuang Sue (Chuang Su-o), "Introduction," *Yan Shuilong* (Yen Shui-lung), Taiwan Fine Arts Series 6 (Taipei: Yishujia Chubanshe, 1992).

37. Wang Jingdai (Wang Ching-tai), *Li Meishu* (Li Mei-shu), Taiwan Fine Arts Series 5 (Taipei: Yishujia Chubanshe, 1992).

38. "Introduction," David Teh-yu Wang, *Li Shiqiao* (Li Shih-ch'iao), Taiwan Fine Arts Series 8 (Taipei: Yishujia Chubanshe, 1993). Also see the article in the popular press by Liu Jian (Leu Chien-ni), "A Painter for All Seasons," *Free China Review* (February 1993), 66–77.

Although Li's painting, *Reclining Nude,* intended for private showing at the second Taiyang exhibition in 1936, was rejected by the jury as pornographic, nudes in fact were successfully exhibited from time to time at Taiten by Taiwanese artists. In 1975, Li's painting of nudes, *Three Graces,* was banned by the Nationalist Government (David Wang, 38).

39. Ye Sifen (Yeh Ssu-fen), "Introduction," *Chen Zhiqi* (Ch'en Chih-ch'i), Taiwan Fine Arts Series 14 (Taipei: Yishujia Chubanshe, 1995). Also see the study, with English summary, by Yan Juanying, "Painting Taiwan: A Stylistic Reading of Chen Zhiqi," in exhibition catalogue, *Chen Zhiqi* (Taipei: Taipei Fine Arts Museum, 1995), 10–14.

40. Yan Juanying (Yen Chuan-ying), "Introduction," *Chen Chengbo* (Ch'en Ch'eng-po), Taiwan Fine Arts Series 1 (Taipei: Yishujia Chubanshe, 1992); and *Chen Chengpo bainian jinianzhan* (Chen Cheng-po Centennial Memorial Exhibition) (Taipei: Li Meishu Museum, 1994). Also see an illustrated popular article by Wang Feiyun (Wang Fei-yun), "Nostalgia in Oils," *Free China Review* (March 1996), 63–73.

41. "Introduction," Lin Xingyue (Lin Hsing-yueh), *Liao Jichun* (Liao Chi-ch'un), Taiwan Fine Arts Series 4 (Taipei: Yishujia Chubanshe, 1992); Clark, "Taiwanese Painting under Japanese Occupation," 98.

42. Lin Baoyao (Lin Pao-yao), *Yang Sanlang* (Yang San-lang) Taiwan Fine Arts Series 7 (Taipei: Yishujia Chubanshe, 1998). For art schools in Kyoto, see Sakakibara Yoshio, "The Kyoto Prefecture Painting School and the Kyoto Municipal Special School of Painting," Conant (ed.), *Nihonga,* 84–85.

43. Jiang Xun (Chiang Hsun), *Hong Ruilin* (Hung Jui-lin) Taiwan Fine Arts Series 12 (Taipei: Yishujia Chubanshe, 1993; Clark, "Taiwanese Painting under the Japanese Occupation," 95.

44. For Liu Qixiang, see Yan Juanying (Yen Chuang-ying), *Liu Qixiang* (Liu Ch'i-hsiang), Taiwan Fine Arts Series 11 (Taipei: Yishujia Chubanshe, 1993). A third category of Taiwanese oil painters included those who had graduated from the Taipei Normal School or had studied privately with Ishikawa. These artists either closely followed the example of their Japanese teacher or the styles of returned Taiwanese painters who had managed to study in Japan (see table, *Retrospective Exhibition of Early Western Art in Taiwan,* 174).

45. Also of interest is a surrealist work by resident Japanese artist Yamashita Takeo, *Breakdown of the Solitary* (first Futen, 1938), which won a special award (Wang Xiuxiong, "Development of the Official Art Exhibition," 120, Plate 36). Such painting stood out as conspicuously different in the midst of the other works shown in these basically conservative exhibitions.

46. Ye, Chen Zhiqi, 59. For Chen Qingfen, see *Retrospective Exhibition of Early Western Art in Taiwan,* 86; and Xie Lifa, *The Taiwanese Painting in the Twentieth Century,* Biographies, 140.

47. Lin Boting, "Taiwan Dongyanghua de fazhan yu Tai-Fuzhan," 78.

48. Yan Juanying, "The Art Movement in Taiwan in the 1930s," 51–52; Kerr, *Formosa: Licensed Revolution,* 151–155; and Dai Guohui, *Taiwan* (Tokyo: Iwanami Shoten, 1993), 77–79.

49. Yan Juanying observes that creative writers in Taiwan were ahead of painters in expressing cultural nationalism under colonial rule ("Art Movement in Taiwan," 48–49). Some effort was made by the Mouve Society (Action Society), founded in Taiwan in 1938, to reflect avant-garde trends in Japan and Europe; Clark, "Taiwanese Painting under Japanese Occupation," 69.

50. For brief accounts of the Pacific War and Taiwan, see Kerr, *Formosa: Licensed Revolution,* 189–202. Also, Tsurumi, *Japanese Colonial Education in Taiwan,* 167–132, including population estimates, 131, 280 (n. 43).

51. For example, Chen Qingfen changed to Tanaka Seifun, Liao Jichun to Akinaga Keishun, and Lin Zhizhu to Hayashi Rinnosuke. Nevertheless, they must still be regarded as Taiwanese painters. There were some other Taiwanese painters who took Japanese names, but their number was limited and does not influence the statistics.

52. Clark, "Taiwanese Painting under the Japanese Occupation," 92.

53. Lin Boting, *Guo Xuehe,* Chinese introduction. With Japanese expansion into much of eastern China during the Sino-Japanese War, followed by Southeast Asia and Indonesia early in the Pacific War, paintings began to appear that focused on the scenery and daily life of these areas. Good examples are Tokuhisa Tokuharu's *Impressions of Central China* (third Futen, 1940) and Mizuya Munemitsu's *Houses in Malaysia* (fifth Futen, 1942); Wang Xiuxiong, "Development of the Official Art Exhibition," 128, Figs. 60 and 61.

54. Wang Hsiu-hsiung, "The Influences of Conservative and Authoritarian Practices of the First-Generation Taiwanese Western-Style Painters in Postwar Taiwan" (Chinese text), in *Taiwan meishu fazhan shilun,* 131–198. For the post-1945 provincial exhibitions and postcolonial Taiwan, see Jason Kuo, "After the Empire: Chinese Painters of the Postwar Generation in Taiwan," in Clark, *Modernity in Modern Asian Art,* 105–127. Also see Martha Su Fu, "Chinese Painting in Taiwan," in Mayching Kuo (ed.), 196–204.

55. See Shi, *Chen Jin,* for illustrations of the artist's postwar acrylic painting, 1970s to 1991 (Taiwan Fine Arts Series 2, 101–192).

56. Lai Tse-han, Ramon H. Myers, and Wei Wou, *A Tragic Beginning: The Taiwan Uprising of February 28, 1947* (Stanford: Stanford University Press, 1991). As recollected by Chen's son, his father was executed, together with other members of the town council, by a Nationalist Army firing squad in front of the Jiayi Station, the morning of March 25, 1947 (Yan Juanying, Chinese introduction, *Chen Chengbo,* Taiwan Fine Arts Series 1).

57. For Li Shiqiao's postcolonial politics and early postwar works, see David Teh-yu Wang, *Li Shiqiao.* As Wang also illustrates (107), in later years Li painted a caricature of Nationalist leader General Jiang Jieshi (Chiang Kai-shek). For a popular tribute, see Liu, "A Painter for All Seasons."

Artistic Trends in Korean Painting
during the 1930s

Youngna Kim

THE LAST TWO OR THREE DECADES of the nineteenth century in China, Japan, and Korea can be characterized as a period of turmoil, foreign aggression, and rapid transformation to modernization as the region became a battleground for power struggles among technologically advanced Western countries. Against this tide of Western intrusion, China, Japan, and Korea reacted quite differently. While China could not effectively block foreign exploitation, Japan reorganized its political and economic systems, modeling them after modern European nations, and soon emerged as the dominant power in East Asia. Korea knew little of what was going on outside, and, insisting upon the preservation of its culture against the Western barbarians, was unable to escape the aggression of neighboring Japan, which successfully forced China and Russia to give up their rights in Korea and finally annexed Korea in 1910.

The thirty-five years of colonial rule, which lasted until the end of World War II in August 1945, were painful to Koreans, who had prided themselves as cultural mentors to Japan for centuries. As an act of imperialist subjugation, Japan argued that Koreans were incompetent and unable to transform their country into a modern nation. By emphasizing the difference before and after colonization, Japan claimed that it had brought progress to the Korean economy and society.[1] In fact, Japan projected itself as a self-appointed purveyor of Western modernization to the colonized, thereby aligning itself with the Western powers. Despite its claim, Japan was not intent upon producing highly cultivated people in Korea, for it considered Korea as merely a stepping-stone for further aggression to China.[2] The only university in Seoul, Kyŏngsŏng (Keijō) Imperial University, which subsequently became Seoul National University after independence, was primarily designed to educate Japanese residents in Korea, and only one-third of the stu-

dents were Koreans.[3] Koreans were permitted to run several private colleges, but students who aspired to higher or professional education and had wealth to afford it went to Japan, primarily Tokyo, where discrimination was less evident. In 1931, for instance, 3,639 Korean students were enrolled in schools in Japan.[4] Many from this group of overseas Korean students later became the leaders of intellectual activities in Korea, with two conflicting results. On the positive side, they brought back home modern currents of thought and a new culture, while on the negative side they received Japanese versions of Western culture, which inevitably allowed an infusion of Japanese influence into the Korean intellectual world. Thus, this first phase of the modern period in Korea is generally characterized by gradual westernization under Japanese influence.

Art was no exception, especially since there was no formal art school in Korea until Korea gained independence. It has been said that Japanese Governor-General Saitō Makoto (1858–1936) attempted to establish professional art and music academies in the 1920s as part of the enlightenment policy but was discouraged due to a lack of funds. More likely this was an empty promise and is highly questionable.[5] For Koreans interested in learning modern art, it was possible to acquire rudimentary skills at private art classes that were operated by individuals or by small groups. It was during the decade beginning in 1910 that the first generation of Korean painters wishing to take up Western-style art left for Tokyo to learn the techniques and aesthetics of oil painting.[6] And these painters, after returning to Korea, taught students at various private art studios or institutions. Beginning in the 1930s, more and more artists went to Japan for formal training, actively participating in group exhibitions not only in Tokyo but also in Seoul, as they could travel back and forth between the two cities easily.

In many respects, the 1930s represent a decade in which Western-style painting in Korea had already passed through an imitative technique-learning stage and was ready to embark upon the creation of new and various kinds of artistic ideas and expressions. But before this new art could blossom, Japan conquered Manchuria in 1931–1932 and helped to create the tense international situation that ultimately led to the Sino-Japanese War and World War II, 1937–1945. The patriotic military hysteria that swept Japan had, by the end of the 1930s, suppressed any free artistic experimentation, and all cultural activities became nationalized not only in Japan but in Korea as well. Korean artists were pressured to paint pro-Japanese themes glorifying the Japanese army. Korean notables, such as Yi Kwang-su (1892–1955?), a famous author, and Yu Chin-o (1906–1987), a law professor at Posŏng Professional School, which later became Korea University, collaborated in exhorting Korean youth to join the Voluntary Student Army or to work in factories producing military supplies.[7]

The art of this colonial period has thus far received little attention from Korean art historians. It is only in recent years that a handful of scholars has begun to express interest in the early beginnings of Korean modern art and to uncover some hitherto unknown facts and documents, as well as works of art.[8] Since 1985,

the Ho-am Art Museum in Seoul has held a series of retrospective exhibitions of early modern artists and published catalogues documenting artworks that have been scattered or are of unknown provenance. A groundbreaking boon for these historians has been the lifting in 1988 of the ban by the South Korean government on artists who voluntarily went to North Korea during the Korean War (1950–1953). Since then, many unknown paintings (or at least photographs of them in art magazines or newspapers) produced by these artists during the 1930s were rediscovered, and this made it possible to have a more balanced view of the period.[9] Art historians and critics are also beginning to uncover the major issues raised among art critics and artists of the time, as well as the aspirations they had for expressing Korean identity in art. The purpose of this essay is to examine the evolution of the first phase of modern painting, with a particular emphasis on the role Japanese art played as a mediator in this complex and dark period of early-twentieth-century Korean art.

Education of Artists

One of the earliest art studios for the public in Korea was Kyŏngsŏng Sŏhwa Misulwŏn (Kyŏngsŏng School of Painting and Calligraphy), later renamed Sŏhwa Misulhoe Kangsŭpso (Sŏhwa Art Institute), which opened in 1911. Yet apart from encouraging its students to sketch outdoors, its training was not much different from conventional apprenticeship. As the number of Korean artists returning from Japan increased, they began teaching students at the Sŏhwa Misulhoe Kangsŭpso, various middle and high schools, and such institutions as the YMCA. Art institutions were founded not only in Seoul but also in Pyŏngyang and Taegu, but, strictly speaking, they were informal art studios rather than formal art education institutions.[10]

At this time, there were also many Japanese artists living in Korea who opened art studios and helped create a climate of interest in new art. The earliest private art studio opened by a Japanese was in 1902 by Amakusa Shinrai (?–1917), a *nihonga* (Japanese-style painting) artist.[11] The reason Amakusa—a former assistant professor in the Department of Nihonga at the Tokyo Bijutsu Gakkō (Tokyo School of Fine Arts)—came to Korea is not certain, but he lived there until 1915. Shimizu Tōun, another *nihonga* artist, also opened a studio in 1908 in Seoul and returned to Japan around 1920. In 1911, Yamamoto Baikai, a *yōga* (Western-style painting) artist, opened a studio in Seoul. Yamada Shin'ichi, a Western-style painter and a graduate of the Tokyo School of Fine Arts in 1923, also opened a studio, the Chosŏn Misulwŏn (Chosŏn Art Institute) in the early 1920s, and among his students was Yi Ma-dong, who later went to Japan for study at Yamada's alma mater.[12] After teaching briefly at Che-i Kobo (Second High School), Yamada actively participated in official art exhibitions in Korea from 1924 to 1926, and again from 1931 to possibly as late as 1944, and apparently remained in Korea until independence from Japan in 1945. Takagi Haisui (1877–1943), a Western-style artist who was a

student of famous Meiji painter Kuroda Seiki (1866–1924) at the Hakubakai Yōga Kenkyūshō (Western Art Institute of the White Horse Society), visited Korea in 1910 and opened his studio in 1916.[13] Takagi stayed in Korea until 1925 and even served as a judge in the first official exhibition in 1922. Although the presence of these Japanese was important, the details as to how many Korean students studied with resident Japanese art teachers and the nature of their relationships have not been confirmed.

On the other hand, since many art teachers at Korean public middle or high schools in the colonial period were Japanese, some students would develop an interest in modern art under their influence. Oil painter Hiyoshi Mamoru, who graduated from the Tokyo School of Fine Arts in 1909 and came to Korea that same year, was such a teacher. He served at the Kyŏngsŏng Middle School (a school for Japanese students that later became the Seoul Middle and High School) and stayed in Korea until 1945. His brief memoir of his life in Korea gives us some information as to who came and what they did during the colonial period.[14] In addition, the names of several other resident Japanese art teachers have recently become known.[15] Toda Katsuo and Ishikuro Yoshikatsu were oil painters and taught at Yŏngsan Middle School, which together with Kyŏngsŏng High School was basically a school for Japanese students. There were also Japanese teachers who taught at schools for Korean students. At Che-i Kobo or the Second High School (later Kyŏng-bok Middle and High School), Satō Kunio taught several Korean students who later became prominent Western-style painters with careers spanning the colonial and postcolonial eras, among them Yi Dae-wŏn (1921–), Yu Yŏng-kuk (1916–), Chang Uk-chin (1917–1990), Kwŏn Ok-yŏn (1923–), Kim Chang-ŏk (1920–1997), and Im Wan-kyu (1918–).[16] Yi Dae-wŏn remembers that Yamaguchi Takeo (1902–1983), who was a pioneer of abstract painting in Japan, lived in Seoul until 1945 and briefly taught painting at Kyŏngsŏng Imperial University for a group of medical students in which Yi, then a law student, took part. Igawa Katsumi, a graduate of Osaka Bijutsu Gakkō (Osaka School of Fine Arts), was an oil painter who taught at Sŏllin Sang-ŏp Hak'kyo (Sŏllin High School of Commerce). In addition, there were frequent solo or group exhibitions in the 1910s by visiting Japanese artists, among them Takagi Haisui and Tsuji Hisashi (1884–1974) in 1914 and the even more eminent Ishii Hakutei (1882–1958) and Kobayashi Mango (1870–1945) in 1918.

Some aspiring Korean artists ventured to Europe or to America to study Western-style painting, despite the hardships in getting passports from the Japanese colonial government in Korea. Most of them, however, chose the Tokyo School of Fine Arts and subsequently became the leading artists upon their return to Korea. The Korean students who graduated from the Department of Western-Style Painting at the Tokyo School of Fine Arts before 1930 numbered sixteen; by 1945, forty-six students had graduated. Also by 1945, one Korean student had graduated from the school's Department of Japanese Painting, seven from the Department of Sculpture, and one from the Department of Wood Sculpture.[17] The Japanese government encouraged this first generation of Korean artists by giving them official

scholarships.[18] From 1924, special admission for foreign students was extended to Korean and Taiwanese students with the proper recommendations.[19] From 1931 onward, however, foreign students were forced to take examinations and compete with Japanese students on an equal basis.

The curriculum of the Tokyo School of Fine Arts was based on nineteenth-century French Academicism.[20] As a result, most of these early Korean pioneers of Western-style painting naturally transmitted this fashion back to Korea. Starting in the 1930s, an increasing number of Korean art students flocked to private universities or art institutions in Tokyo where the atmosphere for learning was less rigid than at the Tokyo School of Fine Arts.[21] Japan, which had begun to assimilate Western art in the 1860s, much earlier than Korea, had been introduced to most of the art from Europe by the 1930s. This was a time when modern art was being actively pursued in many official and private exhibitions. The exposure of Korean art students in Tokyo to new trends in the art world was not readily available through the convention-bound art schools but was possible through various exhibitions and art publications. Korean artists attempted to go beyond Academicism as well as the prevailing Impressionism. They experimented with Postimpressionism, Fauvism, Futurism, even Constructivism and Surrealism, not sequentially but all at once, and without fully understanding the meaning and significance of these styles.

The population of Western-style oil painters in Korea also increased as this first generation began to train their own students. They were joined by self-taught artists who submitted their works for exhibitions. The debut of an artist was usually made through the Chosŏn Art Exhibition, the influential annual art salon established by the Japanese government-general of Admiral Saitō three years after the March First Movement in 1919[22] as a gesture to promote culture and to soften oppressive rule.[23] As journal articles and exhibition reviews in daily newspapers helped to spread more widely the fashion of Western oil painting, the Korean public gradually came to realize that art was no longer just a gentleman's avocation or a mere manual skill, but rather a legitimate expression of human creativity and individuality. Although Eastern- or traditional-style painters in Korea also were aware of the coming of a modern age and tried to cope with new concepts of form and style, they were not quite able to maintain leadership of the art community. One could also experience works by modern Japanese artists at the Museum of the Yi Royal Family, located at the Sŏkjojŏn building of the Dŏksu Palace, Seoul. These were works purchased by the Yi royal family upon recommendation by Japanese authorities and placed on public display during the years 1933–1943.

Western-Style Painting

The main Western-style art activities in Korea during the 1930s were centered around the annual showings of the Chosŏn Art Exhibition. At the time, the exhibition was known as Sŏnjŏn in Korean and Senten in Japanese. Recently, however, the term *"Sŏnjŏn"* has been replaced by Chosŏn mijŏn due to criticism that

it is a Japanese term. Created in 1922 by Japanese colonial authorities, it was modeled after the Teiten (Imperial Exhibition), the state art salon of Japan, which in turn was modeled after the official Salon of France.[24] Twenty-three exhibitions were held from 1922 to 1944. The first section, called *nihonga* in Japan, was cautiously renamed *tongyang-hwa*, or Eastern-style painting, for Korea (and later also for official exhibitions in Taiwan). The second section, as in Japan, was called *sŏyang-hwa*, or Western-style painting. The Chosŏn mijŏn not only served as the gateway for promising young Korean artists but also became the main means for resident Japanese to exert influence on Korean art. This was because Japanese artists were allowed to submit works if they had lived in Korea for more than six months.[25] Whereas Japanese artists who were accepted in the first Chosŏn mijŏn in the Western-style painting section numbered fifty-five, only three Korean artists were accepted to display.[26] Generally, Japanese artists constituted 65 percent of exhibitors,[27] which indicates that the Chosŏn mijŏn was in part a platform for Japanese artists in Korea. Given the fact that Japanese Prime Minister Hara Takashi (1856–1921) had remarked in 1918 on the necessity of an all-out institutional refurbishing to assimilate Korea into the empire, it follows that the establishment of the Chosŏn mijŏn would also have been a means of assimilating Korean artists into the Japanese art community.[28]

Soon all of the judges were invited from Japan. Those who served more than twice were mostly professors from the Tokyo School of Fine Arts, such as Fujishima Takeji (1867–1943), Wada Eisaku (1874–1959), Minami Kunzō (1883–1950), Tanabe Itaru (1886–1968), Kobayashi Mango, and Ihara Usaburō (1894–1926) in Western-style painting; and Komuro Suiun (1874–1948) and Yūki Somei (1875–1957) in Eastern-style painting.[29] This could mean two things. One would be that the organizers probably deemed Korean artists unfit to serve as judges. This would be conceivable for the Western-style painting section, where Koreans were lacking in number and also without outstanding artists; but in the section on Eastern-style painting, where Korean artists had a long tradition, such discrimination is incomprehensible. Another factor could be that it was intended for the Japanese sentiments to filter naturally into Korean art because the Japanese judges might naturally favor works expressing familiar Japanese sentiments or representing Korean folk themes. Whatever the case might have been, such preferences were to determine the later course of the art presented at the Chosŏn mijŏn. In other words, the Chosŏn mijŏn served the function of distributing Japanese versions of both Western- and Eastern-style painting. Since art professors from the Tokyo School of Fine Arts were regularly invited to serve as judges, inevitably the style of this school, with its blend of Academicism and Impressionism, was the standard for acceptance in the Chosŏn mijŏn. At the first and second exhibitions there was also a display of works by famous contemporary Japanese artists in each section to serve as reference works, but later this practice was abolished.

The Chosŏn mijŏn was initially set up to replace or suppress the Hyŏpjŏn, or Society Exhibition, a forum established by Korean painters in 1921, a year earlier than the opening of the Chosŏn mijŏn.[30] Although some nationalistic-minded

Korean artists boycotted the Chosŏn mijŏn, more and more painters began to participate in the official exhibition because it was viewed as a venue to public recognition.[31] Thus in 1922, as noted, the number of Korean artists accepted by the Chosŏn mijŏn in the section on Western-style painting was only 3 out of 57. Ten years later, in 1932, the number jumped to 86 out of 137.[32] In the section on Eastern-style painting, the total was only 15 out of 60, showing how far modern painting styles had eclipsed traditional art. As a result of this competition, the Hyŏpjŏn gradually declined in the 1930s, not only in the number of participants but also in the quality of paintings. In addition, the Hyŏpjŏn did not publish any catalogues, as the group was always in financial difficulty, coming to an end in 1936 after nineteenth exhibitions. The Chosŏn mijŏn, backed by the wealth of the colonial government in Korea, provided catalogues with photographs of each entry. These catalogues still remain as valuable documents of the period.[33]

Group activities also increased in the 1920s and 1930s as artists organized exhibitions in Seoul, Taegu, and Pyŏngyang.[34] Alumni groups, regional groups, or groups of those who shared similar interests or belonged to the same art movement exhibited together. The most representative of these organizations in Korea was the Nok Hyang Hoe (Group for a Green Country). This particular association of Western-style painters was organized in 1928 by such artists as Kim Chu-gyŏng (1902–) and Sim Yŏng-sŏp (?–?), both of whom were trained by Korean artists at the Koryŏ Misulhoe (Association of Korean Art) and participated in Hyŏpjŏn shows. Members stated clearly their ideological position of developing a mode of Western painting that was fit for the ethos of the Korean people. The biggest group overseas was the Paek U Hoe (White Bull Group) in 1932, an organization of Korean art students in Tokyo whose core members were students at the Imperial School of Fine Arts, which by the 1930s had the largest number of Korean students. The Japanese police, however, suspected that the name *bull* symbolized Korean independence. A bull or a cow does not have specific symbolic meaning to the Korean people, but many artists at the time favored painting oxen, and as 80 percent of the population was in agriculture, bulls and cows were the most familiar of animals in Korea.[35] As a result, the name *bull* was suspect in the eyes of the Japanese police. In 1935 the group was forced to change its name to the Che Tongkyŏng Misul Hyŏphoe (Association of Artists in Tokyo). Later it was completely forbidden to exhibit. Korean students from the Tokyo School of Fine Arts joined the White Bull Group but also organized their own association called Tongmi Hoe (Group for the Tokyo School of Fine Arts).

Figures and Nudes

As mentioned earlier, the most prominent artists featured at the Chosŏn mijŏn (1922–1944) were the Academic painters. Academicism in the West usually refers to classicism, which is based upon the belief that art can be taught according to rules set by the ancients and the great masters of the Renaissance. At the École des Beaux-Arts in Paris, the seat of Academicism in the nineteenth century, instruction was centered on copying plaster casts and drawing from life as a means of

gaining technical proficiency. But most important was the choice of subject matter, which had to show grandiose, noble, or moral themes of historical or religious significance.

When the first generation of Japanese painters, such as Kuroda Seiki, went to Paris at the end of the nineteenth century, however, European art was in the midst of radical change. Although still adhering to the importance of line and finish, some Academic painters began to incorporate elements from Impressionism, taking everyday scenes as subject matter or adopting informal composition and showing the effects of light on objects. Raphaël Collin (1850–1917), who was the teacher of Kuroda and later of Kume Keiichirō (1866–1934) and Okada Saburōsuke (1869–1939), also professors at the Tokyo School of Fine Arts, was a good example of this eclectic Academicism. The education Kuroda received from Collin was Academic training. He was also, like Collin, interested in light and atmosphere, or in the play of direct and reflected colors. When Kuroda came back to Japan, he and his followers became known as the Impressionistic Academicists because of the bright colors and sense of fresh air in their work. Kuroda later became the chairman of the newly established Department of Western-Style Painting at the Tokyo School of Fine Arts, and his fashion became the dominant trend in modern Japanese Art.[36] As the mainstream Western-style painting in Tokyo, this Impressionistic Academicism was introduced to Korean artists as the "Academic style" without any proper historical context. Even today, the term *Academicism* is not correctly understood in Korea, where it has such diverse meanings as realistic art, orthodox art, official art, conservative art, and traditional art.

The most popular subject reflecting Academicism in Korea from the 1930s until the 1960s was the seated or standing female or male figure. Good examples of such figures in the 1930s are *A Man* (Plate 41) by Yi Ma-dong (1906–1981), dated 1931, and a *A Girl Reading* (Plate 42) by Kim In-sŭng (1913–), dated 1937. Since Yi graduated from the Tokyo School of Fine Arts in 1932, this work was painted when he was a student. It is not clear whether Kim painted in Tokyo or Seoul, since he graduated from the same school in 1937 and returned to Korea that year. Yi studied with Fujishima Takeji; Kim with both Tanabe Itaru and Kobayashi Mango. Here the painters were very much concerned with the realistic rendering of figures, observing carefully the contrast of light-and-dark to create volume as well as three-dimensional space. They emphasized the importance of good drawing, a quality that was at the core of the curriculum of the Tokyo School of Fine Arts. Like their professors, Yi and Kim probably thought that it was important to transplant Academicism, with its emphasis on sound training in realistic drawing, to the old tradition of Korean-style Eastern art.

The nude genre, another frequently painted subject by Academic painters, was completely new.[37] Moreover, such painting caused a great deal of embarrassment in the conservative Confucian society of Korea. Earlier, in 1916, when Kim Kwan-ho (already identified as the second-known Korean to study Western-style painting at the Tokyo School of Fine Arts) won a special prize at the Bunten in Tokyo with *Sunset* (Plate 43), a painting with two female nudes standing, the *Mae-*

il Shinbo (Mae-il Newspaper) reported the news but with the explanation that it would not print the photograph in order to guard public morality. A similar incident occurred with his painting entitled *Lake,* submitted to the 1923 Chosŏn mijŏn. The Japanese government-general gave permission to exhibit the work but banned its reproduction in the newspapers. Nevertheless, in art circles at least, it was widely understood that studying the nude figure was an important practice in learning Western-style techniques. But painters had a hard time finding nude models and sometimes had to recruit them from *kisaeng*—courtesan houses.[38] In spite of this difficulty, many nude paintings were presented at exhibitions.

Kim In-sŭng's *Nude* (Plate 44), painted when he was a student in Tokyo and accepted for the Teiten exhibition of 1936, is a study of a Japanese female model. The long legs and the proportion of the body indicate that this painter idealized the Asian model to the likes of nude figures in Western paintings. This also occurs in paintings by Kuroda, such as *A Maiko Girl* (1893) and *Wisdom, Impression, Sentiment* (1899). That is, to Kuroda and later to Kim In-sŭng, the Western nude figure was perceived as the ideal form that they then duplicated in their work. Not only the nudes by Kim In-sŭng but also many of the nude paintings that were submitted to the Chosŏn mijŏn depicted the human figure according to set archetypes found in Western examples, where the figure is standing or reclining in a passive pose.

Kim repeatedly exhibited his works and won prizes at the Chosŏn mijŏn, and he was designated one of the aristocrats of the exhibition.[39] His most successful piece was *Spring Melody* (Plate 45), painted during the war in 1942 and depicting a group of young men and women in one monumental composition. Kim, who is now in his eighties, recalls that it was a painting in praise of youth. One senses hints of Edgar Degas (1834–1917) or early Edouard Manet (1832–1883) in Kim's treatment of the music player, as well as in the compositional concept. Similarities with Japanese painter Koiso Ryōhei (1903–1988) are also evident in his choice of subject matter, downward perspective, poses of the figures, and touches of highlight on the foreheads of the figures. One also notices the men's Western-style attire and the modified version of Korean dress in the womens' costumes. Above all, the theme of the cello player reveals the changed outlook of the new intellectuals in Korea society, a representation of modernity.

If the nude in Kim In-sŭng's painting is an ideal Western nude, the *Reclining Nude* (Plate 46) by Im Kun-hong (1912–1979), painted in 1936, is a compromise between a Western and an Eastern nude. Im was an artist who took painting classes at the Kyŏngsŏng Yanghwa Yŏn'guso (Kyŏngsŏng Western-Style Painting Institute) while working at dentistry. Although he did not receive formal training, he submitted works at the Chosŏn mijŏn as well as the Hyŏpjŏn. The reclining pose he utilized is certainly from the Western repertoire, yet it lacks the sense of exotic feeling that is found in Kim's robust Westernized nude. The artistic inspiration in such works as *Nude with Her Left Hand on the Lips* (Plate 47), painted in 1937 by Sŏ Chin-dal (1908–1947), another student of the Tokyo School of Fine Arts, may have come from Paul Cézanne (1839–1906), but the notion of a strong woman as an ideal female is also rooted in Korean tradition.

Modern Landscape Paintings

Landscape was another favored subject matter of the early-twentieth-century Korean oil painters. Painting actual scenery from nature had a long history in Korea, going back to the Koryŏ dynasty (936–1392), and it was popular during the seventeenth and eighteenth centuries—the late Chosŏn period. Thus the Impressionistic practice of recording the immediate visual phenomena of nature met little resistance among modern Western-style Korean painters and, in fact, revived the practice among traditional ink painters of painting outdoors. During the late Chosŏn dynasty, it was famous scenic spots of topographical landscapes that had been favored. Now, ordinary urban or rural scenes became common subjects of modern artists. Yet few Korean oil painters really understood the lessons of the European Impressionists—above all, that color constantly changes according to varying conditions or light. Instead, early modern Korean artists were still very much concerned with form, volume, and line.

Perhaps the only Korean artist who could claim to be an Impressionistic landscape painter was O Chi-ho (1905–1982), who successfully conveyed sunlit provincial landscapes. A student of Fujishima Takeji at the Tokyo School of Fine Arts from 1925, O participated in the Group for a Green Country upon his return to Korea in 1931. This association called for the rejection of Japanese sentiment and sought Korean colors, which they considered to be bright, clean, and radiant. Although its activities were short-lived, O continued to work at capturing the luminosity of nature that he saw in his Korean surroundings by adopting Impressionistic or Neo-Impressionistic brush strokes. He believed that the Impressionistic practice of painting outdoors was better suited to Korean weather, which is dry and clear compared to the dampness in Japan. He painted directly from nature and left notes; for example, he wrote that from May 8 in 1938, he painted *The Field with Apple Trees* (Plate 48) for three days, morning to night, and when he was finished the flowers began to fall. Another painting, *A House Facing the South* (Plate 49), completed in 1939, reveals strokes of brightly colored pigments to represent the transcending speckled light. O eliminated black shadows, so that the trees in the painting cast irregular violet and blue patterns diagonally across the wall and the roof of the house.

Another landscapist who should be mentioned was Kim Yong-jo (1916–1944). He first learned to paint from a well-known local artist. He was so talented that his work was accepted at the Chosŏn mijŏn when he was just sixteen—and thereafter more than six times in the 1930s. He made his way to wartime Tokyo in 1940, where he worked for money during the day, painted at night for classes at the Taiheiyō Bijutsu Gakkō (Pacific School of Fine Arts), and submitted his works to the Shin Bunten. But his health could not withstand his workload, and after returning to Korea in 1943 at the age of twenty-eight, he died of tuberculosis, one of the most common causes of death in those days. The paintings he left are mostly seascapes produced during the 1930s while he was still living in his hometown in Taegu. Works such as *Nakdong River* and *Seascape* (Plate 50) show that he was interested

in Fauvism in his arbitrary use of color and loose brush strokes. Leisurely scenes of people enjoying the beach were definitely a subject favored by Impressionists and Fauvists. But it was not common for Koreans in the 1930s to go out and have a leisurely time at the beach, so perhaps Kim was inspired by Fauvistic subject matter and style from the color reproductions found in Japanese art publications available in Korea.

The most successful and highly proficient painter of the decade was probably Yi In-sŏng (1912–1950). His works were accepted at the Chosŏn mijŏn and won special prizes for six consecutive years, whereupon he became a "Select Artist" in 1937 at the age of twenty-five. He showed his talent early when he was in elementary school. In 1931, when he was nineteen, he went to Tokyo for two years and attended the Pacific School of Fine Arts. During this period, his works were accepted several times by the Teiten. His stay in Tokyo gave him the stimulus needed to assimilate his personal style with Postimpressionism. His watercolor entitled *From the Summer Interior*—the kind of work that Pierre Bonnard (1867–1907) might have painted—was accepted by the Teiten in 1934. In this painting Yi used short, divisionistic strokes with patches of broad strokes to catch the sunny atmosphere of the interior.

Yi's painting, *A Day in Autumn* (Plate 51), also done in 1934, won a special prize at the Chosŏn mijŏn and is a good example of a composition combining rural landscape with a figure. Here his concern for conveying light with the divisionistic brush technique is minimized, and he brings back volume and composition into his work. The portrayal of a girl with her upper torso naked and the flat treatment of form are reminiscent of the Tahitian women of Paul Gauguin (1848–1903). Similar to this is *In the Mountains of Kyŏngju* (Plate 52), in which he painted two male figures against the background of Kyŏngju, the capital of the ancient Silla Kingdom (57 B.C.E.–668 C.E.) and of unified Silla (668–936). Yi's attempt to deal with folk people in sentimental landscape settings has led scholars to form two different interpretations. In the 1970s, critics like Kim Yun-su criticized Yi, a child of the city, for trying to pander to the taste of a Japanese judge who found Yi's painting of the countryside to be highly exotic.[40] Another critic, Yi Kyŏng-sŏng, on the other hand, praised Yi for incorporating a theme that was typically Korean into his original conception.[41] Although it is difficult to tell, it seems true that Yi tried to show Korean color by using a reddish hue for earth. At that time, the Japanese called the Korean land *akatsuchi* (reddish earth), and Yi In-sŏng himself said that he liked the fragrance of reddish earth.

Yi In-sŏng was not the only artist who tried to imbue painting with folk flavor. In the early 1930s, an increasing number of paintings at the Chosŏn mijŏn depicted scenes of folk life, such as Korean farms with cows and thatched houses, or other sentimental scenes like sunset landscapes and deserted back alleys. *A Village Scene* (Plate 53), by Kim Chung-hyŏn (1901–1953), a self-taught artist who participated in Chosŏn mijŏn from 1925 to 1943, is an example of this. Another change was the use of dominant colors like ochre and earth brown, and this trend con-

trasted sharply with the decorative palette of Japanese painting. Art critic Yi Kyŏng-sŏng has argued that such works should be viewed as an expression of naïveté on the part of these early artists who tried to bring back the identity of a lost nation.[42] It is, however, hard to tell whether these works should really be interpreted as an attempt to express nationalistic sentiments. It is true that around 1930, art critics and artists such as Kim Yong-jun (1904–1967) and Sim Yŏng-sŏp actively debated issues regarding the reconstruction of Korean national identity or the creation of a new artistic trend called "local color." They warned against undue Japanese influence and urged painters to reflect the reality of Korea or to express Korean aesthetics in their works.[43] The art critics at this initial stage were mostly literary critics or artists themselves, like Sim, who were either strongly nationalistic or influenced by the ideology of proletarian art, which had begun to spread among literary circles around 1925.

It may be logical to argue that if such subject matter were really meant to be an expression of nationalism, it could not have survived strict Japanese censorship. This would be the cause for the almost complete lack of representation of any resistance or challenge to colonialism in the paintings of this time. One must bear in mind that sentimentalism and scenes of folk life appealed to the tastes of Japanese judges at Chosŏn mijŏn. In fact, Japanese painters who visited Korea were attracted by such subjects, as exemplified by the paintings of Fujishima Takeji. He visited Korea in 1913, an experience that ultimately led to a turning point in his art and a search for Asian subjects—and to his return in 1924.[44] Art critic O Kwang-su has insisted that this genre of "local color" should be viewed as a deliberate effort on the part of the Japanese colonial government to encourage localism or exoticism and a clinging to the past in Korean art as a means of diverting artistic interest away from contemporary Korean reality.[45]

Avant-Garde Paintings

In the 1930s, when most progressive painters followed in the footsteps of Realism, Impressionism, or Fauvism, there was nonetheless an experimental art that could be regarded as avant-garde. The term *avant-garde* originated from modernism in the West, and in the early phase of modernism in Japan it was used to designate the artists who denounced the established position and sought new forms of art. In Korea, avant-garde artists during the 1930s could be divided into two groups: those who were politically affiliated with an avant-garde ideology and those who practiced avant-garde pictorial forms. The politically avant-garde group was the KAPF (in Esperanto, Korea Artista Proletaria Federation), which was formed in 1925. The writers and artists who were members of KAPF worked with cartoons, printmaking, and stage productions. They organized an exhibition at Suwŏn in 1930, but the Japanese police confiscated 70 works out of the 130 on exhibit and closed the exhibition after three days. Yet their influence on Korean art was limited, and paintings that actually embody this ideology are scarce.[46]

Those who were avant-garde and were aligned to new developments in Euro-

pean modernism were primarily artists who had been to Tokyo. While most Korean artists thought that being accepted at the public Salon was an honor, they preferred small group exhibitions or one-man shows. Ku Pon-ung (1906–1953) was such an artist, and he had a one-man exhibition in 1931 at the Dong-A Ilbo Building. He was a hunchback, owing to a childhood accident, and therefore was often compared to Henri de Toulouse-Lautrec (1864–1901). Encouraged to become a painter by his family and by a teacher in high school, he first learned painting from Yi Chong-u (1899–1981), an artist who had studied at the Tokyo School of Fine Arts and in France, and exhibited at the Salon d'Automne in the late 1920s.[47] Ku was in Tokyo from 1928 to 1932, where he studied art at the Kawabata Gagakkō (Kawabata Painting School) and aesthetics at Nihon University before entering the Pacific School of Fine Arts. In Japan he was able to show his works at exhibitions of the Nikakai (Second Division Society) and 1930 Nen Kyōkaiten (Year of 1930 Association), as well as those of the Dokuritsu Bijutsu Kyōkai (Independent Art Association), which was a hotbed of Fauvism and École de Paris-style—and quite influential to those like Ku who looked for free expression.[48] *Nude and Still Life,* painted in 1937, shows that he knew the works of Saeki Yūzō (1898–1928) and Satomi Katsuzō (1895–1981), both of whom were key members of the 1930 Nen Kyōkaiten and produced canvases of great spontaneity, lively surface texture, and bold color. There were similarities between Ku's work and those of the two Japanese in the employment of downward perspective and the use of letters on the book cover. The subject matter of a nude and still life may have come from Henri Matisse (1869–1954).

In *Woman* (Plate 54), 1935, Ku violently distorts form and, by using daubs of primary colors, successfully conveys a sense of wild, primitive passion. The intensity and the dramatic emotion exhibited in his painting made him probably the sole Korean exponent of Expressionism. The face of the nude, which takes up most of the painting, invites the viewer closer to the picture plane, allowing the viewer to relate intimately to the figure as the artist would have done. The rejection of the previous distance that lay between the pictorial surface representation and the viewer was often apparent among Fauvist and German Expressionist paintings. But it is more likely that the direct source would have come from Satomi, who had exhibited Expressionist paintings of nudes at the Nikaten and the 1930 Nen Kyōkaiten. Another work, *Portrait of a Friend* (Plate 55), painted in 1935, portrays the poet Yi Sang (1910–1938), a close friend of Ku and twenty-six years old at the time. Yi was the most famous symbol of decadence in literary circles of the period. Being decadent was perhaps Yi's own way of displaying disgust toward the darkness of the period. Sporting a proletarian hat and pipe, the image of Yi is reminiscent of the painting of *Le Père Bouju* by Maurice de Vlaminck (1876–1958) created in 1900–1901. Yi's sneering smile expresses the despair of the intellectuals of this time.[49]

In the 1930s, Japan's art world was entering into the so-called Yasui Sōtarō (1888–1955) / Umehara Ryūsaburō (1888–1986) period, reflecting an eclectic trend

134

of Impressionism, Postimpressionism, and Fauvism, which was characterized by a use of decorative and sensuous color and simplified form.[50] Japanese artists now tried to turn away from imitating Western style and to establish Japanized Western-style painting. With almost eighty years of history, one may say that Japanese Western-style painting had reached maturity, and yet it should also be noted that it revealed rising nationalism within Japanese society. It might have been that the decorative and sensuous appeal of Impressionism or Fauvism was compatible with the tradition of Japanese art, whereas the cool intellectual and rational approach of geometric abstraction was not. Thus Cubism, which was first introduced in Japan as early as the 1910s, did not exert much influence. And even though geometric abstraction in the form of Constructivism was one of two mainstreams of European painting in the 1930s (the other was Surrealism), it was not experimented with widely until the mid-1930s, when artists like Hasegawa Saburō (1906–1957) and Murai Masanari (1905–) came back from Europe and organized (in 1937) the first exhibition of the Jiyū Bijutsuka Kyōkai (Association of Free Artists). Among the participants in this show were several young Korean painters who would exhibit works until 1943.[51]

In the 1930s, Korean artists knew about the Yasui-Umehara style but did not seem to be too much affected by it. Korean progressive artists were rather interested in abstract art, and around the mid-1930s, for the first time, a group of Korean artists emerged who pioneered in abstract painting. For Korean artists in Tokyo, it was difficult to make a name for themselves through such large-scale major art exhibitions as the Nikaten or Dokuritsu Bijutsu Kyōkaiten or 1930 Nen Kyōkaiten. Smaller-scale progressive artists' organizations, such as the Jiyū Bijutsuka Kyōkai and the Bijutsu Bunka Kyōkai (Art and Culture Association, founded in 1939), were much more accessible to them. This was especially true of Korean students at the Bunka Gakuin (Culture Academy) in Tokyo, where their close relationship with teachers like Murai Masanari and Tsuda Seishū brought them into the artists' circles.

Unfortunately, almost all of the works submitted by Korean artists to exhibitions of the Jiyū Bijutsuka Kyōkai are lost, and one can only guess about their styles from a few photographs that were printed in art magazines of the period. Kim Hwan-gi (Kim Whanki, 1913–1974), who came to Tokyo in 1931 and first studied at a middle school before entering the Fine Arts Department of Nihon University, where he graduated in 1936, participated in the first exhibition. He was already experimenting with nonrepresentational painting as early as 1937 in a work entitled *Aerial Beacon,* and he later became one of postcolonial Korea's foremost abstract painters. In this painting, the rejection of traditional perspective and the search for dynamic relationships between geometric forms on a flat surface reminds us of works by Kasimir Malevich (1878–1935) or other Russian avant-garde painters. Even though Kim was working with abstract elements of form and line, his characteristic lyricism surfaces in such works as the *White Swan* of 1938 or the *Window* (Plate 56) of 1940, where he fills his canvases with forms suggestive

of those in nature. He had also attended, together with art students Kil Chin-sŏp (1907–) and Kim Byŏng-gi (1916–), the Avant-Garde Yōga Kenkyūsho (Avant-Garde Studio for Western-Style Painting), which was briefly run by Fujita Tsuguji (1886–1968) and Tōgō Seiji (1897–1978) in 1933 and where they could hear bits and pieces about the art scene in Paris.[52] Another pioneering abstract painter was Yu Yŏng-Kuk (1916–), who studied at the Culture Academy from 1935 to 1938. Compared to Kim Hwan-gi, Yu was more adventurous in his use of materials and experimented with collage, wood relief, and photographic works (Plate 57). It is clear that he was working in the realm of Mondrian's Neo-Plasticism or Constructivism. Yu participated in avant-garde group exhibitions until 1942 and left for Korea in 1943.

135

When the Jiyū Bijutsuka Kyōkai held an exhibition in Seoul in 1940, the reaction of the public to abstract painting was a mixed one. On the one hand, articles appeared in newspapers explaining what abstract art was. On the other hand, landscape artists like O Chi-ho denounced abstract art as nothing but an excessive formalism that ignored the reality of the Korean people.[53] Since no visible changes occurred in art circles following the exhibition, one can surmise that Korean artists were not ready to accept this new trend.

Among the Korean artists accepted for exhibitions of the Jiyū Bijutsuka Kyō-kai were several who did not follow modernism but tried to exploit uniquely Korean themes and styles. Mun Hak-su (1916–1988), also from the Culture Academy, was such an artist, and his works were much praised by Japanese critics.[54] He even became a member of Jiyū Bijutsuka Kyōkai, which was an exceptional honor for a Korean artist. Unfortunately, no painting by him is preserved in South Korea, since he lived in Pyŏngyang and remained there after the Korean War. Kim Byŏng-gi, a close friend of Mun, testified that Mun admired Eugène Delacroix (1798–1863), and like Delacroix he often took literary themes as subject matter for his paintings.[55] A good example of this is the *Conviction of Chun-hyang* (Plate 58), 1940, which one can see only from a photograph and is based on a famous Korean love story. Judging from photographs and the testimony of Kim Byŏng-gi, he consciously used such motifs as a horse or cow, a little boy or girl in Korean dress, or a Korean farmhouse to evoke a sense of the Korean landscape. Korean artists continued to show their works at the Jiyū Bijutsuka Kyōkai and its wartime successor organization until 1943, when they seem to have been forced to return to Korea.

Eastern-Style Painting

Traditional Korean ink painting also underwent transformation during the 1920s and 1930s as a result of indirect contact with modern Western art. Perhaps the most symbolic change was that painting with calligraphy, or *sŏhwa* (the traditional term) was now officially designated as *tongyang-hwa* (*tōyōga* in Japanese), or Eastern-style painting, at the Chosŏn mijŏn. It has already been pointed out that the Chosŏn mijŏn was meant to be the counterpart of the Teiten of Japan, which in 1922 was

divided into three sections: Western-style painting, Japanese-style painting or *nihonga,* and sculpture. The Chosŏn mijŏn system followed the Teiten closely.[56] However, instead of using the term *"nihonga,"* the Japanese authorities in Korea established a section called *tongyang-hwa.* The name has survived until today in spite of arguments that it is a remnant of Japanese colonial rule and should be changed to *han'guk-hwa,* or Korean-style painting.[57]

Perhaps the most popular subject matter of Eastern-style ink painting was landscapes. Landscape painting in traditional ink had a long tradition from the Chosŏn dynasty. But even before the 1930s, the young generation, headed by Yi Sang-bŏm (1897–1972), No Su-hyŏn (1899–1978), Yi Yong-u (1902–1953), and Pyŏn Kwan-sik (1899–1976), felt the need to adopt a new spirit and turned away from the practice of endlessly imitating the old masters. In 1923, they organized a group called Dong Yŏn Sa (Society for Studying Together) and began to produce ink paintings that reflected the realism evident in Western art, often taking as subject matter scenes from daily life. The interest in realism must have come from the practice of Western-style painters and the writers of the time who were influenced by realism. Instead of employing the traditional practice of multiperspectives in one picture plane, they used one-point perspective or atmospheric perspective, thus creating a sense of open space as if viewed through a window. Also, they created light and dark contrasts and three-dimensional volumes with these techniques.

Yi Sang-bŏm is perhaps the most representative artist of this group.[58] Educated at the Sŏhwa Misulwŏn in the 1910s, he adhered to traditional brush techniques but sought a more individualistic path. He painted with short texture strokes to express desolate fields or rolling hills and mountains with isolated farmers at work, all based on direct observation. His paintings are successful representations of the calm and poetic atmosphere of the unspoiled country, as in *Early Winter* of 1925 (Plate 59).

Whereas Yi Sang-bŏm and his group preferred landscapes in traditional ink brush, reminiscent of the Chosŏn dynasty, the most important genre was figure painting in color, and here a definite influence from *nihonga* is perceived. The most influential painter of figures was Kim Ŭn-ho (1892–1979).[59] His talent in this area was already noted as early as his twenty-third year in 1915, when he was asked to paint a royal portrait of Sunjong, the last Korean king. He was especially skilled in using detailed and minute strokes and delicate colors. He later went to Tokyo in 1925 and studied privately with Yūki Somei (1875–1957) at his studio for three years, thereby thoroughly learning the techniques of *nihonga.* Although there was a long tradition of figure painting in Korea, Kim's concept of figural depiction was closer to *nihonga* in terms of color, composition, and detailing. This is especially evident in the painting of *A Solitary Player,* 1927 (Plate 60). He trained many students who carried on his style and formed a mainstream tradition of figure paintings at the Chosŏn mijŏn in the 1930s. Ko Hŭi-dong, previously mentioned as Korea's first Western-style painter but now having changed his medium to tra-

ditional ink painting, was critical of this Japanized taste. In 1930 he said: "Our East Asian painting is in serious condition. Before even growing out of the Tang Dynasty [618–906 C.E.] style, many paintings have become imitations of *nihonga*. I am not saying that learning *nihonga* is bad, but one must create one's own style after digesting *nihonga*."[60]

Yi Sang-bǒm, Kim Ǔn-ho, and a third ink artist, Hǒ Paek-ryǒn (1891–1979), were three leading figures of the 1930s art community of Eastern-style painting. All three of them operated private art studios and trained a younger generation of future ink artists. However, Hǒ, the most conservative of the three, stayed mostly in Chǒlla Province, and his influence was thus limited. It is really Yi Sang-bǒm and Kim Ǔn-ho who formed the two mainstream traditions of figure painting and landscape painting in traditional ink in the 1930s.

Japanese Militarism and Its Effect on the Korean Art World

The emergence of Japanese militarism in the late 1930s accelerated forced assimilation and brought about significant restraints on cultural activities within Korea. In 1938, Japanese became the national language, and in December 1939, all Koreans were ordered to select and register Japanese names. In 1940, Korean newspapers such as *Dong-a Ilbo* and *Chosǒn Ilbo* were closed. In 1943, the draft system was established for Korea, and students were forced to take military drill. This also applied to Korean students abroad in Japan. Kim Hǔng-su recalls that as a student at the Tokyo School of Fine Arts in 1940 he was forced to attend military drills and was pressured to enlist in the volunteer student army.[61]

The Japanese government recruited the better-known artists in Japan to paint the "holy war," and there was also pressure upon artists in Korea—especially those who had become famous through the Chosǒn mijǒn—to produce paintings glorifying the empire's war effort. Tankwang Hoe (Red Sunlight Association) was an organization that was founded for such purposes.[62] Its nineteen members, including Korean painters Kim In-sǔng, Sim Hyǒng-ku (1908–1962), Park Yǒng-sǒn (1910–1994), Son Ǔng-sǒng (1916–1979), and resident Japanese painters Yamada Shin'ichi, Sakurada Shōichi, and Takahashi Takeshi, coproduced in 1943 the documentary oil painting entitled *Memorial Painting of the Draft System in Korea*. There were such military art exhibitions as the Sǒngjǒn Misuljǒn (Exhibition of the Holy War) in 1940; the Pando Chonghu Misuljǒn (Exhibition of the Peninsular Rear Area), which was sponsored by the Department of Information of the Colonial Government and held three times (1943–1945); and the Kwaejǒn Misuljǒn (Exhibition of the Glorious War) in 1944.

Although war paintings produced by Japanese painters were never shown in Korea, there was a plan for such an exhibition as revealed by former resident Japanese painter Yamada Shin'ichi. On August 8, 1998, the *Mainichi shimbun* reported that Yamada's disclosure was made public several years before his death. He testified that in August 1945, while serving as a squad leader for war art at the army's

public affairs bureau, he received crates containing sixty-four works of war paintings by Japanese artists at the Kyŏngsŏng train station. However, with Japan's surrender to the United States on August 15, Yamada was repatriated to Japan, leaving the war paintings in the hands of Korean friends. In June of 1946, with the permission of General Douglas MacArthur, he returned to Korea accompanied by an American officer to reclaim them and send them back to Japan.

There were two different objectives to the exhibitions. One was to propel people on the home front to engage in efforts toward victory, and another was to raise funds through sales of the paintings to support the military. Surviving photographic reproductions of such works include Kim Ŭn-ho's 1937 ink painting, *Donation of Gold Jewelry*, and Sim Hyŏng-ku's oil painting, *We Guard Asia* (Plate 61). Sim also published an article in the October 1941 issue of *Shin Sidae* (New Period) entitled "The State of Things and Art," in which he wrote that artists should not adhere to the dogma of art for art's sake but rather respond to the nation in need and produce art that serves the nation.

Such pro-Japanese art production began to be reviewed critically, especially since the publication of the 1983 spring issue of *Kegan Misul* (Quarterly Art, which has subsequently converted to *Wŏlgan Misul* or Monthly Art). In this issue, about forty artists, including practically every artist who was more or less successful during the colonial period, were criticized by name as having been pro-Japanese, and this caused a furor within the art world. In the 1990s more articles appeared on pro-Japanese artists, once again stirring up controversy.[63] It is still not quite clear who had or had not been actively involved and whether or not collaboration would have been something that was unavoidable under the circumstances at the time. The issue of pro-Japanese activities in the Korean art world is still an unresolved problem.

Conclusion

The decade of the 1930s was in a sense a short heyday for modern Korean art, despite the lack of public understanding and the hardships of the colonial period. During this time, artists continued what the previous generation had achieved and tried to go beyond it. Although there were no formal art education institutions at home, artists returned to Korea after studying in Japan to teach student artists, and gradually art education in Korea achieved a firm grounding. Also, whereas it was formerly the custom for art lovers to see privately only a few paintings at a collector's home or artist's studio, the new institution of public art exhibition assembled a large number of artworks at one site. This provided the public with a modern form of experiencing art. By the 1930s, most of the modern art of the West had been introduced to Korea, and the population of the art community had also increased substantially. The art produced in Korea went beyond simple technical mimicry and acquired diverse expressive styles and understanding of many aesthetic concepts.

It is undeniable that Japanese influence is deeply rooted in the background of modern painting in Korea. Within the process of modernization, the assimilation of new, modern culture did not come directly from the West but was filtered through Japan. Particularly in regard to the new genre of Western-style painting, there was no opportunity to experience Western works firsthand, and there was little information available about the ideas behind that art. Under such circumstances it would have been difficult for artists to distinguish modern Japanese art from modern European art. Unlike Japan, Korea in the 1930s did not have the infrastructure of art historians and aestheticians to lay down the theoretical groundwork,[64] and not a single book on Western art was written in Korean or translated into the language, so that Korean artists were obliged to read books and catalogues from Japan. These are some of the causes of the superficial nature of Korean art at the time.

Korean artists, however, were not overwhelmed by Japanese contemporary activities. It is true that they considered Japan as a channel for learning modern culture; yet there were efforts within the Korean art world to work toward acquiring a national identity in Korean art in the 1930s. This is evident in the group affiliated with Yi Sang-bŏm, who continued his stubborn pursuit of monochrome ink painting, or in the search for Korean color and sentiment by oil painters affiliated with the Group for a Green Country (Nok Hyang Hoe), or in the Korean themes produced by Mun Hak-su, all of which were part of the nationalist effort. Nevertheless, there were no paintings that represented the anguish of the nation and its people under colonialism. Though it is generally acknowledged that there were fewer artists than literary figures at this time and that art typically develops more slowly than literature, the Korean art world did not produce any painters comparable to such dissident literary figures as Yi Yuk-sa (1904–1944) or Yun Tong-ju (1917–1945), whose symbolic poems for the independence of Korea brought their deaths in prison. This would have been due in part to Japanese surveillance, but another reason was that the major artists of the 1930s, intent on taking up Western modernism, were more caught up with this new art form and its formal stylistic aspects than in social or political issues. After Korean's independence in 1945, there was a movement in Korean circles to purge traces of Japanese influence, and this was especially strong among Korean ink painters. Thus Kim Ŭn-ho's style was criticized, and his followers were unable to exhibit in the new official National Art Exhibition in Seoul, called Kukjŏn, which began to replace the Chosŏn mijŏn from 1949 on.[65]

The liberation of Korea from Japanese rule in August 1945 brought rejoicing and hope to Koreans. But this joy was short-lived as the nation faced serious political and social confusion. Postcolonial Korea was divided into North and South under the competing occupation forces of the United States and the Soviet Union. The Korean War broke out in June 1950 when the North suddenly attacked the South, and the ensuing battles almost destroyed the whole country. When the armistice was finally signed in 1953, the country was permanently divided along a

newly set demilitarized zone. It was not until the late 1950s that South Korea was able to resume normal cultural activities.[66]

140

During the war, artists who had lived in the North came down South in droves to find freedom, while about forty to fifty artists went to the North voluntarily or in some cases forcibly. The circumstances are varied or uncertain for each person.[67] To name a few well-known artists who went to the North, in traditional ink painting they include Yi Sŏk-ho (1904–1971) and Chŏng Chong-yŏ (1914–1984); in Western-style painting, Pae Un-sŏng (1900–1978), Kim Chu-gyŏng, Kil Chin-sŏp, Kim Man-hyŏng (1916–?), Yi Kwae-dae, Im Kun-hong, Kim Yong-jun, and female artist Chŏng On-nyŏ (1920–). Among the sculptors were Cho Kyu-bong (1916–?), Kim Chŏng-su (ca. 1920–?), and Yi Kuk-jŏn (1914–?). In the cases of Kim Chu-gyŏng, Cho Kyu-bong, and Kim Chŏng-su, they went North in 1945 before the outbreak of the Korean War and helped to establish the Pyŏngyang Art College, with Kim Chu-gyŏng being appointed as director.[68] While little information is available about their further activities after the 1960s, Chŏng On-nyŏ apparently continued to be active and honored as was Mun Hak-su, who had lived in the North before the Korean War and died there in 1988.

Those who were active during the 1930s continued their work after the Korean War and became the leading force in the development of a distinctive modern Korean art. Especially after 1946, the ones who were capable of teaching at art colleges were those who had studied in Japan, and the majority of the artists trained in Japan were employed as art professors. They taught students according to the art education that they themselves had received and, therefore, despite the anti-Japanese sentiments of the postwar years, Japanese influences still prevailed in the 1950s and 1960s and Korean artists continued to exhibit in Tokyo.

The next generation of avant-garde painters in South Korea emerged in the years around 1957. They demanded reform of the Kukjŏn, which they considered to be a hotbed of Academicism and too authoritative. This second generation of avant-garde artists was different from the previous one in several respects. They were born during the 1930s, witnessed Korean independence in their teens, and experienced the cataclysm of the Korean War or fought actively on the war front. Most of them were graduates of art colleges that were founded after 1946, and their cultural models were no longer Japan but Europe and America. They denounced Academic realism as being insufficient for the expression of their despair and the spirit of revolt. L'Informel, or Abstract Expressionism, became the newest artistic movement for them. The influence of this postcolonial generation was far-reaching, and the number of modern artists increased at an astounding rate. Contemporary Korean art today is still undergoing transformation. On the one hand, there is an ongoing tendency to preserve Korean culture and the spiritual heritage, while on the other hand, there are attempts to get closer to the spirit of free experimentation and to keep abreast of international art developments.

Notes

1. For changes in the Korean economy, culture, and education under Japanese colonial rule, see Andrew C. Nahm, *Korea: Tradition and Transformation*, 2nd ed. (Seoul: Hollym, 1996), 223–260; Peter Duus assesses Japan's initial motivation and goals in *The Abacus and the Sword: The Japanese Penetration of Korea, 1894–1910* (Berkeley: University of California Press, 1995).

2. No Tae-don, No Myŏng-ho, Han Yŏng-u, Kwŏn Tae-ŏk, and Sŏ Chung-sŏk, *Siminul wihan han'guk yŏksa* (A Korean History for Citizens), (Seoul: Changjak kwa Pipyŏng, 1997), 359–360. The Japanese colonial government, which first began ruling Korea under a harsh gendarmerie police system, shifted toward a more enlightened administration after the March First Movement in 1919 and proclaimed less severe regulations on education and the press. But the misnamed "cultural policy" of the 1920s remained superficial. In policy changes after the Manchurian Incident in 1931, a Rural Revival Movement was initiated with the aim of maximizing productivity in Korea to fight economic depression and support military aims. Investment was concentrated on developing such heavy industries as the Chosŏn Hydroelectric Power Company and the Chosŏn Nitrogenous Fertilizer Company and encouraging the mining of minerals. See Yi Ki-baek (Ki-baik Lee), *Han'guksa sinron* (A New History of Korea) (Seoul: Ilchokak, 1990), 440; in English translation, 1976 revised text, *A New History of Korea* (Harvard University Press, 1984), 350–358; also Michael Robinson, chapters 16–17 in Carter J. Eckert et al. (eds.), *Korea, Old and New, A History* (Seoul: Ilchokak, 1990), 276–326.

3. Han Yŏng-u, *Tashi channŭn uri yŏksa* (A New Searching for Our History) (Seoul: Kyŏngse-wŏn, 1997), 503.

4. Yi Ki-baek, *A New History of Korea*, 368.

5. Yi Ku-yŏl, *Kŭndae han'guk misulsa yŏn'gu* (A Study of the Modern History of Art in Korea) (Seoul: Mijin-sa, 1992), 422–423. For Saitō's reforms, see Michael E. Robinson, *Cultural Nationalism in Colonial Korea, 1920–25* (Seattle: University of Washington Press, 1988) 44–46.

6. The first Korean artist to attempt oil painting was Ko Hŭi-dong (1889–1965). While working as a clerk in the Korean royal court (1904–1905), Ko had a chance to observe sketches of Rémion (first name is not known), a French ceramic artist who had been invited to the court. Impressed by the new methods of representation, Ko decided to go to Tokyo to study oil painting and was admitted to the Tokyo School of Fine Arts in 1909. Ko, however, did not decide to go to Tokyo out of a sheer desire to become an oil painter. He was frustrated by Korea's political situation and the direction in which the country was heading and decided to indulge in the freer world of painting and a freer artistic life. Ko Hŭi-dong, "Nawa Sŏhwa Hyŏphoe sidae (Me and the Period of Sŏhwa Hyŏphoe)," *Shinchŏnji* (The New World) (February 1954), 181. Also see Youngna Kim (Kim Yŏng-na), "Modern Korean Painting and Sculpture," in John Clark (ed.), *Modernity in Asian Art* (Sydney: Wild Peony, 1993), 155.

7. For collaboration of artists, see Yi Tae-ho, "1940 nyŏndae choban chin'il misul'ŭi kun'guk chu'ŭijŏk kyŏnghyangsŏng" (The Militaristic Tendency of Pro-Japanese Art in the Early 1940s), in *Kŭndae han'guk misul nonchong* (Papers in Modern Korean Art), 320–360. An eminent scholar of the Korean Constitution, Yu Chin-o became president of Korea University in 1952 and was elected as a congressman and leader of the Sin Ming Dang (New Democratic Party) in 1967. For Yi Kwang-su's role as a collaborator, see

Grant S. Lee, "A Philosophical Appraisal of Yi Kwang-su: Man and Writer," *Korea Journal* 17:1 (January 1977), 48–52.

8. Most of the surveys of Korean early modern art were written in the 1970s and 1980s by such art critics as Yi Kyŏng-sŏng, now in his eighties, and Yi Ku-yŏl and O Kwang-su, now in their sixties. Since the last decade, a younger generation presently in their early fifties, such as critic Yun Pŏm-mo, art historians Hong Sŏn-pyo and Kim Yŏng-na, and even some from the newer generation, has published a number of related papers. They have together uncovered various records of artworks in private collections and articles in newspapers and publications. The most pressing problems in reconstructing early modern Korean art are locating and authenticating works of art and verifying details of artists' lives.

9. Especially important was the 1991 exhibition of Yi Kwae-dae (1913–?), a graduate of Teikoku Bijutsu Gakkō (Imperial School of Fine Arts), Tokyo, and an artist of leftist ideology who was in a prisoner of war camp at Kŏjedo during the Korean War and again chose the North during an exchange of prisoners in 1953. He is believed to have been active in North Korea until the late 1950s. This first showing of several of his multifigured compositions left a deep impression on viewers and critics. See *Wŏlbuk chakka Yi Kwae-dae chŏn* (The Exhibition of Yi Kwae-dae, An Artist Who Went to the North), Exhibition Catalogue, Shinsege Misulkwan (Museum of Shinsege), 1991, 10.8–10.27.

10. For a survey of Korean art education during the colonial period, see Kim Chŏng, "Han'guk misul kyo'yuk-ŭi kinŭng chŏnsu-mit kyosŏp pyŏnchŏn-sa" (A Study of the Transmission of the Function and History of Teaching Methods of Korean Art Education), in *Kŭndae han'guk misul nonchong* (Papers on Modern Korean Art) (Seoul: Hakkoje, 1992), 127–155, a collection of essays celebrating the sixtieth birthday of Yi Ku-yŏl.

11. Yi Ku-yŏl in addition mentions *nihonga* artists Sakuma Tetsu'en, Kubota Ten'nan, Fukui Kōmi, and Fujino Seiki, all of whom either visited or stayed in Seoul before 1910 (dates of these artists are unknown); see *Kŭndae han'guk misulsa ŭi yŏksa*, 169–183; also Choi Yŏl, *Han'guk kŭndae misul ŭi yŏksa* (History of Korean Modern Art) (Seoul: Yŏlhwa-dang, 1998), 114–115.

12. Yi Kyŏng-sŏng, *Sok kŭndae han'guk misulga nongo* (A Sequel to Essays on Modern Korean Artists) (Seoul: Ilchi-sa, 1989), 33.

13. Yi Chung-hi, "Chosŏn misul chŏllamhoe changsŏl-e daehayŏ" (About the Establishment of the Chosŏn Art Exhibition), in *Han'guk kŭndae misulsahak* (History of Korean Modern Art) 3 (1996), 104–120.

14. Hiyoshi Mamoru, "Chōsen bijutsukai no kaiko" (Recollections of the Art World in Korea), in Wada Yayoe and Fujihara Kizū (eds.), *Chōsen no Kaiko* (Recollections of Korea) (Seoul: Konozawa Shoten, 1945).

15. This information came from an interview with painter Yi Dae-wŏn, August 4, 1998. See also biographical details for twenty painters in one of the rare sources on modern Korean art to appear in English, *Modern Korean Painting* (Seoul: Korean National Commission for UNESCO, 1971), especially the section on Yu Yŏng-guk (Yu Yŏng-kuk), 76–77. Dates for many of the resident Japanese art teachers are as yet unknown.

16. Yi Dae-wŏn, who is now president of Korea's National Academy of Arts, recalls that Satō talked about Picasso and Matisse during classes and that it was Satō's influence that made him decide to become an artist. Satō, a graduate of the Tokyo School of Fine Arts, was a friend of well-known painter Saeki Yūzō (1898–1929) and participated in the Dokuritsu Bijutsu Kyōkai (Independent Art Association) exhibitions in Tokyo in the 1930s.

17. For modern Korean sculpture, see Kim Youngna, "Modern, after 1910" in the section "Korea III: Sculpture," in *The Dictionary of Art* (New York: Grove, 1996), vol. 18, 300–302. Several brief memoirs by these students tell in general what kind of education they received or provide information about fellow Korean students, but they say little about how they felt toward Japanese professors. See Kim Hŭng-su (Kim Soo), "Chŏnsiha-ŭi yuhak saenghwal; kŭ ŭmjiwa yangji" (Student Life under War: Its Shadowy and Sunny Part), and Kim Kyŏng-sŭng, "Kŭndae chogak-ŭi cheil sedae yŏttŏn tongmundŭl" (Alumni of the First Generation of Modern Korean Sculptors), *Wŏlgan Misul* (September 1989), 60–63; also Kim Pok-jin, "Chogak saenghwal 20 nyŏn'gi" (Twenty Years of Life as a Sculptor), *Chokwang* (Morning Light), (June 1940), 3–10.

18. *Hwangsŏng-Shinmum* (Hwangsŏng Newspaper), July 22, 1910, noted that Ko Hŭi-dong was sent to Japan by the Japanese vice-minister of the Department of the Royal Household, who had been impressed by the outstanding draftsmanship of the young artist. It should be noted that after the establishment of the Protectorate in 1905, all of the positions of vice-minister in the Chosŏn dynasty cabinet were filled by Japanese. Also, the second known Western-style painter to go to Japan, Kim Kwan-ho (1840–1959), received a scholarship from the newly established Korean government-general (Sōtokufu). See Yi Ku-yŏl, "Yanghwa chŏngchak-ŭi paekyŏng kwa kŭ kaechŏkjadŭl" (The Background of Western-Style Painting and Its Pioneers), in *Han'guk kŭndae hoehwa sŏnjip* (Selection of Modern Korean Paintings), vol. 1 (Seoul: Kumsŏng Chulpan-sa, 1990), 97.

19. *Tokyo Bijutsu Gakkō Ichiran, Taishō 15–16* (Bulletin of the Tokyo School of Fine Arts, Taishō 15–16), 68–69.

20. Yamanashi Emiko, "Kuroda Seiki to Tokyo Bijutsu Gakkō no yōga kyōiku" (Kuroda Seiki and Education in Western-Style Painting at the Tokyo School of Fine Arts), *Misulsahak* (Art History) 9 (1995), 101–121.

21. For the activities of Korean art students in Tokyo during the 1930s, see Kim Yŏng-na, "1930 nyŏndae tongyŏng yuhaksaengdŭl: Chŏnwi kurup-chŏn-ŭi hwaldong'ŭl chung-shimŭro" (Koreans Studying in Tokyo in the 1930s, Based on the Activities of Avant-Garde Group Exhibitions), in *Kŭndae han'guk misul nonchong* (Papers in Modern Korean Art), 273–319.

22. This March First Movement in 1919 was the first and most significant nationwide independence movement against Japanese rule by Koreans.

23. For Chosŏn Art Exhibition, see Chŏng Ho-jin, "Chosŏn misul chŏllamhoe chedo-e kwanhan yŏn'gu" (A Study of the Systems of the Chosŏn Art Exhibition), *Misulsahak Yŏn'gu* (Korean Journal of Art History) 205 (March 1995), 21–48.

24. The state art Salon of Japan started with the Bunten (Exhibition of the Ministry of Education) in 1907, renamed Teiten (Exhibition of the Imperial Art Academy) in 1917 when the sponsor was changed to the Imperial Art Academy. From 1935 to 1943, it was again renamed Shin Bunten (or New Bunten) and sponsored by the Ministry of Education. See essays by Ellen P. Conant and J. Thomas Rimer on Bunten and Teiten in Conant (ed.), *Nihonga, Transcending the Past: Japanese-Style Painting, 1868–1968*, (St. Louis: St. Louis Art Museum, 1995), 36–56.

25. Due to the increasing number of participating artists, the qualification was changed in 1935 to three years of residence in Korea. For rules of the Chosŏn mijŏn, see Chŏng Ho-jin, "Chosŏn misul chŏllamhoe," 21–48.

26. *Dong-a Ilbo* (East Asia Daily Newspaper), April 5, 1922.

27. Chŏng Ho-jin, "Chosŏn misul chŏllamhoe chedo-e kwanhan yŏn'gu," 34–35.

28. Yi chung-hi, "Chosŏn mijŏn sŏllip chŏn'ya ŭi misulge tonghyang" (Trends on the Eve of the Establishment of the Chosŏn Art Exhibition), *Han'guk kŭndae misulsahak* (History of Korean Modern Art) 3 (1996), 93–146.

29. For names of the judges from the fifth Chosŏn mijŏn, see *Chosŏn misul chŏllamhoe torok* (Catalogues of the Chosŏn Art Exhibitions), 1–19, 1922–1940, (Seoul: Chosŏn Sajin Tongshin-sa). Names of judges were also published in the newspapers. Initially there were several Korean judges for the calligraphy section, but only two Korean judges, Yi Do-yŏng (1884–1933) and Sŏ Bong-o (1862–1935), for Eastern-style painting from the first to sixth exhibitions. After 1927, all of the judges for Eastern- as well as Western-style painting were Japanese. See Chŏng Ho-jin, "Chosŏn misul chŏllamhoe chedo-e kwanhan yŏn'gu," 37.

30. The parent organization was the Sŏhwa Hyŏphoe (Society of Calligraphy and Painting), founded in 1918. See Youngna Kim, "Modern Korean Painting and Sculpture," 157.

31. One of the reasons for this was that the Chosŏn mijŏn adopted the prize system, whereas the Hyŏpjŏn was merely a group exhibition based on friendship. For the Hyŏpjŏn, see O Kwang-su, *Han'guk hyŏndae misulsa* (History of Korean Modern Art), revised edition (Seoul: Yŏlhwa-dang, 1995), 34–37.

32. *Chosŏn misul chŏllanhoe torok* (Exhibition Catalogues of the Chosŏn Art Exhibition) (Seoul: Chosŏn Sajin Tongshin-sa, 1922–1940), vol. 11 (1932).

33. Black and white plates of all of the selected works were printed in the exhibition catalogues, 1922–1940. However, catalogues were not published during the war years (1941–1944).

34. Kim Mi-ra, *1920–30 nyŏndae han'guk yanghwa tanche-ŭi yŏn'gu* (A Study of the Group Activities of Korean Western-Style Painters in the 1920s–30s), M.A. thesis for Ehwa Womens' University, 1996.

35. Even in the 1960s, the late president Park Chung Hee (1917–1979) chose a bull as the symbol of the Republican Party. As another sign of the appeal of this animal to the Korean people, Chŏng Ju-yŏng, president of the Hyundai business group, announced that he would send a thousand bulls and cows to North Korea in 1998.

36. Yamanashi Emiko, "Kuroda Seiki to Tokyo Bijutsu Gakkō," 106.

37. Kim Yŏng-na (Kim Youngna), "Kankoku no kindai bijutsu ni okeru ratai" (The Nude in Modern Korean Painting), in *Hito no katachi, hito no karada* (Human Form, Human Body), Tokyo National Research Institute of Cultural Properties, ed. (Tokyo: Heibonsha, 1994), 305–319. For a revised version by the author in Korean, see "Han'guk kŭndae ŭi nudŭhwa," in Kim Yŏng-na, *Issip segi ŭi Han'guk misul* (Art of Twentieth-Century Korea) (Seoul: Yekyong, 1998), 115–142.

38. For ordinary Korean women in the first half of the twentieth century, it was unthinkable to pose nude in front of male artists. It was not until the 1950s that professional models became common in artists' studios. See Yi ku-yŏl, "Han'guk-ŭi kŭndae misul 60 nyŏn" (Sixty Years of Modern Korean Art) (Seoul: Ŭlyu Munhwa-sa, 1972), 182–203.

39. Kim and other painters, such as Yi In-sŏng and Sim Hyŏng-gu, were stars of the Chosŏn mijŏn, winning special prizes several times and becoming "Select Artists." From 1936, under the new system, Select Artists could assist the judges at the Chosŏn mijŏn, which meant they could influence the vote of visiting Japanese judges who knew little of Korean art activities.

40. Kim Yun-su, *Han'guk hyŏndae hoehwasa* (A History of Contemporary Korean Painting) (Seoul: Han'guk Ilbo-sa, 1975), 122–158.

41. Yi Kyŏng-sŏng, "Yi In-sŏng ŭi saeng-e wa misul" (Yi In-sŏng's Life and Art), in *Yi In-sŏng Chakpumjip* (The Works of Yi In-sŏng) (Seoul: Han'guk misulchulpan-sa, 1972), 81.

42. Yi Kyŏng-sŏng, "Kŭndaejŏk kamgakju'ŭi" (Aestheticism in the Modern Sense), in *Han'guk hyŏndae misul chŏnjip* (Complete Works of Korean Modern Art), vol. 15 (Seoul: Han'guk Ilbo-sa, 1978), 88.

43. Yu Hong-jun, "Han'guk kyŏndae hoehwasa ŭi chŏntong kwa changjo" (Tradition and Creation in Korean Contemporary Painting), *Misulsahak* 5 (1991), 25–35.

44. Kagesato Tetsurō, "Tōyōteki Tenkeibi no Sōzō" (Imagining Typical Asiatic Beauty), in *Art Gallery Japan 20 seiki Nihon no Bijutsu 11: Kuroda Seiki, Fujishima Takeji* (Art Gallery Japan Twentieth Century Japan's Art 11), (Tokyo: Nihon Art Center), 1987, 83. Also Fujishima Takeji, *Geijutsu no esupuri* (The Spirit of Art) (Tokyo: Chūō Kōron Shuppan, 1982), 247–251. Here Fujishima wrote that Korea—a peninsula with a long history and distinguished tradition, clear weather, and interesting people's costumes—reminded him of Italy.

45. O Kwang-su, *Han'guk hyŏndae misulsa*, 70–71.

46. Only a few photographs of prints and paintings expressing leftist ideals or depicting the proletariat have survived.

47. For Yi Chong-u, see Yi Il (Lee Yil), "The Influence of French Art on Korean Art—What Is French and What Is Korean," *Korea Journal* 24:6 (June 1987), 46–47.

48. Nikakai was formed in 1914 by artists who believed that the standards applied to artworks at the official exhibitions were too rigid and lacked sufficient understanding of progressive art. They exhibited at Ueno in the fall to coincide with the official exhibition and became the center of alternative art practices against the establishment. During the 1930s, however, even Nikakai lost its vitality and was bypassed by many art groups that sprang up randomly. The 1930 Nen Kyōkai was founded in 1926; the Dokuritsu Bijutsu Kyōkai in 1930.

49. For a recent assessment of Yi Sang and his poems, which were published primarily in Japanese, see M. J. Rhee, "Border Writing: Yi Sang and Colonial Korea," in *The Doomed Empire: Japan in Colonial Korea* (Brookfield, VT: Ashcraft, 1997).

50. See Michiaki Kawakita (Kawakita Michiaki), *Modern Currents in Japanese Art,* trans. by Charles S. Terry (New York: Weatherhill, 1974), 108–115.

51. The Jiyū Bijutsuka Kyōkai was forced to change its name in 1941 to Bijutsu Sōsakuka Kyōkai (Creative Artists Association) but continued to hold exhibits until 1944. See Kim Youngna, "1930 nyŏndae tongkyŏng yuhakseng dŭl: chŏnwi group chŏn ŭl chungsimŭro" (Korean Avant-Garde Artists in Tokyo in the 1930s), 173–319.

52. Kim Byŏng-gi, "1930 nyŏndae tongkyŏng yuhaksaeng kwa avant-garde" (Koreans Studying in Tokyo in the 1930s and Avant-Garde), *Kana Art* (publication of Kana Art Gallery, Seoul), 7:8 (1994), 170–177. See also Nagoya Municipal Museum, *Nihon no Surrealism, 1925–1945* (Japan's Surrealism, 1925–1945), Exhibition Catalogue (1990), 56.

53. O Chi-ho, *Yi in Hwajip* (Two-Man Painting Catalogue) (Kyŏngsŏng [Seoul]: Hangsŏng Dosŏ, 1938), 10.

54. Takiguchi Shūzō singled out "a landscape with a horse and human figure in our Eastern kind of style. . . . I hope he can continue to develop," *Atelier* (July 1938). Hasegawa Saburō said, "The works by Mun-Hak-su are the best in this exhibition. The judges selected him unanimously as a member" (*Bi no kuni* [The County of Beauty] [July 1938], 24).

55. Kim Byŏng-gi now resides in New York State. An interview with the author took place on March 1, 1992.

56. The Chosŏn mijŏn system changed over the years. When it started, there were three sections: Eastern-style painting, Western-style painting, and calligraphy. In 1925 sculpture was added to the Western painting section, and in 1932 calligraphy was replaced by crafts, to which sculpture was added in 1935.

57. For instance, writer Yi Kwang-su claimed very early that traditional Chosŏn painting lacked variety of subject matter and modern artists should depict scenes of contemporary life and culture (*Mae-il Shinbo*, October 31 and November 2, 1916). O Kwang-su has recently addressed the problem of terminology and special characteristics in defining a Korean painting in "Trends in Korean Painting," *Koreana* 10:3 (Autumn 1996), 62–69.

58. For a recent monograph on Yi Sang-bŏm, see *Yi Sang-bŏm*, essays by Hong Sŏn-Pyo, and *Yi Sŏng-mi* (Seoul: Samsung Cultural Foundation, 1997). An older source in English is O Kwang-su, "Posthumous Exhibition of Yi Sang-bŏm's Works," *Korea Journal* 13:1 (January 1973), 50–54.

59. The latest source is *I Tang Kim Ŭn-ho*, Exhibition Catalogue (Seoul: Ho-am Art Galley, 1992).

60. *Dong-A Ilbo*, October 9, 1930. Pyŏn Kwan-sik, a student for five years at the private studio of Komuro Suiun, is another example of a landscape artist who learned *nihonga* styles from a master in Tokyo and who represents the Japanization of traditional Korean ink painting in the 1930s. See O Kwang-su, "The World of Pyŏn Kwan-sik," *Korea Journal* 9:5 (May 1969), 27–28; also, UNESCO, *Modern Korean Painting*, 50–51.

61. "Chŏnsiha-ŭi yuhak saenghwal," 62–63.

62. Choi Yŏl, *Han'guk kundai misul ŭi yŏksa*, 522.

63. See Yi Tae-ho, "1940 nyŏndae choban chin'il misul'ui kun'guk ju'ŭi jŏk kyŏng-hyang-sŏng," 320–360.

64. Ko Yu-sŏp (1905–1944), who studied aesthetics and art history at Kyŏngsŏng Imperial University, was the only Korean who attempted to write Korean art history. Yet Ko died at the age of thirty-nine, leaving many essays but only one book on Korean Celadon written in Japanese during his lifetime. His other writings were published posthumously in a book series.

65. Because of the Korean War, this national art exhibition was not held again until 1953 and after; by the late 1950s, many modern painters were restless under its rules and aesthetics and began forming new associations. See Yu Chun-sang, "Forty Years of Fine Arts in Korea, 1945–1985," *Korea Journal* 16:1 (January 1986), 4–11, 37.

66. For postcolonial art, see O Kwang-su, *Han'guk hyŏndae misulsa* (History of Korean Modern Art), revised edition (Seoul: Yŏlhwa-dang, 1995); also Kim Yŏng-na, *Issip segi ŭi Han'guk misul*.

67. For information about artists who went to North Korea, see *Pugŭro kan hwangadŭl* (Painters Who Went to the North), ed. by Yi Ku-yŏl (Seoul: Kŭmsung chulpan-sa, 1990).

68. Yi Ku-yŏl, "Fine Arts in North Korea: Changes and Characteristics," *Korea Journal* 34:4 (Winter 1991).

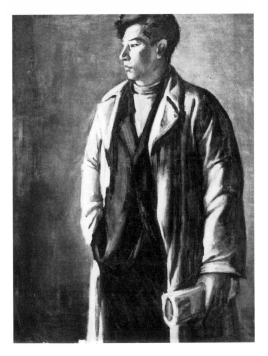

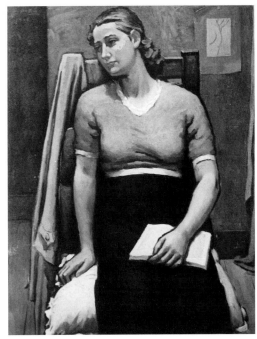

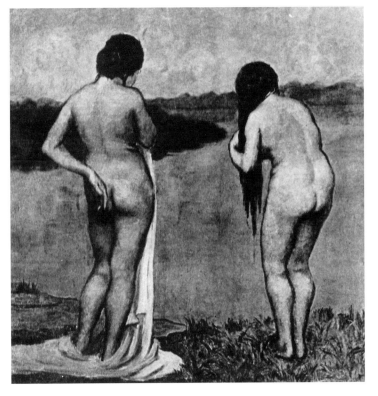

Plate 41. *(Top left)* Yi Ma-dong, *A Man*, 1931. Oil on canvas. 115 cm x 817 cm. National Museum of Contemporary Art, Kwach'on.

Plate 42. *(Top right)* Kim In-sŭng, *A Girl Reading*, 1937. Oil on canvas. 116.5 cm x 91 cm. Private collection.

Plate 43. *(Left)* Kim Kwan-ho, *Sunset*, 1916. Oil on canvas. 127.5 cm x 127.5 cm. Museum of the Tokyo University of Arts, Tokyo.

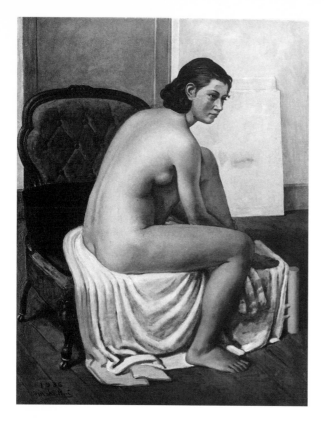

Plate 44. *(Left)* Kim In-sŭng, *Nude,*
1936. Oil on canvas. 162 cm x 130 cm.
Ho-am Art Museum, Yong-in.

Plate 45. *(Below)* Kim In-sŭng, *Spring
Melody,* 1942. Oil on canvas. 209 cm x
147 cm. Bank of Korea, Seoul.

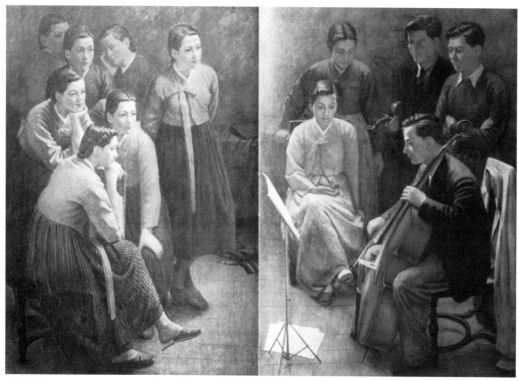

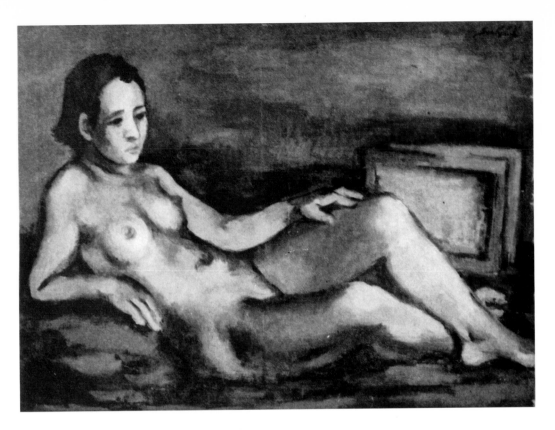

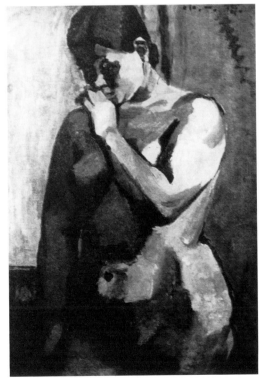

Plate 46. *(Top)* Im Kun-hong, *Reclining Nude,* 1936. Oil on canvas. 59 cm x 78 cm. Private collection.

Plate 47. *(Left)* Sŏ Chin-dal, *Nude with Her Left Hand on the Lips,* 1937. Oil on canvas. 71 cm x 51 cm. National Museum of Contemporary Art, Kwach'on.

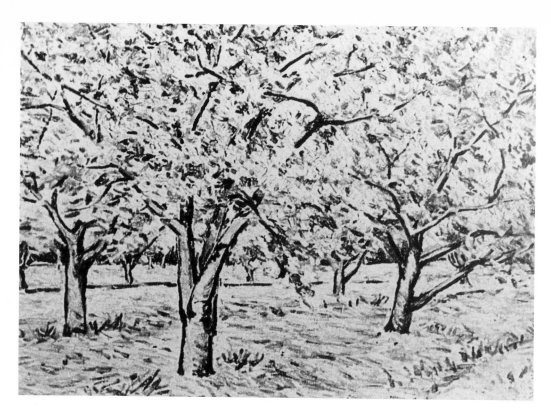

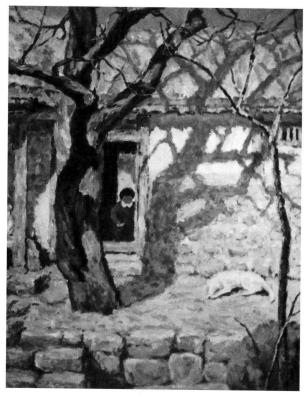

Plate 48. *(Top)* O Chi-ho, *The Field with Apple Trees,* 1938. Oil on canvas. 73 cm x 91 cm. Private collection.

Plate 49. *(Right)* O Chi-ho, *A House Facing the South,* 1939. Oil on canvas. 79 cm x 84 cm. National Museum of Contemporary Art, Kwach'on.

(Opposite page)

Plate 50. *(Top)* Kim Yong-jo, *Seascape,* painted during the 1930s. Oil on board. 40.5 cm x 52.5 cm. Private collection.

Plate 51. *(Bottom)* Yi In-sŏng, *A Day in Autumn,* 1934. Oil on canvas. 97 cm x 162 cm. Ho-am Art Museum, Yong-in.

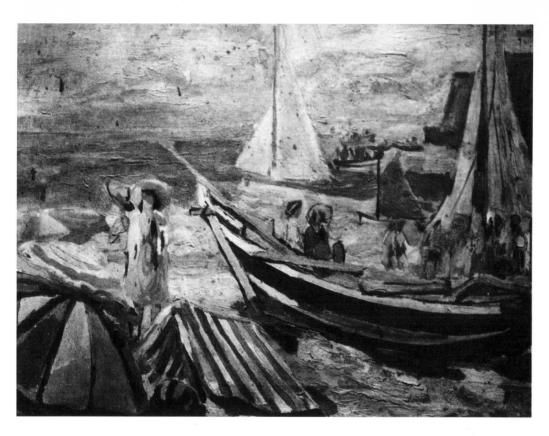

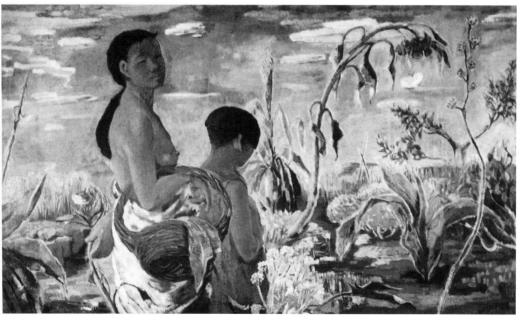

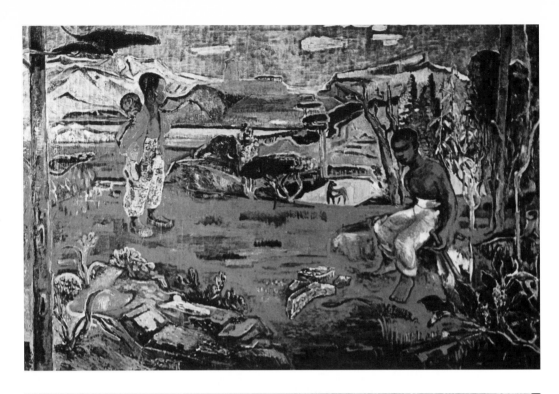

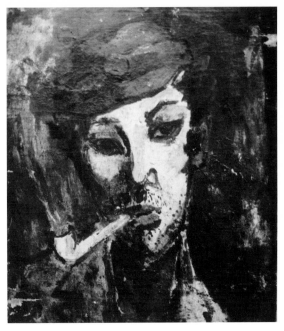

Plate 54. *(Top left)*
Ku Pon-ung, *Woman*, 1935.
Oil on canvas. 50 cm x 38
cm. National Museum
of Contemporary Art,
Kwach'on.

Plate 55. *(Top right)*
Ku Pon-ung, *Portrait of a
Friend*, 1935. Oil on canvas.
65 cm x 53 cm. National
Museum of Contemporary
Art, Kwach'on.

Plate 56. *(Left)*
Kim Hwan-gi, *Window*,
1940. Oil on canvas.
80.3 cm x 100.3 cm.
Private collection.

(Opposite page)

Plate 52. *(Top)* Yi In-sŏng, *In the Mountains of Kyŏngju*, 1935.
Oil on canvas. 136 cm x 195 cm. Private collection.

Plate 53. *(Bottom)* Kim Chung-hyŏn, *A Village Scene*, 1940.
Oil on canvas. Dimensions not known. Private collection.

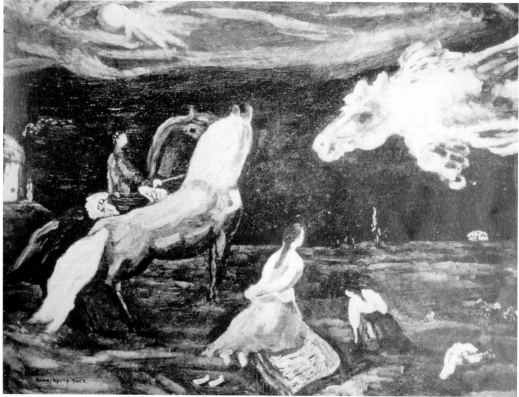

Plate 59. *(Top)* Yi Sang-bŏm, *Early Winter,* 1925. Ink and light color on paper. 153 cm x 185 cm. National Museum of Contemporary Art, Kwach'on.

Plate 60. *(Right)* Kim Ŭn-ho, *A Solitary Player,* 1927. Color on silk. 138 cm x 85.5 cm. Ho-am Art Museum, Yong-in.

(Opposite page)

Plate 57. *(Top)* Yu Yŏng-Kuk, *Work R3,* 1938. Wood relief. 65 cm x 90 cm. Destroyed.

Plate 58. *(Bottom)* Mun Hak-su, *Conviction of Chun-hyang,* 1940. Present whereabouts unknown.

Plate 61. *(Top)* Sim Hyŏng-ku, *We Guard Asia*, 1940. Location unknown.

Plate 62. *(Bottom)* Fujita Tsuguji, *Nomonhan, Battle Scene at the Halha River*, 1941. Oil on canvas. 140.0 cm x 448.0 cm. Photograph from the collections of the Tokyo National Museum of Modern Art.

(Opposite page)

Plate 63. *(Top)* Fujita Tsuguji, *Final Fighting at Attu*, 1943. Oil on canvas. 193.5 cm x 259.5 cm. Photograph from the collections of the Tokyo National Museum of Modern Art.

Plate 64. *(Bottom)* Fujita Tsuguji, *End of American Soldiers, Solomon Sea*, 1944. Oil on canvas. 193.0 cm x 258.5 cm. Photograph from the collections of the Tokyo National Museum of Modern Art.

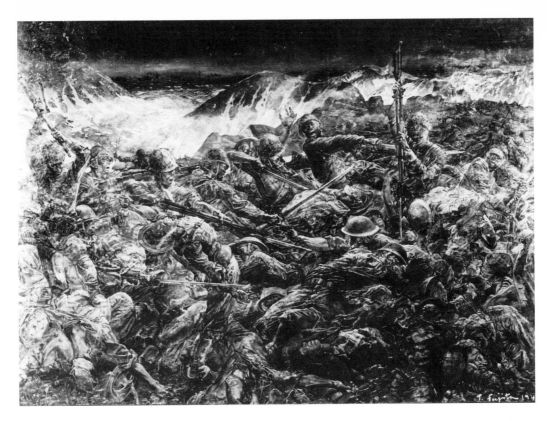

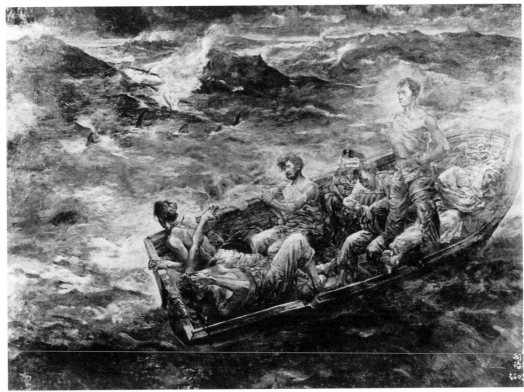

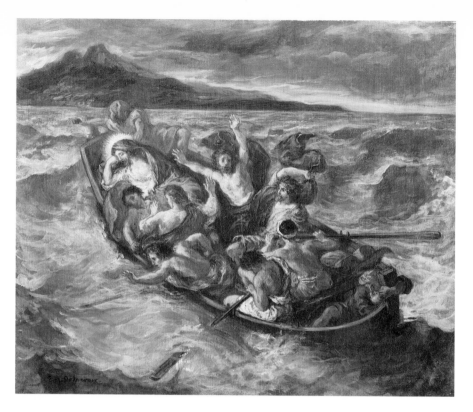

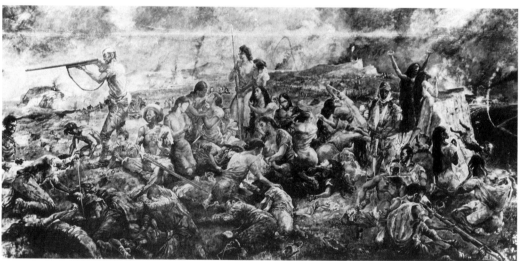

Plate 65. *(Top)* Eugène Delacroix, *Christ Asleep during the Tempest*, ca. 1854.
Oil on canvas. 50.8 cm x 61 cm. The Metropolitan Museum of Art,
H. O. Havemeyer Collection. Bequest of Mrs. H. O. Havermeyer, 1929.

Plate 66. *(Bottom)* Fujita Tsuguji, *Japanese Prefer Death by Suicide to Dishonor
at Saipan*, 1945. Oil on canvas. 181.0 cm x 362.0 cm. Photograph from the
collections of the Tokyo National Museum of Modern Art.

CONFLAGRATION:
World War II in East Asia and the Pacific

The Many Lives of *Living Soldiers:*
Ishikawa Tatsuzō and Japan's War in Asia

Haruko Taya Cook

Japan launched a full-scale war with China in the summer of 1937, following the Marco Polo Bridge Incident near Beijing on July 7, 1937. First, Japanese divisions poured into northern China, and then a battle erupted outside the international city of Shanghai that raged for weeks before imperial army troops broke out and drove on the Chinese Nationalist's capital of Nanjing. From its inception, this conflict was accompanied by active public interest and desperate efforts by Japanese news organizations to cover "The China Incident," as the conflict was designated by Japan's government. Almost immediately after hostilities began, large numbers of professional authors flocked to the fronts as special correspondents.[1] Their reports soon adorned newspapers and magazines back home in Japan.

Ishikawa Tatsuzō (1905–1985), thirty-two years old in 1937, was commissioned to write a war novel by *Chūō kōron* (The Central Review)—one of the country's leading monthly magazines. Ishikawa had won the first Akutagawa Prize in 1935 for *Sōbō* (The Common People), a novel about Japanese immigrants to Brazil based on his own experiences as an immigrant to Brazil for a brief time in 1930.[2] Ishikawa was the third son of a schoolteacher in Akita Prefecture who traced his descent to both warriors and Buddhist priests. If one examines his autobiographical short stories, they seem to evoke a complex and psychologically troubled childhood. His formal education was often interrupted by moves or the financial difficulties of his family—they had to move in with relatives—though he did spend one year at the English Department of Waseda University. He then worked as an editor for industrial papers while writing his fiction in obscurity, until his Akutagawa Prize thrust him into prominence.[3] Now he found himself headed for China with an open brief to write a novel about the war there.

Ishikawa left Kobe by military freighter on December 29, 1937, and landed at

Shanghai on January 5, 1938. Together with five imperial army officers he had met aboard the ship—men heading to Nanjing to take up positions of platoon and company commanders replacing those who had been killed in action—he made his way through several cities to the capital, a hundred miles up the Yangzi River. He stayed in Nanjing from January 8 to January 15.[4] He then returned to Japan.

Back home, Ishikawa Tatsuzō produced a 330-page manuscript in just eleven days. "I exerted all my strength," he declared later. "I did not leave my desk while I was awake," setting down "an average of thirty manuscript pages each day."[5] He entitled the work *Living Soldiers (Ikiteiru heitai)* and submitted it to his magazine. Scheduled for publication in March 1938, the novel was suppressed by the authorities, and the case escalated with the indictment and prosecution of its author and publisher. Yet this particular case did not become a cause célèbre; it was merely one more instance of government action against writers—of the censorship and suppression that were so frequent in Japan in this era.

Often censorship is seen as a fairly straightforward phenomenon. Its effects are well recognized: literary energies derailed; ideas repressed; the authorities holding the upper hand over the creative mind. This essay explores the censorship of Ishikawa's *Living Soldiers*. It demonstrates how insidious and multilayered censorship can be. Censorship was exercised by author, publisher, government, and army during the war, and by the Allied Occupation authorities after it. It was even *advocated* by other Japanese writers.[6] Histories of Japanese wartime literature have glossed over the Ishikawa story and made pronouncements that seem, on examination, to be little related to the novel. The fate of Ishikawa's work may help to bring about a fuller understanding of the essence of censorship itself and some of its effects on the creative process.

Living Soldiers

What was the nature of the work that was at the center of controversy early in Japan's war with China? Ishikawa's *Living Soldiers* tells the story of a platoon in the Japanese army over the month prior to the capture of Nanjing on December 12, 1937. At the onset of the novel, a brief passage sums up the history of the platoon up to this point. Their unit advanced, chasing the enemy through the dust and swarms of flies all throughout the lingering heat of the summer. They lost two company commanders and one-tenth of the men in action by the time the fall frost had come. They have heard nothing about when they may expect the arrival of a reserve unit to augment or replace them.

After this short introductory passage, *Living Soldiers* begins with a scene in which Corporal Kasahara catches a Chinese youth near a burning house behind the regimental headquarters. Whether the prisoner is viewed as a common civilian or an accused spy is not made clear. Kasahara casually chops off the youth's head with his sword, then kicks the body into the river. The scene is both graphic and explicit:

Instantly the cries of the young man ceased and the field was restored to a quiet evening scene. The head did not fall off, but the cut was sufficiently deep. The blood gushed out over the shoulders before his body fell. The body leaned toward the right and dropped into the wild chrysanthemums on the bank, and rolled over once more.[7]

Ishikawa is not interested in the strategy and tactics of the battles, although he uses the advance of the Japanese force as a chronological frame for the work. He focuses on the behavior and mental state of individual soldiers, noncoms, and officers who find themselves placed down in war, something he sees as "a matter for the state." The protagonists of the novel are a group of soldiers of Kurata Platoon, Nishizawa Regiment, Takashima Division. They are divided between two general types. The first is exemplified by Corporal Kasahara, a farmer who is able to keep a stable head in any combat situation and is able to kill without hesitation. Buddhist chaplain Katayama also belongs to this category. We see him beating captured enemy soldiers to death with a shovel in one hand and a priest's Buddhist rosary in the other.

The second category consists of three men with enough literary education to justify their status as members in the first rank of Japan's prewar "intellectuals." Second Lieutenant Kurata was once an elementary schoolteacher; Private First Class Kondō was formerly a medical student; and Private First Class Hirao had been a proofreader at a newspaper.[8] Kurata continues to keep a diary even after the most severe combat. He wonders whether or not he should write a letter bidding farewell to his pupils, since that might cause a shock to their young minds. He is one of those rare characters who is able to think from the enemy's perspective. Kondō, who arrived at the front with a medical student's respect for human life, comes to realize that life is not something to venerate and concludes that his intelligence is of no use in the war. A romantic, urban youth, Hirao suffers emotionally; his delicate mind is unable to maintain its balance and he becomes totally confused.

They go through an agonizing process as they lose their sensitivity, reverence for life, and "intellectual morality" in the face of their own deaths. After they are freed from delicacy and the ability to reason, they at last become comfortable at the front and can face combat. They cease to be men and seem to turn into animals. After one battle, Ishikawa describes them that way (Ishikawa's original draft presented to his editors—but omitted from the work published in 1938—included the lined out words indicated here):

The friendly force headed for Changzhou chasing the stragglers, while the ~~Nishizawa Regiment~~ [replaced by **unit**] took rest in Wuxi for three days. It was in such a situation that the surviving men most ~~desired women.~~ They walked around with large strides inside the town and ~~searched for women like dogs chasing a rabbit.~~ This ~~aberrant behavior~~ was ~~strictly controlled~~ at the battle front in northern China. However, it was difficult ~~to restrain their behavior~~ here.

They came to feel proud and willful, as if every one of them was ~~an emperor~~ or a tyrant. When they ~~failed to achieve their objectives in town,~~ they went out ~~to civilian houses~~ far outside the wall. They could run into perils from stragglers who were hiding themselves and from armed natives in the area. But the soldiers had no sense of either hesitation or scruples. They felt as if none would be stronger than they themselves in the world. Needless to say, ~~morality, law, introspection and humanity completely~~ lost their ~~power~~ in the midst of such feelings.[9]

By the end of the novel, every character takes on the characteristics of Kasahara, a man who does not flinch from slaughter. Ishikawa concentrates on the intellectuals, and we are shown how each is transformed from human being to a full-fledged soldier. The author seems to assert that war must draw out the worst in men. Ishikawa's omniscient narrator says: "A battlefield seems to have such strong and powerful effects that it makes every combatant the same in character while one is unaware of it, and makes him think of only matters of the same level and demand merely the same."[10]

Ishikawa's portrayal of the enemy dead is extremely powerful and callous, using concrete language. A few examples of the matter-of-factness of enemy death make this clear:

> Still, the dead bodies were lying on the wide streets, too. They became black and withered as the days passed. Eaten away by cats and dogs overnight, the bodies grew leaner each succeeding day. One was literally a skeleton already, its legs mere bones. The corpses got so old that they looked like mere trash.[11]

And later:

> "Hey, Kondō, this guy has shoes on. [He] still intends to escape. Aha ha ha!" A dead body covered by a straw mat lay in front of a tobacco shop [Kasahara] had chanced to pass. Five cats kept a sharp watch on it. The cats, on guard, glared into the street, the tips of their noses red and wet.[12]

Graphic and expressive descriptions of the horrors of the dead of his own side are not to be found in the pages of *Living Soldiers*.[13]

Ishikawa's portraits of Japanese soldiers at the front are neither glorified nor beautified, although in combat they do fight bravely and are killed. Whenever fighting ceases, no matter how briefly it may be, they forage for food and "fresh meat"—the euphemism for women.

> The cow has started walking along unconcernedly, [raising] a cloud of dust in the path. The men have begun to feel good. There are unlimited riches on this continent. And ~~[the men] seize~~ [them] as if the continent's riches were theirs. ~~The private possessions~~ of the residents now lie open to the desires of soldiers, as if [they] were wild fruit.[14]

Soldiers slaughter the captured and set fire to houses before they move on to their next fight. They brutally kill Chinese civilians, men and women, on their advance to Nanjing. Ishikawa seems to assert that these acts are carried out *because* of war. War seems to have its own logic, separate even from time and place.[15]

While Ishikawa's two intellectual characters, Privates Kondo and Hirao, are billeted in a residential area on the road to Nanjing, they enter a grandiose residence with a Western-style entrance hall, chandelier, and a fireplace faced in marble that has already been "ransacked by the Chinese [*Shina*] Army." There Hirao locates a sundial bearing the twelve signs of the zodiac. He is astounded: "Oh! This is the everlasting *Shina* [China]. *Shina* exists in modern times, but it is not modern. It dreams the culture of ancient times and breathes in the ancient culture."[16]

At great cost, the regiment succeeds in taking Zijing Mountain, the ridge overlooking Nanjing. During this attack, men sleep in a skirmish formation on the frosty mountainside. They sleep side-by-side with "fallen war comrades," protecting the corpses. A soldier takes his coat off and covers himself and his fallen buddy with it. At one point, the transcendent narrator of *Living Soldiers* describes the soldiers' feelings toward the dead and their remains:

> They did not have the eerie sensations and feelings of repugnance toward these remains that might be felt about ordinary dead or corpses; contrarily [they] felt particularly close [to the remains]. The bones themselves seemed to be still alive. They each might have felt already that his [own] life was only a temporary form and that within the day he might become just like the bones. They might be just living remains.[17]

Skillfully, Ishikawa presents the notion that, in battle, there is no clear distinction between life and death. Rather, a total confusion between the two takes place. He suggests that this confusion is reality for soldiers at war in China.

From Zijing Mountain, a hill overlooking the city, the soldiers see the city of Nanjing in a "whirlpool of flames."[18] The regiment enters the Chinese capital on December 13. Soon, Japanese merchants move up from Shanghai to establish commissaries in the city. "Comfort Places"—brothels for the soldiers—open up.[19] Things having settled down, after a brief stay in Nanjing the regiment moves on, bound for an unknown destination. The war continues. There is no final resolution for the men and no end to the war even seems possible. Thus ended the story Ishikawa Tatsuzō set down for his publisher.

The Publisher and the Story

Chūō kōron is perhaps best known as the monthly magazine that played a central role in the Taishō democracy. Professor Yoshino Sakuzō, who taught at the Tokyo Imperial University and a leading liberal, was a regular contributor.[20] Together with *Kaizō* (Reconstruction), *Chūō kōron* reigned over the magazine world among the intellectuals, priding itself for upholding its liberal tradition even at the onset

of the conflict with China. According to Hatanaka Shigeo—a member of the magazine's editorial staff at the time—*Chūō kōron* provided opportunities to publish to authors who were accused, arrested, and released under the Peace Preservation Law of 1925. At the same time, the magazine also carried writings from military men to stave off censorship. Hatanaka said that kind of article was referred to jokingly among the magazine's staff as "our magic shields."[21] Something of a golden era for Japanese magazines came with the start of the war in China. The stars who emerged through their fiction would become much-sought-after bearers of the story of Japan's war.[22]

Suppression of Ishikawa's new work was not completely unexpected by the editorial staff. Editor-in-Chief Amemiya Yōzō later recalled his feelings: "While reading this [the manuscript], I thought it would either be crushed or it would achieve a great hit. I made the decision to carry it with that [last] expectation. It was my ambition and gamble as editor-in-chief. . . . Reading at the proof stage, I thought, 'this might be [it].' There was no other work to replace it. I touched up the work."[23]

When the March issue was published, *Living Soldiers* was placed in the back of the magazine, with separate pagination, beginning with a new page one, as if in anticipation of censorship.

Amemiya's concerns were appropriate in the atmosphere of the late 1930s. Numerous publications were banned and could not be sold or distributed.[24] Yet as Hatanaka Shigeo describes it, there was a sense of resistance among the editorial staff: "[We] dared to publish, taking a calculated risk. Long-standing resentment toward those arrogant people who were conducting the war and our dissatisfaction with the unreasonable war must have been factors in our psychology."[25]

At least this is what they say looking back on it decades later. Clearly, they ran a great risk in publishing *Living Soldiers*. They also had considerable experience at running such risks. *Chūō kōron* and *Kaizō*—each with a monthly circulation of approximately one hundred thousand in the early 1930s (compared with about one million for a leading daily newspaper like the *Asahi shimbun*)—have even been called by one student of prewar mass media "an excellent test of permissiveness" for censorship based on political content.[26] Again and again, the journal *Chūō kōron* was "tested." Its liberalism of earlier days had slipped considerably by the time the "China Incident" began in July 1937.[27]

In fact, the editors who published Ishikawa's novel were not as bold in their defiance of government-imposed standards as they may have recalled. Prior to the scheduled publication in the March 1938 issue, *Chūō kōron* conducted its own extensive prepublication self-censorship. As a result, Ishikawa's 330-page manuscript was reduced by 80 manuscript pages. Numerous words, phrases, lines, and even pages were deleted, as we shall see below. The traces of the cuts were clearly noticeable throughout. Lines of periods, ellipses—empty circles—and sometimes completely blank spaces pock-marked the pages of the magazine in place of the omitted words. Moreover, the last two chapters were completely deleted, indicated merely by

two dotted lines.[28] It seems appropriate to ask, in light of the mentality of the editorial staff described above, why the novel was so severely cut. Indeed, it may well be asked why they went on to even attempt to publish.

One answer important to understanding the world of magazine publishing in the wake of intensive "thought control" may be found in the relationship established on "trust between the magazine and its readers." Hatanaka Shigeo asserts that readers of the magazine were capable of doing even more than "reading between" the dotted lines. He believes they were capable of deciphering even the blank spaces.[29] A strongly "liberal" readership, used to code words, educated in accepting blanks for such forbidden terms as *Communism,* were, the editors claim today, capable of supplying a word for a given blank. The destroyed sentences, paragraphs, and stories might have told their readers more than the complete text had revealed, they believed. While such statements cannot be tested here, it seems to me that the publisher and the reader almost became partners in accepting censorship. They were prepared to substitute an egotistical sense of their own superiority over the censors for true freedom of expression.[30]

Figure 1. The first page of *Living Soldiers* of Ishikawa Tatsuzō, from the suppressed March 1938 issue of *Chūō kōron.* (From a microfilm supplied by the National Diet Library, Tokyo)

The publishing date of the March issue was scheduled to be February 19, 1938. On February 17, a copy of the March issue of *Chūō kōron* containing *Living Soldiers* was submitted for inspection to the Book Section of the Home Ministry—responsible for keeping control over literature—while the magazines went to the distributors. The editorial members at *Chūō kōron* spent the eighteenth anxiously, dreading a possible phone call from the authorities. That night, while Ishikawa and the editorial staff were celebrating the novel's publication, they learned that an announcement prohibiting publication of *Living Soldiers* had been issued by the Home Ministry.[31] The editors, office clerks, errand boys, and the whole distribution crew now had to race through the darkened streets of Tokyo to local police stations where the issues were stacked in great bundles. The novel had to be cut from each magazine individually, meaning that 105 printed pages had to be sliced out of about 600 bound pages.[32] While this left a loosely covered remnant, it meant no break in pagination, since the table of contents records the fact that *Living Soldiers* had been at the back of the issue and its pages numbered separately from 1 to 105.

The author knew that it would not be enough to present this work as a novel; he felt he had to emphasize that it was fiction. In a brief author's postscript to the novel, Ishikawa wrote: "This manuscript is not a faithful record of actual battles. The author has attempted a free creation. Please understand that the names of units and officers and soldiers are all fictitious."[33]

Self-Censorship

Of course, the first censorship of this work was no doubt undertaken by Ishikawa himself. The Nishizawa Regiment in *Living Soldiers* entered the city of Nanjing on December 13, 1937. The almighty narrator introduces the unit's entry into the city with the phrase, "The mopping up of the friendly force within the walled city was most ghastly."[34] He then describes the machine-guns of the Japanese forces opening fire on Chinese stragglers in the river. Such "mopping-up" operations, inside and outside the city walls, continue on the fourteenth, fifteenth, sixteenth, and the seventeenth. The reader is never told what the protagonists did on these days. Ishikawa says no more about Chinese civilians and the captured in Nanjing. Other contemporary Japanese observers were not so delicate.

A special telegram from the Shanghai office of the *Asahi* on December 15, 1937, reported:

> All imperial units that brought about the fall of the Nanjing citadel gathered within and outside the walls; some [units] participated in operations to mop-up the [enemy] stragglers—who hid and then reappeared—and were engaged in putting the city in order. It has been estimated that those captured and annihilated by our forces amount to more than 60,000 men in the battle to capture Nanjing.[35]

A special telegram from the Shanghai *Yomiuri* at 6:00 P.M. on December 29 reported:

> Damage to the enemy resulting from the attack on the Nanjing defense line to the complete capture of Nanjing has been announced in part. According to precise studies, the number of abandoned enemy bodies alone amounted to the large figure of 84,000, while the total of "our" killed-in-action and injured was about 4,800.[36]

Ishikawa's novel purports to be about the month prior to the fall of Nanjing. We know, however, that he did not even arrive in the city until January 8. Historically, in those days in December—just after the breaching of the walled Citadel—began what became known throughout the world as the "Rape of Nanjing." Many who have unearthed the full horrors of the Japanese army's actions have said that the "rape" went on well into the next year.[37]

When *Living Soldiers* went to the publisher, the next stage in the process of censorship began. A comparison of the two texts—an actual *Chūō kōron* issue of March 1938 that survived the war and was available for this project and the first complete postwar text, published by Kawade Shobō in late 1945—affords us an unusual opportunity to examine the publisher's insight into censorship at the time the book was first suppressed.[38] The publisher's own clearly visible self-censorship may reveal as much about conditions of freedom of expression as does the suppression of the work by the Home Ministry.

The first major cuts were the uniform substitution of the word "units" for all references to "divisions" and "regiments." Terms for commanders at each level and military rank were represented by "unit commander." Place names survived as they were, with the exception of Dalian [Dairen], in Manchuria, which was deleted and replaced by two ellipses instead of the characters. Nanjing, however, is named repeatedly and seems to glower at us from the pages of the book today.

Editors carefully removed words or phrases that indicate the sexual desires of men, including such things as "sensed brutal carnal desire," "want to torment women," "buy a woman," "bring prostitutes," "geisha,"[39] "forage for fresh meat," and *"kūnya"*—a Chinese term for a young girl.[40] Also removed were expressions of contempt for life, or particular attachment to it, such as: "[They] won't go back home anymore. [They] bit their lips in silence;" or "Life is something like garbage on the battlefield;" or "It is great to be alive."[41]

Graphic depiction of cruel murders of Chinese women by soldiers, the soldiers' ruthless pillaging of food and "fresh meat," and the killing of captives or torching civilian houses were cut severely. One example may show how this was done. In this scene, a woman's crying reaches the soldiers when the shooting stops. The group discovers a whimpering seventeen- or eighteen-year-old Chinese girl in a house with her dead mother who has been killed by a bullet. Night falls. The girl's crying continues with an added tone of lamentation. The soldiers become irritated.

"I'll ~~kill her.~~"

So said Private First Class Hirao over his shoulder, dashing out holding his rifle, crouching low. Five or six men stamped out of the trench and ran along the trench chasing him.

They rushed into the pitch-dark house. ~~A figure of a sobbing woman~~ was crouching in the starlight that streamed in through a window broken by shells, as it was in the evening. Hirao ~~grabbed the back of her neck and dragged her. The woman was holding the corpse of her mother~~ and didn't let go. One soldier ~~twisted her hands~~ and separated ~~the corpse of the mother. Dragging the lower half of her body across the floor,~~ they brought ~~the woman~~ out the door.

Hirao ~~pierced~~ the area of ~~the woman's chest with a bayonet,~~ while screaming in a shrill voice, as if he had gone mad. All the other soldiers also kept ~~thrusting at her head, stomach, and all over with their bayonets. The woman was hardly alive~~ after about ten seconds. ~~She lay~~ worn out ~~on the dark soil~~ like a flat piece of ~~futon. The fresh smell of blood,~~ stifling and warm, wafted up to the flushed faces of the soldiers.

Second Lieutenant Kurata stretched himself out back in the trench and sensed it from the atmosphere, but he did not say a word. When the excited soldiers returned to the trench, repeatedly spitting saliva, Corporal Kasahara mumbled in a laughing voice, smoking a cigarette in his crouched position, "What a wasteful thing they did, really!"

It is impossible to exaggerate how much his saying that saved Second Lieutenant Kurata from his pain.[42]

Although we can see that specific physical acts were removed by the publisher, the implications of these acts survived in the remaining text. In another passage later in the book, explicit descriptions of the slaughter of captured soldiers were edited out. Nonetheless, the reader is still told that the captured Chinese were killed because the Japanese could not drag captives along in their desperate offensive.

In this kind of pressing-on combat, the treatment of ~~the captured~~ was a problem for any unit. At a time when [we] were about to commence a desperate battle, [we] were unable to advance while guarding and taking along the captured. The easiest method of disposing of them was to ~~kill.~~ However, when [we] had once accompanied them, it was laborious even ~~to kill [them].~~ "When one ~~takes a captive, kill the captured~~ at the site." It was not an order exactly. But these kinds of ~~policies~~ were dictated from ~~above.~~

In this kind of situation, Corporal Kasahara carried it out bravely. He continued to ~~sever [the heads of] thirteen who were chained like a rosary,~~ one by one.

They were in official military uniforms, but were barefooted. [They]

carried long, thin bags containing baked rice on their backs and wore blue cotton long-coats stuffed with cotton. Two of them appeared to be noncoms and were properly dressed and had shoes on.

The ~~thirteen were taken~~ to a stream at the edge of an airport and made ~~to line up.~~ As soon as Kasahara ~~unsheathed his dull sword~~ with its ~~nicked blade,~~ he ~~cut, lowering his sword deep into the tip of the shoulder of the first man.~~ The remaining ~~twelve~~ instantly knelt down on the ground and ~~prayed,~~ screaming and slavering. Two in particular, the men who looked like noncoms, trembled miserably. Further, Kasahara ~~cut~~ the second and third ~~soldiers~~ without any time between.[43]

The largest deletion made by the *Chūō kōron* editors was the omission of the aforementioned final two chapters. Chapters 11 and 12 in Ishikawa's original manuscript tell how Privates First Class Hirao and Kondō and Corporal Kasahara go out to buy geisha in Nanjing. While drinking sake, Kondō is tormented by his memory of a Chinese woman he once stabbed. Drunk and mentally deranged, he shoots and wounds a Japanese geisha with a pistol. This leads to an investigation of Kondō by the military police, but he is allowed to rejoin his unit, which departs for a new destination. Although it is only possible to speculate on why these two chapters were cut, since no explanations are offered it seems a reasonable guess that what distinguishes the soldiers' actions in this incident is not the act of violence, which did not even prove to be fatal, but the fact that the victim is a *Japanese* woman.

When the March issue of *Chūō kōron* containing Ishikawa Tatsuzō's novel was suppressed at the end of February, the author was taken to the Metropolitan Police Office for investigation. His questioning lasted only one day, and he was then released. This is probably why it was such a surprise when the prosecutor indicted Ishikawa as author, Amemiya Yōzō, the magazine's editor-in-chief, and Makino Takeo, the department head most related, for violation of the Newspaper Regulations on August 4, nearly six months after the initial arrest. The first trial began on August 31, 1938.[44]

Records of the pretrial investigation and the trial itself illuminate the state of the author's mind at that time. Ishikawa eloquently explained his motivation for going to the front. "The people view soldiers at the front as gods," he said. "They think that a paradise will be built immediately on the soil occupied by our forces. [They think] that the Chinese masses are cooperating in this." "War," he continued, "is not such a carefree matter. However, I believed that to let the people know the truth of the war was essential in order to get the people to acknowledge the emergency and to adopt a determined attitude toward the situation."[45]

In testimony at his first public trial, Ishikawa described how he gathered information for his book: "I thought that I would be able to grasp the real situation of the war better by mingling with and speaking to soldiers than by having contact with officers. . . . I saw and heard the true feelings of human beings at the front."

What he learned from soldiers was "the progress of battles, from the landings in front of the enemy [outside Shanghai] to the fall of Nanjing," and "how [men] killed the enemy." He personally witnessed, too, "the disastrous scene after the battle in the parts of the city near Xiaguan, Zhongshan Gate, and Suixi Gate.[46] Xiaguan was among the sites where the most horrific massacres were alleged to have occurred in Nanjing. His testimony confirms that Ishikawa himself was in Nanjing either when atrocities were taking place or just after they had occurred, and it provides evidence that he spent time with soldiers who could have been directly involved.

160

The vast range of issues raised by the Japanese behavior at Nanjing cannot be addressed here, but it is possible to get some sense of what Ishikawa actually observed. The regiment with which Ishikawa spent time was the Noda Regiment, in the Thirtieth Brigade of the Sixteenth Division from Kyoto.[47] Thirtieth Brigade Commander Sasaki Tōichi was known as one of the Japanese Imperial Army's experts on China during the war. He left a substantial body of writings.[48] One of these, which he himself titled *Battle Records: Operations in Central China (Senjō kiroku: Chūshi sakusenhen),* was not published during the war years although he had completed it and it was typeset and ready for publication prior to the end of the conflict.[49] It includes descriptions of the battles for Nanjing from the perspective of the brigade commander. The entry in Sasaki's record for December 13 reads:

> Afterwards the captured came to give up in large numbers, reaching several thousands. The infuriated men massacred them, one after the other, defying their superior officers. Looking back on the blood shed by many of their comrades, and [recalling] ten days of hardships, each would like to say, "Slaughter them all, whether they're soldiers or not."[50]

On December 14, Sasaki described mopping-up operations inside and outside of the wall: "Some stragglers hid themselves in villages and mountains and continued shooting. Therefore, [we] unsparingly and instantly slaughtered those who resisted or did not show submissiveness."[51] Such descriptions, unusually frank but still circumspect, may help the reader glimpse the landscape Ishikawa's soldiers passed through, and we may sense what Ishikawa might have learned by looking through their eyes, if not his own.[52]

Ishikawa did not set his protagonists in scenes of massacre within Nanjing, although he presented them engaging in brutal murders of Chinese civilians and captives. This could be interpreted as an instance of censorship by the author himself. Perhaps he was consciously avoiding any precise mention of the Nanjing massacre in anticipation of the trouble that writing about it might cause him. Yet *Living Soldiers* seems a prelude to the army's entry into the enemy's capital city, and the cruel acts of the imperial forces in the following days are presaged by the author. Ishikawa is saying that killing civilians did not begin after the capture of the capital but was an ongoing activity of the Japanese soldiers.

Ishikawa seems to assert that it is war that causes these acts. Judge Hatta asked

Ishikawa at his trial whether or not this kind of writing would "result in injuring [the people's] trust in Japanese military men." Ishikawa's response was direct: "I tried to damage that. On the whole, it is a mistake for the people to consider soldiers at the front as gods. I believed that the people should see the real appearance of human beings and build true trust based on that. Therefore, I thought I would destroy the mistaken views that people had."[53] This statement sounds outrageous and unbelievable in the atmosphere of wartime, but his assertion of the intention to damage trust in military men may be taken at face value. This can only be true, however, if it is acknowledged that disclosing the cruel nature of soldiers at war is not necessarily an antiwar sentiment. It can be a revelation of reality—that is, a manifestation of "realism" like battle paintings by Fujita Tsuguji.[54] To see war as horrific does not, in and of itself, reject its utility or necessity. It is not essential to romanticize war in order to support it. Fujita and Ishikawa's "realistic" approaches to the presentation of the truths of war make for interesting parallels. Neither seems to be "antiwar," while both seem convinced that the ugly face of war requires someone to capture its true portrait, whether in oils or words.[55]

During his pretrial investigation, Ishikawa maintained, "when I wrote the cruel scenes, I believed they shouldn't end merely in cruelty. I wrote as if the [cruel] behavior took place for justified reasons."[56] For example, in the manuscript a Chinese cook is stabbed to death by Private First Class Takei for stealing a piece of sugar that had been saved for the regimental commander's dinner. Ishikawa, at his investigation, asserted that the killing was justified, but the story in the novel does not end there. This incident makes Private First Class Kondō realize that "a piece of sugar was exchanged for a life" and forces him to again agonize over what life is.[57] It is not necessary to accept Ishikawa's argument that the killing of this cook was justified. Indeed, it is not convincing when the text is examined closely. Rather, it seems that in Ishikawa's logic the fact that he is making a desperate attempt to convince the authorities that he did not deliberately try to injure the image of the imperial forces is also at work. By saying at his trial that the killings were justified, Ishikawa actually may have been denying the facts and undercutting the perceptive argument he so skillfully set out in his novel.

The vast majority of the readers in Japan did not have an opportunity to see even the *Chūō kōron*'s dotted-line version of *Living Soldiers*. It was kept from publication during the war. The story of suppressing *Living Soldiers* might have ended there without much impact had police censorship procedures been airtight. Breaches occurred, however. According to the 1939 Publishing Yearbook, a partial translation of *Living Soldiers* appeared in a major Chinese newspaper in Shanghai, under the title *Soldiers Who Have Not Yet Died*. It was used as a tool to attack Japan. The yearbook also reported the discovery that a major newspaper in San Francisco was about to publish a translation, and only last-minute intervention by the Japanese consulate and furious negotiations blocked it.[58] It has not been possible to confirm that report, but clearly some copies of the book as published in the magazine did make it to consumers. Indeed, the former Imperial Library's own uncut

copy of the *Chūō kōron* issue containing the novel was stamped "Accessed February 28, 1938," although it was also stamped "Sale Prohibited." Handwritten instructions not to circulate the part containing the novel were also attached. This is the text used throughout this chapter.

On September 5, 1938, the second day of his trial, Ishikawa Tatsuzō was sentenced to four months imprisonment with three years probation for "depicting the slaughter and pillage of noncombatants by, and relaxed military discipline among, the soldiers of the Imperial Armed Forces, and for writing things that disturb peace and order." He was also judged guilty for having put his name on the work. The charge of disturbing peace and order was levied not only because the passages themselves were likely to cause unrest, but because they were written "in the present public knowledge that the China Incident is in progress."[59] Thus the court held that not only was the depiction of the soldiers' behavior a crime, but also that the author was guilty of an all-encompassing thought crime—"disturbance of peace and order." Moreover, this vague and subjective offense had been committed while his country was at war. Editor-in-Chief Amemiya Yōzō received the same sentence. The head of the publishing department, Makino Takeo, was sentenced to a fine of one hundred yen. The prosecution appealed the convictions the next day, indicating that they considered the court's sentences far too lenient.[60]

The Writer and the War

The major Japanese offensive against the Wuhan cities ("Bukan" to the Japanese army) had begun while Ishikawa's trial was being held. The Cabinet Information Division dispatched their own well-known authors to the front in September 1938 to cover Japan's ongoing battle in China. This so-called Pen Brigade included twenty-two established authors such as Niwa Fumio, Ozaki Shirō, Yoshikawa Eiji, and Kikuchi Kan, as well as two women writers, Yoshiya Nobuko and Hayashi Fumiko. Painters such as Fujita Tsuguji and Nakamura Ken'ichi were also dispatched to the front in 1938.[61]

Chūō kōron suggested that Ishikawa again travel to the front as their special correspondent, but since he was a convicted criminal, facing a prosecutor's appeal, permission from the army would be required for him to make the trip. To his surprise, the army's press office not only granted permission, but they even provided him with a letter of introduction to the head of the reporting division in Shanghai. Such an attitude suggests that what Ishikawa wrote in *Living Soldiers* did not bother the army enough to make him persona non grata with officials eager to promote the cause in China.[62] There appears to have been some discordance in censorship between the army and the Home Ministry. While it can only be speculation, it is possible that events unfolded this way for Ishikawa because the military police—the Kempeitai—and the special higher police—the Tokkō—were at this time sorting out their respective responsibilities over thought crimes at the onset of the war. In any event, on September 12, just one week after his conviction for "disturbing

peace and order," Ishikawa found himself on a flight from Haneda Airport, bound again for the war zone.

Ishikawa spent about two months with the army in China from the end of September 1938. Upon his return, he completed *Bukan sakusen: senshi no ichibu to shite* (The Wuhan Operation: As Part of War History), which appeared in the January 1939 issue of *Chūō kōron*. This time, publisher censorship was hardly required. The author's self-censorship was vigorously at work. His approach is manifestly obvious in his brief postscript: "The objective was to let the home front know the breadth, depth, and complexity of the war. In other words, as the author, I tried to construct a faithful history of the battles. . . . My attempts to study individuals resulted in a legal problem caused by something written. This time, I have sought to avoid individuals and to observe the movement as a whole." [63] This attitude probably accounts for Ishikawa's use of a chronology of military operations as his vehicle in *The Wuhan Operation*. Rather than focusing on men in the vanguard of the army, he portrays behind-the-line activities such as automobile transport units, a field hospital, and ship engineering units. There are no central characters who reveal their anguished minds in the heat of battle as in *Living Soldiers*. The graphic depiction of brutal behavior is totally absent this time.

Nevertheless, the author does not completely avert his eyes from the soldiers. Ishikawa picks up the "strange fear of being alive" felt by a soldier facing a landing opposed by the enemy. [64] In the final chapter, the seriously wounded Private First Class Kawakami thinks, "When the oblivious Japanese people forget the severity of this war, all that remains is merely this disabled, injured body." [65] Ishikawa cannot let himself fail to capture the exploitation of the greedy merchants and members of "the National Defense Women's Association" who follow the army and "comfort" the troops. [66] Undoubtedly Ishikawa had to compromise himself in this work, but he did not utterly succumb to the authorities. In *The Wuhan Operation* he never adopts the tone of beautification and glorification used to describe the war that we can see in many other writings of the time. Such popular expressions as "sacred war," "imperial forces," and "imperial nation" that punctuate and virtually permeate novels of this period appear only once each in the entire novel. [67]

Ishikawa was to spend the remainder of the war in literary activities. He visited Saigon for the navy. He was an active member of the Nippon Bungaku Hōkokukai (Japan Literature Patriotic Association). Nevertheless, again he ran afoul of the authorities when he dared to write that the Japanese fighting spirit could not be raised to its maximum capacity due to the fact that the people were not free to express their thoughts. [68] Ishikawa's wartime works were often cut and sometimes they were suppressed, but he always had sponsors and he was frequently in print until the end of the war. [69] *Chūō kōron*, the magazine that had started him on his war literature way, was not as fortunate. The magazine was shut down in July 1944 for repeated violations of an ever-stricter standard of military and police censorship. Some of its editorial staff, including Hatanaka Shigeo, were imprisoned. [70]

The War after the War

In December 1945, after the Pacific War ended and the Occupation of Japan began —nearly eight years after the novel's completion—Ishikawa's *Living Soldiers* was reconstructed for publication. It had to be put together from the first galleys prepared by *Chūō kōron,* since Ishikawa's original manuscript had been confiscated as evidence by the police; it was assumed to have been burned in the course of the war. The 1938 galleys were themselves covered with the red marks indicating deletions made at that time.

When Ishikawa had painstakingly reassembled the book, the new complete text of *Living Soldiers* had to pass through one more layer of censorship before it was allowed to reach its readers at last. This time, the primary censor was the Press, Pictorial, and Broadcasting Division (PPB) of the Civil Censorship Detachment (CCD) of the Civil Intelligence Section (CIS) of the Supreme Commander for the Allied Powers (SCAP) in Tokyo.[71] The extensive program of censorship, requested by Washington and conducted under supervision of SCAP, was carried out with the claim that they were acting in order to create a democratic society in Japan.[72] The "File Copy" of *Living Soldiers,* now held by McKeldin Library, University of Maryland at College Park, carries two handwritten dates: "17-12-45"— the date the censors received it—and "21-12-45," with the mark showing it had been "passed" by the censor. Fifty thousand copies were subsequently printed by Kawade Shobō, and it sold out within two months.

The speedy passage of the book through the SCAP censors stands out. It also raises questions about the motives of guidance officers in the Civil Information and Education Section (CI&E). Did they too wish to have a fuller version of the story of Japanese atrocities in China available in Japanese?[73] A large number of books and magazines were precensored by PPB during the first two years of the Occupation. They were postcensored from September 1947. The primary targets of this censorship were ultraright-wing works and, later, Communist and left-wing works.[74] Ishikawa's book did not belong to either category.[75]

In his new introduction to the *Living Soldiers* of 1945, Ishikawa set down what he said was his state of mind in 1938:

> It was beyond my imagination that I would be criminally punished because of this work. That might have been due to my youthful ardor. My intention was to let the people on the home front, who were haughty in victory, know the true conditions of the war, and to ask them to reflect greatly upon the war. They buried my intention. On the home front, where freedom of speech was lost, both the officials and the people fell in disorder and were confused, and finally encountered the tragic fate of the state. Even after so long a time, it is regrettable [to me].[76]

Despite drastic changes in both his own and Japan's circumstances, Ishikawa uses similar reasoning to explain why he wrote *Living Soldiers* both at his 1938 trial and in the early Allied Occupation period. He seems to accuse not the military

and government authorities who conducted the war, but the people on the home front. He comes far short of expressing antiwar sentiment. In 1974, more than three decades after he wrote the novel, Ishikawa discusses *Living Soldiers* in a passage of his *Experimental Theory of the Novel* and raises what seem to him the key questions:

> What do human beings become in the extremity of war? In what shape does human morality, wisdom, a sense of justice, egoism, love, or fear of peacetime survive? . . . Without knowing these [things], it is possible to understand neither war nor battles. What kind of world is it where extremely evil conduct, called killing, openly takes place and is encouraged? What are the appearance and the state of mind of individuals who endure this in [war]? [77]

As a novelist, Ishikawa Tatsuzō depicted the cruel and brutal acts of Japanese soldiers at the front—as seen with his own eyes. He seems convinced that war caused such horrible behavior. He appears to be satisfied with this paradigm of war and the individual. He does not go on to ask what war is, why war occurs, or ultimately who causes it.

Ishikawa's novel became a postwar success, but he found that he was not free from war's entanglements. In March 1948, he received a notice that he was being investigated by the Occupation authorities as a "potential war criminal." He was assigned to the category of suspects who were allowed to raise objections within thirty days. It is not yet known precisely what happened in the investigative process of this author at SCAP, but the *Yomiuri shimbun* reported on May 15, 1948, that the charge against him and three other authors had been dropped. According to that newspaper article, this was because *Living Soldiers* had been suppressed by an angry military. *Wuhan Operation*, it said, while written under the watchful eye and imminent threat of suppression by the authorities, did not actually advocate militarism.[78]

The nature of Ishikawa's contacts with Occupation authorities is still only vaguely understood. He has left no detailed description of his experience and thoughts that can allow us to pin them down to a particular time or a precise incident. What he did leave was another passage in his book on the writing of novels, telling the following story:

> After the defeat in the war, the American prosecutors attempted to use *Living Soldiers* as a proof of the Nanjing massacre at the Tokyo Tribunal. They took me to the investigation room of the prosecution at the court in a jeep. It was unpleasant. They told me, "We'll arrest you if you don't cooperate."
>
> I did not see the site of the Nanjing massacre, but I knew about it in general. I was unable to deny the incident, but I defended the position of Japanese military forces at that time. In other words, I explained that the massacre had a certain inevitability about it, and that half of the responsi-

bility rested on the Chinese forces. First, there was their scorched-earth and resistance policy. Then there were the stragglers mingling with the civilians [and the fact] that [Japan] didn't have supplies to feed the captured. . . . After everything, the prosecution side failed to get any meaningful testimony out of me. [79]

Living Soldiers was hardly mentioned in literary circles at all during the war years. Afterwards, the novel became the target of a barrage of strong criticism. In the March 1946 issue of *Shin Nihon bungaku* (Literature for New Japan), critic Odagiri Hideo sharply denounced Ishikawa's novel:

Isn't this novel the first fruit born by a literature of aggression? . . . The authorities of aggression concealed the work because it was disadvantageous to themselves, and [the authorities] attempted to use the opportunity afforded to them to make a convoluted threat against literature and culture. This work appears at [first] glance to be a sacrificial lamb, but in reality it is a wolf cub, with a mouth stretching from ear to ear.[80]

In 1952, Nakano Shigeharu, the well-known novelist and critic, wrote:

[The author] apathetically affirms and approves the process through which military officers, soldiers, scholars from different fields, and a priest become the tools of war. All their abilities, intelligence, and humanity are destroyed by pillage, rape, arson, murder, and torture. The work does not see the characteristics of the war waged by Japan, which bring about such changes in [these men's] abilities, intelligence, and humanity.[81]

Criticism continued even three decades after the end of the war. "The cruel behavior of Japanese forces is vividly depicted," wrote Tsuzuki Hisayoshi in 1976, "while the author's eyes are not directed at the Chinese, the side against which the [brutalities] were committed."[82] Although the nature of the criticism varied, Ishikawa's grasp of the nature of the war came under the most severe attack.

Ishikawa himself first counterattacked in his *Jidai no ninshiki to hansei* [Perceptions and Reflections on the Period], published in 1947. Raising the issue of his critics' own silence during the war, he argued further that "the true nature of the aggressive war lies in the General Staff Headquarters and the Navy General Staff." He defended himself saying, "I merely depicted the war at the battlefront."[83] He drew a clear line between the battlefront and the political structure that he viewed as the conductor of the war. But in the same work, echoing the wartime claims of the Pan-Asianist mask of the Greater East Asia Co-Prosperity Sphere, Ishikawa also argued:

The Japan and China Incident and the Pacific War appear to have resulted in the aggressive war. Yet, it has not been without some merit. Anyway, the war resulted in a great revolution, which is today in progress. Asia

looks as if it is making new progress. Japan is in disarray today, but Japan's war had vital significance. I view its significance as crucial. I think we have to consider the Asian great revolution, rather than get angry at Japan's defeat and denounce the people. At the same time, it is not an issue for me whether the Great War was aggressive or not. For those who must take every opportunity to label [it] as an aggressive war in order to satisfy themselves, I suspect that they have a secret plot to avoid their own war responsibility by calling it an aggressive war [now].[84]

He revealed himself as one who can justify Japan's war in China and placed himself on the side of those who might justify that aggression by its consequences, whether or not they were intended by Japan's leaders.

When provoked, Ishikawa was even prepared to lash out directly at the United States. When he heard, apparently in 1953, that Eleanor Roosevelt had said that the use of the atomic bombs was necessary in order to end the war and to reduce the number of victims, Ishikawa expressed rage by snapping, "'True relations between subjects and ruler' is often just the same as the 'self-defense' of the more powerful."[85] Ishikawa was unable to see that he himself defended Japan's policy in China the way Mrs. Roosevelt defended the use of the A-bombs.

Final Thoughts

Living Soldiers ran a veritable gauntlet of censorship from the time it almost appeared in 1938, extending through the war, and continuing into the postwar years. Many other works and enterprises faced the same obstacles. First the Japanese Home Ministry police, then the imperial army, and then the Allied Occupation forces censored art and literature "justifiably." Censorship was not imposed only by the authorities, however. It was practiced on other levels just as keenly and just as destructively. Authors became active participants in the process of thought control by limiting their subjects, their language, their expression, and even, perhaps, their field of vision. Publishers, too, played a crucial role in censorship. In the case of *Chūō kōron* and *Living Soldiers,* even the potential reader was invited to join in the conspiracy against free expression.

Ishikawa Tatsuzō's fellow writers rejected *Living Soldiers* after 1945. It was often suggested that Ishikawa should not have written a work that approved of the war. They proffered the opinion that he would have done better not to have written the novel at all.[86] If the author's primary task is to write what he feels he must, under any circumstances—a view easy enough to subscribe to in the abstract— such a course of action would have been unacceptable, of course. Yet many Japanese authors did silence themselves when they were forced to choose between dangerous thoughts and virtuous but totally ineffective self-censorship. Many more wrote precisely along the lines laid down by authority, regardless of their own creative impulses.[87]

While there is a great deal still left to be examined before the extent to which the climate of censorship worked against creativity can be fully appreciated, it can never be known what would have happened had Ishikawa chosen to censor himself completely in the 1930s—or had remained silent throughout the war. I, for one, am glad that we are able to learn from *Living Soldiers* something of what occurred on the China front, however limited in scope it may appear in retrospect. It is also to be hoped that the lessons of the insidious nature of multilayered censorship can be understood from the many lives of Ishikawa Tatsuzō's work.

Notes

1. The conflict in China also produced a new type of writer—the soldier-author *(heitai sakka)*. These men were soldiers and established themselves as writers by depicting their own experiences. Hino Ashihei (1907–1960) was drafted in 1937 and sent to the China front, where he learned that he had been awarded the prestigious Akutagawa Prize for the work he published prior to his conscription. This resulted in Hino's transfer to the Military Reports Division. His *Wheat and Soldiers (Mugi to heitai)*, *Earth and Soldiers (Tsuchi to heitai)*, and *Flowers and Soldiers (Hana to heitai)* were published from September 1938 through June 1939 and established him as one of the most popular writers at that time. *Wheat and Soldiers* was made into a movie in 1939, with scenes shot on location in China. *Wheat and Soldiers* was published in English (New York: Rinehart, 1939), trans. (Baroness) Shidzue Ishimoto. Hino is also known for *Rikugun* (The Army), which was serialized in the *Asahi* from May 1943 to April 1944 and made into a well-known movie in 1944. For a full-length study, see David M. Rosenfeld, "'Unhappy Soldier': Hino Ashihei and Japanese World War Two Literature," Ph.D. dissertation, University of Michigan, 1999.

Following in Hino Ashihei's footsteps were Ueda Hiroshi and Hibino Shirō. Both were drafted, fought in China, and wrote about their experiences as soldiers. Their works were enormously popular with the home front audience, which was eager to learn the conditions of soldiers. See Haruko Taya Cook, "Voices from the Front: Japanese War Literature, 1937–45," unpublished M.A. thesis, University of California at Berkeley, 1984, 5–12. See also Ben-ami Shillony's discussion of "The Pen as a Bayonet" in his *Politics and Culture in Wartime Japan* (Oxford: Clarendon Press, 1981), 110–120, esp. 117. Donald Keene has written of these times in "The Barren Years," *Monumenta Nipponica* 33 (Spring 1978), 67–112; and "Japanese Writers and the Greater East Asian War," *Journal of Asian Studies* 23 (February 1964), 209–225, also to be found in his *Landscapes and Portraits* (Tokyo: Kodansha International, 1971). See also Keene's survey of modern Japanese war literature in Donald Keene, *Dawn to the West: Japanese Literature in the Modern Era—Fiction* (New York: Henry Holt, 1984), 906–961.

Joshua A. Fogel has provided us with a marvelous record and stimulating analysis of the "traveling mind" of Japanese in China. Of particular interest is his discussion of "Wartime Travel in China," in Joshua A. Fogel, *The Literature of Travel in the Japanese Rediscovery of China, 1862–1945* (Stanford: Stanford University Press, 1996), 276–296.

2. Ishikawa had a continuing interest in the Japanese who built the colonies. He visited Saipan and Tinian in the Mariana Islands in 1941, before Pearl Harbor. His eyes were focused on the nature of the Okinawans and the Kanaka "natives" who had been absorbed

into building the "Japanese South Seas," but he betrayed disappointment that, while they may have sung Japanese songs, they did not capture their true spirit. He characterized the Okinawan immigrants and laborers as "interested only in money."

> These Okinawan laborers did not know culture. Rather, I should say, they did not demand culture. They were cool about their lives, which was poorer even than that of the Kanaka tribesmen. They sent their wages to their families at home or simply spent them on sake. They have never thought to improve their lives since the moment of their births. Perhaps this character may have been created by the oppressive policies [endured] over hundreds of years in the Tokugawa period.

See Ishikawa Tatsuzō, "Kōkai nisshi" (Diary of a Voyage), *Ishikawa Tatsuzō sakuhinshū*, vol. 23 (Tokyo: Shinchōsha, 1973), 405–416. He quotes a young man he met on the ship to Saipan: "I'm living now in Tinian with my dad. My grandfather's grave is on Guam. My father tells us grandly that we should fight a war with America and occupy Guam so that we all can pray at Granddad's tomb," 405–406. Mark R. Peattie describes Ishikawa's visit to Palau in *Nanyō: The Rise and Fall of the Japanese in Micronesia, 1885–1945* (Honolulu: University of Hawai'i Press, 1988), xxii, 382.

3. See Nihon Kindai Bungakukan, ed., *Nihon kindai bungaku daijiten* (Japanese Modern Literature Dictionary), vol. 1. (Tokyo: Kōdansha, 1977), 100–104.

4. Pretrial Investigation Report, cited in Yasunaga Taketo, "Senjika no bungaku" (Wartime Literature), part 2, *Dōshisha kokubungaku* (Dōshisha Japanese Literature), no. 2 (Kyoto: Dōshisha Daigaku, 1966), 64. Also see Ishikawa Tatsuzō, *Keikenteki shōseturon* (Experimental Theory of the Novel), in *Ishikawa Tatsuzō sakuhinshū* (Ishikawa Tatsuzō's Literary Works), vol. 25 (Tokyo: Shinchōsha, 1974), 327–328.

5. Ishikawa, *Keikenteki shōseturon*, 329.

6. Perhaps on an even more jarring note, when an early version of this paper was presented at an academic conference, one American college teacher of Japanese history joined the historic chorus of those who argued that "Ishikawa never should have written the novel."

7. Ishikawa Tatsuzō, *Ikiteiru heitai* (Living Soldiers), in *Sensō bungaku zenshū* (War Literature Collection), 8 vols. (Tokyo: Mainichi Shimbunsha, 1972), vol 2, 8. Quotations are taken from this edition where possible and are cited in this essay as *Living Soldiers* (my translations). See also Zeljko Cipris, who provides a complete translation under the title *Soldiers Alive*, in "Radiant Carnage: Japanese Writers on the War against China," Ph.D. dissertation, Columbia University, 1994, 225–396; his source is the reconstructed edition of October 1945 (see note 38).

8. In the 1930s, when educational opportunities were limited and available jobs scarce, these people were viewed as intellectuals. So too were the readers of the *Chūō kōron*.

9. *Living Soldiers*, 41. The words and phrases struck through here were present in the original draft Ishikawa presented to his editors, who cut them from the text when it was printed in the March 1938 *Chūō kōron*. It was then suppressed nevertheless. That censorship is discussed later in this essay, but the full content of the original is included here for completeness and to capture the strength and flavor of the author's original work.

10. Ibid., 29.

11. Ibid., 66.

12. Ibid.

13. Asai Tatsuzō, a cameraman for Dōmei News at the front in China, said that he did not film the corpses of the Chinese dead or the Japanese dead out of his certain knowledge that such pictures would not be included in any final films presented at home. Moreover, he said "You can't really direct your camera at the corpses of your kind." Haruko Taya Cook and Theodore F. Cook, *Japan at War: An Oral History* (New York: The New Press, 1992), 205–206. Asai clearly censored himself in the choice of subjects for his shooting because of his own feelings for Japanese soldiers *and* the official censorship exercised over newsreel pictures and photographs shown or printed in wartime Japan. Much of the footage Asai did shoot did make its way into newsreels; those scenes, together with film never shown, were confiscated by the Allied forces after the war and taken to the United States. Since those films were returned to Japan some years later, they have remained largely unavailable for examination or investigation. According to Asai, the Japanese government has told him that he cannot see the pictures he himself took "for reasons of privacy."

Japan was not alone in this, of course. The first pictures of American dead taken by American news teams in the Pacific were not released to the public until late 1943. George Strock's famous photograph, "Here lie three Americans," showing the bodies of three American soldiers sprawled and partially buried in the tidal sands, taken on the beach at Buna, New Guinea, in February 1943 and published in *Life*'s September 20, 1943, issue, was the result of a reversal of a policy by the War Department and the Office of War Information that had dated back to World War I. Pictures of enemy dead, even parts of enemy dead—especially Japanese—had been appearing for some time. See Susan D. Moeller, *Shooting War: Photography and the American Experience of Combat* (New York: Basic Books, 1989), 205–208.

14. *Living Soldiers*, 19.

15. The depiction of Japan's aggression, in the very best late-imperialist tradition of behavior, can be viewed as within the structure of "Orientalism" as presented by Edward W. Said in *Orientalism* (New York: Random House, 1978). Ishikawa, however, does not rely on a binarism of uncivilized versus civilized as a vehicle for writing *Living Soldiers*. In this he separates himself from other popular writers such as Hino Ashihei and Ueda Hiroshi, who presented Chinese people as inferior to Japanese. For example, Ishikawa revealed an empathy for both the Chinese and Japanese soldier, referring to them as "patients who suffered from the same illness" imposed by their states (*Living Soldiers*, 26). His almighty narrator points out that Japanese soldiers find comfort in their casual conversations with Chinese, even while they "despise them" (44). Ishikawa shows the current military and political relations between the two nations, while at the same time making clear his criticism of the general air of contempt directed at China and the Chinese. In this limited sense, Ishikawa does not fall into the trap of Japan's "Orientalism," choosing to recognize it even when he does not name it.

16. *Living Soldiers*, 52–53. This seems to fit the paradigm of "Orientalism" in Japan presented by Stefan Tanaka in his *Japan's Orient: Rendering Pasts into History* (Berkeley: University of California Press, 1993). It would be interesting to learn how the Japanese distinction between *Tōyō* and *Shina* affected the consciousness of Japanese writers (and readers as well) during the war years.

17. Ibid., 44–45.

18. Ibid., 60.

19. Ibid., 69. "Comfort women" and "comfort places" are euphemisms used by Japanese servicemen and civilians during the war. A "comfort woman" sexually served military men at or near the front. Some were "volunteers" (occasionally women already in the sex trade), while other women were dragooned into sexual service either directly or after being recruited for domestic work or other labor. Comfort women who served officers were primarily Japanese; those who served soldiers were often Koreans, Chinese, and other women native to the occupied areas. The Japanese military officially organized this structure in cooperation with private businesspeople. See Senda Kakō, *Jūgun ianfu: seihen* (Military Comfort Women: Main Part) (Tokyo: Sanihi Shobō, 1992) and his earlier *Zoku jūgun ianfu* (Sequel: Military Comfort Women) (Tokyo: Kōbunsha, 1985).

20. *Chūō kōron* was at the center of censorship controversies even earlier than the Taishō period. For example, in 1909 there was the case of Oguri Fūyō's "Elder Sister's Younger Sister." See Richard H. Mitchell, *Censorship in Imperial Japan* (Princeton, NJ: Princeton University Press, 1983) 167, 216–217.

21. Interview with Hatanaka Shigeo at his home in Tokyo on February 23, 1989. See also Haruko Taya Cook and Theodore F. Cook, *Japan at War*, 64.

22. Magazine publishing did extremely well in 1938, despite the rationing of paper that included a tighter allocation of paper for publishing; annual sales grew by 3.7 percent in that year alone—from 72,733,000 in 1937 to 75,474,200. The annual report of the publishing industry noted that general magazines and mass magazines both owed much of their growth to their decision to carry war literature. Stories that began as magazine features were eventually to become war novels and war movies. The yearbook stated that even the prohibition on the publication of *Ikiteiru heitai* (Living Soldiers) by *Chūō kōron* became the fuse that led to *Kaizō*'s October 1938 issue, which contained Hino Ashihei's best-selling *Mugi to heitai* (Wheat and Soldiers) mentioned in note 1 above. See Tōkyōdō Nenkan Henshūbu, ed., *Shuppan nenkan Shōwa 14 nenban* (Publishing Yearbook for 1939) (Tokyo: Tōkyōdō, 1939), 12.

23. See *Shūkan gendai*, September 24, 1961, 52.

24. Between 1934 and 1939, the sale and distribution of 4,234 items was prohibited under the Publishing Regulations and Newspaper Regulations. Some 1,426 items were declared to be disturbances of peace and order and 2,808 were said to be destructive of public morals. See Hatanaka Shigeo, *Nihon fashizumu no genron dan'atsu: shōshi* (Suppression of Free Speech in Japanese Fascism: An Abridged History) (Tokyo: Kōbunken, 1986), 19. Richard H. Mitchell, *Thought Control in Prewar Japan* (Ithaca: Cornell University Press, 1977), discusses the establishment and implementation of the 1925 Peace Preservation Law, 56–68. His *Janus-Faced Justice: Political Criminals in Imperial Japan* (Honolulu: University of Hawai'i Press, 1992) looks even more closely into the political dimension of "thought-crime."

25. Hatanaka Shigeo, "'Ikiteiru heitai' to 'Sasameyuki' o megutte," (On "Living Soldiers" and "Sasameyuki") in *Bungaku* (Literature) 29:12 (December 1961), 93.

26. Gregory J. Kasza, *The State and the Mass Media in Japan, 1918–1945* (Berkeley: University of California Press, 1988), 44–51, has discussed this for the early 1930s. Hatanaka Shigeo said each *Chūō kōron* issue was selling about sixty thousand copies monthly when Ishikawa signed his contract to write about the China war in 1937.

27. Kasza documents the process of expanding military control in the 1930s, *State and the Mass Media*, 121–167. The role of the special higher police, the Tokkō, is discussed by

Elise K. Tipton, *The Japanese Police State: The Tokkō in Interwar Japan* (Honolulu: University of Hawai'i Press, 1990), esp. 56–73.

28. A copy of the 1938 March issue of *Chūō kōron* is available on microfilm at the Diet Library in Tokyo. The cover of the magazine has a seal indicating a purchase date of February 18, 1938 (unclear) by the Imperial Library. In addition, "fiction column (all)" and "removal" are handwritten on the upper part of the cover.

29. Interview with Hatanaka Shigeo.

30. They were ready to consider the censors "obtuse" and "narrow-minded," attitudes that many students of the process seem to have absorbed.

31. From the point of view of the Book Section of the Home Ministry, Mitchell has speculated that *"Chūō kōron's* most serious sin was not the contents of the story, but the fact that specimen copies given the police read differently from earlier copies." Mitchell, *Censorship in Imperial Japan,* 289.

32. See *Japan at War,* 65.

33. *Living Soldiers,* 83.

34. Ibid., 60.

35. Shimbun Taimususha, ed., *Shina jihen senshi: kōhen* (War History of the China Incident: Part 2) (Tokyo: Kōtoku hōsankai, 1938), 203–215, esp. 203. This is a collection of newspaper reports touting Japan's war on the continent.

36. *Living Soldiers,* 215.

37. See the discussion in Cook and Cook, *Japan at War,* 39–40. See also H. J. Timperley, *Japanese Terror in China: Documents Revealing the Meaning of Modern War* (New York: Modern Age Books, 1938), 157–166, for the classic description of the horrors; the appendices include violent incidents occurring well into February 1938. More recent treatments include Fujiwara Akira, *Nankin daigyakusatsu* (The Nanjing Great Massacre) (Tokyo: Iwanami, 1988), Hata Ikuhiko, *Nankin jiken: Gyakusatsu no kōzō* (The Nanjing Incident: The Structure of a Massacre) (Tokyo: Chūō Kōronsha, 1986), and Nankin Senshi Henshū Iinkai, ed., *Nankin senshi* (History of the Nanjing Battle), 2 vols. (Tokyo: Kaikōsha, 1989). See the compendium of sources on the incident in Daqing Yang, "A Sino-Japanese Controversy: The Nanjing Atrocity as History," *Sino-Japanese Studies* 3:1 (November 1990), 14–35; also his "Challenges of the Nanjing Massacre: Reflections on Historical Inquiry," in Joshua A. Fogel, ed., *The Nanjing Massacre in History and Historiography* (Berkeley: University of California Press, 2000), 133–179. Two recent studies of value by Kasahara Tokushi are *Nankin jiken* (The Nanjing Incident) (Tokyo: Iwanami, 1997) and *Nankin nanminku no hyakunichi: gyakusatsu o mita gaikokujin* (The One Hundred Days of the Nanjing Safety Zone: Foreigners Who Saw the Massacre) (Tokyo: Iwanami, 1995).

38. Ishikawa Tatsuzō, *Ikiteiru heitai* (Tokyo: Kawade Shobō), 1945. This copy, passed by SCAP censors, is held in McKeldin Library, University of Maryland, as part of the Gordon W. Prange Collection.

39. Strictly speaking, *geisha* refers to Japanese women highly trained in the arts of music, dance, and service. It is extremely expensive to be served by geisha. But, the term *geisha* is often used in a loose, broad meaning to refer to all serving women, almost euphemistically for dancing girl or prostitute. Ishikawa's men use the word *geisha* in the latter sense.

40. These are found here and there throughout *Living Soldiers.*

41. *Living Soldiers,* 12, 39, and 70.

42. Ibid., 37–38. The words struck out in the example were replaced by "……" in the version *Chūō kōron* attempted to publish, indicating that some words had been deleted.

43. Ibid., 49–50.

44. Hamano Kenzaburō, *Ishikawa Tatsuzō no sekai* (The World of Ishikawa Tatsuzō) (Tokyo: Shinchō, 1976), 121.

45. Yasunaga, "Wartime Literature 2," 53.

46. *Living Soldiers,* 64. The Japanese pronunciations and references to Chinese place names were Shakan, Suiseimon, and Chūzanmon.

47. Ibid., 65.

48. He died of illness in the Fushun prison in 1955 while he was in Chinese custody.

49. Shōwa Sensō Bungaku Zenshū Henshū Iinkai, ed., *Shōwa sensō bungaku zenshū, Bekkan: Shirarezaru kiroku* (Shōwa War Literature Collection, an Extra Volume: The Unknown Records) (Tokyo: Shūeisha; 1965), 463.

50. *Shirarezaru kiroku,* 254.

51. Ibid., 257.

52. Hata Ikuhiko finds similarities in the records of the movements of the Sixteenth Division. He expresses his admiration of Ishikawa's work and notes in particular how remarkable it was that a writer with no military experience could capture so well how soldiers' violence could take place with the silent approval—or even the encouragement—of higher military authorities. Hata Ikuhiko, *Nankin jiken: gyokusai no kōzō* (The Nanjing Incident: The Structure of a Massacre) (Tokyo: Chūō Kōronsha, 1986.), 19–21.

53. Hamano Kenzaburō, *Ishikawa Tatsuzō no sekai,* 118.

54. Fujita's war paintings, such as *Final Fighting at Attu* and *Japanese Prefer Death by Suicide to Dishonor at Saipan,* were extremely realistic and presented the stark cruelty of war. But Fujita did not paint these works to promote antiwar sentiment among the viewers. Instead, he was one of the most active painters who worked to promote the fighting spirit and hatred of the enemy among Japanese people. See the essay by Mark Sandler in this volume.

55. I do not reach this conclusion lightly, but only after an extended study of their works. The little available material on these men's wartime art—particularly Fujita's—cries out for expanded research and analysis. See especially Naruhashi Hitoshi et al., eds., *Taiheiyō sensō meigashū* (The Pacific War Art Collection) (Tokyo: Nōberu shobō, 1967). "Sensōga o kangaeru: Shōwa bijutsu no kūhaku" (Thinking about War Art: The Vacuum of Shōwa Art), a special section in *Bijutsu no mado* 10:8 (August 1991), 33–71, addresses the problem. See also Tsukasa Osamu, *Sensō to bijutsu* (War and Art) (Tokyo: Iwanami Shoten, 1992) and Bert Winther-Tamaki, "Embodiment / Disembodiment: Japanese Painting during the Fifteen-Year War," *Monumenta Nipponica* 52:2 (Summer 1997), 145–180.

56. Yasunaga, "Wartime Literature 2," 67.

57. *Living Soldiers,* 42.

58. *Shuppan nenkan Shōwa 14 nenban* (Publishing Yearbook for 1939), 61. The authorities concluded that some complementary copies of the magazines had been sent out and crossed to China, America, and the Soviet Union via sailors. Due to this incident, the Newspaper Regulations were revised so that the publishers had to submit magazines three days prior to the publishing dates rather than two days.

59. During the trial, Judge Hatta cited nine sections of the book, summarized in the trial record into four groups, that he felt depicted illegal and cruel acts such as soldiers steal-

ing an ox from an elderly Chinese woman. See Tsuzuki Hisayoshi, *Senji taiseika no bungakusha* (Literary Men under the Wartime System) (Tokyo: Kasama Shoin, 1976), 15–16.

60. Yasunaga, "Wartime Literature 2," 51. Ishikawa's second trial was held in April 1939. The same sentence was handed down. Ishikawa's prison term was reduced to three months due to the general amnesty announced on the occasion of the celebration of the twenty-six-hundredth Anniversary of the Founding of Japan, celebrated in November 1940, according to Hamano, 121–122.

61. Tsukasa, 52–61; Cipris, "Radiant Carnage," Appendix 1, 397.

62. Hamano, 126

63. Yasunaga, 70.

64. Ishikawa Tatsuzō, *Bukan sakusen* (The Wuhan Operation) (Tokyo: Bungeishunjū, 1976), 57.

65. Ibid., 199.

66. Ibid., 114–115, 181. In this novel, Ishikawa never uses the term *comfort women* or *"ianfu,"* but instead uses "Kokubō Fujinkai" (National Defense Women's Association), by which he means women serving the troops sexually. This is a colossal euphemism. That organization, officially sanctioned and supported throughout the country, was composed largely of the sisters and mothers, aunts, and female neighbors of all Japanese soldiers back home. It served to mobilize the communities and helped "send off" the men to war with parades and cheers. It steeled the national will to the demands of war. The National Defense Women's Association also contributed to the dispatch of entertainers, including famous actors and personalities, to pay visits to the theater of war. Yet there is no doubt what the groups Ishikawa refers to actually do near the front. His is no USO show! See Sandra Wilson, "Mobilizing Women in Inter-War Japan: The National Defense Women's Association and the Manchurian Crisis," *Gender and History* 7:2 (August 1995), 295–314.

67. Keene, *Dawn to the West,* 915–916.

68. See *Mainichi shimbun,* July 14, 1944.

69. While his trial was in progress, Ishikawa wrote a three-hundred-page manuscript and Shinchōsha published *Kekkon no seitai* (The Ecology of Marriage) in November 1938. This time, he adopted the I-novel style. The book was based on his own marriage. From 1940 to the end of the war, his literary work drastically decreased, although his essays and discussions on contemporary topics appeared in newspapers and magazines. His novel, *Naruse Nanpei no gyōjyō* (The Behavior of Naruse Nanpei) began in the Mainichi newspapers in July 1945, but it was prevented from appearing by the government after fifteen installments had come out. The reduction of literary publications during this stage of the war was not limited to Ishikawa alone, of course. See Tsuzuki Hisayoshi, *Senji taiseika no bungakusha,* passim, and *Nihon kindai bungaku daijiten,* 100–103.

70. See Cook and Cook, *Japan at War,* 222–227. Mitchell also tells Hatanaka's story in *Censorship in Imperial Japan,* 326–328.

71. See Marlene J. Mayo, "Literary Reorientation in Occupied Japan: Incidents of Civil Censorship," in Ernestine Schlant and J. Thomas Rimer, eds., *Legacies and Ambiguities: Postwar Fiction and Culture in West Germany and Japan* (Washington, D.C.: Woodrow Wilson Center Press, Johns Hopkins University Press, 1991), 135–161.

72. See Marlene J. Mayo, "Civil Censorship and Media Control in Early Occupied Japan: From Minimum to Stringent Surveillance," in Robert Wolfe, ed., *Americans as Proconsuls: United States Military Government in Germany and Japan, 1944–1952* (Carbondale, IL: Southern Illinois University Press, 1984), 263–320, 498–515 n.

73. Marlene Mayo has speculated that the Occupation authorities, including information officers as well as censors, may have been extremely anxious for the Japanese public to learn about the Nanjing incident through Japanese authors. This seems quite possible, since Americans in CI&E made early efforts to provide Japanese newspapers and other media with photographs and accounts of battles to show the public "the truth about the war." See, for example, an item in the *Nippon Times*, October 17, 1945, headlined "Books Banned in War Set for Publication," including Ishikawa's "Surviving Soldiers," described as "a book banned for depicting in part the atrocities committed by Japanese soldiers following the fall of Nanking" (Graduate History Seminar on Modern Japan, University of Maryland, November 1996). It seems that such attempts to convey "truth" were often taken in quite the opposite way by the Japanese, who saw them as confirmation of Japan's "heroic struggle."

74. Mayo, "Literary Reorientation in Occupied Japan," 13.

75. In the holdings of the Prange Collection is a reprint of Ishikawa's *Sōbō* (The Common People), which was published by Shinchōsha in 1948. One page of the book was blue-penciled and marked "disapproved" by the censor on August 23, 1948. The disapproved passage is a description of the Japanese immigrants to Brazil—who are the protagonists of the novel—being allowed into the public toilets and buses, which had been prohibited to "colored people." While it is not certain why this passage drew the gaze of the censor, the contrast with policies toward equality for the "Negro" in the American South in 1948 is obvious.

76. See Introduction to Kawade edition of *Living Soldiers*, 2.

77. Ishikawa, *Keikenteki shōseturon*, 328.

78. Tsuzuki, *Senji taiseika no bungakusha*, 41–42.

79. Ishikawa, *Keikenteki shōseturon*, 331.

80. Odagiri Hideo, "'*Ikiteiru heitai*' hihan: sensō to chisikijin no baai" (Criticism of "Living Soldiers": A Case of War and an Intellectual), *Shin Nihon bungaku* (Literature for New Japan) 1:1 (March 1946), 23–24.

81. Nihon kindai bungaku kenkyūkai, ed., *Gendai nihon shōsetsu taikei* (Modern Japanese Novel Collection), vol. 57 (Tokyo: Kawade Shobō, 1952), 323.

82. Tsuzuki, *Senji taiseika no bungakusha*, 19.

83. Ishikawa Tatsuō, "Jidai no ninshiki to hansei" (Perceptions and Reflections on the Period), in *Ishikawa Tatsuō saku hinshu*, vol. 125 (Tokyo, Shinchōsha, 1974), 48–54.

84. Ibid. 52–53.

85. Ishikawa Tatsuzō, *Ningen no ai to jiyū* (Human Love and Freedom) (Tokyo: Shinchōsha, 1975), cited by Asada Takashi in "Ishikawa Tatsuzō 'Ikiteiru Heitai' kō: hyōka no datōsei ni furete" (An Interpretation of "Living Soldiers": On the Appropriateness of Evaluation), *Nara Daigaku kiyō* (Nara University Bulletin) 9 (December 1980), 27. For Eleanor Roosevelt in Japan, see Nobuya Bamba and John F. Howes, eds., *Pacifism in Japan: The Christian and Socialist Tradition* (Kyoto: Minerva Press, 1978), 238–241, and Appendix, 247–249.

86. See Odagiri, 23–31, and Nakano Shigeharu, "Kaisetu" (Interpretation), in *Gendai nihon shōsetu taikei*, vol. 59, 315–326.

87. See Keene, "The Barren Years," 67–112, and "Japanese Writers and the Greater East Asian War," 209–225. The horrific consequences artistically are all too clear in the selections Keene presents.

Paris in Nanjing:
Kishida Kunio Follows the Troops

J. Thomas Rimer

KISHIDA KUNIO (1890–1954) was one of the leading playwrights of the interwar generation in Japan and the man who, perhaps more than any other writer and intellectual interested in the challenge of creating a Western-style drama, helped to make possible a modern Japanese theater sensitive to the insights of modern psychology. By the 1930s, he achieved the level of literary skill needed to reflect in his dramatic works the emotional and spiritual vicissitudes of the kinds of Europeanized upper-class Japanese whom Kishida had come to know and understand. He was therefore able to create on stage the nervous and sometimes nihilistic world in which they lived, showing in his dialogue a psychological deftness and linguistic finesse that made him famous.

Kishida gained his ability to sketch the outlines of this segment of modern Japanese society because his natural talents were bolstered by his visit to France. In his early years, in the period just after World War I, the example of France and French culture loomed as a crucial model and benchmark in the arts. French culture seemed to set standards of what writers and artists might achieve; so, like a Japanese Gertrude Stein or Hemingway, Kishida set out for Paris in 1919. There he was able to observe the theatrical productions of the renowned Parisian director Jacques Copeau. His stay in Europe was relatively short. Had his father's death not brought him back to Tokyo in 1922, however, Kishida might well have remained —as did the Japanese painter Léonard Foujita (1886–1968)—for a much longer time, in what seemed to him an altogether glamorous and perhaps productive environment.

Kishida went to France to learn. He was, like many in his generation around the world, a suppliant—a kind of colonial subject, spiritually speaking—journeying far in order to witness the capital of his aspirations. There is, therefore, a certain sense of banishment, of spiritual fatigue, in much of Kishida's work written

after his return to Japan. And as so many writers, artists, and intellectuals of his generation were struggling to amalgamate their talents with what they took to be world standards and currents of excellence based on the European model, that sense of fatigue rings true. He certainly could not (nor made any claims to) speak for the whole nation, for the subject of his observations was to be a highly Europeanized and implicitly isolated Japanese elite. Nevertheless, his reading of the emotional temperature of the travails involved as the intellectuals of one culture try to assimilate and participate in the culture of another reveals their state of soul with a rueful authenticity.

In the late 1930s, theatrical activity, particularly if any political implications were involved, became more and more difficult under the increasingly severe eye of the Japanese government. Kishida's last play during that period, *Fūzoku jihyō* (A Comedy of Manners), produced in 1936, appeared critical of certain changes Kishida found in contemporary society. After the celebrated coup d'état in that same year, in which dissident young army officers attempted to take over the government and assassinated a number of prominent government officials, Kishida wrote little for the theater until after the war.

Kishida's trip to France represented an opportunity to study and observe what he admired and loved. It was a voyage he chose to take. The fact that European connection had brought him to fame now obliged him to undertake a second journey, one for which neither his training nor his interests had prepared him. Like so many of the intellectuals of his generation, he had faced the West. Now his very prominence forced him to go out of Japan again, not to the core of the Western culture he had long admired, but to China, the center of an Eastern tradition discarded since his father's time.

Like other writers and intellectuals in prominent positions, Kishida was asked to observe and comment on current events. In this regard, the military wished to put the intellectuals of status to work in defending contemporary Japanese policies. After the Marco Polo Incident in 1937, public attention turned increasingly to the situation in China. Kishida was asked to tour the front to report on the aftermath of the "incident"—as the Japanese came to refer to it—and its long-term effects on relations between the two countries. In October of 1937, Kishida visited northern China as a special correspondent for a leading literary magazine, *Bungei shunjū*. This first trip lasted about a month. In the following year, 1938, he was requested by the government to visit the southern front for a period of close to two months.

From the government's point of view, Kishida was considered a good choice for such an assignment. From his writings, the public knew he was a sophisticated traveler, a man already widely appreciated for his cultured, humane, sometimes gently ironic views of Japanese and European society; and he was politically "safe," no left-leaning ideologue. As Kishida's writings on his China trip were later to make clear, he felt himself in some ways to be a very bad choice: Kishida confessed that he knew virtually nothing about China, although, in fact, he had stopped briefly in Shanghai, then in Vietnam, on his way by ship to France virtually two decades before. Now, Kishida's trips to China were to represent a voyage

178

of exploration and, of necessity, self-exploration as well. The book-length account of his voyage, *Jūgun gojūnichi* (Following the Troops for Fifty Days),[1] which combines his observations made on both trips, represents more than anything a reflective souvenir of a man who has glimpsed a civilization from which his own modern civilization had wooed him and his own compatriots away, for since the time of the Sino-Japanese War in 1894–1895, in which the Japanese were victorious, China had lost its attraction as a cultural model for many Japanese. Few of his insights gained in Europe, or indeed of his techniques for gaining insight there, were of substantive help to him in examining this vast civilization, now at war again with his own nation. In the course of the trip, then, Kishida learned unexpected things both about himself and his own limitations.[2]

Written under difficult conditions and doubtless checked over by censors, Kishida's account cannot be read as a source book for insights into the realities of military or political history; indeed the thrust of much of the story represented here is rather an interior one, revealing how Kishida implicitly seeks to maintain both his self-respect and his independence of judgment as he tries to find a way to establish his own "self-worth," to paraphrase an insight of Dennis Porter, who maintains that this is a task many travelers assign themselves, wittingly or unwittingly.[3]

Kishida's text suggests all the complexities of the period. Writers sent abroad during these years are now often criticized as dupes, willing or unwilling, of the Japanese government. If Kishida's example is at all typical, however, the matter of making judgments is far more complex. In a sense, to use a currently fashionable word—*intertextuality*—*Following the Troops* should doubtless be read in conjunction with other works composed during the period, documents that Kishida himself may well have read. As Donald Keene points out, a violent, shocking account such as Ishikawa Tatsuzō's *Ikiteiru heitai* (Living Soldiers), which implicitly condemned the activities of the imperial army in China, was already published (although in censored form) and circulated before Kishida's trip.[4] There is evidence therefore that, in some way, a sense of malaise was already developing among the kind of readers concerned with the war who would be likely to read Kishida's account. Parts of the manuscript were first published in the Tokyo *Asahi* newspaper, as well as in *Bungei shunjū,* both highly prestigious forums for intellectuals of the period.

In the preface to the work, Kishida remarks that his published text is drawn from his own notes made while traveling in China: "Based on the little I was able to see, I believe that I have the duty, within the limits permitted me, to tell the people of our country what it is that they must know; and I know as well that I can only render my own personal opinion."[5] The narrative forms itself, therefore, from a collage of impressions. Kishida's phrase concerning "the limits permitted me" is perhaps best defined by the thanks he renders in the book to the Cabinet Information Division of the Japanese cabinet, as well as to the relevant military authorities, for the help they provided in the planning and execution of his trip.

Shortly after his arrival in China, Kishida's main concern finds a voice: What are ordinary Chinese thinking—and thinking about? In one sense, this thread ties the disparate threads of the narrative together. Kishida's question is asked repeatedly in shifting circumstances, yet it is never answered. In incident after incident described in the book, Kishida speaks, or tries to speak, with the Chinese who surround him, yet he learns little that satisfies him.

Part of his problem appears to him to be mechanical in that there are few if any adequate interpreters at his disposal. In particular, Kishida reserves his sense of disappointment over several opportunities lost because one of the interpreters assigned to him—a Chinese man who had worked as a hairdresser in Tokyo before returning to his home country—knows only broken Japanese and is incapable of rendering any kind of nuance from one language to the other. One Chinese prisoner of war he interviews describes a life of exhausting poverty; captured by guerrillas, he was forced to serve in their army and now only wants to be left to lead his life without politics of any sort. Two Chinese college students he interviews, he comes to realize, apparently know absolutely nothing whatsoever about the issues at stake between the two countries—or indeed anything at all about Japan, either as a nation or as a culture. Kishida finds himself isolated inside a kind of spiritual glass box.

For Americans familiar with the circumstances of the war in Vietnam, many sections of this diary-like narrative make painful reading, as observations resembling those of Kishida have since been made by many Americans and Europeans who visited Vietnam during the war years there. My analysis of Kishida's remarks made throughout his account suggest that his convictions concerning the real nature of the conflict involve three issues: (1) He came to realize that the war was one between the plains, inhabited by the Chinese and their Japanese "protectors," versus the hills, from which guerrillas descend to attack, then withdraw; (2) he believed that this war was basically a civil war, a fact he believes has sometimes escaped the Japanese military officials; and (3) he was convinced that the Japanese made no efforts to ameliorate a dangerously low level of communication skills with regard to the indigenous peoples whom they were attempting both to govern and, presumably, to win over to their way of thinking.

But Kishida's greatest anguish, as a man of words, remained the fact that he was asked to travel through and come to some understanding of a region of the world in which his own words, and so his questions, fell on ears that literally could not understand them. Silence was the chief source of his anxiety, and that anxiety can be felt on virtually every page.

In Kishida's text, his trip begins as a *personal* memory. His descriptions of Shanghai are sketched in terms of the memories he had from his brief visit there on the way to France twenty years before. He meets old Japanese friends now living in the city, including some of his students at Meiji University in Tokyo, where he had for several years taught courses on the theater. He also meets a number of Chinese intellectuals who maintained friendly relations with the Japanese.

By the time Kishida leaves Shanghai, however, the trip is transmuted into a trip of *cultural* memory, as he tries to juxtapose his own present, personal experience of the country with remembered notions of the greatness of classical China learned during the period of his formal education. With a friend, Kishida visits a beautiful lake area west of Shanghai; they climb the hills, recite classical Chinese poetry both have long loved, and look at the temples. Kishida's poetic reverie on the greatness of the Chinese past is soon shattered by the shabbiness of the present. Now Kishida and his colleague find the temples dirty, their walls battered and frayed. Neglect is everywhere. Kishida's romantic vision of China gained from the classical literature he read as a child now disappears. This shock of disappointment, Kishida comments, reinforces in him a sense that there exists—indeed there *must* exist—in the Chinese "a stoicism, allied to a kind of epicurean spirit." Later in his text he will suppress history altogether, coming to a vision of the Chinese as a "timeless people." Kishida seems disappointed in himself as he puts forth what he tacitly acknowledges to be clichés. Yet from the vantage point of a reader today, the fact that he does so is perhaps not surprising. The gap between the little he acknowledges he knew concerning China and the actualities of the political moment in which he found himself immersed was surely too great for him to bridge with any confidence.

In his writing, Kishida remained a close observer; he was the kind of writer who can describe quickly and deftly any given situation he observes. Throughout the voyage, he continues to watch, look, and describe, yet he cannot interpret what he finds before him. Kishida's determination to confront his sense of puzzlement over the true meaning of what he observes begins during his visit to Shanghai and was to continue throughout his entire voyage. Kishida witnesses, for example, a party of Chinese schoolchildren with the Japanese teacher. They are waving flags. The occasion is supposed to be festive, Kishida muses to himself, yet why does the atmosphere seem somehow so forlorn?

On leaving Shanghai, a sense of malaise, of his "going to war himself" floods over him, yet the reasons for his gloom seem obscure; he cannot manage to articulate them.

> When I awoke, the first thing I heard was the sound of heavy rain. I pulled myself up and went to the window. I pulled aside the dark curtains provided for the blackouts and looked outside. In the faint light, like a meandering serpent, a line of troops and heavy vehicles passed by. What I had thought was only the sound of the rain turned out to be the systematic sound of I wonder how many horses' hooves clattering on the asphalt pavement. No one spoke; nothing squeaked; the horses hung their heads in silence as they moved off to whatever their destination. I suddenly realized that it was time for me to start off as well.[6]

The images are recorded with precision; their import is obscure.

Once into the villages, the problem of dealing with the guerrillas remains uppermost in the minds of the military commanders with whom he is traveling.

Kishida worries at finding himself slipping into what might be a termed a "means" rather than an "ends" psychology, as he acknowledges that he finds himself setting aside questions concerning his doubts over larger matters of policy and political responsibility on the part of the Japanese military, replacing them with issues concerning the kind of "techniques" required for the successful pacification of the areas he is taken to visit.

In his wanderings through the dangerous Chinese countryside, Kishida seeks to communicate so as to reach some level of understanding of what he witnesses. He finds little opportunity to achieve any deeper understanding by talking with the military officers assigned to escort him since they, like he, cannot speak Chinese. It is thus not surprising that he finds himself particularly happy to visit English and French missionary churches and hospitals, a type of excursion seldom undertaken by his Japanese military comrades. One reason for his interest is obvious even to himself. He knows some English and speaks French well. He can communicate with Europeans in their own languages and so seek to gain a certain outside view of the larger military and political situation. The most sympathetic of such figures he portrays is that of a French missionary doctor who tells him that the fierce guerilla attacks "were a frightening time; as for myself, I read Pascal."[7]

On his arrival in Nanjing, the same feelings he harbored in Shanghai now return to haunt Kishida again, like some jarring refrain: "How can I come to know the state of mind of the Chinese people?" As he walks about in the city, he observes a grinding poverty and witnesses a terrible fatigue on the faces of its citizens, yet he can find no means to talk with anyone in order to seek corroboration of the meaning and significance of his anxious vision. His glass cage continues to surround him.

In one remarkable scene, too long to reproduce here (and one again evocative to Americans familiar with reports from the Vietnam War), he watches a peasant woman busy farming, digging the earth with her crude tools, apparently oblivious of the battle raging about her. He can watch this scene, record it, he notes in frustration, but he knows he lacks the means to analyze it, to learn its significance. The site of the burned-out village becomes no more than a stage set for a play he cannot compose. Indeed, Kishida goes on to remark, he is not even able to learn for sure who has destroyed these poor houses. Was it the Chinese guerrillas, or possibly the Japanese troops themselves?[8]

Kishida is haunted as well by the anti-Japanese propaganda he observes: slogans written on walls, defiant lyrics in Chinese songbooks, critical newspaper stories in Shanghai. All that he can put up against the difficult present is his sense of the beauty of the Chinese classical past. On the river near Nanjing, he hears a Chinese folk song floating out over the water. For an instant, he feels at peace. But the poetry of place belongs to another time, he ruefully acknowledges. He is not to find it again on his journey.

The mosaic of incident, impressions, and apprehensions continue until Kishida finds himself back in Shanghai, his official itinerary completed. It is at this point that Kishida draws back from the welter of his impressions and attempts to com-

pose an essay intended to sum up his own views of the war. The style of the earlier sections of the narrative had been appropriate to his specific sketches, often filled with insight and composed in a loose and flowing style. In this section, on the contrary, the style is clotted with abstract words and difficult character compounds. It is almost as though the author now were attempting to hide behind the abstract language he employs. In one sense, the disparity between what is observed and what is understood is here repeated in the texture of the very web of language created. Nevertheless, this abstract language is not empty of content; in a real sense, such a heightened rhetorical pitch appears to have been adopted at least in partial measure to justify Kishida's experiential sense of ambiguity concerning the experiences he has undergone and so, by extension, of the difficulties of creating a general structure of response.[9]

Kishida's observations can be summed up as follows: (1) The battlefield in China is not merely centered on a congruence of lines drawn on a map. The whole nation of China is involved. The specific danger of the current situation, in which guerrillas mix freely with their own people, is that they will always maintain an advantage based on an innate cultural patriotism felt strongly by all Chinese. (2) He asks, how can *we, as Japanese,* separate the guerrilla "bandits" from those Chinese who simply want to live in peace? If Japanese troops withdraw altogether, civil war will result. (3) Japan will do best, Kishida is convinced, if she works to sustain and support the natural patriotism of those Chinese who wish to help their nation. "The appearance of such a group of persons, for thoughtful Japanese, marks a turning point and gives a real basis for hope," he notes.[10]

Earlier in his account, Kishida remarked with some rhetorical force that his countrymen must learn to appreciate the significance of the need the Chinese feel for self-esteem. Every country, he insists, has its proper social or racial self-respect.[11] Given these principles, Kishida continues, the Japanese must take a number of concrete steps to create a viable situation.

In the first place, the military must look to the cultural aspects of the war situation and, in particular, to the need for establishing lower and middle schools throughout the country. These schools, of course, should include a Japanese language teacher, so that at least some Chinese can learn to communicate with the Japanese. Secondly, continuing efforts must be made to teach the Japanese language to those young Chinese who sincerely wish to work with the Japanese. Thirdly, those Japanese working in China, either in a civilian or a military capacity, must take cognizance of the realities of Chinese culture, and they must sincerely wish to help the Chinese to modernize and to realize what is best for their own country.

Next, the Japanese must observe carefully the kind of work that the Europeans (Americans included) have already accomplished in China, particularly with regard to establishing and maintaining hospitals, schools, and other cultural institutions. Most importantly, Kishida emphasizes again and again, the Japanese must not disdain such efforts and what they have accomplished in the eyes of the Chi-

nese. Japanese should join together with the Europeans in an effort to study the complexities of contemporary Chinese political and social life. The Japanese must fully acknowledge that most Chinese indeed truly appreciate what the Europeans and Americans have done. Finally, Kishida cautions that the Japanese must observe and study the sources of emotional friction between his country and China. There is, as he puts it, no room for "slack" now; the destinies of the two people are now closely bound together.

Specifically, Kishida concludes, such principles call for the establishment of a number of cultural and humanitarian activities that could be carried out as joint projects between the two countries. Many of these should be privately sponsored, Kishida insists, adding that he found a great need for medical and printing facilities. In the midst of these various recommendations, a remarkable passage occurs in Kishida's text:

> Without setting aside the good points of Japan and the Japanese, we must ask of what use is the kind of fanaticism that results from our narrow thinking concerning the realms of culture, our stiff formality, and the lack of clarity in our own minds as concerns our conceptions of the problems of national development? We keep spinning out, and with a real lack of common sense, ideas concerning our own special qualities as Japanese and our love of nature; these in turn give rise to our meaningless slogans that the West is materialistic but that Japan is spiritual. That is a childish view from which we must escape.[12]

The traveler has turned back into himself and (even if in a fashion doubtless limited by the restrictions imposed upon him) has reflected on what another culture has taught him about himself. In this context, the gap between the specificity of Kishida's individual observations and his generalized proposals remains significant; the trajectory of movement in his mind from specific observation to general recommendation is certainly not always clear; and as suggested by the language he employs, they seem on occasion (at least to a reader from our contemporary vantage point) to have been virtually wrung from him.

What did Kishida wish his experience—and what he drew from that experience—to convey? The deeper meanings of words on the page must sometimes be found between the lines; on the other hand, reading by hindsight is dangerous. The challenge, of course, is for the reader over sixty years later to attempt in some effective way to ascertain the contours of Kishida's beliefs and convictions when he took his original notes and composed his text in 1938. Kishida clearly worked within the necessary framework of the official position that the Japanese were in China to help improve the future of Asia; it is certain that he did not feel himself able (or permitted) to raise the question as to whether the presence of Japan in China was of merit of any kind in and of itself. Rather, he was limited to commenting upon how effectively the Japanese presence in China, which constituted the given, was made manifest.[13] In any case, Kishida never explicates the nature

of the limitations placed upon him. Certainly his narrative never oversteps reasonable bounds. He could not, or would not, publicly question the basis of the whole enterprise.[14] Edward Said remarks in his *Orientalism* (New York: Random House, 1978) that distinctions made between a nation's sense of its home space and that of others can lead to a concept of "us" versus "the barbarians." In many real ways, of course, Japan was treating or attempting to treat China as though she were a colony—and a recalcitrant one at that. As Said explains, however, "imaginative geography of the 'our land-barbarian land' variety does not require that the barbarians acknowledge the distinction."(54). Whatever Japan's sense of her superior relationship to China, the Chinese held a very different view. In hindsight, the results were in some ways inevitable; to quote Memmi, "If colonization destroys the colonized, it also rots the colonizer" (xvii).

Reading *Following the Troops* now, more than sixty years after its composition, what is conveyed? From our own point of view, the document stands as a tacit, weary testimony to the powerlessness of the intellectuals, the "thinking people," when faced with the realities of military control. Kishida's humane impulses, however well intentioned, seem swept aside here by the onrush of a harsher history. There is, therefore, an implicit sense on the author's part of personal betrayal contained in these pages as well.

Why should this be so? Specifically, it seems clear that a generation of Japanese artists and intellectuals such as Kishida, who by temperament and training had taught themselves to move in sympathy within the higher reaches of sophisticated European culture, possessed few if any of the tools needed to help them in coming to an understanding of Asia, or more specifically of a China that, economically at least, was an underdeveloped country. The only sympathetic points of repair in the intellectual vocabulary of Kishida and his generation (notably Buddhist architecture and Chinese classical poetry) represented more of an obfuscation than a help in grasping the realities of a huge country mired in a complicated war.

Then too, in Kishida's case, there remains the problem of silence: Without language, without mutual communication, he knew nothing could be learned. The tonality of his text, then, is one of malaise and anguish. In one of the most striking passages in the book, Kishida wonders what will remain of Japan's legacy in China. What will future generations say of this period, he muses. He does not, of course, provide an answer. It is now his turn to fall silent.[15]

In the case of Kishida, this voyage, and what it asks of him, represent an unpleasant stretch of his sensibilities. It is thus not surprising that he finds little if any sense of ease or adventure in what he undertakes. As the narrative concludes, he is happy—indeed relieved—to be at home in Tokyo, with a sense of comfort, a "wholesome feeling," as he puts it.[16] He trusts Japan, he concludes, and he is happy to lay down the burden imposed upon him. In hindsight, of course, it is precisely this "laying down" of the burden that represents one kind of intellectual betrayal so often practiced during these difficult years. Or so it may seem now, in comfortable hindsight.

Much ink has been spent over questions of Kishida's wartime "guilt," since he did continue to work with the government in various cultural activities during the earlier stages of the war. In the course of this present research, I have not examined this question directly, since those later years from 1939 to 1942 are not the focus of my present concern.[17] In passing, however, I might mention that it does seem to me that Kishida's sense of personal betrayal in 1938 is worth examining; by the time he had come to take cognizance of these feelings in himself in the later period, the object of his scorn was to become at least in part the European humanistic culture he had so long admired.

Why? Possibly it was because the defenses against the kind of political confusions and repressive forces in society he assumed that the informed intelligence of the Japanese intellectual class could provide were no longer heeded. The skills and insights he had been at such pains to acquire through his French experience had, he surely felt, earned him the right to a voice of some stature in his position (one certainly acknowledged by the government) as an important Japanese writer and intellectual. Kishida's trip to China, however, taught him all too well that any kind of cultural understanding could provide at best a frail bastion against the realities of the Japanese military machine.

In emotional terms, then, if in no other way, Kishida may well have felt that his French experiences had failed him. For it was in Paris that he received his first lessons in grasping the larger opportunities that might come to him as an artist and an advocate of modern Western artistic values. Yet by the later 1930s, those lessons and all that they first promised seemed increasingly empty and without present relevance. Kishida might well have finished by blaming the source of the lessons he thought he had come to master so well.[18] It is, therefore, perhaps not altogether inexplicable that Kishida went through an increasingly nationalistic phase in the early years of the war before lapsing into total silence in 1943.

Nevertheless, in 1938, at this particular moment in the trajectory of his understanding and self-understanding, Kishida was attempting to bear witness. He asked questions—as many of the right questions as he was permitted to ask; and he attempted to understand what he saw and what he felt. In this, at least, he bore an artist's witness to a terrible time.

Notes

1. Tokyo: Sōgensha, 1939. He was a member of the official Pen Brigade.

2. For a useful overview of Japanese writers traveling to China in this period, see Joshua Fogel, *The Literature of Travel in the Japanese Rediscovery of China, 1862–1945* (Stanford: Stanford University Press, 1996), 250–275. Here are a few sentences from Fogel's thoughtful introduction: "Travel, be it in the ancient West or in modern East Asia, has never been innocent. But neither has it been motivated solely by imperialist or colonialist obsessions. Human experience is far too complex for such simplistic explanations" (9).

3. See Dennis Porter, *Haunted Journeys: Desire and Transgression in European Travel Writing* (Princeton, NJ: Princeton University Press, 1991), 12.

4. See Haruko Taya Cook's essay in this volume, as well as Donald Keene, *Dawn to the West* (New York: Holt, Rinehart and Winston, 1984), vol. 1, 910.

5. *Following the Troops,* Preface, unpaginated. Watanabe Kazutami, in his highly regarded study of the writer, *Kishida Kunio ron* (Tokyo: Iwanami shoten, 1982), makes in the sections of his text dealing with the war years a number of trenchant comparisons between Kishida's writings and those of other "patriotic" writers, often to Kishida's credit.

6. *Following the Troops,* 21.

7. Ibid., 35.

8. See ibid., 90–91.

9. Watanabe Kazutami, in his sections on the war years (see note 5) indicates that, in his view, Kishida went to the limits of the possible in setting forth his criticisms in print.

10. Ibid., 233.

11. Ibid., 203.

12. Ibid., 239–240.

13. In this context, it is important to note what is known about the limitations generally placed on writers during these years. Donald Keene, in discussing the problems of writing in wartime Japan, cites remarks made after the war by Hino Ashihei (1907–1960), author of such well-known works as *Mugi to heitai* (Wheat and Soldiers), who insisted, in retrospect, that he had been forced to follow certain rules. They were as follows:

> 1. The Japanese army must never be described as having lost a battle. 2. Certain kinds of criminal acts that inevitably accompany warfare must not be alluded to. 3. The enemy must always be portrayed as loathsome and contemptible. 4. The full circumstances of an operation must not be disclosed. 5. The composition of military units and their designations must not be disclosed. 6. No expression of individual sentiment as human beings is permitted to soldiers. (See Keene, *Dawn to the West,* vol. 1, 918)

14. Certainly Kishida raises no larger questions concerning the validity of Japan's presence in China. In this regard, certain remarks made by Albert Memmi in his well-known study, *The Colonizer and the Colonized* (Boston: Beacon Press, 1967), seem pertinent here, despite the fact that of course China, strictly speaking, was not truly a colony of Japan.

> But what is fascism, if not a regime of oppression for the benefit of a few? The entire administrative and political machinery of a colony has no other goal. The human relationships have arisen from the severest exploitation, founded on inequality and contempt, guaranteed by police authoritarianism. There is no doubt in the minds of those who have lived through it that colonialism is one variety of fascism. (62–63)

Had Kishida, as he wished, been able to converse with the Chinese, to *speak,* he might at least have learned certain specifics concerning the oppression felt by the Chinese. Yet in 1938, how many Japanese—other than the Marxists—could have, in the shifting flux of history at that point, precisely defined (even to themselves) their nation as a fascist one? After all, at that point in the development of a rapidly changing situation, the civilian government by most accounts was still attempting to gain ascendancy over the military and its initiatives.

15. *Following the Troops,* 212.

16. Ibid., 224.

17. For significant details on Kishida's later wartime activities, see David Goodman, ed., *Five Plays of Kishida Kunio* (Ithaca: Cornell East Asia Series, 1995), 6–8.

18. In reading an earlier version of this essay, David Goodman commented with great perspicacity to me on the difficulties of understanding Kishida's later responses to his years in France. He wrote: "Kishida's French experience was primarily his Copeau experience. While Copeau may have been a good artistic model, I don't think that he necessarily offered Kishida a useful role model to meet the historical and political challenges that he faced. I also do not think that Kishida necessarily followed the Copeau model through, particularly in terms of Copeau's devout religiosity. Would it be possible to compare Kishida's response to the coming of war with the response of Copeau and other conservative French intellectuals, such as Gide? I wonder if Kishida's French experience did not actually guide him the direction he took, rather than 'failing him' as you suggest." I hope to contribute to an exploration of this complex issue on another occasion.

A Painter of the "Holy War":
Fujita Tsuguji and the Japanese Military

Mark H. Sandler

Total war, by definition, engages every aspect of a nation's being. In wars of the twentieth century, modes of creative expression were deployed in the service of political and military strategy as swords and shields of the national psyche. In protracted conflicts, images have been employed by governments to invoke the iconography of authority, bolster morale, and insure loyalty on the home front, persuade the populace of occupied territories, demoralize enemies, or record for posterity the glorious and grim reality of the fight. In the Second World War, every combatant nation, imperial Japan included, used the talents of its artists for one or more of these purposes. During the decade of conflict that ended in 1945, the exigencies of war and the policies of government impinged upon the lives and creative processes of artists on all sides.

While almost every artist was affected in some way by the war, the case of one Japanese painter, Fujita Tsuguji (1886–1968), is truly unique.[1] Fujita's transformation from successful member of the School of Paris, master of pale nudes and society portraits, to leading propagandist for the Japanese military and maker of graphic depictions of the carnage of warfare, is a remarkable story. Beginning in 1938, Fujita emerged as the most visible and enthusiastic supporter of the war effort among the painters of Japan. He was the leader of the Army Art Association (Rikugun Bijutsu Kyōkai), an alliance of patriotic painters sanctioned by the military and actively supported by the *Asahi* newspaper chain. Favored by the armed forces, Fujita was accorded preferential treatment in the allocation of precious art supplies, showered with attention in the government-controlled press, and dispatched as a dignitary on military-funded tours to China and Southeast Asia to record the victories of Japanese forces.[2] In return, the artist enthusiastically produced immense, patriotic canvases for exhibition in official shows of war art and

eventual installation in government ministries and Tokyo's Yasukuni Shrine.[3] Were that not enough, he signed his name to articles espousing the subservience of art to the cause of national defense and authored hollow justifications for his actions after the war.

Through all this, his domestic reputation underwent wild fluctuations, as he went from recipient of high honors during the war years to target of vehement charges of opportunism and hypocrisy in the months and years after August 1945.[4] The narrative of Fujita's story alone justifies our attention. Beyond the basic facts, however, it is the unresolved questions about the artist's war work, even after the passage of half a century, that make this matter so compelling.

In a recent reminiscence of their experiences as painters in wartime Japan, Maruki Iri and his wife Toshi voice a strikingly ambivalent opinion of their countryman and fellow artist, Fujita. The Marukis, almost alone among their generation of Japanese artists, never collaborated with the military propagandists. They could be expected to roundly condemn Fujita, the leading icon maker for the imperial forces during World War II. Yet in the course of a single conversation, they refer to Fujita as both "the number-one war criminal among war painters" and a "brilliant painter" whose works "reveal the misery of war" and permit one to almost imagine that they were made to oppose conflict.[5]

The Marukis' contradictory image of the man and his war paintings mixes admiration for Fujita's great talent with contempt for his willing perversion of it to serve despotism. It is a view shaped by their firsthand knowledge of the dire conditions people endured in wartime Japan. This is a perspective that is vital if one is to understand and not simply condemn. Their ambivalence neatly captures the problematic reputation that Fujita has in Japan, even while his image in the West is unclouded.

To appreciate the nature of Fujita's wartime artistic career, we must consider several issues. What was the political environment in wartime Japan within which all artists worked? How was Fujita, as an individual, equipped to function in that environment? By what process did he become a war painter? Finally, what may be gained from an examination of some of his key war paintings? If, after having considered these matters, we remain unable to render a definitive judgment concerning his motives and the meaning of his paintings, we will at least have gained a better understanding of the extraordinary circumstances in which he and most other Japanese artists worked and lived during World War II.

Any effort to understand Fujita's involvement in war painting must begin with a consideration of the political climate affecting artistic expression in Japan from the mid-1930s. The authoritarian perversion of the prewar Japanese art world, facilitated by the very structure of that world, was part of the larger strategy of the military to mobilize and control public opinion in support of the right-wing values and expansionist policies it favored. Euphemistically called by the military "the diffusion of defense thought," this propaganda strategy was an aspect of Japan's political descent into dictatorship in the 1930s.[6] It evolved against the backdrop of the

worldwide economic depression, widening Japanese aggression in China, and growing friction with the West.

The uses of propaganda to shape domestic opinion, first among the rank-and-file troops and civil servants, later among the general populace, had been a topic of government study since 1932.[7] The campaign to guide public opinion in support of the government required the commandeering of all forms of public expression, information, and communications by ultranationalist elements of the armed forces and their civilian allies. While the focus of official interest was the censorship and propaganda uses of press and radio, cultural activities also received attention. For example, beginning in April 1939, laws were enacted concerning the content and country of origin of movies permitted to be publicly screened.[8]

From the late 1930s, government authorities moved with great skill to limit the expression of political dissent in the visual arts and to enlist the support of creative individuals and groups in the war effort. In pursuit of the strategic goal of a compliant art world, the Cabinet Information Bureau and the propaganda units of the armed forces employed an evolving set of tactics that combined a subtle grasp of group psychology with a readiness to use brute force. State policy addressed artists in terms both general and specific. At the broadest level, the government affected the working conditions of all artists by controlling access to art supplies and opportunities to exhibit. At the personal level, individual painters were either courted and flattered, harassed and threatened, or simply conscripted or imprisoned, depending on their status and their willingness to comply with official demands.

One tactic used by the propaganda machinery involved approaches to revered senior figures in the arts, with the aim of enlisting their cooperation and also gaining the support of their many followers. Two influential artist-teachers and imperial Academicians—the *nihonga* painter Yokoyama Taikan (1868–1958) and the master of Western-style oil painting Fujishima Takeji (1867–1943)—were early targets of government persuasion.[9] Both lent their reputations and talents to the cause of imperial Japan. Yokoyama Taikan was a fervent nationalist whose views were shaped by his youthful exposure to the pan-Asian philosophy of his mentor, Okakura Kakuzō.[10] Taikan donated the sales proceeds of his shows at the Nihonbashi Mitsukoshi and the Takashimaya department stores in 1940 to the army and navy. Throughout the war years, he produced stirring works, such as scenes of Mt. Fuji or the Pacific Ocean beneath a rising sun. Most significantly, from May 1943, Taikan served as chairman of the Nippon Bijutsu Hōkokukai (Japan Art Patriotic Association), an organization formed to coordinate the activities of artists' groups for the war effort.[11]

Fujishima Takeji's credentials as doyen of Western-style painters were impeccable. A pupil of the first generation of Meiji masters of *yōga*, he had also studied in France and Italy. Long a professor of painting at the Tokyo School of Fine Arts, his pupils were legion. In the spring of 1938, Fujishima led a group of painters, including his student Nakamura Ken'ichi (1895–1967), on a two-month, military-sponsored tour of Shanghai and the portions of central China under Japanese

occupation.[12] On June 27, the day after Fujishima returned to Japan, he and the other traveling artists formed the Dai Nihon Rikugun Jūgun Gaka Kyōkai (Greater Japan Army Painters' Association), the prototype for the Army Art Association in which Fujita was to be prominent.

Fujishima seems to have been a somewhat reluctant participant in this endeavor. Pointing to his advanced years and frail condition, he expressed the hope that the mantle of leadership would be passed to a younger artist.[13] The government appears to have been responsive, and his pupil Nakamura—and eventually Fujita himself—came to shoulder the leadership responsibilities for the oil-painting faction of war artists. Fujishima's death in 1943 merely sealed the generational transition.

At the other end of the spectrum from these celebrated masters were the great number of young art students and unheralded painters who were pressed into service. Their names did not add luster to the propaganda campaign of the military, but their production was in demand for a variety of domestic and overseas uses. It must be assumed that most artists acquiesced out of patriotism or the need to conform to the views of the majority. But some painters resisted government manipulation as best they could. Recounting their experiences as artists opposed to the war, the Marukis describe intimidating visits from a saber-wearing military man, urging them to paint war pictures. Despite these pressures, they were steadfast in refusing to paint for the propaganda apparatus.[14] Maruki Iri was above the age limit for conscription, but younger men were drafted out of their studios and the art schools and put to work making images for the army. A particular form of cultural conscription was aimed at writers, visual and performing artists, and other intellectuals. As the war widened, they were subject to compulsory service in propaganda units attached to the Japanese armies occupying newly conquered territories. Several of the leftist intellectuals and writers drafted into this service considered their selection to have been punishment for antiwar views, and some of the military men involved also saw it as such.[15]

Between the promulgation of the National Mobilization Act in March 1938 and the end of the war in August 1945, the military government, in collaboration with puppet art organizations, systematically choked off the production, display, and critical discussion of art it regarded as unwholesome. A widely used tactic of the military and its allies, from the time of the Manchurian Incident of 1931 onward, was the formation of "patriotic societies" (*hōkokukai*). These organizations were used to orchestrate and channel the efforts of supporters of the military among various sectors of society.[16] With the deepening conflict of the late 1930s, such societies took on the added function of enhancing government control over media industries and professions previously outside its grasp.[17] In the art world, this process gained speed as global war approached. At the same time, military-accredited artist groups, such as Fujishima Takeji's Greater Japan Army Painters' Association, were set in motion. Long-established independent painters' organizations and exhibition societies were consolidated under the umbrella of new enti-

ties with names such as Bijutsu Dantai Renmei (Federation of Art Organizations), formed in November 1940, Nihon Gaka Hōkokukai (Japan Painters' Patriotic Association), set up in March 1942, and Bijutsuka Renmei (Artists' Federation), organized in May 1942. The formation of new collectives culminated in the establishment of the previously mentioned Japan Art Patriotic Association, formed under the guidance of the Ministry of Education in May 1943 and intended to plan the coordinated control of the art world. This story of consolidation was paralleled in other fields of public life in Japan. In a world fraught with violence and the predations of the thought police, many must have welcomed the opportunity to assert their loyalty by attaching the word "patriotic" to their professional organizations, even at the expense of true autonomy. The logical consequence of this process of creating captive art organizations was the abolition of the older, independent exhibiting groups that could have offered a forum for art outside the bounds of official taste. Thus, in October 1944, as the nation spiraled toward defeat, the Cabinet Information Bureau ordered the disbanding of a number of august private painting groups, starting with the Nikakai.

Coupled with the weakening and eventual abolition of independent artists' groups, the prewar cycle of open, juried exhibitions held by painting societies and government agencies, such as the Ministry of Education, was converted into a series of patriotic Salons and military fund-raisers. Privately sponsored exhibitions and department-store shows carried on for a time, and the Marukis make clear that fringe groups continued to show their work in a kind of artistic underground.[18] But in September 1944, after the loss of Saipan, the government canceled all open exhibitions except those of the Japan Art Patriotic Association. Thereafter, until air raids in early 1945 made any public exhibition impossible, participation in major shows was limited to "safe" artists—those who had received awards in competitions from 1937 onward.

Another weapon that the military government brought to bear in its campaign to co-opt the visual arts was control of the art press. In July 1941, the thirty-eight magazines then covering the visual arts were consolidated, leaving eight in print.[19] This followed publication in the April issue of the art journal *Mizue* (Watercolor) of an article critical of the army's art policies. A second integration took place in October 1943. Thus, beginning in January 1944, the only publication covering the fine arts was a monthly magazine called, generically, *Bijutsu* (Art).[20]

Perhaps most critically, the government placed art supplies under its control in late 1942, and access was limited to painters doing approved work. In January 1941, the military government issued a clear statement of its intention to apply pressure on artists by rationing the tools of their trade. In the issue of the art journal *Mizue* published that month, official pronouncements about the obligation of the arts to support the military state included a reference to art supplies as the "bombs of ideology."[21] The precedent for this policy to ration the materials of creative expression was the control of newsprint allotments, a tactic used with great effectiveness by the military to cow the newspapers in the wake of the Marco Polo Bridge Inci-

dent of July 7, 1937.[22] The economic hardships imposed on artists inclined not to cooperate with the authorities were as potent as the threats of punishment in gaining compliance. One of the bitterest accusations leveled at Fujita after the war was that he fawned on the military in return for art supplies.[23]

In this environment, artists supported the war out of patriotic conviction, intimidation, opportunism, or simply through participation in the puppet art organizations that were the defining contexts of their professional lives. Indeed, over the course of World War II, most established artists in Japan were co-opted in some manner by the government authorities. Even the by then grandmotherly Uemura Shōen (1875–1949) did her bit for the war effort by contributing her lyrical paintings of beautiful young women to exhibitions meant to raise funds for the construction of aircraft and battleships.[24]

That Fujita would find himself making war art in such a situation is thus unremarkable. Yet it is worth considering the unusual circumstances of Fujita's personal and professional life in Japan on the eve of the Sino-Japanese War that made him especially susceptible to the blandishments of the military. In 1933, exactly two decades after he first ventured to Paris as a fresh graduate of the Tokyo School of Fine Arts, Fujita came home to Japan. It is high irony that, by returning to live in his native land, Fujita placed himself socially and artistically in unfamiliar territory. With war approaching, he was less able than most to draw strength from either a circle of old friends or a secure place in the world of art. As a flamboyant, self-centered, former expatriate, with a huge foreign reputation, he was an outsider in the tight-knit communities inhabited by most Japanese artists. Here, careers were shaped by school affiliations and membership in a network of exhibition societies as much as by talent and luck. Belonging to a recognized group was personally and professionally important for Fujita, and his election to membership in 1934 to the Nikakai (Second Division Group), a highly respected group of innovative painters, was a significant milestone in his reentry into the Japanese art world. Yet his welcome here was tepid, and one wonders how his celebrated bohemian persona, so well received in Europe, struck the Western-style painting establishment with whom he now exhibited.[25]

If, for personal reasons, Fujita found Japan in the 1930s to be not totally congenial, he may also have felt himself at odds with the arbiters of artistic merit. In those years, he enjoyed commercial popularity but was denied coveted approval from the art critics in the modernist press. In Europe in the 1920s, Fujita's chic portraits and female nudes, done in a style that combined thin washes of color and wiry black outlines, all on an exquisite, milky-white ground, had an exotic, quasi-Oriental allure. By 1934, the novelty was lost on Japanese critics who were more conscious of how dated Fujita's work appeared, in both style and subject matter.[26] That the painter engaged in a number of commercial mural-painting projects further distanced him from the critical mainstream as the decade progressed. In sum, Fujita was primed to respond with enthusiasm to the fawning attention soon to be shown him by the military.

The story of how Fujita was recruited to paint for the armed forces is a complicated and fascinating one. The artist began his career as a war painter in the autumn of 1938 in what can be regarded as something of a false start. For much of that year, Fujita engaged in the normal peacetime life of an artist. In the spring, he undertook painting trips to the Kuriles and Okinawa. In June, he exhibited the paintings done on Okinawa at his Tokyo dealer, Nichido Gallery. He also exhibited at the autumn Salon of the Nikakai painting society. In September, Fujita joined with other members of the Nikakai to form the Kyūshitsukai (Room Nine Society), an avant-garde caucus within the larger group.

That same month, the erstwhile champion of artistic freedom responded to a summons from the Imperial Navy Information Office to join a contingent of artists on a trip to observe the fighting in central China.[27] On September 27, Fujita found himself at a farewell party hosted by naval officers in Tokyo's Shiba Kōen. Among Fujita's fellow guests were the painters Fujishima Takeji, Ishii Hakutei (1882–1958), and Nakamura Ken'ichi. Posing on the stone steps of the Suiko Shrine for a commemorative group photograph, Fujita contemplated the possibility of being killed by an enemy bullet during his impending visit to the battlefront. Undeterred by this thought, he left Tokyo by train on the first day of October. His jaunty mood was reflected in the costume he affected for the initial leg of the trip, a somewhat bohemian assortment of military headgear, gaiters, and other oddments. This outfit led a traveling companion, a *Life* magazine reporter named Dorsey, to dub Fujita "an army-navy cocktail." In Fukuoka, bad weather made it impossible to fly directly to Shanghai, so Fujita booked passage by ship from Nagasaki. Arriving in the great coastal metropolis in the first week of October, he sought the company of the painters Ishii Hakutei and Nagasaka Haruo and made the rounds of other Japanese writers and artists who had established themselves in the occupied city.

The military campaign that Fujita had been brought to observe had been underway since early June 1938. Forces of the Japanese Second and Eleventh Armies, supported by a river flotilla and aircraft of the imperial navy, were slowly pushing their way westward from Nanjing, along both banks of the Yangzi (now Chang) River. A key objective of the campaign was the tri-cities of Hankou, Hanyang, and Wuchang, since 1950 a single city named Wuhan. The offensive to capture the Wuhan area had begun in June. By mid-autumn, Japanese forces were moving to encircle the cities from three directions.[28]

For Fujita, the China war became reality on October 9. On that day, he was flown to the Yangzi River town of Jiujiang, located near the juncture of Jiangxi, Anhui, and Hubei Provinces. Traveling in a group that included photographers and writers for *The Saturday Evening Post, Life,* and other American publications, Fujita found himself in a forward staging area for the fighting at Wuhan. The town, which had fallen to the Japanese in July, also served as base for the military propaganda machine. Along with a swarm of foreign journalists accredited by the military, Fujita encountered during his stay at Jiujiang a number of Japanese cultural luminaries who, like himself, had been called upon to record the progress of

the troops. Never far from his military escorts, he discussed music, art, and literature in the context of the "holy war" with Kume Masao (1891–1952), Saijō Yaso (1892–1970), and Kishida Kunio (1890–1954). Meeting such well-known personalities at the front probably reinforced Fujita's readiness to lend his own talents to the patriotic cause.

On October 10, Fujita was taken aloft in a military plane for his first view of the actual fighting, northwest of Jiujiang. In his wartime memoirs, he tells of witnessing from this lofty vantage the red-brown flashes of artillery fire, soundless in the far distance. At dawn the next day, he set out aboard a navy riverboat with two Western journalists and a military escort, to sail up the Yangzi in the direction of Hankou. That afternoon he went ashore briefly and did a watercolor study of transport troops. Surrounded by soldiers, Fujita felt the concussion of heavy cannon fire.

Over the next three days Fujita remained onboard a warship as the squadron fought its way upriver. With his vessel holding station near the flotilla flagship, he had an excellent view of the artillery duel fought with the Chinese defenders. His vivid account of the sights and sounds of this battle, including descriptions of the shells that passed over his ship to explode in the river, conveys Fujita's rising excitement and growing martial spirit.

Returning to Jiujiang on October 15, he had a chance to relive the experience with Kume and others in the literary crowd. On the eighteenth, he went to visit several young officers of the naval air squadron stationed nearby. With them he watched a flying demonstration and heard the details of their exploits in the fighting with the Chinese.

For reasons that he does not specify, Fujita flew from Jiujiang to Shanghai on October 22. It was there that he heard of the fall of Hankou three days later. Having failed to witness the actual event, he hurriedly returned to Jiujiang on the twenty-sixth. The next morning he boarded a ship for the captured area and arrived late that night. On the twenty-eighth, he went ashore to tour the Japanese and French concessions of the city and to hear about the fighting from eyewitnesses, including the writer Hayashi Fumiko (1904–1951). That night he participated in an unofficial shipboard celebration with Kume Masao and other civilian observers.

On October 29, Fujita sailed back to Jiujiang. Shortly thereafter, he returned to Shanghai by air. There he ended his first stint as an artist following the troops when he boarded a ship bound for Nagasaki and home. The thirty-three days he spent on this junket afforded Fujita his one and only experience of actual combat. Even this view was filtered. Seen from the passenger seat of an observation plane or the deck of a gunboat, the fighting must have been thrilling—but impersonal and safely remote. Although his painting of war would eventually evoke the brutality and suffering of hand-to-hand combat, he himself appears to have never witnessed it at close quarters.

His journey on the Yangzi provided Fujita with the subject matter for his first

two war paintings, executed for the imperial navy, the sponsors of his trip to Wuhan. These are *River Scene during the Capture of Hankou*, dated 1938–1940, and *Destruction of Chinese Aircraft at Nanchang*, dated 1938–1939. Both works are now in the collection of the National Museum of Modern Art, Tokyo. *River Scene* is a conventional marine history painting, featuring gray gunboats steaming across a flat body of water toward the fallen city. Columns of smoke rise into a leaden sky. The total effect is surprisingly somber, given its celebratory intent. The second painting is altogether different. Here Fujita employed a bright palette and a striking compositional arrangement to depict an attack on a Chinese airfield. A Japanese biplane taxis into the scene from the lower right, its propeller a shining blur. Pilot and tail-gunner turn in their cockpits to look back toward the viewer. Ahead of them, across the grassy airstrip, a second Japanese aircraft stands in front of the smoldering ruins of hangars. Overhead, Chinese and Japanese fighter planes wheel and dive in aerial combat. The sunlit scene is painted in energetic brush strokes of bright color. The viewer is drawn into the action by the *repoussoir* airplane and the psychological connection with the two flyers who gaze outward. All in all, this is an exciting evocation of the bravery and skill of Japan's naval aviators. Published discussions of this painting have erred in identifying the event depicted.[29] They have also failed to explain why Fujita chose this particular subject. Because of this, they have missed the significance of the painting for elucidating the artist's relationship to his military patrons.

Earlier, mention was made of Fujita's visit with imperial navy airmen during his sojourn at Jiujiang. These men were members of the Fifteenth Air Group, which had been organized on June 25, 1938, out of elements normally based on the aircraft carrier *Sōryū*.[30] The air group, equipped with carrier fighters, bombers, and attack planes, arrived at its base at Anjing on July 10 and commenced operations in support of the Wuhan siege.

On July 18, under the command of Lieutenant Commander Matsumoto Naomi, planes of the Fifteenth Air Group attacked the Chinese military air base at Nanchang, south of Jiujiang. Fifteen Chinese aircraft attempted to rise to meet the assault but were strafed and bombed before they could become airborne. At this point, having run out of machine-gun ammunition, four of the Japanese bombers landed on the enemy airfield. Crewmen leaped from their planes and set fire to the remaining Chinese aircraft. They then made a deliberate search of the hangars for additional targets and, finding none, returned to their planes and took off. In all, nine Chinese planes were shot down, with an additional two listed as likely downed, and nineteen Chinese aircraft were destroyed on the ground.[31]

All of the navy bombers and attack planes that raided Nanchang reached their base safely. However, six planes from the group's fighter escort, under the command of Lieutenant Nangō Mochifumi, failed to rendezvous with the bombers at the start of the mission and had turned toward home. Enroute, the squadron engaged eleven of the enemy in a dogfight over Lake Biyang. Debris from a falling Chinese plane struck Nangō's aircraft and he crashed into the lake, becoming the sole Japanese casualty of the Nanchang engagement.

Nangō Mochifumi came from an illustrious naval family.[32] His grandfather had been a senior official of the Navy Ministry and an influential member of the National Diet. His father was a rear admiral and head of a martial arts studio in Tokyo. Nangō himself received his high school education at the prestigious Peers' School (Gakushūin) and had gone on to the Naval Academy, from which he graduated with honors in 1927. After flight school and a tour on the aircraft carrier *Akagi,* Nangō was posted to the Japanese Embassy in London, where he served as an assistant naval attaché. China duty began for Nangō in October 1937, and he was appointed first commander of the fighter squadron of the new Fifteenth Air Group when it was organized in the spring of 1938. Photographs of him reveal a dashing figure in a fur-trimmed leather flight jacket and helmet, with goggles tilted up over the visor. A handsome man, he sported a trim mustache and small goatee. He appears to have been the very model of the Japanese fighter ace. At the time of his death, he was thirty-three years old. His loss was mourned far and wide in Japan, and the vice minister of the navy and future commander of the Combined Fleet, Admiral Yamamoto Isoroku, is said to have wept at Nangō's wake. He was given a posthumous promotion to the rank of lieutenant commander and was designated a *gunshin,* or "war god."

Clearly, Nangō was a symbol of particular potency for the navy. Interservice rivalry, always keen in Japan, had grown even more heated during the late 1930s. The expansion of fighting in China tended to bolster the prestige of the imperial army, while the navy's role was distinctly subordinate. Navy image makers must have seen the public relations value of the Nanchang coup, coupled as it was with the tragic loss of a young hero. Additionally, Nangō's family connections insured that his last engagement would receive attention from the Navy High Command.

It is highly probable, therefore, that Fujita's encounter with airmen of the Fifteenth Air Group at Jiujiang was no coincidence. The artist's escorts from the Navy Information Office were in complete control of his itinerary on this junket, and it is reasonable to assume that a painting celebrating the Nanchang victory was, for them, an intended outcome of his trip to China. Thus, while it is tempting to read this painting exclusively as Fujita's romantic recollection of the dashing World War I aviators he had observed in his youth in France, it is hard to support such a notion. Rather than regard Fujita as an independent artistic observer, freely making aesthetic choices, we should see him as fundamentally dependent upon his military sponsors for thematic guidance. Furthermore, we should recognize the complex nature and motivations of his patrons. To speak of the military as monolithic is incorrect, as each branch—and each command unit—had its own purposes for commissioning art. Personal considerations such as the desires of influential families and individuals must also have shaped the artistic decisions of painters recording the war—Fujita included. The artist's navy-sponsored trip to China in the autumn of 1938 made abundantly clear to him the nature of his responsibilities to his military patrons.

Given the enthusiasm he expressed during his observation of the Wuhan campaign, one of the more intriguing questions concerning Fujita's behavior during

the war years is why he departed Japan for France in April 1939. In the very month that he sailed for Europe, accompanied by his wife, Kimiyo, Fujita was included among the founding members of the new Army Art Association. Also in April, the Navy Ministry exhibited his tableau celebrating the exploits of the naval aviators at Nanchang. Despite this active support of the patriotic cause, it is possible that the artist sought to avoid further involvement in war painting by departing from Japan. Although he did not sell his house and studio in Tokyo, the fact that Kimiyo traveled with him suggests that he anticipated a long sojourn in France. The motivation for this journey does not appear to have been the search for fresh artistic inspiration. While Paris had always been a congenial place for Fujita, as a figure painter he did not require constant exposure to the sights of the city to nourish his art. Rather, the city seems to have offered Fujita a sanctuary from the conflict in Asia.

Traveling first to the United States, Fujita and Kimiyo eventually reached Paris in June. The artist leased a residence on Rue Ordener in the Montmartre district, where their neighbors included Japanese *yōga* painters Miyamoto Saburō (1905–1974) and Inokuma Gen'ichirō (1902–1993), who had returned to Paris in advance of Fujita.[33] Whatever hope these expatriates had of escaping the reality of war evaporated with the German invasion of Poland in September 1939. After a sojourn in the Dordogne region, Fujita and Kimiyo departed from Marseilles in May 1940 aboard the evacuation ship *Fushimi Maru,* bound for Kobe. The artist's arrival in Tokyo on July 9 was covered by the ever-attentive press, which reported his comments on the fighting in France.[34]

In the weeks after his return, Fujita gave every appearance of continuing to focus on themes unrelated to war. In August, he exhibited at the Nikakai Salon fifteen canvases he had executed in France. In the next month, however, the military reentered Fujita's life in the form of a retired lieutenant general of the imperial army. His second involvement with war painting served to tie the artist permanently to the military in a way that his junket to view the Wuhan campaign had not.

Although the Japanese army consciously modeled its propaganda units after those of Nazi Germany, no individual emerged to play a role comparable to that of the highly visible Josef Goebbels.[35] The administrators of Japan's propaganda machinery were, rather, faceless bureaucrats and staff officers. Therefore, encountering among the military men involved in the production of war art General Ogisu Ryūhei, an extraordinary personality with a direct connection to Fujita, arouses our immediate interest.[36]

In early September, Fujita was visited in his Tokyo studio by General Ogisu, a man two years his senior. While the artist's biographer believes Ogisu carried a letter of introduction from Fujita's father, himself a retired general in the army medical corps, it is also possible that the two had encountered each other in China in 1938, when Ogisu commanded the Thirteenth Division of the Second Army during the Wuhan campaign.[37] In any event, the general had come with a com-

mission to create a special painting, an apotheosis of the troops who had fought and died under his command at Nomonhan in the summer of 1939, when Japanese forces suffered a stinging defeat at the hands of the Soviet Union. Considerations of the circumstances that sent Ogisu to Fujita and of the motivations behind his commissioning a painting are in order if we are to understand the new relationship between the artist and the armed forces that ensued.

The Nomonhan Incident, actually a bloody, if short-lived, border war fought between the Japanese Kwantung Army, based in occupied Manchuria, and forces of the Soviet Union in Mongolia, is an often-overlooked chapter of World War II. Yet it is integral to both the military and diplomatic history of that conflict.[38] After initial success in fighting on the grasslands straddling the Halha River on the Mongolian frontier in July 1939, the lightly equipped Japanese were badly mauled in August by reinforced Soviet armored and air forces under General Georgi Zhukov. The Russians forced the Japanese Sixth Army to retreat back into Manchuria and sue for a truce, after sustaining more than twenty thousand casualties.

In the judgment of the battle's historian, Nomonhan was, for the Japanese army, "the graveyard of reputations."[39] For none was this statement truer than for Ogisu Ryūhei. Although outwardly absolved of responsibility for the fiasco by investigators from Army High Command, Ogisu was forced into early retirement, a move that could only be read by his peers as censure. Thus, the man who came to see Fujita in September 1940 likely carried not only a sense of obligation toward his soldiers, living and dead, but also a desire to restore his tarnished reputation. Moreover, General Ogisu was intent on playing a role in public affairs, even if his active duty service was behind him. During the war years, he dabbled unsuccessfully in mayoral politics in Sendai and later in Nagoya. More significantly, shortly after his meeting with Fujita, he used his connections with his military academy classmate, General Tōjō Hideki, to become influential in the newly formed Imperial Rule Assistance Association (Taisei Yokusankai).[40] Inaugurated on October 19, 1940, this mass organization superseded all legitimate political entities at the national, prefectural, and local levels. Among the issues in its purview was the guidance of public opinion.[41]

The gist of the September 1940 meeting between the artist and the general involved Ogisu's commissioning from Fujita a large canvas to pay homage to the fighting spirit of the Japanese troops who died at Nomonhan. Wartime press accounts emphasized that, to pay for the work, Ogisu expended the last of the money he received when he was cashiered from active duty.[42] For his part, Fujita seems to have been equally dedicated to the project, for he set off almost immediately, on September 12, for Hsinking (now Changchun) and the Nomonhan region to gather impressions and conduct research for the picture. Although the enterprise was presented as a matter of private patronage, it is hard to imagine that Fujita could have traveled to such a militarily sensitive region without official sponsorship. As with his earlier travel to Wuhan, Fujita donned a faux-military costume for this journey.[43]

In Manchuria, the painter had an opportunity to observe the terrain where the fighting had occurred in the previous year. He took in the vast skies stretching over featureless steppe, so unlike the small valleys encircled by hills that characterize Japanese scenery. He also saw military equipment, some of it Soviet, and likely perused combat photographs of the Nomonhan fighting.[44]

Upon his return to Tokyo, Fujita went to work on the painting. He labored with great diligence, and there is evidence that he produced more than one version of the subject.[45] In the spring of the following year, Fujita was ready to present the finished work to the eager public (Plate 62). In April, the *Asahi shimbun* carried a photograph of the proud artist, standing beside an immensely long canvas that depicts Japanese infantrymen surrounding and atop an immobilized Soviet tank.[46] The soldiers, tank, and the land they occupy are painted in a pale, sun-bleached palette. The straight horizon is low on the picture plane, emphasizing the treeless expanse of grass and the immense sky, marked by a column of smoke, a few pale clouds, and minuscule aircraft. The accompanying story discusses General Ogisu's patronage of the painting and his noble intention to donate the work for public exhibition. Significantly, the article identifies the incident portrayed as having occurred on July 3, when Japanese fortunes at Nomonhan were high, rather than a month later, when Ogisu himself was in command.

The degree to which Fujita, Ogisu, and the press censors coordinated their efforts to conform to propaganda guidelines may be judged by the headline of the *Asahi* article: "The Terrible Life-and-Death Struggle between a Tank and Human Beings." Throughout the war years, official dogma stressed the superior fighting spirit of the forces of Japan. From Prime Minister Tōjō on down, the nation's leaders asserted that spiritual warfare was crucial to victory.[47] To calm domestic fears about the economic and technical might of the enemy, public-opinion makers were continually directed to emphasize the advantage that Japan had in "human resources." In the early years of the conflict, the full and terrible implication of that term was not evident to most Japanese. Fujita's Nomonhan painting, celebrating the triumph of foot soldiers over a Soviet tank, fed the illusion that fighting spirit outweighed matériel in assuring final victory. Thus it seems likely that the painter received some direction, from Ogisu or others, in making his choice of composition for the work, although no documentary evidence can be advanced that this was the case.

In July 1941, Fujita publicly exhibited the Nomonhan painting at the Second Holy War Art Exhibition (Dainikai Seisen Bijutsu Tenrankai), sponsored by the Army Art Association and the *Asahi shimbun* and held by the Nihon Bijutsu Kyōkai at Ueno. Following the show, where it provoked considerable positive discussion, the canvas was returned to General Ogisu and eventually hung in the precincts of Yasukuni Shrine. There it was confiscated by the Allied Occupation authorities in 1945.[48] Today, as with the other Fujita paintings discussed here, it is held on permanent loan from the U.S. government to the Japanese Ministry of Education, at the National Museum of Modern Art, Tokyo.

The link between Fujita and Ogisu, forged by their collaboration on the

Nomonhan painting project, permanently tied the artist's name to the military cause and completed the process by which he became the leading exponent of war painting. With the execution of this painting, Fujita became the favorite artist of the military. The work showcased his skill as a narrative painter and his ability to paint rapidly and on a monumental scale. With an influential patron such as General Ogisu, and with his demonstrated willingness to hew to official propaganda guidelines, Fujita insured himself a continuous flow of painting assignments until the last months of the war.

We must now turn to a consideration of some of the subsequent paintings Fujita produced for his military sponsors. To do so will shed light on how Fujita worked, as well as illustrate the highly ambivalent nature of some of these images. Throughout his career, Fujita was a rapid and prolific painter. An incomplete catalog of his oeuvre numbers nearly twelve hundred works.[49] During the war, Fujita developed a reputation for tremendous speed and total involvement with his work. After interviewing the artist for a March 1943 article in the journal *Shinbijutsu* (New Art), the critic Imaizumi Shigeo estimated that he devoted an average of fourteen hours a day to painting.[50] Fujita told Imaizumi that the three immense canvases he showed at the recently concluded Greater East Asian War Art Salon, for which he was awarded the Asahi Culture Prize, had taken him twenty-six, sixteen, and seven days, respectively, to complete. To drive home this image of speed, Imaizumi cited Fujita's wife Kimiyo to the effect that, following breakfast, the painter would enter his studio and by the time Kimiyo had cleared away the dishes he had already painted in the arm of a figure. Postwar writers use the word *"jōnetsu,"* or *"passion,"* with its exculpatory nuance of loss of judgment, to describe Fujita's approach to making war art.[51] In any event, his ability to turn out a great many large canvases in short order endeared him to his military patrons.

His deep knowledge of the idioms of European history painting, like his immense artistic energy, also made Fujita well suited to produce the heroic images that the military craved. In articles written during the war, his quintessentially Western style of detailed realism was deemed by Japanese critics to be the best method for conveying the drama of conflict. To understand his much-praised and emulated style, rooted in the nineteenth-century Romanticism that Fujita imbibed in Paris, we need to turn to some examples of his war painting. In the process, we will gain a sense of the ambivalent imagery Fujita occasionally incorporated in his paintings—elements that continue to generate mixed responses.

Fujita exhibited *Final Fighting at Attu* (Plate 63) at the Peoples' Full Effort for Total Victory Art Exhibition (Kokumin Sōryoku Kessen Bijutsuten), held by the Army Art Association at the Tokyo Metropolitan Museum of Art from September 1 to 16, 1943. The event it depicts had occurred on May 30, only three months earlier, in the ridges above Chichagof Harbor on the Aleutian island of Attu. On that day, the remnants of a Japanese occupation force under Colonel Yamazaki Yasuyo launched a final suicide assault on the American troops that had landed to retake the island. Of Yamazaki's original force of 2,379 soldiers, 2,351 died. The remaining 28 were captured. It was the first instance in the Pacific War of *gyokusai* (shattered

jewel), which might be paraphrased as "fighting to the death," and it amazed the American soldiers who participated in the engagement.[52]

The failure of the Japanese military chiefs to relieve the besieged Attu detachment drew a rebuke from the emperor, and high-ranking navy officers criticized their army counterparts for the loss of strategic cover for their northwest Pacific bases.[53] These issues were not aired in public. Instead, the government declared a celebration for the national heroes, whose actions were "a tremendous stimulant to the fighting spirit of the nation."[54] Public grief over the deaths of the Yamazaki Corps was coupled with national mourning for Admiral Yamamoto Isoroku, commander of the Combined Fleet, whose airplane had been intercepted and shot down by American fliers in April shortly before the Attu fighting. In the media, these deaths were used to stoke popular anger toward the Allies, rather than be allowed to feed defeatism and war-weariness.[55] It was to this end that Fujita painted *Final Fighting at Attu*.

For his depiction of the bloody battle, Fujita filled the canvas with a tumult of intertwined Japanese and American soldiers, both living and dead. Friend and foe are hard to distinguish, as the men grapple with each other in a dark and rocky landscape.[56] Fujita brings the viewer close to the action, so that the chaotic and desperate nature of hand-to-hand combat is conveyed with great power. The artist's brilliant draftsmanship, a hallmark of his oeuvre, was never better exhibited than here, where it is used to describe the contorted bodies of the dead and dying.

Today, the painting is freighted with terrible meaning: an incitement for other Japanese youths to throw away their lives for a lost cause. At the time it was exhibited, however, the work was praised for its highly realistic depiction of the blood and death of battle. The August 31, 1943, issue of *Mainichi shimbun*, previewing the exhibition, referred to the Attu picture as the model for a new style of documentary war painting.[57]

Two days later, *Asahi shimbun* concurred in a review article on the "Total Victory Exhibition" contributed by Yamagiwa Yasushi, a professor at Nihon University.[58] The review carried the title "The Power of Attu *Gyokusai*," and it opened by invoking the indignation of all 100 million Japanese over the deaths of the Attu heroes. Fujita's painting, Yamagiwa wrote, admirably met the nation's need to visualize this traumatic event and witness the bloody battlefield. The reviewer then commented favorably upon the dark and heavy sky depicted over the scene, noting that this element had begun to appear in Fujita's previous war canvases. Significantly, Yamagiwa labeled this sky *Romansei* or "Romantic." He added that Fujita's detailed realism invited—indeed required—the viewer to examine the painting at close range.

Elsewhere in his exhibition review, Yamagiwa decried the failings of other exhibitors and prescribed a suitable formula for war painting based on the model of Fujita. Reducing art to mathematics, he recommended a ratio of 70 percent objective realism and 30 percent Romantic sensibility. The irony is that Fujita neither witnessed the battle nor did he debrief its participants. Although he did get right the Aleutian fog and the muskeg terrain, he erred in portraying the American

soldiers in prewar vintage helmets. Rather than combat reportage, the true source for this powerful picture is the classical tradition of struggling heroes, which, by way of Michelangelo, informed countless set-pieces of Salon history painting that Fujita had seen in the museums of Europe.

A close reading of another painting by Fujita reveals how deeply he drew upon the symbolism and aesthetic sensibility of nineteenth-century Romanticism, at the same time that he invoked images from Japan's feudal past. Inscribed by the artist with the title *End of American Soldiers, Solomon Sea* (Plate 64), this large canvas was exhibited by Fujita at the Second Greater East Asian War Art Salon (Dainikai Daitōa Sensō Bijutsuten), held at the Tokyo Metropolitan Museum of Art from December 8, 1943, to January 9, 1944. One of four works by the artist in the show, it drew special mention in the critic Araki Hideo's review of the exhibition for *Asahi shimbun*.[59] This painting depicts seven American soldiers, some of them wounded, adrift in a small boat at dusk in rough, shark-infested seas. The proximate reference here is to the Allied naval and amphibious forces in the Solomon Sea, amassed for the landings on Guadalcanal and Tulagi in August 1942. At first glance, the artist appears to gloat over the mortal perils Nature could visit upon the enemies of Japan. In creating this tableau, Fujita may have had in mind the abortive Mongol invasions of 1274 and 1281, when typhoons scattered the enemy fleets. The memory of those heaven-sent winds was to be invoked as well in connection with the suicide missions of young Japanese pilots. Yet Fujita's painting is not fully consistent with Mongol invasion imagery. For one thing, while Khublai Khan sent a huge armada of warships and transports, the American soldiers pictured here drift in a solitary lifeboat.

The Mongol invasion story is not the only possible source in Japanese tradition for this painting. Descriptions of warriors in small boats, imperiled by stormy seas, are in fact surprisingly abundant. Vivid marine episodes, very close to that which Fujita has presented, are notable features of the rich literary and pictorial cycles stemming from the final battles between the Minamoto and Taira clans in the late twelfth century, especially the tales concerning Minamoto no Yoshitsune (1159–1189) and his kinsman, Minamoto no Yukiie (D. 1186).

In his Solomon Sea painting, Fujita may have been making a deliberate reference to either or both of these celebrated heroes, enshrined as they were in traditional popular culture and still resonant for a portion of the visitors to the War Art Salon. If that was the case, it raises an interesting question concerning the artist's intended meaning for the work. Given its title and the circumstances under which it was exhibited, one might logically expect that the plight of the shipwrecked Americans would elicit no sympathy from the Japanese audience. However, Yoshitsune in particular was a beloved figure, with whom viewers identified emotionally. As the archetypical failed hero, Yoshitsune has long been the object of a sentimental attachment on the part of the Japanese.[60] Thus there exists the real possibility that the picture humanized the enemy in a manner contrary to the purposes of patriotic propaganda. Whether Fujita intended this will never be known.

Fujita's cultural horizons were not confined to Japan, however. As rich as were

the pictorial and literary resources of his native country, Fujita was by training and experience a European painter. To fully appreciate the profound ambiguity that resides in this work, we must consider the Western sources of its imagery. Behind the Solomon Sea picture is one of the key icons of French Romanticism: the Storm-Tossed Boat.[61] As a venerable literary and pictorial symbol of man's fate, the drifting boat held a firm grasp on artistic imagination in the nineteenth century. Especially in France was the image compelling. Romantic sensibility there required that the subject's allegory be concealed in the context of narrative, realistically presented.[62] This is true, I believe, in the case of Fujita's painting as well.

I am not alone in recognizing Fujita's debt to a corpus of celebrated shipwreck pictures by French Romanticists. Tanaka Jō, in his biography of Fujita, points to Gericault's *Raft of the Medusa* (1818–1819) and Delacroix's *Bark of Dante* (1822) and *Shipwreck of Don Juan* (1841) as likely sources for the Solomon Sea painting.[63] Curiously, Tanaka fails to mention the most obvious model for the work, *Delacroix's Christ Asleep during the Tempest* (Plate 65), several versions of which exist in Western museums.

Crossing the Sea of Galilee with his disciples in a small boat, Christ is awakened by the frightened men when a storm threatens to drown them. He commands the wind and waves to become calm, and then chides his followers for their lack of faith. Superficially similar to the other scenes of men in boats, the *Tempest* picture is quite different in meaning. The first group refers to the just punishments meted out to debased men. *The Medusa* and *Don Juan* paintings allude to cannibalism; Dante crosses the River Styx. On the other hand, the message of "The Stilling of the Tempest" (Matthew 8:23–27 Revised Standard Version) is the crisis of faith and the ultimate salvation of humankind through Christ.

This Christian meaning was probably invisible to the crowds visiting the War Art Salon. That Fujita knew Delacroix's treatments of this subject cannot be doubted, given the former's long residence in Paris. He was very likely aware of the biblical narrative as well. Fujita was steeped in a Catholic environment in his early years in France (he was himself baptized in 1959).[64] The identity and significance of the reclining cloaked figure in the Delacroix work must have been clear to him. What, then, was the meaning Fujita assigned to the bandaged American soldier who occupies the same position in his painting? Are we meant to see this man as Christ?

Even more intriguing is the question of the semiotic significance of the heroic standing figure, posed to defend the sleeper. Who is this embattled man, uncowed by his predicament, with features that are neither purely Caucasian nor Japanese? In speaking of the storm-tossed boat as a subject in art, Lorenz Eitner warned that "there is always the danger of mistaking for plain realism or for borrowings from tradition what artists intended as a personal parable."[65] The possibility that Fujita privately projected himself among the disciples in a painting celebrating victories by the "divine soldiers" of Japan merely adds another layer of ambiguity to the complex matter of his war art.

Japanese Prefer Death by Suicide to Dishonor at Saipan (Plate 66) is the last major work in Fujita's corpus of war paintings. This extraordinary canvas depicts the mass suicide of Japanese soldiers and civilians at Marpi Point, on the northern end of the strategic island of Saipan. There, in early July 1944, as a coda to the struggle that had begun with the American amphibious landing a few weeks before, some surviving members of the Japanese garrison exhorted a larger group of Japanese civilians to join them in accepting death before dishonor. Witnessed from a distance by horrified American personnel and war correspondents, remnants of the preinvasion Japanese population of the island, which numbered more than ten thousand men, women, and children, killed themselves with hand grenades, knives, and other weapons, or hurled themselves from the cliffs into the sea.[66]

The painting Fujita produced conveys the ghastly nature of this episode. Soldiers, many of them wounded, fire at the advancing enemy, or turn their guns upon themselves. One trooper, in the lower right corner of the canvas, has placed the muzzle of his rifle in his mouth, as he reaches with the toes of his bare foot to pull the trigger. It is the women who predominate in the scene, however, both compositionally and iconographically. Grouped in the center of the picture, the female figures form a pyramid culminating in a single young girl, gallantly clutching a bamboo spear. In the main, the women are calm and resolute in the face of impending death. A few fold their hands in prayer, while others nurse infants or tend to the injured. Only one, a figure in the upper right of the painting, raises her arms in a gesture of supplication.

The Saipan picture, along with the *Final Fighting at Attu*, is mentioned by name in the Marukis' speculations on Fujita Tsuguji's true sentiments concerning war.[67] Viewed as an image of civilians caught up in the horrors of war, the painting can summon up comparisons with two celebrated protests against war: Eugène Delacroix's *Massacre at Chios* (1822–1824) and Pablo Picasso's impassioned *Guernica* (1937). The former work captures the Romantic impulse in Western Europe in the early nineteenth century to side with the beleaguered Greeks against their Turkish overlords, while the latter was painted in outraged response to the German bombing of the Basque capital during the Spanish Civil War. Artistic intention in both cases is clear. By contrast, Fujita's painting remains multivalent.

In the context of modern Japanese constructs of the meaning of the Pacific War and of Japan's role in that conflict, the painting can be read today as a virtual icon to the victimization of Japanese civilian populations—by both the enemy and their own wartime leaders. In this light, Fujita can be seen as having undergone a profound transformation, as the war progressed, from advocate of military conquest to heartfelt pacifist.

Yet in the context of late 1944 and early 1945, when the work was actually produced, a somewhat darker interpretation of Fujita's intention emerges. In late 1944, as bombing of the capital intensified, the artist and his wife left Tokyo for the relative safety of a mountain village in Kanagawa Prefecture. Fujita's Tokyo house and studio in Kōjimachi were destroyed in an air raid in April 1945. Since the Sai-

pan painting carries a date of 1945, it seems likely that it was executed after his evacuation to Kanagawa, where working conditions were difficult at best.

In these dire circumstances at the war's end, Fujita probably undertook this task only because he had a commission to do so. To begin with, it is unlikely that the artist would have been allocated the scarce canvas and paints for the project unless it met approved standards. Moreover, in August 1945 the Saipan painting was housed not in Fujita's home, but in the Army Ministry, from which it was confiscated a few months later by Occupation authorities.[68]

Although public exhibitions had been suspended, government interest in an image of the Saipan suicides can be adduced from contemporary documents. In connection with his study of Japanese wartime psychology, the historian Iritani Toshio has examined official guidelines issued to the domestic news media in Japan from Pearl Harbor to the end of the war.[69] On July 7, 1944, during the latter stages of the American conquest of Saipan, the government information authorities promulgated a "Summary of Essential Points on News and Propaganda to Cope with the Current State of the War" *(Senkyoku no gekyō ni sokuō suru hōdō senden yōryō)*. This document began: "We want to emphasize that the people must now fight to the end and be ready to die if necessary, in order to retain the fundamental characteristics of the state and the national defense."[70] Preservation of the imperial institution, implied by the phrase "fundamental characteristics of the state," could require each person's individual sacrifice, as an expression of ultimate loyalty. The second paragraph of the summary addressed the media on how to bolster the mental state of the populace in the face of this challenge. Civilians were to be instructed to defend their workplaces to the death, with a feeling of composure and calmness. Willpower was the key to victory.

The message contained in this media guide is reflected with perfect fidelity in Fujita's Saipan painting. The calm expressed by the heroic women, the readiness to sacrifice themselves in the name of honor, all conforms to official doctrine. Thus, the notion that Fujita painted the terrible truth about war out of an opposition to it is hard to sustain. To the end, the painter appears to have been responsive to official direction and the propaganda needs of the military, even when the subject he glorified was the self-immolation of the Japanese nation.

The meanings of a work of art are as many and varied as its audiences. A painting speaks to one viewer about noble sacrifice for a holy cause. A generation later, the same picture leads one to reflect on the tragic consequences of totalitarianism. Each meaning is valid, yet each is historically relative. In the effort to judge Fujita's war painting, appeals to artistic intention are likewise only partially satisfying. Perhaps the best we can do is to recognize that his work is set apart from the mass of such paintings by virtue of his personality and unique history. Made by a complex, conflicted artist to fulfill a mix of purposes both personal and public, Fujita's war paintings remain the source of active speculation and interest, while those of his contemporaries are now merely dry documents of a fast-receding past.

Notes

Editors' Note: Since Professor Sandler wrote this essay on Fujita's war paintings, some additional materials have been published that deal with the Japanese art of this period. Those with interest in this subject may wish to consult: Mimi Hall Yiengpruksawan, "Japanese War Paint: Kawabata Ryūshu and the Emptying of the Modern," *Archives of Asian Art* 46 (1993), 76–90; Bert Winther-Tamaki, "Embodiment/Disembodiment: Japanese Painting during the Fifteen Year War," *Momentum Nipponica* 52:2 (Summer 1997), 145–180; Mark H. Sandler, "The Living Artist: Matsumoto Shunsuke's Reply to the State," *Art Journal* 35:3 (Fall 1996), 74–82; J. Thomas Rimer, "Encountering Blank Spaces: A Decade of War, 1935–1945," in *Nihonga: Transcending the Past* (St. Louis Art Museum, The Japan Foundation, 1995), 57–61; [author unnamed] "Pioneering Artist, Fascist Propagandist: Yokoyama Taikan and his Turbulent Times," *East* 31:2 (July/August 1994), 30–34; and Tan'o Yasunori and Kawada Akihisa, *Imēji no naka no sensō* (War from Images) (Tokyo: Iwanami Shoten, 1996). In addition to newspaper accounts of Fujita's activities cited in Professor Sandler's essay, there is an English-language article, with photograph, in the *Japan Times and Advertiser* for June 16, 1941, concerning Fujita and his Nomonhan painting. Reproduction rights for this article could not be secured, but it is well worth seeking out.

1. A full recounting of Fujita's colorful and productive life is beyond the scope of this study. The best treatment of the subject in a Western language is to be found in Sylvie Buisson and Dominique Buisson, *La vie et l'oeuvre de Léonard-Tsuguharu Foujita* (Paris: ACR Édition Internationale, 1987). The principal Japanese biography of the artist is Tanaka Jō, *Fujita Tsuguji: Hyōden* (A Critical Biography of Fujita Tsuguji) (Tokyo: Geijutsu Shimbunsha, 1988) (hereafter *Hyōden*). In the literature on Fujita, the second character of the artist's given name is read alternatively as "ji" or "haru." Furthermore, during much of his career, he employed the French romanization of his surname, "Foujita." Late in his life, following his conversion to Catholicism, he took the name Léonard, possibly to suggest comparisons with the Renaissance great master.

2. Fujita undertook official trips to occupied China in October 1938, the puppet state of Manchukuo in September 1940, and the former French Indochina in October 1941. He made two trips to Singapore and Malaya in 1942, one in March for the army and another in May for the navy. In the latter case, he traveled with the rank of an officer at the head of a large delegation of painters. An extrovert since his early days in Paris, Fujita courted publicity, and the wartime press was happy to comply. For example, *Asahi shimbun* ran at least seventeen articles about Fujita between July 1940 and March 1944.

3. Not all of Fujita's wartime paintings have been cataloged. An extremely prolific painter, he produced many works that are now lost. One authoritative list of extant war paintings, that of the National Museum of Modern Art, Tokyo, lists fourteen canvases by Fujita. See Tanaka Hisao, *Nihon no sensōga: sono keifu to tokushitsu* (Japanese War Painting: Its Lineage and Characteristics) (Tokyo: Perikin-sha, 1985), 207 (hereafter *Sensōga*).

4. In May 1941, at the age of 55, Fujita was elected a life member of the Imperial Academy of the Arts. Subsequently, he resigned from the private painting society, Nikakai. Fujita received a second mark of distinction in January 1943 when he was awarded the Asahi Culture Prize, given by that newspaper chain in recognition of his war paintings of the previous year. The Imperial Academy was a governmental entity, and election to it would have required vetting by the military. The *Asahi* newspapers were active sponsors of major exhibitions of war art and were in fact closely affiliated with Fujita's own Army

Art Association. Thus these honors appear to have been based on politics as much as on artistic merit. Ironically, it was in a letter to the editor printed in the pages of the *Asahi shimbun* on October 14, 1945, that Fujita was attacked as a lackey of the military and a hypocrite.

208

5. Haruko Taya Cook and Theodore F. Cook, eds., *Japan at War: An Oral History* (New York: New Press, 1992), 255–256.

6. Toshio Iritani, *Group Psychology of the Japanese in Wartime* (London: Kegan Paul International, 1991), 53–55.

7. An informal government propaganda group evolved into the Cabinet Information Committee (Naikaku Jōhō Iinkai) in July 1936. After the Marco Polo Bridge Incident, it was reorganized in September 1937 and given divisional status. Finally, in December 1940 it became the Cabinet Information Bureau (Naikaku Jōhōkyoku), the central agency controlling all aspects of public information and mass media in wartime Japan. The role of this bureau in the management of the visual arts was paramount (Ibid., 49–50).

8. Ibid., 49.

9. The twin categories of modern Japanese-style painting, *nihonga*, and oil painting in the Western manner, *yōga*, had been established in the Meiji period (1868–1912). Wartime art policies retained these categories for exhibition purposes. No stigma was attached to Western styles. Indeed, *yōga* was deemed to be superior to *nihonga* for the purposes of war-record painting. The exception to the government's catholic attitude concerning art styles was Surrealism, which was condemned by the Japanese Right because of the movement's close association with Marxism in Europe. See Tanaka Atsushi, "An Essay on the Art of the Showa Period: A Bridge to Connect Modern Age [*sic*] to the Present Day," in *Shōwa no bijutsu: shozō sakuhin ni yoru zenkan chinretsu* (Art of the Showa Period: From the Museum Collection) (Tokyo: Tokyo Kokuritsu Kindai Bijutsukan, 1989), 17.

10. Okakura Kakuzō (1862–1913) was a key figure in the effort to preserve traditional Japanese art in the Meiji era. A student of Ernest Fenollosa (1853–1908), Okakura later became Fenollosa's collaborator in government projects to establish a state-run art museum system, art schools, and other institutions intended to protect Japan's cultural patrimony. Fluent in English, Okakura addressed his late writings, notably *Ideals of the East* (1903) and *The Awakening of Japan* (1904), to readers outside Japan. His concept of a pan-Asian community of the Spirit, contrasted with the materialist Western world of Technology and Reason and summed up in the phrase "Asia is One," foreshadows the ultranationalist and imperialist propaganda of the 1930s and 40s in Japan. See Miyagawa Torao, "Meiji nashunarizumu to Okakura Tenshin" (Meiji Nationalism and Okakura Tenshin) in Hashikawa Bunzō, ed., *Okakura Tenshin: hito to shisō* (Okakura Tenshin: The Man and His Thought) (Tokyo: Heibonsha, 1982).

11. Yokoyama Taikan Denki Hensen Iinkai, ed., *Yokoyama Taikan den* (A Biography of Yokoyama Taikan) (Tokyo: Ibaraki-ken, 1959), 145–146.

12. Yanagi Tadashi, "Dai Tōa sensō to kirokuga no shōchō" (The Greater East Asian War and the Rise and Decline of War Painting), in Naruhashi Hitoshi et. al., eds., *Taiheiyō sensō meiga shū* (The Pacific War Art Collection) (Tokyo: Nōberu-shobō, 1967), 64–66.

13. Tanaka, *Sensōga*, 123–127, 132.

14. Cook and Cook, *Japan at War*, 256.

15. Yoji Akashi, "Japanese Cultural Policy in Malaya and Singapore," in Grant K. Goodman, ed., *Japanese Cultural Policies in Southeast Asia during World War II* (New York: St. Martin's Press, 1991), 118–119 ff.

16. Iritani, *Group Psychology of the Japanese in Wartime*, 34–36.

17. See Gregory J. Kasza, *The State and the Mass Media in Japan, 1918–1945* (Berkeley: University of California Press, 1988), 165.

18. Cook and Cook, *Japan at War*, 255.

19. This consolidation was part of a much larger program of press control. See: Kasza, *State and Mass Media in Japan*, 194–231.

20. Tanaka, *Sensōga*, 158–161.

21. Thomas W. Burkman, ed., *The Occupation of Japan: Arts and Culture* (Norfolk: General Douglas MacArthur Foundation, 1984), 232.

22. Iritani, *Group Psychology of the Japanese in Wartime*, 49.

23. Miyata Shigeo, "Artist's Integrity," *Asahi shimbun*, October 14, 1945. Reprinted in Tanaka, *Sensōga*, 184–185.

24. For example, Shōen's painting entitled *Yuki* (Snow) was shown at the 1942 exhibition held to raise funds to build fighter planes, the Kennōten. Her paintings *Shizuka* (an imaginary rendering of this famous medieval heroine, the mistress of the great general Minamoto Yoshitsune) and *Hotaru* (Firefly), both painted in 1943, were donated to the Senkan Kennō-ten of the following year, intended to raise money for battleship construction. These and works by several other artists eventually found their way from such wartime exhibitions into the permanent collection of the National Museum of Modern Art, Tokyo. See *Shozōhin mokuroku: kaiga* (Catalogue of Collections: Paintings) (Tokyo: Tokyo Kokuritsu Kindai Bijutsukan, 1991), 17.

25. Evidence abounds of Fujita's ready adoption of the form and substance of Montparnasse bohemianism, from the wristwatch tattooed on his arm to the earring he sports in self-portraits shared with a feline familiar. Married for a period to one French beauty, he had notorious affairs with others. The last of these, a red-haired cabaret dancer named Madeleine Lequeux, he brought home to Japan as his mistress in 1933. Before her sudden death in 1936 from an overdose of cocaine and alcohol, she became something of a radio chanteuse and danced occasionally with the Takarazuka troupe. See Buisson and Buisson, *La vie et l'oeuvre de Léonard-Tsuguharu Foujita*, 93, 174–175. For an account, in words and photographs, of Fujita's Parisian adventures, see Billy Kluver and Julie Martin, *Kiki's Paris: Artists and Lovers 1900–1930* (New York: Harry N. Abrams), 1985.

26. Shūji Takashina and J. Thomas Rimer, eds., *Paris in Japan: The Japanese Encounter with European Painting* (St. Louis: Washington University Press, 1987), 144.

27. Fujita published an account of this trip in a collection of his essays in 1943. See "Seisen jūgun sanjūsan nichi" (Thirty-Three Days Following the Troops in the Holy War), in *Chi o oyogu* (Swimming on Land) (Tokyo: Kōdansha, 1984), 79–100. In the following discussion, information on Fujita's movements and observations in China is derived from this source.

28. Kuwata Etsu et. al., *Nihon no sensō: zukai to daita* (Japan's Wars: Diagrams and Data) (Tokyo: Hara Shobō, 1982), unpaginated, section 20.

29. Buisson and Buisson, *La vie et l'oeuvre de Léonard-Tsuguharu Foujita*, 192. The authors do not properly identify the locale as Nanchang, and place the date of the incident at March 29, 1939. The actual event occurred eight months earlier. The Buissons' source for this erroneous date appears to be *Taiheiyō sensō meiga shū*, which carries the same information in an entry explaining the painting, 28; for color illustrations, see Plate 4, *River Scene during the Capture of Hankow*, and Plate 7, *Destruction of Chinese Aircraft at Nanchang*.

30. This account of the activities of the Fifteenth Air Group in the Wuhan campaign

is based on the unit history in Hata Ikuhiko and Izawa Yasuho, Don Cyril Gorham, trans., *Japanese Naval Aces and Fighter Units in World War II* (Annapolis: Naval Institute Press, 1989), 101–102.

31. Ibid. See also details of this incident contained in an unsigned and undated typescript description of Fujita's painting on the subject. The description is part of the Occupation-era documentation of confiscated Japanese war-record paintings contained in two folders now in the possession of the U.S. Army Art Collection, U.S. Army Center of Military History, Washington, D.C. (Editors' note: U.S. Army Signal Corps photographs of ten of Fujita's fourteen war paintings, as listed by the Tokyo National Museum of Modern Art, are included in the 153 black-and-white images taken in 1947 of confiscated Japanese war art then in the custody of U.S. Army of Occupation, Japan; consult two albums and a print box at Still Pictures, National Archives, College Park, MD. A large album containing excellent photographs of the same images, "Collection of Japanese War Painting," has also turned up at the U.S. Army Art Collection.)

32. Hata and Izawa, *Japanese Naval Aces and Fighter Units in World War II,* 364–365.

33. That these three found themselves together in Montmartre as war loomed can hardly be coincidental. Both Inokuma and Miyamoto were later active as war painters, alongside Fujita, in the Army Art Association, after the three returned to Japan in the wake of the German invasion of France in May of 1940. Immediately after the war, all were criticized for having collaborated with the military. Unlike Fujita, Miyamoto and Inokuma were soon rehabilitated. It is noteworthy that the Japanese American sculptor Isamu Noguchi maintained a close friendship with Inokuma through the postwar period at the same time that he made a point of downplaying his youthful association with Fujita in Paris. See Dore Ashton, *Noguchi: East and West* (New York: Alfred A. Knopf, 1992), 23.

34. *Asahi shimbun,* July 9, 1940.

35. Akashi, "Japanese Cultural Policy in Malaya and Singapore," 154, n. 6.

36. Born in Aichi Prefecture on January 24, 1884, Ogisu graduated from the military academy in the seventeenth class in 1905. He served as chief of staff of the Taiwan army from August 1935 to March 1937, when he was promoted to lieutenant general. In September 1937, he was named commander of the Thirteenth Division, which saw action in central China. Ogisu became commander of the newly formed Sixth Army in Manchuria in August 1939, in the midst of the border war with the Soviets at Nomonhan. Recalled to Tokyo under a cloud in November 1939, he retired from active service in January 1940 at the age of 55. Ogisu died in Tokyo on December 22, 1949. See Nihon Kindai Shiryō Kenkyūkai, *Nihon riku-kaigun no seido soshiki jinji* (The Japanese Military System: Organization and Personnel) (Tokyo: Tokyo University Press, 1971), 21.

37. Tanaka, *Hyōden,* 178.

38. For the definitive study of the Nomonhan affair, see Alvin D. Coox, *Nomonhan: Japan against Russia, 1939,* 2 vols. (Stanford: Stanford University Press), 1985.

39. Ibid., 952.

40. Ibid., 954.

41. Iritani, *Group Psychology of the Japanese in Wartime,* 127–129.

42. *Asahi shimbun,* April 22, 1941.

43. *Asahi shimbun,* September 12, 1940.

44. Coox, *Nomonhan,* reproduces a large number of these photographs, some of which correspond closely to elements in Fujita's painting, including a close-up of Fujita's Nomonhan painting showing four soldiers attacking the Soviet tank.

45. A comparison of the extant Nomonhan painting in the possession of the Museum of Modern Art, Tokyo, and the version illustrated in an April 22, 1941, *Asahi shimbun* news photograph reveals some minor differences between the two. These do not alter the basic composition, however. Which of these paintings was executed first remains uncertain. The extant version seems to be somewhat shorter today (140 x 448 cm) than as originally painted. It gives evidence of having had a section trimmed from its center, with the remaining portions rejoined to produce a vertical seam in the middle of the composition.

46. *Asahi shimbun,* April 22, 1941.

47. Iritani, *Group Psychology of the Japanese in Wartime,* 61–65.

48. Records of the U.S. Army Art Collection, U.S. Army Center of Military History, Washington, D.C.

49. Buisson and Buisson, *La vie et l'oeuvre de Léonard-Tsuguharu Foujita.*

50. Imaizumi Shigeo, "Fujita Tsuguji no geijutsu" (The Art of Fujita Tsuguji), *Shinbijutsu* (New Art) 20 (March 1943), 1–8.

51. Tanaka, *Hyōden,* 173 ff.

52. John Costello, *The Pacific War* (New York: Rawson, Wade, 1981), 405.

53. John Toland. *The Rising Sun: The Decline and Fall of the Japanese Empire, 1936–1945* (New York: Bantam Books, 1971), 503–504.

54. Costello, *Pacific War,* 404–405.

55. Iritani, *Group Psychology of the Japanese in Wartime,* 150–152.

56. Art historian Tanaka Hisao relates that, as a young child, he saw the Attu painting in the 1943 exhibition. He recalls being unable to differentiate among the dead soldiers until his father instructed him that those with tranquil faces were Japanese and those who looked terrified in death were American. See: Tanaka, *Sensōga,* 150–151.

57. Cited by Shimizu Toshio, "Leonard Foujita: La vie d'un peintre," in *Leonard Foujita: 1886–1968* (Tokyo: Tokyo Metropolitan Art Museum, 1988), 94.

58. *Asahi shimbun,* September 2, 1943.

59. Araki Hideo, review reprinted in Bijutsu Kenkyūjō, ed., *Nihon bijutsu nenkan: Shōwa 19-20-21 nen han* (Japan Art Yearbook: Shōwa 19-20-21 Edition) (Tokyo: Kokuritsu Hakubutsukan, 1949), 59.

60. Earl Miner, Hiroko Odagiri, and Robert E, Morrell, *The Princeton Companion to Classical Japanese Literature* (Princeton, NJ: Princeton University Press, 1985), 198–199. See also various entries in Ivan Morris, *The Nobility of Failure: Tragic Heroes in the History of Japan* (New York: Holt, Rinehart and Winston, 1975).

61. Lorenz Eitner, "The Open Window and the Storm-Tossed Boat: An Essay in the Iconography of Romanticism," *Art Bulletin* 37:4 (December 1955), 281–90.

62. Eitner, "The Open Window and the Storm-Tossed Boat," 287.

63. Tanaka, *Hyōden,* 202–203.

64. Buisson and Buisson, *La vie et l'oeuvre de Léonard-Tsuguharu Foujita,* 268.

65. Eitner, "The Open Window and the Storm-Tossed Boat," 282.

66. Ienaga, *The Pacific War, 1931–1945: A Critical Perspective on Japan's Role in World War II* (New York: Pantheon Books, 1978), 197–198.

67. Cook and Cook, *Japan at War,* 255.

68. National Archives, College Park, Still Pictures (editor's note).

69. Iritani, *Group Psychology of the Japanese in Wartime,* 52–61.

70. Ibid., 58.

Japanese Filmmakers and Responsibility for War: The Case of Itami Mansaku

Kyoko Hirano

Since the 1950s, Japanese cinema has been known in the United States mainly from the work of traditional directors such as Mizoguchi Kenji (1898–1956), Ozu Yasujirō (1902–1962), and Kurosawa Akira (1910–1998). In the late 1980s, however, the late Itami Jūzō (1933–1997) suddenly appeared on the international film scene with a series of extremely popular comedies: *Osōshiki* (The Funeral, 1986), *Tampopo* (Tampopo/Dandelion, 1987), *Marusa no onna* (A Taxing Woman, 1988), *Marusa no onna 2* (A Taxing Woman's Return, 1989), and *Mimbo no onna* (Mimbo— or the Gentle Art of Japanese Extortion, 1992). With a style containing elements associated with Hollywood films—rapid pace, explicit dramatic development, moralizing, and an ingenious blend of humor and suspense—Itami immediately became one of the most sought-after celebrities of Japanese cinema in the international arena. American viewers have tended to note in Itami's work a genius for harshly criticizing Japanese society and culture that they had rarely seen before in the Japanese film industry. Japanese viewers, on the other hand, particularly of the older generation, recognize in Itami Jūzō's work the legacy of his father, the prewar Japanese film master Itami Mansaku (1900–1946). This essay will introduce the senior Itami, an unusual Japanese filmmaker who is scarcely known outside of his home country. In particular, I will discuss the ideological positions in his writings as they relate to Japanese war policy and war responsibility.

In Japan, Itami Mansaku (né Ikeuchi Yoshitoyo) is a highly respected director, screenplay writer, and essayist. He was born in 1900 as a civil servant's son in Matsuyama on Shikoku Island, a city known for its literary tradition.[1] At Matsuyama High School, Itami started a literary magazine with his classmates, Itō Daisuke (1898–1981), who later became a film director of the samurai genre, and Nakamura Kusatao (1901–1983), who eventually became a haiku poet. Itami studied

literature, painting, and cinema. At the age of twenty he was drafted by the army and served for four months. Poor and working as an illustrator for children's books under the pen name Ikeuchi Gumi, Itami moved in with Itō, who was working as a film director at Nikkatsu's Kyoto Studio in 1927. At Itō's suggestion, Itami wrote a few screenplays and for a short while worked as an actor in Taiwan with a traveling troupe. In 1928, after studying with period film master Inagaki Hiroshi (1905–1986) for four months as an assistant director, Itami made his directorial debut with the silent film *Adauchi ruten* (Wandering Avenger).

213

In total, Itami went on to write thirty-four screenplays and direct twenty-two films, many of which are acclaimed period films, including the silent *Kokushi musō* (Invincible Master, 1932) and talkies *Chūji uridasu* (Debut of Chūji, 1935) and *Akanishi Kakita* (1936). These films gradually established Itami as a successful director both critically and commercially. Itami's work is characterized by satire, subversive

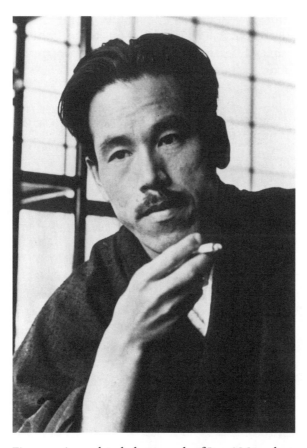

Figure 2. An undated photograph of Itami Mansaku.
Photograph courtesy of the Kawakita Memorial Film
Institute, Tokyo.

ideas against deified figures or notions, and an intellectual approach to his subject matter. For example, *Kokushi musō* is a satire about a famous sword master who is supposed to be invincible but is in fact easily defeated by an obscure samurai disguised as the master himself to take advantage of a great name. *Chūji uridasu* concentrates on the early life of a legendary *yakuza* (traditional-style gangster / gambler) character, Kunisada Chūji, with no heroic glorification. Based on Shiga Naoya's short story about a samurai, *Akanishi Kakita* is a comic spy romance revolving around a well-known attempted rebellion in the 1660s against the daimyo of the Sendai domain. Along with Yamanaka Sadao (1909–1938), a contemporary who was known for his pursuit of his characters' psychology, Itami established the Japanese film subgenre labeled *mage o tsuketa gendaigeki* (modern film with topknot characters). In these films, characters living in—to Itami—feudal (not early modern) Edo-period Japan behave and think like contemporary Japanese, with modernist critical minds.

In 1938, Itami contracted tuberculosis. Thereafter and until his premature death in 1946, Itami's activities were limited to writing.[2] He wrote screenplays, criticism, theoretical pieces, and even essays on current cultural, social, and political affairs. Unfortunately, many of Itami's films are no longer available. Currently existing titles include: *Akanishi Kakita; Atarashiki tsuchi* (The New Earth, 1937), the

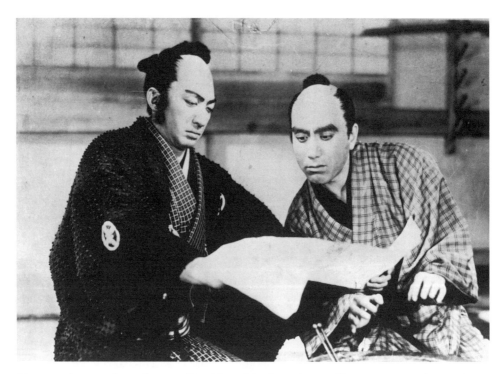

Figure 3. A scene from the 1936 film *Akanishi Kakita,* directed by Itami Mansaku. *Right:* Kataoka Chiezō; *left:* Sugiyama Shōsaku. Copyright: Nikkatsu.

first German-Japanese coproduction in a contemporary setting;[3] *Kyojinden* (The Tale of Giants, 1938), an adaptation of *Les Misérables;* and a part of *Kimagure kaja* (Capricious Servant, 1935), a satirical period film. His screenplays, however, were compiled and published in 1956. Another selection of his screenplays and other critical essays was compiled and published in 1961. In 1971, Itami's son-in-law, novelist Ōe Kenzaburō, further edited and published Itami's writings.[4]

215

Itami demonstrated a remarkable ability to recognize talent in young screenplay writers, such as Kurosawa Akira,[5] Hashimoto Shinobu, and Uekusa Keinosuke.[6] Itami is often harsh in his criticism of veteran screenplay writers, pointing out irrational and unreasonable treatments of dramatic situations that were created for the sake of *seishinsei* (spirituality) or *seishinshugi* (spiritualism), which were vigorously cultivated in filmmaking by the wartime government policy from the 1930s to 1945. Moreover, amid the fanatic turbulence of the war effort, Itami wrote and to some extent was able to publish his criticism of the militarist government in a calm and cynical tone.

After the war, with the same deliberate tone, Itami refused to join the bandwagon of the so-called pacifists who claimed that they had been against the war and who wanted to condemn others for their war crimes. In the famous article entitled "Sensō sekininsha no mondai" (The Problem of Those Responsible for the War), published in the first issue of the film magazine *Eiga shunjū* (Cinema Art) in August 1946—one month before his death—Itami outlined his position.[7] Not wanting to be one of the postwar self-proclaimed antiwar activists, he closely analyzed the Japanese psyche and the irresponsible attitudes that made the militarist government policy possible.

In the postscript included in *Itami Mansaku esseishū,* Ōe defines Itami as a "moraliste." According to Ōe, a *moraliste* is one who understands human ethics based on solid observation of actual human nature. He believes that Itami never placed himself beyond criticism when he accused others of their lack of morality. Moreover, in his daily life, Itami fought situations that he felt were unjust. Ōe argues that Itami was in a true sense a *moraliste* who considered what is moralistic in relation to *dōtoku* (morality) and *fūzoku* (custom). Itami finds good elements in American films and their positive influence on the Japanese youth at a time when American films were widely attacked as being poisonous. Itami praises the philosophy of life portrayed in American films, believing that this is the morality of their protagonists and that it is truly the American spirit. However, Itami feels that the Japanese interpretation is to see it as the expression of morality. For Americans, such a philosophy is already a part of their customary behavior and thus is practiced unconsciously in everyday life. Therefore, Itami concludes that one thing could be equivalent to custom in one society while the same thing could be considered morality in another. Ōe sees Itami as one who tries to practice such moral values.[8]

This theory of Itami stems from his 1941 article entitled "Eiga haiyū no seikatsu to kyōyō" (Film Actor's Life and Cultivation),[9] and Ōe points out that in

Itami's writing, even works in specialized areas still contain universal significance and educational relevance. Itami values what one discovers by oneself, not what one is taught, and he encourages individualistic and creative thinking in actors as well as directors. In addition, Itami argues that directors must have a good sense of humor as well as good verbal skills in explaining what they want from actors.[10]

Itami further sees a great danger in the Japanese people's easygoing, fad-following attitude, which stems from a lack of intellectual, individualistic, and responsible thinking. For example, in February 1941, a mob surrounded Tokyo's Nichigeki Theater in order to see the live concert of Ri Kōran (the Japanese pronunciation of the Chinese name Li Xiang lan, who was promoted as a Manchurian actress but who in fact was Japanese, born Yamaguchi Yoshiko and raised in China.[11] In 1973 she was elected to the Diet as a candidate for the conservative Liberal Democratic Party, resuming her current husband's family name, Otaka Yoshiko; she is now retired from political life).[12] Mobilization of the police was required in order to restrain the excited crowd. Upon this monumental event, Itami wrote:

> Recently, to see the live concert of an actress, a hundred thousand people rushed to a theater and created a serious problem. When I read it in a newspaper, the image of a herd of locusts came to my mind. Some explained that improper measures by the government toward the entertainment business caused such a situation.
>
> I heard that this actress is a product of Japan and developed in Manchuria. We may have to put up with the business people who imported her once again, presenting her as a foreign product. The problem is rather the people who are made to believe such a thing. This is another example of the fundamental Japanese character—not to spare money in order to buy an imported product whether it was in fact made abroad or made in Japan, as long as its label is written in a foreign language. I feel myself truly unfortunate as a Japanese writing this now.
>
> When Madame Curie visited the United States, the American public showed a similarly fanatic interest, exactly as in this case. I dislike America in general, but as far as this comparison goes, our level of cultivation is in no way equal to that of Americans. Even if a herd of "Madame Curies" visited Japan, the Japanese public would not show any interest.
>
> It is fine to show an unusual interest in one actress. However, if you do not show the same degree of interest in other areas, you must be mentally handicapped as a human being and as a nation.
>
> If you blame your government in the end, it is convenient, but this looks every bit like the Japanese are smearing mucus on Mt. Fuji. After all, every Japanese should consider his/her own personal actions and thoughts equally seriously.[13]

In some sense, Itami predicts that a nation like Japan, whose people are thus intellectually underdeveloped, will never be able to defeat Americans, whose

behavior or interests are generally healthier. In the above essay, Itami assigns ultimate responsibility to the individual, while similarly criticizing the Japanese government's war policy. In an earlier series of jottings, dating from September 1939, Itami says:

> None of us says that *sufu* [cheap fabric mixed with staple fibers, widely recommended by the government then] is strong. However, none of the government officials says that *sufu* is weak.
>
> No one loves spiritualism more than the government officials do. How about reducing their budgets and making them work, depending only on their spirituality? People will be so impressed that everybody will convert to spiritualism.
>
> I recently heard some news that made me feel envious. In France the Minister of Education was drafted. I envy the people whose government drafts its own Minister of Education. I envy the nation whose ministers are so young that they are eligible for the draft.
>
> I read the news from France. There, a drafted soldier quietly leaves his family behind as if it is a part of their daily life. In Japan, too, in old times, samurai used to go to battle like this. Such an action is far more respectable than the current Japanese style in which people sing military songs and swing flags as if part of a festival. If you send many soldiers at one time in this manner, this style may be acceptable. However, I wonder why nobody realizes that it is rather cruel to the departing soldier when people are sending him off at a station like this. I believe that such festivity will be unsuitable from the point of view of the national security as well.

The above four passages were apparently published in a film journal in 1940, not long after they were written.[14] If so, it is surprising that such critical views of government policy and the Japanese people's prowar and conformist attitudes were allowed to reach the public at a time when Japan was mired in the China war.[15]

In January 1944 the second integration of film magazines took place. Only two magazines by one publisher, *Eiga hyōron* (Film Review) and *Shin eiga* (New Film), and one trade publicity journal, *Nihon eiga*, were allowed publication. Shimizu was appointed editor-in-chief of *Eiga hyōron*, since the government wanted such positions filled by young people with experience in Japanese-occupied areas (Shimizu had worked for a film company in Shanghai). Then the regulation became even tighter, as galley proofs had to be submitted for approval to both the government's central media section and the police, who substituted for the Jōhōkyoku censorship.[16] However, the following diary entries seem to have been written at the end of the war, while Itami was living in Kyoto, and published posthumously in the early postwar period.[17]

(July 27, 1944) Enemy landed in Tinian. I am prepared for the fact that they will some day reach the mainland. It becomes obvious that ignorant spiritualism, inflexible bureaucrats, greedy capitalists, and stubborn militarists destroy Japan. Day by day, the war situation gets worse and hopeless. Not a single day is pleasant, with a nauseating and uneasy feeling as if pressed by dark clouds.

(January 15, 1945) The enemy bombed the Ise Shrine [the most important shrine in Japan, since it is dedicated to the Sun Goddess and is for the imperial family]. There was damage. Newspapers are making noise. It is the enemy's freedom as to where they bomb. This is a war. If Japanese have time to complain, they should think about how to defeat the enemy.

(March 2, 1945) It rained all day long. Thinking it is spring rain, I feel better. I wish there was no war. I love the Japanese land and people, but I do not like at all our government and our political direction. Particularly, I hate our bureaucracy. I feel that its weakness has become completely exposed through this war. Our low scientific achievements and material meagerness are closely related to our government's policy of spiritualism and *kokutaishugi* [the doctrine of *kokutai* or national polity]. Everything shows uncivilized behavior, beginning with unclear political theories and leading to secretism, favoritism for formalities, suppression of public opinion, abuse of people, irresponsible politics, too much preaching, lack of concrete policies, and prevalence of abstract ideas. These only reveal the government's idiocy, and basically, everything stems from this *kokutaishugi*. It is natural that Japan will be defeated in this war, but I wonder how we can utilize this lesson.

(July 4, 1945) As usual, there is a bomb siren. In Kyoto, only one bomber plane passed. Newspapers only repeat the news on the aggravation of air raids. It is as if they are spreading propaganda for the enemy. Our leaders never come up with a unified policy, even after repeated bombings.

I had a calm stomach but high fever today. It is quite strange that not a single person can express critical views on the war when a nation of 100 million is fighting that war. In any country, at any time, antiwar opinions will not prevail. However, which is a braver act during a period like today —thrusting yourself at the enemy on a battlefield or proclaiming an antiwar opinion in a fanatic society?

In more peaceful times, most of this 100 million nation of ours were pacifists. However, I cannot find the strong will and form of spiritual life of a "selected people" in the nation with such a simplistic and opportunistic attitude. As if dyed by chemicals, this nation of 100 million converted from pacifists to prowar activists without exception.

George Bernard Shaw managed to announce his antiwar opinions

during the European War. If Shaw lived in Japan, he probably would have been killed before the war ended. It is admirable that a nation lets their dissidents express their opinions. A high spiritual culture exists there.

(August 10, 1945) The government explained that a new type of bomb [dropped on Hiroshima] affected a xxx kilometer radius.[18] We may have to live with such suppression if this concerns our own military secrets. However, we do not have to protect our enemy's military secrets. The government may be taking into account the possible influence on the people from such devastating news. Nevertheless, which is more productive, to announce the actual figure of the damage or to induce endless imagination in the people's minds by suppressing the real figure?

Itami's ideological stance in these writings makes a remarkable contrast with that of the mainstream Japanese film industry of the period. The Japanese censors insisted on the "primacy of spirituality," as if to hide Japan's comparative lack of resources. They based their judgments on abstract ideas, such as "seriousness of the [film's] subject" and "sincerity," to the dismay of filmmakers who needed more practical and concrete guidelines.[19] It was widely propounded in Japan that the Pacific War was a war between Japanese "spirituality" and American "materialism" or "science." It was obvious that American science and technology were more advanced than those of Japan. This was a problem for Japanese filmmakers, who knew the extent to which filmmaking was based on modern technology. This made it harder for them to rationalize the claim that Japan had ultimate superiority.[20]

Yet most of the Japanese filmmakers, reluctantly or willingly, followed this unscientific theory of government policy. Sawamura Tsutomu, a screenplay writer and one of the most enthusiastic war-policy propagandists of the Japanese filmmaking community, argued that America's material supremacy was based on "American aggressive fighting power and spiritual inferiority." Furthermore, in contrast with the Western view of one God governing human beings on earth and saving their souls after death, every Japanese could himself or herself become a god by "crystallizing divinity." While Japan had progressed toward becoming a *shinsei* (divine) society, other nations had not "purified" themselves as Japan had. To defeat these people of "animalistic nature," Japan needed war-making power as well as spiritual power. Thus, Japanese films should help defeat the nation's technologically superior American enemy by emphasizing Japan's spiritual primacy. For example, Sawamura promoted the *kamikaze* (divine wind) suicide missions, pointing out that their pilots were assured of becoming divine *gunshin* (military gods).[21] The emphasis on spiritual purity was thus connected with fanatic patriotism and was propagated in war films by stressing complete submission and self-sacrifice to the national cause.

Director Kumagai Hisatora (1904–1986), brother-in-law of film star Hara Setsuko, was another filmmaker who enthusiastically embraced the war effort in

his films. He directed successful propaganda films: *Shanhai rikusentai* (Troops for Land Battles in Shanghai, 1939; written by Sawamura), a war film including location sequences shot immediately after the real battles; and *Shidō monogatari* (The Tale of Guidance, 1941; also written by Sawamura), on war collaboration between the military and railroad workers. After making these two films, his activities were centered on the *Sumerajuku,* an ultraright religious group that he founded.[22]

Mizoguchi is also believed to have been excited about his collaboration with the war effort. As early as in 1932, he made a film, *ManMō kenkoku no reimei* (Dawn of the Founding of Manchukuo and Mongolia), a melodrama set against the Manchurian Incident of 1931. The film has been described as the glorification of Japanese colonialist aggression on the Chinese mainland.[23] He was extremely honored when he was selected as a representative of the wartime nationalist film organization. He responded to governmental propaganda policy by producing a series of films emphasizing self-sacrifice for a higher cause, such as *Roei no uta* (The Song of the Camp, 1939), *Genroku Chūshingura* (The Loyal 47 Rōnin, Parts I and II, 1941, 1942), *Meitō Bijomaru* (The Famous Sword Bijomaru, 1945), and *Hisshōka* (Victory Song, 1945).[24] Mizoguchi was sent to China by the Japanese army, July to August 1943, along with his screenplay writer, Yoda, and two assistant directors. They toured several cities while doing research for Mizoguchi's film on China; however, this project does not seem to have materialized.[25]

Kurosawa resentfully describes his fights with Japanese wartime censors in his autobiography.[26] However, his wartime films were well received by the government for their themes of heightened spiritualism (in *Sugata Sanshirō,* 1943); self-sacrifice by women war workers for military causes (in *Ichiban utsukushiku,* The Most Beautiful, 1944); and racial superiority (in *Zoku Sugata Sanshirō,* Sanshirō Sugata, Part II, 1944). Screenplay writer Uekusa has revealed Kurosawa's wartime passion for filmmaking, despite the imposed militarist themes. Many filmmakers at Tōhō Studio believed that the success of the studio's war films by Yamamoto Kajirō (1902–1973) owed much to his assistant director Kurosawa. These include *Hawai Marei oki kaisen* (The War at Sea from Hawai'i to Malaya, 1942), a film made to commemorate the first anniversary of the Pearl Harbor victory; *Katō hayabusa sentōtai* (General Katō's Falcon Fighters, 1944), depicting an airplane hero in the China–Southeast Asia war; and *Raigekitai shutsudō* (Torpedo Squadrons Move Out, 1944), glorifying the volunteers for human-torpedo missions. Because of their commercial and critical success and the government's favorable reception of these war films, Yamamoto and his group were powerful at the studio, and Kurosawa was jubilant. To Uekusa's eyes, Kurosawa seemed to be single-mindedly devoted to filmmaking on any subject for the sake of his love for filmmaking, and so he was not bothered by introducing the prescribed militaristic themes.[27]

Most other filmmakers probably collaborated with the wartime policy with less enthusiasm. According to film critic Satō Tadao, many of the Japanese filmmakers were not strongly and actively opposed to the government war policy, but they passively accepted it or tried to avoid collaboration as much as possible.

Some of them, like Gosho Heinosuke (1902–1981), did not make any collaboration films. Intentionally or unintentionally, Gosho kept failing to come up to the military censor's standard and specialized in melodramas rather unfit for military themes. Then he fell ill, and he did not have to make any militaristic films.[28] In the case of Ozu Yasujirō, after his script of *Ochazuke no aji* (The Flavor of Green Tea over Rice) was rejected in 1938 by military censors for its lack of respect for the military services, he directed two films—*Todake no kyōdai* (The Brothers and Sisters of the Toda Family, 1942) and *Chichi ariki* (There Was a Father, 1942)—that pleased government officials for their themes of self-sacrifice. Then he was assigned to make a propaganda film about the Southeast Asian Theater and the Indian independence movement against British colonial rule, but he again failed to please the military censors.[29] In general, Japanese filmmakers chose not to consciously oppose the war policy and did their best to work within the limitations prescribed by the government.

Rare exceptions were Marxist producer Iwasaki Akira (1903–1981) and leftist documentary director Kamei Fumio (1908–1987). Iwasaki was engaged in the prewar proletarian film movement and was arrested in 1938 and imprisoned for two years.[30] Kamei studied filmmaking in the Soviet Union in the late 1920s and made *Shanhai* (Shanghai, 1937) and *Tatakau heitai* (Soldiers at the Front, 1940), both of which infuriated military censors as too sympathetic to the Chinese and lacking in glorification of the Japanese war effort. The latter film was banned and never shown to the public. Kamei was arrested in 1941 and imprisoned for a year.[31] In other spheres of Japanese culture, too, only a handful of Communists and their sympathizers refused to convert to the government war policy and so were kept in prison or went underground. Along with the Japanese filmmakers, the Japanese people at large demonstrated an astounding degree of conformity with the war effort policy.

With the same easiness, "as if dyed by chemicals," the Japanese nation of 100 million seemed to convert from prowar activists or silent supporters of the war to pacifists as soon as the war ended. In the film industry, almost everybody—including the studio heads, producers, directors, screenplay writers, actors, actresses, and craftsmen—suddenly changed their opinion on the war by 180 degrees. Those who had been busily and loudly preaching the value of suicidal missions, selfless collaboration with the war effort in every walk of life, self-sacrifice to the national war effort, and the unquestionable supremacy of the *Yamato minzoku* (variously used by Japanese to mean race, nation, or *volk*) over the rest of the world in their wartime films changed their minds on August 15, 1945. After surrender, the same people began to make films harshly critical of the wartime militarist and expansionist policy, the *gunbatsu* (military clique), and the people who followed this policy, while praising those who had fought against fascism and militarism.

It is extraordinary that Itami could maintain such a cynical and distant attitude in the middle of such fanatic militarism, but it is equally significant that he could maintain the same distance and equanimity amid the heated rhetoric of early post-

222

war democracy. Itami refused to participate in the blacklisting movement of the film industry, which was being waged early in 1946 in the aftermath of the Occupation's mandated political purge by the Jiyū Eigajin Renmei (The Association of Free Film People).[32] In his essay, "The Problem of Those Responsible for the War" (published as indicated in August 1946 but signed on April 28), Itami, in a characteristically rational but severe tone, condemns the opportunistic and conformist attitude of the Japanese people. Itami is as candid and harsh in criticizing himself as he is in criticizing others. He explains that the reason he did not make any war collaboration films was not because of his antiwar conviction but merely due to his ill heath. Furthermore, he admits that he wanted Japan's victory in the war, and the survival of himself and those he loved.[33] But Itami questions the way in which everybody was claiming that he or she was "deceived" by others during the war but nobody was claiming to have been actually doing the "deceiving." For Itami, such an argument is absolutely nonsensical: Everybody is blaming somebody higher as the deceiver. If this were true, only a handful of people at the top of the government stood to be blamed. It is very unlikely, Itami believes, that as many as 100 million people were in fact being deceived by only one or two leaders.[34]

Itami further argues in this essay that the reality of the wartime situation was such that as soon as one was deceived by somebody, one began to deceive another, and this eventually spread all over Japan. As a result of this crazy war, every Japanese person was forced to deceive his or her peers in this manner. Itami sees such an attitude as essentially irresponsible and chides that "if you are so naive as to believe that you are exempt from the responsibility upon claiming that you were deceived, and that thus you now belong to the right causes, you must wash your face [and wake up]." For Itami, the act of allowing oneself to be deceived is in itself an evil action.

Itami believes that one who has been deceived holds as much responsibility for the war crimes as those who did the deceiving.[35] Similarly, in the 1970s director Ōshima Nagisa began to criticize his elder generation of filmmakers for portraying war experiences only from the side of the "victimized" and not from that of the "victimizer."[36] Those guilty of complicity, Itami continues, lack a critical intellect and sense of principle. In a broader sense, complicity is symptomatic of a lethargic national culture that has failed to remain conscious, reflective, and responsible. The result is a kind of servility that allows deceit. Itami finds the roots of this problem in Japanese history: The feudal system and the isolationist policies of Japan had not been overturned by the Japanese themselves. Rather, it was foreign forces that brought the era of feudalism to a close. The Japanese had never grasped the notion of basic human rights. Itami believes that it is the servility of the Japanese people that allowed such a tyrannical and oppressive government to exist. Such compliance means the "infringement of individual dignity, abandonment of self, betrayal of humanity, lack of energy to get angry at wrongdoings, lack of morality," and, in the end, "unfaithfulness to the masses and the subjugated."

Since the Japanese people are politically liberated, to blame war responsibility only on the military, police, and bureaucrats is foolish as well as dangerous. Itami claims that the people themselves had allowed the abuses of wartime Japan. Until the Japanese people can understand this, they will never be truly liberated. He believes that it is absolutely necessary for the Japanese to understand the meaning of being deceived, to analyze such a weakness, and to make a firm resolution to completely change themselves.

Itami concludes that it is more urgent to conduct a thorough self-critique than to assign blame. This is the reason he refused to join in the movement to blacklist the "war criminals" of the film industry.[37] There is a clarity in Itami's thought and criticism that was unparalleled in the Japanese film industry of the period.

The final war criminal list prepared by the Association of Free Film People was very similar to that drawn up by the newly amalgamated trade union, Zen Nippon Eiga Engeki Jūgyōin Kumiai Dōmei (All-Japan Motion Picture and Drama Employees Union]. Both lists were made public in April 1946 as a first step toward democratization of the film industry. The alleged war criminals were divided into three categories. Class A, which included twenty-three film company presidents, executives, and ex-officials of the wartime censorship agencies, Naimushō (Home Ministry) and Jōhōkyoku (Bureau of Information), were recommended for permanent exclusion from the film industry. Temporary suspension was sought in the cases of Class B war criminals—certain film executives and one director. Thorough self-criticism was recommended for those in Class C, which included war collaboration filmmakers.[38] These lists in fact had no practical impact on Japanese filmmakers or the public, despite their militant proclamations.

Thirty-one film industry heads were, however, expelled from their positions by the Allied Occupation media purge of October 1947. This affected company presidents and executives who had held their positions between July 7, 1937, and December 8, 1941. These executives were held responsible for warfare between the Marco Polo Bridge Incident and Japan's attack on Pearl Harbor. Yet the directives seem to have been implemented as a formality rather than as an attempt to influence deeply the Japanese film community and public. All of those purged were rehabilitated and returned to their positions in October 1950.[39]

Years later, Kurosawa rather simply and honestly admitted in his 1978 autobiography:

After the war my work went smoothly again, but before I begin to write about that, I would like to look back once more at myself during the war. I have to admit that I did not have the courage to resist in any positive way, and I only got by ingratiating myself when necessary and otherwise evading censure. I am ashamed of this, but I must be honest about it.

Because of my own conduct, I can't very well put on self-righteous airs and criticize what happened during the war. The freedom and democracy

of the postwar era were not things I had fought for and won: They were granted to me by powers beyond my own. As a result, I felt it was all the more essential for me to approach them with an earnest and humble desire to learn, and to make them my own. But most Japanese in those postwar years simply swallowed the concepts of freedom and democracy whole, waving slogans around without really knowing what they meant.[40]

In Kurosawa's statement, there are elements similar to Itami's. Both men humbly admit that they did not fight or resist wartime militarism. Furthermore, both of them wished to avoid the self-righteous criticism of others. Itami, however, searches more deeply in April 1946 as to why he, along with other Japanese, fell into such a shameful and cowardly attitude. He then devises an argument that suggests collective responsibility for the war. In contrast to Kurosawa's lukewarm resolution to regard postwar freedom and democracy with an "earnest and humble desire to learn and make them my own," Itami suggests a thorough self-critique in order never to repeat such an immoral mistake. It is even more notable that Itami wrote his war criminal essay shortly after the war, three decades before Kurosawa was able to look back publicly at this period.

One of Itami's most significant statements is his insistence that the Japanese people must show individualistic thinking and principles. Many Japanese directors, producers, screenplay writers, and actors were able to make any kind of film, regardless of ideology, including war films and postwar democratic films. Japanese directors were (and are) often described as not really *geijutsuka* (artists) but as *shokunin* (artisans), catering to the demands of their superiors without seriously questioning the political and ideological implications of their films. Such directors were obsessed with making technically brilliant films, regardless of the ideological messages imposed upon them by the political climate. Once assigned a project, the Japanese filmmakers simply worked hard until it was completed, with relatively little concern for the rationale behind the project. This obsession with work may be ascribed to the Japanese national character, the same character that the wartime regime had exploited for its own ends. There is also a Japanese proverb—*nagai mono ni wa makarero*—that means roughly "Be embraced by the powerful," and might be translated as "Seek cover with the strong," or "If you can't beat 'em, join 'em." However universal such an attitude may be, this may reflect the traditional emphasis on harmony over conflict rooted in the nation's geographical, historical, and sociological imperatives.[41] Itami wanted to challenge this imbedded notion, for it leads to servility and allows the authorities to abuse the people.

Although Itami claimed it was his illness that prevented him from making films during the war, this is not altogether true. There were, in fact, instances when Itami's screenplays faced wartime censorship. The first case took place in 1943 when several scenes were ordered cut from the complete film *Muhōmatsu no isshō* (Life of Muhōmatsu; known abroad later as *Rickshaw Man*), written by Itami and directed by Inagaki in 1943. The Naimushō censor found it objectionable that the rickshaw

man nicknamed Muhōmatsu falls in love with a widow of a military officer.[42] Even platonic love between an officer's widow and a low-class character, such as a rickshaw man, was impermissible in the eyes of the censors. The widow in such a case must remain dedicated to her late husband—and, by extension, to the emperor and the war—and act as a role model for citizens of the military regime.

In another case, Itami's screenplay *Fushaku shinmyō* (Dare Your Life) did not pass censorship after Itami published it in *Nihon eiga* in January 1943, and it was never allowed to be filmed. Based on a historical novel by Yamamoto Yūzō, it portrays a samurai named Ishitani Jūzō and his life from the 1615 Seige of Osaka Castle (fought between Tokugawa Ieyasu and Toyotomi Hideyori) to the 1638 Shimabara Rebellion.[43] The focal point of the story is Ishitani's transformation from a reckless warrior whose motto was "Dare Your Life" to a cautious philosopher whose motto became "Value Your Life." This conversion takes place when Ishitani is given advice by Lord Tajima, the swordplay teacher of the shogun, to the effect that true heroes do not waste their own lives or those of others. Thus, when appointed to suppress the peasant revolt in Shimabara by the Tokugawa government, Ishitani makes his utmost effort not to be engaged in useless battles. His effort fails, much to his dismay and regret, and he is forced into a brutal encounter that brings unnecessary death on all sides.[44]

Itami's screenplay emphasizes the futility of war and the horrors of the battlefield. The end of the screenplay provides for a series of images portraying fierce battle scenes, bloody bodies on the ground, and close-ups of a flag saying "Dare Your Life." Not included in the original magazine version (possibly cut by the film magazine censor who read the script) but restored in *Itami Mansaku zenshū* are two episodes. One is a peasant's statement that both Christian and non-Christian peasants are joining the rebel forces. In another, the peasant is commenting that the resistance fighters are well aware of the futility of their cause but still must fight the oppressive rule of their tyrannical lord. These scenes are not in Yamamoto's original novel; they are the creation of Itami, who wanted to portray this historical event from the side of the oppressed.[45]

Another screenplay, *Momen taiheiki* (Cotton [or Modest] Version of the Record of Great Peace), was completed in 1943 but never filmed. No details are available as to what was problematic about this screenplay in the eyes of censors. Itami did not want to conform with the studio's request for change, but it is very likely that Itami's ideological position did not fit the government's censorship policy.[46] Itami wrote a tanka poem in July 1945: "I wonder if *Momen taiheiki* was killed because I wrote of matters that are too true." [47]

It may not be the case, then, that Itami's illness was solely responsible for his reduced output during the war. There is certainly evidence that his stubborn resistance to censorship kept Itami at a distance from the opportunistic film industry. What is clear is that Itami stands almost alone in the film world of this period as a unique critic of Japanese culture.[48]

Toward the end of his life, Itami began working on a screenplay portraying

the life of Tanaka Shōzō (1841–1913), an activist and a Diet member during the late Meiji era who led the antipollution movement on behalf of farmers who were victims of poisoning caused by the Ashio copper mine.[49] Like Itami, Tanaka had the courage to speak out against the prevailing authority. Itami died before finishing this screenplay. One can only imagine what such a film would have been like. Nonetheless, it somehow seems fitting that Itami, the critic, would be working on a piece that so prefigures a growing concern of the world today.

The universality of Itami's aphorism appeals to readers a half-century later, and perhaps it will also transcend national borders as his son's films now do. Itami Jūzō's social and cultural criticism, which fascinates international audiences, thus descends from themes that existed in his father's work.

Notes

Acknowledgments

The author gratefully acknowledges the generous assistance of the late Akira Shimizu and Kyoko Sato of the Kawakita Memorial Film Institute. Thanks also to Prof. Marlene Mayo, Akira Tochigi, Judy Ames, and Jonathan Glick.

1. Matsuyama produced novelists Natsume Sōseki (he was not born there but spent his youth there; his first novel, *Wagahai wa neko de aru* [I Am a Cat] is based on his experience as a high school teacher in Matsuyama); Ōe Kenzaburō (who married Itami Jūzō's sister); and haiku poets Masaoka Shiki, Takahama Kyoshi, and Nakanishi Hekigodō, among others.

2. Sources on Itami's life and career include: Fujita Motohiko, *Eiga sakka Itami Mansaku* (Filmmaker Itami Mansaku) (Tokyo: Chikuma Shobō, 1985); Saeki Kiyoshi, "Itami san no enshutsu" (Mr. Itami's Direction), in *Kōza Nihon eiga* (Japanese Cinema Studies), vol. 3, *Tōkī no jidai* (The Period of Talking Pictures) (Tokyo: Iwanami Shoten, 1987), 156–157; Urayama Kirio, "Itami Mansaku san: 'Akanishi Kakita' o megutte" (Praising Mr. Mansaku Itami: On the film *Akanishi Kakita*), in Nihon Eiga Kōza Jikkō Iinkai, ed., *Nihon eiga o yomu: tamashii no messeiji* (Reading Japanese Cinema: Messages of Souls) (Osaka: Breen Center, 1987), 14–30. Also, Tanikawa Tetsuzō, "Shiga Naoya 'Akanishi Kakita'" (Shiga Naoya's "Akanishi Kakita"); Mansaku Itami, "Kakita sensei" (Teacher Kakita) and accompanying film note, all in Nihon Eiga TV Producer Kyōkai and Iwanami Hall, eds., *Eiga de miru Nihon bungakushi* (History of Japanese Literature Seen through Cinema) (Tokyo: Iwanami Hall, 1979), 80–83. The Shiga Naoya story, "Akanishi Kakita" (1917), which figures so prominently in recent discussions of Itami's work, has been translated by Lane Dunlop in *Paper Moon and Other Stories by Shiga Naoya* (San Francisco: North Point Press, 1987), 65–81.

3. In the aftermath of the Anti-Commintern Pact (November 1936), Itami was assigned by his studio to cowrite and codirect *Atarashiki tsuchi,* featuring Hara Setsuko, with German director Arnold Fanck. However, differences between the two directors in approaching the subject became increasingly apparent while shooting, and two versions instead of one were released. Fanck's was called *Die Tochter der Samurai* (Daughter of the Samurai); see Joseph Anderson and Donald Richie, who cite Sawamura Tsutomu's criticism of Fanck's version as "no more than an attempt to form essentially alien [to Japan] Nazi pro-

paganda out of Japanese raw materials": *Japanese Film: Art and Industry,* expanded version (Princeton, NJ: Princeton University Press, 1982), 148–149. Sawamura was the author of *Gendai eiga ron* (Discussion of Contemporary Film) (Tokei Shobō, 1941). In Itami's version, the protagonist (Kosuji Isamu), after studying in Europe, is torn between the two cultures but chooses Japanese traditional values by marrying his fiancée (Hara) instead of his German love, and the two move to Japan's new empire in Manchukuo. See the Itami Mansaku section in *Nihon eiga kantoku jiten* (Encyclopedia of Japanese Film Directors) (Tokyo: Kinema Jumpōsha, 1976), 38; and the "Atarashiki tsuchi" section in *Nihon eiga sakuin zenshū* (Encyclopedia of Japanese Films) (Tokyo: Kinema Jumpōsha, 1973), 30–31.

4. Itami's first book of essays, *Eiga zakki* (Miscellaneous Writings on Movies), was published in 1937. His second collection of essays, *Seiga zakki* (Miscellaneous Writings by an Invalid), appeared in 1943. He had edited his third book, *Seiga kōki* (Postscript by an Invalid) before his death, and this was published in 1946 posthumously. Print censorship in Occupied Japan was in full operation in 1946, and a search is underway for Itami's last work in the uncataloged books of the Gordon W. Prange Collection, McKeldin Library, University of Maryland. Itami's comments on current affairs were published in the daily newspaper between 1936 and 1943; see Ōe Kenzaburō, *Itami Mansaku esseishū* (Essays of Itami Mansaku) (Tokyo: Chikuma Shobō, 1971).

5. Kurosawa writes that he is fortunate to have had a number of mentors in his life. As for Itami, Kurosawa says that although he never studied with him, Kurosawa received Itami's warm encouragement. Kurosawa Akira, *Gama no abura: Jiden no yōna mono* (Toad's Oil: Something Like an Autobiography) (Tokyo: Iwanami Shoten, 1984) (originally published serially in the weekly *Shūkan yomiuri,* March to September 1978), 118; also see Audie Bock's translation of this book, *Something Like An Autobiography* (New York: Alfred A. Knopf, 1982), 56. Another famous screenplay writer, Yahiro Fuji, is quoted as stating: "It is not an exaggeration to say that throughout my twenty-year professional life, the only criticism that was useful to me came from my colleague, Itami Mansaku" (Fujita Motohiko, *Eiga sakka Itami Mansaku,* 186).

6. Uekusa (1910–1994), an elementary school classmate of Kurosawa, later became a renowned screenplay writer for Kurosawa and Gosho Heinosuke, among others. Hashimoto (1918–) wrote for Kurosawa, Nomura Yoshitomo, and many other important directors. Adachi Kazu in his serial articles, "Purojūsā gunyūden" (The Record of Producers), No. 21, discusses Itami, Kurosawa, Hashimoto, and Uekusa; see *Kinema jumpō* (March 1989), 110–112.

7. The essay itself is dated April 28, 1946 (though it appeared in August), and is included in Ōe, ed., *Itami Mansaku esseishū,* 75–85. The original is in the Prange Collection, University of Maryland.

8. Ōe Kenzaburō, "Morarisuto to shite no Itami Mansaku" (Itami Mansaku as a Moraliste), in Ōe, 318–329.

9. Originally appeared in *Eiga engigaku dokuhon* (Text for the Study of Film Acting) (August 1941) and included in Ōe, 115–146.

10. Itami, "Engi shidōron sōkō" (A Draft on Teaching How to Act), originally appeared in *Eiga enshutsugaku dokuhon* (Text for the Study of Film Directing) (December 1940) and included in Ōe, 89–114.

11. Born to Japanese parents in Manchuria in 1920 and educated in Beijing, she was first promoted as a singer at the age of thirteen. She made her screen debut in 1938 as a "Chinese, fluent in both Japanese and Chinese," becoming an important propaganda vehi-

cle of the Japanese-ruled Manchuria Film Corporation. In a series of highly popular films made in order to promote the "Japan-China Friendship," Ri was typically cast in roles of a Chinese girl who fell in love with a Japanese and helped him, symbolizing Chinese collaboration with the Japanese effort in China. See such films as *Byakuran no uta* (Songs of the White Orchid, 1939, directed by Watanabe Kunio), *Shina no yoru* (Night in China) (1940, directed by Fushimizu Osamu), and *Nessa no chikai* (The Pledge of Burning Sands, 1940, directed by Watanabe).

Upon the end of the war, she once again began to call herself by her Japanese name, escaped Chinese execution as a collaborator, and was repatriated to Japan in 1946. She returned to the Japanese stage as a singer in 1946 and to the Japanese screen in 1948. She visited Hollywood in 1950, married sculptor Isamu Noguchi the following year, appeared in both Japanese and American films (to Americans, she was known as Shirley Yamaguchi), divorced, and remarried a Japanese diplomat in 1957. She became a popular TV show host, reporting on social and political issues.

12. See Yamaguchi Yoshiko and Fujiwara Sakuya, *Ri Kōran: Watakushi no hanshō* (Ri Kōran: My Half Life) (Tokyo: Shinchō-sha, 1987).

13. Itami, "Sungenchū" (Brief Essay), which originally appeared in *Miyako shimbun* (February 1941) and is included in Ōe, *Itami Mansaku esseishū*, 54–55. The fact that "Ri Kōran" was in reality a Japanese national was strictly hidden by the Manchurian Film Corporation and Tōhō Studio, which produced and promoted "Japan-China Friendship" films. I wondered how it was possible for Itami to learn this fact and to expose it publicly, and so I asked Shimizu Akira (1916–1997), who had been a film critic since 1939. According to Shimizu, a *Miyako shimbun* reporter was able to get a scoop on the story that Ri was in fact Japanese after seeing her enter the Japanese immigration office and present a Japanese passport. Other Japanese newspapers did not reveal this (although the English-language *Japan Times* also carried the news), partly because Tōhō Studio denied it and partly because it was then considered frivolous to sensationalize gossip in the entertainment business during the austere atmosphere of wartime. The general public, with some doubt, believed that the actress was Chinese. The Manchurian Film Corporation's "business secret" was kept, as no one in the media wanted to challenge it. Shimizu himself learned from film businesspeople that Ri was Japanese when he became acquainted with her in Shanghai, but he was not allowed to write or talk about it (Shimizu Akira's letter to the author, August 26, 1992).

14. The first two passages date from September 11, 1939; the last two from September 29, 1939. They are taken from Itami's serial essays, "Nikkifū byōsho zakki" (Dairy-Like Miscellaneous Writings of an Invalid), covering the period from August 20, 1939, to January 19, 1940. As evidence of actual publication, they are compiled in the section of Itami materials appearing in the April, May, and September 1940 issues of the film journal *Nihon eiga* (Japanese Film). See *Itami Mansaku zenshū* (Anthology of Itami Mansaku's Writings) (Tokyo: Chikuma Shobō), vol. 2, 302, 304–330, 328.

15. Shimizu Akira believes that these writings, including as they do such incisive criticism of the bureaucrats, were in fact not allowed publication. In 1939, Shimizu joined his classmates at Tokyo Imperial University in creating a film coterie magazine, *Eiga hyōron*. In 1940, owing to lack of raw materials and also as a measure for media control, the government's Jōhōkyoku (Bureau of Information) permitted the publication of only eight film magazines by three publishers. Shimizu's *Eiga Hyōron* was integrated with a larger maga-

zine of the same name. The editors were often pressured to comply with government policy, and Shimizu was once summoned by the *kenpeitai* (secret police) for his film criticism.

16. Shimizu, letter to author.

17. These entries are taken from Itami, "Seishin dōshinroku" (The Record of an Immobile Body and an Active Mind), included in *Itami Mansaku zenshū*, vol. 2, 329–337. It is difficult to determine whether or not Itami rewrote these entries after the war (the ones that were not published during the war). Although I am not able to give a definite answer, I tend to doubt it because Itami was very ill by the end of the war, and it would have been difficult for him to use up his remaining energy to revise what he had already written.

18. Although these entries were published after the war, Itami apparently intended to convey criticism of the wartime and early postwar Japanese government for withholding information by using "xxx" marks. However, Occupation censors forbade the use of any marking system or symbols to indicate deleted material, and the format in which this was initially published remains unclear.

19. For example, Kumamido Sadamu's statement, "Genka no Nihon eigakai ni atau" (Giving [Guidance] to the Present Japanese Film Industry) in *Eiga hyōron* (January-February 1944), 3.

20. For wartime film censorship and national policy themes, see Shimizu Akira, *Sensō to eiga: Senjichū to senryōko no Nihon eigashi* (War and Cinema: Japanese Cinema History during the War and under the Occupation) (Tokyo: Shakai Shisōsha, 1994); and Peter High, *Teikoku no ginmaku: Jūgonen sensō to Nihon eiga* (The Imperial Silver Screen: The Fifteen-Year War and Japanese Cinema) (Nagoya: Nagoya Daigaku Shuppan, 1995). Also, chapters 7 and 8 in Anderson and Richie, *Japanese Film*; Richard M. Mitchell, *Censorship in Imperial Japan* (Princeton, NJ: Princeton University Press, 1983), 204–209, 299–302; and Shimizu Akira, "War and Cinema in Japan," in Abe Mark Nornes and Fukushima Yukio, eds., *The Japan / America Film Wars: World War II Propaganda and Its Cultural Contexts* (Chur, Switzerland: Harwood Academic, 1994), 7–57.

21. Sawamura Tsutomu, "Shinario zuisō: Eiga no hyōgen ni kansuru hansei" (Essays on Scenario: Reflections Concerning Cinematic Expression), in *Eiga hyōron* (December 1944); and "Daitōwa eiga o meguru sōnen" (Concept Governing Greater Asia Cinema) in *Eiga hyōron* (January-February 1945).

22. Iida Shinbi, "Kumagai Hisatora," in *Nihon eiga kantoku zenshū*, 151–152. Kumagai did not return to filmmaking until 1949, when he became a producer, and he directed his first postwar film in 1953 following the period of Allied Occupation.

23. Audie Bock, *Japanese Film Directors* (New York: Kodansha International, 1978), 39; Kishi Matsuo, "Mizoguchi Kenji," in *Nihon eiga kantoku zenshū*, 389.

24. Kishi, "Mizoguchi Kenji," 390. Mizoguchi's "The Loyal 47 *Rōnin*" was based not on the famous eighteenth-century Kabuki play, *Kanadehon chūshingura* (Treasury of Loyal Retainers), but rather on Mayama Seika's new 1930s version, *Genroku chūshingura*, which the military preferred for its greater emphasis on loyalty to the emperor. See Brian Powell, *Kabuki in Modern Japan: Mayama Seika and His Plays* (New York: St. Martin's Press, 1990), 178; and Keiko I. McDonald, *Japanese Classical Theater in Films* (Madison, NJ: Fairleigh Dickinson University Press, 1994), 61, 66–69.

25. After the war, Mizoguchi commented that he was not enthusiastic about these propaganda films. Yoda Yoshikata, who closely collaborated with Mizoguchi as his screenplay writer from the 1930s through the 1950s, agrees that he was not very excited about

these projects, not so much because of antiwar conviction but rather out of aesthetic concerns that his cinematic style would be perverted in creating war propaganda; see Yoda, *Mizoguchi Kenji no hito to geijutsu* (The Person and Art of Mizoguchi Kenji) (Tokyo: Tabata Shoten, 1970), 78–80, 120–130; and "Ace Japanese Director and Staff Tour China Front for Picture," *Nippon Times,* August 18, 1943. For further discussion of Mizoguchi's cinema aesthetic and the propaganda requirements of Japan at war, see D. William Davis, "Militarism and Monumentalism in Prewar Japanese Cinema," *Wide Angle* 18:3 (1989), 16–25; and "*Genroku chūshingura* and the Primacy of Perception," in Linda C. Ehrlich and David Desser, eds., *Cinematic Landscapes: Observations on the Visual Arts and Cinema of China and Japan* (Austin: University of Texas Press, 1994), especially 187–190.

26. Kurosawa cites, for example, the birthday party scene in his screenplay, *San Pugita no hana* (The San Pugita Flower, date unclear), which was not allowed to be filmed because of Kurosawa's dispute with the censors, as well as the so-called love scene in *Sugata Sanshirō* (Sanshirō Sugata, 1943), which was ordered to be cut. The censors labeled both cases as "Ei Beiteki" (Anglo-American). See Kurosawa, *Something Like an Autobiography,* 111, 131.

27. Uekusa Keinosuke, *Waga seishun no Kurosawa Akira* (Kurosawa Akira of My Youth) (Tokyo: Bungei Shunjūsha, 1985), 45–84.

28. Satō Tadao's presentation at the symposium "Japan at War," Japan Society, New York, March 28, 1987.

29. Ozu had firsthand experience of the war. He was drafted and served in China from 1937 to 1939. In 1943, he was tapped by the military to make propaganda films and sent to Singapore (where he was able to view many confiscated American films); in 1945, he became a British prisoner of war and was repatriated to Japan in early 1946. See Kishi Matsuo, "Ozu Yasujirō," in *Nihon kantoku zenshū,* 104–105; and Donald Richie, *Ozu* (Berkeley: University of California Press, 1974), 226, 231–232. Joan Mellen's views of selected Ozu and Mizoguchi wartime films are in *Voices from the Japanese Cinema* (New York: Liveright, 1975), 151–162.

30. Iwasaki did not escape postwar criticism as a war collaborator. After his release from prison in 1940, he became a part-time employer of the Tokyo office of the Manchurian Film Corporation, a Japanese government colonial institution.

31. For Kamei's films and postwar relationship with Iwasaki, see Kyoko Hirano, "The Japanese Tragedy: Film Censorship and the American Occupation," in Robert Sklar and Charles Musser, eds., *Resisting Images: Essays on Cinema and History* (Philadelphia: Temple University Press, 1990), 200–224. For further activities of Iwasaki and Kamei in the Occupation period, see Kyoko Hirano, *Mr. Smith Goes to Tokyo: Japanese Cinema under the American Occupation, 1945–1952* (Washington, D.C.: Smithsonian Institution Press, 1992), 114–119.

32. This association is believed to have been organized mainly by leftists before April 1946, when it announced its list of culprits. *Eiga engeki jiken* (Encyclopedia of Film and Theater) (Tokyo: Jiji Tsūshinsha, 1947) cites Iwasaki Akira, Yagi Yusutarō, and Kishi Matsuo as the organizers (41), but it is not clear whether Yagi and Kishi were to the right or left.

33. On August 15, 1945, the day Japan surrendered, Itami writes: "In the morning, no newspaper came. At noon, I heard for the first time the voice of His Majesty on my neighbor's radio. I could hardly understand it. After all, it became obvious that Japan surrendered unconditionally. For the first time, I experienced defeat in the war. With bitter, bit-

ter tears. However, this result is too natural since all over Japan there have been many factors revealing defeat. Around noon, Mr. Tamura came with lots of vegetables. He brought his own lunch and left about 2 P.M. I was restless because no newspaper came in the evening either. At night, my stomach felt bad. I could not sleep. I heard crickets singing. It was quiet" (Itami, "Seisin dōshinroku," in *Itami Mansaku zenshū*, vol. 2, 337). Itami's reasons for self-criticism are evident in a wartime *tanka*, written in 1942 and deleted by Occupation censors from an essay about him in 1946: "How happy and glorious am I! / To be born and live in the land of Yamato / In the day of the great War going / Under the glorious reign of the Emperor" (translation by Occupation scanners); see "Letters of the late Itami Mansaku," *Eiga* (Cinema) (December 1946); Prange Collection, University of Maryland).

34. This argument seems to have been used conveniently by the Japanese people, who ascribe war responsibility to higher levels, ultimately to the top of the system—the emperor. Because the emperor was not prosecuted by the International Military Tribunal for the Far East (Class A Tokyo War Crimes Trials), no one in the end did or will take responsibility.

35. This theory is obviously applicable to people at any time of history, anywhere in the world. Recently, Aleksei Gherman (1938–), a director whose films were long suppressed by the Soviet Union government (e.g., *Trial on the Run/Checkpoint*, 1971; *Twenty Days without War*, 1976; and *My Friend Ivan Lapshin*, 1984), made similar remarks. According to Gherman, everybody shares a little bit of responsibility for the government's deceit, because nobody is fool enough to believe the government's lies. Those who lied, who gave orders to lie to others, who pretended to believe the lies, and who genuinely believed such lies are all responsible. Some people want lies because it is easier for them not to think about what to do or not to be responsible for their actions. Interview by the editors, *Cine Front* (July 1992), 33.

36. See Ōshima Nagisa, *Taikenteki sengo eizōron* (A Theory of Postwar Film Imagery Based on Personal Experience) (Tokyo: Asahi Shimbunsha, 1975).

37. Itami, *Sensō sekininsha no mondai* (The Problem of Those Responsible for the War).

38. These three categories paralleled those for the international war crimes trials. Class A names included Kido Shirō and Ōtani Takijirō, both of Shōchiku Studios, and Kikuchi Kan of Daiei. Among the film executives listed in Class B were Kawakita Nagamasa of the China Film Corporation, Mori Iwao of Tōhō, Soga Masahi of Daiei, and Negishi Kan'ichi of the Manchuria Film Corporation; the only director singled out was Kumagai Hisatora (who did not make films again until 1953). Class C designated those who had planned, written and directed, or collaborated in such films as *Hawai Marei oki kaisen* (1942), *Ano hata to ute* (Fire on that Flag, 1944), *Shingapōru sōkōgeki* (All-out Attack in Singapore, 1943), *Nikudan teishintai* (The Human Bullet Volunteer Corps, 1944), or in *Nippon News* newsreels, but it did not list directors or screenplay writers. Ultimately, thirty-one individuals were named. The Association of Free Film People put out a smaller list—fourteen for Class A, seven for Class B, and none for Class C (*Eiga engeki jiten*, 41–42, 48–49). See Anderson and Richie, *Japanese Film*, 162–164; Hirano, *Mr. Smith Goes to Tokyo*, 214.

39. Tanaka Jun'ichirō, *Nihon eiga hattatsushi* (History of the Development of Japanese Cinema), vol. 3, updated (Tokyo: Chūkō Bunko Paperback Series, Chūōkōronsha, 1984), 221.

40. Kurosawa, *Something Like An Autobiography*, 145.

41. For the double conversion of Japanese filmmakers and the wartime and early post-war film industry, see Kyoko Hirano, *Mr. Smith Goes to Tokyo;* also, more broadly, Sheldon Garon, *Molding Japanese Minds: The State in Everyday Life* (Princeton, NJ: Princeton University Press, 1997).

42. A total of 294 meters of footage, involving five scenes, were cut. See Fujita, *Eiga sakka Itami Mansaku,* 179–180. *Rickshaw Man* was remade three times after the war. Inagaki himself directed the 1959 version with Mifune Toshirō in the starring role. Misumi Kenji made the 1965 version with Katsu Shintarō as the lead. These two versions employed Itami's original screenplay. Murayama Shinji made the 1963 version, using Ito's screenplay and starring Mikuni Rentarō.

43. In 1939, Itami read the novel of the same title by Yamamoto, originally published in the magazine *Kingu* (King) in January and March of 1934. Inagaki was supposed to direct it and also published his version of the screenplay in *Eiga hyōron's* January 1943 issue. Somehow, Inagaki's version was not filmed either.

44. Fujita introduces Yoshida Koshitarō's explanation that Yamamoto wanted to teach a lesson through this novel to a friend who was arrested and imprisoned for leftist activities and who attempted to commit suicide—that one's life is invaluable. (He quotes Yamamoto's novel, in the Kadokawa Bunko series; Fujita, *Eiga sakka Itami Mansaku,* 198.) Fujita also states that an American psychological warfare officer used this story to encourage and teach captured Japanese POWs not to commit suicide but to live (209).

45. Ibid., 182–212.

46. Ibid., 209; *Itami Mansaku esseishū,* 301. Possibly Itami meant the commoners' version of the *Taiheiki.*

47. Itami Mansaku, "Seishin dōshinroku" (July 20, 1945), included in *Itami Mansaku zenshū,* vol. 2, 333.

48. Onuma Yasuaki recognizes the significance of Itami's ideological position in the context of the problem of war responsibility, although Onuma concludes that no matter how respectable and admirable such a position is, it is the position of a "saint," not a "commoner." See his book, *Tokyo saiban kara sensō sekinin no shisō e* (From the Tokyo Trial to Thoughts of War Responsibility) (Tokyo: Yūshindō Kōbunsha, 1985), 156–158.

49. In 1974, Yoshimura Kozaburō directed *Ranru no hata* (Ragged Flags), a biography of Tanaka, played by Mikuni Rentarō. See Nimura Kazuo, *The Ashio Riot of 1907: A Social History of Mining in Japan* (Durham: Duke University Press, 1997), 19–21.

AFTERMATH OF TOTAL WAR:
Allied-Occupied Japan and Postcolonial Asia

The Double Conversion of a Cartoonist:
The Case of Katō Etsurō

Rinjirō Sodei

FROM THE EARLY 1930S until the outbreak of the Pacific War, writers, artists, and even cartoonists on the left had difficulty escaping the onerous experience of conversion *(tenkō)*. Such conversions were political, not religious, and they most often came about through the coercive power of the government—usually through persuasion, sometimes through naked violence. Men of culture willingly or unwillingly were forced to abandon their own personal ideologies and, more often than not, "convert" to the "healthy thought" sanctioned by the government.

While Japan was on its way to building an autocratic and militaristic regime in the early 1930s, it was the Communists who were first subject to this process of conversion. Later, after they were disposed of, the remaining range of leftists became the target. In the case of liberals, however, their conversion was most often achieved not through governmental coercion but by means of their own desire to accommodate. As a reactionary mood set in, many liberal intellectuals began with a certain good will to cooperate with the national policy of building the "New Order." When the attack on Pearl Harbor came in December 1941, the great majority of them joined in helping Japan's war effort. Thus the national conversion was completed.

But less than four years later, when Japan surrendered, there took place yet another enormous, nationwide conversion—this time a shift toward democracy. At this point those intellectual leaders during the war years now stated in unison that the Great East Asia War—that very war they had been promoting—had been wrong, and that they had been totally deceived by the wartime authorities. Democracy now became the new ideology of the times, promoted by the powerful yet righteous forces of the Occupation.

Most of those intellectuals who had been advocating Japan's military aggression in Asia managed to escape from the charge of having served as propagandists

235

for the war effort. Among thousands of those who might be termed men of letters, less than three hundred—286 to be exact—were purged from public office. The remainder of these writers and all the artists (cartoonists included), filmmakers, and playwrights who had assisted in promoting the war now began to sing a new song—that of democracy. This "double conversion" was, in fact, sanctioned by the Occupation authorities and became a common phenomenon among the intellectuals of the time.

This degree of the process of double conversion—from prewar Communism, socialism, or liberalism, first to cooperation with the war effort, then to democracy in some broad sense—varied depending on individual cases. The present example concerns an unusual example: that of the highly active political cartoonist Katō Etsurō (1899–1959).

Katō began as a left-leaning liberal—perhaps even a Communist sympathizer —then became a fierce propagandist for the war. When his frantic efforts came to an end with the defeat of Japan, he seems to have realized his mistake. Still, his reconversion process was not as smooth as certain other "born-again" intellectuals. Unlike them, Katō was not able to jump on the bandwagon of democracy so readily. After some serious soul-searching, he decided to join the Communist Party of Japan, thereby promoting the model of a Soviet-style socialism as the best means of rebuilding his country. In this way, Katō tried hard to atone for his crime in helping to promote Japan's war of aggression. Once he decided to embark on this course, Katō never wavered until his death.

Starting as a Left-Leaning Liberal

In order to understand the nature of Katō's double conversion, a brief biographical sketch will be helpful. Katō was born in Hakodate, the port city of southern Hokkaido. Brought up in the family of a local merchant, he received only eight years of formal education, as indeed did most of the cartoonists of his time in Japan. Katō was a self-taught artist, and his basic training was undertaken while working at a lithographic factory. He spent his apprentice period working for several local newspapers in Hokkaido. Eventually he became a news cartoonist. In 1926 the Nippon Manga Kyōkai (Japan Cartoonists League) was founded, the first organization to encompass the full ideological spectrum represented by its members. Katō was made the chief of the Hokkaido branch. His political outlook was that of a typical left-leaning liberal—a common attitude at the time—and he produced cartoons that depicted genre and social scenes from a critical point of view. From the late 1920s to the early 1930s, as the left-wing movements seemed to be gaining some ascendancy, Katō became all the more radical. For example, when Japan held its first general election in 1928 under the new laws permitting universal male suffrage, Katō produced a cartoon that characterized the new voters as members of the proletariat, from whom the old establishment parties now solicited votes (Figure 4).

Katō ran a weekly contest column in the *Hokkai Times* for amateur cartoonists; he served as the sole judge. In 1931, when the cartoons he had been selecting became increasingly critical of the power elite, the management of the newspaper stepped in and had the column suspended. It may have been this incident that motivated him to abandon his local base in Hokkaido; in 1932 he left for Tokyo, the intellectual center of the country, in order to become an independent cartoonist. While in Hokkaido, Katō had already earned a reputation for his excellent caricatures. Once he reached Tokyo, he was given choice assignments with several national magazines and newspapers. His work for *Bungaku hyōron* (The Literary Review), published by Naukasha, one of the leftist publishers, reveals both his superb technique and his sympathy for writers on the left.

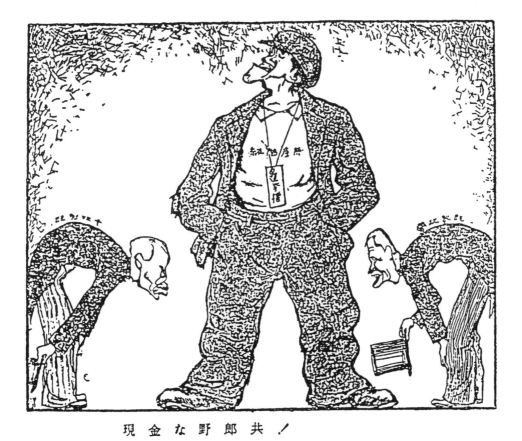

現 金 な 野 郎 共 ！

Figure 4. "Mercenary Fellows!" The large figure in the center has the word "proletariat" on his shirt and "right to vote" on the pendant hanging on his chest. The bowing figures represent two political parties. Katō Etsurō, "Genkin na Yarō domo!" *Hokkaido manga*, 1928; in Katō Etsurō Mangashū Kankōkai, ed., *Katō Etsurō mangashū* (Collected Cartoons of Katō Etsurō), (Tokyo: no publisher cited, 1960), 17.

Katō's forte, however, was in the creation of cartoons with serious social and political messages. In 1933, Hitler came to power in Germany and he soon ordered the infamous book burnings; in Japan, the same year saw Japan's Minister of Education Hatoyama Ichirō accuse Professor Takigawa Yukitoki of Kyoto University of being a Marxist, forcing him to resign. The "Takigawa Incident" caused a furor in the nation's academic circles, since this action was viewed as an infringement of academic freedom. Katō coupled these two events by depicting Hitler and Hatoyama together in his cartoon (Figure 5). The captions reads, "Here's another book burning!"

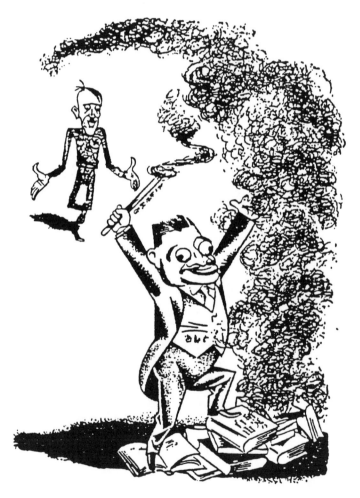

Figure 5. "Here's another book burning!" Katō Etsurō,
"Koko ni mo funsho," *Tokyo Puck,* n.d.; in Suyama Keiichi,
Manga hakubutsushi (Cartoon Encyclopedia), Japan Volume
(Tokyo: Bancho Shobō, 1972), 146.

Opposing "Nonsense Cartoons"

To Katō, whose aim was to produce cartoons with clear social and political mes-sages, the opposing camp of cartoonists—those who advocated the creation of "nonsense cartoons"—remained archenemies. When the Japan Cartoonists League quickly split into two groups, the so-called nonsense cartoon group came under the able leadership of Kondō Hidezō. Katō remained with the proletarian group of cartoonists. The work of this group was increasingly suppressed by the government, which closed most of the magazines and newspapers where they could publish their work. The nonsense group thus came to represent the main-stream of activity in the period. Kondō's motto was for a "healthy nihilism." What-ever he may have meant by this, he and his group avoided facing social realities and attempted, at least in Katō's view, to sell their audiences on cheap laughter.

At this juncture it may be useful to consider the traditional status of cartoon-ists in Japanese society at this time. Certainly their status was not high. Under the older Confucian tradition, laughter itself was considered somewhat undignified. Therefore cartoonists, as makers of laughter, were not given a social status on the level of artists and critics. Rather they were looked down on simply as producers of funny—thus not so important—pictures that, in the Meiji period, were first lumped together in the term *"ponchie."* The word *"ponchi"* was adapted from the English word *punch,* and *"e"* stands for *pictures.* The word *punch* began, of course, with the famous British magazine of humor, but in the Japanese context it origi-nated with the title of the publication *Japan Punch* begun in 1869 by the British artist Charles Wirgman.

Katō maintained himself that successive generations of cartoonists since the early Meiji had tried hard to rescue the art of the cartoon from the degraded status of *ponchi* pictures. Now he lamented the fact that such efforts were being blocked by a group of nonsense cartoonists. "Today we seldom hear the word *ponchi-e,*" he wrote, "but these cartoonists have merely changed the label to 'nonsense car-toons.'"[1] Elsewhere Katō defined these nonsense cartoons as follows: "They are simply funny pictures that try to force upon the audience a laughter that has no meaning at all." He went on to insist that "these so-called nonsense cartoons are the flowers of a fungus that flourishes on the wall of ignorance. They have no health in them. There is no cheerfulness about them. They are the corpses of 'beauty' and 'truth' eaten up in degeneration."[2]

As opposed to nonsense cartoons, Katō praised what he termed *shin no manga* (true cartoons). In his view, the essence of a good cartoon was something that could "enlighten, encourage, and comfort the masses."[3] Katō would challenge again and again what he called "nonsense cartoons" throughout his life. A good example of what he termed "true cartoons" can be seen in two cartoons he created in the wake of the infamous attempted coup d'état on February 26, 1936, when a group of young military officers killed several cabinet ministers and other digni-taries. Katō immediately executed two cartoons for the *Miyako shimbun,* a Tokyo newspaper for which he had worked as a cartoonist since 1934. One of his works,

entitled "Footprints in the Snow," depicts the two major political parties closing up shop while their leaders meekly peek out at the footprints of the soldiers in the snow (Figure 6). No other cartoonists dared to depict the event. Under the circumstances, in which the coup might well have been accepted by the nation's leadership, Katō's work showed exceptional courage.

240

Katō not only published such cartoons about the February 26 Incident. He also wrote directly about the danger this incident posed to freedom of speech and to the very existence of political cartoons: "According to some wise men, [the disappearance of political cartoons] has come about because 'freedom of speech' is increasingly being purged from this Country of the Rising Sun since the XXX [the characters for the date, February 26, were censored] Incident took place. That is, they say, because some unusually powerful pressure is being exercised so that it has become very 'unfree' for we, the people, to talk, write, or draw anything concern-

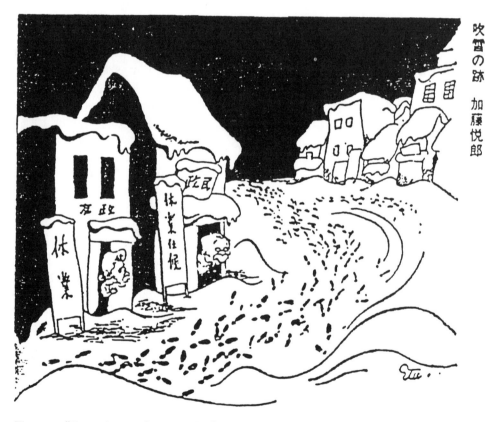

Figure 6. "Footprints in the Snow." The signs indicate that the two political parties, the Minseitō and the Seiyūkai, are "respectfully closed." Katō Etsurō, "Funbiki no ato," *Miyako shimbun* (Evening edition), March 2, 1936. See Katayori Mitsugu, *Sengo manga shisōshi* (Intellectual History of Postwar Cartoons) (Tokyo: Miraisha, 1982), 90.

ing politics. Now this is the way it is . . . but I want to say this: The more we feel that 'this is the way it is,' the more important our task as cartoonists has become!" Katō therefore emphasized the "task" of cartoonists as follows: "The task of the cartoonist is to put the surgeon's knife into the belly of 'the questionable' and bring into the open its real nature. History tells us that every notable cartoonist of the world, virtually without exception, has been a shining warrior who fought to fulfill this 'task' of the cartoonist."[4]

Indeed, throughout the dangerous period of 1937, Katō continued on, true to his words. January saw the inauguration of the new monthly magazine *Jiyū* (Liberty), and Katō never failed to contribute to each issue. His cartoons covered a wide range of topics: ridiculing the inactivity of the established political parties, warning against the military's attempt to deny the existence of political parties altogether (Figure 7), attacking the newly emerging fascist parties (Figure 8), criticizing governmental efforts to suppress popular opposition movements against increased taxation, belittling the declaration of the Sōdōmei (Labor Federation) to suspend all strikes for patriotic reasons (Figure 9), and so forth. Katō's series of cartoons revealed a real spirit of liberalism that still remained in Japan.

Yet there can be found a telling awkwardness in Katō's cartoons when he came to deal with the country's external affairs. Katō rightly ridiculed the blind alliance of the various political parties in supporting the expanded military budget made necessary by the Sino-Japanese War, which began in 1937 (Figure 10), yet he did not seem to criticize the war itself. When looking beyond Japan's national boundaries, Katō began increasingly to reveal his nationalistic sentiments. For instance, he ridiculed Generalissimo Chiang Kai-shek, himself the direct victim of Japan's aggression, and poked fun at the inactivity of the League of Nations. He even blindly criticized the foreign policy of President Franklin Roosevelt as hypocritical (Figure 11). In sum, Katō in these cartoons did not face up directly to issues concerning Japan's military expansion.

As the Sino-Japanese War progressed, so did the governmental suppression of the remaining leftists in the country. In December 1937 and early in the following year, many of those leftists were arrested en masse under the charge that they were engaged in organizing a "popular front" in accordance with new directions from the Comintern. These men and women were either put behind bars or otherwise totally silenced. This meant the virtual collapse of the magazine *Liberty*, which ceased publication with the January 1938 issue.

Although Katō was still able to publish his cartoons in some innocuous publications, he seemed at this point to be arriving at a crossroads in his career. In this regard, his cartoon in a 1938 issue of *Tokyo Puck* was altogether symbolic of his dilemma. This particular magazine, which featured social satire and genre material, was regarded as the last citadel for those liberal cartoonists who wished to continue working and did not mind contributing their works without payment. Katō's cartoon, entitled "An Agonizing Intellectual," (Figure 12) depicts an "artistic writer" who has just taken off his old suit and now agonizes over a difficult

Figure 7. Don Quixote's shield is marked "political parties" and on the bottom of the tank looming over the Diet is written an injunction to deny political parties. Katō Etsurō, no title, *Jiyū* (February 1937), 1.

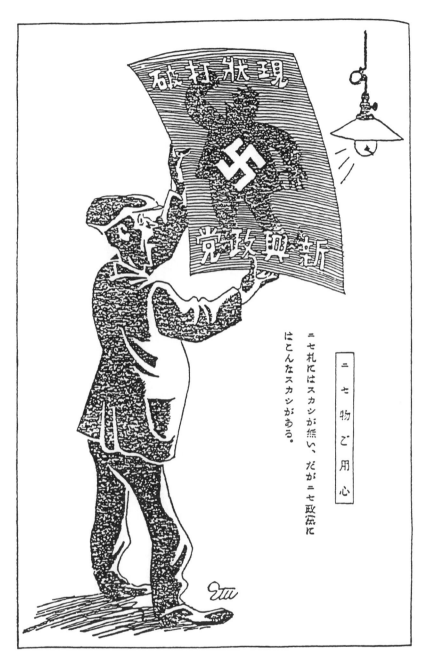

Figure 8. The boxed text on the right warns, "Be careful of counterfeits!"
To the left is the warning, "counterfeit money does not have a water-
mark, but counterfeit political parties have a watermark like this one."
The paper held by the worker, which says "breaking away from the log-
jam" and, at the bottom, "new political parties," shows a Nazi swastika.
Katō Etsurō, "Nisemono goyōjin," *Jiyū* (May 1937), 27.

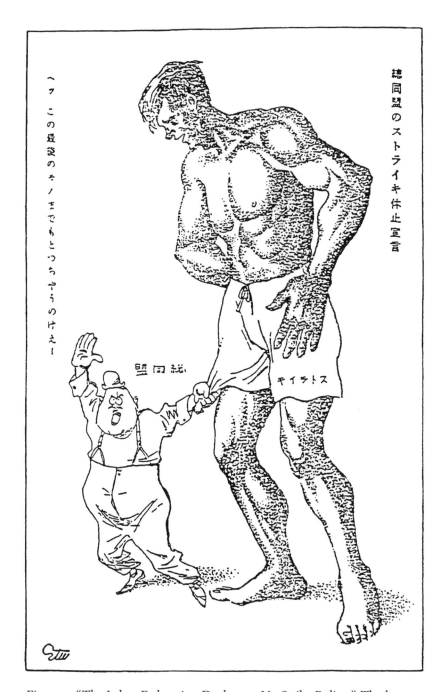

Figure 9. "The Labor Federation Declares a No-Strike Policy." The large muscular figure has the word "strike" written on his drawers. The small figure, representing the union, is being told "What, you want me to take off my last piece of clothing?" Katō Etsurō, "Sōdōmei no sutoraiki kyushi sengen," *Jiyū* (November 1937), 101.

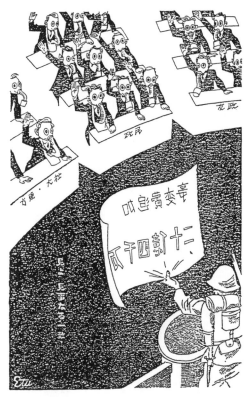

Figure 10. *(Left)* "Look at this miraculous agreement," says the caption. The placard indicates "A Supplementary Budget for the China Incident: 2,040,000,000 yen." Members of the political parties, already in gas masks, are lined up meekly in their seats. Katō Etsurō, "Miyo, migotonaru itchi," *Jiyū* (October 1937), 61.

Figure 11. *(Below)* "The Essence of Modern Music." President Roosevelt plays the violin, with its call for "international peace," while the smoke from the gun indicates an active armament policy. Katō Etsurō, "Kindai ongaku no sui," *Jiyū* (April 1937), 33.

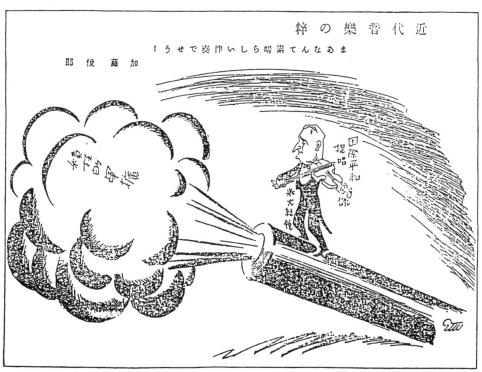

choice: Should he now wear a laborer's attire, or don a traditional Japanese kimono with a swastika crest? The caption warns that he may get cold unless he wears one or the other of them. It is of interest to note that the "artistic writer" resembles Katō himself. And indeed, this choice was a tough one. To become a laborer meant that he must abandon his vocation as an artist, which Katō could ill afford to do. Yet if he wished to remain an artist, then, as the cartoon suggests, he must wear a kimono and follow the nationalist, fascist line that the country was now in the process of adopting.

That Katō made the decision to wear a kimono, with a swastika crest included, became apparent in a cartoon of his that appeared a year later, in 1939. Entitled "Crush Them Down to the Last!" the drawing depicted the Nomonhan Incident, in which Japan and the Soviets engaged in a fierce military conflict at the Mongolian border. Although it was Japan that initiated the conflict and whose forces in turn were crushed, virtually to the last soldier, Katō's depiction showed only what the government wanted to tell the public concerning the incident.

Figure 12. "An Agonizing Intellectual." The text continues, "It's a good thing that he bravely took off his old jacket, but now the question is which one to wear, the one on the left or on the right, before he catches cold!" Katō Etsurō, "Nayamu interi," *Tokyo Puck* (? 1938); see Katō Etsurō, *Mangashū*, 33.

1939: A Watershed

The year 1939 marked a watershed in Katō's career. He abandoned his liberal stance and became a propaganda cartoonist for Japan's official stances, which were becoming increasingly authoritarian and militaristic. Ironically, his conversion came not through any governmental coercion but through his very success as a cartoonist. In this year, Katō was invited to become a regular cartoonist for the *Japan Times,* the semigovernmental and largest English-language newspaper of the nation. Now, presented to the world at large as a representative cartoonist of Japan, Katō no longer was able to criticize the policies of his government. Nor, apparently, did he wish to do so. When he created a caricature of Chiang Kai-chek, for example, in a cartoon entitled "It Won't Be Long Now!" (Figure 13), Katō

Figure 13. "It Won't Be Long Now!" Katō Etsurō, "Mō nagaku wa nai zō," *Japan Times* (Tokyo: September 24, 1939); in Katō Etsurō, *Mangashū,* 35.

became nothing more than a mouthpiece for the Japanese government in its propaganda directed at the outside world.

When he turned his pen to domestic issues, Katō eagerly promoted the "mobilization of the national spirit" that was being carried out by the government. As one of the mottoes of the National Spirit Mobilization Movement was "Luxury Is Our Enemy," Katō produced a cartoon to propagate that idea (Figure 14), in which a huge pair of scissors is cutting off the permanent-waved hair of a Western-style woman. The lengthy title can be summarized as "No Luxury, No Excess, No Greed." It is clear from this cartoon that long hair was apparently banned for men as well.

しゃれっ毛 ひだっ毛 欲っ毛は一本も残さぬように (東京パック) 加藤悦郎

Figure 14. "No Luxury, No Excess, No Greed." Katō Etsurō, "Sharekke, mudakke, yokukke wa ippon mo nokosanu yō ni," *Tokyo Puck* (April 1940); see Ishiko Jun, *Shōwa no sensō karikachua* (Shōwa War Caricatures) (Tokyo: Horupu Shuppan, 1985), 81.

At some point during this year, Katō was introduced in a Nazi German newspaper as a leading cartoonist of Japan who vehemently ridiculed the British and American leaders. By this point, Katō surely must have felt that he had actually attained the status of an international figure, a fact that increased his sense of solidarity with the government. In July of 1940, Prince Konoe Fumimaro assumed the premiership for the third time, with renewed expectations from the general population. Under his titular leadership, the Imperial Rule Assistance Association was organized and a strong drive for the establishment of a "New Order" was begun.

Amidst the official proclamations of this New Order, many separate groups and organizations were unified under larger umbrella structures. Various cartoonists' groups were no exception; in the summer of 1940, they were consolidated, at least in theory, into the Shin Nippon Manga Kyōkai (New Japan Cartoonists Association). As the official organ of the association, a monthly magazine simply entitled *Manga* (Cartoons) was inaugurated in October, which defined its maiden issue as "A National Magazine: A New Order Issue." The cover, which provided a drawing that praised the Tripartite Axis Treaty, was executed by Kondō Hidezō, the editor of the magazine and a longtime archrival of Katō. Japan's so-called New Order in Asia thus became a counterpart of the New World Order declared by Nazi Germany and fascist Italy.

In this inaugural issue, Katō was as active a contributor as Kondō, contributing two cartoons and one essay. Taken together, they show clearly how far Katō had come from his old liberal position. The first cartoon, entitled "The Task of Cartoonists," shows Katō himself, shirtsleeves tucked up, wildly swinging his multi-barreled pen in order to clean up every vice and their practitioners—indulgence in luxury, black market dealings, "evil culture," the cult of the West, nihilism, hedonism, self-righteousness, decadence, and so on. Many of these villains were already consigned to a huge trash box. One cannot help remembering that, as late as 1936, Katō had defined the task of the cartoonist in terms of an ability to "cut open the belly of 'the questionable'" and bring the true facts to light. Now, apparently, the cartoonist's task was to help promote the mobilization of the national spirit.

More significant was his second cartoon, entitled "No Luggage, Please!" (Figure 15). The message was clear and simple: For a bus named "The New Order," individualism and liberalism were unwanted, excess baggage.

Katō's short essay, entitled "Building Up New Japanese Cartoons," was his verbal expression of his new convictions. First, he advocated a policy that would require all the cartoonists of Japan to throw off every influence of the West and "reclaim citizenship" in the cartoons they create. Indeed, he went on, the entire task of this new association was to "rebuild a new Japanese art of the cartoon." Katō went on to say that "only by putting every effort in this direction will we be able to open up the gates of a new order in the world of cartoonists. When we accomplish this task, we cartoonists will be given the power and status of cultural coworkers in building a true, new, national order."[5]

In short, Katō was now insisting that the cartoonists of Japan should become nationalists and work hard to create "purely Japanese cartoons"; only then could they be given membership in the New Order and reach that long-sought-after status of true artists, which could now be given to them. Thus the war cry of Katō was not merely against Western influences on his profession but also a plea for winning a dignified status for his fellow cartoonists.

The Concept of *Kensetsu:* "Being Constructive"

Soon after the inauguration of *Manga,* however, Katō left the New Japan Cartoonists Association and ceased any contribution to the magazine. According to Mineshima Masayuki, the official biographer of Katō's rival Kondō, there were two reasons why Katō left the association.[6] In the first place, Katō's cartoons in *Manga* were quite unpopular with his colleagues, who regarded them as utterly humorless, like political posters. Secondly, Katō's essay in the first issue infuriated his fel-

Figure 15. "No Luggage Please!" The bus is marked "The New Order," and the bus stop sign indicates a stop for the "progressive political state." The boarder is asked to leave his bags, marked with such things as "individuality" and "liberalism," behind. Katō Etsurō, "Onimotsu wa okotowari!," *Manga* (inaugural issue, October 1940), 5.

low members of the association, who found his remarks to constitute a thinly disguised attack on the "nonsense cartoonists," who in fact constituted the majority of the associations's members. In any case, Katō could simply not work with Kondō, who was not only his personal rival but the leader of the "nonsense" group as well. A year later, sometime in 1941, Katō, together with a few like-minded comrades, organized his own group of cartoonists, which he called Kensetsu Mangakai (Constructive Cartoonists Association). This notion of *kensetsu*, or "being constructive," remained virtually an idée fixe for Katō throughout the entire Pacific War period, as we shall see.

In their cartoons, the group's campaign against America was as vigorous, if not more so, than in Kondō's *Manga*. In June of 1941, the Constructive Cartoonists Association published a remarkable book of cartoons entitled *Taiheiyō manga dokuhon* (The Pacific Cartoon Reader).[7] With three of his colleagues, Katō devoted his energies to depicting Japan's historical conflicts in the Pacific with the United States. His ten cartoons include the following: the Paris Peace Conference of 1919, at which the Japanese delegation unsuccessfully submitted a resolution for racial equality of all people (thus the hypocrisy of the white races); America's 1924 Immigration Act, which excluded the Japanese people (racial discrimination); President Franklin Roosevelt's bad-mouthing Japan's "Holy War," as well as the actions of the Axis (Figure 16); poisons brought by American films (individualism, liberalism, the worship of money, hedonism, infidelity, white supremacy, a taste for eroticism and the grotesque, etc.); and America's assistance to the regime of Chiang Kai-shek. The last cartoon in the volume was by Katō and was entitled "Defend Our Ocean, the Pacific," presumably for the sake of building the Great East Asia Co-Prosperity Sphere (Figure 17).

The contents of the *Reader* were the anti-American staples redolent of those attitudes promulgated by Japan's right-wingers and militarists; as such, these topics were not exceptional. Two facts surrounding this collection, however, are worthy of note. One is that, as early as June of 1941, six months before Pearl Harbor, Katō was already promoting a belligerent attitude toward the United States. The second and more important fact is that the *Reader* was published by the Dai Nippon Sekiseikai (Greater Japan Loyalty Society), headed by an army colonel, Hashimoto Kingorō. The society was one of the more powerful right-wing organizations in Japan, and Hashimoto himself provided some introductory remarks for the collection.

Colonel Hashimoto had been the mastermind of another abortive coup d'état that preceded the one mentioned above on February 26 of 1936. After the February 26 Incident, Hashimoto was reduced to reserve status when a purge of the army was carried out. He then began a fascist movement that he called Dai Nippon Seinentō (Greater Japan Youth Party), which he later reorganized into the Greater Japan Loyalty Society. When the Sino-Japanese War broke out in 1937, he was returned to active status and led a military campaign that succeeded in sinking a British naval vessel, the *Lady Bird*. In 1942 he was to be elected to the Lower House,

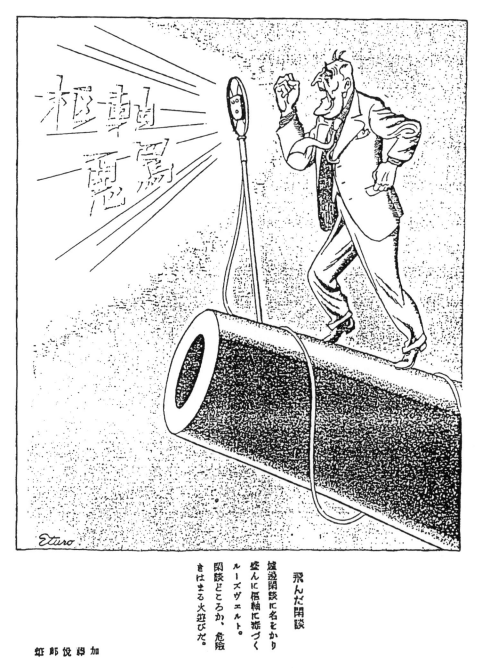

飛んだ閑談
娯遊閑談に名をかり
盛んに悟軸に滋づく
ルーズヴェルト。
閑談どころか、危険
きはまる火遊びだ。

Figure 16. "An Outrageous Chat." From Roosevelt's microphone come the words "Curse the demons of the Axis!" while the text below indicates that the American president, under the guise of one of his Fireside Chats, is spitting out vile language. "It's dangerous to play with fire," the caption concludes. Katō Etsurō, "Tonda kandan," Kensetsu Mangakai, ed., *Taiheiyō manga dokuhon* (Tokyo: Dai Nihon Sekiseikai shuppanbu, 1940), 42.

where he advocated the doctrine of "One Nation, One Party." In essence, Hashi-moto was arguably the leading militarist-turned-fascist politician. As such, he was tried after Japan's defeat at the International Military Tribunal for the Far East and sentenced to life imprisonment.

Katō, who previously had courageously criticized the military coup of 1936, seems just a few years later to have ended up becoming the henchman of this mil-itary fascist. Did Katō simply sell his soul to Hashimoto and his cause? I can pro-vide no concrete answer. Certainly he did require a wealthy sponsor in order to sustain his own group of cartoonists. In this regard, Katayori Mitsugu, a younger friend of Katō, testified that "while Kondō Hidezō was a 'merchant cartoonist,'

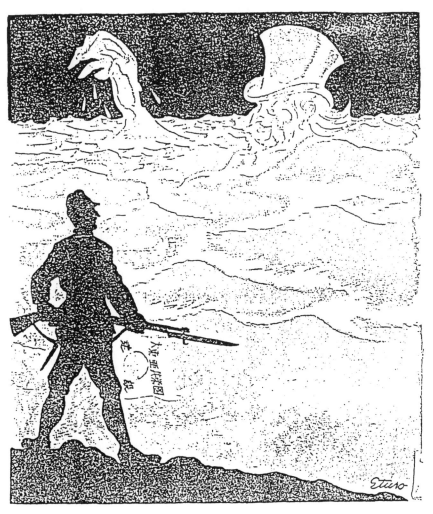

Figure 17. "Defend Our Ocean, the Pacific!" Katō Etsurō, "Warera no umi tai-heiyō-o mamore!," *Dokuhon,* 54.

Katō Etsurō was an 'artisan cartoonist.'" By this he meant that Katō was not as successful at fundraising as Kondō. Katayori went on to say that "Kondō was relying mostly on the Imperial Rule Assistance Association for financial help, while Katō was attempting to obtain funds from the Sangyō Hōkokukai (Patriotic Association of Industrialists)."[8]

Be that as it may, fascist organizations such as Hashimoto's must have served as a source of some quick and easy money. When Katō joined with the colonel and so obtained financial assistance from him, the former liberal now had to be regarded as a cartoonist oriented toward fascism. And indeed, his successive activities seem to sustain that indictment. For example, Katō's group organized a show of anti-American cartoons that was shown on the Ginza on December 10, 1941, only two days after the attack on Pearl Harbor. All of the works exhibited were filled with hatred and belligerence toward the Americans—and the British as well.

After leaving the *Manga* magazine, Katō and his group relied on *Ōsaka Puck,* a small but tenacious monthly cartoon magazine published in Osaka since 1906. Its cover contained the wartime self-definition of the magazine: *Kenzen manga zasshi* (Wholesome Cartoon Magazine) (Figure 18). Such an emphasis on "wholesomeness" or "healthiness" would suggest that Katō and his group were claiming that their cartooning was a serious business, and one that would help to keep society healthy. In any case, "wholesome" cartoons were understood to represent by definition an antidote to "nonsense" cartoons. Still, what wholesomeness can be found in Katō's design of this cover?

Sometime in 1941 Katō published his own cartoon booklet, *Kensetsu Okusan* (Mrs. Constructive). As the title suggests, the main thrust of this work was to assist housewives in building up their families in accordance with the New Order and Japan's war aims. To Katō, the war was neither a negative nor a destructive enterprise; rather, as the slogan "Building Up the Greater East Asia Co-Prosperity Sphere" suggests, it was the realization of a positive value: construction. As Katō wrote in 1942: "The Greater East Asia War is a great, historic, and constructive war that will contribute to the real peace of the world by securely establishing the Greater East Asia Co-prosperity Sphere, which represents a Greater East Asia for all its peoples."[9]

Katō used the term *"seisan"* (production) as a synonym for *"kensetsu"* (construction). "Although *kensetsu* and *seisan* are different words," he wrote, "both have the same spirit."[10] He elaborated this idea of *seisan* in a roundtable discussion that appeared as part of a 1944 volume entitled *Zōsan mangashū* (A Cartoon Book for More Production), a collection of amateur cartoons that Katō himself solicited and selected from young laborers all over the country. In this discussion, Katō elaborated the concept of "productive cartoons" *(seisan manga)* and mentioned three necessary elements: (1) The graphics should be produced by the workers themselves; (2) the topics chosen should represent scenes of production, such as factories and farms; and (3) the cartoons produced should help promote a spirit of production.

Katō's view appeared to be mere common sense, and his emphasis on the importance of production for the war seemed nothing new. However, when he said that by promoting "productive cartoons" one could actually increase the productive power of the country, it seems clear that his real target was his longtime enemy, the "nonsense" cartoon. Katō argues in this discussion that "the fatal flaw of these status quo cartoons resides in the fact that they have not yet been cleansed

Figure 18. The cover of *Osaka Puck* for February 1942. The cover was drawn by Katō Etsurō. The phrase at the bottom says, "Bring Swift Death to Those Who Meddle with World Peace!" (*Sekai heiwa no kakuransha ni todome o sase!*).

from the accumulated poisons of the nonsense cartoons." Katō goes on to say that "nonsense cartoons originated in America. They are the illegitimate children of a deadlocked society based on liberalism. Therefore they contain no concept of nationalism; there is no hope that they can express belief in race. They can survive only through individualistic and temporary stimuli. In short, nonsense cartoons are like opium." [11] By this attack, Katō was attempting to kill two birds—or more precisely, two enemies—with one stone.

Katō concluded his arguments for cleaning up nonsense cartoons by insisting that "we should establish a truly Japanese art of the cartoon as soon as possible. There is no other way to proceed." Of course, what he may have meant by a "truly Japanese art of the cartoon" is not at all clear. Katō merely observed that by sticking to the production of cartoons based on a "truly Japanese worldview," there would emerge naturally a Japanese character.[12] Such abstract remarks, like some sort of oral zenlike exchange, are difficult to comprehend when carried out in the atmosphere of a desperate war. In addition to his part in the discussion, Katō contributed some ten of his own cartoons to this amateur collection. Naturally his works appear much more skillful than those by the young amateurs whose work he selected, but his contributions also convey an overall impression of the moral, the pedagogic. In the discussion, Katō spoke of "leadership by cartoons." Perhaps he took real pride in his leading role in this area in wartime Japan.

To my dismay, I have been able to see only one of Katō's cartoons executed in 1944, the year in which it became apparent that Japan was losing the war. Entitled "You Can't Lay a Finger on Me!" (Figure 19), the cartoon depicts an enemy plane portrayed as an ominous skeleton, symbolizing "destruction of productive capability," while a sturdily built defender of Japan holds a hammer in his hand in order to attack the oncoming plane. His sole purpose is to defend the production line for the coming decisive battle. By the time this cartoon was actually published in October of 1944, everyone felt that Japan would soon be at the mercy of American air raids. The cartoon, therefore, suggests a sense of desperation; it is neither humorous nor satirical. Surely no "nonsense cartoon," it must have made Kato's audience feel decidedly chilly.

In May of 1944, a deluxe book of cartoons, all in color, was published containing works by almost all the cartoonists then active in the nation. Entitled *Kessen mangashū* (A Collection of Cartoons for the Coming Decisive Battle),[13] the volume contained some eighty cartoons as well as cartoon reports from thirteen areas of Asia then under the control of the Japanese military government. Katō's work was conspicuously absent, however. From today's vantage point, the book is of considerable historical interest because most of the cartoonists who remained active after the war are included. The overall impression made by the book, however, is rather weak. Perhaps the cartoonists were as exhausted as other Japanese citizens, since the nation was now losing the war and not much fighting spirit remained. Yet I have also learned that around this time Katō was contributing a series of car-

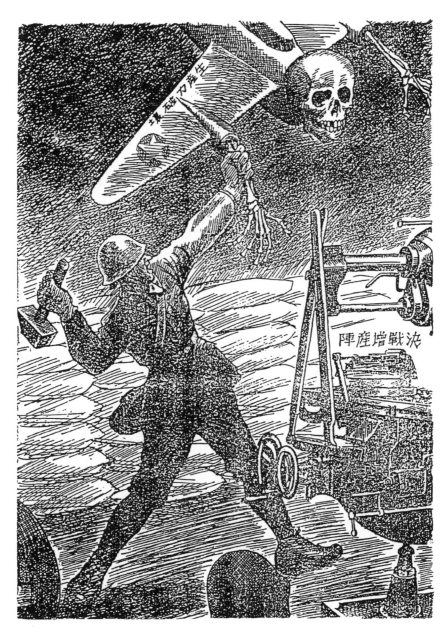

Figure 19. "You Can't Lay a Finger on Me!" On the wing of the plane is writ-
ten, "destruction of production capability" and above the machine, on the
right, "increased production for the battle on the homeland." Katō Etsurō,
"Onore, yubi ippon de mo furete miro . . . ," *Manga Nippon* (October 1944), 19.

toons entitled *Kensetsu Fujin* (Madame Constructive) to the *Osaka mainichi* newspaper. He was apparently still holding on, as an article of faith, to his ideas of *kensetsu,* even at this late hour of the war.

A Slow Process of Reconversion

Then the war ended, with Japan's defeat. We have no immediate record of how Katō reacted to this catastrophe. Katayori, the friend of Katō mentioned above, remembers that Katō felt crushed and could not come up with any new ideas for work; he seemed in a state of absentmindedness. No doubt this was to be expected. Despite all his efforts, not only was Japan defeated, but he himself had to learn that the war itself had been an unjustifiable one. This realization must have been a tremendous blow to him. It took one full year before Katō could write about his immediate reactions to the defeat. To his booklet of cartoons, published in November of 1946, he gave the title *Okurareta kakumei* (A Revolution Received from On High).[14]

In a brief preface dated August 1946, Katō wrote: "For a long time, I have been forced to hold my pen in my gaitered foot, not in my hand." In a drawing placed above this statement, he caricaturized himself as an upside-down artist, drawing war propaganda with a pen held in his foot (Figure 20). Nevertheless, this statement, as well as the drawing itself, were nothing more than a weak attempt at self-justification. Katō was less than honest in his confession, since he was never forced to execute cartoons of war propaganda; rather, he had accommodated himself to the trends and demands of the time. Having gained his status as "Japan's representative cartoonist," he became convinced of the righteousness of the Greater East Asia War and so had vehemently and energetically produced cartoons to support it.

Therefore, when he wrote in his preface that "I had no courage, at gunpoint, to claim that I was against the war," his remark is disingenuous. Katō was never forced at gunpoint; he was more than willing to cooperate with the war effort. Even if he had executed his war cartoons with "a pen held in his foot," he was fully responsible for misleading the people through his works and statements. At this point in time therefore, Katō was less than candid about admitting his responsibility for promoting the war. Katō was hardly alone, of course. Most of Japan's intellectual leaders during the war, once defeat had come, began to claim that they were forced to act as they did, or that they were deceived by the military. They seldom if ever admitted that their wartime activities helped to deceive the people.

Some years later, Katō came up with his own excuse: He could not leave Tokyo during the war. Unlike many fellow cartoonists who gave up their jobs and fled to the countryside, he had to stay and survive. He executed cartoons supporting the war first in order to survive, and secondly because he wished to be engaged in nothing else but cartooning.[15] This short confession is naturally filled with afterthoughts. When it came to his wartime activities, Katō sought to justify himself

even to the extent of falsifying some facts. For instance, he stated that "I executed cartoons to help the war just around the time that the war was coming to and end."[16]

However, my concern here is focused not on Katō's excuses for his wartime activities, but rather on the process of his reconversion. The cartoons in the booklet *A Revolution Received from On High* took him one full year to complete. Now, Katō maintained that he could execute them with a pen held in his hand, not his foot. The cartoons were done voluntarily, he stated, but he confessed that he found the process of creation a difficult one. His complex feelings toward the democratization of Japan are apparent in every cartoon. First of all, as far as Katō was concerned, Japan's democratic revolution was a bloodless one that started simply dropping from the sky, as it were, as soon as the heavy bombing stopped.[17] Katō posed the rhetorical question, "How did the Japanese people accept this gift, and

Figure 20. Reproduced from Katō Etsurō, *Okurareta kakumei* (A Revolution Received from On High) (Tokyo: Kobarutosha, 1946), 1.

how are they accepting it now?" He seemed rather skeptical concerning the prospect of a democratic Japan. Katō could not trust the old leaders who could so easily change their attire as well as their slogans (Figure 21); he had no confidence in Japanese politicians who relied solely on the efforts of the Occupation forces and were reluctant to do anything for themselves for democratization and for the welfare of the people. Nor could he count on average people—particularly on the female population, he felt—who were too tired and badly fed to even attempt to understand the nature of democracy. Because of such a situation, he saw the danger of a revival of nihilism and decadence (Figure 22). In his concluding page, Katō

260

Figure 21. "A Conveniently Bloodless Revolution." The vest indicates "militarism," while the new coat is marked "democracy." The scroll in the *tokonoma* reads "co-prosperity sphere," but the word "Asian" is conveniently masked. The man with glasses, having left his sword behind, says "I shall follow the strategy of Taira no Kiyomori and put on a morning coat for the time being," a reference to the infamous head of the Taira clan who, while claiming to be a priest, on occasion wore armor under his vestments. With his arrogance, he brought down his whole clan in the disastrous civil wars of 1181–1185. Katō Etsurō, "Keiben muketsu kakumei," *Okurareta kakumei*, 9.

「怠惰日本」となる勿れ

Figure 22. "Don't Become a 'Lazy Japan'!" The sign in the garden indicates "the future site of a democratic Japan," but the man inside is caught up in his own selfish decadence. Katō Etsurō, "'Taida Nihon' to narunakare," *Okurareta kakumei*, 32.

laments that "looking back over the past twelve months, our Japan has indulged too much in the sweetness of a 'revolution presented to us' and so avoided aggressive efforts to make this precious present our own flesh and blood."[18]

262 Apparently Katō was so pained by his wartime efforts that he could not commit himself immediately to working for another important cause. He still remained very hesitant to jump on the bandwagon of democratization, which he regarded as a revolution presented by America. Katō was not an intellectual acrobat in the fashion of his biggest rival, Kondō Hidezō. Kondō had depicted President Roosevelt in a hateful fashion in the last phase of the war, yet now, as soon as the war was over, he was quick enough to put General Tōjō behind bars (Figure 23). Katō could not overlook these twists and turns of Kondō. In one of the few cartoons Katō did publish before his August 1946 collection, he caricaturized Kondō in his masterful "An Intellectual's Way to Survival" (Figure 24). In this cartoon, an intellectual, who clearly resembles Kondō, is standing on the hip of a militarist crying "Down with liberalism and freedom!" Then, after the war, the same figure stands on the hip of a proletarian, now crying, "Down with the imperial system!"

Figure 23. Kondō Hidezō, no title (Tōjō behind bars), *Manga* (January 1946).

Always singing the fashionable song of the day, Kondō was indeed, as Katō charged, a "convenient intellectual." As we know now, although Katō himself once denounced liberalism before the outbreak of the war, he was not quick to sing the song of the new era.

263

Indeed, Katō's steps toward reconversion were not lightly taken at all. His friend Katayori observed that "for the first three years after the war, Katō was bewildered and hesitant."[19] Eventually, in 1948, he found his own path and joined the Communist Party of Japan. As noted above, until the mid-1930s Katō was sympathetic to leftist causes, but he had never become a Communist. Now he was a card-carrying member. The party did not attack him for his wartime activities, however, because many prewar Communists, who themselves had converted to the cause of the war, had now reconverted to Communism as soon as the war ended. The party accepted them in order to strengthen its ranks. Katō's case, however, was a different sort of reconversion. He chose the cause of Communism for the first time, and through his devotion to the working people he attempted to atone for his past crimes in helping the war of aggression. As a way

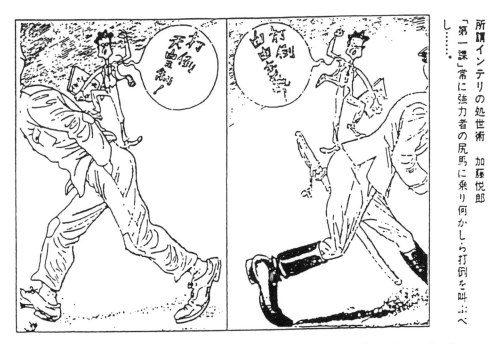

Figure 24. "An Intellectual's Way of Survival." The text to the right indicates that Lesson One is "to ride on the back of the strong and shout some kind of slogan." The right panel shows the militarist, and the intellectual shouts "Down with liberalism and freedom!" On the left, the intellectual shouts, "Down with the imperial system!" Katō Etsurō, "Iwayuru interi no shoseijutsu," *VAN* (May 1946).

of rebuilding Japan, Katō chose not American-type democracy, but a Soviet-style form of revolution.

Once he set out on this path, Katō never wavered. In this respect, he was not like his rival Kondō, who went through a whole series of conversions until he finished by establishing himself as a cartoonist for Japan's ruling conservative party.

Once having joined the Communist Party, Katō remained faithful to the party line. His activities included the production of wall newspapers to propagate anti-government sentiment and contributing cartoons to the party organ *Akahata* (Red Flag) as well as to similar publications of leftist labor unions such as the Japan Teachers Union. His cartoons of this period were not distinguished, for they inevitably became dogmatic in content and stereotyped in technique.

In 1948, Katō joined a new radical cartoon magazine, *Kumanbachi* (Hornet), along with such other colleagues as Matsuyama Fumio, another *Red Flag* cartoonist. The magazine was never a success, but a cartoon can be found here by Katō that links Prime Minister Yoshida with Nazism (Figure 25). As the Yoshida government grew more repressive toward the activities of the radical union workers, Katō's cartoons became all the more militant. When General MacArthur suspended publication of *Red Flag* in the summer of 1950, Katō continued to contribute cartoons under different pen names to successive—though now illegal—pub-

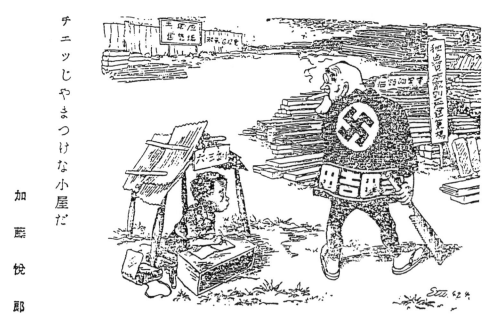

Figure 25. "Tsk, tsk, What an Unsightly Shack!" The carpenter is identified as Yoshida Shigeru, while the lumber is marked "cost of price controls." Various other Yoshida policies are referred to in the drawing. Katō Etsurō, "Che' jamakke na koya da!," *Kumanbachi* 6 (June 1949).

lications of the Communist Party. Ever faithful, Katō even ran for election from Tokyo's Nakano District as the Communist candidate. As anticipated, he lost badly.

How Katō perceived the American Occupation of Japan and its aftermath can be seen in a cartoon, published posthumously in 1960, entitled "From One Cage to Another" (Figure 26). His message here is that the Japanese people were simply being transferred from the cage of "The Occupation" to another cage represent-

265

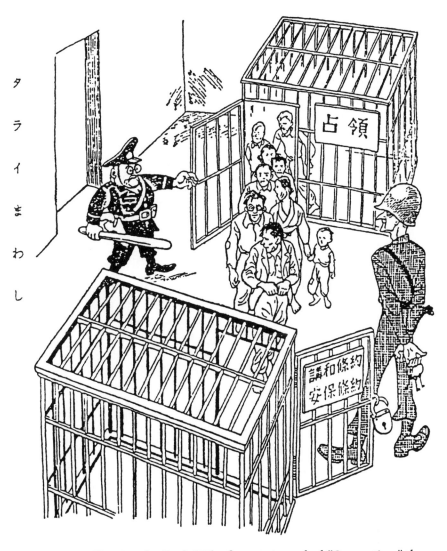

Figure 26. "Passing the Buck." The far cage is marked "Occupation," the closer one "Peace Treaty, Security Treaty." Katō Etsurō, "Taraimawashi," *Katō mangashū*, 52.

ing the "Peace and Security Treaty Regime." A Yoshida-looking policeman is handling the people; nevertheless, an American MP is watching, with all the keys in his hands. This cartoon was a reflection of the Communist Party's position, as well as the mood of many other militant workers and radical intellectuals, who felt that the transition from the Occupation to nominal sovereignly simply represented another form of American occupation that had in fact another root. Throughout his life, Katō seems never to have trusted—let alone liked—America. Nonsense cartoons, which he despised, originated in the United States, after all.

Satō Tadao, a noted critic, praised Katō highly as a "bona fide political cartoonist." It is true, of course, that Katō was a solid cartoonist who almost always attempted to provide serious political messages for his audiences. Satō further commends him as "a cartoonist who consistently criticized policies with his sharp techniques and assured good sense." [20] There is certainly no doubt about Katō's "sharp techniques"; he was a consummate artisan. But his "assured good sense" was totally lost in the madness of the war and only returned when the fighting

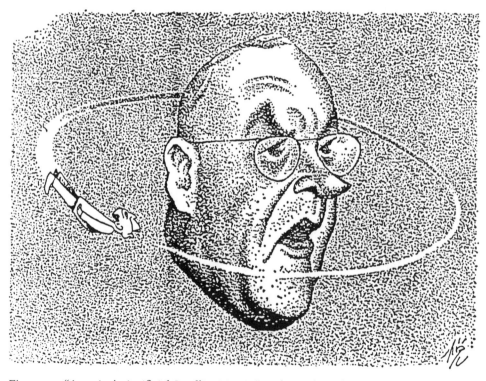

Figure 27. "America's Artificial Satellite No. O." Kishi circles John Foster Dulles. Katō Etsurō, "Amerika jinkō eisei zerogō," *Manga tsūshin* (Cartoon Newsletter) (1958); in *Katō mangashū, 62.*

was finished. Even then, his judgments were constrained by the straightjacket imposed on him by the Communist Party.

It should be mentioned, however, not in passing but as his last accomplishment, that Katō was invited to become a regular contributing cartoonist for the Kyōdō News Agency, the largest in Japan. The fact that such an establishment institution as Kyōdō invited him to become a syndicated cartoonist testified to the presence of a certain degree of latitude in Japanese society. Katō reciprocated this spirit of tolerance by contributing to Kyōdō many cartoons that could be widely accepted by a broader audience and yet at the same time possessed sharp political messages. One of his masterpieces of this period, although not created for Kyōdō, was entitled "America's Artificial Satellite No. 0" (Figure 27). It caricaturized Prime Minister Kishi as a satellite circling around the head of John Foster Dulles. Katō would doubtless have produced more such mature cartoons had he lived longer. But he suddenly passed away a year later, in 1959, thus bringing an end to his stormy life.

Conclusion

In brief, the case of Katō Etsurō seems one that exhibits an honest double conversion. Beginning as a left-leaning liberal cartoonist, he first became a fanatic nationalist, promoting the cause of war, then converted himself again to the cause of socialist revolution in Japan. And because he was a true "bona fide political cartoonist," a rare specimen in Japan, it is worthwhile to examine his accomplishments—war propaganda and all—once more. For in doing so, we may find the kind of nourishment needed to enrich the soil of a field in which true, solid political cartoons can grow.

Notes

Editors' Note: Katō's cartoons, 1945–1949, may be found in the censored magazines, newspapers, and books of the Gordon W. Prange Collection, University of Maryland.

1. See Katō, "Gendai Nihon mangaden no tembō" (A View of Contemporary Cartoon Exhibits), in Nihon Mangakai, ed., *Manga Kōza* (Essays on Cartoons), vol. 4 (Tokyo: Kensetsusha, 1934), 180–181.

2. See Katō, "Manga no hihan to kanshō" (Criticism and Appreciation of Cartoons), in *Mangaka yōsei kōgiroku* (Records on Training Cartoonists) (publisher unknown, ca. 1936), 61.

3. Katō in *Manga kōza,* 181.

4. Katō in *Kōgiroku,* 5–7.

5. Katō, "Shin Nihon manga no kensetsu" (Construction of New Japan Cartoons), *Manga* (Inaugural Issue, October 1940), 30.

6. Mineshima Masayuki, *Kondō Hidezō no sekai* (The World of Kondō Hidezō) (Tokyo: Seiabo, 1984), 203–205.

7. Kensetsu Mangaikai, ed., *Taiheiyō manga dokuhon* (Tokyo: Dai Nihon Sekiseikai Shuppanbu, 1940).

8. Interview with Katayori Mitsugu, March 21, 1992.

9. Katō, *Manga no gihō* (Cartooning Techniques) (Tokyo: Geijutsu Gakuin Shuppanbu, 1942), 171.

10. See Katō Etsurō, ed., *Zosan mangashū* (Tokyo: Shinkigensha, 1944), Appendix (roundtable discussion), 26.

11. Ibid.

12. Ibid., 27.

13. *Kessen mangashū* (Tokyo: Kyogakkan, 1944).

14. Katō Etsurō, *Okurareta kakumei* (Tokyo: Kobarutosha, 1946). See also John W. Dower, *Embracing Defeat: Japan in the Wake of World War II* (New York: W. W. Norton, 1999), 65–71.

15. Katō, "Watakushi no manga" (My Cartoons), in Katō Etsurō Mangashū Kankōkai, ed., *Katō Etsurō mangashū* (Collected Cartoons of Katō Etsurō) (Tokyo: no publisher cited, 1960), 67.

16. Ibid., 68.

17. *Okurareta kakumei*, 3.

18. Ibid., 32.

19. *Katō Etsurō mangashū*, 74.

20. Satō Tadao, "Sakka to sakuhin," in Tsurumi Shunsuke et. al., eds., *Gendai manga kōza: manga sengoshi* (Essays on Contemporary Cartoons: Postwar History of Cartoons) (Tokyo: Chikuma Shobō, 1970), vol. 14, 341.

268

To Be or Not to Be: Kabuki and Cultural Politics in Occupied Japan

Marlene J. Mayo

In November 1943, *Life,* Henry Luce's popular weekly picture magazine, featured a lavishly illustrated article on kabuki drama to expose the barbaric, feudal mentality of America's Japanese enemy in the Pacific War. "The most popular play in Japan," proclaimed the story's banner headline, "reveals the bloodthirsty character of our enemy." The terrible tale was *The 47 Rōnin,* or *Chūshingura* (Treasury of Loyal Retainers), in its 1740s version, which was portrayed as the ultimate in revenge plays. "In this bloody vendetta story are gruesome scenes of hara-kiri, torture and murder, all honorably justified in the sacred cause of blind loyalty." A set of woodblock prints, mainly by Hokusai in 1798 and reproduced in splendid color from collections at the Boston Museum of Fine Arts and the New York Metropolitan Museum of Art, together with photographs of leading actors, complemented the text in demonstrating the viciousness of the play and its themes.[1]

This was wartime propaganda for home front mass consumption. However, similar convictions about the presence of Japanese feudal values and culture in modern Japan, not simply a hastily devised critique of the recent years of militarist aggression, would be transmitted to specially selected American army and naval officers during civil affairs training for duty in defeated Japan. Few of these potential occupiers had ever visited, lived in, or studied Japan; most were ignorant of kabuki or other forms of Japanese drama. Yet on the basis of six-month crash courses in Japanese language and culture conducted at six American universities between 1943 and 1945, they were expected to take on the awesome task of remolding Japan, including democratizing its theater. Other would-be reformers who arrived in the months following Japan's surrender in the fall of 1945—not only military officers but also civilian recruits of the Department of the Army—had even less knowledge of Japan, although their policy guidelines tended to be

the work of knowledgeable specialists in Washington, D.C. Despite widespread ignorance and enthocentric bias, the Americans who were assigned to control kabuki turned out to be surprisingly sympathetic and well equipped for the job. Conscientious about their assignment to fight feudalism and often disturbed by what they saw presented on the stage, they nevertheless soon came to view kabuki as a valuable art form. Before the Occupation ended, Americans and Japanese worked together to recast kabuki as a cultural treasure, along with fine arts, architecture, and archives, and to preserve and protect it under the Cultural Properties Law of 1950.

Media and Cultural Policies for Occupied Kabuki

In the summer of 1945, as the Pacific War was ending, officials in Washington began putting the final touches on a policy of systematic reeducation of postsurrender Japan through control of the mass media and reform of the educational system. Their recommendations to the president were the outcome of several years of wartime debate about the necessity of reshaping the militaristic mentalities of the defeated Germans and Japanese in order to ensure the enemy's permanent conversion to peace and democracy and to a firm place in the American postwar global security system. In Japan's case, the term *feudal mentality* was a catchphrase in Occupation planning documents for such traits as subservience to authority, glorification of the sword, and class consciousness rather than a sophisticated reference to medieval history or Marxist thought. During the Occupation years, the term tended to be used even more loosely to refer to backward Tokugawa Japan (1603–1868), the period that nurtured kabuki drama. Western and Japanese scholars had not yet redefined the era as early modern rather than late feudal or fully grasped the intricate interplay of Neo-Confucian, Buddhist, and Shinto elements in the emergence of Tokugawa ideology.[2]

Reeducation was in potential conflict with another high policy. It had also been American wartime practice to prevent, insofar as possible on the battlefield, the destruction of archives and great works of art and architecture. In Europe, this was deemed vital to saving Western civilization from Nazi barbarism—but difficult to attain in the cataclysm of total war. For the Pacific Theater, too, art became a consideration in sparing the treasures of Kyoto and Nara from firebombs and atomic bombs, although it did not save monuments elsewhere or urban populations from indiscriminate air attack. Once the Occupation officially began in early September 1945, General Douglas MacArthur, as Supreme Commander for the Allied Powers (SCAP), had the difficult assignment of reshaping Japanese ideology without unduly tampering with its artistic legacy or desecrating religious and historical sites. In reforming Japan, he was expected to refrain from the kinds of cultural excesses that characterized Nazi-occupied Europe, such as looting art museums or burning books. Presumably, this also meant avoiding Japan's example as colonial master, such as attempts to replace the Korean language and family

names with Japanese. In the Allied equation, Western cultural imperialism in Asia was seen as less pernicious than Japan's aggression or was rationalized as benevolent. MacArthur's cultural mandate in action, however, did not embrace complete creative freedom. The classical fine arts were protected, but certain wartime books were burned and paintings and films confiscated. Newly produced fiction, poetry, and plays were censored or suppressed.[3]

Washington's reeducation policy required extensive control of occupied Japan's mass media as well as cooperation with liberal and moderate Japanese. Media control, in turn, was defined as a twofold task: telling the Japanese what approved themes to promote on the stage and screen, in print, or on the air and which harmful ones to abandon. To carry this out, two distinctly separate SCAP hierarchies were created in MacArthur's General Headquarters, beginning in September 1945. The job of instilling democratic ideas—above all respect for the individual—was assigned to officers in the Information Division of the Civil Information and Education Section (CI&E). Removal of banned topics—ranging from militarism and ultranationalism to anything that might disturb public tranquility or was critical of MacArthur, the Occupation, or Allies—was the task of civil censors in the Press, Pictorial and Broadcast Division (PPB) of the Civil Censorship Detachment (CCD), an important part of intelligence operations in Japan. More detailed guidelines were devised for the various media, including theater. The functions of the two organizations sometimes overlapped, confusing the Japanese and leading to jurisdictional squabbles, but officially, only censors had the authority to ban, delete, or suppress.[4] Although censors and guidance officers were also well aware of a possible conflict with preservation of the classical as opposed to modern or mass arts, in the opening weeks of the Occupation they had not yet clearly recognized theater—specifically kabuki—as a work of art.[5]

Both CI&E and PPB set up theatrical units to monitor all forms of stage performances from classic drama to modern plays and review shows. Although SCAP gave primary emphasis to filmmaking and to radio broadcasting, it assigned a high priority to theater. PPB reports in 1946–1947 declared "categorically that there is more theatrical activity in Japan, in proportion to the population, than there is in any other country," and fully 75 percent was of the "Kabuki type."[6] The potential for interference in Japan's creative life was extensive, running the gamut from suggestions by CI&E at the script and scenario stage to censorship review by PPB of the final product and actual performances. Japanese theatrical producers—in particular Shōchiku Enterprises and its actors—risked the loss of considerable income through failure to comply with suggestions that in many cases were really orders.

SCAP officers had few doubts about the necessity of their job in Japan. Arriving with a negative mindset intensified by wartime hatred but also imbued with democratic values, they justified media controls as a temporary evil to create psychological receptivity to democracy and also idealized their own culture. Although SCAP in its various media and cultural activities did at times pry inordinately into the Japanese psyche from 1945 to 1952, often displaying a racist bias against Japa-

nese culture and values or interfering with creativity, as Japanese critics of the Occupation have charged, it of course preferred to believe that it was liberating creative energies from wartime militarism and feudal traditions. Moreover, many of the occupiers were charmed, transported, or themselves reeducated by things Japanese.[7] This was certainly the case with kabuki. It presented SCAP officials with a conundrum. Seen as both a reflector and shaper of feudal ideology, kabuki was politically dangerous but was also undeniably an important part of Japan's cultural patrimony. Moreover, Japanese devotees were determined to fight for kabuki's survival as a national treasure beyond mere popular entertainment. As the occupiers developed a deeper understanding of the Tokugawa legacy, invented and otherwise, a few even become lifelong students of kabuki and contributed to a growing academic and popular appreciation of Japanese theater in postwar America. This ironic outcome was a complete turnabout from the views expressed by *Life* magazine in 1943.

Kabuki at Risk

Although numerous foreign visitors to Japan in the prewar period had seen and commented on kabuki plays—including theatrical and film luminaries George Bernard Shaw and Charlie Chaplin, as well as a parade of diplomats—none of the first American theatrical officers to serve in occupied Japan had ever seen a kabuki performance, and, moreover, their written sources in Western languages were limited. It was strictly on-the-job training. As more knowledgeable officers were appointed to theatrical posts and continued the investigations, SCAP would learn that kabuki had a long history of contending with homegrown censorship from the time of its inception in the late sixteenth century to the present. It had managed, said an extensive "Special Report" compiled by theatrical censors in April 1947, to stay alive through the skill of its all-male actors, the appeal of its playwrights to emotion, and the adaptation of dance, story, and spectacle to the tastes of commoner audiences. And it had developed coded words and gestures to outwit its oppressors. Although New Kabuki, featuring great actors in new plays by professional playwrights, had developed after the Meiji Restoration in 1868, modern audiences had become increasingly elitist. In decline as a people's theater, kabuki, like Elizabethan drama in the West, was nevertheless able to maintain a large following of aficionados.

Relying extensively in this "Special Report" on Japanese informants and sources, the authors also pieced together a more recent but sketchy history of how kabuki had fallen into bad financial times even before the rise of militarism and had barely survived competition in the 1920s from movies and other new forms of popular entertainment. Expensive to produce, it was heavily promoted and sustained by Shōchiku Enterprises, whose founders, the Ōtani brothers, were among its most devoted fans and whose losses were greatly offset by film and stage profits. After the Manchurian Incident of 1931, however, kabuki was saved less by an ador-

ing public than by war profiteers ready to spend money on expensive entertainment like kabuki, "with its luxurious costumes, large casts, high salaried actors and special theaters." When full-scale war began with China in late 1937, the authors continued, Japanese government propagandists utilized the kabuki boom to reawaken audiences to samurai virtues and the gospel of *Yamato damashii* (Japanese spirit). Shōchiku, which continued to monopolize kabuki productions in Tokyo and Osaka, had worked willingly with the Bureau of Information in carrying out cultural mobilization. Police censors had banned certain classic plays as injurious to public morals, such as dramas featuring love suicides and brothel scenes. On the other hand, favored loyalty plays of that time had included *Terakoya* (Village School) and also *Kanjinchō* (The Subscription List). The latter had been filmed live at the Kabukiza in 1943 both to preserve the artistry of the actors and to show a wider audience the desired type of loyalty. Above all, the military loved, as did the public for centuries, *Kanadehon chūshingura* (the 1740s kabuki play that was the object of *Life* magazine's diatribe). This ever-popular drama of the loyal *rōnin* however, was rewritten to conform better to war needs. "The sword fighting, disdain of human life, loyalty and obedience to the suzerain were exhibited as fascist virtues." This last comment in the "Special Report" was perhaps not only a reference to manipulation of the 1740s version but also to performances of *Genroku chūshingura,* a retelling of the story in a cycle of ten separate dramas written between 1934 and 1940 by Mayama Seika (1878–1948), who introduced a new theme of unconditional loyalty to the emperor.[8]

In fact, kabuki—including actors, writers, producers, directors, and critics—had conformed with nationalist and wartime goals far more profoundly than SCAP censors had been able to reconstruct in their "Special Report" or their sources had been willing to reveal. As a rallying point for cultural pride and patriotism, it was far from a genre in decline. Prophetic of the later dispatch of pen brigades or famous literary figures to the China front, Uzaemon and a large group of over one hundred actors and musicians toured Manchukuo in 1935 on behalf of the War Ministry, with the stated purpose of using kabuki plays to console soldiers and to promote good relations between the new state and Japan. In a patriotic display two months after the Marco Polo Bridge Incident in July 1937 and the onset of total war with China, audiences in Tokyo were greeted at the entrance to the Kabukiza with a huge reproduction of a tank assault on a Chinese gateway and a display of real barbed wire and sand bags. Major actors in Tokyo and Osaka performed in newly written kabuki-style dramas with war themes as well as in approved classics. They participated in benefits, as did famous painters, to raise large sums for war matériel. Among the most famous, Kikugorō and Kichiemon starred in the June 1940 debut of *Taikōki* (Record of the Taikō—a high court title bestowed upon Hideyoshi by the emperor), based on a highly popular 1939 newspaper serial by novelist Yoshikawa Eiji tracing the rise of Hideyoshi, and appeared with Uzaemon and Kōshirō in the October 1940 sequel, *Shutsujin no asa* (Morning of Departure for the Front), a drama of Hideyoshi's dispatch of troops to Korea in the 1590s as

a step toward the conquest of Ming China. With the war bogged down in China, Ennosuke took the title role in *Wang Jingwei* (China's most prominent collaborator with Japan) in May 1940. He also played in modern dramas opposite popular stage actress Mizutani Yaeko in December 1939 as a loyal Tokugawa *rōnin;* and with young Chinese film star Li Xianglan (Ri Koran, shortly exposed in the press as in fact a Japanese national, Yamaguchi Yoshiko) in August 1940 in a play about a bandit chief during the Manchurian Incident. In late 1940, as suspect leftist actors and playwrights in Japan's modern theater movement, *Shingeki* (New Drama), went off to jail and as political parties were on the verge of official dissolution, senior kabuki actors discussed details of unified theatrical censorship with Bureau of Information officials, together with ways of cutting back on costly settings and costumes while maintaining art. In June 1941, Kawarazaki Chōjūrō's ensemble company, Zenshinza (Vanguard Theatre), originally a leftist group that had discovered the pleasures of popularity and profits on stage and screen, gave a special performance of Mayama's *Genroku chūshingura* for a foreign audience.

As the China war broadened into World War II in the Pacific and Greater East Asia, one of Ennosuke's hastily written new vehicles in the spring of 1942 was *Sensuitei dairokugo* (Submarine No. 6), a tribute to the special attack force at Hawai'i. That summer, Kikugorō led a large troupe on a goodwill tour of Manchukuo in celebration of the tenth anniversary of the state's creation. On Army Day, March 10, 1943, as Japan's best-known actor, he reappeared on radio for the first time in eighteen years, reciting "Letter from a Unit Commander," which was relayed by Japan's international broadcasting network to all parts of Greater East Asia. Meantime, Ennosuke and Kan'emon (a member of Zenshinza), joining playwright and novelist Kubota Mantarō and select theater critics and stage designers, had met as a subcommittee of the official Theatrical Council to discuss such problems as setting up a drama investigation commission. In early August of 1943, Ennosuke starred with other kabuki actors in *Kaigun* (The Navy), based on a popular war story by Iwata Toyō. Throughout 1943, kabuki remained active in Tokyo and Osaka, highlighted by a full-scale performance in June of *Kanadehon chūshingura* by Kichiemon's troupe. The play, raved the *Nippon Times* to readers of English throughout Greater East Asia (and no doubt to American military intelligence officers), was a "literary masterpiece" and had "no equal," not only in expressing loyalty but all "heroic, pathetic, comical, and tragic features" (June 9). Chōjūrō performed frequently in the *Genroku* variation of the drama between 1941 and 1943 and took the lead role in Tōhō Studio's government-sponsored film adaptation, *The Loyal 47 Rōnin,* directed by Mizoguchi Kenji and released in two parts, from December 1941 to January 1942, shortly after the strike on Pearl Harbor. By early 1944, however, deluxe performances of kabuki had become much too difficult to stage or to justify on Japan's austere home front. In March, well before American B-29 bombing raids began, the Tōjō cabinet closed theaters in Japan's main cities as a form of luxury. By then, some of the younger kabuki actors had been drafted. Veterans like Ennosuke and Sumizō joined minor actors in traveling troupes orga-

nized to entertain miners and workers in approved plays, at times reduced to dancing to the music of phonograph records. Nevertheless, as proud evidence of Japan's distinctive culture, a grand performance of *Terakoya* was mounted in Tokyo on June 23 for foreign residents and diplomats. German Ambassador Heinrich G. Stahmer declared to the press that "Kabuki plays best reveal the true spirit of Japan to the foreigner"—the spirit of Bushidō. This was precisely the kind of propaganda that Allied occupiers would soon turn against the Japanese to rationalize their own censorship.

After March 1945, few major theaters in large Japanese cities survived American carpet bombing. Kikunosuke (the future Onoe Baikō VII), who was in Hakone at the time while his adoptive father, Kikugorō, remained in Tokyo, has recalled in a memoir how his mother, a skilled samisen musician, instilled discipline and kept up family morale by chanting old narratives during air-raid blackouts. In late May, the Kabukiza and surrounding area were destroyed by firebombs in the same raid that damaged a portion of the imperial palace and obliterated a huge part of metropolitan Tokyo. When defeat and foreign occupation came in the fall of 1945, stage props were gone or scattered, costumes in disrepair, and performing houses in short supply. In August, one day after the emperor's surrender broadcast, Ennosuke had proclaimed the readiness of kabuki actors "to perpetuate the glorious tradition of the ancient dramatic art," and to do so at street corners and without costumes if necessary. "So long as the kabuki actors live, the kabuki drama will remain." Nevertheless, the immediate future of kabuki seemed bleak. This would soon turn to despair as SCAP instituted its media policy and revealed its initial animosity to much of the kabuki repertoire.[9]

In September and October of 1945, SCAP began the process of systematically dismantling Japan's wartime media controls while simultaneously imposing its own press, film, radio, and theatrical codes and setting up special staff sections in Tokyo for liaison with the Japanese government. As early as September 22, officers of the newly created CI&E Section alluded to kabuki during a briefing for over forty leaders from Japan's film and theatrical industry. "Kabuki theater is based on feudalistic loyalty," they asserted, "and sets faith in revenge. The present world does not accept this morality any more." They listed approved topics for possible dramatization on screen and stage, such as social consciousness and human rights, and in a follow-up session warned the head of the Japanese Theatrical Association that war motifs must be removed from future productions. Within PPB at about the same time, a censor began laying out the duties of the new Pictorial Section. He stressed the "tremendous importance" of theater on the "psychology of the average Japanese" and singled out "kabuki as the glorification of the Bushido spirit of the past." Kabuki plots, he charged, were punctuated with "murder, swordplay, death and hatred," and its warrior heroes were always forced to choose loyalty to a lord over personal desires. In this censor's view, plays, films, radio broadcasts, exhibits, and commercial art all fell within the proper realm of pictorial surveillance—but definitely not the fine arts: "Any suppression of the artist is in funda-

mental conflict with the spirit of democracy." What he could not foresee at this point was an expansion of the concept of artistry or cultural patrimony to include kabuki drama.[10]

276 The complex task of getting good plays onto the Japanese stage and bad ones off led at first to friendly collaboration between officers in CI&E and PPB. CI&E took the lead in searching for cooperative Japanese to provide insights and background information or respond to guidance whether staging kabuki or modern theater. At a conference of Japanese and Americans on October 15, the topic of kabuki came up again. Although Lt. John P. Boruff Jr., the chief CI&E theatrical officer present on that occasion, was as yet ignorant of kabuki, he had a good professional background in civilian life for his assignment. A graduate of Yale University in 1932, where he was president of the Drama Club, and a young actor-playwright on Broadway, Boruff had enlisted in the navy after Pearl Harbor and was recruited in 1944 for a civil affairs training course on Japan at Harvard University. Among the Japanese invited to this joint conference was Itō Michio, identified in CI&E records simply as someone who had once worked on the American stage. In fact, Itō, who had been repatriated to Japan from the United States on a 1943 exchange ship, was well known in prewar European and American modern dance circles and had once taught dance classes in Hollywood and San Francisco. His brothers were prominent prewar theatrical figures, including actor, producer, and director Senda Koreya, an early member of the *Shingeki* movement for realistic Western-style drama and a key figure in CI&E's efforts to encourage democratic theater. Itō "explained," recorded Boruff in his daily report, "that kabuki plays are harmless from a propaganda point of view. The audiences pay no attention to the ideas expressed in them, viewing everything as fairy tales." What they most enjoyed was, according to Itō, the "highly specialized techniques of the actors."[11]

Since Boruff knew nothing firsthand about Japan's theater, he decided to see for himself. A few days later, he pronounced the kabuki performance he had just witnessed at the Imperial Theater to be "a work of art and harmless." What he had seen was the first postwar appearance of Kikugorō in one of his best-known roles, *Kagami jishi* (Lion Dance), along with a modern play, *Ginza fukkō* (Reconstruction of the Ginza), which was set in the aftermath of the devastating 1923 earthquake and obviously selected to symbolize Tokyo's current rubble and ashes. *Ginza,* too, did not displease Boruff, though he suspected it was played "with tongue in cheek" to satisfy everyone, since it left unanswered what kind of Japan would rise from the "wreckage." Another American who saw the performance, future Tokyo war crimes defense lawyer Ben Blakeney, not only was thrilled with Kikugorō's acting but deeply touched by his final curtain speech encouraging everyone present to work together in reconstructing Japan.[12]

In early November, Boruff's attitude abruptly hardened after concluding that Shōchiku Enterprises had betrayed SCAP in deliberately staging bad plays. *Terakoya* had opened, starring the great actor Kichiemon. Its enthusiastic reception in the midst of privation provided clear evidence that many Japanese, almost as hun-

gry for entertainment as food, were longing to see the old plays and famous actors. Fans lined up by the thousands to purchase tickets at the shabby Tokyo Theater, one of few houses suitable for staging kabuki to escape bombing or conversion to cinema. At the same time, a second Shōchiku troupe led by Nizaemon, who specialized in female or *onnagata* roles, began performing a popular 1916 play, *Banchō sarayashiki* (Mansion of Broken Dishes) at the Daiichi Theater in Shinjuku. After attending both plays, an alarmed Boruff got his equally upset counterpart in PPB, Lt. Victor Ehlers, to press Shōchiku in mid-November for "voluntary" suspension and then a permanent ban on both productions as violations of SCAP guidelines. "From a social point of view," reported an outraged Boruff, *Broken Dish* was "a vicious play affirming the inferiority of woman and suggesting a samurai has god-like rights over her, in this case for breaking a precious dish." Shōchiku's synopsis had concealed the play's "true content," omitting the part "where the Samurai kills" and obscuring the motivation. Even more repugnant to Boruff was *Terakoya* —an old Edo drama set in Heian times in which a retainer accedes to the sacrifice of his own son to spare the heir of his master in the name of loyalty.[13]

During SCAP negotiations with producers over the fate of these two plays, the head of Japan's Entertainment Association confided in Boruff on November 16 that Shōchiku had staged its plays on the assumption that Americans would not understand kabuki. Indeed, Shōchiku's scripts were "so anti-social," he added, "that Japanese reporters were heard laughing at our naiveté in permitting their showing." He further warned Boruff not only to obtain detailed scene-by-scene explanations of plays but also to take note of the casting of parts. In order to poke fun at liberal ideas and the Occupation, actors who were well known to audiences as villains might instead star in crossover democratic roles. That same day, an anonymous letter arrived from a puzzled Japanese asking why dramas showing feudal loyalty were being performed. In quick time, the two plays were gone from the boards.[14]

As a precaution, Boruff and Ehlers next asked Shōchiku producers to submit paragraph synopses in English of their entire stockpile of plays and evaluate them as "vicious" or "harmless," based on the taboos recently indicated in SCAP's November code for the film industry, such as revenge, chauvinism, degradation of women or children, approval of suicide, and distortion of historical facts. Others in both CI&E and PPB began debating the wisdom of more drastic action, such as banning kabuki plays by name in a SCAP directive to the Japanese government—a notion undoubtedly derived from MacArthur's November 16 directive naming and ordering the confiscation of 236 Japanese wartime feature films. Boruff, though disgusted, was resistant to this solution. The old plays, "despite vicious content," should be banned, he said, "only in extreme instances." They were "known by heart by devotees of kabuki" but had limited influence since "the ancient language used" was "hardly understood" by the general public. Also, Boruff, who was a guidance officer, believed that it was "better to fight these plays with new ideas" rather than with the "crude weapon of censorship." While

engaged in monitoring kabuki, he also interviewed Hijikata Yoshio, famed director of Western plays recently released from prison under the Civil Rights Directive; attended rehearsals for a French play, *Toulon Harbor,* depicting underground resistance to the Nazis; and encouraged a revival of Chekov's *The Cherry Orchard.*[15]

Frustrated by the "translation bottleneck" and in need of a trustworthy expert, Boruff turned to another Japanese national as his key consultant: Enko Vaccari, who was coauthor with her husband, Italian linguist Oreste Vaccari, of several prewar Japanese-language grammars and readers for foreigners. She told him on November 20, in one of several meetings, that there were five types of kabuki plays—adulation of warriors; celebrations of the triumphs of the Edo common man over samurai; love triangles; Robin Hood stories; and dance plays. This time, on November 22, Boruff attended *Sakura giminden* (Martyr of Sakura) at the Tokyo Theater and was pleased with this drama of an early-seventeenth-century Tokugawa peasant leader, Sakura Sōgorō, who had sacrificed himself for the good of his impoverished village: "This is a work of art," he reported, "and a worthwhile play showing a man's individual effort to better the conditions of the poor around him. Method of action is feudal—appeals to Shogun at risk of his life. However the play is excellent, all that could be expected of a play written long ago."

Clearly, Boruff was beginning to view at least some kabuki plays as serious art. Although he found Nō drama to be "weird," pictorially, kabuki fascinated him. It was "exquisite," and the costumes produced "an atmosphere of gorgeous opulence." Murder and suicide were "so stylized" that "hideous melodrama" became instead "a magnificent spectacle." Before leaving, he would meet Kikugorō twice but was put off by—to him—the actor's overwhelming ego, behaving like "God Incarnate" in the theater and an "autocratic businessman" in daily life. Just as Boruff was feeling more hopeful, to his great disappointment twelve "bad" plays turned up in Shōchiku's new list of supposedly harmless kabuki.[16]

By early December 1945, three months into the Occupation, officers in both CI&E and PPB were convinced that Shōchiku Enterprises could not be trusted on their own to withdraw the worst plays, but at the same time they also wished to avoid charges of meddling with art. Boruff, his colleague 1st Lt. Harold Keith Jr., and a newly arrived theater censor, Lt. Earle Ernst, joined by Vaccari and interpreters, held four conferences, lasting in all over sixteen hours, from December 3 to 5, with a group of seven Japanese producers, scholars, and critics in order to review plot summaries of kabuki plays and tabulate those that in SCAP's view were harmful. Among the Japanese in attendance at Shōchiku's invitation were Kawatake Shigetoshi, professor of drama at Waseda University and curator of its Theatrical Museum; Atsumi Seitarō, prominent scholar, drama critic, and editor of a theater magazine, *Engekikai* (Theater World); and the well-known *Shingeki* playwright Kubota Mantarō. Unknown to SCAP at this time, Kawatake and especially Kubota had been involved in wartime cultural propaganda programs. The outcome of the joint conferences was devastating to lovers of kabuki—the worst crisis in its history, as it was termed years later by Kawatake's son. About 320

plays—that is, two-thirds of the existing repertoire of 500 plays, including the most popular—were designated as harmful. Producers, primarily Shōchiku, were to understand that they should withdraw them voluntarily from public performance; that is, they should refrain from submitting suspicious scripts to censorship so that SCAP could maintain the fiction that the Japanese were taking such drastic action on their own. During this review, the determining criteria for bad plays were the familiar ones of feudal ideology, blind loyalty to a lord, glorification of militarism and the sword, cheapness of human life, subservience of women to men, approval of suicide, and recurrent revenge themes.

Boruff supported voluntary withdrawal as the best solution. When the Japanese "produced their own effective refutation of feudal ideology" and learned "to look upon kabuki for what it is—an interesting museum piece of their people's past—then these plays should be released again." Not surprisingly, the play most detested by Americans in SCAP was *Kanadehon Chūshingura*. Its theme of calculated and delayed revenge of a lord by a group of dedicated samurai secretly biding their time was seen as dangerous during a period of foreign occupation. Also placed in the bad category were loyalty plays like *Kanjinchō*, *Terakoya*, and *Kumagai jinya* (Kumagai's Camp). Although such classics as *Sukeroku yukari Edo zakura* (Sukeroku, Flower of Edo) and *Shibaraku* (Wait!), which mocked samurai pretensions and were out of favor with militarists in the 1930s, were candidates for revival on the kabuki stage, after these conferences little else was left for the great actors other than lesser plays or dance dramas.[17]

Rumors about "banned" kabuki plays began to surface in December and January even in the SCAP-controlled Japanese-language press. First, the *Nippon Times* of December 24 ran a column, "Banned Kabuki Play Revealed," which named several of the targets, leading with *Chūshingura* and *Terakoya*. Inattentive press censors had apparently already started their Christmas vacation. The GI newspaper, *Pacific Stars and Stripes,* which tended to pay little attention to Japanese culture, suddenly took note of the issue on December 27, when staff writer Sgt. Barnard Rubin cited a book he had just discovered characterizing kabuki as "kindred to Fascism" and "militarist in character." His source, damning to him but written either with pride or to comply with propaganda, was a 1938 English-language guide, *Kabuki Drama,* prepared under official auspices by Japanese scholar Miyake Shutarō. On December 31, the *Nippon Times* followed with a long column on the paucity of democratic themes in kabuki. In the midst of unwanted publicity, CI&E and PPB had a showdown over the best procedure for removing undesirable kabuki plays—by a directive or voluntary withdrawal. This dispute reflected changes in SCAP personnel, as several early media officers completed their tours of military duty and left for civilian life. Boruff returned to Broadway and eventually to the world of daytime television soap operas. Lt. Keith took over guidance duties in early January and adopted a tougher stance. To the Japanese, he seemed more insensitive to their culture than Boruff and overly brisk in personal contacts. Keith, in fact, felt driven, like Boruff but even more so, to democratize modern

Japanese drama and to stage great foreign plays. For a long time, neither he nor his successors in CI&E took an informed interest in Edo kabuki but instead concentrated on promoting modern plays containing approved themes.[18]

By contrast, in PPB, the new main theater censor Lt. Earle Ernst (1911–1994) was an officer whose education and background were an excellent fit for the job. Although he too had never before seen a live kabuki performance before arriving in Japan, he was a scholar of comparative theater and open to learning from other cultures. Ernst had already earned a Ph.D. in drama and theater from Cornell in 1940, with support from the Rockefeller Foundation, and had just begun his academic career at the University of Hawai'i when Japan attacked Pearl Harbor. In 1944, Ernst was recruited to the army's Intensive Japanese Language School at the University of Michigan and received further language training at the Military Intelligence Service Japanese Language School. Unlike the first civil censors on the scene in late 1945, his handling of his duties in PPB would be enhanced and complicated by his knowledge of Elizabethan theater, his view of Tokugawa Japan as feudal, and his growing conviction that kabuki was indeed great art.[19]

Ernst, whose role in the Occupation's kabuki drama is little known, was in Tokyo by early December, just in time for the kabuki script review and just as CI&E began intensifying its campaign for a theater directive. He and Boruff met again on December 20 to exchange views. Soon after Boruff's departure three weeks later, Lt. Keith and his superior in CI&E, civilian David Conde, a film official primarily intent on liberalizing Japanese cinema, expressed fears that small producers and lesser traveling troupes would stage harmful plays throughout Japan unless SCAP ordered the Japanese government to enforce specific bans. On January 14, 1946, their chief, Brig. General Kermit Dyke, evidently in agreement, pressed General Elliot Thorpe, head of the Office of Counterintelligence in which CCD was housed, for an effective plan. A former advertising executive with the NBC radio network and an information and education specialist for troops in MacArthur's Southwest Pacific campaigns, Dyke took his reeducation assignment seriously. Thorpe's reply on January 22, however, vigorously endorsed the views of his new theater censor, Lt. Ernst. He agreed with CI&E that kabuki had dangerous content but gave preference to voluntary withdrawal as the best method in handling an art form. A directive, argued Thorpe, would not be foolproof and perhaps even counterproductive. Existing theatrical censorship, he reminded Dyke, was based on a still incomplete knowledge of scripts. Since compiling the December lists, for example, censors had learned that two of the supposedly approved kabuki plays were in fact harmful and had banned them. Moreover, titles and subjects were changeable and sometimes misleading. "In a given play," some scenes might be harmless, but others "should be suppressed." In remote areas, troupes might put on bad plays under a nonbanned title. "If a directive is issued, we shall then find ourselves in the ridiculous position of having approved a part of a play which has been banned, and the only ones who are the wiser will be the Japanese." By contrast, in the West, "*Hamlet* is always *Hamlet*," Thorpe

declared, in the ongoing resort to Shakespearean analogies by both Japanese and Americans.

Thorpe saw other dangers in resorting to a directive, such as having to rely on the Japanese police for enforcement. It was also imperative to avoid Japanese mockery of Occupation policy and criticism of MacArthur. A directive might attract "more attention and sympathy" for kabuki than warranted and convert kabuki into a "martyr," even though it was not widely popular with the masses. Present-day audiences consisted mainly of older people who had learned to enjoy it in their youth or "intellectuals who regard it as the most highly developed artistic form of the Japanese theatre, which it undoubtedly is." Without past government encouragement, kabuki would probably have disappeared from the modern stage. Since it was a world-recognized art, a directive could lead to a "cause celebre." However, "if left quietly to itself," kabuki would become "no more than a museum piece." Here, once again, was SCAP recognizing kabuki as an art form—but one without great popular appeal.

General Thorpe's recommendation, therefore, as scripted by theatrical censors, was to continue circulating the existing list of bad plays to producers and troupes as a guide to productions and to cooperate with CI&E in getting "the right kind" of modern plays onto the stage, "thus in time, forcing the old ones into oblivion." Dyke yielded to this argument, just before taking home leave and resigning.[20] His successor, Marine Lt. Colonel Donald Nugent, would prove much more cautious about overt or undue interference with classical culture and give strong support to CI&E officers in their job of preserving Japanese fine arts and democratizing museums and art exhibitions. He would be similarly cautious with respect to SCAP interference in Japanese-language reform. A prewar student of modern Japanese history at Stanford University, one of few American universities to offer such a course, and seasoned by several years of living in Japan as an English language instructor at preparatory schools, Nugent had served as a psychological warfare officer in South Pacific campaigns against Japan. Possibly he had even attended kabuki during his stay in pre–Pearl Harbor Japan.

In the midst of this policy exchange, Shōchiku, alarmed by SCAP's stringent theater policy and worried about profits, released a story on January 21 declaring that it was banning all classical kabuki plays except a few dance dramas as "too feudalistic and undesirable." Soon *Asahi shimbun* and other Tokyo newspapers carried reports that kabuki was on the verge of dying and implying SCAP oppression. No doubt the sense of crisis generated by such publicity had some influence on Thorpe's stand against a kabuki directive—as Shōchiku may have intended. To counter the rumors and get Shōchiku to reverse its decision, SCAP prepared a press statement for instant release. Its spokesman on January 22 was Lt. Colonel Harold Henderson, CI&E senior education officer and a Japan specialist in prewar life. As a professor of Japanese at Columbia University in the 1930s and one of the founders of its Department of Chinese and Japanese, he had developed a love of haiku and woodblock prints. Shōchiku had been asked, explained Henderson,

shaving the truth a little, to give its own opinion of good and bad plays from a democratic point of view. "GHQ wishes no art form to be killed, but GHQ is, of course, encouraged when the tendency of the Japanese theater is to present demo-cratic material." *Asahi* soon ran a reassuring follow-up story that "kabuki would not die," and a headline in the English-language *Mainichi* newspaper promised that "SCAP will not intervene in Activities of Kabukidom." [21]

In fact, SCAP's evolving policy, though officially supportive of kabuki as an "art form," had seriously reduced its repertoire in early 1946. Kichiemon, one of kabuki's three leading actors, was especially hard hit and able to perform only five of his one hundred starring roles. Kikugorō was less affected but could perform only about thirty major dance narratives. There was little that Kōshirō could do. In March, tragedy struck veteran actor Nizaemon, who had few acting jobs and was in financial trouble. The actor, his young wife, and their small son, along with two women in his household, a total of five victims, were murdered by a stage assistant who was living with them, apparently in a dispute over food rations.[22]

To give leading kabuki actors employment (Shōchiku paid wages to its con-tract players only for actual performances) but at the same time to encourage democratic theater, Keith told Japanese producers in early January, the day after Boruff's departure, that they should present one modern drama for every two kabuki plays (the previous formula was 30 percent). Ernst much later quipped that this was like asking a classical pianist to play "Chopsticks" after performing Bach. Oblivious, Keith continued to push for change and was pleased with Shōchiku's February production of *Takiguchi nyūdō no koi* (The Love of Takiguchi), starring Ennosuke as a samurai who becomes a priest. He liked the radical rewriting of an old story by popular modern novelist Funabashi Seiichi to show youthful rebel-lion against authority and praised the performance of the woman's role by a woman, famed *Shingeki* actress Mizutani Yaeko. She is "not killed," he observed, "but is forgiven her transgression," and there is even a stage kiss. According to Keith's reports, "The audience reaction was overwhelmingly in favor of the muta-tion," yet what the Japanese probably liked was not so much the play but seeing two great stars once again acting together.

Keith encouraged plans to modernize another kabuki play and a Nō drama and was elated with the March 1946 production, starring Kichiemon, of *Takatoki* —a late-nineteenth-century "living history" warrior play by Mokuami about the last Hōjō regent of the Kamakura period—for its stress on punishment of corrupt officials. By May, although kabuki actors were by then playing in a matinee revival of *Sukeroku,* their evenings were spent performing modern dramas. Since *Sukeroku* was seen as a farcical tale of an upstart merchant who bettered an old samurai in a contest for the love of a courtesan, the play pleased CI&E and was easy for PPB to clear. The old kabuki spirit of commoner mockery of samurai pretensions and its aesthetic of *yatsushi,* or disguise, were fine as long as the targets were neither MacArthur nor the Occupation. In fact, the unexpurgated play centered on dou-ble identity (the merchant was a transplanted samurai, one of the famous twelfth-

century Soga brothers in search of their murdered father's stolen sword) and incorporated a revenge theme. Although the Soga episode was downplayed, the joke was on the pretensions of the occupiers.[23]

Though CI&E was happy, Japan's theater world was aghast. Kabuki actors, like their Shakespearean counterparts in Britain, were sufficiently versatile to act in other dramatic forms, but the modernized plays in which they were appearing seemed inferior and contrived to critics. Ennosuke won plaudits from CI&E for his progressiveness but drew scorn from Japanese for his kissing scene with Mizutani. A daring and inventive actor, he was losing respect as a masterful exponent of pure kabuki. In PPB, censors feared that CI&E experiments in modernizing kabuki were making democratization a laughingstock. Under Major John Costello, head of PPB from March 1946 through 1948, the days of friendly banter and cooperation between the two hierarchies ended, especially on issues dealing with films and plays. Cautiously, Ernst and his colleagues began reassessing bans on older kabuki plays since most of the acceptable repertoire would soon be exhausted. In May, just as Lt. Keith was completing his tour of duty and feeling good about his accomplishments, he learned to his surprise that censors had reversed their stand on the play *Kanjinchō*.[24]

At this point, another American officer on the scene, Major Faubion Bowers (1917–1999), assistant military secretary in MacArthur's headquarters, had become instrumental not simply in fostering liberalization but in broader efforts to rescue kabuki from creative interference. Unlike SCAP's first theatrical officers, he had actually attended kabuki performances before the Pacific War and had become an avid fan. As a piano student on fellowship at the Julliard School of Music in 1939, Bowers had somehow taken an interest in Indonesian music and landed in Yokohama in March 1940 while on his way by freighter to Bali. Intending to make only a seventeen-day stopover for sightseeing, be became fascinated by Japan and remained a whole year. Once in Tokyo, he began language study and was soon dazzled by kabuki, seeing all of the famous actors perform in a variety of plays and reluctantly leaving Japan in 1941 at the urging of the American Embassy. Early in the Pacific War, Private Bowers honed his linguistic skills as one of the first recruits to the army's intensive Japanese Military Language School. Rising rapidly in rank, he served in Australia and New Guinea with the Allied Translator and Interpreter Service from 1943 to 1945, and at war's end was soon posted as Major Bowers to MacArthur's Occupation headquarters in Tokyo.

Bowers' legendary question to Japanese reporters upon landing with the small American advance party at Atsugi Airbase in late August 1945 is said to have been, "Is Uzaemon still alive?" (confirmed by Bowers in numerous interviews). He quickly slipped back into the kabuki world while carrying out unrelated duties as a military aide to MacArthur. Baikō recalls that Bowers attended his father's first postwar performance, *Lion Dance,* in October 1945 and came to the dressing room afterward, speaking fluent Japanese and offering encouragement. He later privately invited the great actors to his quarters at the American Embassy. Bowers

gave them food and cigarettes, found powdered milk for their children, and befriended the younger actors. This became dangerous, given SCAP's nonfraternization and black market rules. Japanese theaters were technically off limits except for GI nights; it was illegal for Japanese to have goods from American sources. In March 1946, Bowers supplied Kikugorō, "Japan's foremost actor and an old friend of mine from before the war," with a letter stating that "the cigarettes he may be smoking are my personal gift to him and have not been purchased on the black market nor are they intended to be sold on the black market."

Bowers also began meeting Japanese theater scholars and critics and heard their concerns. Although he did not officially belong either to CI&E or to PPB (and was apparently not yet acquainted with Lt. Ernst), Bowers embarked upon a personal campaign to enlighten the occupiers about kabuki and, no doubt, to ensure his own viewing enjoyment. As he would later complain in 1947 to Santha Rama Rau, the American-educated daughter of the new head of independent India's liaison mission to Japan and a member in good standing of the elite younger set in Tokyo, the occupiers did not know how to approach a play as a means to understand the Japanese. "Does any colonizer," he said to her, "understand the people he tries to colonize? You can only be a successful colonist if you believe that your civilization, culture, religion, way of life—anything—are superior." [25]

Major Bowers had first come to the attention of censors in early 1946 as something of a nuisance when he phoned PPB headquarters on January 25 (a few days after the Henderson press conference) to ask if Japanese newspaper stories were true about Shōchiku's "suicidal" ban on kabuki and, if so, to suggest that this was interference with art—a point that SCAP already conceded but that Bowers would persistently make much harder to evade. Three weeks later, press censors in PPB suppressed his newspaper interview with a skeptical *Tokyo shimbun* for stirring up unnecessary controversy, although Bowers had taken care to question the wisdom of Shōchiku, not directly to criticize the Occupation. "We must not forget," he had said, "that kabuki plays have been the people's theater for years." *Sukeroku* was in fact democratic, and *Kumagai's Camp* was antimilitary. Why, he wondered, was Shōchiku killing hundreds of plays at a time when the Japanese were going through a severe test? Moreover, the great actors required long years of training and must have plays in which to show their skill and technique. Subsequently, upon learning of plans to revive *Sukeroku*, Bowers and his Japanese friends provided an English translation of the plot, which the *Nippon Times* published in five installments for its Western readers—estimated at fifty thousand—in early May. [26]

To see *Sukeroku* again was sheer delight for Japanese fans, but few other great kabuki plays could be performed at that time under existing SCAP policy. During the run, Bowers went with a select group of actors to plead with PPB censors to approve *Kanjinchō*, arguing that it was in reality a humanistic play. To withhold it, Bowers reportedly said, was "comparable to the suppression of the *Ring* of Wagner." If so, this was an unfortunate reference. Theatrical officers in the American Zone, occupied Germany, had in effect suppressed the *Ring* cycle but were allow-

ing performances of other Wagner operas, such as *Tristan and Isolde*. The Bayreuth Theater would remain dark and out of commission until July 1951.[27] The intervention was partly successful. PPB censors—primarily Ernst and his chief, Arthur K. Mori, both already so inclined—gave special permission on artistic grounds for a month-long performance of the play in June. This was even though the highly popular play featured extreme loyalty—Benkei at the pass, masquerading as a priest to protect his disguised lord, Yoshitsune, from detection by enemy guards under the command of Togashi. As a safeguard, censors required that the play be performed only in Tokyo and by an all-star cast. And indeed it was: Kōshirō as Benkei, Kichiemon as Togashi, and Kikugorō as Yoshitsune. Twice during July, the *Nippon Times Magazine* ran special articles by Bowers to enhance foreign understanding of the "hyperbolic" nature of the kabuki acting style. There was a separate night for Allied personnel, who seemed, not surprisingly, to be more excited by news that Gilbert and Sullivan's *The Mikado* would soon be staged for the first time in Japan.[28]

A prime source of opinion and influence in achieving further liberation of kabuki by late 1946 and early 1947 was Japanese confidants. Chief among the expert scholars was Professor Kawatake, though PPB also began viewing him as a bit of a "charlatan" for promoting democratic kabuki as vigorously during the Occupation as nationalist kabuki during the war. Believing that kabuki's future was endangered, Kawatake's solution in May 1946, already shared by a previous minister of Education, was to classicize kabuki and give it state support. In May 1947, as the new peace constitution went into effect, Kawatake blamed Meiji perversions for obscuring commoner protest against feudal superiors in Edo kabuki and thanked the Occupation for opening the eyes of Japanese to "true and eternal humanity." Kabuki must be saved from extinction, he repeated, as "a symbol and glory of a nation that is henceforth to be dedicated to culture."[29]

Dr. Komiya Toyotaka was also influential. A scholar and translator of German literature as well as a disciple of Natsume Sōseki and student of Japanese classics, Komiya became the new postwar head of the Tokyo Academy of Music. He contended that the good side of kabuki had almost been swallowed up. The first performances arose from the people and were for the people. Often, the plays either mocked the samurai way of life or were a quiet protest. Still other Japanese experts insisted that kabuki was primarily a theater for the actors' art, not the playwright's talent. For the people, it was spectacle, a series of colorful tableaus, or a medium for humor, emotion, and pathos. A few Japanese critics, however, such as Kitamura Kihachi, were emboldened to protest that kabuki deserved criticism as a product of Tokugawa values—not all of which were admirable—and could benefit from introspection.[30]

Established kabuki actors too had great impact on the discourse, especially on Bowers, who spent much of his free time in the theater watching rehearsals and endlessly discussing plays and details of performances. He grew especially close to Kichiemon, whose advice to Bowers, as recalled by close friend Santha Rama Rau,

was to explain kabuki to the occupiers in terms they could understand: "These plays are a protest against *bushido;* there is always the cry against the samurai in kabuki. Remember, these plays were written by commoners whose enemies were the samurai. Of course they were fascinated by their lives; who is not interested in kings and queens and nobles? Before the war our government tried to forge kabuki into a weapon for their side by deleting lines and suppressing plays. Now, by doing the same things you show yourselves no better than the government which you claim were your enemies [*sic*]."[31] Bowers was adept in transmitting such advice, and his love of kabuki was deep and genuine. However, there was also something almost amoral in such exchanges—in placing art above politics, in refusing to hold actors accountable, or in distorting the history of kabuki.

It is also possible that senior PPB officials like Major Costello were encouraged to relax kabuki policy somewhat by the results of an internal office poll in late 1946 of the views of ten translator-examiners working in PPB book and magazine censorship. All but one were either Japanese or Japanese American, and the exception, a German national, held similar views. In their comments, they tended to regard samurai literature and drama as part of Japanese historical reality and the people's common life and were not inclined to wholesale dismissal of the genre. It was primarily for pleasure or forgetting troubles and not particularly detrimental to the democratization of Japan. Although the military had slyly distorted such literature to instill a spirit of "sacrificial death," it could also serve to "heighten morality and culture." Samurai heroes were not really dangerous models of behavior. Although avid kabuki goers or devotees of martial arts tales might revel in the portrayal of past feats, they would not be tempted to emulate them in the present—not any more than Western opera goers, weeping at the demise of Mimi in *La Bohème,* would wish to adopt her Bohemian lifestyle, or readers of Homer, though appreciating the "grand beauty" of his epics, would wish to return to those "heroic ages." To strike out a whole era, warned one respondent, would be tantamount to "impoverishing our national literature and historical education." Why not leave samurai literature alone but counter it with democratic and progressive ideas?[32]

Kabuki Saved

Support for liberalization continued to grow, but kabuki remained lackluster in the early fall of 1946. The programs lacked variety, and tickets were too expensive in a time of high inflation and sluggish economy, even though the practice of letting fans see favorite scenes at reduced prices had been reinstituted in May. Nagging questions recurred within PPB. If kabuki should die, who would be blamed for killing a classical art—kabuki itself or the occupiers? PPB, specifically Ernst, believed that it could neither abolish kabuki nor give it a free hand, and feared "unskillful handling of kabuki could easily cause repercussions in the press and art publications of the world which would equal the criticism aroused by Hitler's pro-

scription of Mendelssohn and Heine." By late September Ernst was ready to admit, as he reassessed the play *Ichinotani futabi gunki* (Chronicle of the Battle of Ichinotani)—in particular its most important act, "Kumagai's Camp," by which name the play itself is best known—that "censorship had really raised hell with kabuki" and was "stifling" an established art form "just because it was used as an instrument of propaganda." He further noted: "The situations are not exactly parallel, but Wagner's *Ring* was interpreted in the Nazi ideology and much trumped up by the propagandists, yet censorship has not forbidden its production in Germany." As already indicated, Ernst, Bowers, and others were in error about Wagner and occupied Germany, where American media advisers had once even recommended a temporary ban on two Shakespearean plays, *Coriolanus* and *Julius Ceasar,* for exhorting dictatorship.

Ernst's answer to the problem in Japan, arrived at hesitantly in late September, was to give special approval for single runs of additional kabuki classics if not "too damnable." As further controls, the plays had to be of great artistic merit and performed by actors of the highest professional skills. On this basis, Ernst passed *Kumagai's Camp* as a vehicle for Kichiemon in October 1946—but with deletions and changes in the script. The decision was "difficult" for him since he believed that the play was "feudalistic as all get out." He understood that this was a play about a famous 1180s warrior, Kumagai, who spared the life of a young enemy soldier and sacrificed his own son, then gave up the military life "in disgust" for the Buddhist tonsure. Although uncertain that Kumagai's renunciation of war sufficiently counterbalanced the feudalism in the rest of the play, he did not believe the performance would do great harm. In the sanitized production, there was reduced emphasis on compliance with duty and more cynicism about unreasonable sacrifice and the tragedy of war. "I think it's better to exercise common sense and permit the kabuki as much leniency as our consciences will allow." The play was approved for only one month in Tokyo, and at the end of the run the script was to be returned to PPB.[33]

Ernst's recommendation may have been influenced by his involvement in an internal squabble at this same time over passing a radio script for a proposed NHK production of *Anthony and Cleopatra.* Broadcast censors wanted to suppress this particular Shakespeare play as too "martial in many scenes" and further suspected that NHK had an ulterior motive "of kindling subversive ideas or disturbing public tranquility" in an "unwholesome society" beset with a crime wave of murders, rape, holdups, and kidnappings. Ernst disagreed, and his views were endorsed by his nervous superiors who did not relish the reputation of having suppressed a Shakespeare tragedy in Japan. With a touch of irony, Ernst had argued that none of the "best psychologists" would agree that "a play showing intrigue, murder, suicide, sacrifice of patriotism to love, [or] general moral decay" would cause an audience to go on a crime spree or to engage in antisocial behavior. In fact, as *Aristotle's Poetics* argued, the opposite effect on audiences might be expected. If PPB was to suppress this play, then in all honesty it should "forbid the performance of

all Shakespeare tragedies; for there is not one of them which does not deal with crime, murder, suicide, and other horrors." Ernst went through the list. In *Hamlet*, there was revenge and an "unwholesome court"; in *Othello*, "the danger of fraternization"; in *Lear*, "a study of feudalistic cruelty"; in *Macbeth*, murder to gain power; and in *Romeo and Juliet*, a reminder to the Japanese "of the feudal family system which still prevails—besides, it is full of sword fights." Why did the Japanese like *Coriolanus?* Probably it came "closer to Oriental psychology than any other of the tragedies." In the end, radio censors ordered only one deletion in the proposed script; this was from the announcer's commentary, drawing a parallel between Anthony and Cleopatra and Hideyoshi and Yodogimi. Concluded the PPB officer in charge: To believe that exposure to a Western classic would incite Japanese listeners to violence "is either a reflection upon the merits of Western culture or an admission that SCAP-occupied Japan is an explosive powder-keg, or both." [34]

Meanwhile, Bowers continued his crusade in the public arena. In October he wrote a clever piece for the *Nippon Times Magazine,* extolling pure kabuki and explaining the plot of the newly liberated *Kumagai* (which he, unlike Ernst, either did not find to be "feudalistic as all get out" or perhaps did not care). When performed by an actor of the stature of Kichiemon, he declared, it became "the finest piece of propaganda against feudalistic Japan to appear to date." The tale of murder or sacrifice of one's own child was reminiscent of a classic thirteenth-century French story. And the appearance onstage of a decapitated head (*kubi jikken,* or head inspection) should not "startle Westerners," who had seen the severed head of John the Baptist in either the opera or play, *Salomé.* [35]

By the time Bowers left military life and formally joined PPB on civilian pay in January 1947 (his first recorded appearance on an office roster), more as a patron of kabuki than as a censor, he was no longer a nuisance but a welcome addition. A modified kabuki policy, largely the doing of Ernst, was already in place—that of allowing limited runs of approved complete masterpieces by great actors in Tokyo. This policy of cautiously liberating plays of artistic merit was extended by Ernst and Bowers, working together, to include full-length revivals of *Jidaimono* (period pieces), so that bad or dangerous scenes took their place as part of the play as a whole and were deprived, as the censors argued, of undue importance. To stage performances only of "exciting bits of plays" would be comparable, they both agreed, "to a performance in America of a Shakespeare program embracing: The Murder of Duncan, Ophelia's Mad Scene, The Battle Scene in France, and Hamlet's Revenge of his Father's Murder" (a ploy perhaps, since this is what kabuki did and continues to do regularly). The two pushed Shōchiku for unrevised scripts, "for we suspect that they are unnecessarily butchering plays which could be played intact." They saw themselves as caring more about the survival of kabuki than did many Japanese. Following an April field trip by Bowers, they also approved productions in Osaka by skilled kabuki actors. Kabuki's loss, said Ernst in defense of their leniency, "would be as great a blow to the Japanese cul-

tural heritage as the destruction of the National Treasures."[36] Once again, an eloquent case was made for the equation of classical theater with the fine arts as a cultural treasure.

In March 1947, PPB passed *Adachi,* a play with two suicides and performed by virtuoso actor Kichiemon in a male and female role, but this became possible only after several lines had been altered to create acceptable points of sympathy. The part of the father, who was supposed to commit suicide because he had lost his lord's fortune, "was revised so that he commits harakiri out of sorrow because the feudal system prevents him from being kind to his daughter who has married his mortal enemy." Kōshirō was given a chance in April to star in one of his prewar favorites, the 1897 *Ōmori Hikoshichi,* a period play set during the Kemmu Restoration in the 1330s. In the approved PPB version, General Ōmori of the victorious army of the Northern Court, under the spell of a beautiful woman, returned a sword entrusted to him by her dying father, the great loyalist hero, Kusunoki Masashige of the Southern Court, even helping her to escape pursuers and feigning madness so that he would not be punished for breaking the warrior's code. PPB deliberately allowed certain loyalty plays to show Japanese audiences that the heroes of old were not always faithful repositories of blind loyalty and to teach that higher realms of humanity controlled action. By May, PPB even permitted a performance of the play that had so distressed Boruff a year and a half earlier, *Terakoya,* but only as part of a whole production of the parent play, *Sugawara denju tenarai kagami.*[37]

To elevate kabuki and make it more palatable on the occupied stage, Ernst and Bowers continued to draw upon analogies with Shakespearean and Elizabethan drama. Said the two in their previously cited "Special Report" of April 1947: "The problems of life and death, scandals in high places, and the contrast between the commoners who witnessed the plays and the warriors who were the subjects of the plays, made for excitement much as Shakespeare's kings and queens and blood and thunder held the fancy of Elizabethan audiences." Moreover, the language and customs of kabuki were so remote from modern-day audiences, they observed, that the content of kabuki was not harmful. "Similarly, Shakespeare's plays with their royal heroes are quite compatible in republican theaters." Unfortunately, wartime abuse by militarists had "tainted" kabuki and made it "doubly dangerous for today's audiences who see only surface and are incapable, perhaps, of drawing more from kabuki than a vague sense of glorification of the old feudal days." Continued censorship was therefore necessary but "particularly difficult," they repeated, "since the problem concerns a world-wide recognized art." In their "Special Report," however, the two had given little attention to the actors themselves and the choices they felt constrained or compelled to make in wartime Japan or to internal theatrical discourse. With the exception of the Zenshinsha troupe, this is a subject that remains neglected in postwar studies of kabuki. The guiding premise was apparently set earlier by General Dyke—that in the Japanese media purge, patriotism not be confused with ultranationalism.

By early summer 1947, when Bowers took over as senior theater censor following Ernst's return to academic life in Hawai'i, the economy was in the doldrums but conditions on the kabuki stage had considerably improved. Major kabuki actors had more roles to play, standards were high, and the repertoire was more varied than in years. In self-congratulation, he and Ernst had declared in their "Special Report" that "kabuki actors are freer from oppressive censorship than they have been since 1607." It seemed that kabuki was "bending as far as possible in the democratic direction, if by not directly extolling contemporary life, at least by presenting the sorrows of the past so poignantly that even war-torn Japan seems better by comparison." Thus, "the thinking public" in Japan is filled with "a deep sense of gratitude towards the Occupation for freeing a heretofore grievously oppressed art."[38]

In reality, this freedom remained limited under July policy regulations. Censors, including Bowers, still made deletions of passages that glorified Bushidō or withheld approval of bad scripts. Actual performances were selectively monitored to check strict adherence to approved scripts. Since actors on the kabuki stage had more flexibility in spontaneously changing words or lines than their Western counterparts who played according to script, PPB had decided that the best way to control subversive interpretations—gesture, nuance, grimace, improvisation—was to permit only the best actors to perform controversial or rightist plays in their complete original form and to limit productions to Tokyo, Kyoto, and Osaka, where audiences were astute. This policy was a boon to the Great Five—Kikugorō, Kichiemon, Kōshirō, Baigyoku, and Enjaku—but did not automatically extend to lesser troupes or minor actors. In performance of his more punitive duties, Bowers also routinely chastised in writing directors of modern plays who violated SCAP codes.[39]

With Ernst gone, the great passion of Bowers was to revive *Kanadehon chūshingura,* and he launched his campaign in July with a barrage of internal notes and memoranda. Recalled Santha Rama Rau a few years later:

> I would find him in Kichiemon's dressing room, sitting back on his heels like a Japanese and lecturing furiously about the stupidity of the censorship policy. "The idiocy of it!" he would say. "Can you imagine?—they want to suppress it because it is a 'revenge play,' so it will give the Japanese ideas. *Hamlet* is a revenge play, too. Do you want to rush out and murder your uncle when you've seen it? But then," he added bitterly, "the British aren't a defeated nation, so I suppose it's all right for them to have undemocratic ideas." Kichiemon told him to stress the principle, "one should not interfere with a classic art."[40]

Kichiemon's principle was, of course, already well understood within SCAP and had come to apply to theater as well as the fine arts. As for this particular play, Bowers successfully argued from his position within PPB that its revenge theme, which he articulated as "loyalty to a superior unjustly ordered to die," was much

diminished, indeed even acceptable when performed in its entirety. The play had been so "twisted into nationalistic propaganda" by militarists that it had come to be seen abroad merely as propaganda. Bowers cited James Murdoch's turn-of-the-century *History of Japan* and Zoë Kincaid's 1925 study of kabuki as informed foreign sources that extolled the play's artistic worth. Moreover, Japanese were blaming SCAP for nonperformance of the play, "which is regarded as one of the greatest Japanese dramas" and the one they most wanted to see.

With solid support from his unit chief, Bowers won his struggle in late September 1947, when General Charles Willoughby, chief of the Civil Intelligence Section, backed a month's run in a strong recommendation to General MacArthur's chief of staff. Only the 1748 orthodox version of *Kanadehon chūshingura* would be permitted. All eleven acts would be performed by a cast of Tokyo and Osaka stars. There was, however, more at work in the timing of SCAP's approval than the persuasive powers of Bowers. In Washington, officials in the State and Defense Departments had begun discussing a shift of emphasis in Occupation policy from unrelenting democratization to greater focus on economic recovery. SCAP had already begun to relax press and radio precensorship in the fall of 1947, though it continued to deal harshly with nationalistic writings and closely monitored atomic bomb literature, film, and art. To protect kabuki would be a way to blunt accusations that Americans were going too far in attacking Japanese culture. It would also sustain the image of a benign Occupation just as MacArthur was considering running for the American presidency. A final point was Willoughby's certainty that the play would be the first one to be performed upon termination of censorship and "become a symbol of Japanese freedom from the yoke of Allied Occupation." Relaxation might forestall mockery and criticism.[41]

A grand revival of *Chūshingura* took place in November 1947 to packed audiences at the Tokyo Theater and much favorable publicity in the Japanese press. Performance of the full cycle took both the afternoon and evening sessions. John Allyn Jr., a pictorial censor in Nagoya who made a special trip to Tokyo to see the dream cast, remembered the play as "the most exciting theatrical event" he had ever witnessed. To Baikō, the performance was "unprecedented." The *Nippon Times* ran two anonymous columns on November 19 and 20, in fact written at the newspaper's request by Bowers as background material for foreigners. The real meaning of vengeance in the play, he wrote, was righting a grievous wrong. The drama conveyed longstanding popular resentment against Bushidō and embodied an undercurrent of social protest.[42]

Although *Life* magazine failed to cover the glorious revival, several foreign correspondents applauded the performance. SCAP reveled in Japanese press comment professing "gratitude to the Occupation Forces who aim at the preservation of genuine classic art which transcends its feudal subject matter." Negative remarks did appear, however, particularly in leftist and Communist organs, such as the Japan Communist Party newspaper, *Akahata* (Red Flag), which asked if the producers were making fun of the Japanese. *Jinmin shimbun* (People's Newspaper)

charged that the play contributed to the "corruption of postwar social conscious-ness" and destroyed "the constructive energy of the people." A Korean forum in the Japanese language, *Kokusai taimusu* (International Times), criticized it for glori-fication of revenge. More moderate voices had also been wondering for some time if Shōchiku was overly greedy and kabuki too conservative and out of touch.[43]

Chūshingura, however, was not performed freely from this point on, as some-times indicated. Special permission was required for its production anywhere in Japan—as for other allegedly dangerous plays—and often denied. In fact, only big-time or pure kabuki enjoyed leniency. From late 1947 to late 1949, approved kabuki masterpieces were performed regularly by skilled actors at only seven the-aters in three cities, where audiences were thought to be more knowledgeable than in rural areas and also better able to pay high prices in a still sluggish econ-omy. Under Costello's successor, Robert M. Spaulding Jr., previously a news agency censor and an army-trained Japanese linguist, worries about kabuki and rightist ideology resurfaced in PPB. In early 1949, a year after the departure of Bow-ers, the special permission policy for presentation of great works on an artistic basis came into question as undemocratic. When Allyn was transferred to Tokyo to take over theatrical censorship in District I, his orders "were to grant special privileges to no one." PPB was not inclined to end precensorship of the theater or to let it try out full artistic freedom, especially not in the countryside where ideas were thought to change slowly and bans and deletions were therefore necessary. Wil-loughby and the senior censors still feared danger from the Japanese right, but even more so from the left as traveling troupes came under increasing surveillance as possible vehicles for the dissemination of Communist propaganda. Under the proposed new policy, estimated Allyn, about two hundred plays could still be per-formed, "so kabuki would not be crippled." Then, suddenly, the threat was gone. In the wake of budget cuts and Washington's desire to alter Occupation policy for larger security goals, CCD was completely disbanded in October and censors were released for other jobs. And as predicted, Kichiemon's troupe performed *Chūshin-gura* in March 1950, two years before the Occupation ended.[44]

Before its demise, other forms of Occupation censorship had also plagued kabuki. From 1945 to 1949, for example, PPB magazine and book officers routinely removed or disapproved laments for banned kabuki plays or references to the-atrical censorship. In early 1946, censors suppressed an entire article on classical poetry, which also defended feudal kabuki as a classic art capable of sophisticated appreciation by a modern audience. Prior to publication, the following italicized words were deleted from an essay in April: "I thought *Terakoya*, which has such a feudalist theme, would not be performed in this age of democracy. But contrary to my expectation, it was staged. After several nights of performance, just as I expected, *due to the intervention of GHQ or something else*, it was *suddenly* withdrawn."

In September 1946, a magazine was required to drop a critic's expression of sympathy for Kichiemon as the actor suffering most "from the ban, as many of his favorite plays have been shut out." That same month, satirical lines were caught

and thrown out of another magazine essay: "'A warrior's son is not hungry even if his stomach is empty.' This is a famous speech in *Sendaihagi* [Disputed Succession], one of Chikamatsu's famous plays. Its performance has been banned by order of SCAP. However, what is not banned is the pressing condition of the public who are tasting the hardships of Chikamatsu's words."[45] In November, comments by actor Kōshirō about the former "banned play, *Kanjinchō*," were cut from a published talk: The play was suppressed, said his lost words, because its fight scenes were considered "jingoistic," but the harmful part was "revised according to advice from Mr. Bowers, who is an American drama student and understands kabuki so well that performance of the play was permitted in June." In this case, the PPB net had not only stopped a reference to censorship but had also turned up valuable clues to behind-the-scenes activities of Bowers.

A year later, in November 1947, with Bowers in PPB and *Chūshingura* in revival, magazine censors again suppressed an entire article, this time for stating that one of President Theodore Roosevelt's favorite books was an 1879 translation of the *Tale of the 47 Rōnin*. Even Bowers agreed that this particular item was "nationalistic progaganda." In September 1948, however, book censors approved a new work that debunked the 47 *rōnin* as "a dissipated lot," who were secretly hoping by their dramatic act of supposed loyalty to win reinstatement as samurai and live idle lives. And, somehow by alchemy, kabuki was transformed from 1938 "fascist drama" into 1948 "humanist theater" in a revised and approved version of Miyake's official guide to theater for the postwar Japan Travel Bureau. "Humanism is a quality that characterizes the kabuki play," said Miyake, "and its characters advocate social justice, which they go to great length even at risk of life and limb to defend." In addition, both the original 1938 passage on vendetta and the word "*Bushidō*" were permanently dropped in all subsequent editions of the handbook up to its final printing in 1963.[46]

Finale

When PPB censorship ended in October 1949, kabuki was largely free both of foreign controls and of 1930s militarism, although CI&E continued surveillance activities to the end of the Occupation. But had kabuki engaged in internal reflection and criticism comparable to that of filmmakers and novelists? After the deaths of Kōshirō and Kikugorō that summer, critics speculated on their legacy and the future of kabuki as classic art. In May 1950, the revised Law for the Protection of Cultural Properties created a new category of "intangible cultural properties," including dramatic arts that "possess a high historical or artistic value in and for this country."[47] Kabuki came under state protection as a theatrical form in 1966, following earlier designations in the 1950s of Nō and Bunraku. By 1951, the Kabukiza had been handsomely restored. Audiences were large and enthusiastic, and kabuki was much more than the museum piece the occupiers had predicted. *The Tale of Genji*, staged in two parts in October 1951 and June 1952, was an exciting

moment in postwar theater as the theme of emperor and court was treated for the first time on the kabuki stage. When television broadcasting began in Japan in February 1953, the first program was a kabuki dance performance. In 1955, legislation was enacted to establish a national theater (opened in 1966).

But whose kabuki had it become? Was it safe kabuki, conservative kabuki, pure kabuki, scornful of innovation and dependent on the *iemoto* or family-head system for entry and promotion? It was safe enough for American Ambassador Robert Murphy to attend in June 1952 and to host Shōchiku's president and eleven kabuki actors at an embassy luncheon in September. In perfect tandem, American High Commssioner to Germany John J. McCloy was on hand in July 1951 for the postwar revival of the *Ring* cycle at Bayreuth, where there was more excitement about Wieland Wagner's revisionist staging and direction than reflection on the ghosts of the Nazi past. In December 1952, Sadanji headed a special kabuki benefit performance at the Ernie Pyle Theater for the Boy Scouts of America; in separate public appearances in March and November 1953, the empress and emperor attended kabuki charity shows. Kabuki was fortunate with friends in high places, whereas in the larger world of Japanese cinema and theater, as in the United States, artists on the left were watched, harassed, or blacklisted. Censorship had been a dangerous tool, even in the hands of sympathetic Americans. SCAP became accustomed to it, was reluctant to end it, and ready to restore it during the Korean War.

On another level, the occupiers, perhaps unknowingly, had taken sides in a highly political internal debate among Japanese about tradition, modernization, and uniqueness. In saving kabuki, in projecting it as world-class art, American censors had inadvertently helped to protect it from self-criticism and to recreate it as a national treasure. The kabuki world, in turn, was so intent on staging its full Edo-period repertoire during the Occupation that it became overly defensive. To point to American hypocrisy was not to confront creativity in the service of Japanese militarism or to examine the complex interrelationship between art and society. Back in 1928, leftist poet and writer Nakano Shigeharu had called for overcoming kabuki—his metaphor, says Miriam Silverberg, for liberating drama and the masses from feudal forms. This "demand" was similar, she argues, "to Walter Benjamin's 1940 call for the reform of appropriated culture"—for wresting tradition from conformism. In 1951–1952, a few Japanese scholars would echo such sentiments, declaring that they did not admire the ideology embodied in kabuki. They were reluctant to give it uncritical acceptance simply because it was old and Japanese and not modern or Western. Their admonitions generated little momentum, certainly nothing comparable to postwar Shakespearean discourse in addressing issues of anti-Semitism, gender, and exoticism, or to recurring debates in Germany about Wagner's music, fascist theater, and German culture. After 1945, believes Gilles Kennedy, "the traditional Japanese theater was promoted as a cultural icon. It was used to help redefine a precious national identity—and, as such, was closely guarded" by conservative critics, older actors, and capitalist management.[48]

Kabuki's reputation as great theater and a credit to the artistic creativity of Japan fared well abroad in the period immediately following the end of the Occupation in April 1952. Both Bowers and Ernst soon authored the first significant American books on kabuki. In 1954, Bowers published a work for general readers, *Japanese Theater,* giving half of the book to kabuki, and in future years would serve as kabuki's interpreter on American tours, becoming in effect kabuki's ambassador to the West. Ernst followed in 1956 with a full-length scholarly monograph, *The Kabuki Theatre,* and continued a career at the University of Hawai'i devoted to probing many facets of the Japanese theater, including the first staging of kabuki plays by an American university. Academic articles and dissertations soon began to appear, primarily by authors who had served in the American war against Japan. Kabuki's refurbished image was also on clear view in a 1956 British publication, *The Kabuki Handbook,* authored by the Halfords (she a cousin of British stage and screen actor Laurence Olivier; he a diplomat), who wrote approvingly but with a touch of condescension: "Kabuki plays are both dramatic and moving; the characters are just as human as those of the Western stage, although not always actuated by the same motives."[49]

By 1953, Broadway producer Josh Logan and best-selling author James Michener, who had both thrilled to kabuki during recent visits to Japan, were busily engaged in attempts to bring a troupe to the United States and tried to interest Secretary of State John Foster Dulles in the project. An earlier prewar Shōchiku plan to sponsor Kikugorō's troupe had been given up in 1935 as too expensive and too risky aesthetically with uninformed American audiences. In 1953, it was again apparently too soon. Instead, impresario Sol Hurok, with backing from Prince Takamatsu and Japan's Foreign Ministry, brought the Azuma Kabuki Dancers and Musicians, a troupe that included skilled female performers, to New York City in early 1954. As conceded at the time, this was not real or pure kabuki, but it was certainly enjoyable and prepared the way. At last, in June 1960, during the centennial celebration of the first Japanese embassy to America to ratify the U.S.–Japan trade treaty, Grand Kabuki played to critical and popular success in Los Angeles, San Francisco, and New York. American audiences, conditioned perhaps by violence in their own culture and media or simply the appeal of the story and the bravura acting, seemed to prefer the scenes from *Chūshingura. Life* magazine took note of kabuki's American presence, but, like much of the U.S. press of the time, was distracted by riots in Japan against the government of Prime Minister Kishi over renewal of the U.S.–Japan Security Treaty and by the cancellation of President Eisenhower's visit to Tokyo.[50]

The Allied Occupation with its agenda of reform and punishment had paradoxically contributed to growing Western interest in Japanese culture and helped to counter, if not to curtail, wartime hatred. Interaction with the occupiers had added new American layers to Japan's already westernized popular culture but in the end did not destroy older forms of theater and literature. After 1952, under strictly Japanese management, kabuki remained alive and gained state support,

not only reaching new Japanese audiences and winning admiration overseas but also serving as a repository of national culture and identity. The years of Tamasaburō's experiments in roles and Ennosuke III's electronic Super Kabuki lay ahead. And for better or worse or beyond simple binaries, whether perceived as social protest, loyal sacrifice, the righting of a grievous wrong, or exciting derring-do, the appeal of the *Tale of the 47 Rōnin* has remained undying. Art overcame censorship, but just barely—and not without harm to internal discourse, reflection, and creative freedom.

Notes

1. "Japanese *Kabuki* Play: 'The 47 Rōnin,'" *Life,* November 1, 1943, 52–57; photographs and additional prints courtesy of New York collector Louis V. Ledoux. In fact, Japanese wartime propaganda used the play primarily to promote sacrifice, hard work, and loyalty to a higher cause, not revenge. Another Henry Luce publication, *Time* magazine, had earlier that year (March 19) lauded a new work by Dr. Gustav Eckstein, *In Peace Japan Breeds War* (New York: Harper and Bros.). Eckstein, a medical doctor who believed that "you could work out the mind of a nation from its theater, especially an inflammable nation," had also singled out the tale of the 47 *rōnin,* an oft-told story "used by the greatest of painters and print makers," but full of "murderers of pathological sensibility." Chikamatsu, playwright of one version, though called by Japanese their Shakespeare, "lacks the poetry of Shakespeare, certainly, but he has sometimes a bloodiness of imagination that Shakespeare either never attained or never employed" (158, 164–171). A visitor to Japan in the 1920s and author of an earlier book about Japanese bacteriologist Noguchi Hideyo (1931) and a play about artist Hokusai (1935), Eckstein was well connected with New York publishing and theatrical circles (see obituary notice, *New York Times,* September 25, 1981) and may have helped to inspire *Life's* elaborate attack. Ignored was Sir George Sanson's more balanced discussion of the play and of Bushidō in his book, *Japan: A Short Cultural History,* as revised and published in early 1943. In contrast, Joseph Grew's wartime publication, *Ten Years in Japan* (New York: Simon and Schuster, 1944), based on his personal diary, characterized an evening at the Kabukiza in 1932, shortly after presenting his credentials as the new American ambassador, as "the best theater in Japan and the best classical drama and dancing" (entry for June 11: 28). Grew's reference was to actor Kikugorō in his famous performance of the *Lion Dance;* his escort was Ōtani Takejirō, president of Shōchiku Theatrical and Film Enterprises and chief patron of kabuki. In 1940, Shioya Sakae published a full-length English-language account of the play in question, *Chūshingura: An Exposition,* handsomely illustrated with full-color Hiroshige prints (Tokyo: Hokuseido Press).

2. A rereading of Sansom's revised 1943 text confirms this. Use of the term *"kindai"* and modernization debates, including the new look at Tokugawa Japan, lay in the future; Sansom's account of Neo-Confucianism lacks the precision of such later works as Herman Ooms, *Tokugawa Ideology: Early Constructs, 1570–1660* (Princeton, NJ: Princeton University Press, 1985). Sansom's prime contender for serious reading on Japanese history at that time was E. Herbert Norman, *The Making of Modern Japan* (New York: Institute of Pacific Relations, 1940), a work informed by a Marxist analysis of feudalism in Japanese history. For a lively review of the changing discourse on Edo and feudalism, see Carol Gluck,

"The Invention of Edo," in Stephen Vlastos, ed., *Mirror of Modernity: Invested Traditions of Modern Japan* (Berkeley: University of California Press, 1998), especially 265–266.

3. For U.S. media agendas within an overall framework for occupied Japan, see Marlene Mayo, "American Wartime Planning for Japan: The Role of the Experts," 3–51, 447–472; and "Civil Censorship and Media Control in Early Occupied Japan: From Minimum to Stringent Surveillance," 263–320, 498–515; both in Robert Wolfe, ed., *Americans as Proconsuls: United States Military Government in Germany and Japan, 1944–1952* (Carbondale: Southern Illinois University Press, 1984). For an extensive study of modern Japan's media controls, the indispensable work is Gregory J. Kasza, *The State and the Mass Media in Japan, 1918–1945* (Berkeley: University of California Press, 1988). Lynn H. Nicholas explains the work in Europe of the American Commission for the Protection and Salvage of Artistic and Historic Monuments in War Areas (the Roberts Commission) and of Arts and Monuments officers in *The Rape of Europe: The Fate of Europe's Treasures in the Third Reich and the Second World War* (New York: Knopf, 1994). Transposed to the Japan scene, sources include Sherman Lee, "My Work in Japan: Arts and Monuments, 1946–1948," in Mark Sandler, ed., *The Confusion Era: Art and Culture of Japan during the Occupation, 1945–1952* (Washington, D.C.: Sackler Gallery, Smithsonian Institution, 1997), 91–103; and David Waterhouse, "Japanese Art under the Occupation," in Thomas Burkman, ed., *The Occupation of Japan: Arts and Culture* (Norfolk, VA: MacArthur Memorial, 1988), 205–230.

4. CCD began operations on September 3; its PPB section was created on September 11, with a Pictorial Section in place by the end of the month. CI&E evolved on September 22 from an earlier Information Dissemination Section (IDS) and was reorganized on October 2, when additional special staff sections were created in MacArthur's headquarters for liaison with Japanese government counterparts. Here and later, documentation is in Record Group 331 (Records of the Supreme Commander Allied Powers, Japan), files of the Press, Pictorial, and Broadcast Division (PPB), Civil Censorship Detachment (CCD); and of the Civil Information and Education Section (CI&E). The enormous parent collection of over ten thousand packing boxes was recently transferred from the National Records Center, Suitland, MD, to the National Archives, College Park, MD (Archives II); microfiche copies are in the National Diet Library, Tokyo. Unless otherwise indicated, all Occupation documentation hereafter is from RG 331 and is cited either as PPB files for censors or CI&E files for guidance officers.

5. In response to pressure from the War Department and a communique forwarded from the Roberts Commission, MacArthur expanded the duties of CI&E to include preservation of the fine arts. A naval officer soon arrived who had performed similar duty in Europe: Lt. Commander George Stout, an art professional; Langdon Warner of the Fogg Art Museum (an adviser to the Roberts Commission) served a short stint in 1946 as consultant to Arts and Monuments, followed by the recruitment of East Asian art historian Sherman Lee; RG 331, Arts and Monuments, CI&E files; also Waterhouse, "Japanese Art under the Occupation."

6. RG 331, PPB files, Theatrical Sub-Section (no author) to Chief of Pictorial, Monthly Operations Report, September 9, 1946; Check sheet, AKM (Arthur K. Mori), Head of Pictorial Unit, to Chief of PPB/I (I refers to Tokyo station), January 13, 1947.

7. A good example of such criticism is Etō Jun, "Sealed Linguistic Space: The Occupation Army's Censorship and Postwar Japan," translated by Jay Rubin, *Hikaku bunka zasshi* (Annual of Comparative Literature) 2 (1984); 3 (1988). For Japan's own record in occu-

pation and cultural politics, see Edward M. Gunn, *Unwelcome Muse: Chinese Literature in Shanghai and Peking, 1937–1945* (New York: Columbia University Press, 1980); Poshek Fu, *Passivity, Resistance, and Collaboration: Intellectual Choice in Occupied Shanghai, 1937–1945* (Stanford: Stanford University Press, 1993); Grant Goodman, ed., *Japanese Cultural Policies in Southeast Asia during World War II* (New York: St. Martin's Press, 1991); Michael E. Robinson, "Colonial Publication Policy and the Korean Nationalist Movement," in Ramon H. Myers and Mark R. Peattie, eds., *The Japanese Colonial Empire* (Princeton, NJ: Princeton University Press, 1984), 312–343; and Richard E. Kim's novel, *Lost Names: Stories from a Boyhood in Japanese Occupied Korea* (New York: Praeger, 1970).

8. Summary based on Special Report, "Censorship and the Present State of the Japanese Theater," April 25, 1947, revised June 15, 1947 (RG 331, PPB files, hereafter "Special Report," 1947), coauthored by Earle Ernst and Faubion Bowers. The purpose here is to convey what these two censors believed to be true at that point about kabuki history, including the recent past; as indicated below, they were heavily dependent on a small and rather closed circle of Japanese scholars and actors who were eager to protect their personal vision of kabuki. The finished report (authorship not indicated) also appears as a documentary appendix to *Operations of Military and Civil Censorship, USAFFE/SWPA/AFPAC/FEC* (GHQ, Far East Command, Military Intelligence Section, General Staff, 1950), vol. 10 of Intelligence Series, Civil Intelligence Section (Record Group 23, Willoughby Papers, MacArthur Memorial Archives, Norfolk, Virginia). Also, see Brian Powell, *Kabuki in Modern Japan: Mayama Seika and His Plays* (New York: St. Martin's Press, 1990); and "The Samurai Ethic in Mayama Seika's *Genroku Chūshingura*," *Modern Asian Studies* 18:4 (1984), 725–745. Although Powell provides a wealth of detail about Mayama's career and plays, including interaction with actor Sadanji II and Shōchiku management, he does not deal as extensively with the wartime record of the actors as in his essay on Zenshinza, "Communist Kabuki: A Contradiction in Terms?" in James Richmond, ed., *Drama and Society* (Cambridge University Press, 1979), 147–167.

9. This account is reconstructed from columns, theatrical notes, and advertisements in the *Asahi shimbun* and *Nippon Times*. Stahmer comment is from *Nippon Times*, June 24, 1944; Ennosuke is quoted in the same source, August 16, 1945. Also, Donald Keene, *Dawn to the West: Japanese Literature of the Modern Era, Poetry, Drama, Criticism* (New York: Holt, Rinehart and Winston, 1984), 393–395 (kabuki's lack of success with up-to-date war themes during the first Sino-Japanese War and the Russo-Japanese War) and 380–381 (World War II); Onoe Baikō, *Ume to Kiku* (Plum and Chrysanthemum) (Tokyo: Nihon Keizai Shinbun, 1979), 80–81. Much more needs to be done on wartime domestic and overseas performances, using theatrical magazines and other sources. Of great interest, Still Pictures, Archives II, has a photograph dated December 26, 1937, captioned: "News of the Nanking siege reaches a Japanese theatre. Tokyo, Japan—Actors of the Tokyo Kabukiza Theater in the costumes of the 47 Ronin (Lordless Samurai), a classical drama, shouting 'Banzai' on the stage with the audience as news of the fall of the gate of Nanking reach the city" (#306-NT-1150-A-5). Until mid-1943, kabuki programs tended to be balanced, including entertainment or crowd pleasers as well as old and new plays designated by the Cabinet Information Bureau as edifying or patriotic national dramas. Audience reception of patriotic plays and the inner feelings of actors are unclear. Major kabuki actors referred to in this essay include Ichimura Uzaemon XV, Onoe Kikugorō VI, Nakamura Kichiemon I, Matsumoto Kōshirō VII, Kataoka Nizaemon XII, Ichikawa Ennosuke II, and Kawarazaki

Chōjūrō IV. No actor in any media was purged during the Occupation; indeed, the question seems not to have been raised, although directors of Shōchiku Theatrical Enterprises, including President Ōtani, were examined in 1947 (RG 331, PPB files). An excellent source on the complex choices of an egotistical stage actor in Nazi Germany is the Klaus Mann novel (1935) and Istvan Szabo film (1981) *Mephisto,* based on the career of Gustav Gründgens (a reference I owe to my colleague, Richard Wetzell, historian of twentieth-century Germany).

10. For early CI&E media instructions, see Kyoko Hirano, *Mr. Smith Goes to Tokyo: Japanese Cinema under the American Occupation, 1945–1952* (Washington, D.C.: Smithsonian Institution Press, 1992), 34–35; *Nippon Times,* October 6, 1945 (CI&E was out of order in telling the Japanese media what motifs to drop; technically, their job was to recommend and guide, not to censor). For PPB's initial conception of its role, see RG 331, CCD files, Memorandum issued to Japanese Government by GHQ, September 22, 1945; and Draft, "Background, Activities, and Aims of the Pictorial Section," PPB Division, CCCIG-J, no author, no date (internal evidence indicates late September 1945 as the time of writing; the author may have been Capt. Charles B. Reese, a pictorial censor who gave the Japanese their first briefings on new codes for the legitimate stage and who departed Japan in early November. Other early pictorial censors were Hugh Walker, a British national who was in prewar Japan; Lt. Victor W. Ehlers (no background information); and Japanese American Arthur K. Mori, future head of the theatrical unit. In final form, ten censorship regulations for theater were issued by letter, not directive, to individual troupes and producers, including bans on "glorification of feudalism, militarism," or "blind loyalty to undemocratic feudal ideals," depictions of women as unequal, playing of military music, use of General MacArthur's name, "false or unfavorable criticism" of the Occupation, and distortions of historical events. "The job is yours to see that the theater be used for building a thinking nation of free people." Large Tokyo producers were required to submit scripts for precensorhip; postcensorship entailed viewing the actual approved plays (RG 331, PPB files, section on theater in "Manual for Censors of the Motion Picture Department," 15 August 1946; and Policy-Theater folder, no date, but at least early 1946).

11. RG 331, CI&E Daily Reports, Film and Theatrical Unit, October-November 1945; later, Semiweekly Reports, December 1945–January 1946; also, John Boruff, "Under New Management: The Japanese Theater," *Town and Country* (September 1946), 161. Itō's prewar career is assessed in Helen Caldwell, *Michio Ito: The Dancer and His Dances* (Berkeley: University of California Press, 1977). During the Occupation, Itō was relegated to training dancers and directing reviews for GI audiences at the Ernie Pyle Theater ("Tokyo Special: U.S. Army Plays Impresario in Tokyo," *Dance* [July 1947]).

12. RG 331, CI&E, Daily Theater Reports, Month of October 1945; Boruff, "Under New Management," 275; Ben Bruce Blakeney's eulogy, "Rokudaime," *Contemporary Japan* 18 (October/December 1949), 505, 514–515. Though Boruff did not understand Japanese, PPB censor Hugh Walker, who did, recommended on October 17 the deletion of propaganda lines from the Ginza script, such as: "You should lead reconstruction like Oishi Kuranosuke in *Chūshingura*"; and "To die in battle is fruitful but to die in an earthquake is sheer waste." He also thought that the cry of "Banzai!" by the whole cast at the end of the play was unacceptable (RG 331, PPB files).

13. RG 331, CI&E files, Daily Theater Reports, November 1945. *Broken Dish* (also translated as *Haunted House of Plates* or *Mansion of Dishes at Banchō*) was a New Kabuki play

written by Okamoto Kidō; see Keene, *Poetry, Drama, Criticism,* 427; and Kabukiza playbill, June 2000, *Kabuki* (Tokyo: Kabukiza). *Terakoya* (Village School) was in fact a scene and separate play in itself taken from a Tokugawa period classic, *Sugawara denju tenarai kagami* (Secrets of Sugawara's Calligraphy).

14. For Japanese concerns and Shōchiku's countermaneuvers, see Watanabe Toshio (Professor Emeritus, Waseda University), "Senryōka no kabuki" (Kabuki under Occupation), *Bungei shunjū* (Literary Review) (December 1995), 208–221. Kawatake debunks the story that Japanese police and American MPs walked onto the stage from a hiding place in the theater and suddenly stopped a performance of *Terakoya* in September (some variations say November), just as a severed head was being inspected. As CI&E theatrical records indicate, this play was not presented until November. SCAP had forbade Japanese police intervention, and the initial preference of pictorial censors (Reese and Ehlers) was to ask Shōchiku to exercise self-restraint and voluntarily (and perhaps permanently) withdraw the play after completion of its run. Although the play in fact closed within a week, following several exchanges of phone calls, still unclear is whether or not it was terminated earlier than intended or finished according to schedule (not to be revived). Whatever the precise explanation, Reese, Ehlers, and Boruff became angry with Shōchiku, looked for trustworthy Japanese consultants, and moved toward stricter control.

15. RG 331, CI&E theatrical records for November and December 1945. Also Kawatake Toshio, who lists thirteen forbidden themes specified by SCAP in late November, no exact date, in "The Crisis of Kabuki and Its Revival after World War II," *Waseda Journal of Asian Studies* 5 (1983), 37–38. Both of the Western plays were selected by Japanese actors and producers and not recommended by CI&E. Boruff was aware that the theme of French resistance to Nazi occupation might have double meaning to actors in occupied Japan but decided that the democratic thrust of the play undercut any subversive intention. At this early stage, SCAP media officials also found *Shingeki* to be tainted by wartime nationalism but had hopes that this would change with the return of Hijikata, a leader in the Tsukiji Little Theater movement in the 1920s, and with the liberation of modern forms of drama from Japanese thought control. In March 1946, Hijikata came through with the first postwar production of Ibsen's *A Doll's House*. For general background, see David Goodman, "Shingeki under the Occupation," in Burkman, ed., *The Occupation of Japan,* 189–198; also see Keene, *Poetry, Drama, Criticism,* 437–497.

16. RG 331, CI&E daily theatrical reports; Boruff, "Under New Management," 275–277; *Sakura giminden* (a New Kabuki drama written by Kawatake Mokuami, not an old Edo drama), if performed according to the basic story line, would have contained a final scene of the crucifixion of the village hero following the execution of his wife and children; Anne Walthall, "Sakura Sōgorō Story," chapter 1 in *Peasant Uprisings in Japan: A Critical Anthology of Peasant Histories* (Chicago: University of Chicago, 1991).

17. RG 331, CI&E files, Weekly Theater Reports, December 1–14, 1945; PPB files, December 21, 1945, "Disapproved List of Kabuki and Neo-Classical Plays"; Boruff, "Under New Management," 277; also, Kawatake Toshio, "The Crisis of Kabuki," 38–39; updated and expanded in his "Senryōka no Kabuki" (213–214), which relies on a handwritten memo by his father, Kawatake Shigetoshi, adopted son of late Tokugawa and Meiji kabuki playwright Mokuami and leading theater scholar. The senior Kawatake, who was present for two of the four days, characterized the talks as "give and take," "nothing prosecutorial," and not like the Japanese military. Boruff was singled out as especially gentlemanly.

In one play, the theme of revenge by peasant women against a samurai was considered acceptable; but a comic play about the seventeenth-century travels of Mito Kōmon (first daimyo of the Mito domain), was suspect because his nineteenth-century successor, Mito Nariaki, advocated *sonnō-jōi* (revere the emperor and repel the barbarian). The Kawatake memo (more detailed than the SCAP record) further noted that Vaccari and the nisei interpreters (not identified) were armed with a copy of Iizuka Tomoichirō's *Kabuki Saiken* (A Close Look at Kabuki) (Tokyo: Daiichi Shobō, 1926). For Kawatake Shigetoshi's own account of this period, see "Kabuki tsuihō no kiroku" (Records of the Proscription of Kabuki), *Engekikai* (January 1961), 34–41. Among the few English-language works on kabuki were Zoë Kincaid, *Kabuki: The Popular Stage of Japan* (London: Macmillan, 1926), the first full-length treatment by a Western author; Frank A. Lombard, *An Outline History of Japanese Drama* (London: Allen and Unwin, 1929); and two publications by Miyamori Atsumori, *Tales from Old Japanese Dramas* (New York: G. P. Putnam, 1915), devoted largely to Bunraku but with photographic illustrations from the kabuki stage; and *Masterpieces of Chikamatsu: The Japanese Shakespeare* (London: Allen and Unwin, 1926). There is no evidence that they were used by SCAP at this time. Kincaid's views were laudatory, and in the 1920s she had found no fault with *Terakoya*. "Of all the countless loyalty scenes of the Japanese stage," this play "for construction, pathos, and swiftness of movement cannot be surpassed" (279). In a recent essay, Takashi Sasayama denounces Miyamori's works as "jingoistic" and "shallow," one of the many examples of "ransacking" Chikamatsu's plays "for likenesses to those of Shakespeare," while showing little "awareness of the differences" or dissimilar "cultural contexts"; see "Tragedy and Emotion: Shakespeare and Chikamatsu," in Takashi Sasayama et al., eds., *Shakespeare and the Japanese Stage* (Cambridge; Cambridge University Press, 1998), 145.

18. RG331, CI&E, Weekly Theater Reports, January 1946; Hal Keith, "Occupation and the Japanese Stage," *Theatre Arts* (April 1946), 240–241; Kawatake Toshio, "The Crisis of Kabuki," 37. Miyake's 1938 guide was part of a series published under the auspices of the Board of Tourist Industry, Japanese Government Railways. According to the senior Kawatake's personal memo, a farewell dinner party for Boruff was hosted by President Ōtani of Shōchiku at a Japanese restaurant on January 11. Present for the Americans were Ernst, Keith, and Vaccari; among the Japanese were Kawatake senior, Itō Michio, and Kubota Mantarō. Boruff (backed by Keith) is said to have urged the presentation of at least 50 percent new dramatic material at each performance to help undermine SCAP opposition to kabuki, given kabuki's strong feudal tendency and weak inclination to cooperate with democratization. The next morning, continues Kawatake, Boruff's urging became Keith's order, voiced in stern language: "'Kabuki is feudalistic and counter to democratization. Nevertheless, we are recognizing its artistic values and allowing it to be performed. Show performances that demonstrate democratization. Otherwise, we will shut down Kabuki.'" In retrospect, the senior Kawatake believed that it was poor tactics to entertain at a black market restaurant and show the Americans how much they loved kabuki (Kawatake Toshio, "Senryōka no Kabuki," 216–217). Not unexpectedly, there is no CI&E record of this party.

19. Ernst entry, *Directory of American Scholars* (Lancaster, PA: Science Press, 1957). Ernst provides a critical summary of the early activities and state of mind of CI&E and PPB officers without, however, revealing his own participation; see his "Kabuki and the Western Room," in *Kabuki Theater* (New York: Oxford University Press, 1956). My thanks also

to James R. Brandon, University of Hawai'i, for additional information. Kawatake Toshio's two articles, "The Crisis of Kabuki: Major Bowers, Who Saved Kabuki from Suppression" and "Senryōka no kabuki," pay tribute to Faubion Bowers (see below) for saving kabuki ("authentic" kabuki) from SCAP oppression. In common with other accounts, they do not distinguish between CI&E and PPB, partially misconstrue the official roles of Bowers in 1946–1948, and virtually ignore Ernst.

20. RG 331, in both CI&E and PPB files, January 11, 1946, Check Sheet, CI&E (Dyke) to OCCIO (Office of the Chief of Counter-Intelligence) (Thorpe); ALD (Major Alfred Dibella, chief of PPB) to head of CCD, "Censorship of Kabuki Plays," January 19, 1946; Check Sheet, Thorpe to Dyke, January 22, 1946.

21. RG 331, PPB files, Memo for Record, January 23, 1946, attaching CI&E press release of January 22, 1946, also Memorandum for Record, January 25, 1946; CI&E files, Weekly Theater Report, January 26, 1946. It was perhaps not coincidental that Henderson was much involved in releasing stories about CI&E's efforts to preserve Japanese fine arts and the American decision to spare Kyoto and Nara from B-29 bombing raids. For Nugent, see letters from Japan, Payson J. Treat Collection, Hoover Institution, Stanford University.

22. Details in *Nippon Times*, March 18, 23, and 25, 1946.

23. RG 331, CI&E files, Keith, Weekly Theater Report, March 9, 1946; April 20, 1946 (Keith called Ennosuke a "forward-seeing actor of the old school"); Ernst, *Kabuki Theater*, 267. *Takatoki* was a New Kabuki drama written by Mokuami in 1884. In February, Keith took great interest in a new production starring Chōjūrō and the Zenshinza, *Abraham Lincoln*, a 1919 play by British writer John Drinkwater (see *Life* magazine, "Japanese Lincoln," April 8, 1946, 77–78 and 80). This fascinating troupe, praised by CI&E for its interest in "appropriate" democratic theater, was the same one that was suspected of leftist thought in the early 1930s, played *Genroku chūshingura* in wartime Japan, performed Shakespeare during much of the early Occupation, and joined the Communist Party en masse in March 1949; for possible wartime motives, Powell suggests patriotism, collaboration, and time serving in addition to enjoyment of box-office success ("Communist Kabuki," 160–162). Another possibility might be *tenkō* (forced public conversion from leftist thought to loyalism). On the whole, the monitored *Nippon Times* in spring 1946 carried supportive articles: April 7, "Kabuki Drama Makes Brilliant Comeback"; April 27, "Heian Court Scenes Recreated on Stage"; and May 12, "Kabuki Drama Makes Big Comeback" (reporting the appearance for the first time after the war of "a whole bevy of top-notch Kabuki actors"). The exception was a two-part article on May 26–27 by Kawatake Shigetoshi headlined, "Kabuki Drama Said in Danger of Falling into Rank Decay." PPB magazine censors, in fact, were alert to the revamping of *Sukeroku;* they had caught and deleted a line from a simplified guide to the play in the April issue of *Engekikai:* "Naturally, the episode of Soga is omitted this time out of consideration of revenge." The author, editor Atsumi Seitarō, had participated in the December 1945 CI&E/CCD kabuki review.

24. Unfavorable reactions to innovative kabuki appeared in Japanese newspapers, *Tokyo shimbun*, January 20 and 26, 1946 (highly regarded for coverage of the arts and long interest in kabuki), and *Jiji shimbun*, January 26; RG 331, PPB files, has Shōchiku lists of good plays in three categories (classic kabuki, modern kabuki, and dance drama), apparently dating from late April and naming *Kanjinchō* as good; additional remarks, Ernst/Bowers "Special Report," April 1947. Also, CI&E files, Weekly Theater Report, May 5, 1946. Kissing scenes were also being introduced for the first time into Japanese movies; see *Nippon Times*, May 19, 1946.

25. Faubion Bowers, Interview (by Beate Sirota Gordon), October 2, 1960, Oral History Project on the Occupation of Japan, Columbia University Archives; also *Current Biography*, 1959; *Nippon Times Magazine*, July 20, 1946; Onoe Baikō, *Ume to Kiku*, 88–89 (Uzaemon had died in March 1945); Santha Rama Rau (who was married to Bowers, 1951–1966), *East of Home* (New York: Harper and Bros., 1950), 51; Bowers, *Japan Society Newsletter* (New York: October 1995); Letter, Bowers, To Whom It May Concern, March 31, 1946, MacArthur Memorial Archives, RG 5, Box 1, Correspondence, Master File. In "Crisis of Kabuki," Kawatake Toshio praises Bowers (whom he mistakenly identifies as a censor in 1946 and places in CI&E—not PPB) for helping to save "authentic Kabuki" from stringent censorship and aiding its revival in early postwar Japan (34, 41–42). See also "Special Talk" section, "Sengo kabuki no kyūseishu to kataru" (Talking with the Savior of Postwar kabuki—Roundtable with Faubion Bowers, Onoe Baikō, and Mogi Chikashi), *Engekikai* (November 1993), 133–139. In 1984, Bowers was decorated by the emperor with the Order of the Sacred Treasure (obituary, "Faubion Bowers, 82, Defender of Kabuki in Occupied Japan," November 22, 1999.) A new book by journalist Okamoto Shirō, *Kabuki o sukutta otoko: Makkasa no fukukan Fobian Bawazu* (The Man Who Saved Kabuki: Faubion Bowers, Aide to MacArthur) (Tokyo: Shueisha, 1998), attempts with limited success to correct the confusion between CI&E and PPB. The author, who relies heavily on materials provided by the Kawatakes and Bowers and an interview with distinguished kabuki actor Nakamura Matagorō II, does not adequately probe the wartime period or fully exploit the documentary record in RG 331, Archives II (microfiche copies at the National Diet Library, Tokyo), with the exception of marginally related CI&E summaries of kabuki scripts. Though Bower's role and generosity—and his love of kabuki—were extraordinary, the key role of Ernst in protecting and promoting kabuki, both during and after the Occupation, is given short shrift. Thus far, there is no evidence to support Bowers' claim in interviews that MacArthur attended but had little enthusiasm for kabuki while accompanying President Manuel Quezon of the Philippines on a world tour in 1937. Whatever MacArthur's personal views may have been, SCAP had a clearly articulated art policy; the problem was how to enforce it "so that the charge can never be brought that the Occupation had in any way destroyed any part of the Japanese cultural heritage" (RG 331, PPB censorship files, Ernst memo, September 13, 1946).

26. RG 331, PPB censorship files, Memorandum for Record, January 25, 1946 (Bowers apparently spoke to Major John Costello); copy of suppressed Bowers interview for *Tokyo shimbun*, February 19, 1946 (however, Okamoto, *Kabuki o sukutta otoko*, 226–228, alludes to an earlier article by Bowers in this newspaper, *including his picture,* on February 13; translation of *Sukeroku* was serialized in *Nippon Times*, May 5–9, 1946 (as indicated, the revenge theme was masked). For a deeper reading of the play, see James R. Brandon, *Kabuki: Five Classic Plays* (Honolulu: University of Hawai'i Press, 1975), 14, 51–92; also Barbara E. Thornbury, *Sukeroku's Double Identity: The Dramatic Structure of Edo Kabuki* (Ann Arbor: Center for Japanese Studies, University of Michigan); Laurence R. Kominz, *Avatars of Vengeance: Japanese Drama and the Soga Literary Tradition* (Ann Arbor, Michigan: Center for Japanese Studies, University of Michigan, 1995), 180–181, 218–221. Bowers' special vision of kabuki is well expressed in his ninety-minute PBS television production, "The Cruelty of Beauty" (broadcast in 1981); I am grateful to Bowers for sharing his copy with me.

27. RG 331, PPB files, note, JJC (John J. Costello) to KC (Keith Cameron), March 23, 1946; Pictorial to Chief, PPB, March 25, 1946; also, Shōchiku, "Kabuki plays scheduled to be presented again" (no date), PPB notation in pencil, "Good Plays," including *Kanjinchō;*

Onoe Baikō, *Ume to Kiku,* 89; *Nippon Times,* June 16, 1946, column by Kuwabara Hideo, "Old Favorite Staged for Kabuki Lovers" (a play symbolizing "defense of the just against the unjust"); articles by Bowers, July 20, 1946, "Actors and the Kabuki Today," July 20, 1946; "Acting is the Thing in the Kabuki," July 27, 1946; and *Pacific Stars and Stripes,* June 22, 1946, and August 10, 13, and 14, 1946 (all on *The Mikado*). Several months after the play's revival, magazine censors learned that Bowers had been involved in tinkering with the *Kanjinchō* script to make it acceptable (see below). To assist censors in the Fukuoka District, Ernst explained that the list of approved and disapproved titles was a guide and that individual scripts were to be censored on their merits (RG 331, PPB files, Pictorial to Chief, April 2, 1946). Documents relating to American cultural policy for West Germany are in RG 260 (OMGUS, Office of Military Government United States), Records of the Education and Cultural Relations Division, Archives II; see also Geoffrey Skelton, *Wagner at Bayreuth: Experiment and Tradition* (New York: George Braziller, 1965), chapter 13; and Frederic Spotts, *Bayreuth: A History of the Wagner Festival* (New Haven: Yale University Press, 1994), 183–212.

28. This was a lavish production planned by Special Services, GHQ, at the Imperial Theater and performed only for Allied personnel in Tokyo (though a few Japanese managed to see it). Lt. Col. Nugent intervened on August 24 to stop performances for a Japanese audience (RG 331, observations by Arthur K. Mori and Earle Ernst, September 4, 1946, protesting CI&E interference with a censorship function). For the run, see *Nippon Times,* August 7 and 13; *Pacific Stars and Stripes,* June 22, August 10 and 13–14; and *Life* magazine, September 9, 1946, 42–43. In January 1948, *The Mikado,* directed by Itō Michio, was performed in Japanese for the first time, after Shōchiku with great difficulty obtained renewed copyright clearance. Among those attending were Prince Takamatsu and two other members of the emperor's household; *Nippon Times,* January 31, 1948.

29. "Kabuki Drama Said in Danger of Falling into Rank Decay," translated for *Nippon Times,* May 26 and 27, 1946, from *Seikei shunjū* (Review of Politics and Economics); comments in *Tokyo shimbun,* May 9–10, 1947, as reported in RG 331, Pictorial Section, Monthly Operations Report, May 20, 1947, to PPB/I; Bowers on Kawatake, Memo, February 13, 1947. A sample of Kawatake's wartime writing, supporting cultural mobilization and the replacement of Anglo-American culture in the Greater East Asia Sphere with distinctly Oriental ones, may be seen in *Buyō geijutsu* (Classical Dance Art), translated for the *Japan Times* (before its name change), May 7, 1942.

30. RG 331, PPB censorship files, "Special Report," 1947; Bowers, "Report on Performance of Chushingura," November 1947; Bowers, *Japanese Theater* (New York: Heritage House, 1952), in tribute to Kawatake and Komiya, xix–xx. *Nippon Times* editorial, February 24, 1946, supported Education Minister Abe Yoshishige's proposal for a national theater of classic drama. For other views monitored by censors (references to kabuki were a CCD intelligence target), see Richard Kunzman (head of PPB/I), Memo, September 16, 1946, to Costello, placing hold on Yamaguchi Jūichirō's drama comments for *Minpō* (People's News), and reporting anonymous Japanese letter, August 20, 1946; Kitamura Kihachi, "Future of Kabuki," *Contemporary Japan* (September/December 1946) (if kabuki, though feudalistic and sometimes absurd, dies from neglect, it will "leave an irretrievable void in the classical art of the country"; he recommended government protection, 376); and Atsumi Seitarō, "Whither the Kabuki," *Oriental Economist,* February 8, 1947, 93–94.

31. Santha Rama Rau, *East of Home,* 51. Kawabe Shinzō's article, "Kichiemon Naka-

mura," for *Contemporary Japan,* December 1940, praised the actor as "adept in presenting plays of the traditional *samurai* spirit, which will be welcomed by the people under the new national moral code" and identified Tōyama Mitsuru, director of the Gen'yōsha (Black Ocean Society), and Count Ogasawara Chōsei, a leader in "designing the projected new national structure," as his patrons (1556). In "Senryōka no kabuki," Kawatake reveals that Bowers loaned his father a confidential CCD record in 1948; his description of a copy in translation identifies it as the "Special Report" coauthored by Ernst and Bowers in spring 1947. Kawatake notes that it contains errors, especially in the first half dealing with historical matters, but does not indicate what they were. "It appears," he comments, "that the opportunistic and biased explanations on the Japanese side were swallowed whole" (210). Clearly, Japanese confidants like Kawatake's father and Shōchiku's management were aware of the struggle within SCAP between the desire to preserve art and to abolish "feudal" thinking—and used it to their advantage.

32. RG 331, PPB censorship files, "Samurai Literature," undated poll (internal evidence places it in late 1946).

33. This was a departure from the original tale in which Kumagai in fact reluctantly killed and decapitated the young enemy warrior. RG 331, PPB files, Ernst to Mori and Kunzman, "Chronicle of the Battle of Ichinotani," September 26, 1946; Costello, concurrence with Ernst's decision, September 30 (for October production by Kichiemon's troupe); PPB/I, Monthly Operations Report, Kunzman to Chief, PPB, October 11, 1946. Costello, intrigued by the controversy, wanted to see Kichiemon perform and asked for a reminder when the play opened. According to Kawatake Toshio (relying on his father's personal account), Kichiemon's wife was sent to Bowers, identified in error as assistant to Ernst, to present the request for *Kumagai*'s release and help find employment for her husband ("Senryōka no kabuki," 219–220). Although Bowers, who was neither a censor nor a guidance officer at this point, may well have argued the case, it was Ernst and his superiors who made the decision to clear the play and who determined the conditions of its performance.

34. RG 331, PPB censorship files (U.S. censors were aware that Shakespeare's plays were banned in wartime Japan). There is no evidence that this script was used; however, the Radio Tokyo Drama Workshop subsequently performed two Shakespeare plays in kabuki style while dressed in kabuki costumes, *Macbeth* in 1947 and *Hamlet* in 1948, both under the supervision of CI&E radio officer Bernarr Cooper. Illustrated articles in *Pacific Stars and Stripes,* April 27, 1947; and *BCON* (British Commonwealth Occupation News), November 27, 1948.

35. Bowers, "Finest Example of Pure Kabuki," *Nippon Times Magazine,* October 19, 1945. Seventy-three-year-old Sugimoto Etsu, well-known author of *A Daughter of the Samurai* (first published in 1926), denounced new lines in kabuki plays as "simply trash"; Japanese should not abandon the "genuine beauty" of their "old civilization" (*Nippon Times,* December 15, 1946). After this story, there was very little English-language news about kabuki for foreign readers between 1947 and 1949. Apparently, PPB welcomed praise from Japanese fans for saving kabuki but also hoped to avoid criticism from Americans or their Allies for allowing representations of feudal ideology on the stage.

36. RG 331, PPB censorship files, "Special Report," 1947; Ernst, Memorandum to Mori, Kunzman, and Costello, February 26, 1947; Field trip by Bowers to Districts II and III, Memorandum for Record, April 8, 1947.

37. "Special Report" (*Adachi* was *Ōshū Adachigahara* or Plains of Adachi); Ernst and

Bowers, Memo for the Record, April 16, 1947; Pictorial Section, Monthly Operations Report, May 20, 1947 (which noted approval for *Sugawara denju tenarai kagami,* with a few deletions to lessen glorification of the way of the warrior); Bowers, Memos for the Record, May 29 and June 2, 1947, giving special permission, with deletions, for *Sanemori;* Memo for Record, Mori and Bowers, Pictorial Section, July 1, 1947. *Ōmori Hikoshichi,* one of Kōshirō's favorite roles, was a New Kabuki drama written in 1897 by Meiji journalist Fuku-chi Gen'ichirō; see Kincaid, *Kabuki,* 23, 360; Kabukiza, *Kabuki* (play guide, September 1975). Interference with Bunraku and Nō, never extensively enforced, diminished in the spring and fall of 1947, since both theatrical forms were deemed to be of historical and cultural importance and their audiences were very small. (RG 331, PPB files, "Chronological Index of PPB History," Part 1, 1950). In September 1946, Ernst argued that "the suppression of Noh plays would be a clear-cut and indefensible case of artistic vandalism"; and in Feb-ruary 1947, after a trip to Osaka, he urged the "greatest freedom possible" for Bunraku, "short of a production of Chushingura," since "stringent censorship" would "hasten its early demise"; RG 331, PPB files, Ernst memo, endorsed by Mori, to District I, September 13, 1946; Ernst memo to Mori, Kunzman, and Costello, February 24, 1947; "Chronologi-cal Index of PPB History," Part 1, 1950. Keene, however, raises the issue of Nō drama and compliance with war propaganda in "Japanese Writers and the Greater East Asian War," 306–307.

38. For a critique of the Shakespeare analogy (opera was the other favorite compari-son), see Leonard C. Pronko, "Kabuki and the Elizabethan Theatre," *Education Theatre Journal* 19:1 (March 1967), 9–16.

39. Among many examples in PPB censorship files, see Bowers, Memo for Record, June 5, 1947, reporting submission of unprogressive samurai plays and summoning the manager to his office for severe reprimand; Memo for Record, June 23, 1947, noting sum-mons of troupe manager of traveling group to PPB office for signing of affidavit pledging compliance with censorship regulations.

40. *East of Home,* 50–51 (she mistakenly dates the revival in December 1947). Santha Rama Rau had first taken an interest in Japanese theater at the urging of her father, who recommended it as "the quickest way of learning how a nation thinks." Also, as a diplo-mat, he was able to get her passes to events that were otherwise off-limits (5).

41. RG 331, PPB censorship files, Memo for Record, "Request for Permission to Autho-rize a Special Performance of Chushingura," Mori and Bowers, July 14, 1947; "Authority for Performance of the Kabuki, Chushingura," Kunzman, PPB/I, July 23, 1947; "Further Explanation of Policy Regulation No. 5-408," Mori and Bowers, September 3, 1947; "Com-ments on Chushingura, the Play," Mori and Bowers, September 18, 1947; Checksheet, "Performance of Chushingura," G-2 to Chief of Staff, September 29, 1947. As a symposium discussant in 1984, Bowers declared that in order to get his way, he "lied" to both the Jap-anese and SCAP. "I was interested in art and I wanted an exemplary performance to show the height of artistry"; also, "to have a performance assembling all the great and very aged actors so that the young actors would have a model to remember for the rest of their lives" (Burkman, *The Occupation of Japan,* 204). During the same period, SCAP, fearful of resent-ment, suspended publication of Dr. Nagai Takashi's atomic bomb account, *Nagasaki no kane* (Bells of Nagasaki).

42. John Allyn, "Motion Picture and Theatrical Censorship in Japan," *Waseda Journal of Asian Studies* 7 (1945), 24; Onoe Baikō, *Ume to Kiku,* 90; RG 331, PPB files, Memorandum

for Record, November 10, 1947, identifying Bowers as the author of *Nippon Times* articles (November 19–20, 1947). Allyn, who served as a pictorial censor from November 1945 to October 1949, had studied theater at UCLA before Pearl Harbor and was a recruit to wartime Japanese language training. He retained his interest in the play, and years later, when he was a film professor at the Northridge campus of the California State University system, Allyn published a novel, *Forty-Seven Ronin Story* (Charles E. Tuttle, 1970).

43. RG 331, PPB files, "Special Report," Bowers, "Chushingura (the 47 Faithful Retainers)," November 1947. While the emperor was touring in the Chūgoku region, the empress and empress dowager attended a matinee performance of *Chūshingura* on November 29. According to the *Nippon Times* (November 30), "It was the first time that the first lady of the land and the Imperial mother attended a Kabuki performance in public."

44. RG 331, PPB files, Memo, May 28, 1948, Allyn, District II. On November 9, 1948, a PPB/I Memo stated that *Chūshingura* was the kabuki play most submitted for censorship; in reviewing a total of 78 scripts, censors had passed 40, deleted lines in 17, and suppressed 21 for rightist propaganda. Allyn Memo, March 24, 1949, stating personal support for continuation of theatrical precensorship, particularly in the countryside where feudalism was still deeply rooted, is at odds with his recollection that he supported artistic freedom in 1949 ("Motion Picture and Theatrical Censorship in Japan," 24–25).

45. The full title of this famous 1777 play is *Meiboku sendaihagi;* also, according to the *New Kabuki Encyclopedia,* edited by Samuel L. Leiter (Westport, CT: Greenwood Press, 1997), the author was in fact Nagawa Kamesuke, not Chikamatsu.

46. Examples of magazine censorship are from the Gordon W. Prange Collection, McKeldin Library, University of Maryland: suppressed article, "The Classic Nature of Tanka," intended for *Tanka kenkyū* (Tanka Research); references to *Terakoya* in *Taihei* (Great Peace) and to Kichiemon in *Gekijō* (Theater); "Chikamatsu's Scenario" in *Sekai no ugoki* (World Currents); Kōshirō's "Talks on Acting" in *Gōruden sutaa* (Golden Star). Published magazines and related censorship correspondence for the period 1945 to 1949 are available at Maryland for research on microform; also, approximately 260 microfilm reels of selected censored magazine excerpts from Prange materials are commercially available; see Okuizumi Eizaburō, ed., *Senryōgun ken'etsu zasshi mokuroku, 1945–1949* (User's Guide to the Microfilm Edition of Censored Periodicals: 1945–1949) (Tokyo: Yūshodō Booksellers, 1982). Additional examples from Archives II, RG 331, PPB/I, Memos, January 20, 1948 (suppressed Roosevelt article); September 22, 1948 (praiseworthy book). Elsewhere in Japan, District II (Osaka), in July 1947, censors deleted a passage from a new but already outdated book, *Nippon no engeki* (Japanese Plays), for mourning banned kabuki plays as a great loss to the theatrical world. Why, asked the author, did classical plays "have the power to charm present-day Japan"? Was it their "militarism or nationalism, or their sensitive beauty which appeals to the human senses of sight or hearing?" Still, there was hope for release "through the kindness and understanding of the Censorship Authorities"; RG 331, PPB/II, Memo, July 18, 1947.

47. Under "tangible cultural properties," the law protected "buildings, pictures, sculpture, pieces of calligraphy, classical books, and folk-custom data"; a third category covered "historic sites, places of scenic beauty, and natural monuments"; *Official Gazette* (English edition) 1249, May 30, 1950 (Tokyo: Government Printing Agency).

48. RG 331, PPB files, PPB/I Memo, Allyn, "Reconstruction of Kabuki Theater in Tokyo," September 29, 1949; CCD, Special Report, "Japan Communist Party's Cultural

Front," September 1949. Kuwabara Takeo, author of a 1946 attack on haiku as second-rate art, refers to this debate with Ino Kenji and Kondō Takayoshi in *Japan and Western Civilization* (University of Tokyo Press, 1983), 48–50, 63; original exchange is in *Bungaku* (November 1951 and March, May, and August 1952). See also Hasegawa Kiyoshi, "Future for Kabuki Rests in Keeping Main Features," *Nippon Times*, September 30, 1949 (translated from *Tokyo shimbun*); "Kabuki's Future Faces Struggle with Modern Ideas," in *BCON*, May 20, 1950 ("Whether Kabuki will be able to hold its own against the shifting scene of the Japanese way of life is being debated by the dramatic critic and the average theatergoer as well."); Miriam Silverberg, *Changing Song: The Marxist Manifestos of Nakano Shigeharu* (Princeton, NJ: Princeton University Press, 1990), 111–113; Gilles Kennedy, "Tamasaburō Unchained," in *Tokyo Journal* (March 1993), 43–44. Significant signs of new scholarship include Earl Jackson Jr., who discusses gender and sexuality in "Kabuki Narratives of Male Homoerotic Desire in Saikuku and Mishima," *Educational Theatre Journal* 41:4 (December 1989), 459–477; also Yoko Takakuwa in "Masquerading Womanliness: The Onnagata's Theatrical Performance of Femininity in Kabuki," *Women: A Cultural Review* 5:2 (1994), 154–161; and "The Performance of Gendered Identity in Shakespeare and Kabuki," in Sasayama, ed., *Shakespeare and the Japanese Stage*, 197–213, 345–348. Kano Ayako, in addressing Japan's first modern wars and late Meiji drama, raises important questions about creativity, gender, and the reappearance of women on the Japanese stage and provides an excellent model for research on the later wartime and occupation periods; see "Japanese Theater and Imperialism: Romance and Resistance?" *U.S. Japan Women's Journal* 12 (1997), 17–47.

49. Aubrey S. Halford and Giovanna M. Halford, *The Kabuki Handbook: A Guide to Understanding and Appreciation, with Summaries of Favorite Plays, Explanatory Notes, and Illustrations* (Rutland, VT: Charles Tuttle, 1956). Between the two books was Donald H. Shively, "Bakufu versus Kabuki," *Harvard Journal of Asiatic Studies* 18 (1955), 326–356. Another British publication from these years was Adolpe Clarence Scott, *The Kabuki Theater of Japan* (London: Allen and Unwin, 1956). In 1956, Hokuseido Press reprinted Shioya's 1940 book on *Chūshingura* using printing blocks that had survived B-29 bombing raids. From this point until the late 1960s, general Western understanding would be heavily shaped by the sentiments, tastes, and scholarship of Kawatake Shigetoshi and Kawatake Toshio. Kawarasaki Kunitarō (a leading member of Zenshinza) comments on Bowers and also on the stifling of creativity in postwar kabuki in *Oyama no michi hitotsuji* (The Straight Road of the Female Impersonator) (Tokyo: Yomiuri Shimbun, 1979), 56–57. Nakamura Matazō discusses the difficulty of breaking into family-controlled kabuki in *Kabuki Backstage, Onstage: An Actor's Life* (New York: Kodansha International, 1990). Addressing some of these issues of "living museum" and "living contemporary theater," the Kabukiza presented several New Kabuki plays scripted in the postwar years by well-known authors, such as *Genji monogatari* (Tale of Genji), Hidemi Kon, 1952; *Shinsho Taikōki* (New Account of Hideyoshi), Matsuyama Zenzo, based on a historical novel by Yoshikawa Eiji, 1962; *Oku no hosomichi* (Narrow Road to the North) and *Kasuga no Tsubone* (Lady Kasuga of Tsubone), both by Hōjō Hideji, 1974–1975. See, for example, *Kabuki*, Kabukiza program for October 1975. What is needed is a sequel, with special attention to the state and to commercial enterprise, to Jean-Jacques Tschudin's study, *Le Kabuki devant la Modernité (1870–1930)* (Lausanne: Éditions L'Age d'Homme, 1995).

50. Michener, "Japan" (on revisiting his former enemy: "*Kabuki* hit me like a thunder-

bolt. . . . Most *kabuki* plays would be flops in any other medium, but the masterpiece of *kabuki* would be a success in any language. It tells the story of the Forty-Seven *Rōnin* and as long as Japan exists this strange and horrible tale will bear retelling"), *Holiday* magazine (August 1952), 34; Michener to John Foster Dulles, January 6, 1953, RG 59 (Diplomatic Records, Archives II), 894.451/1-653; Donald Richie and Miyoko Watanabe, postscript, *Six Kabuki Plays* (Tokyo: Hokuseido Press, 1963); Donald Richie (drama critic), *Nippon Times,* June 13, 1960; reviews, *New York Times,* June 3 and 12, 1960; Kawatake Toshio, "Kabuki Goes to America," in *Japan on Stage: Japanese Concepts of Beauty as Shown in the Traditional Theater* (Tokyo: 3A Corporation, 1990). As a postscript to the odyssey of kabuki's rehabilitation in the Western gaze, Leonard C. Pronko would extol *Terakoya* "as not only a masterpiece of the kabuki theater," but also as "one of the summits of world theater," in *"Terakoya:* Kabuki and the Diminished Theater of the West," *Modern Drama* 11 (May 1965), 47–57; Samuel L. Leiter would argue that kabuki fight scenes "have an enormous amount to offer" in enriching productions of Western theater classics," in "The Depiction of Violence on the Kabuki Stage," *Educational Theater Journal* 21:2 (May 1969), 155.

51. See Douglas Strunk, "Tale of 47 Samurai Stirs Questions in Modern Japan," *Washington Post,* January 1, 2000.

Pleading for the Body: Tamura Taijirō's 1947 Korean Comfort Woman Story, *Biography of a Prostitute*

H. Eleanor Kerkham

REPRESENTATIONS OF WOMEN in the Japanese popular media during World War II centered around the good wife/wise mother or "maid-in-waiting" struggling to remain cheerful as she sent her men off to war, stoically accepted the death of a loved one in battle, or contributed to the war effort at home, on the farm, or in the factory.[1] A role for "the other" woman was assumed, if not openly depicted—that of comforting and sexually servicing Japanese men in the homeland, in overseas territories, and on or near the front lines.[2] In the context of a militarized Japan, direct and indirect intervention in women's lives was seen as part of the "natural, common-sense" solution to a variety of crucial strategic and civil problems. Men must serve as soldiers; women must be mother, nurse, emotional comforter, and sexual satisfier of soldiers.[3]

In her study of the militarization of women's lives, Cynthia Enloe says the following about militarized prostitution:[4]

> The history of the various attempts to control the sexual behavior of soldiers and the women whose bodies they buy has yet to be written. It is a history that is especially hard to chart because so many women who have been subjected to such control have lacked the resources—money, literacy, fluency in the language of military officialdom, access to other women's support—that have given some select women a "voice" and a place in written histories.[5]

The history of militarized prostitution is long and extends across many national boundaries, yet it remains, as Enloe suggested, largely unwritten.[6] Its policies are difficult to document because the existence of such a policy is normally denied and because responsibilities for its implementation are passed "down the chain of com-

mand to the level of field officers, where politicians and citizen groups have great trouble monitoring and holding the military as a whole accountable." This "does not mean," says Enloe, "that a military elite has no policy. It may only suggest that the military is aware that its attitudes and practices surrounding sexuality are fraught with contradictions and political risks." Enloe concludes that although risks can be minimized by combinations of informal, decentralized decision making and "official acknowledgment only of 'health issues,'" still, *under certain circumstances and at rare times, . . . militarized prostitution does become visible and does acquire the status of a public issue.*"[7]

While many Japanese knew of the existence of women sexually serving the military on and near battlefront areas, stories of militarized "comfort women" (*jūgun ianfu*) were not told in the popular media.[8] Official silence about them prevailed throughout the war. Repatriated to Japan from the Chinese mainland in February 1946, Tamura Taijirō (1911–1983), an established writer before the war, assumed that he would be allowed to break this silence. He soon began, in his words, "openly describing things which stagnated in my breast during the long war years."[9] One of the things that lay heavily in Tamura's heart was the plight of the Korean *ianfu*, young women used by the Japanese military in the frontline camps in which he too had served as an ordinary soldier for almost seven years. In his preface to an unpublished, censored version of *Shunpuden* (The Biography of a Prostitute, 1947), a short novel that centers on the tragic life and death of one Korean woman used by the Japanese military in China, the author reveals his concern:

> I dedicate this story to the tens of thousands of Korean women warriors [*Chōsen joshigun*] who, to comfort ordinary Japanese soldiers deployed to the Asian mainland during the war, risked their lives on remote battlefields where Japanese women feared and disdained to go, thereby losing their youths and their bodies [*nikutai*].[10]

Tamura's popularity in the immediate postwar period was such that publication of *Shunpuden* in the maiden issue of an important new literary journal, *Nihon shōsetsu* (Japanese Fiction), would have provided this group of abused women a public voice and may have, or was apparently perceived as having, the potential to create one of those times "rare times" when militarized prostitution "acquired the status of a public issue." For this and other possible reasons discussed in more detail below, its publication was halted by Allied Occupation censors in April 1947 (Figure 28). A short story by Sakaguchi Ango, *Furen satsujin jiken* (Incident of the Discontinuous Murder), was substituted in its place.

It happened that a complex confluence of local and global circumstances created, beginning in the early 1990s, another one of those rare times.[11] The Japanese Imperial Army's exploitation of Korean, Chinese, Filipino, Taiwanese, Dutch, Indonesian, Vietnamese, Japanese, and other women has become an international political and human rights issue.[12] The exposé of the wartime exploitation of these women and concomitant attempts to seek redress and a proper apology from the

Japanese government came about initially as a result of work by a coalition of women's groups in Korea.[13] The groups centered one prong of their activities around the regular exchange of state visits between Japanese prime ministers and Korean presidents starting in 1990.[14] Prior to Prime Minister Kaifū Toshiki's visit to Korea in November 1990, for example, the women demanded that the Japanese government "apologize and compensate South Korea for the Japanese military's forced use of Korean women for sexual and other services during World War II."[15] Earlier, in June of that year, or several months before Kaifū's visit, an official of Japan's Labor Ministry had denied any connection between the Japanese government and the "comfort women" and had refused to initiate an official investigation into the matter.[16] Nor did Kaifū respond to the demands. Pressed by opposition parties in the Diet, however, a Japanese government spokesman announced in April 1991 that "there was no evidence of the forced draft of comfort women, so there would be no public apology, disclosures or memorial."[17] The official Japanese position was that "comfort women" were recruited by private entrepreneurs and not by the military.

The attempt to dismiss what Rhonda Copelon has called "the massive industrialization of sexual slavery on the battlefield" as a matter of legalized prostitu-

Figure 28. Table of Contents for the April 1947 galley of *Nihon shōsetsu,* showing the censor's marks for the deletion of Tamura Taijirō's *Shunpunden* (The Biography of a Prostitute). From the Gordon W. Prange Collection, University of Maryland.

tion or of ordinary commercial dealings between individuals, although proven to be untrue, has remained part of a typical semiofficial Japanese response to the matter and is reminiscent of the prewar Japanese state's defense of licensed prostitution for purposes of social management.[18] This is in spite of the fact that the Japanese government acknowledged, in July 1994, that the military had established an extensive system of "comfort houses" and had engaged in forced recruitment.[19] As for compensation for the surviving women, the Japanese government has not wavered in its insistence that the question of official war reparations was settled by the 1952 San Francisco Peace Treaty and, in the case of South Korea, settled in 1965 when the two countries signed a Claims Agreement and established full diplomatic relations. "Comfort women" were not covered in this agreement. Behind the Japanese insistence is the denial that the imperial army's military comfort system or its treatment of women constituted a war crime or crime against humanity. This stance includes any sort of war reparations for Japanese "comfort women" as well.[20]

The drama that began to unfold in 1990 features former "comfort women" and their supporters struggling with the Japanese bureaucracy, the courts, and, as of fall 2000, seven successive Japanese prime ministers and their governments. A previously silenced group is attempting to alter the dominant memory of wartime events in which it played a major part. Its efforts were met first by denials, followed by new revelations, partial admissions and apologies, and then by more sophisticated denials. Further revelations led to new admissions, apologies at higher levels, promises to investigate further, more admissions and apologies, and finally to the attempt to help arrange not reparations but compensation from private funding, a tactic strongly opposed by many of the former "comfort women" and their supporters.[21] We can see in this drama Japan's continued resistance to coming to terms with its past—a resistance that Allied Occupation censors facilitated fifty years earlier. Changes in international gender ideologies and in global political, economic, and state structures, however, have made it much more difficult for the Japanese government to control and contain powerful memories of the past. The impulse to silence, to discredit, and to stall, the failure to reveal crucial records, and the refusal to acknowledge that the comfort system involved mass rape and was a violation of basic human rights will, however, continue to cloud our understanding of the events themselves, of the forces that allowed their occurrence, and of the opportunities for redress and healing. Former "comfort women's" voices have, in the meantime, significantly challenged Japan's view of itself, just as they have forever altered our views of the problem of violence against women.

Tamura's *Shunpuden*—particularly its original, uncensored version—represents the author's attempts to deal with some of his own memories and feelings about his experiences as a combat soldier. Its fictional reality and the attempts to alter and suppress this reality share important messages and motifs with the 1990's "comfort women" drama. Our examination of Tamura's aborted attempt to create a voice for the Korean women whose "youths and bodies" were taken from them reveals an author limited by the myths about female roles and male sexual-

ity that allowed the story to be played out in the first place and that has allowed Japan's official voice to continue to deny that the comfort system was indeed a crime against humanity. Tamura is vividly aware of the multiple atrocities imposed on the bodies and souls of a large group of Korean women, and he depicts situations of unequivocal captivity for the women, exposing in the process the fact of multiple rape and the murderous destruction of innocent women. He also accepts as given—indeed he expounds in detail upon—the fact that ordinary fighting men must have women by their sides. Tamura's unidentified narrator (and we assume Tamura himself) is not unconscious of the clash between these two. His interest in the needs of the flesh, however, seems to be as intense as his concern for the Korean women, and when the two come together in the site of the woman's body, a profound contradiction is exposed. This provides the work with a powerful structural tension that is resolved only in the destruction of the woman and the erasure of her memory. Ironically, however, *Shunpuden* was to be published just at the moment when Tamura was gaining notoriety for his *nikutai bungaku* (physical body or flesh literature) theory, and he seems to have intended, at the very least, that the life story of his Korean heroine become a topic of serious public scrutiny and discussion as well.

I begin below with an account of the historical transition from brothel-based to camp-based control of women—a transition dramatized in *Shunpuden*. I allow two of Tamura's soldier-narrators the privilege of presenting, in their own eloquent but chilling manner, the Japanese military's rationale of the need for increasingly close, slavelike control of young and healthy women's bodies. I next briefly examine Tamura's literary career, focusing on his efforts to resume his profession as a writer in postwar Japan. I place *Shunpuden* into the context of Tamura's attempts to redefine his literary world and to play a role as writer and spokesman for *nikutai* literature during the early years of the Allied Occupation. I try also to indicate the novella's relationship to his *nikutai no ron* (theory of the body). Finally I recreate the circumstances surrounding the suppression of *Shunpuden* by foreign censors. My goal is to provide social and historical contexts for understanding Tamura's aborted attempt to confront some of the issues of ethnic, sexual, and class discrimination surrounding the use of Korean women by the Japanese military during World War II, to articulate feelings about his own actions on the battlefield, and to revive his creative life in defeated and occupied Japan.

From "Brothel" to Front Line

One institution utilized by the Japanese military to help identify, recruit, and organize women for distribution to strategic spots was the brothel. Japanese-owned brothels were scattered in Siberia, Manchuria, Korea, China, Southeast Asia, and the South Pacific. These houses, some of which had been established in the late nineteenth and early twentieth centuries as part of Japanese overseas expansion, originally featured women known as *karayuki-san* (one who goes to China or to a foreign land)—Japanese women often sold by parents or tricked by procurers into

contracts requiring that they work as maids (they were often as young as ten years old) and then as prostitutes (from as young as fourteen or fifteen years old) in China or Southeast Asia.[22] Although they are thought to have been recruited from all areas of Japan, many of the *karayuki-san* were daughters of impoverished rural families living in western and northern Kyushu.[23] Their number was probably greatest around the time of the Russo-Japanese War (1904–1905); figures range from 32,000 to 100,000 women.[24] Conscious of its international reputation after World War I, however, the Japanese government sought to control traffic in overseas prostitution, and by 1920 the number of women had dramatically decreased.[25]

At some point not yet fully documented, as more Japanese soldiers were sent to the Asian mainland after the Manchurian Incident in 1931, and particularly after the outbreak of full-scale war in the fall of 1937, the military began to help supply privately owned brothels and to set up its own "comfort stations" for which women were more systematically and aggressively "recruited" to "follow the troops."[26] Just as the Japanese government had begun to enlist ever-larger numbers of men and women workers from Korea—a Japanese colony from 1910 to 1945—it also began to search out young Korean women, as well as women from Taiwan, China, and other places in Southeast Asia, as the emperor's "gifts" to his fighting forces.[27] It will be difficult to know, if we are ever to know, exactly how or when official decisions were made in creating and maintaining the extensive "comfort women" system, which stretched into all areas where there were Japanese troops. As mentioned above, dramatic testimony to the results has been found in several different primary sources.[28] Here, for instance, is a statement made by "KUMAGAE, Shigeshisa (JA 145077), First Class Private," a prisoner of war captured December 10, 1942 and interviewed by the Allied Translator and Interpreter Section (ATIS): "Whenever troops were stationed in a locality in numbers, brothels were immediately established by both the Army and Navy. Korean women and Chinese women were usually employed but occasionally suitable native women would be enrolled. Profits go to the services."[29] The majority of women sent to work in both the older and the newly established "comfort houses" and to supply frontline camps seem to have been from Korea. Of the estimated 70,000 to 200,000 *ianfu* active during the Greater East Asian war years (1937–1945), approximately 80 percent are estimated to have been Korean.[30]

In the novel *Shunpuden,* Tamura depicts his three Korean "Amazon soldiers" as having first been sold by their parents to what seems to be a privately owned brothel for Japanese army officers and civilians in the city of Tianjin, Hebei Province.[31] Tamura treats their sale as a commercial transaction—a family matter and unfortunate occurrence that is apt to befall poor women. They were next recruited by the Japanese army for duty in a frontline army-controlled "comfort house" in Shanxi. Tamura's narrator is aware of the triple jeopardy—of gender, class, and ethnicity—for Korean women forced to play the prostitute role, even in the city brothel. As non-Japanese subjected to a harsh cultural assimilation policy, the women soon learned that their "differences" made them yet more vulnerable to abuse by their Japanese customers:

Harumi was born in a town from the area of P'yŏngyang and Yuriko and Sachiko were born in P'yŏngan Pukto. All had their own Korean names, but when sold to the Akebono-chō in Tianjin by poverty-stricken families, they were given professional Japanese names [*Genjina*]. Having been addressed by their customers only by these names—which they used most often even among themselves—their real names were known only to themselves. There were even times, indeed, when it seemed they had forgotten their own names. The feelings and way of thinking of these women, who had left their homes when very young and had dealt only with Japanese customers, were very Japanese-like, and they were completely unaware of anything unnatural in this. When a drunken customer hurled words of abuse at them, however, they were forced to realize that they were as of a different race from their partners. At such times they became enraged and felt that they were being torn asunder by an unspeakable despair. The sensitive customer, however, moved beyond race and made love to them gently.[32]

The use of the phrase *"minzoku wo koete"* (surmount, move beyond "race," or more accurately, ethnicity), hints at the narrator's own sense of ethnic superiority, feelings that, nevertheless, could somehow be overcome by a customer's sensitivity toward the women.[33]

In what appears to be a common pattern for such arrangements, Harumi's parents had, we are told, received an "advanced loan" *(zenshaku),* a sum several times what she would have to repay to secure her freedom from the house.[34] As Tamura presents the situation, Harumi believes that she can eventually work herself free from her contract. The narrator explains that, during her three years in Tianjin, Harumi had fallen in love with a young Japanese businessman. While working hard to pay off her debt to the brothel so that they might marry, her lover goes back to Japan only to return with a Japanese wife. Thus deceived, Harumi threatens the new wife and violently attacks her lover. The man's colleagues intervene to calm Harumi, but her next impulsive act is to respond to a call for women to go to a Japanese military camp in the town of Yu Xian, northern Shanxi Province. The economics of her transfer remain unclear. We are simply told that Harumi and two friends, "each with her own reasons, were excited to leave Tianjin together, following their new master."[35] Once in the walled village of Yu Xian, the women are under strict army control. Two private homes have been made over into comfort houses. There are ten women for more than a thousand soldiers.

These few women took on the throbbing, desirous young bodies [*nikutai*] of the whole battalion of soldiers who defended the area centering around the provincial seat. Not one of the men failed to go to the women. Even the youngest went to them. The women's rooms were laundries for the soldiers' souls. Just as one washes piles of dirty clothes at the cleaners, so the soldiers came here to launder their flesh, to launder their souls. No matter how exhausted they might be, when they came here their energies

were completely renewed, and they could carry out their duties and sorties the next day with invigorated hearts, exactly as if they had been reborn.[36]

The military assumption made here is clear: In order to periodically renew the spirits and bodies of fighting soldiers, "laundry rooms" with "laundry women" must be provided.

To make it possible that all might have a chance to cleanse their souls with the women, each company was given a different day of the week off. "Thus, while the soldiers came to play once a week, the women had this cruel labor every single day" and, the narrator later reveals, every night.[37] Ordinary soldiers were entertained during the day, noncommissioned officers in the early evening, and an officer or two through the night. The night stint could include drink, song, and possible violent assault:

> The women, however, had to be much more vigilant at night than during the day, since there were those among the officers who could not hold their liquor. They would unsheathe their swords and turn ugly and violent. The men assumed that these women had no thoughts in their heads, but the women knew instinctively to be constantly on guard.
>
> There were many among the officers who thought themselves the finest creatures on earth and who did not consider the women to be human beings at all. The women were, to them, simply instruments to be used to satisfy their physical needs. The officers had ample opportunity, under the pretext of the need for communications and such, to go to the towns along the railroad lines where there were Japanese women. There they could indulge in more humane delicacies. For these men, playing with Korean women on the front lines was merely a physiological thing, like drinking a glass of sake or pissing. When ordinary soldiers managed to get into town, with their one shoulder star and dirty, thread-bare uniforms, they were despised and shunned by the Japanese women. Thus, ordinary soldiers elected to go to their Korean women, cursing the Japanese women as they went. The Koreans were kind enough to face these soldiers in all earnestness. And the soldiers, making love to them, crying with them, quarreling and swearing with them, felt that life was worth living, just this tiny bit. The Japanese women in the towns along the railroad lines meant nothing at all to the common soldier.[38]

The narrator's emotional resentment toward the Japanese women and his conviction of the importance of the role the Korean women played become even more pronounced when he attempts to contrast the work situations of the Japanese and Korean women:

> While Japanese prostitutes in the towns along the railway curled up snugly in silk bedding and fell asleep intertwined on the tatami with military officers, businessmen, or national development company executives, these

318

[Korean] women, on straw bedding in local, unheated houses built of the mud and dirt of the front lines or inside fortified defense battlements even closer to hostilities—when comforting troops of the detachment this was actually how it was—while attacked by bedbugs and threatened at times by enemy fire, responded to the powerful, insatiable desires of the ordinary fighting soldiers.[39]

The narrator appears to be convinced that only the Korean women were willing to take on the difficult but necessary task of caring for the needs of the ordinary soldier.

Tamura next describes the therapeutic emotional dramas created by the soldiers and their Korean women:

It was strenuous labor to try to satisfy the hard, rough desires of these young men who lived only for the moment, unable to assume they would survive another day. The soldiers in this old district seat had each chosen his own play partner from among the women of the Hinode-kan and the Kiminoya. And then, somehow or other, each woman, too, if she discovered her man fooling around with another woman, would chase him down, cursing him roundly. But soon they would make up again, and back he would go to her.[40]

Although the brief testimonials and oral histories of surviving former "comfort women" available to us today only hint at this, the survival technique adopted by the soldiers (having a favorite woman) might, as Tamura suggests, have been adopted by the women as well. To consider the frontline houses as "brothels" is surely a misnomer. And yet to provide even the battlefront houses and their women with professional brothel-like names preserved for the military and its soldiers a semblance of recreational normalcy.

Interaction with the officers is depicted as being more deeply disturbing. In his descriptions of Harumi's unfortunate encounters with her nemesis—a particularly contemptuous officer given to insults and physical abuse—the narrator vividly exposes the assumption of ethnic superiority expressed in the attitude of the officer toward his Korean sex slave. On the occasion of their first meeting, for instance, Harumi has gone to bed for the night with another officer. The higher-ranking second lieutenant, Aide-de-Camp Narita, demands admittance. Harumi refuses to allow him in and Narita kicks open her door, forcing her previous guest to leave. She continues to resist, however: "Get out of here! I won't be with a damn fool; I won't have you!" "'Even if he murders me,' she thinks, 'I will not become the partner of this officer.'" Yet the man will not be deterred. He hisses this slur: "Damn fool! How dare a low-class Korean whore say such a thing?"[41] Shaking with anger, the spirited Harumi comes back with a tactic that had, back in the city, silenced unpleasant customers: "Korean? You wonder how a *Korean* can say such a thing, but we have the same emperor." This bit of logic sends the officer into a

rage and he slaps Harumi down: "You fool, how could the emperor know the likes of one such as you! You utter the word 'emperor'! How dare a dirty slut like you say such a thing?"[42] A groan emerges from deep inside Harumi as she understands for the first time that it is this man, the high-ranking Japanese military officer, who is her "new master":

> While it may be that as a non-Japanese this woman did not understand the received-kindness [*arigatasa*] of the emperor, she spoke as she did because it had always been a useful way to lessen Japanese men's violence. With this officer, however, it had not worked, and a strange, unsettling terror gripped her. She suddenly realized that she had no protection at all, even in the face of brute force such as this. A painful anxiety seemed to ooze up from a deep fathomless abyss. She had unconsciously assumed up to now that the one system of order that existed, even here on the front lines, was that of the emperor. She had placed the safety of her own being in this system. When she saw, however, that there was no such support at all, she knew that even if this officer were to angrily murder her with his military sword, she would become nothing more than a war casualty. All the strength left her body and she sensed a heavy physical numbness.[43]

Here and in subsequent descriptions of Narita's abuse, Tamura's narrator is clearly moved by the mistreatment of Korean women at the hands of an individual officer. He continues, nevertheless, to reason about and theorize on the fact that ordinary combat soldiers must have their women, not simply to satisfy their physiological needs, but also for emotional support.[44] To borrow once again from Cynthia Enloe: "The military needs women as the gender 'woman' to provide men with masculinity-reinforcing incentives to endure all the hardships of soldiering." To handle the practical, strategic problems of health, morale, and "readiness" for combat, women must, the military assumes, be supplied and, particularly near the front, must be under strict army control.[45]

In his 1964 story, *Inago* (Locusts), which centers on a similar group of Korean women transported to fighting areas in China, Tamura again dramatically reveals the gender-based, militarized assumptions about this role that certain women must be asked to play. The opening scenes are similar for the two stories. Sargeant Harada has been sent to field headquarters to pick up a trainload of plain wooden coffins for their unextectedly high battle casualties. He is also assigned the task of transporting five Korean women back to his unit. Sitting in the stiflingly hot freight car, Harada gazes at one of the five, a woman whom he had visited at least ten times in the city brothel:

> Harada fastened his gaze on that seemingly endless dark space below her stomach. He knew very well what that inner space was like; he knew just what was there and how much warmth and moisture it held. Nothing was there, in fact, and yet if pressed he would have to say that there was some-

thing, something that forced him to understand that nothing was there. Every time he entered this space, an ache like a flame ran down his spine, his brain went numb, and in the next instant his heart was empty, a cold wind blew, and he was overcome with the unpleasant feeling that there never was anything there at all. Grit collected in his mouth and he fell into a dull state of mind, not knowing whether he was dead or alive. To Harada, however, to a man like himself who assumed he might very well die tomorrow, that dull state represented a step forward. It allowed him to approach the world of death unafraid. In that sense, the thing right before his eyes that enabled him to enter into a state in which he did not know whether he was dead or alive was, so long as he was a soldier, an absolute necessity.

The thing he had to have was there, three meters away, cradled between the two columns of ample flesh. In the humid, suffocating darkness of the freight car, he knew in his own body that this was what he needed. The train had entered a war zone. When it occurred to him that he had been placed in a destiny in which he had no idea when, where, or in what manner death might visit, he could not pull his hot gaze away from that dark space. In order to thrust aside the fear of death, to make death his companion, he wanted to creep, body and soul, into that dark recess.[46]

Harada resists his desire for the woman, however, and in pondering why he had not allowed his men or himself to touch them en route, he realizes it is because in this perilous situation—that is, while moving through a dangerous war zone from city brothel to battlefield "comfort house"—he and the women are united as equals in a life-and-death struggle. Neither commercial nor military relationships prevail, and he and his men should not touch the women. It happens, however, that they are stopped several times along the way by Japanese soldiers who have heard about the women's presence on the train. Each time they are stopped, the women are pulled out and, in essence, gang-raped by the soldiers. During the last of such stops, the train has driven into a swarm of locusts. An inexperienced, drunken young battery commander demands the women and, when Harada refuses, the officer threatens them with his sword. The women are again compelled to face a gang of soldiers who rape them in the midst of the hot wind, sand, and horde of locusts. When the women return, battered and angry, they fall down exhausted, completely oblivious to the fact that their bodies are exposed to the three soldiers awaiting their return. Seeing the women thus, they become excited and beg Harada, who, painfully aware of their roughened feelings, finally allows them to at least bargain with their favorite woman.

The sight of the women's flesh made them feel they were no longer human. They need not be human. The thing they had to do was abandon those mental constraints that come from being human. They wished to experience that same total abandon that allowed the women to spread

their legs and expose their inner parts in the humid air. To be able to do this, in their situation, would be a strength. The soldiers wanted to be strong. They knew that without this strength, they would not survive the battle.[47]

Once again, while sympathetic to the women (he himself does not approach even his favorite woman), Tamura's Sergeant Harada assumes that to allay his men's fears and to assure that they remain effective fighting men, the women must, finally, be asked to bear the danger, the anxiety, the heat, the locusts, and the Japanese soldiers.[48]

Tamura Resumes a Literary Career

Tamura was born in Yokkaichi City, Mie Prefecture, on November 30, 1911. His father was a prominent English teacher and principal of the prefectural middle school from which Tamura graduated.[49] In 1929, Tamura entered Waseda High School in Tokyo and in 1931 he progressed on to the Waseda University French Literature Department. Tamura became involved very soon in extracurricular literary activities in Tokyo, which he continued through his six years as a student. In December 1930, for instance, he helped launch a new literary journal, *Tokyo-ha* (Tokyo School), in which he published two essays and a short story, and in 1933 he became involved with Sakaguchi Ango, Inoue Tomoichirō, Kitahara Takeo, and others in the creation of another literary magazine, *Sakura* (Cherry Blossoms). Although he did not complete the one fictional work that began serialization here, *Orochi* (The Giant Serpent), this was the work by which he began to be known as a promising new young writer. During the early 1930s he associated with several different literary groups, publishing both critical essays and short stories in a variety of coterie magazines. One of the groups with which he was linked was Nakagawa Yoichi's (1897–1994) Shinkagakuteki Bungei (New Scientific Arts), a loose association of writers who—reacting in part to proletarian literary practices—wished to bring artistry into a new realism.

When Tamura entered the Tokyo literary world in the early 1930s, the proletarian literary movement had been effectively suppressed under increasingly stringent enforcement of the 1925 Peace Preservation Act and its 1928 amendment and with the arrests of prominent writers and leftist leaders. While influenced by socialist thought and by the debates over politics and literature that were part of his historical literary and intellectual contexts, Tamura's primary concern during his university years and immediately after appears to have been to publish—fiction or nonfiction, in whatever vehicles were available to him—and thus to gain acceptance into Tokyo literary circles.[50] His other great love was prowling the cafes, bars, and night streets of Shinjuku. His critical essays reveal an overall interest in problems of literary style and structure and in various modernist trends in European literature that engaged the Japanese literary world at the time. Titles of

322

some of his essays reveal the range of his work: "The Spirit and Activity of a New Literary Group: A Manual of the Tokyo-ha," "A Discussion of Control in Stream of Consciousness Writing," "A View of the New Literature: Joyce's Methods and Goals," "Weaknesses of 'Pure Literature' [*jun bungaku*]" "A Discussion of the New Romanticism," "The I-Novel and Its Separation from Realism," "On the Concept of the Devil," and "On the Methods and Demands of Modern Literature." [51]

After graduation from Waseda in 1934, Tamura remained active in the literary world, publishing essays and short fiction in several coterie magazines and taking on the job of literary and art critic for the Keiō University publication *Mita bungaku.* By 1935, Tamura had gained a name in the literary world with the publication of a series of stories dramatizing student life in the 1930s or focusing on the lives of women employed in Tokyo's small cafes and bars. "Senshu" (Champion), published in 1934 in *Shinchō,* centers on a school kendo club and its leader; "Natsu" (Summer), published in 1934 in *Waseda bungaku,* explores the world and way of life of the live-in cafe waitress; and "Fuyu" (Winter), published in 1935 in *Kōdō,* depicts Tamura's Shinjuku bar world. The latter two, seen at the time as genre novels or popular fiction, were among the few prewar stories that Tamura chose to include in collections published immediately after the war. These were followed by a longer work, *Daigaku* (University), which focuses again on student life and is said to be the representative work of his prewar efforts; it was published serially in 1936–1937 in *Jinmin bunkō* (People's Library). This was the first of several of Tamura's contributions to a periodical established by Takeda Rintarō (1904–1946) with the help of Takami Jun (1906–1965), two writers previously associated with left-wing literary groups who had apparently undergone *tenkō* (recantation), allowing them back into the literary world. [53]

Tamura is said to have been closest philosophically and aesthetically to a group behind the magazine *Kōdō* (Action/Behaviorism). [54] Organized by Abe Tomoji (1903–1973), Funabashi Seiichi (1904–1976), and others in 1933 and active until about 1936, this literary group took as its ideal the sensuous, activist humanism of André Malraux, a writer influential in Japan after the suppression of more radical left-wing groups. They, like the *Jinmin bunkō* writers, attempted to provide some opposition to the period's growing militarist atmosphere. In 1936 Tamura published in the journal *Kōdō bungaku* (Activist Literature) an essay, "Toward a New Start for Activist Literature: My Honest Feelings," in which he articulated his understanding of the behavioristic humanism and social engagement of Malraux. [55] Subjects that seriously engaged Tamura during these years—the writer's consciousness, the ways in which an author reflects and influences his age, the writer's active search for (rather than passive research on) his own human self, and the energy and natural intelligence to be captured in roughened or poorer city landscapes—returned as topics that caught his imagination after the war.

In December 1936, Tamura, Takami Jun, and other members of *Jinmin bunkō* were visited by the police at a meeting of the Tokuda Shūsei Study Society. All were arrested for meeting without a proper permit, and Tamura spent a night in

jail. Troubles continued with the journal, and it was forced to end publication in January 1938. Between 1937 and 1940, Tamura's literary output decreased dramatically. Among his few published articles was one based on a trip to the Chinese mainland during the summer of 1938. The next year he again traveled to Manchuria and northern China with a group of writers, including Itō Sei.[56] This, too, yielded a newspaper article: "The Problem of Intellectuals and the Mainland." In 1940, at the age of twenty-nine, Tamura was drafted and sent to the China front as an ordinary soldier. He was in active combat in various parts of northern China and eventually rose to the rank of sergeant. He survived several harrowing war experiences, including becoming a prisoner of the Chinese Nationalist Army and as such being forced to fight against Chinese Communist forces. In mid-1945, Tamura narrowly escaped certain death when, because of his involvement with the Engei Senbu-dan (Entertainment Pacification Brigade), he was sent too late to join his unit, which had been redeployed and then wiped out in the Battle of Okinawa.[57] Tamura was one of the few writers to serve this long—nearly seven years —as a fighting soldier.

After his repatriation to occupied Japan in February 1946, Tamura immediately resumed a literary career, one not surprisingly to be profoundly influenced both by his war experiences and by the drastically transformed literary and social scenes in war-torn Tokyo. Six months after his return to his native home and before returning to Tokyo, Tamura completed and succeeded in publishing a serialized novel, *Nikutai no akuma* (Devil of the Flesh), beginning September 1946 in the magazine *Sekai bunka* (World Culture). The work's setting is the China front. It deals with the brutal life of an ordinary infantryman, centering on a brief affair between a Japanese soldier and a Chinese Communist woman prisoner. It is presented as a monologue in the voice of the soldier addressed to the Chinese woman. He recounts memories of her, from the first moment he saw her in captivity, through her trials with sometimes cruel Japanese captors, his attempts to protect her, their stolen sexual encounter, and his sense of atonement toward her and other native Chinese. It ends with an account of the day he and others of his unit deliver her back to a Chinese village. Although Tamura does not in this story—the first of his so-called *nikutai* (flesh) works—attempt to set up a stark dichotomy between thought and action or human ideals and human desire, he does suggest that his heroine was willing, at least temporarily, to abandon her ideals and devotion to the Communist struggle for the pursuit of physical passion.

During the Occupation years, Tamura uses the China war setting in only two other stories, one of which is *Shunpuden*. Tamura probably prepared *Shunpuden* for publication in the period from middle to late 1946. The apparently self-censored version of the novel mentioned above—one that excises all uses of the words *Korea* or *Korean,* as well as other key terms such as *race, ethnic characteristics,* or phrases that would identify to a Japanese audience Korean as opposed to Japanese women (the phrase "women who loved garlic and hot red peppers," for instance)—seems to have been submitted in January 1947 to the book section of the Press, Publica-

tions, and Broadcasting (PPB) of the Civil Censorship Detachment (CCD) as the lead story in an anthology of his own stories entitled *Shunpuden*. This book was published in May 1947. As will be discussed below, the original (Koreanized) version of *Shunpuden* was suppressed in its entirety when submitted in April to the magazine section of PPB. Like the female figures of Tamura's other works, the heroine of *Shunpuden* is a woman who gives up everything—here it is her life—for a passionate, romantic love. Harumi's short, rebellious life can be read as a series of courageous and futile acts of defiance against war, Japan, and one Japanese officer who added a special personal horror to the drama into which she and her friends had been drawn. The site of her defiance was most often her own body, and her decision to use for double suicide a grenade stolen from the Japanese army officer who demands her services each night represents her last defiant act.

In March 1947 Tamura's most famous fictional work, *Nikutai no mon* (Gateway to the Body), was published in the periodical *Gunzō*. He focuses here on the life of the immediate postwar *"pan pan* girls" or "women of the night."[58] *Nikutai no mon* became an instant best-seller and drew Tamura into public literary debates that made of him a popular, if disapproved, public figure.[59] In his depiction of a small band of women attempting to survive as prostitutes in a war-torn city, Tamura again creates a female hero who abandons her tough, survival-oriented group ethic in order to explore her body or her attraction to a repatriated vagabond-thief who has taken up residence in the women's bombed-out basement home. Seeking physical pleasure in the act of love, she violates community rules and is punished by her companions. In spite of the harsh physical reprimand, she has discovered a new joyful self in her ecstatic experience of physical passion—or, as Tamura's narrator expresses it, in the fact of being a "fallen one" *(darakusha)*.[60] The defiance against conventional notions of morality and norms for proper human relationships, the description of the discovery of physical desire and of violent, chaotic human actions and emotions seem to have answered a need in its readers. *Nikutai no mon* not only became a best-seller and a popular stage play and film, it also very quickly helped define and advertise the new literary theory with which Tamura was to be identified, the previously mentioned *nikutai bungaku* (human body literature, translated most often as "literature of the flesh").[61]

The inordinate success of *Nikutai no mon* and the enthusiasm for Tamura's *nikutai* theory brought sudden monetary profits, public controversy, eager publishers, and the demand for more shocking sex-related stories—a demand that he hastily filled.[62] Indeed, Tamura seems to have focused his attention exclusively on satisfying his readers' desire for frank descriptions of "improper" sexual liaisons.[63] Although highly controversial and carefully scrutinized, his *nikutai* fiction—literary works that would have been seen as injurious to public morals and censored in prewar or wartime Japan—was for the most part left untouched, opening new areas in the publication of erotic or sexual materials.[64] The decision to focus on sexual relationships was a lucrative one for Tamura, and within a three-year period he produced countless essays and as many as thirty-five works of popular fiction.

Most critics, even those writing from the perspective of the 1970s, insist that his Occupation work soon lost the freshness and originality that characterized his first *nikutai* stories.[65] It is unfortunately Tamura's reputation as a *nikutai* writer that has defined his place in modern Japanese literature and that undoubtedly accounts for his relative critical neglect, even to the present.

During the 1950s Tamura withdrew from the literary scene temporarily, due in part to ill health.[66] He traveled abroad several times, to Russia and to Paris, becoming involved in the art world as painter, art critic, and gallery owner. He did not return to fiction until 1963, at which time he published a series of short novels considered today to be his best work.[67] As it happens, the subject that captured his literary imagination during this third period in his career was again his war experiences in China, *Jiraigen* (Mine Field), *Kōdo no hito* (Yellow Earth Man), and *Inago* (Locusts) being the most important among these. As we have seen, Tamura returns in *Inago* to the more realistically depicted, truly cruel experiences of Korean "comfort women" transported to Japanese soldiers in the harsh misery of the China front lines. It is significant that while traveling (at the invitation of the Soviet Writers Union) to the USSR and Eastern and Western Europe in 1965, whenever he was asked by other writers about the main theme of his work, Tamura is reported to have answered, "It is women and war; it is ordinary human beings in the battle zone [*senjō*]."[68] I believe Tamura's war stories (including the earlier *Nikutai no akuma* and *Shunpuden*) deserve more critical attention and should to be translated into English. They reveal a serious attempt to confront and understand the agonies, the pain, and the inhuman dilemmas that both military and civilian victims must confront in war.[69] Writing in April 1965 in an afterward to a collection of his stories featuring *Inago,* Tamura says the following about his work:

> I believe that the theater of war [*senjō*] is the theme of my lifetime. I was unmistakably an eyewitness there, while at the same time I was also a living participant in its midst. I must admit that I still do not understand just what the theater of war is—its true essence. I also cannot say that I want to boast about being the witness of an age. If, however, my own process of pursuing the battlefield has, of itself, made me a witness of a certain place at a certain time, then I have no greater ambition as a writer than this.[70]

Shunpuden and Tamura's *Nikutai* Theory

If we return to *Shunpuden* as a whole and to its relationship with Tamura's theory of the body (*nikutai no ron*), conceived at the moment that his first "comfort woman" story was being censored by Occupation authorities, the author's complex postwar creative dilemmas become clearer. The novella opens on a cold winter night within a convoy of fifteen trucks transporting Japanese troops from a supply depot in northern Shanxi Province. During a windy rest stop along the nar-

row, dirt-yellow, winding mountain road, soldiers jump from their vehicles to affirm the rumor that three young women are being transported to the front lines with them. Crude conversations among the men are mixed with the women's first reactions of distaste toward the "dirty mountain soldiers" who are soon to be their new customers.

"Hey, you dog! You look like you think you could make it with them."

"Huh? Better than a mess like you could."

"Hold on, this is just a rest stop. We've got to go on to Yu Xian fast." The driver of the women's vehicle cautioned the bantering men, revealing a protective, proprietary attitude.

"When do they start to work?"

"Tonight. I've got my pass to be the first to stick it to them. It's all set up."

"Let me be next. Come on! Put in a word for me."

"You'd dare come after me?"

"Sure, anything's OK by me. Damn! We're friends aren't we?"

Inside the truck Yuriko shuddered in disgust; her pencil-thin frown disappeared in her fur cap. "How sickening! Mountain soldiers! They're drooling."

"They're starved for women." Sachiko spit out her words; she felt an instinctive repulsion, as if she could smell their animal-breath stench just by looking at them. They all looked the same.

It was natural, perhaps, that these women should have felt as they did, having lived until now in Tianjin. While it was true, given their profession, that they had men every night, their Tianjin customers, men who lived in the area and even army personnel, were always clean and well groomed. The stolid bearlike bodies of these soldiers were parched dry, like the gleam in their dull eyes. The thought of burying deep desires in that flesh [*sono nikutai no naka ni*] made the women feel uneasy. Seen for the first time by eyes accustomed only to the sights of the modern city of Tianjin, this inhospitable winter scene, one in which everything—mountains, temples, homes—was submerged in the desolate land's uniform, yellow-earth hue, forced upon the women feelings of deep anxiety and loneliness. Even the soldiers stationed in this dreary place seemed like creatures living outside all normal, commonsense reality.[71]

Once settled in Yu Xian, Harumi soon becomes a favorite among the soldiers because of her looks, her general zeal for her job—based, we are told, on her desire to forget her previous betrayal in love—and her refusal to flatter and fawn, even upon Aide-de-Camp Narita, who physically attacks and insults her on their first meeting. Narita, however, forces himself on Harumi whenever he cares to do so. With each Narita visit, a Private Mikami is present to help the drunken officer back to his billet or to deliver and accept messages. It happened that this young

man had been on the same transport truck with Harumi on the trip to Yu Xian. Sitting with his back toward the chatting women, he had remained silent through the long ride until their convoy was struck by a mine. Then Harumi drew him into conversation. She learned that he is a young man straight from the Japanese countryside, that he had been wounded in battle, and that he was on his way back to his battalion. As they parted upon their arrival in Yu Xian, their eyes met. Now it is these eyes that haunt Harumi as Mikami hovers about waiting for his superior. One night she confronts him, asking why he looks at her so coldly. Receiving no response, she slaps him and in their scuffle they discover a strong attraction. They begin to meet secretly. He is, in the beginning, her only defense against the arrogant officer Narita:

> The one thing that made her mind light up as if by a flash of lightning was the eyes of Mikami Masayoshi. To have stolen the aide-de-camp's eyes in this way, to have made her own the lieutenant's orderly, the soldier who followed his officer's every command with absolute submission, was to fight against the military structures that joined Mikami and the aide-de-camp. It was her challenge to the invisible power that the officer wielded over her. She would stir with her own body [*shintai*] the pool of Mikami's eyes—clear eyes that had not one tiny speck of suspicion in them. And yet Harumi feared the aide-de-camp. She cursed his vigorous body [*nikutai*] and at the same time she hated her own body's slovenliness when it was forced to respond to his, even against her own will.[72]

Mikami is eventually caught with her during forbidden hours and is put in confinement in another part of the village. When this area of the village is attacked, Harumi rushes to him and is told by fleeing soldiers that he has been injured and left to die. She runs into the gunfire to find him, and the two are taken prisoner by a small Chinese Communist guerrilla band. Harumi is allowed to stay with him, and she and the Chinese doctors successfully care for his wounds. It is during these days of constant movement from village to village that she experiences the only moments of happiness since her childhood. The young soldier will reveal nothing to his Chinese captors, however, and after his recovery the two are returned to the walls of Yu Xian. Having allowed himself to become a prisoner, Mikami is put under guard to be court-martialed. Harumi is forced once again to entertain Narita. She nevertheless finds a way to see Mikami, and when he asks her to bring him a grenade by which they both might escape, she steals one from the officer. Learning too late that Mikami in fact intends to kill himself, she determines to die with him. Narita records the private's suicide as death from injuries in battle. Harumi is cremated by the other women, who, not knowing her real name, scatter her ashes to the wind.

In May 1947, Tamura published in *Gunzō* his most frequently quoted essay, "Ningen wa nikutai de aru" (The Human Being *Is* the Body). The piece was written, he tells us in its introduction, in response to the criticism that his first *nikutai*

story, *Nikutai no akuma,* "contained no ideology." Assuming that the same judg-
ment would be made of *Nikutai no mon* and, presumably, of *Shunpuden,* Tamura
counters with what became the foundation of his "flesh literature" theory.[73] The
essay is structured as an "answer " to his unnamed literary critics:

> A certain critic [*hihyōka*] has stated, in connection with my work, *Nikutai
> no akuma:* "This work contains no ideology" [*kono sakuhin ni shisō ga nai*].
> Critics will undoubtedly hand down the same judgment of my recently
> completed *Nikutai no mon.* When I first read this criticism, I was forced to
> think very hard about that thing we Japanese call "ideology" [*shisō*]. I
> believe that I have pretty much figured out just what the critics mean
> when they use the term *ideology.* Japanese nowadays do name a certain
> thing "ideology," and even today, after our defeat in war, the term *ideol-
> ogy* still signifies the same thing it did before the war. During the war this
> "ideology" got lost somewhere in the shadows, but since the defeat it has
> proudly pushed itself forward, acting exactly as if it had been a leading
> actor in the overthrow of the Japanese military clique.
>
> Seen from the point of view of this "ideology," my works probably
> are "novels without ideology." I, however, cannot for a minute believe
> in an "ideology" that was so utterly lacking in the power to save us from
> the tragedy of war. Not only do I not believe in it, I can only feel anger
> and hatred toward such "ideology." Thus, to be told that my novels "con-
> tain no ideology" is rather, given the nature of this "ideology," quite an
> honor.[74]

What Tamura proposes as the alternative to *shisō* is of course *nikutai* (literally
"meat"; flesh, body, meatiness or the concrete reality of the human body).[75] His
effort is twofold: to reverse the conventional power relationship in which ideology
(mind, conceptual thought, abstract reasoning) is valued over flesh and to return
public discourse to the heretofore neglected physical body. It was *shisō,* he argues,
that had in fact led the Japanese to war and bestiality.

> I think that my ideology is my own body and that no ideology exists at all
> beyond one's own body. Thus, while I am aware that I have not yet appro-
> priately captured my own bodiliness [*nikutaisei*] as narrative action in my
> works and that my novels are thus not yet sufficiently ideological, I do not
> at all agree that they "contain no ideology." I believe that I can pursue ide-
> ology only by pursuing the depths of my own physical body. In fact, it is
> inconceivable to me that an ideology can even exist without knowledge
> of one's body.
>
> During the war I saw that this so-called ideology that had forgotten
> the human body was unable to restrain or defy the actions of people who
> had lost their way. During my long bloody military days I personally
> encountered Japanese associated with the grandest "ideology" and the

most "respectable" of ideals who had turned into beasts. I too became a beast. Crying pitifully on the battlefield at the impotence of the Japanese people's "ideology," I lamented that I had ever been born a Japanese. I was forced to understand that the established "ideology" had absolutely no connection with the human body and that it had not a shred of authority over its functioning. After being demobilized, I have felt the same thing. I wonder if "ideology" has contributed anything at all to the betterment of contemporary Japan, full as it is of black-marketering, crime, prostitution, and hunger. The established ideology still spouts to us its threats and time-worn doctrines. The people, however, now reject "ideology." [76]

Tamura does not define the content of the ideology that he condemns; nor does he name its practitioners. His effort is not to critique specific ideas but to revalue the body, to free human desire. After setting up a clear bipolar opposition between *shisō* and *nikutai,* he then points out that the former—this abstract intellectual system based on false logic and divorced from that which is genuinely human—was now thoroughly discredited. Given this reasoning, the first bedrock step for the Japanese in their attempts to recover from defeat and to repair that which was defective was to listen to the one thing left to them as survivors—to their bodies.

Today, all that "ideology " does is attempt to oppress and threaten us. This "ideology" has, for many years, held the Japanese people captive with its strong, bright colors, but now *nikutai* is openly trying to oppose this. Our distrust of "ideology" is so complete that the only thing we can believe in is our bodies. Our bodies are the only truth. Pain, desire, anger, ecstasy, agony, and sleep—these are the only things that are real. Only through these can we become aware of the nature of human existence.

Nikutai now resembles insubordinate students working together to carry out an insurrection. Isn't it true that in the present reality the body stands with its homemade banner, placard, and sounding gong facing down "ideology"? A starving widow walks the streets selling her own flesh [*niku*] in order to feed her child. A young man commits a crime because he wants to run off to Atami with a beer-hall dancer. A "fine gentleman" rapes, binds, and murders any woman he gets his hands on. A student shoots a companion who exposed his scheme—selling white flour, at 50,000 yen, for opium. Stray orphans and wild dogs roam the city square, pilfering and scavenging in the garbage. Their bodies ache, they cry and flail about, while blood flows and sparks fly. All of this can only mean an utter lack of belief in "ideology." I have come to know deep in my bones that the strongest, if not the only, human impulse is the biology of the body. Therefore, I believe in the liberation of the body and in the study of the body. I believe that no matter how fine the ideal or how high sounding the philosophy, it will not be believable if it does not take the body as

its foundation. The human body is all there is. My 37-year-old body firmly believes this. I absolutely do not believe in any "ideology" or any way of thought that does not originate in the body.[77]

Nikutai becomes a metaphor here for human desire, physical desires that govern our thoughts and emotions and that are thus our essence and must be understood. He goes on to suggest that it has been the traditional moralists and Neo-Confucianists who were responsible "for convincing the Japanese that it was vulgar or improper to study the body." "The Japanese," he says "have for too long thought in a distorted and prejudiced manner about the problem of *nikutai,* that which is the very essence of the human being." Ignorant of their own physical desires, the key to human nature, the Japanese were bound to taste defeat:

> It is very fashionable nowadays to say "I, at least, have no responsibility for our defeat in war." Even if they deceive other people with such talk, can they actually deceive their own spirits? I believe that in an age such as this any "ideology" that is not chaotic is not a real ideology. I do not believe people who speak logically in an age such as this. Because of my seven years of army life, I am like a baby and I cannot think logically. I do not believe anybody who speaks logically. I have no faith at all in a soul that does not secretly chew all night long on the tragedy of the defeat in war, a spirit that does not rip open its own flesh, grasp its heart and throw it against the wall, wailing against this great sadness.
>
> Why did we plan such an all-encompassing war? Why did we lose it? There are undoubtedly many reasons. One of the most compelling, however, was this "ideology" of ours that separated itself from the body. What strength can there be in a human character not based in the body? To know the human body is to know the human being.[78]

It is not what the ideologues think but rather their tendency to use words to rationalize, to reason, to dehumanize, and to distance and protect themselves from real life—the body, its needs, and its desires.

Tamura next takes on the Home Ministry (Naimushō) and the problem of the suppression of flesh literature. Ironically, when this May 1947 issue of *Gunzō* was first submitted to CCD for publication approval, only this portion of the essay was marked for censorship action.[79] After stating his strong opposition to the regulation of erotic materials and castigating the "ideologues" *(shisōka)* who were making no such protests, Tamura moves as close as he comes in this essay to defining what he calls *taihai bungaku* (depraved literature):

> If by depravity one means the actual reality of the Japanese people today, then no "depraved literature" has yet appeared. If there were literary works that captured today's reality, that would, I believe, be rather healthy. It seems, however, that there are as yet few novels that do so. I believe that more such stories ought to appear, one after another. The Jap-

anese people today are sincerely building a reality that resembles that of a defeated people; none of our "ideologues" or novelists, however, are "ideologues" or novelists of a defeated nation. Japanese "ideologues" and novelists are inveterate, unredeemable liars. Because they are such chronic liars, they are not themselves aware that they are liars. It seems that they have not even noticed that we lost the war. Our literature ought to be more like that of a defeated nation; it ought to be more confused, more chaotic, more erotic, and more abandoned. We are a defeated people, so this naturally must be the case. And if it is not, then this is proof that we are somehow deceiving ourselves. Rather than being conscious deep in our souls of the awesome fact of our utter defeat in war, we cunningly try to smooth it over with "refinement," much as a well-dressed pickpocket slides through his plotted schemes.[80]

In concluding remarks, Tamura urges the Japanese to create an ideology of the body, a way of thought based on *nikutai*. He encourages those who have survived the war, people in bombed-out homes and untidy cities who are nevertheless still alive, to turn to their own bodies, both for guidance in human liberation and human joy and as a conduit to their own true inner selves. When Tamura urges the Japanese in food-scarce Japan to "fatten their bodies [*nikutai*] more and more," he again uses the term *"nikutai"* metaphorically—not in opposition to soul, as in body and soul, but rather as something nearer to a human body inseparable from spirit and standing in opposition to a discredited, reasoning intellect. While he seems to be urging the Japanese to be reborn and to do so listening, this time, to the voices and needs of their inner and outer "bodies," he is courageous enough or Marxist-influenced enough not to try to spell out what the new body ideology will be.

Not missing the unique opportunity that the defeat in war has brought to us, all Japanese should, I believe, fatten their bodies more and more. The Japanese people absolutely must embrace their bodies in leisure and freedom and welcome the erotic with open arms. Taking the body as their foundation, they must create a strong, stable humanity.

This is the only way we can evolve into human beings who emerge from the web of Japanese sentimentality and who are free of the pat assumptions of contemporary "common sense." I think that such a "human being" will be one who has an ideology. With this as our base, we might finally create a world culture that is free. But since even these words are becoming too glib in their logic, it is probably best that I go no further.

We must, at any rate, become more human human beings. We must release our bodies—this is the basic condition for building the human spirit. We must free ourselves of the many restrictions that have bound our bodies up to now. We must study the body, breathing naturally like a baby. In doing this we will surely come to know what the true human

being is. We must stop spouting those lies that have bewitched us up to now. I want to become the novelist of a defeated nation, one who, in the midst of the terrible upheavals of an ever-pounding reality, can avoid lies and create a genuine transformation within myself.[81]

Tamura's thinking resembles and was perhaps influenced by Sakaguchi Ango's attempt to free the Japanese people of, to quote Alan Wolfe, devotion to those "contrivances" designed to control and limit the human nature they pretend to protect and nourish. They resemble, too, Dazai's dramatization, particularly in *The Setting Sun,* of the need for a genuine internal revolution, one that will eventually give birth to new definitions of all basic human relationships. Using very different metaphors and fictional strategies, each of the three writers urge radical change based on an honest critique of the penchant for self-deception and an unmasking of the self—one that will reveal the individual's natural, "decadent" or bodily, desire-filled self. Tamura concerns himself only with what was an essential first step. This was, for him, the freeing of human desire and the affirmation of the human body and of human sexuality. He is honest enough to go no further than this.

Tamura suggests, in *Shunpuden,* that a woman like Harumi had no false "ideology." Living in the raw, fighting to survive, she could yet still allow herself to feel and express her deepest desires. She loved and cared for her friends, and she hated and opposed cruelty and evil. As a result, she experiences for a brief moment a satisfying physical and emotional human relationship, and she loses her life. Suicide was not her first choice, but death with her lover was preferable to life without him—life as a sexual slave in the army camp. In his other *nikutai* works, Tamura focuses on women and men in extreme situations who do not have the luxury to worry about love, but who are, at the very least, unafraid of exploring their sexual selves. They are drawn to sexual liberation as a defiance of the dominant social morality, and they have no time to consider what true sexual liberation ought to bring. In either case, Tamura's essays and fictional narratives struck a chord with the Japanese, and his voices for the body had an impact upon those involved in the attempt to use literature as a tool to help reconstruct a broken people suffering national defeat. As Tamura himself suggests, he may never have worked out an adequate literary expression of his body/soul ideology (in the way, for instance, that Dazai and Sakaguchi were able to do), but his use of the *nikutai* image, that of a living, passionately responding body/soul, was an imaginative device for focusing attention back to what Tamura felt must be the basis of self-identity and self-knowledge. Some of the opposition to Tamura, on the other hand, may have been based on a fear of the human energy and passion he sought to unleash in his early *nikutai* novels.

Tamura's artistic problem, however—his sense that he had not yet found an adequate literary expression of the "body ideology"—is closely related to his conflicted appropriation of the larger Korean "comfort women" story in *Shunpuden.* In order to "study *nikutai*" in a work of narrative fiction, Tamura needed, or appar-

ently thought that he needed, female characters awakened or in the process of awakening physically, unafraid of sexuality, rebellious, revolutionary, naturally spirited or otherwise free enough to throw off traditional morality and to think for themselves—to think with their bodies. As concerned as Tamura personally may have been over the fates of young Korean women forced by foreign occupation and by war into situations of true human horror, their condition is mere background. He foregrounds his narrator's mind, which frequently moves from the real circumstances of the lives of the Korean *ianfu*, into an exploration of what we can only call the *nikutai* theory. An early passage in *Shunpuden* will illustrate this. The narrator declares his (and Tamura's) theoretical delight with the "pure physicality" and the instinctive intelligence of the Korean women—described here in their city brothel setting:

> With a customer they disliked, they were apt to curse foully and wave him out, but with guests they liked, they would entertain lavishly, even spending money of their own. These women lived in innocent naïveté; when happy, they would belt out a song, and when sad they would cry out loud. They possessed an extraordinary passion. It was not something that came from logical reasoning or from knowledge found in books. It was an intense life ideology that they hammered out with their bodies [*nikutai*]. When their body liked something, they accepted it with complete abandon, and when it disliked something, they rejected it totally. The intensity of their expression revealed the intensity of this life force within their bodies. The bodies [*nikutai*] of these women who ate garlic and red hot peppers, their very flesh and bones, were sharp, containing a willful intelligence. And even after strong emotions that might flare up within that willfulness, they experienced no remorse. Perhaps this was a special ethnic characteristic of these women.[82]

In another typical passage, one that occurs just after the first rape scene with the sadistic officer Narita, we see not only the narrator's keen interest in describing the waves of physical "pleasure" that brute violence and strong *nikutai* stirred in the women, but also his more sophisticated understanding of Harumi's complex emotions:

> These women felt no pleasure from their work because their bodies [*nikutai*] were abused and numb with overwork. This is exactly why workers who engage in painful, strenuous physical labor feel almost no pain. However, in just the same manner that the worker does at times experience an instant of unbearable pain in his labor, these women too feel periodically a moment of erotic pleasure in their bodies. And this, after all, is not an evil thing. It comes of itself from the unconscious waves of their own bodies and is, finally, intertwined with emotions evoked upon contact with the vital physicality of their male customer's own flesh [*nikutai*].
> Harumi's flesh [*nikutai*] too became one with that of the aide-de-camp

and was at that moment given this sort of pleasure. At the same instant, however, she also felt as if she had just swallowed a noxious poison, and she was deeply depressed. She had, up to now, been ambiguous in her feelings toward Japanese men. With a customer like Aide-de-Camp Narita, however, she was forced to be sharply self-conscious of the repulsion and deep discontent she felt in the whole of her being. To be led toward physical pleasure with a man like Narita was a wretched thing. And now she realized that Tomita's [her Tianjin Japanese lover] flesh too, which she was forced to feel through Narita's, was Japanese men's flesh pinning her body down, taking her body from her. This, to her, was a bitter harvest. The longing she had felt toward Tianjin [and Tomita] seemed to have become more and more tenuous with each day. She wanted to escape from the aide-de-camp, but trapped here within the walled city of Yu Xian, surrounded by an unknown enemy, she was subject full force to his power. She hated the filth of her own body that cursed Narita's lust and at the same time responded to it even against her will. His power pressed in on her. The aide-de-camp's violence, which at most was pure bodily lust, could not be opposed. If one resisted with the body, defeat was certain. Thus she was given that pleasure about which she felt such shame and, unable to know what to do, she was left in a numb stupor, feeling as if her body were being forced to swim in dirty slime. And every night she greeted the aide-de-camp.[83]

The narrator idealizes Harumi and the other Korean women, who are seemingly unafraid of their emotions and in tune with their bodies' instinctive intelligence. Harumi reserves responsive passionate love for the men for whom she actually cares, and, after meeting Mikami, for the one man who—though naïve, countrified, and forever loyal to the Japanese army—is yet gentle and respectful of her. At first the two risk their lives for passion and even after being captured by the Chinese they manage to steal moments of happiness. When Harumi cannot persuade Mikami to try to escape with her, she determines to die with him rather than return to her life as a military sex slave. As tragic as Tamura's picture is of the "life of a prostitute," contemporary accounts of the experiences of survivors of the military camps suggest that Tamura has projected his own fantasies and theories onto what was undoubtedly a far more violent, crude, and joyless existence. The profound irony with which Tamura does not deal is the fact that these young women were there on the bloody Chinese front lines presumably because of the vital force of *nikutai* that Tamura so admires—and that he believes must be properly nourished by women's flesh.

It is important to be able to place Tamura's fictional images beside the stark testimonies now available of Korean and other women who managed to survive their wartime experiences as "comfort women." Theirs are stories of hunger, illness, pain, fatigue, and torture, including a grisly array of different forms of physical and mental abuse. They are, for the most part, silent about any emotions other than

fear, disgust, and hatred. Tamura's fictional vision is colored not only by his *niku-tai* theory but also by a fantasy that he and other contemporary Japanese government officials and former military men have used to justify their own actions and attitudes—that these women were "prostitutes" (the term *"shunpu"* in Tamura's title is literally "woman of spring" or "sex woman"). Tamura seems to have sensed originally that their stories must be told, however, and the tale he spins is that of Koreans treated as sexual slaves whose bodies had been snatched away from home and security and sent into strange, lonely landscapes. As characterized in *Shunpu-den*, Harumi can be seen as Tamura's perfect *nikutai* heroine. He uses her body in part to explore and illustrate his *nikutai* theory. As an author in defeated Japan, however, Tamura is also trying to piece parts of himself back together after almost seven years on battlefields where he too, as he tells us, acted as a beast. Perhaps the only "war memories" that made sense to him, back in the postwar rubble, were those of his moments with Korean women. It was his feelings toward these women that he instinctively wished to memorialize, and it was they, ironically, who were excised from his story.

"Leave This Thing Out!": The Suppression of *Shunpuden*

In April 1947, one month after the publication of *Nikutai no mon,* in accordance with SCAP's established Press Code censorship procedures, the editors of a new literary journal, *Nihon shōsetsu* (circulation listed at fifty thousand) submitted galleys of their premier issue to the Press-Publications unit of the Press, Publications, and Broadcasting Division (PPB) of the Civil Censorship Detachment (CCD).[84] The journal had adopted as its manifesto the vow to "bow our heads before the finest literary works, while remaining aware of the happiness and pleasure of sitting amidst popular culture."[85] *Shunpuden* was to be the lead story of its maiden issue. The relatively long work (twenty-nine pages in the double-page journal format) was illustrated with sketches of voluptuous naked women sitting around languidly together in sumptuous, boudoir-looking chambers (Figures 30 and 31).[86] It was at least twice the length of all but one other piece of fiction in the issue, more than half of which were installments of serialized fiction. Allied censors in PPB were not as enthusiastic about the story as the editors of *Nihon shōsetsu*. A content sheet dated April 16, 1947, prepared by a Japanese examiner (Nakamura), calls attention to *Shunpuden* as containing "possible violations."[87]

As briefly described on an accompanying data sheet, *Shunpuden* "depicts the tragic story of a Korean Prostitute who committed suicide with a Japanese soldier at the China front. At the same time, it emphatically illustrates the corruption of the former Japanese army." A two-page résumé of the story is attached. This was sufficiently intriguing to prompt a check in late April with W. H. Fielding, identified as chief of the Ryukyu-Korea Division, chief of staff, but in fact a member of the Government Section. His response, presumably after reading the English brief was: "Leave this thing out! The mere mention of a Korean prostitute is dangerous,

let alone the whole article" (as Fielding incorrectly referred to the short novel). A long diagonal line is drawn down the proof's first page, the handwritten word *hold* is struck out, and the word *SUPPRESS* is written by hand and then stamped here and on each subsequent galley page (Figure 29). The reason given for this extreme action—suppression of the story in its entirety—was "incitement to violence and unrest."

At some point in the censorship process, the reason for suppression was changed from "incitement to violence and unrest" to "criticism of Koreans," which is to say, "criticism of an ally." [88] This decision was confirmed by Robert Zahn, chief of PPB, District I (Tokyo). [89] The subsequent information sheet, which was circulated to other units within CCD for intelligence purposes in late May, provided a translation of the brief preface or authorial introduction that had been submitted as an integral part of the story. [90] As the preface and my summary of *Shunpuden* should suggest, Tamura's story is not critical of Koreans. Its Korean heroine is depicted as a victim of several forms of Japanese aggression. The decision to suppress the story in its entirety was maintained, however, and as mentioned above, a story by Sakaguchi Ango was substituted for *Shunpuden*. Had Tamura's story passed censorship inspection, his name would have headed an impressive group of writers, including Takami Jun, Dazai Osamu, Niwa Fumio, Hayashi Fumiko, Hayashi Fusao, and Mushakōji Saneatsu.

Tamura may not have been completely surprised at the suppression of this still overtly Koreanized version of the story, since he or his book publishers had already taken out what they must have anticipated as dangerous wording in their submission of the manuscript to the book unit of PPB. Victor Groening, a senior censor, does seem to have been surprised, however, when he discovered that the book section had—five or so months earlier, on January 2—approved the galleys of this collection of Tamura's short stories, entitled after its lead story, *Shunpuden*. Groening apparently learned this quite by accident when one of his Japanese employees came across the published version while browsing in a bookstore. [91] The Prange Collection at the University of Maryland contains the CCD file copy of this particular anthology. Its publication date is May 1947, and it includes seven other stories by Tamura, written, as he states in his introduction, soon after his repatriation to Japan in 1946. While the basic plot line of the two versions of *Shunpuden*—the suppressed and the apparently self-censored—is identical, the *Nihon shōsetsu* version does, as mentioned above, openly identify the three military "comfort women" as Korean, while the book version of the story does not. [92] It is clear that the problem for CCD was the mention of Korean women who were not only officially transported to frontline troops, but also maintained, controlled, and finally destroyed by the Japanese army. Once attention was drawn to the work, the *Nihon shōsetsu* publishers apparently believed that they could not at that point turn their Korean heroines into women "born on the peninsula," as Tamura or his book publishers had done earlier.

It is important to note here that the first film script for *Shunpuden,* entitled

Figure 29. Opening page of *Shunpunden,* marked "hold," then "suppressed." From the Gordon W. Prange Collection, University of Maryland.

Figure 30. An illustration from the suppressed magazine version. From the Gordon W. Prange Collection, University of Maryland.

Akatsuki no dassō (Escape at Dawn), shared a similar although less extreme fate. As Kyoko Hirano reveals, when the first version was submitted to guidance officers in CI&E in September 1948, its female protagonist had already been transformed into a professional *Japanese* prostitute. By the time the script was finally accepted, six or more versions later, and released as a finished product in 1950, she was an entertainer (singer/dancer), and the official military brothel was a bar. She and her young Japanese soldier do not commit suicide together but are murdered by the now even more thoroughly detestable aide-de-camp as they try to escape together.[93]

We can only speculate on the question of why the magazine section of PPB changed its official reason for suppression from "incitement to unrest" to "criticism of Koreans." Tamura's remarks on *Shunpuden* in his overall preface to the published book in which the novella appears are considerably longer, and although all direct references to the women as Korean have been eliminated, the author's outrage at the way in which "non-Japanese women" on the front lines were treated is even more pronounced:

Figure 31. Another illustration from the suppressed version. From the Gordon W. Prange Collection, University of Maryland.

During the war there were undoubtedly a great many women who sacrificed their youths and their bodies, while held in contempt by Japanese officers and the Japanese prostitutes serving as their war wives in the rear guard. They lived within the range of gunfire along with us lower-ranked soldiers stationed deep in the Asian mainland. The Japanese women, assuming they must not go out to the battlefields, conspired with commissioned officers and despised ordinary, lower-ranked soldiers. I have written this story with a heart-wrenching longing toward those frontline women and with feelings of disdain toward the Japanese women. This is a work in which, just as in my *Nikutai no akuma* [Devil of the Flesh] and *Nikutai no mon* [Gateway to the Body], I have openly described things that stagnated in my breast during the long war years. To tell the truth, I cannot yet judge its literary quality. I have simply felt, with a clarity deep within my flesh and bones, that there was within me a dark, inchoate cloud of grief that smoldered unbearably with the scent of blood and gunpowder smoke. Dazed, like a man lost in a dream, I knew that I must try to put my feelings into words.[94]

Tamura depicts himself here as an emotionally involved author, dedicating his story to women pointedly identified as not being Japanese—women who helped him survive the war. The soldier-author was deeply affected by his memories of a group of women who lost their youths and lives and any opportunities to tell their sad stories. He feels an equally powerful resentment against both Japanese commissioned officers and their Japanese rear-guard comfort women, and the novel's unidentified narrator shares these longings and resentments. Although occasionally and with powerful irony the author is distracted by his own *nikutai* theory, he nevertheless succeeds in capturing the desperate tone of his heroine's brief life and in eliciting in his readers sympathy for her and her companions. As the CCD note for the magazine version quoted above suggests, while the story "emphatically illustrates the corruption of the former Japanese army," it suggests little that might be construed as "criticism of Koreans," unless one wishes to assume, as some Japanese did and still do today, that the Korean women desired to be sold into this life by their destitute families, or unless we believe that Tamura's story implies criticism of a (Korean) society that would allow women to be so used.

It happens that in 1947 occupied Japan, SCAP officials were indeed troubled by the brewing "Korean problem." Korean nationals, many of whom were forcibly brought to Japan as contract laborers during the 1930s and 40s, were demonstrating for their civil rights, seeking repatriation to Korea, or were at odds among themselves along Communist/non-Communist, South/North Korean lines.[95] Although there is no indication that the problem of Korean "comfort women" was then an issue of concern to any of the parties involved—Japanese, Korean, or American—SCAP anxiety about "incitement to unrest" was undoubtedly real.[96] The censorship category, "criticism of an ally," might have been chosen as the safer,

less precise—if less accurate—rationalization for suppressing *Shunpuden*. Although the narrator does not suggest a military role in the original sale of the young Korean women from their homes to houses of prostitution in China ("each of the three," we are told, "was sold to the Akebono-chō in Tianjin because of hardships experienced by her family"), he does openly dramatize the direct role of the Japanese military in their subsequent conscription, transportation, and essential enslavement after having been selected for "duty" on the front lines. The story depicts a woman victimized and abused by a society at war, by deeply discriminatory gender and ethnic assumptions, and by individual Japanese men. Perhaps we can assume, based on the recent strong and deeply emotional Korean and Japanese reactions to revelations of such official abuse, that SCAP officials might have been anxious about inflaming emotions within different Korean and Japanese groups. Furthermore, military commanders in occupied Japan were themselves indirectly involved in the control of Japanese women for the "comfort" and recreation of American forces in Japan.[97] For this and other reasons, "fraternization" was one of the unlisted but frequently employed reasons for Allied censorship of written and other materials.[98] They were perhaps not at all eager to have the topic of militarized prostitution become a "public issue" and may have preferred to disguise their reasoning with the more legitimate sounding "criticism of an ally."

Finally, Occupation authorities were also troubled by the problem of pornographic materials. Pornography was not included as a violation in the SCAP Press Code and was therefore beyond the authority and official role of CCD.[99] However, the Japanese government, local police, officials, and women's groups were upset by the new freedom in this area of publishing. Thus, different groups were pressuring various agencies to do something about literary works that they believed were obscene and certain to corrupt public morals. In extreme cases, CCD contacted CI&E officers to remonstrate privately with publishers or theatrical producers.[100] Since Tamura was at the center of this controversy as well, his name recognition and leadership in the area of "flesh literature" might have complicated the *Shunpuden* censorship case. The story was suppressed during the time of the sensation caused by *Nikutai no mon*. Furthermore, portions of Tamura's *nikutai* essay discussed above were earmarked by PPB for suppression when it was submitted for publication in the May 1947 issue of *Gunzō*. Two sections of the essay were marked for deletion on the grounds, initially, that they would "disturb public tranquillity."[101] A second examination seems to have yielded the judgment "encourages obscenity, delete," while a third look, initialed by senior censor Robert Zahn, resulted in a large "OK" and "material pass." The censors may first have thought that Tamura's reasoned defense of flesh literature would encourage more purely pornographic materials, or they may have been concerned by Tamura's statement that he absolutely opposed the Home Ministry's threat of censorship of erotic materials, which, he insisted, "should be left to the discretion of the individual." As discussed above, Tamura's major thesis, dramatized in his stories, articulated in his published essays, and discussed in numerous *zadankai* (edited panel

discussions), was that human liberation can only be realized through liberation of the body and freedom to discover one's sexual being. Scenes of sexual encounters were thus apt to be a part of his literature, and he had reason to defend their use, even though it put him on Japanese and Allied suspicion lists. [102]

342

Conclusion

The larger subject of Tamura's taste and use of "erotic materials" in works other than *Shunpuden* constitutes a problem beyond this study. Tamura's descriptions of sexual encounters in this particular piece of fiction, however, are not gratuitous and would not today be labeled pornographic. They are, rather, an important part of the novel's subject and themes. As illustrated above, however, there are numerous passages that must be seen as Tamura's special pleading for his *nikutai* theory, passages that are an intrusion into Harumi's world and mind. Given his theory on the goals of literature of the human body *(nikutai no bungaku)*, the author believed he must depict a heroine who is awakened sexually and who at some point chooses the body over "ideology." That this theme was not relevant to the lives of the Korean *ianfu* did not deter Tamura a great deal. On the other hand, as Tamura's use of the traditional term *"den"* (used to designate "biographies" primarily of great men of the past) in his non-*nikutai* title suggests, his desire to re-create and dignify the "lives" of not just one but a larger group of abused and, he feared, forgotten women, was genuine and admirable. The uncensored *Shunpuden* assures that the meaning and significance of Harumi's life and death not be forgotten, and it was perhaps this, not the sex or the implied criticism of an ally, that most bothered SCAP censors.

Beleaguered and, I believe, at least partially misunderstood, Tamura Taijirō and his literary career were intimately affected by their historical contexts. While it is difficult to prove that the delicate, sometimes tenuous will to creativity has been negatively affected, it is not difficult to see that Tamura himself may have been swept into what his critics have regarded as less creative directions by the issues with which he and the Allied Occupation became involved in the aftermath of war. Had it not been suppressed, Tamura's story dedicated to and centered upon the unfortunate Korean women could have had a far wider audience as the lead story in the inaugural issue of *Nihon shōsetsu*. Tamura's name might have ensured greater and longer circulation for the periodical, and he would also have been associated with a serious postwar effort to "democratize" Japan's literary culture. The censorship action surely interfered with a repatriated soldier's and writer's genuine attempts to reconstruct both himself and his country's literature, to bring to light an exploitative military policy, to expose corruption and cruelty within the Japanese army, and to give a voice and literary existence to a tragically destroyed Korean woman. That Tamura elected not to restore his original version of the story when he arranged for subsequent publications of *Shunpuden* during and after the Occupation—and long after censorship had ceased—remains an important, if unsettled, issue.

Notes

1. Nicole Ann Dombrowski, "Soldiers, Saints, or Sacrificial Lambs? Women's Relationship to Combat and the Fortification of the Home Front in the Twentieth Century," in Nicole Ann Dombrowski, ed., *Women and War in the Twentieth Century: Enlisted with or without Consent* (New York: Garland, 1999), 2–3. Dombrowski characterizes "three female roles" for women in war: "warrior, maid-in-waiting, and helpless victim." She describes the latter two as follows: "Likewise, the ideal of the soldier's wife in waiting has stirred and nourished the morale of fighting men. Perhaps the most evocative of all the female heroines is the defenseless victim raped or ravaged by war, an image that provokes declarations of revenge as well as pity. These three female roles have existed simultaneously as complements to the vocation of the male soldier and as encouragement to his task" (2).

2. For a review of representations of Japanese women in films produced during the war, see *Japan at War: Rare Films from World War II* (New York: Japan Society, 1987), 2, 4–29; and William B. Hauser, "Women and War: The Japanese Film Image," in *Recreating Japanese Women, 1600–1945* (Berkeley: University of California Press, 1991) 296–313; for women in other roles, see Yoshiko Miyake, "Doubling Expectations: Motherhood and Women's Factory Work under State Management in Japan in the 1930s and 1940s," in *Recreating Japanese Women, 1600–1945*, 267–295; see also Thomas Havens, "Women and War in Japan, 1937–1945," *American Historical Review* 8:1 (October 1975), 913–934; and references to women in Havens' *Valley of Darkness: The Japanese People and World War II* (New York: Norton, 1978). Havens does not discuss women who performed the so-called comfort role. For a few wartime paintings with women as subjects, see *Taiheiyō sensō meigashū* (The Pacific War Art Collection), 2 vols. (Tokyo: Noberu Shobō, 1967). For a discussion of wartime images of "mothers and the male child," "charitable deeds of the Empress," "the working woman," and "the military nurse," painted in oil on canvas and reproduced as war propaganda in the popular women's magazine, *Shufu no tomo* (The Housewife's Friend), see Wakakuwa Midori, "Jūgonen Sensō ka no joseizō" (The Fifteen Years War and Images of Women), *Bijutsushi* 44:2 (March 1995), 261–262.

Shimada Yoshiko, a contemporary print, installation, and performance artist, began in the early 1990s creating, exhibiting, and performing works that call attention not only to the mutually damaging mother/prostitute binary role division that formed the basis of the Japanese military's rationale for its use of women during World War II, but also to the complicit role Japanese women played, both during and since the war, in silencing the voices of victimized Asian women. For discussions of Shimada's retrospective work on women and war, see E. Patricia Tsurumi, "Censored in Japan: Taboo Art," *Bulletin of Concerned Asian Scholars* 26:3 (1994), 66–70; Hagiwara Hiroko, "Comfort Women, Women of Conformity: The Work of Shimada Yoshiko," in Griselda Pollock, ed., *Generations and Geographies in the Visual Arts* (London: Routledge, 1996), 253–265; and Rebecca Jennison, "'Postcolonial' Feminist Locations: The Art of Tomiyama Taeko and Shimada Yoshiko," *U.S.–Japan Women's Journal, English Supplement* 12 (1997), 84–108. For a discussion of the term *comfort women*, see note 8.

3. I transfer to Japan descriptions of the realities of other nations at war as discussed by Cynthia Enloe in her studies on the roles military institutions have assumed women must play, both in peace and in wartime; see *Does Khaki Become You? The Militarization of Women's Lives* (Boston: South End Press, 1983) and *Bananas, Beaches, and Bases: Making Feminist Sense of International Politics* (Berkeley: University of California Press, 1990). Drawing broadly on Euro-American and some Third World examples, Enloe examines the "military's need to

exploit and yet ideologically marginalize women" and the ways in which the military and political manipulation of women have grown from and fed stereotypical views of gendered roles. While these views differ from culture to culture, the manipulation of women by military institutions is a phenomenon common to patriarchal societies. See *Does Khaki Become You?* 1–17, 212–213, and 220; and *Bananas, Beaches, and Bases,* 65–92.

4. Enloe is primarily examining officially sanctioned military exploitation of women for sexual services. Feminist scholars working in the context of the more recent mass rapes and sexual torture of women, particularly in Bosnia-Herzegovina, continue to probe "into the meanings and functions of collective sexual violence against women." For an excellent articulation of the problems involved and discussion of recent scholarship, see Ruth Seifert, "The Second Front: The Logic of Sexual Violence in Wars," *Women's Studies International Forum* 19:1/2 (1996), 35–43. Seifert's analysis of the cultural functions of crimes against women in war is especially pertinent to the Japanese exploitation of Korean and other women in World War II.

5. Enloe, *Does Khaki Become You?* 20. See also Ruth Seifert, "War and Rape: A Preliminary Analysis," in Alexandra Stiglmayer, ed., *Mass Rape: The War against Women in Bosnia-Herzegovina* (Lincoln: University of Nebraska Press, 1994), 54–72.

6. In presenting a brief historical account of earlier officially sanctioned systems, Australian journalist George Hicks goes back to the Roman Empire, which "had a comfort system remarkably similar to that of the Japanese military." Its established system of slavery "ensured a regular supply of captive females for the military brothels which were attached to every Roman garrison or campaigning army. The task of these Roman comfort women was to provide sexual services at all hours of the day and night, as well as to do traditionally female chores such as nursing, washing and cooking." For this and further examples up through "the German army's prostitution facilities during World War II" and comments on British and French "military field brothels," see *The Comfort Women: Sex Slaves of the Japanese Imperial Forces* (St. Leonards, Australia: Allen and Unwin, 1995), 1–6. Susan Brownmiller presents a valuable, if piecemeal, account of sexual violence against women during World Wars I and II and in Bangladesh and Vietnam: *Against Our Will: Men, Women and Rape* (New York: Simon and Schuster, 1975), 23–118; Yuki Tanaka examines the Japanese World War II example, which he briefly compares and contrasts with German, Russian, American, and Australian World War II and Occupation practices, in *Hidden Horrors: Japanese War Crimes in World War II* (Boulder, CO; Westview Press, 1996) 79–109.

7. Enloe, *Does Khaki Become You?* 20. Italics mine.

8. *Jūgun ianfu* ("comfort women" who follow the troops), or simply *ianfu,* are two of a variety of terms used by the Japanese during and since World War II to identify women more accurately described today as militarized sex slaves. As Tamura Taijirō's descriptions of the Korean women's lives in the camps suggest, the giving of comfort (emotional, psychological, and physical) was indeed—from the point of view of the men receiving it—a crucial element in the rationale behind the need for these young women's enslavement. It is also clear from former survivors' testimonies, as well as from Tamura's descriptions, that the women were in fact victims of sanctioned multiple rape. I use the term "comfort women" in this paper because of its wide contemporary media recognition. For an important discussion of the "Criminal-Centricity Enacted and Reproduced in the Term *Ian,*" see Tomo Shibata, "Japan's Wartime Mass-Rape Camps and Continuing Sexual Human-Rights

Violations," *U.S.–Japan Women's Journal, English Supplement* 16 (1999), 52–56. Shibata proposes replacing *ianfu* with *kokka tairyō gōkan jo seizonsha* (national mass-rape camp survivors) and *ianjo* with *tairyō gōkan jo* (mass-rape camps). The Korean term most often used was *"chongshindae"* ("volunteer laborer," or *"teishintai"* in Japanese). For a discussion of these and other terms, used primarily by different branches of the Japanese military to refer to their sex slaves ("female forces," "military supplies," "working women," "special women," "military prostitutes," "whores," "professional entertainers," "special forces," "street girls," "gifts for the Japanese forces," "hygienic public bathroom," and others), see Shin Young-sook and Cho Kye-ran, "On the Characteristics and Special Nature of the Korean 'Military Comfort Women' under Japanese Rule," *Korea Journal* (Spring 1996), 52–54; and Chin Sung Chung, "The Origin and Development of the Military Sexual Slavery Problem in Imperial Japan," *Positions* 5:1 (1997), 220–222.

9. Tamura Taijirō, *Shunpuden* (Tokyo: Ginza Shuppansha, May 1947), 1. The quote is taken from the preface to a collection of stories featuring what appears to be a self-censored, "de-Koreanized" version of the short novel *Shunpuden*. This version did, to the later surprise of the magazine section, get past the Book Unit of the Press, Publications, and Broadcasting Division (PPB) of the Civil Censorship Detachment (CCD) and was published in May.

10. Translated from the galley of the story submitted for publication in *Nihon shōsetsu*, April 1947, 14; the galley can be found in the *Nihon shōsetsu* censorship file (Reel 140), Gordon W. Prange Collection, McKeldin Library, University of Maryland, College Park. Even this brief preface, which was originally presented with the single short story (and thus was never published), was de-Koreanized by Tamura in his overall preface for the published book. Tamura's censored and uncensored prefaces and the suppression of the *Nihon shōsetsu* version of *Shunpuden* are discussed below.

11. Preparing the stage for public discussion of military sexual slavery as a human rights issue were such international events as the 1988 Summer Olympics in Seoul, Korea; the strengthening of democracy and of a feminist consciousness in South Korea and elsewhere in East and Southeast Asia; the death of Emperor Hirohito; and the growing importance of Asian-Japanese economic and political relations. In discussing this same issue, Norma Fields suggests additional factors: the "markedly improved economies of the region, the unloosening of the cold war order (slower in Asia than in Europe), and the growing awareness of citizens about their rights and the desire to pursue them while they are still able. In the case of the so-called military comfort women, the rise of women's movements and the growing criticism—both in Japan and abroad—of the contemporary Japanese overseas sex industry have been crucial in raising public consciousness so that the problem could be recognized as a problem, rather than as an instance of normal male behavior exaggerated by wartime conditions" ("War and Apology," *Positions* 5:1 [Spring 1997], 23).

12. The question of why the "comfort women" experience remained a so-called hidden or forgotten nonissue for fifty years, in spite of the fact that reliable information on its broad outlines had been available in print and documentary film for some time, is complex. For thoughtful discussions of the social, psychological, and historical circumstances that fostered the years of silence, see Alice Yun Chai, "Asian-Pacific Feminist Coalition Politics: The *Chongshindae/Jūgunianfu* (Comfort Woman) Movement," *Korean Studies* 17 (1993), 74–76; Chung, "The Origin and Development of the Military Sexual Slavery Problem in Imperial Japan," *Positions* 5:1 (Spring 1997), 232–234; and Executive Committee,

International Public Hearing Concerning Post War Compensation of Japan, ed., *War, Victimization and Japan: International Public Hearing Report* (Tokyo: Tōhō Shuppan, 1993) 86–89.

13. It should be noted that although individual scholars, journalists, participants in the events, filmmakers, and women's groups in Korea and Japan had, since at least the late 1960s, used their various media to draw attention to the abuse of women by the Japanese military during World War II, the subject did not capture international media attention until it was linked to high-level Korean-Japanese political relations. The media attention and consequent denial of involvement by the Japanese government in turn encouraged an intensified search for official documents proving Japanese military control of the "comfort women" system. The discovery of documentation brought increased public attention. The story of how the "comfort women" issue was guided into the international arena is complex and speaks primarily to the strength of individual Korean women and to the support given by various individuals and groups in Korea, Japan, and elsewhere. For two detailed, well-documented accounts of the process in English, see Chai, especially 76–83, and Chung, 234–245; see also Watanabe Kazuko, "Militarism, Colonialism, and the Trafficking of Women: 'Comfort Women' Forced into Sexual Labor for Japanese Soldiers," *Bulletin of Concerned Asian Scholars* 26:4 (1994), 11–15; and Hicks, *The Comfort Women*, 128–226; much of the information Hicks provides in these chapters is telescoped and better documented in his article, "The 'Comfort Women,'" in Peter Duus, Ramon H. Myers, and Mark R. Peattie, eds., *The Japanese Wartime Empire, 1931–1945* (Princeton, NJ: Princeton University Press, 1996), 305–310.

14. For a detailed chronology of events covering the period from January 1990 to December 1996, see *"Ianfu" kankei bunken mokuroku* (A Bibliography of Publications on the "Comfort Women" Issue), Asian Women's Fund (Tokyo: Gyōsei, 1997), 207–227. The chronology is organized around (1) activities of "comfort women" and their supporters, (2) responses of the Japanese government, including those of the National Diet, and (3) reactions, movements, and activities in other countries, the United Nations, and other international groups. The extensive bibliography includes Japanese, Korean, and Chinese monographs, articles, reports, and book reviews written on the subject through December 1996.

15. Sent in the form of an open letter to Prime Minister Kaifū dated October 17, 1990, and signed by thirty-seven organizations, it was delivered initially to the Japanese Embassy in Seoul. A copy was later delivered to the Japanese Foreign Ministry in Tokyo. For English text and an account of events that led to its composition, see Hicks, *The Comfort Women*, 143–145. The letter listed at its conclusion these six demands: "that the Japanese government admit the forced draft of Korean women as comfort women; that a public apology be made for this; that all barbarities be fully disclosed; that a memorial be raised for the victims; that the survivors of their bereaved families be compensated; and that these facts be continuously related in historical education so that such misdeeds are not repeated." The Korean Council for the Women Drafted for Military Sexual Slavery by Japan is, as of the fall of 2000, still seeking to have these demands met.

16. The original letter to Kaifū challenges the labor minister's denial of direct government involvement in the drafting of Korean women. The line of activism resulting in this letter began with a request from the Korean Church Women's Federation to South Korean President Roh Tae Woo asking that he raise the "comfort women" issue with the

Japanese during his ensuing state visit to Japan in May 1990. While Roh did not comply, public attention to this and other problems of Korean forced labor during World War II prompted a Social Democratic Party member of the Japanese Diet, Motooka Shoji, to ask (in June 1990) for an investigation of the military "comfort women" problem. The response given during a Diet session was that "the comfort women affair was the work of neither the Government nor the military, but rather that of private businessmen." This denial of responsibility and refusal to investigate became the immediate spur to the letter to Kaifū and to the formation, in July, of the Korean Research Group of Women Drafted for Military Sex Slavery by Japan. A larger umbrella group of Korean women's organizations, known as the Korean Council for Women Drafted into Military Sexual Slavery by Japan, was created in November of 1990. The work of these groups has been instrumental in elevating the "comfort women" issue to an international level.

347

17. Having received no response, help was solicited from a Social Democratic member of the House of Councilors, Shimizu Sumiko, who reported on the contents of and asked for responses to the letter at both the Labor and Foreign Ministries. While Shimizu also failed to elicit a response, another Social Democratic Party member, Motooka, *was* able, by April 1991, to confront Kaifū with the issue and to force the Labor Ministry response. Korean and Japanese media headlined the story. See also Chai, "The *Chongshin-dae* Movement," 79; Hicks, *The Comfort Women*, 146–148; and Hicks, *Far Eastern Economic Review*, February 18, 1993, 36.

18. Copelon characterizes here what she describes as "the Japanese army's alternative to open mass rape," in her "Surfacing Gender: Reengraving Crimes against Women in Humanitarian Law," in Dombrowski, ed., *Women and War in the Twentieth Century*, 332. One of many examples of a public dismissal of the comfort system as a matter of private enterprise is a statement made on the eve of a summit meeting between Japanese prime minister Hashimoto Ryūtarō and Korean president Kim Young Sam on January 25, 1997. Chief Cabinet Secretary Kajiyama Seiroku, commenting on planned coverage of the "comfort women" issue in junior high school textbooks, is quoted as saying: "It is odd teaching [children] about the 'comfort women' issue without telling them about the social background of the authorized prostitution system at that time. Those who are making a fuss over the 'comfort women' do not know that an authorized prostitution system existed in those days" (*Japan Times Weekly International*, February 3–9, 1997). In April and May 1994, Nagano Shigeto, briefly minister of justice, articulated the same attitude when he stated that the "comfort women" were "licensed prostitutes, so it's not fair to denounce their treatment from today's vantage point as contempt for women or discrimination against Koreans"; he suggested too that the military "comfort women" system was "an extension of public prostitution and not all bad" (see Chung, "Military Comfort Women," 242; and Suzuki Yūko, "Writing on the 'Comfort Women' Issue," *Japanese Book News* 7 [1994], 4). For an extended discussion of licensed prostitution and the modern Japanese state and society, 1890s–1946, see Sheldon Garon, *Molding Japanese Minds: The State in Everyday Life* (Princeton, NJ: Princeton University Press, 1997), 88–114. In a critique of the 1996 United Nations' "comfort women" report, military historian Hata Ikuhiko reflects the prewar official defense of licensed prostitution in arguing that comfort women were "Asian prostitutes who served the Japanese military during World War I," and "were under contract not with the Japanese military but with brothel owners" ("The Flawed U.N. Report on Comfort Women," *Japan Echo* [Autumn 1996], 66 and 69); this article is drawn from a May

1995 article in *Bungei shunjū:* "Yugamerareta watakushi no ronshi" (My Argument Distorted), 188–189. Hata not only dismisses all oral and written testimony of former "comfort women," but also rejects accounts of many other participants who have described widespread forced and duplicitous recruitment (see *Shokun* article by Hata, "Ianfu 'mi no ue no hanashi' o tettei kenshō suru," (Scrutinizing the "Life Stories" of Comfort Women), 54–69.

19. For discussion of the documentary evidence available to date that suggests prolonged, forced, military-controlled prostitution, see Yoshimi Yoshiaki, *Jūgun ianfu* (Tokyo: Iwanami Shoten, 1995) and his *Jūgun ianfu shiryōshū* (Documents on the Japanese Imperial Army's Comfort Women) (Ōtsuki Shoten, Tokyo, 1992); Society on the Issue of the Korean Comfort Women, ed., *Chōsenjin jūgun ianfu shiryōshū* (The Korean Comfort Women Issue: Documents, vols. 1 and 2) (Kobe, Japan: Kobe Gakusei Seinen Center Shuppanbu, 1992); and Kim Yong Dal, *Chōsenjin jūgun ianfu/Joshi teishintai shiryōshū* (Documents on the Korean Comfort Women and the Female Work Corps) (Kobe, Japan: Kobe Gakusei Seinen Center Shuppanbu, 1992). See also Suzuki Yūko, *"Jūgun ianfu" mondai to seibōryoku* (The "Military Comfort Women" Question and Sexual Violence) (Tokyo: Miraisha, 1993). For a discussion of the problem of memory and truth, see Hyunah Yang, "Revisiting the Issue of Korean "Military Comfort Women": The Question of Truth and Positionality"; and Hyun Sook Kim, "History and Memory: The "Comfort Women" Controversy," both in *Positions* 5:1, 51–106.

20. In response to a formal inquiry in November 1992 by Yoshikawa Haruko, Japanese Communist Party member of the House of Councilors, the Japanese government stated that former Japanese "comfort women" would not be compensated for their wartime services. As in other such cases, the government insisted that they have found no written evidence proving that women were recruited against their will (*Japan Times*, November 28). For a discussion of the legal and political issues involved, see "Japanese Reparations Policies and the 'Comfort Women' Question," Park, *Positions*, 107–134. The problems of official apologies and official denials are as manifold and difficult in relation to the "comfort women" issue as they are to any other nationally perpetrated war crimes. For thoughtful considerations on the meaning and value of apology and of the importance of an acceptance of national responsibility for past actions, see Field, *Positions*, 1–49 and Milton Leitenberg, "Japan's Postwar Ambiguity: The War, Denials, and the Future," *Japan Times Weekly International*, April 28–May 4, 1997, 11.

21. I have covered this story of revelations, denials, added pressure, further revelations, and continued denials in a paper presented at the New York Conference, Association of Asian Studies, October 16, 1998, entitled "Sexuality: Needs of the Flesh and Tamura Taijirō's 'Comfort Women' Stories."

22. For an excellent theoretical discussion of the role that "poverty, patriarchy, and prosperity" played in the "financial, physical, sexual, and emotional abuse" of Chinese and Japanese women sold into prostitution, see James Francis Warren, *Ah Ku and Karayuki-san: Prostitution in Singapore, 1870–1940,* (Oxford, England: Oxford University Press, 1993), especially 25–37; for author's summary of the "Japanese Traffic," see 81–88. In her *Sandakan hachiban shōkan* (Sandakan Brothel No. 8) (Tokyo: Chikuma Shobō, 1972), Yamazaki Tomoko, focusing on poor rural women from the island of Amakusa and the Shimabara Peninsula who were forced into prostitution, also sees poverty and patriarchal attitudes toward female family members as the prime motivating factors in selling daugh-

ters. For a translation of Yamazaki's work, including an excellent introduction that reviews the history of Japanese exploitation of poor women, see Karen Colligan-Taylor, *Sandakan Brothel No. 8: An Episode in the History of Lower-Class Japanese Women* (Armonk, NY: M. E. Sharpe, 1999).

23. Colligan-Taylor, xx–xxv. See also Imamura Shōhei's documentary, *Karayuki-san: The Making of a Prostitute*, 1975, and Kei Kumai's 1975 film based on Yamasaki's work, *Sandakan hachibankan* (Sandakan Eight). It should be noted that these two excellent films appeared some fifteen years before the "comfort women" issue gained international attention.

24. Ronald Hyam, *Empire and Sexuality* (Manchester, England: Manchester University Press, 1990), 142–143 and 154, note 23, citing League of Nations, *Report of Commission of Enquiry into the Traffic in Women and Children in the Far East* (C.849.M.393. 1932. IV), 103–104; and F. Henriques, *Prostitution and Society*, *III* (London: MacGibbon & Kee, 1963), 295–306. For another discussion of the creation and use of the term *"karayuki-san"* and a consideration of the relationships between the sale of women and Japanese political and social objectives of the time, see Bill Mihalopoulos, "The Making of Prostitutes: The *Karayuki-san*," *Bulletin of Concerned Asian Scholars* 25:1 (1993). For an account of the *karayuki-san* and of the transition from *karayuki-san* to *ianfu*, see Kim Il-myon, *Nihon josei aishi* (The Tragic History of Japanese Women) (Tokyo: San'ichi Shobō, 1981), 182–267.

25. James Francis Warren, *Ah Ku and Karayuki-san*, 164–169. Warren describes the perceived need to persuade women to return to Japan (149–50) and the "sly brothels" or the "sly *karayuki-san*," women who secretly remained, in spite of increasingly forceful techniques of persuasion, in the city of Singapore (166).

26. Yoshimi, *Jūgun ianfu shiryōshū*, 26–86. Yoshimi was one of the first historians to find documentary evidence; he coordinates the story of the establishment of comfort houses, the recruiting and transportation of women of various nationalities, and the conditions of their wartime lives with documents available to him in 1992. He lists four types of comfort houses used by the Japanese military: (1) those that were military-run; (2) those outwardly privately owned and run but actually controlled by the military primarily for military use; (3) those privately owned and open to civilians but with priority ("special services") given to the military through agreements with them; and (4) those that were privately owned brothels (27–28, *War Victimization and Japan*, 84; see also Yoshimi's 1995 monograph, *Jūgun ianfu*, 85–158). Yuki Tanaka discusses the question of why "the Japanese military decided that comfort houses were necessary"; his four reasons are: to prevent the rape of civilians in occupied areas, to provide recreation for the troops, to control venereal and other diseases, and to prevent espionage. During a Japanese Diet Budget Committee meeting in March 1992, the Defense Agency director of the Secretariat, Naoki Murata, gave this explanation for the establishment of military-run brothels: "The comfort women system was needed to maintain order. It was to ease the anti-Japan feeling aroused by the Japanese soldiers' deeds. It was also for the soldiers' health maintenance."

27. Tanaka, *Hidden Horrors*, 96–97. Tanaka suggests "racial prejudice" against other Asian women as one reason for the heavy recruitment of non-Japanese women. He sees in international law another explanation for why the supply of Japanese women was limited. Japan had been signatory to two international legal agreements; one (1910) suppressed trade in women for the purpose of prostitution and another (1921) banned trade in women and children. As Tanaka writes, however, "Officials believed these laws were

not applicable to Japan's colonies, and this, combined with the belief in the superiority of Japanese women and the suitability of women of other races for prostitution, cemented the decision to use women from colonies and occupied territories as comfort women" (97). Evidence that the Japanese military specifically sought out healthy young virgins in the colonies and occupied territories is overwhelming, having been confirmed by personal accounts of Japanese military and medical personnel, by Japanese women involved in recruitment, and by Korean, Dutch, Philippine, Taiwanese, Indonesian, Chinese, and other "comfort women" survivors.

28. For translations into English of accounts by South Korean, North Korean, Chinese, Dutch, and Taiwanese women, see the two previously cited works: *War Victimization and Japan* and *True Stories of the Korean Comfort Women*.

29. Interrogation Report, Serial No. 55, 7. See ATIS, South West Pacific Area, Research Report entitled "Amenities in the Japanese Armed Forces," February 16, 1945, I.G. No. 6310, 7–9. This report quotes nine such statements of Japanese POWs captured in Burma, Sumatra, and the Southwest Pacific area. Five of the nine mention Korean women; one other mentions native (Sumatran) and Chinese women. Historian Grant Goodman, a former Occupation officer and translator, was apparently the first to call recent public attention to this report (see the *Korean Herald,* February 9, 1992).

30. When, in January 1992, the Japanese government made its first formal announcement and apology concerning the "recruitment" of Korean *ianfu,* it was reported that the army had gathered as many as 160,000 Korean women and forced them to work as prostitutes for thousands of imperial Japanese army troops; see, for instance, the *New York Times,* January 14 and 27, 1992. This figure, routinely repeated, represents 80 percent of the highest estimate of 200,000 women. The Japanese government's second "comfort women" report summary states that "it is apparent there existed a great number of comfort women but it is virtually impossible to determine the total number" (*Japan Times Weekly International Edition,* August 16–22, 1993, 3).

31. All discussion of and quotes from translated portions of *Shunpuden* in this paper are based on Tamura's uncensored, suppressed version. That is to say, I use the galley of the unpublished *Nihon shōsetsu* version of the story, submitted by its editors to SCAP authorities probably in March 1947. See further explanation below.

32. *Shunpuden,* 16 (Ginza Shuppansha edition, 5–6 and Kōdansha, 432). In all citations of the original, I list first the *Nihon shōsetsu* page numbers taken from the galley version; I cite in parentheses the page numbers for the apparently self-censored Ginza Shuppansha May 1947 version published as the lead story in the collection of short stories entitled *Shunpuden,* and next I cite page numbers for the 1953 Kōdansha edition published in the *Gendai chōhen meisaku zenshū* (Collection of Modern Masterpieces of Fiction) Series, vol. 13, *Tamura Taijirō, "Shunpuden,"* 431–466. I note differences in the censored and published versions when relevant. *It should be noted that even in the 1953 Kōdansha edition, Tamura chose not to return to his original version. That is to say, he allowed the story to remain de-Koreanized even after the Occupation—and censorship, presumably—had ended.* Note, for instance, that in the suppressed *Nihon shōsetsu* version of the passage translated here, Tamura *names the specific areas in Korea* where the women were born, while in the 1947 and the later 1948, 1949, and 1953 published versions, he states simply that "all were born in a corner of the peninsula on the Asian Continent." He excises the word *Korean (Chōsen no)* again when mentioning the women's names: "All had Korean names" is altered to read "all had their

own real names." Finally, and perhaps most significantly, in the *Nihon shōsetsu* version, Tamura uses the term *"minzoku"* (ethnicity, race) in the phrase *"aite to wa chigau minzoku no hitori de aru koto wo oboesaserarete"* (forced to realize that they were of a different ethnic origin from their partners), while in the published versions the word *"minzoku"* has been eliminated: *"aite to wa chigau ningen no hitori de aru koto wo oboesaserarete"* (forced to feel that they were a different sort of human being from their partners). As discussed below, the version without any mention of Korea or use of key terms such as *race* passed the book censorship inspection and was published in an anthology of Tamura's stories in May 1947.

33. The testimony of Kim Haksun, the first former "comfort woman" to speak out about her experiences, echoes Tamura's descriptions: "Because the soldiers chose which rooms they fancied, each of us had regular customers. They varied in the way they treated us: while one soldier was so rough as to drive me to utter despair, another would be quite gentle" (*True Stories of Korean Comfort Women*, 36).

34. *Shunpuden*, 10 (16); the censored *Nihon shōsetsu* version gives Harumi three years in Tianjin, while the published book versions have her there two years. See 16 (8) for the use of the term *"zenshaku"* (an advance loan). Tamura implies that the Korean families, like those of the Japanese *karayuki-san*, were willing to sell daughters in order to relieve family poverty. Recent testimony of former *ianfu* suggests, on the other hand, that families were forced or tricked into selling their daughters when urged to do so by government (Korean and Japanese) or military authorities, regardless of family income. In addition to the "advanced loan," women sometimes had to repay their fare for passage to China, moneys for clothing, food, rent, and other miscellaneous expenses. For valuable individual case studies on women driven into military prostitution in Korea and other parts of Asia since the end of World War II, see Saundra Pollock Sturdevant and Brenda Stoltzfus, *Let the Good Times Roll: Prostitution and the U.S. Military in Asia*, (New York: New Press, 1992).

35. *Shunpuden*, 17 (11; 433).

36. *Shunpuden*, 20 (18–19; 437).

37. Ibid.

38. Ibid. In this passage, too, the word *Korean* was excised in the published version. Tamura's longer book version preface to *Shunpuden*, translated below, reveals a similar "common sense" assumption that women must be provided for the troops.

39. *Shunpuden*, 20 (19; 437–438). The three passages translated here are contiguous. Interestingly, all texts do identify the Japanese women as "Japanese women" *(Nihonjin no onnatachi)*; Korean women become "those women" *(kanojo-tachi)*. Recent oral testimony by army doctors affirms the fact that Japanese women were often used for "entertainment," primarily in cities, while other women were used in the field. See the *Japan Times*, August 7, 1992. In an interview with the *Japan Times*, Dr. Mitsuyoshi Nakayama, military surgeon between 1941 and 1944 in Manchuria, is quoted as follows: "Korean women were used only to provide sex, and Japanese women served in both entertainment bars and military brothels. Some of the Japanese women said they came there because they were told they could make money. Some of them were geisha girls. I don't think Chinese women were forced at gunpoint, as in the case of many Korean women, to come (to serve as prostitutes)."

40. Ibid., 21 (20–21; 438). We again find, in recent testimony of army medical personnel, stories of emotional attachments between Japanese soldiers and the women. Dr. Yuasa Ken, sent "to check comfort women in Luan in Anhui Province in April 1945," told

a *Japan Times* reporter (August 7, 1993) about "a case in which one soldier and a Korean comfort woman committed suicide together. 'They must have been deeply attracted to each other,' he said."

41. In the published versions, "low-class Korean prostitute" *(Chōsen pii no bunzai de nani o iu ka)* *(Chōsen* is written in katakana in the *Nihon shōsetsu* version) is changed simply to "low-class prostitute" *(Pii no bunzai de nani o iu ka);* ibid., 22 (24–25; 440).

42. Ibid. Again the references to *"Chōsen"* are deleted in the published versions. In the 1968 Kōdansha version, Harumi's comeback to the officer becomes: "A whore! You call me a whore? Would the emperor call me that? We have the same emperor!" *(Pii, piitte, baka ni suru ka. Tennō Heika ga sore iu ka. Tennō Heika onaji zo),* 440.

43. Ibid. A significant change is made in the first sentence in all published versions: *"Iminzoku de aru kanojo niwa Tennō no arigatasa wa wakaranakatta ga"* is altered to read, *"Kanojo tachi ni wa Tennō ga nan de aru ka sonna koto wa, wakarō hazu wa nakatta"* (One would probably not expect these women to understand a thing like [the significance of] the emperor).

44. An interesting literary text that echoes the basic attitudes expressed by Tamura here and elsewhere is Hanama Tasaki's *Long the Imperial Way.* A Hawaiian-born, American-educated Japanese who was an ordinary soldier in the Japanese Imperial Army in northern China, Tasaki was able to publish his autobiographical work (written in English) first in Japan (Tokyo: Itagaki Shoten, 1949) and then in the United States (Boston: Houghton Mifflin, 1950). Here are his soldier's thoughts immediately after his first visit to a Japanese-owned city brothel:

> Forgotten was the dust and grime of the march. Forgotten, the cold fear and ugly savageries of combat. All the slappings and endless oppressions of military life, the humiliations, sorrows, sufferings, and little jealousies were forgotten in the excitement of this single concentrated moment of meeting with a girl who seemed so amply to represent the softness and beauty of femininity he dreamed of so often. (147)

After his own brief encounter, the soldier walks through the town yearning to enter the high-class houses reserved for Japanese officers:

> Everywhere the army went, these houses flourished and *sake* flowed freely to the accompaniment of the Samisen and the lilting songs of the Geisha girls. They were there to help relieve the officers from the strains of combat and to help replenish the confidence of these overburdened men in their own manhood—a manhood which they had been trained to prize as supreme in the world and to defend as precious legacies of an exaggerated history. (155)

For other statements that reveal attitudes similar to Tamura's, see chapter 10, "Ian" (Comfort), 139–157 and 290 (1950 edition).

45. Enloe, *Does Khaki Become You?* 9 and 212–214.

46. Itō Sei et al., eds., *Kitahara Takeo, Inoue Tomoichirō, Tamura Taijirō shū* (Selections from Works by Kitahara Takeo, Inoue Tomoichirō, and Tamura Taijirō), *Nihon gendai bungaku zenshū* (Collection of Modern Japanese Literature), vol. 94 (Tokyo: Kōdansha, 1968), 367. "Locusts" was first published in *Bungei,* September 1964; it appeared the next year (October 1965) as the lead story in a collection entitled *Inago* (Locusts). For a résumé, see

Ted Takaya, "Synopsis, Tamura Taijiro, Locusts," *Japan P.E.N. News* 20 (September 1967), 10–11. All translations here are my own.

47. Ibid., 372–373.

48. After delivering the coffins, the small group of three Japanese soldiers, five women, and one Korean man who is introduced as the women's procurer are forced to travel on foot. During their long march, they encounter crossfire and three women, including Harada's favorite, Hiroko, are eventually killed. Only two arrive to serve the ten thousand soldiers waiting for them at the front.

49. For information on Tamura's life and work, see biographical essays and chronological tables in two collections: *Kitahara Takeo, Inoue Tomocihirō, Tamura Taijirō* in *Nihon gendai bungaku zenshū*, vol. 94 (Tokyo: Kōdansha, 1968), 418–420 and 427–428; and *Tamura Taijirō, Kin Tatsuju, Ohara Tomie shū* in *Chikuma gendai bungaku taikei*, vol. 62 (Tokyo: Chikuma Shobō, 1978), 468–476 and 495–504. See also *Nikutai no akuma*, 1948, 231–240; *Gendai bungaku daijiten*, revised edition, 926–927; *Japan P.E.N. News* 20 (September 1967), 8–10; and SCAP records kept on Tamura by the Press, Publication and Broadcast unit of the Civil Censorship Detachment, National Records Center, College Park, Maryland, Record Group 331.

50. Describing Tamura's "spirited literary activity during his 20s," Okuno Takeo suggests that Tamura's circle of literary relationships was truly wide, and that he was eager to publish wherever he could, "without concerning himself about whether it was the Modernist School or the Proletarian School." See "Hito to bungaku: Tamura Taijirō" (The Man and His Work: Tamura Taijirō), in *Tamura Taijirō, Kin Tatsuju, Ohara Tomie shū*, in *Chikuma gendai bungaku taikei*, 500.

51. See *Gendai bungaku daijiten*, 926; and "Tamura Chronological History," Chikuma, 468–469.

52. *Natsu*, for instance, is included in Tamura's 1948 collection of primarily postwar stories, *Nikutai no akuma* (Tokyo: Nihon Shorin), and both *Fuyu* and *Natsu* are included in the collection *Nikutai no mon* (Tokyo: Fūsetsusha, 1948). In the afterward of the latter, Tamura explains that while *Natsu*, *Fuyu*, and one other, *Haidan* (The Obsolete Bullet), are all earlier works, he included them because they are stories of which he was particularly fond (240).

53. Donald Keene, *Dawn to the West* (New York: Holt, Rinehart and Winston, 1984), 866 and 873–875.

54. The "Behaviorists" are described as being devoted to the realistic observation of relationships between stimuli and action and opposed to post–World War I nihilistic tendencies seen in Dadaists, surrealists and other European artistic movements. Writers thought to have influenced the group are intellectuals such as Lev Shestov and André Gide; the former particularly made an impact as a thinker actively engaged in challenging notions of "universal" ideals and "self-evident, logical" truths. See *Kitahara Takeo, Inoue Tomoichirō, Tamura Taijirō*, 419 and *Nihon gendai bungaku daijiten*, 370; Donald Keene (*Dawn to the West*, 711, note 76) describes the group this way: "Activism, a short-lived literary movement, was inspired by French *humanisme de l'action*, as exemplified by writers like Antoine de Saint-Exupéry, who wrote mainly about his experiences as a pilot. In Japan activism was interpreted as an insistence on intellectuals being socially engaged."

55. *Gendai Nihon bungaku daijiten*, 370.

56. Tamura's 1939 trip to Manchuria and North China was made as a member of the

Mainland Cultivation of the Arts Roundtable (Tairiku Kaitaku Bungei Kondankai), a group
he joined in January 1939. It is unclear with what group, if any, he made the 1938 journey.
Tamura's name is not among the Pen Brigade Writers who were sent to observe the
Wuhan campaign in September 1938 (see *Kitahara Takeo, Inoue Tomoichirō, Tamura Taijirō,*
419 and *Nihon bungaku zenshū,* vol. 6, 259). Okuno states simply that Tamura made the two
trips to the "mainland" and joined the Roundtable as a result of personal desire and inter-
est in China, a desire that was ironically fulfilled with his draft notice one year later (*Kita-
hara Takeo, Inoue Tomoichirō, Tamura Taijirō,* 500–501).

57. Okuno, "Hito to bungaku," 501.

58. Depicted also in Kenji Mizoguchi's SCAP-approved 1948 film, *Women of the Night.*

59. Here, for instance, is a contemporary (1948) view of Tamura's place in the post-
war literary scene:

> He is said to be cutting a spectacular figure among the current writers because
> he takes up actualities so bluntly. It is *Nikutai no mon* that has pushed him out into
> the rank of popular writers. This work is eye-catching in the term of the post-war
> morals because it portrays a street-walker lynched for her breaking the law
> among her circles. This work, being dramatized by KUKI theatre, has broken the
> record by running for 4 weeks. Along with its staging, this "Gateway of the Flesh"
> is selling like a hot dog, which tumbled down a vast sum of royalty into his
> pocket. He has reportedly bought a home at Ogikubo for 500,000 Yen, where he
> lives with his wife whom he married last June. *We may realize it is indisputable that
> he is a lascivious literary writer, if we glance through "The Gateway to the Flesh," "Devil
> of the Flesh" and "Harlot" [Shunpuden], these being his first works published after his
> home-coming from the front.* (Emphasis mine)

This is a translation of a passage from Takayama Tsuyoshi's study of early postwar Japa-
nese literature, *Sengo no bungaku* (Tokyo: Shigakusha, June 1948), produced by PPB as part
of censorship records on current writers; see Record Group 331 (SCAP Records), National
Record Center, College Park, Maryland.

60. *Maya wa darakusha de aru koto no kōfuku wo kanjita* (Maya felt the joy of being a
fallen one [decadent]); *Nikutai no mon* (Tokyo: Fūsetsusha, 1948), 47.

61. For an account of the "flesh literature boom" and its sudden popularity immedi-
ately after the publication of *Nikutai no akuma* and *Nikutai no mon,* including discussion of
other intellectual influences on Tamura's theory, see Mori Keiyu, "Tamura Taijirō no
nikutai no bungaku," *Kokubungaku: kaishaku to kanshō* Special Edition (July 1972), 163–64;
and for a brief account of *Nikutai no mon* that places Tamura's immediate postwar works
"somewhere between the dregs [pulp literature] and Sakaguchi Ango," see Jay Rubin,
"From Wholesomeness to Decadence: The Censorship of Literature under the Allied
Occupation," *Journal of Japanese Studies* (Winter 1985), 82–84.

62. Tadatoshi Okubo, writing in 1949, lists the following "cons" in "Mr. Tamura's way
of thinking":

1. In his conception, the body means only a bundle of sexual pleasures.
2. He exaggerates sexual pleasure.
3. He makes readers, especially younger ones, think of the opposite sex only in
 terms of physical sex.
4. He makes readers disregard ideas, philosophy, and other spiritual values.

5. He justifies any and all anti-social activities. He is at odds with criticism of these activities.
6. In his value scale, criminals, prostitutes, and blackmarketeers are ascribed more prestige than those who work honestly.
7. His words decrease the will to work, and make people think less about their significance in society.
8. He makes no distinction between the liberation of the body and sexual anarchy.

Okubo finds only two "pros":

1. His works are interesting as entertainment.
2. He bravely attacks the old system of morality.

See "The Literature of the Flesh: A Study of Taijirō Tamura's Thought," 85–86; originally published in *Shisō no kagaku* 4:3, (1949); translated and reprinted in *Japanese Popular Culture* (Rutland, VT: Tuttle, 1959).

63. For a list of titles of stories, types of his leading male (for instance, criminal, soldier, blackmarketeer, writer, rapist) and female characters (prostitute, office girl, dancer, waitress, madame, mistress, pickpocket, and others), types of relationships between the two, and presence of sexual material, see ibid., 80–81. Okubo concludes his essay with the following statement:

> Mr. Tamura and other writers of the carnal school are no longer as popular as they were in 1946. In fact the *Yomiuri* newspaper of July 1948 reported that "That group of erotic magazines has almost disappeared. Even a 10-yen price cannot attract readers." However, from a social psychological point of view, this type of literature is still worthy of careful study and analysis because the popularity of carnality was a product of a time of social disorganization when people lost faith in the existing system of values. The study may give us a clue to such times. (86)

64. See Jay Rubin, "From Wholesomeness to Decadence," 73–74; and *Injurious to Public Morals: Writers and the Meiji State* (Seattle: University of Washington Press, 1984), 227–278; Richard Mitchell, *Thought Control in Prewar Japan* (Cornell, NY: Cornell University Press, 1976), 160–161; and *Censorship in Imperial Japan* (Princeton, NJ: Princeton University Press, 1983), 348–349.

65. Mori Keiyu writes that in his later postwar stories, "Tamura vulgarizes, rather than popularizes" what had earlier been his more serious *nikutai* theme; "Tamura Taijirō no nikutai no bungaku," *Kokubungaku: kaishaku to kanshō* (July 1972), 164.

66. Okuno Takeo argues that it was the inordinate popularity of *Nikutai no mon*, not only immediately after the war but also on into the postwar period, and the two unfortunate periods of literary inactivity during crucial years of his writing career—nearly seven war years and this period of illness (he is said to have suffered from cerebral thrombosis)—that together may have done most to shape and limit Tamura's literary life; see "Hito to bungaku: Tamura Taijirō" (Tamura Taijirō, the Man and his Literature), in *Tamura Taijirō, Kin Tatsuju, Ohara Tomie-shū*, (Tokyo: Chikuma Shobō, 1978), 495.

67. Suggested in all of the biographical sources consulted.

68. Okuno, "Hito to bungaku," 498.

69. Okuno reasons that it was primarily the ordinary soldier's and the ordinary civil-

ian's experiences in war that drew Tamura to his subject (ibid., 501). Okuno's is the most thoughtful discussion of Tamura's dramatization, in the 1960s stories, of the barbarous reality of war in which soldiers and civilians must kill or be killed, and an ordinary soldier must sometimes stand by helplessly as he witnesses evil and uncontrolled violence perpetrated by his own side or must struggle with his own powerful instinct to live—an instinct that can lead to pillage and (both Okuno and Tamura insist) rape and that renders human morality meaningless.

70. Quoted by Okuno, "Hito to bungaku," 497–498.

71. *Shunpuden,* 16 (8; 431–432).

72. Ibid., 25–26 (28; 443).

73. The essay is featured in a section of *Gunzō* entitled "The Author's Point of View," 11–14. Tamura continued to publish on this subject through the early years of the Occupation, and in February 1948 (Tokyo: Kusano Shoin) and again in October 1948 (Tokyo: Asaake Shoin) he published two separate monographs, both collections of his own essays on the topic and both entitled *Nikutai no bungaku.* Only two of the essays appear in both volumes, one of which is that discussed here.

74. *Gunzō* (May 1947), 11.

75. Both terms, *"shisō"* and *"nikutai,"* allow Tamura room for ironic play. His readers would have associated *"shisō"* with the prewar and wartime Peace Preservation Law system with its *shisōhan* (thought offenders), *shisō kenji* (thought prosecutors), or *shisō hanzai* (thought crimes); and *"nikutai"* might be seen as a parodic partner with another term associated with the Peace Preservation Law, *"kokutai"* (the political system—regarded as unique to Japan—as embodied in the imperial system). See Richard Mitchell, "Peace Preservation Law of 1925," in *Kodansha Encyclopedia of Japan,* vol. 6, 168; see also Jay Rubin, "From Wholesomeness to Decadence," 82–84, for a brief discussion of Tamura's essay, "Ningen wa nikutai de aru" (Flesh Makes the Man), and his use of the terms *"nikutai"* and *"kokutai."*

76. *Gunzō* (May 1947), 12.

77. Ibid.

78. Ibid., 13.

79. See censorship file for *Gunzō* 2:5 (May 1947), Prange Collection. For discussion of the censorship action and a translation of the marked passages as provided by CCD translators, see text and note 98 below. The Home Ministry was still in existence until December 1947, when its functions were taken over by the Ministry of Home Affairs, Ministry of Construction, and Ministry of Labor.

80. *Gunzō* (May 1947), 13; I have restored deleted sentences and revised somewhat the translation provided by CCD of this suspect passage. See note 98.

81. Ibid., 14.

82. *Shunpuden,* 16 (6; 432). As mentioned earlier, the phrase "who ate garlic and red hot pepper" was deleted in Tamura's self-censored version of the story published in May 1947. The last sentence in this passage, "perhaps this was a special ethnic characteristic of these women," was also deleted in the published versions.

83. *Shunpuden,* 25 (26–27; 443).

84. For a discussion of SCAP pre- and postcensorship procedures and regulations and of the organization of the Civil Intelligence Section of which CCD was a part, see Marlene Mayo, "Literary Reorientation in Occupied Japan: Incidents of Civil Censorship," in

Ernestine Schlant and J. Thomas Rimer, eds., *Legacies and Ambiguities: Postwar Fiction and Culture in West Germany and Japan* (Baltimore: Woodrow Wilson Center Press, Johns Hopkins University Press, 1991), 135–161; and Rubin, "From Wholesomeness to Decadence," 85. As Mayo indicates: "CCD had several branches to carry out its overall mission of surveillance of the media or other channels of public communications. Within this large apparatus, the unit responsible for preventing the mass media from carrying materials harmful to the goal of demilitarization and democratization was the Press, Publications, and Broadcasting Division, or PPB, which, in addition to its functional units, was also divided into three operational districts with headquarters in Tokyo, Osaka, and Fukuoka" (136).

85. See the *Nihon shōsetsu* censorship file, Prange Collection.

86. See galley proofs of the complete story and partially complete PPB censorship files for this issue of the magazine in the Prange Collection.

87. The usual procedure was for Japanese nationals to scan the materials for possible violations. Translations of suspect items were forwarded to senior American censors for final decisions. Occasionally, as in this case, chiefs of other divisions were consulted.

88. Mayo ("Literary Orientation in Occupied Japan," 136–137) summarizes the censorship categories as follows: "The taboos designated in SCAP's Press Code, issued in late September 1945, embraced the broad categories of militarist propaganda, inaccurate statements, incitements to unrest or remarks disturbing to public tranquillity, and criticism of the United States, the Allies, the occupation, or General MacArthur. For internal guidance, there were detailed office manuals and elaborate key logs that extended and periodically updated the list of forbidden subjects." See also Rubin, "From Wholesomeness to Decadence," 85.

89. In an interview in November 1992, Father Zahn, now a Maryknoll Catholic priest residing in Ise, Japan, could not remember the specifics of this particular case.

90. This preface is translated earlier in this essay.

91. The Prange Collection file on this extreme instance of censorship (banning the publication of a story in its entirety) ends with a brief typed note, undated but signed VHG (Victor H. Groening): "Shiro ITO came across a book in a book store "A Story of a Prostitute" by Taijiro TAMURA, which was suppressed when it was presented in the magazine, NIPPON SHOSETSU, May 47 issue. It is a story about Korean prostitutes. Can you give any info concerning the book, was it censored, passed, or what?" A cryptic, handwritten answer sent back to Groening on the original note reads simply: "Passed, 2 Jan 47!" No mention is made of the crucial differences between the two versions.

92. Other significant differences have already been indicated; there are also minor revisions, including corrections of Chinese characters and the addition of occasional clarifying phrases. It should be noted that before the end of the Occupation, after the change from pre- to postcensorship (in late 1947 and early 1948), Tamura published *Shunpuden* in at least two other collections of his stories. In both of these, the self-censored or non-Koreanized version of *Shunpuden* served as lead story; see *Tamura Taijirō senshū*, vol. 2 (Tokyo: Kusano Shobō, November 1948) and *Shunpuden* (Tokyo: Yagumo Shobō, October 1949); the selections of stories for both anthologies are, however, different from that of the earliest collection of the same title.

93. For Hirano's intriguing account of the various rewrites of the film version, see *Mr. Smith Goes to Tokyo: Japanese Cinema under the American Occupation, 1945–1952* (Washington, DC: Smithsonian Institution Press, 1992), 87–95. An interesting sequel to this erasure of

the Korean women is Suzuki Seijun's 1965 "pink porn" version of *Shunpuden* (translated initially as "Joy Girls"), in which Harumi is a Chinese prostitute, Mikami is her boyfriend/pimp whom she persuades to join the army and who is killed in battle, leaving Harumi alone with her memories!

358

94. Tamura Taijirō, *Shunpuden* (Ginza Shuppansha, May 1947), preface, 1.

95. See Changsoo Lee and George DeVos, eds., *Koreans in Japan: Ethnic Conflict and Accommodation* (University of California Press, 1981), 31–72, and especially Changsoo Lee, "Koreans under SCAP: An Era of Unrest and Repression," 73–91; see also Edward Wagner, *The Korean Minority in Japan, 1904–1950* (Institute of Pacific Relations, 1951), 25–72; Richard Mitchell, *The Korean Minority in Japan* (Berkeley: University of California Press, 1967), 75–118. It should be mentioned that the Korean press in Japan was censored, just as the Japanese press was.

96. It is telling that none of the scholarly studies in English cited here (see above note) on Koreans in Japan mention the Korean "comfort women." We can conclude, I believe, that it was not seen as a separate problem. The existence of the ATIS records of Japanese soldiers' allusions to Korean and other comfort women ("Amenities in the Japanese Armed Forces") tells us, at the very least, that Occupation authorities were aware of the imperial Japanese army's use of Korean *ianfu*; see note 32 above and *The Korean Herald*, February 9, 1992.

97. For a monographic study on this topic, see Masayo Duus, *Makaasaa no futatsu no bōshi* (McArthur's Two Hats), first published in book form under the title *Haisha no okurimono: kokusaku ianfu wo meguru senryōka mitsu* (A Present from the Defeated: The Secret Occupation History of State Policy *Ianfu*) (Tokyo: Kōdansha, 1979); reissued by Kōdansha with new title, 1985.

98. Mayo, "Literary Reorientation in Occupied Japan," 142–144; and Rubin, "From Wholesomeness to Decadence," 92.

99. For more on the Occupation and erotic literature, see Rubin, "From Wholesomeness to Decadence," 97–100.

100. See, for example, RG 331, PPB records, Check Sheet dated August 27, 1947, indicating that an obscene theatrical script could "not be suppressed on moral grounds except on CI&E recommendation."

101. See censorship file for *Gunzō* 2:5 (May 1947), Prange Collection. There is no indication of the identity of the second examiner; initials after the third "OK" are RZ, probably Robert Zahn.

102. To suggest the mood of the controversy in which Tamura's literary life became embroiled, we might quote from an article from the *Nihon Times*, Saturday, January 11, 1947, bearing the headline: "POLICE START DRIVE ON OBSCENE BOOKS." The story first quotes a *Yomiuri shimbun* article that describes the "obscene reading material, so-called art pictorials specializing in sexy pictures of women in the nude, and other tawdry and cheap magazines that appeal only to the lower emotions and are put out solely for money making purposes" which "will be the butt of the first clean-up drive of pornographic literature now flooding the reading market." The article goes on to state that "by further extending the application of Article 75 of the Penal Code, literary writings by well-known authors which were suppressed during the war and parts which were suppressed but published later as a separate volume will come under scrutiny once more. Even magazines accepted as first-class will not escape prosecution charges if there is any shadow of doubt as to the purity of its contents."

PPB, which systematically collected information on such activity, later once again netted Tamura in its intelligence web. A file for June 14, 1949, contains the following translation from an Osaka Central Broadcasting Station newscast:

> The Osaka Municipal Public Morals Committee has issued a warning respectively to TAMURA Taijiro and MIZUSAWA Natsuhiko against their two erotic books, for the reason that the books are undesirable from the standpoint of public morals. The books in question are "Bad Girls" [*Furyō shōjo*] written by Tamura and "Observation on the World's Pornographic Literature" by Mizusawa.

The warning to Tamura states: "He should be more careful about his future publication, as 'Bad Girls' is considered to bring undesirable effects upon young people in general." A July 1, 1949, PPB "information slip" on the subject, "EROTICISM: FAMOUS EROTIC WRITER ISSUED SERIES OF STORIES," described Tamura's newest collection of stories and summarized the plot of "Bad Girls." The story in question was about a young and innocent Japanese woman whose virginity is bartered off by a former aristocrat to an older man whom she despises.

From Pearls to Swine: Sakaguchi Ango and the Humanity of Decadence

Alan Wolfe

WHILE THERE ARE MANY IRONIES in critic Etō Jun's claims that postwar Japanese literature was impaired by American Occupation censorship, surely one of them is the explosive impact on the literary scene of writers like Sakaguchi Ango, who can hardly be accused of toeing the line, whether a militarist or a democratic liberalist one.[1] What does one make of a writer who, in the early months of 1946, amidst the lingering chaos, bomb craters, black marketeers, and potential starvation, issues a manifesto on "decadence" in which he exhorts the Japanese people to seek salvation through turpitude, regeneration through degeneration? In December 1946, at a time when even hard-line Communists were singing the praises of American Occupation-sponsored democracy, Ango tells his Japanese public that both American-style democracy and Communism are rubbish, that the new democratic forms are as Machiavellian and contingent as the now-disgraced Bushidō (code of the warrior) and *tennōsei* (emperor system): "It is no less our inevitable destiny that when we destroy the contrivance [*karakuri*] we call the emperor system and create a new system in its place, this new system should turn out to be but one more step in the evolutionary progress of contrivances![2]

Sakaguchi Ango (1906–1955) is associated in postwar literary criticism with the *buraiha,* a motley group of writers labeled nihilistic or "decadent" as much for their styles of life and death as for their writing. Also characterized as "intellectual outlaws" for their iconoclastic irreverence,[3] the *buraiha* included as its exemplars—in addition to Sakaguchi Ango—Dazai Osamu (1909–1948) and Oda Sakunosuke (1913–1947). The *buraiha* were not a literary movement in any familiar sense of the term; but they and their works conjured up, to the public and its journalistic chroniclers of the time, a sense of desperate skepticism that belied the dominant postwar paradigm of joyous resurrection, of democracy and freedom.

It was this same sense of skepticism, moreover, that ironically attracted readers to something genuine behind the Buraiha's very raison d'être, with its denotation of unreliability *(burai)*, for as one critic put it, it was in Ango's text *Darakuron* (On Decadence) of April 1946 that he discovered a genuinely "trustworthy human being" *(shinrai subeki ningen).*[4]

What was "trustworthy" to these generally young readers was the tone of authenticity in the paradoxical perversity of people writing against the ubiquitous opportunism and plastic optimism of the times. Thus, at a time of general criticism of the emperor system, did Dazai Osamu unexpectedly pen a resounding cheer for the presumably discredited emperor.[5] More telling perhaps were Sakaguchi Ango's pointed references to returned kamikaze pilots peddling goods in the postwar black market and war widows no longer as chaste as they were supposed to be. Unlike the ideological left and the intellectuals debating respective responsibilities for the war, Ango did not attack the emperor system with its myth of Japanese divinity so much as he tried to "humanize" it, which is to say that he both equated it with the postwar political reforms and also located these ostensibly "natural" and "given realities" of Japanese life within the mind-sets of the people, inured as they were to restrictive thought processes and behavior patterns internalized under successive authoritarian sociopolitical systems.

It is against this background that Ango's notion of *daraku* emerges to promise a mentally subjugated populace a tool for individualized and self-directed liberation. By undercutting the pervasive cultural and political symbols of hegemony in Japanese daily life, Ango's appeal for decadence resonated with the liberation of desire itself. At the same time, Ango's *daraku* invoked a rhetorical strategy not dissimilar to certain deconstructive techniques, involving most conspicuously a reversal of the hierarchical oppositions conditioning Japanese culture and a resultant displacement of the system constituted by them.[6] To give one example of this strategy, which at the same time predates the postwar and indicates the "consistency" of *buraiha* iconoclasm, consider Ango's March 1942 essay "Nihon bunka shikan" (An Eccentric's View of Japanese Culture), in which, at the height of Japanese ultranationalistic frenzy following Pearl Harbor, he inverted the familiar dichotomy of Japanese esthetics and Western functionalism. Indeed, in his shocking observation that people would never be as put out by the destruction of Japan's holy shrines and relics as they would be a "streetcar breakdown,"[7] he jolted people's consciousnesses more by his bald rhetoric than by what was after all a statement of the obvious.

The present essay, then, offers an examination of Ango's central paradigm of decadence or *daraku*. It begins by arguing that this concept, like *buraiha* literature, is best seen not as a curious or eccentric transhistorical style, a variation on earlier instances of decadent literature, but rather as a problematic specific to the immediate postwar intellectual and literary context. The succeeding sections juxtapose or oppose Ango's *daraku* to such prevalent themes of the postwar as rebirth and regeneration, democratic politics, and individual freedom, considered in conjunc-

tion with the debates on subjectivity or autonomy, the *shutaisei ronsō*. Ango's writings are brought into focus in relation to other representative works of the postwar, and on occasion prewar, including a film such as Kurosawa's *Yoidore tenshi* (Drunken Angel, 1948) or Nakano Shigeharu's paradigmatic 1935 *tenkō* story, "Mura no ie" (A House in the Village). A significant correlation is also noted between Ango's "decadence" and Tamura Taijirō's "carnal literature" *(nikutai bungaku)*. As I will suggest, these two concepts, in their differences as well as their similarities, may be seen to mark a certain literary-philosophical nexus of the postwar. Both may also be said to tend toward a revealing transcendence, to portray women allegorically in a manner highly suggestive of misogynism, and to lend themselves to generic, ahistorical, and universalizing critical categories.

Decadence: A Postwar Problematic

It is tempting, as certain critics have done—encouraged to be sure by statements by *buraiha* writers themselves—to locate *buraiha* texts in a generic tradition of decadent literature, or *burai bungaku,* one cutting across not only much of early modern and premodern Japanese literature, as well as post-*buraiha* writers, but across East and West as well. The pantheon of such writers becomes quite large and impressive indeed. But it is perhaps useful to keep a careful distinction between *burai bungaku* and *buraiha bungaku,* and to focus attention quite specifically on the period from 1945 to 1950. The generic approach, with its invocation of French nineteenth-century and Tokugawa ascendants, can lead to an ahistorical perspective.[8] A focus on a synchronic-diachronic nexus, as I shall argue, leads to very different results.

The *buraiha* phenomenon may best be seen in juxtaposition to the other main literary groupings of the postwar. To take a standard topographical scheme, these would include the "old masters" (Tanizaki, Kafū, Kawabata) and the revived leftist writers. The latter were also instrumental in promoting in and around the literary works of the time a set of vigorous debates on a number of vital issues ranging from responsibility for the war to the relationship between literature and politics to that of the individual and society. These debates were often highly abstract and technical in nature, especially those that dealt with the theme of *shutaisei,* translated variously as "subjectivity," "autonomy," and "leadership."[9] Ranging over a wide area of political, philosophical, and literary concerns, the debates brought together individuals of both Marxist and liberal persuasion. In sum, they reflected a fundamental concern that the intellectual and writer had to articulate, in some meaningful and concrete way, the requirements of individual behavior in the new postwar democratic Japan. Worded differently, the intellectual effort to conceive of a new type of individual could only be part of an attempt to generate a new historical narrative, one that would incorporate a vision of a possible future.

What remains so striking about the debates, however, is their tendency to evoke a mood of déjà vu, not only because they revived many of the issues of the

1930s, but because of the very abstract rhetoric in which they were couched—a rhetoric that once again heightened the intellectual sense of alienation from the Japanese people and from their material struggle for existence. It was thus not only the situation of the intellectual reflecting on the failures of the prewar left; it was also the circularity or empty nature of the debates themselves, designed as they were to forge a new ethos out of a situation whose parameters were predetermined. It took a very different type of discourse to reveal the futility of this enterprise in a situation where, after all, ultimate control lay entirely—if invisibly—out of Japanese hands.

In addition to this synchronic context of the debates, however, consider the acute sense of diachronic discontinuity whereby intellectuals, now free to pursue, argue, or promulgate the forbidden ideas of the prewar, found themselves to some degree stymied by an ironic congruence between their own language and that of the Occupation, the East Asia surrogate for a victorious American capitalism. The language of the postwar necessitated a view of prewar Japan as having "deviated" from the right path, and in this view it implied a failure of responsibility on the part of intellectuals and liberal leaders. This sense of failure and deviation is nowhere more dramatically articulated than in the phenomenon of *tenkō* (apostasy, recantation) and in its literary adjunct, *tenkō bungaku*. As I shall suggest, the *tenkō* phenomenon resonates all too well not only with Japan's defeat but with Ango's "decadence."

Let us now consider the synchronic and diachronic as an interlocking nexus, grounded in the obdurate reality of the U.S. Occupation. The problematic is related to the paradoxical perception that the agent of defeat is also the agent of liberation. Consequently, the narrative structures being erected as guideposts for the new Japan carry a bivalent charge: The ideological "signs" of democracy as introduced via Occupation reforms are already familiar to many Japanese, so familiar that they appear as the fulfillment of the long-desired objective of modernization. Yet, as the debates suggest, even if they do not effectively articulate it, there is a profound sense of alienation here: Change is taking place out of sync, as it were, with thought; thought may be unrestricted, but it is also unrooted in action. And along with this synchronic alienation from the sociopolitical realm is a diachronic sense of rupture and a gap in the narrative scheme of Japanese history. It may not be uncommon for intellectuals at all times to feel a disjuncture between their thought and the "real world," but the loss of control over the narrative structures of history, over the power to shape the story of the past, to erect their "truth"— this disjuncture creates a far more disturbing sense of alienation.

Perhaps this underlying sense of a disjuncture accounts for the apparent circularity, illogic, or remote abstraction of much of the debates. But it also may account for the intersection between philosophy and culture that characterizes the *shutaisei* debate. And most significant for literature and culture, it also provides a revealing instance of how ideological and philosophical concerns resonate with cultural production. Some of the most powerful films and writing of the period

can be seen to articulate the dilemma of *shutaisei*. Kurosawa's film *Drunken Angel*, for example, in tandem with its allegorical evocation of hellish death and rebirth, though admittedly at times maudlin and didactic, is nothing if not a plea for a new, inner-directed democratic individualism.

Yet, despite the allusions to hell as the necessary transition for self-discovery, in *Drunken Angel* the tubercular gangster *yakuza* hero Matsunaga (Mifune Toshirō) fares no better than the alcoholic Doctor Sanada (Shimura Takashi) who tries to save him. Both of them are victims of their generations and their surroundings: The doctor is the guiding spirit from before the war whose own "deviation" *(tenkō?)* through alcohol *(daraku?)* leaves him with the wisdom but not the power to cure either himself or others. Matsunaga is a prototype of the lost generation, afflicted with tuberculosis, a curable disease—but not as long as he remains in the contaminated environment of the feudal past (here the *yakuza*). Only the young schoolgirl, also contaminated by the disease but able to escape the cesspool of feudal relations and thought, is able, via the guidance of the doctor but above all through her own will power, to cure herself and presumably live a healthy life.

Kurosawa's narrative harmonizes so well with Allied Occupation themes that, if it were not for the distinctively grubby Dr. Sanada and the subtle allusion to the return of a *yakuza*-like power structure in the postwar suggestive of the de-purging and the "reverse course," one might be inclined to write this film off as American-inspired propaganda. To read the conclusion as a renaissance of an earlier innocence and purity, or as a return to an interrupted course of progress, would fit only too well with the prerogatives of the modernization narrative. It is a misreading of Kurosawa to say that it does so, but the temptation is there because of the prevalence of the *shutaisei* theme at the time.

This theme, as I have suggested, echoes the debates on *shutaisei* in its positing of a need to create individuals who can transcend their "given" social reality— that is, who can appeal to a "higher" sense of justice. It also echoes the debates in its positing of unsatisfactory solutions suggestive of the set of dilemmas structuring the debates. It is apparent, for example, that the type of transcendence required for concrete political or revolutionary action is not so different from the *tokkō seishin* or kamikaze mentality promoted during the war.[10] Also suggested here is that there may be an inevitable inhumanity or callousness necessary in order to achieve a humane society.[11]

It is in the apparent impossibility of these conflicting demands that Ango's decadence comes like the slap of a Zen master's stick on the shoulder (note the Zen predilection for enlightenment through the *body*). To the static, compartmentalized aspect of the debates, Ango poses a dynamic, open-ended quality in his view of individuals as capable of containing within them a spectrum of tendencies, including both the desire for and fear of freedom.

Let us now shift our attention to a consideration of Ango's concept of decadence as a rhetorical device that may be said to deconstruct the dominant postwar

theme of reconstruction and modernization. Decadence in Ango will be seen as a response to three specific subthemes of the postwar: historical regeneration, the politics of humanism, and democratic freedom or individualism.

Decadence and Rebirth

The ultimate metaphor of the postwar is that of death and rebirth, a phoenixlike national resurrection. Writers of both left and right alike infuse their rhetoric with quasibiblical overtones as they describe the end of the war. To take one prominent example, listen to Honda Shūgo, a literary chronicler of the times: "On that day of total emptiness, the edifice of our entire past collapsed. It was also the first day of creation, when all existence waited to be called into being." [12]

The physical devastation, death, and infrastructural breakdown reinforce the notion of a historical discontinuity here, of radical social and political change. And this sense of change is quickly infused with optimism when the American Occupation turns out to be peaceful and reform-oriented. Thus it is all the more surprising when Ango asserts in his "On Decadence" that "only the surface of things has changed." [13] Contrary to appearances—which in 1946 include kamikaze pilots trading in the black market, soldiers who do not hate the enemy, generals who cling to life instead of committing suicide, war widows experiencing sexual desire anew—Ango tells us that in fact "people have not changed; they have always been this way" (88).

The very notion of a distinction between the war and the prewar—and by implication the postwar—is collapsed by Ango in his short story "Hakuchi" (The Idiot), published in June 1946, two months after "On Decadence." The protagonist, Izawa, a young man working for an educational film company in Tokyo toward the end of the war, rents a room in a neighborhood in which all presumably "normal" relations and assumptions do not seem to apply. Humans and animals live together with "hardly any difference in their style of lodging or in the food they eat." [14] Sexuality knows no bounds: Women are prostitutes, "wartime wives," mistresses; brothers marry sisters; older women discard lovers one after the other. Izawa—on the reader's behalf—assumes that these circumstances are due to the war and its effect on people, only to be set straight by his landlord, the tailor, who tells him in "a quiet, philosophical way: 'No, to tell the truth, things have always been like this in our neighborhood'" (386–387).

Thus, suggests Ango, if what we are seeing in the postwar is decadence, it is not new; it is not, moreover, a consequence of the war or of defeat. It is rather human nature to be this way. Says Ango in "On Decadence": "We are decadent not because we were defeated in the war; we are decadent only because we are human, only because we are alive" (98).

The second point to note in linking Ango's concept of decadence to the immediate postwar is his emphasis on a quasi-Darwinian survival. As we have seen,

decadence is associated with a fall toward a lower state of evolution, allegorized in "The Idiot" as an animal existence. Thus, not only does the house contain various species, including human beings, a pig, a dog, a hen, but the pregnant girl in the attic is likened to a duck: "She had a big mouth and two large eyes, yet she was fearfully thin. . . . The way she ran in a strangely erect posture, with her huge belly and her buttocks jutting out to the front and the rear, bore a striking resemblance to a duck's waddle" (384–385).

Elsewhere Izawa, oppressed by this "world of women" in which he lives, made up of "prostitutes, kept women, pregnant volunteer workers, and housewives," finds that these women "cackle away in their nasal voices like so many geese" (399). And of course Osayo, the mentally deficient woman who is the "idiot" of the title, is portrayed as the essence of animality itself, a "lump of flesh" unconscious of its own existence, compared in a final hallucinatory vision to a pig unaware that a piece of flesh has been sliced off its thigh. At this juncture, the woman's snoring sounds to Izawa like "the grunting of a pig," suggesting to him that, indeed, "everything about her is porcine" (414).

As these passages suggest, the content and description of "The Idiot" resonate only too well with that genre of postwar literature known as *nikutai bungaku*, literally "literature of the flesh," translated as "carnal literature" and suggesting a form of pornography. But if the most prominent writer of *nikutai bungaku* is Tamura Tajirō, and his most famous story *Nikutai no mon* (Gateway to the Flesh, 1947) is the prototype, one is also puzzled by its utter lack of erotic titillation. Indeed, the word *"nikutai"* offers an instance of language trying to become its own referent here, in its apparent attempt to rid itself of its own rhetoricity. Tamura's story of a gang of prostitutes living an animal-like existence is not—any more than is Ango's "Idiot"—an attempt to glorify, estheticize, or eroticize the human body. It is rather a bold effort to concretize language, to arrest the tendency of mind, imagination, and language to elaborate, distort, and distance. In a word, and the play is no more irresistible in English than in Japanese, it is to "give body" *(gutaika suru)* to abstract language.

But, of course, this battle between mind and body is neither new nor is it likely to be resolved by writing. What is perhaps specific to the postwar is the effort to focus on the body as a metaphorical vehicle for philosophy. This aspect is shared by Ango, who found Tamura's novel "not to contain a word of moralizing: only the body [*nikutai*] thinks, only the body speaks".[15] And yet, both novellas appear to succeed at the point where they also fail. The effort to posit a thinking body without a mind inevitably leads to a more acute depiction of the aporetic gap between mind and body. But it also, at this particular juncture, produces an allegory of existence itself that resonates not only with the latter's philosophy but also with the literature of existentialism, from Sartre's *Nausea* (1938) and *No Exit* (1947) to Camus' *The Stranger* (1942). The existential dilemma lies not only in the individual's sense of a distance between him or herself and such external abstractions as time, history, society, or the more mundane "otherness" of objects, people, and everyday

reality; it also stems from a difference within one's own self, a heightened awareness of an alienation between one's own body and mind. It is not surprising, then, that the instrumental means appealed to in order to overcome this gap are the sword and the pen, those tools/weapons whose very juxtaposition symbolizes the desire to effect a fusion between mind and body, thought and action. The ultimate Japanese example of alienation seeking to overcome itself is perhaps Mishima Yukio, whose ideal of fusion had its roots in the synthesis of the cultural (*bun* or writing) and the martial (*bu*) of the medieval warrior class, and whose death fused mind and culture with body and sword in as original a manner as the world may ever expect to see.

But the issue of existentialism—whether it is posed in the fascist esthetic of a Mishima or the "decadent" carnality of Ango and Tamura—is inevitably accompanied by its nemesis of "transcendence." In the case of Mishima, it is the romantic mysticism of nationalism and reincarnation; in the case of Tamura, it is a tribal transcendence via the ritual magic of the tattoo and sacrificial slaughter or the martyrlike transcendence of physical pain through group-inflicted torture.

In Ango, the existentialist dynamic is more nuanced. To the extent that the intellectual issue of the postwar was the quest for a self-directed individualism able to allow for a viable democratic social—if not socialist—organism, this pursuit involved a perception of the Japanese people in their prewar mentality as passive victims of an externally directed hierarchy, of a system of institutions (from the emperor to the family) and codes deemed "natural"—that is, given or unchangeable. The issue for Marxists after the war was how to create or conceive of a type of individual capable of inner direction, one who would be able to act on the basis of a value system that promised him or her equal and inalienable rights. What we see taking place in Tamura's "Gateway to the Flesh," however—in spite of its adherence to a bedrock of survivalist existence—is the establishment of social norms that are as externally motivated as in a feudal system. Indeed, it is a tribal situation and a tribal mentality that is evoked. And the transcendence, described as a form of resurrection (*shinsei* or "new life") that is achieved by one of the young women, Borneo Maya, as she is strung up and tortured for engaging in sex that is forbidden because it is pleasurable and not commercial, is intriguingly likened to that of Christ on the cross: "In the gloom of the cellar, Borneo Maya's body hung shrouded in a faint white glow, as sublime as the prophet on the cross" (332). The suggestion here, enhanced by the reference to the crucifixion, is an internalization not of autonomous democratic values, but of an oppressive social code. To find gratification and "new life" through suffering here does not lead Borneo Maya to social action but to a lingering attachment to the instrument of her suffering, familiar in the Western tradition as romantic or illicit love.

The dilemma posed by the Japanese postwar is thus often resolved in its cultural representation by a form of transcendence. That these instances of transcendence are on several occasions associated with suffering and Christianity may provide us with cause for reflection. In addition to the just-mentioned "Gateway to

the Flesh" and the earlier-mentioned Kurosawa film *Drunken Angel* with their hell and heaven symbolism, one may also take note of Ishikawa Jun's "Yakeato no Iesu" (Jesus of the Bombed-Out Ruins, 1947), with its evocation of Jesus in the postwar black market, and Dazai Osamu's *Shayō* (The Setting Sun, 1947) with its underlay of Christian-Marxist dialectic syncretized in the titular symbol of "the setting sun." [16]

Ango's concept of decadence is also a response to the dilemma of postwar alienation as I have described it. Yet it may be said to differ in its rejection of a transcendental resolution (a rising/risen/suspended body) in favor of a thorough-going immanence (a sinking/falling body or a sinking into the body). What Ango's decadence proposes is not a sublimation of desire but a negation of it through its satiation, not unlike seeking to cure an ill or a vice by indulging in it to excess, to the point where it becomes repugnant.

As Nakamura Mitsuo later characterized Japan's postwar, "It was human desire rather than humanity itself that was liberated here." [17] Such a view of liberation is not unrelated to Ango's conception of decadence, in which animality becomes the object of human desire whose realization would negate desire, consciousness, and thus humanity itself. Ango's statements—even his use of the word *decadence (daraku)*—are described as illogical and contradictory: "At one point he calls for *daraku,* or falling off, from the old morality, at another insists that Japan is in fact sunk in *daraku.*" [18] Yet, as in the use of a homeopathic remedy for a disease, the treatment of a diseased state by recognizing and modulating the pathogenic element rather than violently trying to extract or destroy it is a familiar approach to peoples around the world. And, taking note of Ango's intensive study of Buddhism and self-training in Zen, one is inclined to note parallels with such purveyors of paradox as Dōgen (1200–1255), whose disciples are led to self-awareness by being told—to use Gensha's words to a perspicacious monk—that they/he is already living in the "Black Mountain's Cave of Demons." [19]

Ango's language can thus be seen as an allegory of itself, which is to say that it is a challenge to its own use in ordinary or unreflecting, uncritical usage. *Daraku* is intended not only as a device for stripping humans of their supernatural aspirations; it is also an attempt to strip language of its rhetorical pretensions, if not of its own "desire" to become one with its referent, that which it can never be. By shifting the dynamic and desire downward (and away from its heavenly orientation) via the kinetic term of "*daraku,*" one can, for instance, perceive in the limits and restraints of one's body and language a genuinely self-aware, if modest, individuality. Unlike the transcendental rhetoric of the prewar *kokutai* (national body), which posits a suprahuman fusion with the state and a pure language in which all contradiction is submerged, *daraku* is intended to jolt the mind into a visceral awareness of its incapacity to reach the mystical heights of fusion, harmony, or satiation.

In sum then, Ango's concept of decadence has its tendency to transcendence as well, but it is of a somewhat different nature. For Ango, decadence is not a

rebirth through a violation of norms but a dynamic of self-discovery, an accep-
tance of one's foibles as a human being rather than self-flagellation for not being
superhuman. This downward dynamic can have the effect of revealing the illu-
sory nature of desire as well as the desire of language itself. Ango in a sense negates
the transcendental dialectics of the times in a more materialist mode, where indeed
there is no regeneration without degeneration, no humanity without inhuman-
ity, or no democracy without tyranny. Thus, for example, as we shall presently
see, his "On Decadence" shows how a feudal politics, for all its inhumanity, is as
human an invention as ever existed.

369

Decadence and the Politics of Humanism

Under the American Occupation, revolutionary class struggle is not part of the
scheme of things. The sense is rather of a need to repair a vehicle that has been
derailed from the track of democratic modernization. For the Occupation and its
Japanese associates, the issue in intellectual and cultural terms is not only how to
recycle or democratize social and economic institutions, but also how to "rewrite"
history so that it will conform to the prerogatives of the revised modernization
narrative. On the one hand, there is the adapting, via the constitution and other
means, of the emperor system to the exigencies of a parliamentary ideology. Thus,
if the postwar was to be seen as the continuation of a legitimate ongoing process,
the war itself had to be seen as an aberration, a deviation to be set straight.

Consider in this context Ango's view of politics as contrivances or mecha-
nisms *(karakuri)* that recognize humanity but seek to prevent it from playing itself
out via *daraku*. Ideological critics of Bushidō and *tennōsei* tend to view these as
absolute "evils" of the feudal system that must be "rooted out." In a curious way,
Ango's treatment of these phenomena in "On Decadence," while hardly Marxist,
ends up seeing them as contingent appurtenances of a superstructure, indicative
of what may be called a "politics of humanity." This is not to say that they are based
on a philosophy of humanism, but that they derive from an "accurate" perception
of human nature, to the effect that human beings are basically materialist and
therefore weak.

Thus does Ango argue that the emperor system, and indeed Japanese emper-
ors throughout history, have been "political contrivances" created by astute politi-
cians who sensed, almost olfactorily, what would work in a given situation. From
this, it is clear that political changes alone will not produce fundamental social
change. Says Ango: "A political transformation can be implemented in a single
day, but not so human change" (DRR, 98). In the final analysis, Ango warns, "the
very notion of salvation through politics is superficial nonsense" (98).

Ango's discussion of politics and history manages to do something that leftists
found difficult to do: to rationalize or humanize Japan's past history, with its
emperor and Bushidō, *without*, however, glorifying and romanticizing it. Unlike
the liberals who sought to recuperate prewar institutions for new "democratic"

modes of control, and unlike the radical left, which tended to view those institutions as an implacable enemy to be destroyed, Ango's "soft" approach bears looking at. For it is by trivializing (rather than magnifying) these institutions and ideologies that he shifts the onus of responsibility to the Japanese individual. In other words, to see one's oppression as forever deriving from implacable forces external to oneself, which is the effect if not the intent of a determinist view of history, is to induce a passivity and victim mentality that will only reinforce the state of oppression. To reduce the emperor to a human being, the emperor system to a Machiavellian device, and to humanize kamikaze pilots by justifying their transformation into black marketeers or to see chaste war widows as women susceptible to sexual desire is to say that there is nothing preventing one from following the dictates of one's own desires, which may include rebelling against those external oppressive forces. As Ango puts it, only self-discovery through decadence can lead to human freedom.

This notion of individual freedom ultimately adopts a romantic mode, but one of its premises—to the effect that political systems deny true humanity by setting up impossible ideals—leads Ango to his conflation of left and right in the postwar. It also suggests a parallel between *daraku* and *tenkō* in the oscillatory motion characteristic of both adherents of the *tokkō seishin* or kamikaze suicide mentality.[20] The distinctions made by Marxists in their theoretical debates, however, are echoed in a more accessible mode by Ango, whose trivialization of politics has the effect of shifting the burden of responsibility from "others" and "reality" to oneself. To be sure, Ango is not interested in or sympathetic to a Marxist individualism, not because he does not share a desire for liberty, but because he views the Communists in Japan as equally prone to the totalizing tendencies of the militarists. In writing in 1947 of the prewar, Ango recollects: "I hated Communism. They believed in their own absoluteness, their own immortality, their own truth."[21]

Ango is here very much in the mold of the Western writers who rejected Communism. Like them, he sees Communism in 1946 as a politically imposed homogeneity that leads to a stifling of individual differences. Decadence in this context becomes the individual human being's escape from the "fishnet" of the sociopolitical system, and the possibility of a staunch and vengeful individual opposition.[22]

At this juncture emerges that familiar romantic image of the lone, embattled artist struggling against a cold and unfeeling society: "Decadence itself is always trivial, mere perversity; but one of its attributes is its impressive manifestation of that glorious human quality of solitude. Decadence invariably involves isolation: it carries with it the destiny of being cast out by others, even by one's own parents, and having to rely exclusively on one's own self" (ZDR, 106).

The above would seem to offer an excellent evocation of the phenomenon of *tenkō,* whereby many leftists, including a significant number of writers, renounced their affiliation to—indeed in numerous cases, their innermost convictions about —Marxism, and in extreme cases became active supporters if not believers in the

ultranationalist ideology of *kokutai. Tenkō* has affinities, though only superficial ones, with the "God That Failed" syndrome in the West. The difference with the Western version is significant: Whereas in the latter it is the ideology that is tainted, in Japan it is the person. What is more, the stigma derives not from the person's "contamination" by the "evil" ideology, but with the person's "failure" to be sincere to his or her own beliefs. Thus it is that there is considerable admiration for those who hold firm to their beliefs and do "not turn" *(hitenkōsha)*, while there is deep suspicion of those who switch allegiances before or during the war only to return to the fold at its end.

371

Nakano Shigeharu's *tenkō* story, "Mura no ie" (The House in the Village) is so powerful, among other reasons, because of the "hard-line" attitude of Magozō, the rural father of activist Benji, who is forced to commit *tenkō* while in prison. Magozō's concerns for his son are entirely divorced from issues of right and wrong, justice and injustice, and so on. They are rooted in externally derived values of loyalty to one's ideals and social "face," or *seken*. Sympathies in the tale shift uneasily between Magozō and Benji, whose own loyalties are in conflict. Yet Benji is the prototype of a *tenkōsha,* one who is a victim not only of police duress but of an unsympathetic populace that appears capable of understanding only the form—here, ultimate sacrifice—but not the motivation for his commitment.[23]

For Ango, *tenkō* could be just another indication of decadence as a natural human and Japanese failing, not unlike the "faithful retainers and filial children" of old who were supposed to sacrifice all for the sake of revenge, but who "probably never existed," or the "fickle Japanese" who are more than ready to "be friends today with their sworn enemies of yesterday" (DRR, 95). *Tenkō* is the ultimate reduction of politics to the human being, to the individual confronted with the freedom to choose with responsibility. Like other forms of decadence, *tenkō* brings the individual to a choice between either a total schizophrenic alienation or a fusion of body and mind wherein survival of the body is perceived as a contamination of the spirit. Thus it is that *tenkō* and *daraku* may be said to resonate with each other in the postwar, when individual Japanese who have survived must account for their survival when they might have / could have / should have died.[24]

But even more than the fact of *tenkō*, Ango's insistence on the glorious pain of solitude and rejection, which leaves the "degenerated" individual on the verge of self-discovery, suggests a parallel with the *tenkō* writer because of the role of writing itself. For Ango, the individual, in this lone struggle to maintain an adversary stance *(ko no tairitsu),* is aided by a means of expression—it is literature that "spews forth the voice of one's soul."[25] A *tenkō* writer like Nakano, too, resorts to writing in order to plumb the depths of his "fall." But writing is itself a form of decadence, for the writer who wrote of socialist ideals and saw literature as a form of political action now must use writing to signal the failure of his own pen.

In his brief evocation of the redemptive benefits of literature, Ango has already taken note of a parallel between the paradoxical structures of decadence and literature: "Since literature is always in revolt against the system and against politics,

since it is a form of human vengeance against the system, it also becomes, by that very revolt and vengeance, an instance of collaboration with politics. Revolt is itself cooperation. It is love. That is the destiny of literature. It is the absolute and immutable relationship that obtains between literature and politics" (ZDR, 106).

Decadence and De(con)struction

> Now that the war is at an end, we have been granted a variety of freedoms, but when people are given such freedoms, they may become aware of certain mysterious limitations and restrictions within themselves. Human beings cannot be eternally free both because they must live and must die and because they are thinking beings. (DRR, 97–98)

Consider the above-quoted notion, so central to Ango's vision of decadence, whereby the very ability to "think," that defining characteristic of human existence, becomes one of the ultimate constraints on human freedom. In noting the reversal of expectations here, whereby it is the mind that acts as a brake on the body and not vice versa, we may also hear once again an echo of Zen Buddhism's predilection for seeing mind as an obstacle to itself.

Consider Ango's text "Shinju" (The Pearls) of June 1942, a juxtaposition of an ostensible eulogy to the suicide frogmen who mined Pearl Harbor with a recounting of the narrator's banal everyday activities. The ironic disjuncture here is enhanced by a keen perception of the gap between individual action and history, in the awareness of the contingency with which history impacts on the individual: The narrator learns about the Pacific War breaking out while listening to the radio as he is being shaved in a barber shop. Although—or because—he is also intoxicated at the time, he feels that his existence is now suffused with a new and special meaning: "I might have to sacrifice my life too." [26]

Compare this story with Ango's "The Idiot" of 1946, where not only do sacrifice, individualism, and art no longer have meaning, but communication itself is almost nonexistent. Izawa, the protagonist, is singularly isolated, not fitting in with the world of his strange neighborhood or with the institutional hypocrisy of his professional existence. In the image of Izawa wandering with the mute idiot Osayo on his back through the smoking craters of Tokyo under American bombs, we have the ultimate literary depiction of *daraku*. Izawa, finding that he no longer needs nor can play the "game," decides *on his own* to experience hell. Osayo simultaneously represents a mute testimony to his act and a minimal hope for survival. The term *idiot*, or *"hakuchi"* in Japanese, written with the characters for "white, blank, or bleached" and "ignorance, foolishness"—the latter with the radical for disease and the phonetic for knowledge—appropriately suggest that desired state of nonhumanity, with its pure animality and total obliviousness to thought and knowledge. The idea of pure sensual communication, of a sexuality unhampered

by thought, by emotion, by love, is closely related here, as is the notion of a primal and innocent coupling and insentient creation.

Osayo is a powerful allegorical figure. The role of women and their sensuality is highly problematic in Ango and will only be touched on here, but we may note that Osayo as woman is the bearer of history both in her potential to bear children and in the mute mindlessness or bleaching of knowledge that history inevitably connotes. Osayo's own history, like the history of Japanese women, is repressed/erased and replaced as it were by her physical body. She is reduced to a sleeping, numb lump of flesh that, in Izawa's dream, is so absorbed in copulating that she is oblivious to her own flesh being torn off and devoured by her ravisher. Ango's own frustrated relations with women offer tempting explanation for the not infrequent instances of vicious misogyny that appear in his work. Yet there is a level at which these representations are not quirkish eccentricities; they relate rather to the larger social and intellectual concerns of Japanese society. That a woman can be seen as the metaphor for mindlessness and the epitome of material sensuality, that a female character acts as the foil against which individual males achieve control and autonomy—these persistent and unquestioned instances of literary representation should give cause for reflection on the repressed meanings within the notion of *shutaisei*, that concept whose characters also denote a subjection of or mastery over the body. It is evident that the achieving of mental, spiritual, or political control over oneself may very well depend on or be at the expense of other individuals. It should be noted that Ango's depictions of women are refracted through a variety of textual devices, including omniscient narrators and male protagonists, as well as female narrators and protagonists. In the postwar, a set of highly original female characters with dominating personalities and voracious libidos appear in Ango's texts, causing unimaginable anguish to their equally unusual but ultimately ineffective male counterparts.

A typical example is Motoko in a story of September 1946, entitled significantly "Nyotai" (A Woman's Body). Motoko's sexual drive leads her husband Tanimura to the reflection: "All women appear the same. A woman is a body [*nikutai*] that thinks."[27] These female characters are depicted as cold, domineering, but dazzling creatures with whom even sex cannot overcome the male protagonists' emotional alienation.[28]

Between the two stories, "Pearls" and "The Idiot," however, there is a suggestive kinetic displacement from the sense of alienation between the narrator of "Pearls" and his perception of a pure gemlike fusion of body and mind represented by the frogmen to Izawa's frustrated desire for an animal-like communion with the swinish mindless body of Osayo. In this space of the critical war years may be seen Ango's vision of a Japan that must achieve a state of mindlessness (a Zen *mu?*) in order to be able to experience, reflect, articulate, and achieve its national subjectivity, or *shutaisei*.

Decadence can thus been seen as the act of falling toward a state of animality.

As such it reflects a tendency, a movement rather than a realization, an essence, a destination. What is apparent in both *nikutai bungaku* and in Ango's "The Idiot" and related works is a perception of decadence as an eternally desired but ultimately unachievable state. Animality in its essence would involve a negation of its opposite, humanity, or of humanity's distinguishing characteristic—consciousness or thought itself. The desire to live exclusively by the senses, in the flesh, must include the desire to eliminate the main obstruction—the mind and all of its constructions—as well as the desire for self-destruction.

Thus it is that Ango's works end up incorporating a counterpart or countervalence—that of mass destruction through war—next to which decadence assumes a mediocre or banal "charge," only then to undermine once again the dichotomy. In "On Decadence," this vision of awesome and "beautiful" destruction provides Ango with the ultimate space of freedom, where "there was no need to think because there was only beauty, and there were no human beings" (DRR, 97). In "The Idiot," it is also the cataclysmic upheaval of the bombing that allows Izawa to dispense with thought: "The Americans would land and there would be all kinds of destruction in the heavens and on earth; and the gigantic love extended by the destructiveness of war would pass impartial judgment upon everything. There was no longer any need even to think" (415).

The contrast between the mass destructive power of war and the aftermath of defeat could not be greater. In the face of mass destruction, a gigantic love unites all as equal victims. Thus does Ango take note of "an elegant father and daughter sitting on the grass, a red leather trunk between them, in front of the Imperial Palace" (DRR, 95).

But once again there is a reversal. The opposition between "grand destruction and banal decadence" is undermined: Destruction, a bodily experience, self-deconstructs when it recedes into the experience of the mind, and with it mindlessness gives way to the ruthless demands of memory. The gigantic love, divine beauty, and unrestrained freedom bestowed by the cataclysmic moments are now ephemeral. Izawa's mind cannot help hoping that Osayo will respond, will communicate, that she will give birth, as it were, to herself. If Osayo is to generate a new mind, it will come out of her mindless body via the midwife of mass destruction. The desire here, Izawa's and Ango's desire, is for a new individual, a new society, but one that is untainted by the past, one that is free to shape its own existence. The war is a catalyst, "creating" a destruction of the structures that prevent a truly utopian entity from coming into being.[29]

But Ango significantly undermines the oppositions again, by casting Izawa as a failed revolutionary, a glorious failure, baptized in decadence by the ravages of war and now able to see through the illusion with lucidity. Thus, Osayo no longer appears to him as a newborn human being for whom he feels affection and "immeasurable pride" (410). Now, as he sits in the cold morning air, he is without passion, without desire, without hope, wondering only whether there will be sun to shine "on his back and on the back of the pig that [lies] beside him" (415).

Conclusion

Having argued the historical specificity of Ango's "decadence," we should now take note in proper paradoxical fashion of an important sense in which Ango's *daraku* can be said to be ahistorical as well. Ango's postulation of Japanese institutions like the emperor system as givens—even if not "god-given" or "natural"—nonetheless posits an unchanging and unchangeable objective reality against which individuals can only seek a subjective, idealist alternative. Ango's exhortation to "make up your own Bushidō, devise your own emperor," for all its shock value, in the long run amounts to a mystical immanence in which the individual seeks refuge from the external reality. As with Izawa in "The Idiot," one's hope lies in writing one's own history on a tabula rasa. But without the linkage of social bonds, the ultimate objective can only be for all individuals to achieve *shutaisei* spontaneously in a collective simultaneous enlightenment that is metaphysical and apocalyptic.

In retrospect it is only too easy to assimilate Ango's notion of decadence not only with Tamura's concept of transcendental *nikutaisei,* but even with Yoshida Mitsuru's Christian love as the "harvest gained by venturing into the realm of death and returning alive";[30] or with retired army general Ishiwara Kanji, who in August 1945 felt that the Japanese people had experienced defeat, occupation, and westernization precisely because they had "not suffered enough." For Ishiwara, regeneration of the true Japanese spirit could only come about "after protracted fall to the bottom of the abyss, when the members of the race are at the end of their resources."[31] And thus ultimately can we assimilate it with the *tokkō seishin,* that fusion of body and mind, so glorified and flaunted by Mishima and so abhorred and haunting to the left in Japan. And for Ango and the majority of Japanese, it is a banal reflection of the unresolvable gap between desire and its object, between mind and body, between existence and decadence.

Notes

Editors' Note: Sakaguchi Ango (1906–1955), novelist and social critic (or "intellectual outlaw," as he would have preferred), was, as noted by Wolfe, loosely associated in the immediate postwar period with a group of writers identified variously as the New Burlesque School *(Shin-gesakuha)* or the Unreliables *(Buraiha).* Born the twelfth of thirteen children in a prominent landed family in Niigata Prefecture, Ango describes his early childhood as painful and rebellious, with long hours spent alone gazing at the rocks, winds, and waters of the Japan Sea. Neither parent had very much time for Ango in a period during which his father was expanding the family wealth. At sixteen, Ango withdrew from his Niigata middle school and transferred to one in Tokyo. It was here that he began to pursue his lifelong interests in literature and Buddhism. Upon graduation he accepted a temporary teaching position in a small primary school outside of Tokyo and the next year, 1926, he entered the Indian Philosophy Department at Tōyō University in Tokyo. During his first year and a half, Ango read and worked feverishly, studying those languages that would

give him entry into the Buddhist classics—Sanskrit, Tibetan, and Pali—as well as French and Latin. He also began attending Tokyo's Athénée Français, where he widened his interest in French literature and became associated with a group of young men, including Tamura Taijirō and Inoue Tomoichirō, intent upon pursuing literary careers. While Ango received some recognition and encouragement for his early literary efforts, he also struggled with what he perceived to be nearly irreconcilable clashes between his high spiritual ideals and his attraction to drink and Tokyo's night life. He managed to survive his "dark youth," including flirtations with suicide, deep feelings of discouragement and collapse, a painful love affair with another talented writer from northern Japan, Yada Tsuseko (1907–1944), and periods of poverty, instability, and solitude. After an unhappy sojourn in Kyoto (1936–1938), Ango returned to Tokyo and by 1939 had resumed a serious literary career, editing a journal, writing and publishing enough to survive, and taking a job in 1944 as a scenario writer for war propaganda films. Ango's 1942 essay, "Nihon bunka shiron" (A Personal View of Japanese Culture), is a powerful and iconoclastic work that startled readers at the time, much as did "Darakuron" (On Decadence) in 1946. Although the nature and extent of his wartime compliance remains clouded, he gained an important place in early postwar Japanese literature, publishing widely and capturing a sense of the nihilism and despair felt by many intellectuals during the early Occupation years.

For additional information, including chronology of his career and bibliography, see *Nihon kindai bungaku daijiten*, vol. 2, 88–91; and Sakaguchi Ango, *Chiru Nippon* (Scatter Japan) (Tokyo; Kadokawa Shoten, 1973), Kadokawa Bunko 3004, 293–308. In English, Donald Keene, *Dawn to the West: Japanese Literature in the Modern Era* (New York: Holt, Rinehart, and Winston, 1984), vol. 1, 1064–1087; and Roger Pulvers, "Refilling the Glass—Sakaguchi Ango's Legacy," *Japan Quarterly* (October/December 1998), 56–64.

1. For the controversies surrounding Etō's arguments and an overview of the censorship question, see Marlene J. Mayo, "Literary Reorientation in Occupied Japan: Incidents of Civil Censorship," in Ernestine Schlant and J. Thomas Rimer, eds., *Legacies and Ambiguities: Postwar Fiction and Culture in West Germany and Japan* (Baltimore: Johns Hopkins University Press; Washington, D.C.: Woodrow Wilson Center Press, 1991), 135–161.

2. "Zoku Darakuron" (hereafter ZDR), in *Darakuron* (Tokyo: Kadokawa Shoten, 1972), Kadokawa Bunko 1536, 108. Subsequent references are given in the text. "Darakuron" first appeared, apparently uncensored, in *Shinchō* (New Tides), April 1946; "Zoku darakuron" in *Bungaku kikan* (Literature Quarterly), December 1946 (they were published together the following year in a book-length collection of essays entitled *Darakuron*).

3. The term actually used is the English "school of outlaws." See Moro Jōji, *Nihon no yūrei no kaihō* (The Emancipation of Japanese Ghosts) (Tokyo: Shobunsha, 1974), 158.

4. *Sakaguchi Ango, sono sei to shi* (Sakaguchi Ango: His Life and Death) (Tokyo: Shunjusha, 1974), 13.

5. Dazai Osamu, *Pandora no hako* (Pandora's Box), in *Dazai Osamu senshū* (Dazai Osamu Selected Works); first written during the war and published in 1945–1946. See Phyllis I. Lyons, *The Saga of Dazai Osamu: A Critical Study in Translation* (Stanford: Stanford University Press, 1985), 47, 150, 157, 393–394.

6. See Jonathan Culler, *On Deconstruction* (Ithaca: Cornell University Press, 1982), 86–87.

7. "Nihon bunka shikan," in *Darakuron*, 9.

8. Hasegawa Izumi develops an elaborate genealogy extending from the Chinese clas-

sics to contemporary writers like Nosaka Akiyuki. See his "Burai bungaku no keifu" (A Genealogy of Outlaw Literature) in a special edition of *Kokubungaku: kaishaku to kanshō* (National Literature: Interpretation and Appreciation) (December 1970).

9. See J. Victor Koschmann, "The Debate on Subjectivity in Postwar Japan: Foundations of Modernism as a Political Critique," *Pacific Affairs* 54:4 (Winter 1981–1982), 609–631; also, his "Japanese Communist Party and the Debate over Literary Strategy under the Allied Occupation of Japan," in Schlant and Rimer, *Legacies and Ambiguities,* 163–186; and *Revolution and Subjectivity in Postwar Japan* (Chicago: University of Chicago Press, 1996).

10. This issue is raised by Matsumura Kazuto as part of his criticism of Umemoto Katsumi's position on *shutaisei,* developed by the latter in a previous article. See Matsumura, "Tetsugaku ni okeru shuseishugi" (Subjectivity in Philosophy), *Sekai* (World) (July 1948). In his response Umemoto clarifies and reaffirms his thesis that a revolutionary *shutaisei* must be linked to a specific class consciousness. The whole or totality to which he refers, therefore, is not a mystical notion of *kokutai* or the abstraction of a universal humanity, wherein class differences would be submerged, but rather a "class totality" that is both the source of the individual and the basis for his or her link to human history and progress. See Umemoto, "Shutaisei to kaikyūsei: Matsumura Kazuto no hihyō ni kotaete," (Subjectivity and Class Consciousness: An Answer to the Critique of Matsumura Kazuto), *Risō* (Ideal) (November 1948).

11. The "inhumanity" of leftist politics was one of the stones cast by a group of critics writing for the journal *Kindai bungaku* (Modern Literature) in debates on politics and literature with Marxist writers appearing in *Shin Nihon bungaku* (New Japanese Literature). Ara Masahito and Hirano Ken of the former, in support of their accusations against the Communist Party, argued that the prewar Proletarian literature movement—above all its major writer, Kobayashi Takiji, and his prototypical political novel, *Tōseikatsusha* (Party Life, 1933)—reflected the inhumanity of the Communist view that the "end justifies the means," especially in the way that the first-person male narrator of Kobayashi's novel "uses" his lover Kasahara, justifying it as necessary for the movement. Nakano Shigeharu responded by asserting the essential humanity of politics and the dangers of establishing such dichotomies between art and politics, especially in the contemporary postwar context. See Usui Yoshimi, *Sengo bungaku ronsō* (Postwar Literary Debates) (Tokyo: Banchi Shobō, 1972).

12. Honda Shūgo, *Monogatari sengo bungaku* (Narrative Digest of Postwar Literature) (Tokyo: Shinchōsha, 1966), 11.

13. "Darakuron" [hereafter DRR], 88. Subsequent references are given in the text.

14. "The Idiot," George Saito, trans., in Ivan Morris, ed., *Modern Japanese Stories: An Anthology* (Rutland, VT: Charles E. Tuttle, 1962), 384. Subsequent references are in the text.

15. As cited by Mori Keiyu from Ango's essay, "Nikutai jitai wa shikō suru" (The Body Speaks), in "Tamura Taijirō no nikutai bungaku" (Tamura Taijirō's Flesh Literature), *Bundanshi jiten* (Dictionary of Writers of the Literary World), a special issue of *Kokubungaku: kaishaku to kanshō,* 37:9 (July 1972), 163; Mori provides no further information on the source and date of Ango's comment. References to Tamura's *Nikutai no mon* are from Itō Sei et al., eds., *Kitahara Takeo, Inoue Tomoichirō, Tamura Taijirō shū* (Selections from Works by Kitahara Takeo, Inoue Tomoichirō, and Tamura Taijirō), vol. 94 in the series *Nihon gendai bungaku zenshū* (Collection of Japanese Modern Literature) (Tokyo: Kodansha, 1968).

16. *Editor's Note:* Ishikawa's story has recently been translated by William Tyler as

"The Jesus of the Ruins," in Ishikawa Jun, *The Legend of Gold and Other Stories* (Honolulu: University of Hawai'i Press, 1998), 72–96. Occupation censors cut some lines from the original lead story in this collection, "Ogon densetsu" (Legend of Gold), prior to publication in *Chūō Kōron* (Central Review), March 1946; later that year, publishers removed the entire story from a book of the same title (Mayo, 144). Dazai's *Shayō*, which passed safely through the censors in 1948, was translated early in the post-Occupation period by Donald Keene as *The Setting Sun* (New York: New Directions, 1958).

17. Nakamura Mitsuo, *Contemporary Japanese Fiction, 1926–1968* (Tokyo: Kokusai Bunka Shinkokai, 1969), 47.

18. Keene, Donald, *Dawn to the West,* vol. 1, 1077.

19. Dōgen Zenji, "Ikka myoju" (One Bright Pearl), from *Shōbogenzō* (The Eye and Treasury of the True Law), translated by Kosen Nishiyama (Tokyo: Nakayama Shobō Japan, 1975), 56. Gensha was the Chinese monk, Xuan Sha (835–908 C.E.).

20. See note 10.

21. "Kurai seishun" (Dark Youth), in *Kurai seishun/Ma o taikutsu* (Dark Youth/Devil's Ennui), Kadokawa Bunko 2683 (Tokyo: Kadokawa Shoten, 1973), 62.

22. ZDR, 108.

23. For a translation of "Mura no ie," see Brett de Bary, *Three Works by Nakano Shigeharu,* Cornell University East Asian Papers, No. 21 (Ithaca: China-Japan Program, 1979), 19–73. Miriam Silverberg discusses the story and Nakano's *tenkō* in *Changing Song: The Marxist Manifestos of Nakano Shigeharu* (Princeton, NJ: Princeton University Press, 1990), 198–199.

24. The survivor syndrome is familiar from Robert Jay Lifton's study *Death in Life: Survivors of Hiroshima* (New York: Random House, 1967), as well as from recent interest in and studies of atomic bomb and holocaust literature. The metaphorical fusion of physical with mental aftereffects of the bomb is dramatically presented in Betsuyaku Minoru's play of 1962 entitled "The Elephant" *(Zō),* David Goodman, trans., *Concerned Theatre Japan* 1:34 (Autumn 1970), 72–143. See also John Whittier Treat, *Writing from Ground Zero: Japanese Literature and the Atomic Bomb* (Chicago: University of Chicago Press, 1995).

25. ZDR, 106.

26. "Shinju," in Sakaguchi Ango, *Hakuchi/Niryū no hito* (The Idiot/Mediocre Man), Kadokawa Bunko 1192 (Tokyo: Kadokawa Shoten), 60.

27. "Nyotai," in Sakaguchi Ango, *Gaitō to aozora* (Overcoat and Blue Skies). This first appeared in *Chūō kōron* (Central Review), July 1946.

28. *Editor's Note:* Other recently translated Sakaguchi stories that deal in part with the theme of women and sexuality include "Zoku sensō no hitori no onna," (Sequel, One Woman and the War), which is set on the home front late in the Pacific War as B-29s bomb Tokyo; see Lane Dunlop, trans., *Autumn Wind and Other Stories* (Rutland, VT: Charles E. Tuttle Company, 1994), 140–160. Although this work was in violation of censorship guidelines, it was published in a special issue of short stories by *Saron* (Salon) in November 1946. In contrast, the original story, "Sensō no hitori no fujin," which appeared in a special issue of *Shinsei* (New Star), September 1946, was heavily cut on almost every page by Occupation censors for alleged love of war propaganda (Mayo, 144). Sakaguchi's "Sakura no mori no mankai no shita," a grotesque horror story featuring a demonic heroine and set in medieval Japan but containing allusions to 1930s militarism, has been translated by Jay Rubin as "In the Forest, under Cherries in Full Bloom," in Theodore W. Goossen, ed., *The*

Oxford Book of Japanese Short Stories (Oxford: Oxford University Press, 1997), 187–205; and by Lawrence Rogers as "Under the Grove of Cherry Trees in Full Bloom), *East* 32:6 (March–April 1997), 44–55 (Rogers notes that this now "classic story" was turned down by *Shinchō* and published in *Nikutai* (Flesh), a pulp magazine in June 1947).

29. The Khmer Rouge experience in Cambodia is an unfortunate actual instance of how mass destruction (some believe American induced) can give rise not only to such visions but to attempts at their implementation.

30. Yoshida Mitsuru's words are from his *Requiem for Battleship Yamato,* Richard H. Minear, trans. (Tokyo: Kodansha International, 1985), 147. They were, however, censored by the Occupation and not part of public discourse in this period; Mayo, "Literary Reorientation," 145–146.

31. This statement appeared in the *Nippon Times* of August 31, 1945. For an interpretation of the early postwar activities of Ishiwara (one of the masterminds of the Manchurian Incident, September 1931), see Mark R. Peattie, *Ishiwara Kanji and Japan's Confrontation with the West* (Princeton, NJ: Princeton University Press, 1975), 339–363.

A Final Editors' Note: Darakuron, Part 1, has been translated as "Discourse on Decadence," by Seiji M. Lippet in *Review of Japanese Culture and Society* 1 (October 1986), 1–5.

Contributors

Haruko Taya Cook, assistant professor of Japanese History, Marymount College (Tarrytown, N.Y.) is coauthor of *Japan at War: An Oral History* (New York: New Press, 1992). She has published articles on war, women, and society and on Japanese war memory and representation. She is currently working on a comprehensive social history of Japan's war for Penguin Putnam.

Kyoko Hirano is the director of the Japan Society Film Center in New York City. She is the author of several essays on Japanese cinema and her major work, *Mr. Smith Goes to Tokyo: Japanese Cinema under the American Occupation, 1945–1952,* was published by the Smithsonian Institution Press in 1992. In 1999, she received the Japan Film Pen Club Award and the Kawakita Award for the Japanese translation of her book and for outstanding work in introducing Japanese cinema to overseas audiences.

H. Eleanor Kerkham, associate professor of Japanese Literature at the University of Maryland, is a specialist in classical and early modern Japanese literature and currently chairs the Inter-College Committee on East Asian Studies. She is presently working on a study and translation of Tamura Taijirō's Korean "comfort women" fiction and a study of Matsuo Bashō's early apprenticeships and interactions with the Tokugawa literary world as *haikai* master, recluse, and traveler. She combines scholarship and research on Bashō with an interest in modern Japanese women writers. Her essays, reviews, and translations have appeared in English and Japanese.

Youngna Kim (Kim Yongna) is associate professor of Art History in the Department of Archaeology and Art History, Seoul National University. Before turning to research in modern Korean art, she was trained at Ohio State University in modern European art. Her essays have been published in Korea, Japan, and Australia. Her latest work is *Issip segi ui han'guk misul* (Art of Twentieth-Century Korea) (Seoul: Yekyong, 1998).

David McCann is Korea Foundation Professor of Korean Literature in the Department of East Asian Languages and Civilizations at Harvard University. His numerous critical studies and translations of Korean poetry include *Form and Freedom in Korean Poetry* (Leiden: Brill, 1988) and *Selected Poems of Kim Namjo* (Ithaca: East Asia Program, 1993).

Marlene J. Mayo teaches modern Japanese and East Asian history at the University of Maryland, where she also directs the Undergraduate Certificate Program in East Asian Studies. She is a cofounder of the Inter-College Committee on East Asian Studies, University of Maryland, and past chair of the Northeast Asia Council, Association for Asian Studies. She has published extensively in English and Japanese on the Iwakura Embassy, the origins of the modern Japanese empire, U.S.–Japan economic relations in the 1930s, and the mass media and cultural policies in occupied Japan. Her current research is on women and gender in modern Japanese history and the Japanese diaspora.

J. Thomas Rimer is chair of the Department of East Asian Languages and Literatures at the University of Pittsburgh. He is the author and editor of numerous translations, articles, and books on Japanese literature, drama, and art, among them *A Reader's Guide to Japanese Literature,* the revised edition of which appeared in 1999. He has had a long interest in the writings of the Meiji author Mori Ōgai and is presently at work on a third volume of translations of Ōgai's work to be published by the University of Hawai'i Press. He is also at work with Van C. Gessel on an anthology of modern Japanese literature for Columbia University Press. In 1997 he was awarded the Order of the Sacred Treasure, Gold Rays with Neck Ribbon, by the Japanese government in acknowledgment of his various contributions.

Mark H. Sandler, an independent scholar of Japanese art history, received his Ph.D. in Japanese Art History from the University of Washington. He taught at numerous schools, including the University of Arizona, the State University of New York, College at Potsdam, and the University of Maryland, College Park, where he introduced the first course devoted entirely to the history of Korean art. At the time of his death in the fall of 1997, he was well advanced in a new field of research, modern Japanese war art, producing "The Living Artist: Matsumoto Shunsuke's Reply to the State," *Art Journal* (Fall 1996), and editing *The Age of Confusion* (Washington, D.C.: Smithsonian Institution, 1997).

Sodei Rinjirō is professor emeritus of Political Science at Hosei University (Tokyo), where he also served as dean. He is one of Japan's most prolific scholars on the Pacific War and Allied Occupation and has published extensively in Japanese and English. His works include, in English translation, *Were We the Enemy? American Survivors of Hiroshima* (Boulder: Westview Press, 1998) and *Senryō shita mono sareta mono: Nichi-Bei kankei no genten o kangaeru* (The Occupier and the Occupied: Essays on the U.S.–Japan Nexus) (Simul Press, 1986).

Alan Wolfe was chair of the Department of East Asian Studies at the University of Oregon until his illness and death in 1998. A longtime member of the editorial board of the *Bulletin of Concerned Asian Scholars,* he was also assistant editor of *Comparative Literature,* a journal published by the University of Oregon. His best-known work is *Suicidal Narrative in Modern Japan: The Case of Dazai Osamu* (Prince-

ton, NJ: Princeton University Press, 1990). His two great literary passions were Japanese and French literature, and he was both master and critic of literary theory.

Wang Hsiu-hsiung (Wang Xiuxiong) is one of Taiwan's most distinguished senior art historians. He was a professor and head of the Art Department at Taiwan Normal University, retiring in 1995. He is a professor of the Fine Arts Department at Tunghai University, Taichung, Taiwan. He continues his research on modern Taiwanese art and sculpture, and his publications on the arts of Taiwan span the entire twentieth century. His works include, in Chinese, *Art and Education* (Taipei Fine Arts Museum, 1990), *Essays on the Historical Development of Taiwan's Fine Arts* (Taipei: National Museum of History, 1995), *The Art and Artistic Style of Huang Tu-shuei, the First Modern Sculptor of Taiwan* (Taipei: Artist, 1996), and *Theories and Practice of Art Appreciation Instruction* (Taipei: National Museum of History, 1998).

Angelina C. Yee, former associate professor of Chinese Language and Literature at the University of Maryland, is dean of the Humanities Division, Hong Kong University of Science and Technology. Her research interests include the premodern Chinese novel and feminism, as well as colonial and postcolonial Taiwan and Hong Kong literatures. She has published widely, in both English and Chinese, on the classic novel *Honglou meng* and is working on a book on cultural constructions of Taiwan and Hong Kong identities.

383

Index

393

403